ROME

ROME

A CULTURAL, VISUAL,
AND PERSONAL HISTORY

Robert Hughes

ALFRED A. KNOPF · NEW YORK · 2011

THIS IS A BORZOI BOOK
PUBLISHED BY ALFRED A. KNOPF

Copyright © 2011 by Robert Hughes
All rights reserved. Published in the United States by Alfred A. Knopf,
a division of Random House, Inc., New York, and in Canada by
Random House of Canada Limited, Toronto.
www.aaknopf.com

Knopf, Borzoi Books, and the colophon are registered
trademarks of Random House, Inc.

English translation of Giuseppi Belli's "L'illuminazione de la cuppola"
courtesy of Anthony Merlino.

ISBN 978-0-307-26844-0

Front-of-jacket image: Roman face, marble,
first century B.C.E. Marafona/Shutterstock
Jacket design by Chip Kidd

Manufactured in the United States of America
Published November 2, 2011
Second Printing, November 2011

For Doris, with love, again

Contents

Acknowledgments

The last and I daresay only book I've written about a major city was published over twenty years ago. That book was *Barcelona*, a city I'd visited frequently due to my longstanding friendship with the sculptor Xavier Corbero, and it was through his eyes that I discovered the Catalan gem that was to steal my heart and lure me back with its siren song, so magical and alluring. Several years ago, my literary agent, Lynn Nesbit, called on a bright, early spring day and proposed a book on the subject of Rome. Her enthusiasm and vibrant energy rhymed with the emerging greens of the early spring unfolding outside, making it impossible to decline. Lord Weidenfeld, the formidable publisher of Weidenfeld & Nicolson, London, had been conceptualizing this book for many years and decided it must be done and done as a complete history, to be called "The Seven Hills of Rome." Being handed his vision of this project was a privilege and an honor of which I am eternally grateful.

Rome is a city where I have spent much time, but unlike Barcelona, I had not had the opportunity to live and breathe the air for months on end. My knowledge of the history came to me by my profession as a writer and critic of art. It was the visual language in my travels in and around the city that built the foundation for my historical reference, and in taking on this challenge my internal reservoirs could begin to flow into a cohesive stream of history—Rome in chronology and through my own eyes, the eyes that have seen the priceless art and architecture, the structure of a city that, historically, will never be complete. Master craftsmen, artists, rulers, warriors, and social anthropologists, now long gone, bestowed the world with one of the greatest treasures known to man.

Early on, during one of my first research visits to Rome, I realized what a mammoth undertaking this book was to be, something that was not lost on my wife, Doris Downes. I am deeply grateful on many levels: for her support as a partner, her loyalty, her friendship, and her own knowledge of the city. Because of my compromised state of mobility, the effects of a car wreck in the Australian outback thirteen years ago, I

relied heavily on her and on my many friends in Rome to help negotiate the sites and research facilities as well as the politics. For these noble tasks, I would like to thank Peter Glidewell, advisor for the Foundation for Italian Art and Culture (FIAC), who spent his lifetime in this city and seemed to know every coin in every fountain with his sophisticated views on what Rome had been and what it is today. He spent much time organizing my agenda in and around a city that is not and can never be "disabled-friendly" without razing every street of its paving stones. His knowledge and patience in working with me, as well as his loyalty, I will never be able to fully repay. In addition, I would like to thank my friends Alain Elkann and Rosy Greco for their hospitality in our visits to the city by offering their grace and generosity in providing me with a spectacular space in which to hang my hat, and to Lucio Manisco, my dear old friend and journalist in Rome.

Anyone who is familiar with my past acknowledgments knows that they are never complete without my thanking a major hospital and entire wing of specialists and interns. This time, the gong goes to Policlinico Umberto Primo, located within the city proper. Without their careful attention, I would not have been able to complete this book. I would also like to give my heartfelt appreciation to Doris, who, putting her own important work aside, flew back to Rome to navigate the medical labyrinth of this sprawling teaching hospital and managed for us a safe return back to New York.

I am deeply indebted to my indefatigable editors at Knopf. First, to Peter Gethers, a tireless and most talented editor, made this book entirely possible, along with Claudia Herr. I thank them for their patience and professionalism throughout this long process, as well as editorial assistants Christina Malach and Brady Emerson, production editor Kevin Bourke, jacket designer Chip Kidd, publicist Kathy Zuckerman, and my assistant Ian McKenzie. Nor could it have gone to print without the continued generosity of the New York Public Library in giving me access to the Allen Room, with its rare treasures, that helped to bring this book to life in so many ways.

In closing, I would like to thank my stepsons, Garrett and Fielder Jewett, for their love and encouragement during the years of writing intermixed with my many bouts of self-doubt that it would ever come to completion.

ROME

Prologue

I have eaten, slept, looked until I was exhausted, and sometimes felt as though I had walked my toes to mere stubs in Rome, although I have never actually lived there. I only ever lived outside the city; not on the mediocre *periferia* that grew up to accommodate its population surge in the fifties and sixties, but in places along the coast to the north, like the Argentario Peninsula. I quite often came into Rome itself, rarely for more than a week or two, and not often enough to qualify as a resident by paying rent to anyone but a hotel owner, or having a kitchen wall on which to permanently hang my wicker spaghetti-strainer, which remained in Porto Ercole.

For a time in my adolescence—not knowing Rome in any but the sketchiest way—I longed to be a Roman expatriate and even felt rather hypocritical, or at least pretentious, for having any kind of opinions about the city. Everyone, it seemed to me then—this being a time that began in the early fifties—knew more about Rome than I did. I was nuts about the idea of Rome, but to me it was hardly more than an idea, and a poorly formed, misshapen idea at that. I had never even been to the place. I was still in Australia, where, thanks to an education by Jesuits, I spoke a few sentences of Latin but no Italian whatever. The only semi-*Romano* I knew was actually Irish, a sweet, white-haired, elderly Jesuit who ran the observatory attached to the boarding school I had attended in Sydney, and who from time to time would travel to Italy to take charge of its sister institution, belonging to the pope (Pius XII, aka Eugenio Pacelli) and situated at Castelgandolfo, outside the Eternal City. From there, doubtless enriched with recent astronomical knowledge whose dimensions I had no idea of, he would bring back postcards, sedulously and with obvious pleasure gleaned from their racks in various museums and churches at ten to twenty lire each: Caravaggios, Bellinis, Michelangelos. He would pin these up on one of the school notice boards. Naturally, they were Old Masters of the chaster sort: no rosy Titianesque nudes need be expected. I have no idea what success these gestures might have

had in the direction of civilizing the robust cricket-playing lads from Mudgee and Lane Cove who were my schoolfellows. But I know they had some on me, if only because having such things in a church, however distant, seemed (and was) so exotic, and therefore, if only in miniature reproduction, so attractive.

The religious art one encountered at a Catholic Australian school like mine (and, indeed, throughout Australia) was of a very different kind from this. It was made of plaster and conceived in a spirit of nauseating piety by a religious-art manufacturer named Pellegrini, and it was all of a sweetness and sickliness that I hated then and whose remote memory I still resent today: cupid-lipped Madonnas robed in a particularly sallow shade of light blue, simpering Christs on or off the cross who looked like some gay-hater's fantasy with curly chestnut hair. I don't know how this *bondieuserie* was sold. Maybe Pellegrini's had some kind of primitive mail-order catalogue. Or maybe there was a salesman with a Holden panel van, lugging the samples from church to church: plaster Teresas and Bernadettes, virgins holding stems of plaster lilies, priced at so much per inch of height. How one could be expected to pray through, to, or in front of this rubbish was an abiding mystery to me. As far as I could discover there was not one work of religious art in Australia that anyone except a weak-minded nun, and a lay sister at that, could call authentic.

Where could one see the real thing? Clearly, only in Rome. How would one know what feeling in religious art actually was authentic? By going to Rome. Come down to it, how would one know that art of any kind was any good? Mainly—if not only—by going to Rome, and seeing the real thing in the real place. Rome would be my entry door to Italy and then to the rest of Europe. And with that would come sophistication and taste and possibly even spirituality. Not to mention all the other, more earthly delights I was also looking forward to. From this distance I am embarrassed to admit that I can no longer remember their names, but to me they looked just like the girls I saw in Italian movies. If I was lucky I might even be able to latch on to some of those unbearably chic pants, jackets, and thin-walled shoes from Via Condotti, though where the money would come from I didn't know.

When I finally got there, in May 1959, much of this turned out to be true. Nothing exceeds the delight of one's first immersion in Rome on a fine spring morning, even if it is not provoked by the sight of any particular work of art. The enveloping light can be of an incomparable clarity, throwing into gentle vividness every detail presented to the eye.

First, the color, which was not like the color of other cities I had been in. Not concrete color, not cold glass color, not the color of overburned brick or harshly pigmented paint. Rather, the worn organic colors of the ancient earth and stone of which the city is composed, the colors of limestone, the ruddy gray of tufa, the warm discoloration of once-white marble and the speckled, rich surface of the marble known as *pavonazzo,* dappled with white spots and inclusions like the fat in a slice of mortadella. For an eye used to the more commonplace, uniform surfaces of twentieth-century building, all this looks wonderfully, seductively rich without seeming overworked.

The very trees were springing, tender green, not the more pervasive drab gray of the Australian eucalypts I was used to. Some of them were in blossom—the pink and white bursting into bloom of the oleanders by the roadsides. Azaleas were everywhere, especially on the Spanish Steps: I had been lucky enough to get to Rome at the very time of the year when florists bank the Scalinata di Spagna with row after row, mass upon mass, of those shrubs, whose flowers were all the sweeter for being short-lived. And it was not only the flowers that looked festive. The vegetables were burgeoning in the markets, especially the Campo dei Fiori. Their sellers did not want to constrain them. Bunches of thyme, branches of rosemary, parsley, bundled-up masses of basil filling the air with their perfume. Here, a mountain of sweet peppers: scarlet, orange, yellow, even black. There, a crate filled with the swollen purple truncheons of eggplants. Next to that, a parade of tomatoes, fairly bursting with ripeness—the red egg-shaped San Marzanos for sauce, the broad-girthed slicing tomatoes, the ribbed ones for salads, the green baby ones. Even the potato, a dull-looking growth as a rule, took on a sort of tuberous grandeur in this Mediterranean light.

Then there became apparent something of a kind I had never seen at home in Australia. All this vegetable glory, this tide of many-colored life, this swelling and bursting and fullness, welled up around a lugubrious totem of Death. The piazza in which this market is held, the Campo dei Fiori, translates literally as "Field of Flowers." There are several versions of how it acquired this name. It was not always a garden; possibly it had never been a garden, in the sense of a place where plants were cultivated and picked. One version has it deriving from Campus Florae, 'Flora's Square," and thus named after the (supposed) lover of the great Roman general Pompey, who (supposedly) lived in a house there.

But the male presence that dominates this beautiful, unevenly built

square is not Pompey, but someone later than classical Roman: a dark, brooding figure, cowled, standing on a tall plinth, his hands crossed before him gripping a heavy book—a book, it seems, of his own writing. The whole piazza seems to circulate around him; he is its still point. He is a vertical totem of bronze darkness and melancholic gravity in the middle of all that riot of color, and it may take a moment or two to find his name on a plaque half hidden behind the sprays of flowers. It is Giordano Bruno, and even a tyro from Australia had heard of him. He was a philosopher, a theologian, an astronomer, a mathematician, and, not least, both a Dominican monk and a heretic—all told, one of the most brilliant and unorthodox Italian minds of his time, the last half of the sixteenth century. One of the thoughts Bruno proposed and taught was that the universe, far from being the tight and limited system of concentric spheres conceived by medieval cosmogony, all tied into orbit around their Unmoved Mover, was in fact infinitely large—a vast continuum consisting of sun after sun, star upon star, eccentric to one another and all in independent movement. This was the startling germ of a modern vision, and the more conservative, theologically grounded thinkers of the sixteenth century viewed it with alarm as opening an attack on the very idea of a God-centered universe. It is difficult for anyone in the twenty-first century to grasp how radical Bruno's proposal that the stars we see at night are other suns, identical in nature to our own, seemed over four hundred years ago. The idea of a plurality of worlds, which we have no difficulty in accepting, was not merely novel but threatening in the sixteenth century. Moreover, there were other difficulties with Bruno. He was fascinated by hermetic thought and by ideas about magic. He was rumored, and by the ignorant believed, to traffic with the Devil. This idea arose from his extraordinary, pioneering researches into "mnemonics"—the art of systematic memory, a widely shared obsession among Renaissance intellectuals in which Bruno was a leader. For the unorthodoxy of his views, Bruno aroused further suspicion, especially from an Inquisitor appointed to refute his views—the formidable Catholic thinker, a Jesuit and a cardinal of the Church, in himself a spearhead of the Counter-Reformation against Luther, Robert Bellarmine (1542–1621), who lies entombed in the Church of the Gesù in Rome. This was no mere bigot, but one of the great conservative intellectuals of the Church, its leading authority on the theology of Saint Thomas Aquinas, and he saw in Bruno a dangerous philosophical enemy. The arguments went on, back and forth, for seven years. On February 17, 1600, Bruno

was brought out of his prison cell—the last of several in which he had languished while on trial for a dozen heresies—and led to the center of the Campo dei Fiori, where a pyre had been prepared. *"Maiori forsan cum timore sententiam in me fertis quam ego accipiam,"* he said to his priestly accusers: "Perhaps you pronounce this sentence against me with greater fear than I receive it." The brand was applied to the dry wood. As the flames came roaring up to envelop him, Bruno was heard to utter neither a prayer nor a curse.

Thus perished one of the true intellectual heroes of the Italian Renaissance. He was burned alive for holding erroneous opinions about the Trinity, the divinity and incarnation of Christ, for denying the virginity of Mary, and half a dozen other heretical positions, including belief in "a plurality of worlds and their eternity" and "dealing in magic and divination." His chief Inquisitor, Cardinal Bellarmine, demanded a full recantation, which Bruno refused. When the fire died down to cinders, whatever remained of Giordano Bruno was scraped up and dumped in the Tiber, and all his many writings, both philosophical and scientific, dozens of books, were placed on the Index, the Vatican's list of forbidden texts. The statue was put up in 1889, with the advice of a committee partly Roman and partly foreign, which included such distinguished non-Catholics as the German historian Ferdinand Gregorovius, Victor Hugo, and Henrik Ibsen. The fruit and vegetables of the Campo dei Fiori would renew themselves forever, in freshness, as his best memorial.

Giordano Bruno was the most distinguished but not by any means the last person to be executed for his sins in the Field of Flowers. All sorts of people, from ordinary murderers to practitioners of the black arts, paid there with their lives in the seventeenth century. A surprising proportion of them were renegade priests. This must have suited other visitors to the square very well, since public executions were always popular in Rome—as, indeed, they were throughout Europe. Partly because of this, the Campo also supported a vigorous and profitable hotel trade. One of the best-known inns of the city, named La Locanda della Vacca ("Inn of the Cow"), which occupied the corner of Vicolo del Gallo and Via dei Capellari, was owned by Vannozza dei Cattanei, the former mistress of Cardinal Rodrigo Borgia, who held the papacy from 1492 to 1503 under the name of Alessandro VI. With matchless impudence, Vannozza arranged to have her coat of arms emblazoned in quarter with the Borgia pope's; they can still be seen over the entrance in Vicolo del Gallo. Rome's oldest inn, supposedly, was the Locanda del Sole, built from *spo-*

lia salvaged from the nearby ruins of the Theater of Pompey. It is still open for business at Via del Biscione 76 as the Sole al Biscione Hotel.

I do not visit Saint Peter's every time I go to Rome. The atmosphere of faith is too imposing and even becomes, as rhetorical sublimity sometimes can, somewhat monotonous. Nor do I always make a beeline to favorite places like the Church of Santa Maria della Vittoria, which contains Bernini's wonderful Cornaro Chapel. Sometimes I don't even enter a museum, because in a sense all Rome is a museum inside out. But the Campo dei Fiori, and its statue of Giordano Bruno, has been holy ground to me ever since I first encountered it, in ignorance, and I seldom fail to visit it and reflect on what it represents.

For how could I not? That piazza is quintessential Rome to me: essential Rome five times over.

Essential, first, because of the terrible and authoritarian memory it summons up, of the Roman Church, which without qualms could burn to death one of the most brilliant men in Italy for the crimes of teaching (as Bruno apparently did) that Christ was not God but an inspired magus, and that even the Devil might be saved. (How I wish I could have known him!) A quatrain circulated:

> *Roma, se santa sei,*
> *Perchè crudel se' tanta?*
> *Se dici che se' santa,*
> *Certo bugiardo sei!*

"Rome, if you're holy / Why are you so cruel? / If you say you're holy / You're nothing but a liar!"

Essential, secondly, because some four hundred years after killing him the city could change its mind (against the opposition of the clergy), retract its judgment, and, in recognition of Bruno's individual greatness, raise a statue in his honor. A bit late, perhaps, but certainly better late than never.

Thirdly essential because Rome could only build such a monument when the Church's temporal power over the city ceased to exist, after Rome was captured in 1870 by the newly formed Kingdom of Italy and became politically a secular city.

Fourthly so because the presence of Bruno's great dark totem is such a brilliant urban gesture, and the life that goes on around it is the life of the Roman people, not just of tourism.

Fifthly and last because of the daily superfetation of fruit and flow-

ers, and the appetites they inspire, reminding us that in the presence of Death we truly and absolutely are in Life.

For Rome is certainly a city driven by her appetites. Much of the food one ate, in and out of this piazza, was quite unfamiliar to me, for all its simplicity. In Australia I was never, as far as I remember, offered something as exotic as *baccala,* salt cod: it was simply not a part of the Australian diet. In Rome, of course, *baccala fritta* was a staple of street food: soak the board-stiff slabs of cod for several days in changes of water, take off the skin, remove the bones, cut it into pieces as wide as two fingers, drop it in batter, and then fry it in oil to a rich golden brown. Nothing could be simpler than this, and what could taste better with a cold glass of Frascati, consumed at a table in a foreign piazza in early-afternoon sunlight? The fried foods of Rome, the salads, even the humble cornmeal mush known as polenta were, in every way, a revelation for a hungry young man whose experience of Italian food was as limited as mine. I had never eaten a zucchini flower before getting to Rome. Nor had I ever come across a dish like the anchovies with endive, layered in an earthenware pan and baked until a crust forms, to be eaten hot or cold. Some of these dishes were doubly exotic because of their Jewish origins. As an Australian Catholic, I was all but unaware of the existence of Jewish food, and because of the tiny Jewish population of Australia its recipes had never entered the mainstream of popular cooking, as they had in America. But Rome had ancient Jewish traditions, food among them. What foreign goy could be expected to know about those? One example was the Roman dish known as *carciofi alla giudia,* Jewish-style artichokes, which I soon learned to dote on, as any goy might. Take your artichokes, strip their tough outer leaves, and, holding them stem-upright, squish and whack them down on the table until the inner leaves spread outward. Immerse them, like early martyrs, in boiling oil. Gradually the artichokes will turn spikily golden, like the petals of a sunflower, and then a rich brown. They are almost ready. Sprinkle them with a hand dipped in cold water, and they will begin to crackle invitingly. Then sprinkle again with oil, and serve.

But food wasn't all that had me enraptured on my first hungry visit to the city. In Rome, for the first time in my life, I felt surrounded by speaking water. What trees are to Paris, fountains are to Rome. They are the vertical or angled jets, wreathing, bubbling, full of life, which give measure to the city. I had never seen anything like that before. In other places fountains are special events, but in Rome they are simply part of

the vernacular of civic life; you notice them, you see them as exceptions to the surfaces of stone or brick, but it seems that they are there to be breathed, not just seen. In the center of the great city one is always aware, if only subliminally, of the presence of water. No other city (or none that I know) so incarnates the poetic truth of the opening lines of Octavio Paz's poem "Piedra del Sol" ("Sunstone"), evoking the continuous movement of a city fountain:

> A willow of crystal, a poplar of water,
> A tall fountain the wind arches over,
> A tree deep-rooted yet dancing still,
> A course of a river that turns, moves on,
> Doubles back, and comes full circle,
> Forever arriving.

The fountain is, in its very essence, an artificial thing, both liquid—formless—and shaped; but the jets of Bernini's Piazza Navona, glittering in the sun, mediate with an almost incredible beauty and generosity between Nature and Culture. Thanks to its fountains—but not only to them—Roman cityscape constantly gives you more than you expect or feel entitled to as a visitor or, presumably, a citizen. *What did I do to deserve this?* And the answer seems ridiculously simple: *I am human, and I came here.*

Some of the most wonderful first glimpses of Rome, for me, were quite unexpected and rather close to accidental. I had meant to approach Saint Peter's as it is shown on the city maps—by walking up the broad, direct avenue of the Via della Conciliazione, which runs straight from the Castel Sant'Angelo to the vast, colonnaded space of Piazza San Pietro. Luckily for me, I got this wrong. I went too far to the left and approached the piazza, which I could not see, from near the Borgo Santo Spirito. After some trekking, during which I had little idea where I was, I came across what I supposed was a massive curving wall. It was nothing of the kind. It was one of the mighty columns of the piazza itself, and when I crept around it the space burst into view. No straight approach up the Via della Conciliazione could have offered this surprise. As generations of previous tourists have been, I was thunderstruck by the sight: the fountains, the vertical of the obelisk, but above all the curve of Bernini's double Doric colonnade. The idea of architecture of such scale and effort had never entered my mind before. Of course I had never seen anything like it—for the rather obvious reason that nothing else like Bernini's piazza and col-

onnade can be seen, in Australia or out of it. For a twenty-one-year-old student to go from memories of Australian architecture (which had its moments and its virtues, most conspicuously the Sydney Harbour Bridge, but really none like this) to such near-incomprehensible grandeur was a shattering experience. It blew away, in an instant, whatever half-baked notions of historical "progress" may have been rattling about, loosely attached to the inside of my skull.

It was being gradually borne in on me by Rome that one of the vital things that make a great city great is not mere raw size, but the amount of care, detail, observation, and love precipitated in its contents, including but not only its buildings. It is the sense of care—of voluminous attention to detail—that makes things matter, that detains the eye, arrests the foot, and discourages the passerby from passing too easily by. And it goes without saying, or ought to, that one cannot pay that kind of attention to detail until one understands quite a bit about substance, about different stones, different metals, the variety of woods and other substances—ceramic, glass, brick, plaster, and the rest—that go to make up the innards and outer skin of a building, how they age, how they wear: in sum, how they live, if they do live. An architect's flawless ink-wash rendering of a fluted pilaster surmounted by a capital of the Composite order is, necessarily, an abstraction. But as an architecture student in Australia, I knew little else about the old stuff. It has not become architecture yet, and it will really not do so until it is built and the passage of light from dawn to dusk has settled in to cross it, until time, wind, rain, soot, pigeon shit, and the myriad marks of use that a building slowly acquires have left their traces. Above all, it will not become architecture until it is clearly made of the world's substance—of how one kind of stone cuts this way but not that, of bricks whose burned surface relates to the earth below it. Now, Rome—not the society of people in the city, but their collective exoskeleton, the city itself—is a sublime and inordinately complicated object-lesson in the substantiality of buildings and other made things, in their resistance to abstraction.

This is an awareness that a student cannot really get from listening, however attentively, to lectures, no matter how skilled and sympathetic the lecturer. Nor is he or she well placed to grasp it by looking at photos, though photos are certainly a help. It needs to be got, and can only be acquired, from the presence of the thing itself. And of course the sense of it cannot come into existence, as a general characteristic of a city, unless the city has the clarity and deliberation of something that has been made,

preferably by hand, and bit by bit—unless you can see that the depth of a molding or the sculptural profile of a capital is not there by accident or habit, but by intent, by design. That it is wrought, not just slapped on. It is too much to expect that everything in a city should partake of this quality of attention and intention. But without it, you have a suburb, a mall, whatever you want to call it—not a real city. This is why Chicago is truly a city but Flint, Michigan, can never be.

Rome abounds in such realizations. Sometimes you think that every yard of every crooked alley is full of them. But for the new and uninstructed arrival, such as I was in 1959, it is naturally the very big and rather obvious ones that strike first, and for me the most decisive and revelatory of these first encounters was not in Piazza San Pietro, that mythic center of faith, but on the other side of the Tiber, up on the Capitol, above Piazza Venezia. Its messenger was not a religious work of art, but a pagan one: the ancient bronze statue of the Emperor Marcus Aurelius (121–180) riding his horse, in the most noble silence and stillness, on a pedestal which rose from the center of a twelve-pointed star, in the trapezoidal piazza Michelangelo designed for the Campidoglio. I had seen photographs of it, of course; who hadn't? But nothing really prepared me for the impact of that sculpture, both in its mass and in its detail. It is by far the greatest and, indeed, the only surviving example of a type of sculpture which was widely known and made in the ancient pagan world: the hero, the authority figure, the demigod on horseback; human intelligence and power controlling the animal kingdom, striding victoriously forward. There used to be twenty or so such bronze equestrian statues in Rome, and yet more throughout Italy, such as the *Regisole* or *Sun King* in Pavia, which was so thoroughly destroyed in 1796 that not a skerrick remains, and the only surviving trace of it is a mere woodcut on paper. All were toppled, broken up, and melted down by pious, ignorant Catholics in the early Middle Ages, who believed that their vandalism was an act of faith, an exorcism of the authority of the pagan world. Only Marcus Aurelius survived, and by mistake. The good Catholics mistook it for a horseback portrait of the first Christian emperor of Rome, Constantine the Great. But for that sublimely lucky error, Marcus Aurelius would have joined all the other bronze emperors in history's indifferent melting pot.

I, of course, knew next to nothing of this history when, as a young lad on that summer evening of 1959, I saw the bronze horseman for the first time, dark against the looming golden background of the Palazzo

del Senatore, with the bats beginning to flit around. I knew even less about horses, old or new, bronze or flesh. I was a city boy, despite sojourns in the bush, and to me these animals were "dangerous at both ends and uncomfortable in the middle." The very idea of scrambling up on a fourteen-hand horse touched me with reluctance, even dread. But as I circled the pedestal, looking up at the magnificently robust displacements of space and shape afforded by the limbs and bodies of horse and man, I realized that this horse and this rider were beyond and outside any sculpture—indeed, any work of art—I had seen before.

It may be that Australia had some equestrian bronzes in it—war memorials, perhaps?—but if it did, I do not remember them. It probably didn't, because the fabrication of a life-sized bronze man on a bronze horse consumes a great deal of metal and is prohibitively expensive in a country that had no tradition of public sculpture. Such sculpture also requires a special foundry and special skills, neither of which could have been available in my homeland.

But what really made Marcus Aurelius and his mount unique in my very limited experience was their confluence of sculptural grandeur with intimacy of detail. You can make a big, generalized horse and a full-scale, generalized man without exciting the feelings that more detailed sculpture can produce. But that would not offer what Marcus Aurelius delivers, that passionate apprehension of small things combining and flowing into large ones, the ordered accumulation of details locked together in a larger image of life. This is no rocking horse: the lips, constrained by its metal bit, fold and grimace under the tension on the reins; they look fierce but they testify to imperial control. Marcus Aurelius' hair stands energetically up, a nimbus of corkscrewing locks, not a bit like the conventional signs for hair that plaster so many Roman marble crania. The extended right hand, in its gesture of calming power, is majestic (as befits the hand of an emperor) but benign (as a Stoic's well might be; this was the hand that wrote Marcus' *Meditations*). The different thrusts and directions of the statue's limbs are adjusted to play off one another, the raised left foreleg of the horse against the splayed legs of the man astride it, with an uncanny appreciation of movement. And then there is the color. The bronze carries the patina of nearly two thousand years. It is something which cannot be replicated by applied chemicals. It speaks of long exposure, running out beyond the scale of dozens of human generations, each contributing its small freight of patches, gold blotches, green streaks, and pinhole discolorations to the venerable surface. When I first

saw the Marcus Aurelius, this process had been going on uninterrupt-
edly, like some extremely slow maturation of wine, for a very long time
and was part of the simultaneous but differently scaled aging of Michel-
angelo's architectural frame for the horse and rider—the crisper contours
of the pedestal, the bloom and discoloration of the mellowed surface of
the Palazzo del Senatore.

One's interest in the past is, at a young age, minimal—it seems so
distant and irrelevant and, in so many ways, imbued with failure. The
future is equally inconceivable; one is overwhelmed by the romance of
possibility. But that was the magic of Rome for my younger self. The
city was my guide backward as well as forward. It provided insight into
beauty as well as destruction, triumph as well as tragedy. Most of all, it
gave physical form to the idea of art, not simply as something ethereal
for the elite but as something inspiring, even utilitarian. For me, that first
time, Rome turned art, and history, into reality.

1

Foundation

Although nobody can say when Rome began, at least there is reasonable certainty of where it did. It was in Italy, on the bank of the river Tiber, about twenty-two kilometers inland from its mouth, a delta which was to become the seaport of Ostia.

The reason no one can pinpoint when the foundation took place is that it never ascertainably did. There was no primal moment when a loose scatter of Iron and Bronze Age villages perched on hills agreed to coalesce and call itself a city. The older a city is, the more doubt about its origins, and Rome is certainly old. This did not prevent the Romans from the second century B.C.E. onward coming up with implausibly exact-looking dates for its origins: Rome, it used to be asserted, began not just in the eighth century but precisely in 753 B.C.E., and its founder was Romulus, twin brother of Remus. Here a tangled story begins, with many variants, which tend to circle back to the same themes we will see again and again throughout Rome's long history: ambition, parricide, fratricide, betrayal, and obsessive ambition. Especially the last. No more ambitious city than Rome had ever existed, or conceivably ever will, although New York offers it competition. No city has ever been more steeped in ferocity from its beginnings than Rome. These wind back to the story of the city's mythic infancy.

In essence, the story says that Romulus and Remus were orphans and foundlings, but they could claim a long and august ancestry. It stretched back to Troy. After Troy fell (the legendary date of this catastrophic event being 1184 B.C.E.), its hero Aeneas, son of Anchises and the goddess Aphrodite or Venus, had escaped the burning city with his son Ascanius.

After years of wandering on the Mediterranean, Aeneas fetched up in Italy, where Ascanius (now grown up) founded the city of Alba Longa, not far from the eventual site of Rome, traditionally in about 1152 B.C.E.

Here, Ascanius' progeny began a line of kings, his descendants. The last of the line was called Amulius, who wrested the throne of Alba Longa from its rightful occupant, his elder brother, Numitor.

Numitor had one child, a daughter named Rhea Silvia. Amulius the usurper used his convenient, newly seized power to make her a vestal virgin, so that she could not produce a son, who might be not only Amulius's heir but also a deadly threat to him. But the war god, Mars, no respecter of either virginity or vestality, impregnated Rhea Silvia. Amulius, realizing she was pregnant, had Rhea Silvia imprisoned; presently she died of ill treatment—but not before delivering her twin sons, Romulus and Remus.

We have the great historian Livy's word for what happened next. Amulius ordered his men to fling little Remus and Romulus into the Tiber. But the river had been in flood, and its waters had not yet receded. So, rather than wade right out into the current and get uncomfortably wet, they merely dumped the babies into the shallower floodwater at the river's edge, and went away. The level of the Tiber dropped some more, stranding the twins in the mud. In this state, wet but still alive, they were found by a she-wolf, which benignly nourished them with its milk until they were old and strong enough to be brought to adulthood by the royal herdsman Faustulus. (Most visitors, when they see the bronze sculpture in the Museo dei Conservatori of the Founding Babies sucking on the pendulous conical teats of the *lupa,* naturally think it is one original piece. It is not; the wolf is ancient and was cast by an Etruscan craftsman in the fifth century B.C.E., but Romulus and Remus were added c. 1484–96 by the Florentine artist Antonio del Pollaiuolo.)

In any case, in the myth they eventually overthrew Amulius and restored their grandfather Numitor to his rightful place as king of Alba Longa. And then they decided to found a new settlement on the bank of the Tiber, where chance had washed them ashore. This became the city of Rome.

Who would be its king? This was settled by an omen in the form of a flight of birds of prey. Six of them appeared to Remus but twelve to Romulus, thus marking him—by a majority vote from the gods above, as it were—as the indisputable ruler of the new city.

Where exactly was it? There has always been some disagreement over

the original, "primitive" site of Rome. There is no archaeological evidence for it. It must have been on one of the Tiber's banks—which one, nobody knows. But the district is famous for having had seven hills—the Palatine, the Capitoline, the Caelian, the Aventine, the Esquiline, the Viminal, and the Quirinal. Nobody can guess which one it may have been, although it is likely that the chosen site, for strategic reasons, would have been a hill rather than flatland or a declivity. Nobody was keeping any records, so no one can guess which one of these swellings, lumps, or pimples was a likely candidate. "Tradition" locates the primitive settlement on the modest but defensible height of the Palatine Hill. The "accepted" date of the foundation, 753 B.C.E., is of course wholly mythical. There was never any possibility of authenticating these early dates—of course nobody was keeping any records, and since later attempts at recording the annals of the city, all belonging to the second century B.C.E. (the writings of Quintus Fabius Pictor, Polybius, Marcus Porcius Cato), only began to be made approximately five hundred years after the events they claim to describe, they can hardly be deemed trustworthy. But they are all we have.

Supposedly, Romulus "founded" the city that bears his name. If things had gone differently and Remus had done so, we might now talk about visiting Reem, but it was Romulus who, in legend, marked out the strip of land that defined the city limits by hitching two oxen, a bull and a cow, to a plow and making a furrow. This was called the *pomerium* and would be the sacred track of the city wall. This, according to Varro, was the "Etruscan rite" for the founding of a city in Latium. Ritual demanded that the furrow, or *fossa,* the small trench of symbolic fortifications, should lie outside the ridge of earth raised by the plowshare; this ridge was called the *agger* or earthwork. The walls of the city were raised behind this symbolic line, and the space between it and the walls was scrupulously kept free of building and planting, as a defensive measure. The area within the *pomerium* would come to be called *Roma quadrata,* "square Rome," for obscure reasons. Evidently Remus took exception to it, for reasons equally unknown. Perhaps he objected to Romulus' assuming the right to determine the shape of the city. He showed his disagreement by jumping over the furrow—an innocent act, one might think, but not to Romulus, who took it for a blasphemous expression of hostile contempt and murdered his twin brother for committing it. History does not tell how Romulus may have felt about slaying his only brother over a perceived threat to his sovereignty, but it is perhaps signifi-

cant that the sacred group that ran around the *pomerium* at intervals to assure the fertility of Roman flocks and women in later years was known as the Luperci or Wolf Brotherhood.

So the embryo city, rooted in an unexplained fratricide, had one founder, not two, and as yet no inhabitants. Romulus supposedly solved this problem by creating an asylum or a place of refuge on what became the Capitol, and inviting in the trash of primitive Latium: runaway slaves, exiles, murderers, criminals of all sorts. Legend makes it out to have been (to employ a more recent simile) a kind of Dodge City. This can hardly be gospel-true, but it does contain a kernel of symbolic truth. Rome and its culture were not "pure." They were never produced by a single ethnically homogeneous people. Over the years and then the centuries, much of Rome's population came from outside Italy—this even included some of the later emperors, such as Hadrian, who was Spanish, and writers like Columella, Seneca, and Martial, also Spanish-born. Celts, Arabs, Jews, and Greeks, among others, were included under the wide umbrella of Romanitas. This was the inevitable result of an imperial system that constantly expanded and frequently accepted the peoples of conquered countries as Roman citizens. Not until the end of the first century B.C.E., with the reign of Augustus, do we begin to see signs of a distinctively "Roman" art, an identifiably "Roman" cultural ideal.

But how Roman is Roman? Is a statue dug up not far from the Capitol, carved by a Greek artist who was a prisoner-of-war in Rome, depicting Hercules in the style of Phidias and done for a wealthy Roman patron who thought Greek art the ultimate in chic, a "Roman" sculpture? Or is it Greek art in exile? Or what? *Mestizaje es grandeza,* "mixture is greatness," is a Spanish saying, but it could well have been Roman. It was never possible for the Romans, who expanded to exercise their sway over all Italy, to pretend to the lunacies of racial purity that came to infect the way Germans thought about themselves.

Several tribes and groups already inhabited the coastal plain and hills around the Tiber. The most developed in the Iron Age were the Villanovans, whose name comes from the village near Bologna where a cemetery of their tombs was discovered in 1853. Their culture would mutate by trade and expansion into that of the Etruscans by about 700 B.C.E. Any new settlement had to contend, or at least reach an accommodation, with the Etruscans, who dominated the Tyrrhenian coast and most of central Italy—a region known as Etruria. Where they originally came from remains a mystery. In all likelihood, they had always been there,

despite the belief held by some in the past that the Etruscans' remote ancestors had migrated to Italy from Lydia, in Asia Minor. The most powerful Etruscan city close to Rome was Veii, a mere twelve miles to its north—though the cultural influence of the Etruscans spread so wide that they made themselves felt far in the south, in what later became Pompeii. Until they were eclipsed by the rising power of Rome, around 300 B.C.E., they laid down the terms of culture in central Italy.

Never a centralized empire, they created city-states along the Tyrrhenian coast of Italy: Veii, Caere (now Cerveteri), Tarquinia, Vulci, and others, all of them ruled by high-priestly kings called Lucumones. Some of these settlements were linked in a loose federation, with ritual similarities and defense and trade agreements. Because of their military superiority—the Etruscan "tank" was a bronze-fitted chariot, and the basic unit of Etruscan warfare was a heavy-armored, close-knit phalanx, the ancestor of the Roman legion—they could dominate the less tightly knit forces of their tribal rivals, until the Romans moved in.

Other minor tribal groupings held territory in the neighborhood of Rome as well, one of these being the Sabines. They seem to have been hill people and shepherds, and their settlement may have been on the Quirinal Hill. An expansionist from the beginning, Romulus seems to have decided to go after this territory first. In order to lure the Sabines and their women within reach, Romulus is said to have held some horse races during the Festival of Consus (in August). The whole Sabine population turned up, and at a signal the Romans abducted all the young women they could lay their hands on. This amounted to a declaration of war between the Romans and the infuriated Sabines. (All Romans were Latins, but not all Latins were Romans. Roman power, including the power to confer Roman citizenship, was vested in Rome, and citizenship became an esteemed honor.) The Sabine King Titus Tatius gathered an army and marched against the Romans. But, in another scene made legendary by later artists such as Jacques-Louis David, the kidnapped Sabine women flung themselves between the two sides of furious males—brothers, fathers, husbands—and persuaded them to make peace, not war.

Peace and alliance between Sabine and Latin now prevailed. Romulus supposedly ruled the united tribes for another thirty-three years, and then dramatically vanished from the earth, wrapped in the thick darkness of a thunderstorm. Six kings are traditionally said to have succeeded Romulus, some Latin, others (notably the semi-legendary sixth-century

rulers Tarquinius Priscus and Tarquinius Superbus, "Tarquin the Arrogant") supposedly Etruscan. In legend, their succession began with Numa Pompilius, who reigned for forty-three years and established in Rome "an endless number of religious rites and temples." He was followed by Tullus Hostilius, who conquered the Albans and the people of the Etruscan settlement of Veii; by Ancus Marcius, who added the Janiculan and Aventine hills to Rome; by Tarquinius Priscus, said to have established the Roman Games; by Servius Tullius, who added the Quirinal, Viminal, and Esquiline hills and finished off the Sabines; and by Tarquin the Arrogant, who murdered Servius. Servius' son, Lucius Tarquinius Superbus, made peace between Latins and Etruscans. These kings established the *mons Capitolinus,* the Capitoline Hill, as the citadel and sacred center of Rome. Here the temples to the goddesses Minerva and Juno were raised, and, most sacred and important of all, the temple to Jupiter Optimus Maximus, "Jupiter Best and Greatest." It was (supposedly) dedicated by King Tarquin in 509 B.C.E. Although little is known about Tarquin the Arrogant as a historical figure, he contributed to most languages an expression which lives and is used down to the present day. According to Livy (who was writing about half a millennium later), the king taught a lesson with it to his son, Sextus Tarquinius, the future rapist of Lucretia. Having just conquered an enemy city, Tarquin was strolling with his boy in their garden when he began to chop off the heads of the tallest poppies in it. This, he explained, was the thing to do with leading citizens of a fallen town, who might cause trouble in defeat. Hence the modern term, especially loved and all too often used by sneering Australians to level the society around them, "tall-poppy syndrome."

The authority of kings in Rome lasted about two hundred years. Succession was not hereditary. During this time, the kings were in essence elected—not by all classes of the Roman people, but by the city's richest and most powerful elders, who (with their families) came to be known as the *patricii,* the patricians. These constituted a governing class, choosing and then advising the rulers of Rome. After the disappearance of the last king, Tarquinius Superbus, whom the patricians expelled and refused ever to replace, a system evolved that was designed never to put such authority in one man's hands again. Supreme authority was granted not to one but to two chosen figures, the *consules* (consuls). Their powers were exactly equal, and one could overrule the other: thus the Roman state could take no action on any issue unless both consuls agreed on it. This at least saved the Roman state from some of the follies of autocracy.

From now on, the prospect of "kingship" would be a political bogey to Romans; the consul Julius Caesar, to take the outstanding example, would be assassinated by a cabal of republicans who feared that he might make himself a king. Meanwhile, the religious powers of the kings were hived off and invested in a supreme priest, known as the *pontifex maximus.*

Every Roman citizen not a patrician was classified as a plebeian. Not everyone who lived in Rome enjoyed citizenship; it was not extended to slaves or resident aliens, of whom there were many. The official upper caste of power was next enlarged after 494 B.C.E., when the plebeian citizens—fretting at the arrogance with which patricians treated them—went on strike and refused army service. This could have been a disaster for an expansionist state like Rome, surrounded as it was by potential enemies. The disaster was averted by choosing each year two people's representatives known as "tribunes," whose duty was to see to and protect the interests of the plebeians. Before long, the number of officials granted the tribune's power, the *tribunicia potestas,* grew from two to ten. To clarify their field of action, written laws began to emerge, known at first in their primitive form as the Twelve Tables.

The city on the hill, or by now hills, was unstoppable. It continued to live and grow, to expand and conquer. It was singularly dynamic and aggressive, but about its life and physical traces we know very little, because of the absence of credible historical records and the crumbling away and demolition of buildings. Whatever there was is buried by subsequent Romes. In the words of the French historian Jules Michelet, "The Rome we see, which tears from us . . . a cry of admiration, is in no way comparable to the Rome we do not see. That is the Rome that lies twenty, thirty feet underground. . . . Goethe said of the sea, 'The further you go, the deeper it is.' So it is with Rome. . . . We only have the lesser part."

Perhaps, perhaps not. The deeper you go, the more primitive Roman architecture is apt to be. There are no legible traces of constructed Etruscan-Roman temples left standing. Much guesswork is needed to reconstruct the primal, Etruscan-based temple of Jupiter on the Capitoline, with its deep porch, heavy gabled roof with wide wooden eaves, and profuse terra-cotta roof decoration in the form of antefixes. The columns are very widely spaced, wider than they could possibly have been in stone construction. These forms belonged to wooden architecture, because they rely on the tensile capability of timber; stone is strong in compression and therefore excellent for posts and columns, but in ten-

sion, as a beam spanning a gap, it is weak. The emphasis of the building is on its front façade—unlike Greek temples, which were "peripteral" or designed to be seen with columns all round, on four sides. Vitruvius, the first great classifier of ancient Italian architecture, called this style "Tuscan," and so it remains.

What caused the gradual refinement of this kind of "primitive" Etruscan-Roman architecture was the influence of Greek building in the Hellenic colonies on the Italian mainland—Cumae, Neapolis (Naples), Zancle (Messina), Naxos, Catana, Leontini. Their temples tended to have all-round columning and established "orders" or styles of column-capital. It may be that liturgical changes favored abandoning the single-front temple. Or perhaps the all-round design of the Greek buildings that were rising in Hellenic colonies on the Italian mainland prompted imitation. The fluted column, whose vertical striations, in Greek hands, may have been a highly stylized memory of wood grain, never appears, but certainly the Etruscan builders' use of terra-cotta antefixes along their wooden roofs was adapted from Greek models.

Many of the Etruscan tombs and holy precincts that are recognizable today needed no columns at all, because they were built below ground level. Some of these, particularly in the country inland from Tarquinia, a city which overlooks the coast fifty miles north of Rome, are still in existence today, a tiny minority of them beautifully if somewhat crudely painted with scenes of hunting, fishing, feasting, sacrifice, dance, ritual, and (in the Tomb of the Bulls, behind Tarquinia) of sodomy. But these are hardly architecture—just decorated holes in the ground, or recesses under conical heaps of earth and stones.

Of their religion and gods, frustratingly little is known. Plenty of inscriptions in Etruscan survive, but they are, for the most part, historically quite useless—mere chicken-scratched names, not even memorializing dates and certainly not deeds. Because of the letters' kinship with the Greek alphabet, we can tell what the words probably sounded like, but rarely what they meant. It may be that the triad of principal Etruscan gods, Tinea-Uni-Menvra, corresponds exactly to the Roman triad Jupiter-Juno-Minerva, whose worship would be installed on the Capitol, but it may not—though "Menvra" is probably Minerva.

We know that some Etruscans were capable of exquisite sculpture in terra-cotta, and that some were experts in metalwork: this is clear from such masterpieces in bronze as the *Chimera of Arezzo*; the hauntingly Giacometti-like figure disinterred from a tomb in Volterra and

nicknamed, because of its extreme elongation, the *Ombra della sera* (*Evening Shadow*); the life-sized and elegantly detailed bronze figure of an Etruscan orator, which is one of the treasures of the Archaeological Museum in Florence; and the aforementioned emblematic *lupa* or she-wolf which, glaring fiercely up on the Capitol, suckles little Romulus and Remus. Perhaps the greatest of Etruscan terra-cotta sculptures is the late-sixteenth-century B.C.E. *Sarcophagus of the Spouses,* now in the Museo di Villa Giulia in Rome, a large chest in the form of a bed on which the young couple gracefully recline, the massing and delicate linear balance achieved with such delicacy that, for many visitors, it is the most touching and beautiful image in all Etruscan art. What did they die of? Did they go at the same time? Who could guess now? It was found in Cerveteri, but the most esteemed center of statuary in Etruria was Veii—so much so that the name of one of its artists, Vulca, who was commissioned to make statues for the great Temple of Jupiter on the Roman Capitol, has come down to us, the rarest of commemorations.

The Etruscans seem to have had few if any indigenous potters of the first rank, but their taste for fine ceramics brought remarkable pieces from Greece to Etruria as trade goods, which ended their travels in the tombs of the Etruscan great; the most famous of these, thanks to the sensation and controversy that surrounded its sale to the Metropolitan Museum of Art in New York and its eventual return to its true custodianship in Italy in 2008, was of course the big Greek wine-bowl known as the Euphronios krater, dug up and then stolen from the Etruscan necropolis of Cerveteri, north of Rome. The indigenous pottery material, not found in Greece, was a black clay known as *bucchero,* used unpainted, from which thousands and thousands of utilitarian pots and bowls were made, some of robust monochrome beauty.

Their architecture and most of their sacred artifacts may be gone, but the influence of the Etruscans is written everywhere on the early city-state of Rome. It affected the calendar—its division into twelve months, each with its "Ides" (the middle of the month), and the name of the month Aprilis, were of Etruscan origin. So was the way Romans personally named themselves—with a first and a clan name. The original Latin alphabet, of twenty-one letters, was probably adapted from an Etruscan adaptation of the Greek alphabet. The first temple on the Capitol was Etruscan. It was dedicated to Jupiter Optimus Maximus, with his companion goddesses Juno and Minerva. No ruins of it survive, but it appears to have been very large—two hundred feet square is a common

estimate—and, because of the necessary column spacing, its roof was made of timber: this meant, inevitably, that it often burned down. One can probably get a good idea of the cult image of Jupiter on its roof from the 500 B.C.E. terra-cotta Etruscan *Apollo of Veii* in the Museo di Villa Giulia in Rome.

Rome's Ludi, the games and gladiatorial contests that were to assume such colossal political importance under the Caesars, originated in Etruria. Some of the lifelike qualities of Roman portrait sculpture were already present in the vivid immediacy of Etruscan terra-cotta effigies.

Some Roman technical achievements began in Etruscan expertise. Though the Etruscans never came up with an aqueduct, they were good at drainage, and hence they were the ancestors of Rome's monumental sewer systems. Their land was crisscrossed with irrigation channels up to five feet deep and three feet wide known as *cuniculi*; but after Etruria was crushed by Rome its drainage was not kept up, so that much of the Campagna north of Rome degenerated into malarial heath and swamp and would remain uninhabitable in places until Mussolini's government drenched it with insecticides in the twentieth century.

It is probable that the Etruscans invented the segmental arch, without which Roman architecture could not have developed—the Greeks never had this structural form, but it is the basis of the Etrusco-Roman sewer system that culminates in the enormous, and still-visible, exit of the Cloaca Maxima into the Tiber.

Some Etruscan forms of political organization were kept up, in a broad way, by the early Romans, starting (legend says) with Romulus and continuing through the early Republic. They retained the institution of kingship, backed by patricians or aristocrats. But kingship was not hereditary: because his office as war chief was of absolutely central importance, the king was elected (though not by the common people). As high priest of the state, he had the task to find out the will of the gods by augury and haruspication. He was in charge of taxation and the military draft. He was the military leader. These things made up his executive power, or *imperium*. It was interwoven with the advice of his advisory body, the Senate, composed entirely of free citizens of standing—no paupers, workers, or freedmen (ex-slaves) allowed. The custom was that each patrician would enjoy the services of his plebeian "clients," persons of inferior rank (such as ex-slaves and foreigners) who would serve him in return for a place, however small, in public life. The patron-client

relationship would prove to be as durable in the future history of Rome as that between masters and slaves.

And before long, the institution of Roman kingship would wither away. By the fifth and early fourth centuries B.C.E. the aristocracy was victorious, and it proceeded to replace the king's functions and powers with those of the two consuls. Each consul—also known as a praetor—was elected to office for one year and had complete authority over civil, military, and religious matters. If necessary, the kingly power could be renewed, for a strictly limited term of six months, by an appointed dictator—but this was not often resorted to as a political device, and nobody was prepared to equate or confuse dictatorship with kingship.

The largest class of Romans was the intermediary one, attracted to settle and work in Rome by the steady expansion of the city and its territory. Rome kept pushing outward: in 449 B.C.E., for instance, it annexed a great deal of Sabine territory, and it was in more or less continuous confrontation with the tribes of the Volsci, who wanted—but failed—to cut off Latium from the sea. The Romans correctly saw it as essential to control both banks of the Tiber, and its mouth. The biggest danger of all, in the fifth century B.C.E., came from the north—the hostile Gauls, who had begun a piecemeal takeover of Etruria. One of their raids, in approximately 390 B.C.E., carried them right into Rome, though not for long. (A Gallic scouting party, so the story goes, had seen the tracks of a man on a cliff by the shrine of Carmentis, on the Capitol. They managed to follow up, ascending in such silence that not even a dog barked; but just as they were about to fall on the Roman garrison at the top, they disturbed some geese which, sacred to Juno, were kept on top of the Capitol. The cackling and flapping of these birds gave the alarm to the Roman defenders, who drove the Gauls off.)

The need for strong defensive forces against the Gauls and others increased the value of the plebeians to the Roman state, which could not defend itself with patricians alone—particularly since its territory kept growing through conquest and alliance. In 326 B.C.E. Rome had about 10,000 square kilometers; by 200 B.C.E., 360,000; by 146 B.C.E., 800,000 and by 50 B.C., nearly 2 million. The city on the Tiber was well on its way to ruling the known world.

Naturally, given their growing military and economic importance in their inferior position, the plebeians had demands to make. This was

when the tribunal system was set up. The hereditary aristocratic system of Roman power became less stably fixed because of them. The plebeians wanted champions, men who would defend their interests. Several tribunes were appointed. And the spread of Roman power kept inexorably growing. By the mid-fourth century B.C.E. Rome had swallowed up all the Latin cities, and all Latins in Rome enjoyed the same social and economic rights as Roman citizens. Part of Rome's political genius was that when she absorbed another political entity—*socii,* they were called, or allies—she moved its citizens to full Roman rights. The typical arrangement—with the Samnites, for instance—was that the *socius* tribes and cities kept their own territory, magistrates, priests, religious usages, and customs. But this did not amount to democracy. There was a general feeling that government required special skills, which a citizen or an ally needed to learn and acquire—they did not simply come with territory and land ownership. And meetings of the plebeians were very seldom held without patrician observers.

The Senate of Rome was distinguished from the "people," the mass of Romans. But the two were always envisaged as working in harmony together. This is commemorated in what, since time immemorial, has been the official device of the city of Rome, its *stemma* or shield. Preceded by a Greek cross, four letters run diagonally downward across the shield: SPQR. These have had many jocular interpretations, from *Stultus Populus Quaerit Romam* ("A Stupid People Wants Rome") to *Solo Preti Qui Regneno* ("Only Priests Are in Charge Here") and even, in a gesture toward the household marketplace, *Scusi, il Prezzo di Questa Ricotta?* ("Excuse Me, the Price of This Ricotta?"). But they just mean *Senatus Populusque Romanus* ("The Senate and People of Rome").

Few Romans saw anything amiss with the class relations that developed out of a state run by a patriciate. An exception was a pair of brothers, Tiberius Gracchus and Gaius Gracchus. Tiberius Gracchus was elected tribune in 133 B.C.E. and tried to legislate a redistribution of land from the rich to the poor. It is doubtful whether he was inspired by wholly pure and disinterested motives. More likely, the measures Tiberius Gracchus proposed were meant to curry favor with a plebeian majority so as to advance his own power. In any case, the patricians stamped on him, hard, and when Tiberius took the unprecedented step of seeking a second year's election as tribune, he was killed in a riot which they fomented. Much the same fate befell his brother, Gaius, who in 122 B.C.E., having been likewise elected tribune, tried to bring in laws that would have

given more power to plebeian assemblies and cheap grain to the needy. Patrician landowners viewed such measures with horror and arranged the lynching of Gaius Gracchus, and of several thousand of his supporters. In matters of class interest, the Roman Republic did not hesitate.

Undoubtedly, the chief Etruscan legacy to Rome was religious. Polybius, the Greek historian of the second century B.C.E., argued that Roman power came from Roman religion: "The quality in which the Roman commonwealth is most distinctly superior is, I think, the nature of their religious convictions. . . . It is the very thing which among other peoples is an object of reproach, I mean superstition, which maintains the cohesion of the Roman state." "Superstition" did not mean false fear of untrue fantasies. It related, rather, to the shared idea of *religio,* "re-ligion," a strong binding together. There can be no question that the unifying power of a common religion, linked at all points to the institutions of the state, reinforced Rome's political strength and increased her powers of conquest. Cicero was one of many who agreed with this. "We have excelled neither Spain in population, nor Gaul in vigor . . . nor Greece in art," he wrote in the first century B.C.E., "but in piety, in devotion to religion . . . we have excelled every race and every nation." The highest praise, the supreme adjective that one Roman could apply to another was *pius,* as in the *Aeneid,* Virgil's epic celebrating the mythic birth of Rome and the deeds of its founder, *pius Aeneas.* This did not mean "pious" in the English sense. It implied veneration of ancestors and their beliefs; respect for the authority of tradition; worship of the gods; above all, consciousness of and devotion to duty. It was a firmly masculine virtue whose implications went far beyond our milky notions of mere "piety." The only national sentiment that approached the full sense of Roman piety—and even then, perhaps not completely—was the English Victorians' belief that God was truly on their side, sharing the white man's burden in the immense task of founding, expanding, and glorifying the natural needs of the people in the face of the "fluttered folk and wild" whom it was their destiny to rule. There has probably never been a civilization in which religious imperatives were more entangled with political intentions than they were in early republican Rome. This characteristic of the city would last, of course; it underwrote the enormous political power of religion there from antiquity through papal Rome.

Certain religious practices came directly to Rome from Etruria. The native Roman religion, before it was re-formed by the adoption of Greek

gods, was animistic, not anthropomorphic. Its gods were rather vague and ill-defined spirits known as *numina,* from which our term "numinous" comes. Some of the *numina* survived in later Roman religion, long after the main Roman gods had been personalized and taken on the character of their Greek predecessors—Zeus becoming Jupiter, for instance, and Aphrodite becoming Venus.

Through early republican times, and even into those of the Principate, which brought the beginnings of one-man rule by Augustus and turned the Republic into the Empire, Roman religion was an absurd bureaucratic clutter of minor gods without defined character, who presided over innumerable social functions and needed constant propitiation by prayer and sacrifice. For most of them, only their names and some rather obscure functions have come down to us. In the growth of a baby, for instance, his cradle was supervised by Cunina, his breast-feeding by Rumina, his ingestion of adult food and drink by Educa and Potina, his first lispings of words by Fabulinus. Agriculture attracted a horde of godlets, who saw to plowing, harrowing, sowing, and even the spreading of dung. One *numen* looked after the thresholds of doors, another after their hinges. Among the more important surviving *numina* were the *lares* and the *penates,* who guarded agricultural land and houses; the "Genius," identified as the procreative power of the father (whence its eventual application to the idea of creative talent); and Vesta, guardian goddess of the hearth, center of family life, in whose honor "vestal virgins," six in number, starting as children aged six to ten, were appointed by the high priest. The vestals were supposed to tend the sacred fire on the state hearth in the Temple of Vesta, never letting it go out. If it did, they would be ceremonially flogged. This was in practice a lifetime appointment; it was supposed to last thirty years, but after such a term of office a vestal, having known no other way of life, was most unlikely to marry and raise a family, especially since women in their late thirties or early forties were not considered eligible for childbearing.

Each of the principal gods had priests known as "flamens" devoted to him, to make sacrifices and perform rites. Ancient taboos and rituals surrounded these sacred offices. A flamen could not, for instance, ride a horse, touch a she-goat, wear a jeweled ring, or tie a knot in any of the clothes he wore. The origin of these and other peculiar taboos is, by now, not merely obscure but unknowable.

The flamens were important figures for two main reasons. First, their deliberations were the primitive basis of law and had something of its

coercive force: you could not defy them with impunity. Second, because it was so desirable to have an idea of what the gods approved, from this need arose the practice of augury.

The Etruscans seem never to have done anything important without a religious motive, and respect for what the Romans called the *Etrusca disciplina* was passed on and remained embedded in the codes of Roman public and religious life. Well into imperial times, Rome maintained a "college" of Etruscan diviners, a privileged group known as the haruspices, whose task was to read the will of the gods from lightning flashes (*fulgura*) and other portents, especially the flight of birds (what part of the sky they came from, what their speed and heading were) and the markings on the livers, gallbladders, and guts of sacrificed animals. Some believe that the requirements of these vatic birdwatchers influenced, or perhaps even once determined, the siting of temples (on hilltops) and the orientation of their façades (so that the migratory passage of bird flocks could be compared with them). *Templum* did not originally mean a building; it signified a place set aside for the utterance of formulaic words in augury. The augurs' requirements may also have determined the form of the temples: that they were set on tall podiums and had to have one single façade (unlike Greek temples) may have been ritual necessities. But there is no way of proving such things now.

The aim of augury was not simply to foretell the future. It was to find out whether a proposed course of important action was likely to have the approval of the gods. A common way of doing this was consulting the sacred chickens. These otherwise ordinary fowls (there seem to have been no criteria for telling a sacred chicken from a nonsacred one) were carried in a cage to the field by Roman armies. Before the battle, they would be given chicken feed. If they pecked at it with gusto, letting bits of food fall from their beaks, this was greeted by the augurs as an excellent omen. If they ignored the offering, it was a very bad sign. If they ate halfheartedly or seemed choosy, that too had its meaning for the augurs. Many Romans of the highest rank took this charade perfectly seriously. One who did not was Publius Claudius Pulcher, an admiral of the Roman navy who, just before an engagement between the Roman and Carthaginian fleets off Drepanum during the First Punic War, in 249 B.C.E., cast the grain before the fowl and was told, by the ship's augur, that the birds would not eat. "Then let them drink," Pulcher exclaimed rashly, as he grabbed the chickens and threw them overboard. Alas, he lost the ensuing battle.

If *pietas* was one of the two defining virtues for ancient Rome, then *lex*—law in all its guises and forms, starting with the great and fundamental distinction between civil law and criminal law—was the other. The Romans were tremendously energetic codifiers, and the corpus of Roman law, a conceptual edifice so vast that it defies any possibility of summary here, remains the foundation of all Western legal systems since. Its earliest form, drawn up by a special commission of jurists in the republican period (c. 450 B.C.E.), was known as the Twelve Tables, and so much importance was attached to it that four hundred years later, during the lifetime of Cicero, schoolboys were still obliged to recite it by heart, even though the code of law by then had so hugely expanded as to render the original Twelve Tables, though still fundamental, obsolete. They would remain the cornerstone of Roman law for the best part of another thousand years, until they were at last superseded by the *Corpus Iuris Civilis* of the Emperor Justinian.

What was law in the Roman view? Certainly not the false principle that "might is right," although—particularly in their dealings with non-Romans—you might often suppose that is what they believed. The code of law was not simply a code of power, and this made all the difference between Roman law and its more primitive antecedents. "Justice," wrote the jurist Ulpian (Domitius Ulpianus, d. 228 C.E.), "is a constant, unfailing disposition to give everyone his legal due. The principles of law are these: to live uprightly, not to injure another man, to give every man his due. To be learned in the law is the knowledge of things divine and human, the science of the just and the unjust." Law was the god in the codex.

Its principles, written down by such jurists as Julius Paulus (late second century C.E.) and notably Ulpian, seem so elementary and self-evident now that it is hard to believe they had not existed forever, but of course they had not. "He who has knowledge of a crime but is unable to prevent it is free of blame" (Paulus). "He inflicts an injury who orders it to be inflicted; but no guilt attaches to him who is obliged to obey" (Paulus). "In the case of equal conflicting claims, the party in possession ought to be considered in the stronger position"(Paulus). "No one is compelled to defend a cause against his will" (Ulpian). And *"Nemo dat quod non habet"* (Ulpian): "No one can give what he does not have." Such were a few of the 211 entries in the "General Rules of Law" inscribed in the *Digest* of the Emperor Justinian.

The making of law was, as the name implies, "legislation." Who made

law under the Republic? Popular assemblies, divided at first into military units and later, after the third century B.C.E., by a council of common (i.e., not royal or patrician) citizens known as the Concilium Plebis or Council of the People. Its votes and resolutions were known as *plebiscita,* from which stems our concept of a "plebiscite" or general popular vote. At first the men of money and property, the patricians, vehemently objected to the idea that they should be subject to the same laws as commoners. They thought they should make their own for themselves. But in 287 B.C.E. a dictator, Quintus Hortensius, passed a law that all citizens, patricians included, should be bound by any law passed by the Plebeian Council. This "Hortensian Law" was a milestone in Roman class relations. It deprived the patricians of their last means of arbitrarily dominating the plebeians.

Much of the physical legacy of Justinian's reign would disappear. Most of the hundreds of churches, aqueducts, and other public buildings erected by this fifth-century Christian emperor—with certain great exceptions, such as the Church of Hagia Sophia in Constantinople—have fallen into ruin or disuse, but not the epitomes he made of earlier Roman law. Justinian's Corpus Iuris, despite the Greek and Christian elements that entered it, remained essentially Roman law, and because the imperial constitutions were issued in the names of both Eastern and Western emperors and were held to be binding throughout the Roman Empire, they would eventually radiate—through the universities of England, France, Spain, Italy, and Germany—to encompass the entire legal basis of Europe through the Middle Ages and on into modern times.

We speak of early Rome as a republic, which she was. Nevertheless, she was not a republic in the modern American sense. The root of the term, *res publica,* meant "public affairs," no more than that. But the essential quality of her political life as a republic was, as we have seen, that she was not ruled by a succession of kings, especially not a hereditary one. She had hammered out a system whereby her polity was split into two broad classes—patricians and plebeians. In the early years of the Republic, the patricians held and controlled all the political and social power of the state. Only patricians could be elected to any office, including the all-important senatorships. Only they could serve as priests. The plebeians, by contrast, were excluded from religious colleges, magistracies, and as a rule from the Senate; early on, they were also forbidden to marry patricians. With lawmaking and religion in patrician control, what was left for plebeians? Only agitation and pressure. The patricians needed the

plebeians, could not do without them, because they had to build armies; all military offices up to *tribunus militum* were open to them. As Rome kept annexing more and more land within (and then outside) Italy, larger prospects of economic independence gradually rose before the plebeians.

Rome was still a young republic when it began to acquire the overseas provinces that would form the basis of its immense empire. Doing this required naval supremacy in the Mediterranean, but for the first five hundred years of its history Rome had no warships. The naval power in the Mediterranean belonged to the city of Carthage, founded (allegedly) a little earlier than Rome, in 814 B.C.E., on the Tunisian coast of North Africa, by its legendary Queen Dido. Carthage enjoyed immense trading power in the Mediterranean, and considerable strategic power as well, since it controlled the routes along which tin—that essential ingredient of bronze when alloyed to copper in a proportion of approximately one to nine—was shipped and sold. (Not just the hardness but the brittleness of bronze increased with its tin content. Alloyed with zinc, copper became brass.)

All the islands in the western Mediterranean had been annexed and colonized by Carthage, except Sicily. But the Carthaginians had established a strong presence there, and Rome was worried that if it got any stronger the whole island would be theirs. In 264 B.C.E. Carthage occupied the Greek colony of Messana, in northeastern Sicily. Rome entered an alliance with the Greeks and drove the Carthaginians out of Messana, expelling them (in 262 B.C.E.) from the colonies of Segesta and Agrigentum as well. This was the beginning of the First Punic War. (*Punicus*, in Latin, meant "Carthaginian.") It has often been said that Rome's war on Carthage was a blunder without real justification, but it was not. Rome needed *Lebensraum* by sea as well as by land. It could not move armies freely around the Mediterranean if Carthage remained the dominant sea-power. Hence the monotonous sign-off cry of Marcus Porcius Cato the Elder (234–149 B.C.E.) at the end of every speech he made in the Senate, *"Delenda est Carthago,"* "Carthage must be wiped out." The defeat of Carthage took more than a century, but eventually it ended all serious obstacles to Rome's hegemony over the Mediterranean and the lands that enclosed it; the Mediterranean now became, in the full sense, *mare nostrum,* "our sea."

What kind of forces were locked in this war? How strong were they? The Greek historian Polybius gives what is probably the most balanced sketch. At sea, the Carthaginians were superior—they had been trad-

ing across the Mediterranean for generations, they understood shipping, "seamanship has long been their national craft." They had no standing army, however, and had to employ mercenaries. The Romans were far better at fighting on land. Their army consisted of Romans and their generally loyal allies: most Roman soldiers were fighting for their own land, their own families and nation, and for one another—inducements to courage and obstinacy which no mercenary army could be expected to have.

But as good as their army was, the Romans knew they could not defeat the Carthaginians without naval power. They also knew they had neither a fleet nor any naval tradition. So they set out to create themselves a navy from scratch. According to Polybius, they were very lucky in capturing an enemy prototype they could copy: as the Roman forces were heading for Messana in Greek-built, chartered triremes and quinqueremes (oar-powered warships), the skipper of a decked Carthaginian ship got overexcited in pursuit and ran aground. The Romans "built their whole fleet on its pattern. . . . If that had not occurred they would have been entirely prevented . . . by lack of practical knowledge." They even had to train their rowing crews in mock-ups, built on land. But it worked; the Carthaginian fleet was destroyed at sea off Mylae, a septireme (a battleship with no fewer than seven rowers to each of its enormous oars) and thirty quinqueremes and triremes, all captured or sunk.

The trireme, which by the end of the sixth century B.C.E. had become the standard warship of the Mediterranean, had three banks of oarsmen, one above the other, the topmost ones working from an outrigger. The oars were manageable if not light, between four and four and a half meters long. One reads, in classical sources, of quinqueremes with five banks of oars (or five rowers to an oar), and even sixteen-bank vessels, but it is most unlikely that so many oars, placing the rowers so high above the waterline, could possibly have worked, since they would have had to be unmanageably long.

A trireme's normal crew was two hundred men, of whom about 170 were rowers and fifteen were deckhands. None of these, as a rule, were slaves; and the cartoonists' image of a Roman galley with its whip-wielding bosun striding through the hull and flogging the rowers is unlikely—generally the triremes had drummers and flautists to provide the rhythm of work, and there would have been little point in weakening a rower by corporal punishment. With this motive power, under favorable conditions, a trireme could manage an average of nine

kilometers per hour over long distances, with bursts of possibly 12 kph when the ship was picking up speed to ram an enemy vessel. For that purpose, it was built with a sturdy bronze-sheathed ram projecting forward, underwater, from its bow. The other weapon that proved decisive for the Romans was a massive hinged and weighted wooden hook known as a *corvus,* from its similarity to a raven's beak; it was raised, the enemy ship was rammed, and then the "beak" was dropped, smashing through the opponent's deck and grappling the two vessels together, so that the Roman soldiers could swarm to the attack. The width of the plank was about 1.2 meters, enough to form a bridge. The disadvantage of the *corvus* was its destabilizing clumsiness when raised upright, wobbling heavily in a seaway. Its great advantage was that it enabled Roman marines, always better soldiers than their Punic opponents, to board enemy ships on the high seas.

The cost of the war at sea, and of funding its mercenary army on land, put Carthage badly in debt. It could only raise money by launching a conquest of Spain, which it pursued under the generalship of Hasdrubal and Hannibal. This meant attacking Saguntum, a Spanish city south of the Ebro and an ally of Rome. The Carthaginians hoped to defeat Rome's army in the field and thus cause at least some of her allies to desert. This, Hannibal expected, would not reduce Rome to being a minor power, but it might curb her aggression by rendering her one power among several. Carthage had no hopes or plans for conquering Italy as a territorial whole. "Italy" was not yet a unified state under the control of Rome—it was a patchwork of tribal principalities. But Carthage did hope to regain Sicily, Sardinia, and other lost territories. Hannibal was convinced that the only place for a war against Rome was Italy itself, "whereas if no movement was made in Italy, and the Roman people were allowed to use the manpower and resources of Italy for a war in foreign parts, then neither the king nor any nation would be a match for the Romans."

The Romans did not believe this. They embarked on the Second Punic War confident of victory. Now they had a strong navy, and they designated two uses for it. The first was to take a Roman army under the consul Publius Cornelius Scipio to engage Hannibal in Spain and so neutralize him. The second was to send the other consul, Titus Sempronius Longus, to invade North Africa and conquer Carthage. This might have worked, but the Romans moved too slowly. Seeking a base in the Po Valley, the Carthaginian army under Hannibal marched through south-

ern Gaul and across the Alps into northern Italy. Why did the Carthaginians not invade Italy by sea? Because, now that it had a navy, Rome could blockade any fleet that tried to carry an army along the Spanish coast and down into the Tyrrhenian. Moving elephants around was not easy, either—but the land route, including the perils of crossing the Alps, seemed (for all its difficulties) the only practicable choice. By the fall of 218 B.C.E. Hannibal and his army were among friendly Gauls in the Po. In December, the Romans lost the Po valley entirely to Hannibal.

And so began the Second Punic War (218–202 B.C.E.). When Hannibal began his legendary march with his twenty-one war elephants into northern Italy, he had an army of fewer than 35,000 men with which to confront a total Roman force of 700,000 infantry and 70,000 cavalry (not all of which, of course, could be marshaled together at the same time).

It is still a matter of argument among scholars which route Hannibal might have taken; the most favored view is that he led his army over the Western Alps, via the Mont Cenis pass. Even if he did, the conditions they all encountered were appalling; the descending path was so narrow and steep as to be nearly impassable to horses at one point, let alone to elephants. Landslides had carried away much of the mountain face. But, disheartened as many of his troops were, Hannibal was able to show them something of their destination from the top of the pass; on a clear day, you could see "the actual view of Italy, which lies so close under these mountains that when both are viewed together the Alps stand to the whole of Italy in the relation of a citadel to a city."

One might have supposed that the odds were so much in Rome's favor as to render Hannibal's invasion hopeless. There is still disagreement over the usefulness of those elephants to Hannibal's campaign, but there is little doubt that they terrified many a Roman soldier, and the effort of getting these great beasts sliding and stumbling over the rocks and through the ice and snow of the Alps must have struck most of those who saw or even heard about it as astonishing. The march from Carthago Nova (Cartagena) had taken five months, and fifteen days had been spent in crossing the Alps. Hannibal arrived in Italy with his force reduced to 12,000 African and 8,000 Iberian foot soldiers, backed up by only 6,000 horseback—and the remaining elephants, of which about half had died on the way. He was, however, able to pick up some reinforcements in northern Italy from the formidable Cisalpine Gauls, who were no doubt attracted by the prospect of loot in Rome.

Rome, of course, had long known that Hannibal was coming. The first encounter between a Roman army, two legions led by Publius Cornelius Scipio, and Hannibal's forces took place near Ticino, in northern Italy—gateway to the plains through which an army could move south toward Rome—in 218 B.C.E. The engagement was won by Carthage, so convincingly that thousands of tribesmen of the Boii, hitherto allied to Rome, defected to Hannibal's side. Like a snowball gathering mass as it rolls downhill, Hannibal's army grew as it moved south. It crushed the Romans at the Battle of Trebia, crossed the Arno swamps, kept going past Faesulae (Fiesole) and Arretium (Arezzo), and reached Lake Trasimene in the spring of 217 B.C.E. Here, it was confronted by an army led by the consul Gaius Flaminius. It was another rout. Apparently, the Romans failed to see the Carthaginians, hidden by early-morning mist on the high ground beside the lake. By the end of that morning, 15,000 Romans were dead, including the luckless Flaminius.

The Roman response to this disaster was to appoint a dictator to lead its army. The tactics followed by this supremo, Quintus Fabius Maximus, earned him the nickname of "Cunctator," "the Delayer." Instead of confronting Hannibal's army head-on, he chose to follow and harass it, in the hope of distracting and enfeebling it without a definitive engagement. But Hannibal's forces kept marching unstoppably south, down past Rome, toward the Adriatic coast. Before long, the Romans had tired of delays and longed for a decisive, head-on encounter with Hannibal's army. On August 2, 216 B.C.E., sixteen Roman legions advanced to battle against the Carthaginians near the town of Cannae, in Apulia, south of Rome. The result was the bloodiest and most costly defeat Rome had ever suffered, or ever would.

At Cannae, in one day, Hannibal's army slaughtered some 50,000 of the Romans and their allies, out of 75,000–80,000 men who took the field. For comparison, one should consider that on the first day of the Battle of the Somme in 1916, there were some 57,000 British casualties, most of whom survived; fewer than 20,000 were killed outright, and the weapons they faced were German machine guns, not Punic spears and swords. The sheer efficiency of the slaughter Hannibal's army inflicted on the Romans is amazing. Roman losses in a single day at Cannae were almost as great as American combat losses (58,000) in the entire Vietnam War. And it all happened within about nine hours, on a late-spring or early-summer day, blindingly hot, fogged with the clouds of dust kicked up by thousands of men in their relentless, terminal struggle. Varro,

the Roman commander, had put the mass of his infantry in the center, leaving his wings, with cavalry, weak and mobile. This was the classical deployment. But Hannibal reversed it, concentrating his weight of infantry on the flanks. In this way, the Romans were soon enveloped, and then cut off from retreat by a Carthaginian cavalry charge across their rear. When the Romans tried to retreat, they were massacred.

They had little experience of defeat, certainly none on this scale. Defeat did not make sense to the Roman army. Rome was first and foremost a military state. The prime qualification for citizenship was the ability to bear arms against her enemies. The Roman army was organized as a militia: service in it was an inflexible condition of citizenship, and by the time of the Punic Wars, it was a highly sophisticated and organized machine.

Its higher officers were aristocrats, but the centurions, who commanded the basic fighting units ("centuries" of one hundred men) were commoners, from the same social class as the line soldiers. This contributed greatly to *esprit de corps,* as did the frequent swearing of loyalty oaths. The army had never previously lost a major battle against a foreign enemy, and this time the scale was near apocalyptic. In terms of discipline, arms, disposition of forces, and chain of command, the Roman army was meticulously organized against such an event.

The key figure in this organization was the centurion, who had been chosen for his valor and efficiency in leadership. The centurions, as John Keegan has pointed out, were "long-service unit leaders drawn from the best of the enlisted ranks, [who] formed the first body of professional fighting officers known to history." They were the backbone of the army, the repository of its accumulated service skills, and it was due to them and the example they set that the Romans fought better and with more tenacity than any other tribe or nation in the known world. The centurions turned soldiering into a self-sufficient profession; they did not see their work as a way of entry to the governing class; this was what they were born and trained to do, and there lay much of their strength.

Numerically, the building block of the Roman army was the legion, normally made up of 4,200 men; in times of crisis, its strength was raised to 5,000. They were divided by age and experience. The youngest and rawest recruits were called *velites.* The next-older ones were *hastati,* or spear carriers. Above them in seniority, the men in the prime of life, were the *principes,* and above them came the *triarii.* Typically, a legion had 600 *triarii,* 1,200 *principes,* 1,200 *hastati,* and the remainder *velites.*

The *velites,* besides being the least experienced, were also the lightest armed, with a shield (laminated wood, with a metal rim, about three feet in diameter), two javelins, a sword, and a helmet. Often the tyro would cover his helmet with a piece of wolf skin, to make him look fierce, but also to make it easier for his commanding officer to identify him in a fight.

The *hastati* were more heavily armed. Each man carried a full shield (*scutum*), two and a half feet wide and four deep, giving maximum coverage to the body. Its convex curvature deflected the enemy's spears and arrows better than a plane surface. It, too, was made of wood planks glued together, probably with splined joints; then it received a canvas cover—animal glue again—and an outer sheathing of calfskin. Its edges were iron, and in its center was an *umbo* or iron boss, which gave further protection against sling stones and pikes and was good for bashing in the face of an opponent. It was heavy: reconstructions, iron and all, have weighed in at nine to ten kilos.

Each man carried his *gladius,* a double-edged sword, designed for thrusting, though it was excellent for slashing too. Called a "Spanish sword," it may have been adapted from the weapon carried by Carthaginian mercenaries in the First Punic War, a tribute to its qualities as a killing tool. It was short-bladed (about 60 cm including the tang) and therefore suitable to closely pressed fighting; infantrymen did not fence like d'Artagnan, they stabbed like butchers. A soldier would probably have a *pugio* or dagger on his belt as well. He would also be equipped with a relatively long-range missile, the *pilum* or heavy throwing-spear, weighing perhaps 3.5 kilos, with an ash shaft, an iron shank, and a barbed point. The soldier was normally issued two of these javelins, although lighter ones were available. Their accuracy, when thrown, was of course variable, and their effective range was at the most thirty meters, but within their limits the *pila* were formidable weapons, with enough inertial energy to penetrate the opponent's shield and the opponent himself. On the attack, the Roman soldier would hurl his *pilum* and then charge forward to close combat with the *gladius.* Descriptions of Cannae feature the frightful hissing noise made by volleys of *pila,* which must have been as scary as the shriek of incoming shells in twentieth-century battles.

The two other types of pointed weapon in the Roman army were the cavalry lance, longer than the *pilum* and not thrown as a missile, and the *hasta,* a long thrusting-spear. There was also artillery, of a primitive and awkward kind—large arrow-shooters or stone-flingers, which relied

on the stored energy of twisted animal sinew. But these clumsy devices seem never to have played a decisive role in warfare: they possibly had some psychological effect, but their range was limited and their accuracy slight.

So much for weaponry. What about defense? On the collective level of the army on the march, the Romans displayed unique fortitude and energy in self-protection. Knowing that "barbarians" in occupied territory were likely to attack at night, when the Roman invaders were tired from the day's exertions and darkness was likely to favor confusion and panic, the Romans did not end their day's labor at the finish of each day's march. They first put up a camp: not a mere array of tents, but a fully fortified square *castrum* or encampment, almost an overnight town, with a wall, a ditch (produced by digging out the earth to throw up the wall), and everything that was necessary to protect the mass of troops. The wall or "circumvallation" was some two hundred feet out from the tents, so that missiles, shot or thrown from outside the barrier, could not reach them or do much harm if they did. The space between the wall and the tents also allowed for quick mustering, or for holding booty such as cattle. The whole perimeter was closely guarded, and fearful punishments awaited any soldier delinquent in his sentry duty. The customary one was the bastinado, or *fustuarium,* described by Polybius. The accused man was tried by a court-martial of legionary tribunes. If found guilty, he was touched by one of the tribune's cudgels, whereupon the whole camp attacked him with sticks and rocks, usually killing him in the camp itself. "But even those who manage to escape are not saved thereby: impossible! for they are not allowed to return to their homes, and none of their relatives would dare to receive such a man in his house. So that [he is] utterly ruined."

For defense of individual soldiers, armor existed. Each man had a helmet, either a plain basin of metal or the so-called (by archaeologists) Montefortino pattern, with a narrow neck-guard and large protective cheek-pieces. Shin-protecting greaves are mentioned in the literature, though none have been found. Bronze *pectorales* to protect the heart were not uncommon, though not every soldier got one. Those who could afford it—it was not a cheap item—wore a *lorica,* or chain-mail cuirass, a shirt made from metal rings, worn over a padded undergarment. This probably weighed about fifteen kilos and would have been exhausting on a hot day like the one on which the Battle of Cannae was fought.

The Roman system was designed to produce identical fighting men

with the same basic training. Hannibal's troops were not like this. Being mercenaries, they came from Africa and all over the Mediterranean, and had their own traditions and techniques of fighting, though their higher-ranking officers seem to have all been Carthaginian. The army contained Numidians, Iberians, Libyans, Moors, Gaetulians, and Celts. There were specialists in types of warfare who came from particular areas. Thus the Balearic Islands (Majorca, Minorca, Formentera, and others) got their name from the slingers they produced in antiquity—*ballein* being Greek for "to throw," as in "ballistics."

The Punic forces did not have the fierce allegiance to the legionary standards that helped rally the Roman army in moments of crisis, and only two things mattered to them in the end—winning, and getting paid. And this time, win they did, fighting with the most furious determination until the trampled soil of Cannae was a marsh of blood, guts, excrement, and hacked limbs, so thick and slippery that a man could scarcely move on it without falling.

Cannae caused a paroxysm of social superstition in Rome. The winter of 218 B.C.E. became a time of witnessed prodigies. In the Forum Boarium (Cattle Market), an ox escaped from confinement, climbed to the third story of a house, and then leapt out, as though committing suicide in despair. In the Forum Holitorium (Vegetable Market), the Temple of Hope was struck by lightning. A shower of pebbles fell out of a clear sky in Picenum. Men in shining garments were glimpsed in the sky. A wild wolf ran up to a sentry somewhere in Gaul, grabbed his sword from its scabbard with its teeth, and ran off with it. Worst of all, two vestal virgins, named Opimia and Floriona, were convicted of unchastity; one killed herself, and the other was buried alive, as ritual demanded.

The number of prisoners taken in Hannibal's victory was so great that the Roman Senate had to devise a plan to rebuild the army. Hannibal was known to be short of cash; was he perhaps open to bribery? Could the captives be ransomed? No, said the Senate; that could exhaust the Roman treasury. Then the consul Tiberius Gracchus proposed that slaves should be bought with public money and be trained to fight. About ten thousand were forcibly enlisted in this way. Great emergency efforts, urged on by Scipio the Carthage Destroyer, were made to build up Rome's fleet. The keels of thirty ships—twenty quinqueremes and ten quadriremes—were laid, the timber and all the gear brought from all over Etruria; within forty-five days of the arrival of the first consignments

of timber, Livy recorded, the first ships were launched, "with their tackle and armament complete."

The defeat at Cannae also spread panic among Rome's allies in southern Italy, although the central Italians remained steadfast in their loyalty. "The Campanians," observed Livy, "could not only recover the territory taken from them unjustly by the Romans, but could also gain authority over Italy. For they would make a treaty with Hannibal on their own terms." This hope was delusive; after Hannibal's defeat, the Romans recaptured Capua, the capital of Campania, and inflicted dreadful reprisals on its citizens.

Hannibal's presence in Italy did not and could not last, although the Romans, thanks to his military genius, were unable to beat him on their own land. They slowly drove him southward, and his army weakened as it went. His brother Hasdrubal led an army to Italy to strengthen Hannibal, but it failed, and in 207 B.C.E. a Roman army defeated him at the Metaurus. In the end, Hannibal could only leave Italy because Rome launched an expedition, under Scipio, against Carthage itself. This compelled Hannibal to withdraw to Africa to fight in defense of his own country. In 202 B.C.E., Hannibal was defeated by an Italian for the first time, at the Battle of Zama, in North Africa, on Punic territory. The Romans now had at least a partial revenge for Cannae, though not on the same scale of slaughter. But Carthage would never be a Mediterranean sea-power again; her place had been wrested from her, finally, by Rome.

The Hannibalic wars had inflicted changes on Rome that were longer-lasting and in some ways deeper than military loss. Sometimes an extreme and traumatic defeat in war will provoke a spasm of religious faith among the losers, and this appears to have happened in Rome in the years after Cannae. All sorts of cults and previously exotic or marginal beliefs began to make their appearance, especially among Roman women, who could always be counted on for religious experiment. People traumatized by colossal defeat will not be satisfied by a merely ceremonial state religion. They will want the gods to come closer, to care and protect, to be more responsive to prayer and sacrifice.

These needs would not be met either by the vague gods of traditional Roman religion or by the sterner new ones. But Greek gods filled the bill. Their images, and the rituals addressed to them, were less rigid, more humanly sympathetic and participatory. Rome now saw an expansion of Greek-based mystery religions. And there was a growing constituency

for them, because Rome had an immense desire to be regarded as a part of the Greek-civilized world. Rome wanted a national literature along Greek models, starting with Homer. More and more, its intellectuals and politicians regarded Greek as the true language of civilization, especially now that so much of Greece had been absorbed by conquest and treaty into the heart and soul of Rome.

Rome was full of émigré Greeks, and its air was dense with their voluble, seductive arguments, as the floors of temple and villa were thick with Greek (or Greekish) sculpture. True, some Roman shellback traditionalists resented and resisted the growing influence of Hellenic culture and philosophy on Roman ways. One of them was Cato the Elder, who "wholly despised philosophy, and out of a patriotic zeal mocked all Greek culture and Greek learning. . . . He declared, with a rasher voice than became one of his age, as it were with the voice of a prophet or a seer, that the Romans would lose their empire when they began to be infected with Greek literature. But indeed time has shown the vanity of this prophecy of doom, for while the city was at the zenith of her empire she made all Greek learning and culture her own." Cato was such an extremist in his dislike of luxury as a Greek distraction that he even tried—fortunately, without success—to have water mains laid into private Roman houses ripped out.

The most consequential Roman to be formed, in a fundamental way, by Greek ideas and rhetoric in the midst of republican Rome was Marcus Tullius Cicero (106–43 B.C.E.), Rome's greatest orator and a fervent supporter of the Republic. His education as a public speaker had begun when he was sixteen, under the consulship of Sulla and Gnaeus Pompeius Strabo (Pompey) (89 B.C.E.). His cultural influence went far beyond the spoken word and did not diminish after his death. His letters were collected, and he wrote treatises on rhetoric, morals, politics, and philosophy; he thought his most durable achievement was to be his poetry (though he was wrong about that: Tacitus acidly observed that as a poet Cicero was less fortunate than Caesar or Brutus, because his verse became known and theirs did not). He could be deadly in attack even against minor figures: an otherwise forgotten politican was skewered by a single remark. "We have a vigilant consul, Caninius, who never slept once during his entire term of office." Caninius' term had lasted only one day.

Much of what he said about Rome and its rulers remains true today: "Nothing is more unreliable than the populace, nothing harder to read

than human intentions, nothing more deceptive than the whole electoral system." He was completely undeceived about the wellsprings of most social action: "Men decide far more problems by hate, love, lust, rage, sorrow, joy, hope, fear, illusion, or some other inward emotion, than by reality, authority, any legal standard, judicial precedent, or statute." And he was very sharp about human weakness: "The greatest pleasures," he remarked, "are only narrowly separated from disgust." What a psychotherapist this Roman would have made! One can always read Cicero with profit, and English writers of the seventeenth and eighteenth centuries, including Shakespeare, incessantly did, quoting from him freely.

Of all the currents of Greek thought that flowed into Roman intellectual life, Stoicism had the greatest effect on Cicero and on Roman ideas in general. Stoicism was a school of Hellenistic philosophy founded in Athens by one Zeno of Citium in the early third century B.C. (The name came from a gathering place in Athens where Zeno taught, a colonnade overlooking the Agora known as the Stoa Poikile or Painted Porch.) The basic assumption of Stoicism was that extreme, possibly destructive emotion was to be shunned; the wise man would free himself from anger, jealousy, and other distracting passions and live in a state of calm and contemplative peace of mind; only in this way could he see what was true and guide his actions appropriately. "Permit nothing to cleave to you that is not your own; nothing to grow on you that may give you agony when it is torn away," counseled the Stoic Epictetus (c. 55–c. 135 C.E.). The ideal was *askesis,* "inner calm"; the Stoic did not preach indifference or anesthesia, far from it, but, rather, a reasoned concentration on the truths of life. Only thus could human reason be brought into accord with the "universal reason of nature." In the words of one of the more famous Stoics, the Emperor Marcus Aurelius (121–80 C.E., *reg.* 161–80), "Say to yourself in the early morning: I shall meet today ungrateful, violent, treacherous, envious, uncharitable men. All these things have come upon them through ignorance of real good and evil. . . . I can neither be harmed by any of them, for no man will involve me in wrong, nor can I be angry. . . ."

Clearly, Stoicism went well with the Roman sense of duty and *pietas.* The Romans with whom it was popular—and there were many—were perhaps less interested in the Stoic view that all men were necessarily imperfect than in Stoic injunctions to face misfortune, grin and bear it, which had a powerful resonance throughout the culture of Rome and with many of its intellectuals and public figures. Cicero was one of these,

and he also had a strong philosophical and meditative bent, which displayed itself in his many orations and voluminous writings. The great project of his political life was holding and defending the ancestral system of republican government. He wanted to bring about a "concord" of the conservative, senatorial aristocrats and the rapacity of the growing class of equestrians, but this was beyond his powers, as it would have been beyond anyone's. Neither Cicero nor anyone else could deflect the movement toward one-man rule in Rome, which, in the first century B.C.E., was the chief direction of its politics.

The emblematic figure of this movement was Julius Caesar.

Some family lines last for centuries, are of the utmost nobility, and yet for unknown reasons produce no individuals of special achievement or eminence. One of these was the Julian clan—one of the oldest and most distinguished in Rome, with a generally accepted claim to be descended from Aeneas himself, from his mother, the goddess Venus, and from his son Iulus. Most of its members did little and were mediocrities. But there were two blazing exceptions, men who utterly transformed Rome, its internal politics, its culture, and its relations with the rest of the world, and were, without competition, the outstanding figures of power in their times.

The first of these was Gaius Julius Caesar (100–44 B.C.E.). The second was his grandnephew, his legal and political heir and Rome's first emperor, Gaius Julius Caesar Octavianus (63 B.C.E.–14 C.E.) known at first as Octavian and later, to Rome and the world, after his thirty-sixth birthday, as Caesar Augustus.

Julius Caesar's career had a slow start. He had spent the years 75–74 B.C.E. studying oratory and rhetoric in Rhodes, from which he emerged as a perfected and highly polished speaker, superbly equipped for public political life. He was not a florid speechifier—that, as anyone knows who reads the crisp, unadorned prose of his later war commentaries, was not his way—but he had an exemplary talent for singling out the heart of an issue and driving straight to it. On the voyage back from Rhodes, he gave a foretaste of his future toughness when his ship was taken by pirates and Caesar briefly became their prisoner. He swore that he would crucify every last one, and in time he did.

Cicero, so great an orator himself, was a more astute critic of oratory than any man alive and called him the most elegant of all Roman speakers. But others could perhaps rival Julius Caesar on the podium. Where he excelled was in the manipulation of politics and, later, in the

command of armies on the battlefield. In politics, he first briefly inclined toward the *optimates,* or "top people." This was the name adopted by the Roman upper class, the party of wealth and power, which defined itself and its interests against the *populares,* a "people's party" of workers, farmers, and small traders originally mobilized and led by the brothers Gracchi c. 133 B.C.E. Before going to Rhodes to study rhetoric, Caesar had confirmed his growing allegiance to the popular party by marrying Cornelia, the daughter of Cinna, who was a chief opponent of Lucius Cornelius Sulla (138–78 B.C.E.), leader of the *optimates,* who had given Pompey his basic political education.

Sulla was a vengeful and merciless patrician, who by sheer drive and cunning had obtained a consulship and the command against Mithridates, the Persian king of Pontus, who had rashly invaded Rome's provinces in Asia. Political enemies at home, members of the *populares* faction, canceled Sulla's command, whereupon he retreated to Capua and gathered six legions that were prepared to go with him against the government in Rome and, once they had taken over the city, to go after Mithridates in Asia. In 86 B.C.E. Sulla and his legions invaded Greece and captured Athens. From there he returned to Italy, his army laden with booty. Landing at Brundisium in 83 B.C.E., he and his army were joined by Pompey, Marcus Crassus, and an ultraconservative senator, Metellus Pius, with all their men. The Roman government was not able to withstand them for long. Within a year, Sulla had taken Rome and was proclaimed dictator of Italy. He now began a reign of terror through "proscription," publicly listing for death everyone who was or might have been an enemy; any soldier could murder such enemies, their property went to the state (namely, to Sulla), and all citizens were encouraged to betray and denounce whomsoever they chose—it was proleptic Stalinist justice, pure and simple. In this way, Sulla is thought to have eliminated forty senators and 1,600 *equites,* knights, whose sons and grandsons were also excluded from public life. Such was the exemplar and political patron of Pompey.

In 68 B.C.E. Caesar had been dispatched as a quaestor or magistrate to Hispania Ulterior (Further Spain); in that year, his wife, Cornelia, died, and he made what was clearly a political marriage to Pompeia, a girl in Pompey's family. Now he was elected an aedile, a position of great importance to the plebeians of Rome, since it gave him charge of temples, markets, and (most telling of all) the corn supply, a great collector of votes. During this time, he spent lavishly on the restoration of temples

and the holding of public entertainment, especially gladiatorial shows. He had to borrow the money from the immensely wealthy consul Marcus Crassus, destroyer of Spartacus' slave revolt, who distrusted Pompey but was not above financing his son-in-law's strategies for ingratiating himself with the commoners. Naturally, the cost of winning popularity in this way put Caesar heavily in debt to Crassus and the *optimates,* who did not altogether trust him. To get further as a politician, he needed to bypass their suspicions: to become a consul and then obtain a major military command, whose victories would be as irrefutable as Pompey's. In Rome, Caesar had in 59 B.C.E. become a senator. He made an alliance with Pompey and Crassus (the "First Triumvirate") and joined with Pompey—now consul—in repealing some of Sulla's more extreme and biased alterations to the constitution. There was no sign, as yet, of any discord between Pompey and Caesar. In fact, in 59 B.C.E. Pompey married Julia, Caesar's own daughter by his first wife, Cornelia, thus completing a neat matrimonial symmetry.

In 58, as proconsul, Caesar took on the control of both Cis- and Transalpine Gaul (the Po Valley in northern Italy, and southern France, which he called "the province," a name commemorated ever since as Provence) as well as Illyricum (Dalmatia). From 58 to 50 B.C.E., Caesar concentrated on Rome's northern, Gallic frontiers, methodically wearing down all resistance from them. He did not hesitate when it came to deciding what Rome's overseas policies should be. Rome had to conquer and intimidate any state or people that might give it trouble. That had been the chief lesson of Cannae. Everyone concurred in this, including Cicero, who rather disliked Caesar personally but admired him politically:

> He believed not only that it was necessary to wage war against those who he saw were already in arms against the Roman people, but also that all Gaul must be subjected to our sway. And so he has fought with the fiercest peoples, in gigantic battles against the Germans and Helvetians, with the greatest success. He has terrified, confined and subdued the rest, and accustomed them to obey the empire of the Roman people. . . .

Caesar's conquest and pacification of Gaul was approaching completion by 56 B.C.E. Most of the country had come to heel and was now a Roman province, except for sporadic outbreaks of fierce resistance. In his *Commentarii de Bello Gallico,* Caesar described how the ferocious Helvetii, having left their territory of what is now Switzerland, had

migrated into Gaul, intending to get as far as the English Channel and resettle there. Caesar's armies attacked them in their migration, and in Annecy, on the river Arroux, he wiped them out by the tens, perhaps hundreds, of thousands, turning the survivors back toward Switzerland. The same infiltration into Gaul, followed by the same costly expulsion, was attempted by German tribes. North of the Seine were the so-called Belgae, a warlike people consisting mainly of Germans intermarried with Celts. They were extremely suspicious of Caesar, and should have been. When Caesar established his winter headquarters on Gallic territory, and gave every sign of meaning to stay, they mobilized a full 300,000 warriors. Caesar's reply was to raise two more legions in Cisalpine Gaul, bringing his total force to eight.

The coherence of the Belgic armies now began to disintegrate, largely because of supply shortages. Only the tribe known as the Nervii could keep an army in the field, and Caesar annihilated them in a battle on the Sambre in 57 B.C.E. Thus the resistance in Gaul only lasted for two military seasons. In the end, fully a third of all Gauls of military age were killed, and another third were sold into slavery: a toll which all but destroyed the masculine population of the province, made it incapable of further resistance, and made Caesar even more colossally rich than before. The Gallic leader Vercingetorix, a brilliant, charismatic figure who had given Caesar the most difficult and stubborn resistance of his career, was besieged and finally captured at Alesia in 52 B.C.E. Brought back to Rome in chains, he was paraded in Caesar's triumph and then ignominiously strangled in a dungeon.

By 52 B.C.E., little opposition to Rome was left; by 50, there was none. The conquest of Gaul changed Rome from a Mediterranean power to a pan-European one, since (in the words of the historian Michael Grant) "a vast conglomeration of territories in continental and northern Europe had now been opened up to Romanization." It also radically changed Gaul, transforming it, in effect, into an embryonic form of France. It was opened, though at great cost in blood and suffering, to classical culture.

With long-term thoughts of enlarging Rome's *imperium* still further, Caesar dispatched an expedition across the Rhine to Germany in 55 B.C.E., with inconclusive results; this was less an invasion than a probe. Its purpose was to show Roman power to the Germans on German territory, which would deter them from crossing into Gaul. A friendly, or at least complaisant, German tribe called the Ubii offered him boats in which his troops could cross the Rhine, but Caesar refused—it would

not look good to depend on the Germans to get him into Germany. Instead, by engineering means that are not clear from his own account, his men built a timber bridge across the mighty river. His army spent three weeks or so marauding and burning villages on the German side, and then withdrew, having made its point, and demolished its bridge behind it.

Next came an expedition to Britain. Why Caesar wanted to invade the island, which had never been attacked by Rome before, is unclear. Perhaps he suspected that the Britons would join with the Gauls in some later counterattack; perhaps he was lured by exaggerated stories of fabulous wealth (gold, silver, iron, and pearls) to be looted there. Or perhaps he merely wanted intelligence about this unknown place, and nobody could supply it to him. Whatever the motive, in 55 he led a fleet of transports and men-of-war directly to the southeastern coast of Britain, where they met with vilely contrary weather and stiff resistance from the "barbarian" infantry and cavalry. The Romans eventually succeeded in landing (at the present site of Deal) and making the Britons sue for peace, but they did not penetrate far inland, it was a shallow victory at best, and they brought back little information and less booty.

Caesar tried again the next year, 54. He assembled a new fleet of some eight hundred vessels, carrying five legions and two thousand cavalry. This time the conditions were more favorable, and the Romans fought their way north, crossing the Thames with intent to attack the British commander Cassivelaunus. They besieged this king's stronghold in Hertfordshire, and captured him; terms were made. But then news arrived that an insurrection was brewing among the Gauls, so, with reluctance, Caesar withdrew his army across the Channel; the complete conquest of Britain, and its reduction to a province of Rome, would have to wait for nearly a century, until it was achieved by the armies of the Emperor Claudius.

But precisely because so little was known about Britain in Rome, the very fact of going there endowed Caesar with mystique and celebrity at home, on top of the glory he had earned with his conquest of Gaul and the readership his brilliant *Commentaries,* the best book on war a Roman had ever written, had acquired. He was, moreover, extremely wealthy now from the sale of Gallic prisoners-of-war as slaves. He raised the scale of his influence-buying. One of the consuls of the year 50 B.C.E., Lucius Aemilius Paullus, is said to have raked in 36 million sesterces from Caesar—this at a time when a line soldier in the Roman army was paid

a thousand sesterces a year. Surpassingly rich, overwhelmingly popular: nothing could have been more propitious for a major political career in Rome.

The big problem was that he could not return to Rome. He could not come back with his legions, because by law no commander could enter the city with his troops. But he could not come back without them, for that would have meant laying down his command and exposing himself to prosecution by his many enemies.

But he had been moving south. In January 49, the Senate sent him orders to disband his army. Caesar received them on the northern side of a small river called the Rubicon, the boundary between Cisalpine Gaul and Italy proper. (The name, deriving from the Latin *ruber*, red, referred to the color of its clay-filled water.) Caesar's reaction to this letter was prompt and decisive. "As for myself," he declared in his *Civil War* (1.9), "I have always reckoned the dignity of the Republic of first importance and preferable to life. I was indignant that a benefit conferred on me by the Roman people was being insolently wrested from me by my enemies." And so, in that legendary phrase which has come to mean taking any fateful and irrevocable decision, he crossed the Rubicon and entered Italy with his troops.

This inevitably meant civil war. The commander of Rome's troops in the war was Gnaeus Pompeius Magnus (106–48 B.C.E.), known to history as Pompey, a resourceful and highly skilled commander, the only man in Rome capable of standing up against Julius Caesar. Pompey's career, up to this point, had been marked by brilliant successes which also served dramatically to highlight the weaknesses of the aging republican system. From now on, Roman politics would have less and less to do with democracy, becoming more and more determined by ambitious individuals backed by their own armies.

Quite early in his career, Pompey showed every sign of developing into just such a prototypical strongman, utterly ruthless and bent on power. Sulla had recognized that Rome's growing empire could not possibly be governed by popular acclamation, by democratic votes. That system was too unwieldy. His policy, therefore, was to shift the authority of the state away from Rome's tribunes, magistrates and popular assembly, which he regarded as mere rabble, and return them to the Senate. Under Sulla's new system, the senators got all their judicial powers back, while consuls and praetors, shorn of their military power, had to content themselves with being the Senate's good servants. But there was a question: what

if some new Roman warlord turned on the Senate with his forces and simply threw them out? Sulla's solution was to pass a law whereby there would be no Roman armed force in Rome. As soon as any returning soldiers, or their officers, crossed the limits of the *urbs Romae,* they would automatically have to lay down their arms, surrender their command, and become private citizens once more. Of course, this needed enforcement, which Sulla, the winner of the war against Mithridates, king of Pontus, was prompt to supply. He had accumulated huge reserves of booty and cash, and these financed his own invasion of Italy in 83 B.C.E. Naturally, this did not go without a hitch, for there were strong anti-Sulla feelings in both Sicily and North Africa, and Sulla enlisted the brilliant and ruthless young Pompey to suppress them—which he did with unrestrained butchery and bloodshed. By 81 B.C.E. the anti-Sulla factions were crushed, and Pompey—who was only twenty-five at the time—was in a position to demand a full triumph from Sulla on his return to Rome, and the cognomen Magnus, "Pompey the Great," attached to his name. There was no denying that Pompey had burst through the exclusive ranks of Rome's upper establishment, the *optimates.* No previous Roman had won such an honor so early in his military career.

In 70 B.C.E., he was appointed consul. The other consul, his reluctant and watchful yokefellow, was Marcus Licinius Crassus, the man who had put down Spartacus' slave revolt (it particularly irked him that Pompey, who had mopped up a last remnant of Spartacus' defeated army, took credit for suppressing the whole rebellion) and made a huge fortune by corralling the confiscated property of Roman citizens stripped of their assets in the proscriptions. Friction and ill-submerged conflict between the two billionaires, Crassus and Pompey, were inevitable.

In January 49 B.C.E., seeing that the Rubicon had been crossed and Caesar was now on Italian soil, the Senate voted martial law against Caesar and turned over the government of the Republic to Pompey. But Caesar did not delay for a moment after crossing the Rubicon. He led his ever-growing army in a whirlwind march down the east coast of Italy, and Pompey and the Senate had to skedaddle out of Rome so fast that they even left the national treasury behind. The continuous presence of senators turned out to be a great encumbrance to Pompey. They kept demanding reports, criticizing plans, and in general getting in the way. This did much to neutralize what would otherwise have been a clear advantage for the Pompeians. They had ships, and Caesar had no navy. They were able to assemble and train a large army at Dyrrhachium in the

west of Greece. Caesar's troops were so poorly supplied that many were reduced to eating the bark off trees. And yet, by a combination of superior generalship and good military luck, Caesar was able to beat Pompey, who offered him battle at Pharsalus in August 48 and was roundly defeated. Unnerved, Pompey fled to take refuge in Egypt, where the Ptolemaic government—fearing reprisals from the dreaded Caesar—cut off his head and dispatched that grisly trophy to Caesar.

Julius Caesar now ruled Rome and its enormous, ever-growing empire without opposition. In 46 B.C.E. he made himself dictator for ten years, and in February 44, the appointment was extended for the whole of his future life. The official calendar, which stood badly in need of revision, was indeed revised, with the month which had been known as Quintilis renamed "July." Caesar's head began to appear on coins, an homage which up to then had been reserved for kings and gods. Caesar was the first man to overcome, and in essence overthrow, the ancient Roman republican aversion to kingship. Plutarch believed that Caesar planned to have himself turned into a deified king, and he was probably right, though the issue is still debatable. Certainly the masses of Rome came very rapidly to view him as the next thing to a living god, and a kind of Caesarian cult was fostered by his closest friend, Mark Antony.

Now that the wars were over and won, Caesar, with the support of a thoroughly complaisant Senate, awarded himself no fewer than five complete triumphs, four after destroying Scipio (at Thapsus in North Africa, April 46 B.C.E.) and one more for smashing the sons of Pompey (at Munda in Spain, March 45 B.C.E.). The grandest was the triumph awarded him for his conquest of Gaul, but it was in his Pontic triumph at Zela over Pharnaces, the son of Mithridates, whom he suspected of trying to restore his father's kingdom in the east, that Caesar was inspired to produce the most famous phrase in military history. On the victorious march-past, he displayed on a placard the three laconic words: *"Veni, vidi, vici"*—"I came, I saw, I conquered."

These Roman triumphs were ceremonies of great importance, and they followed a set pattern, whose origins lay in the Etruscan past. To qualify as a *triumphator,* the conquering hero had first to be acclaimed by his soldiers. He must hold a magistracy with *imperium,* the autocratic power to command. (If he did not have such a magistracy, there could be no triumph for him, no matter how resounding his victory.) He must show that he had killed at least five thousand enemy soldiers, and brought home enough of his army to demonstrate their complete victory. Because

Rome itself did not fall within his *imperium,* he must now wait outside
the city limits until the Senate had agreed to grant him that absolute
power for a single day. Once that was done, the triumphant leader could
enter at the head of his troops, preceded by his lictors, each of whom
carried a bundle of rods and an ax—the *fasces* re-adopted by Mussolini
in the twentieth century—to symbolize his power to arrest, punish, and
execute. A dictator had twenty-four lictors, lesser officials fewer. The sol-
diers raised a chant of praise, *"Io triumphe,"* and sang mildly obscene
songs, the "Fescennine verses," poking fun at their leader; a typical verse
about Caesar (who was bald, and renowned for his sexual appetites) ran:

> Home we bring the hairless Fucker,
> Roman maidens, bar your doors—
> For the Roman gold you sent him
> Went to pay his Gallic whores.

Usually the appearance of the victor would be preceded by a long
parade of his spoils. Thus the triumph of Aemilius Paullus was preceded,
according to Plutarch, by an entire day's march-past of some 250 wag-
ons bearing the statues, paintings, and colossal images looted from Per-
seus, king of Macedon. The next day, looted Greek silver, bronze, and
gold were displayed on a similar train of chariots, along with captured
armor. Not until the third day did triumphant Aemilius Paullus make his
appearance, followed by Perseus, "looking like one altogether stunned
and deprived of reason through the greatness of his misfortunes," as he
must indeed have been.

The conquering hero would, of course, dress for the occasion. His face
would be painted with red lead, to signify his godlike vitality. He would
be arrayed in triumphal purple, with a laurel crown on his head and a
laurel branch in his right hand, and wear amulets to avert the evil eye.
Addressing a mass gathering of civilian citizens and his troops, he would
praise the patriotism of the former and the noble courage of the latter.
He would distribute money and decorations to them. These gifts were
expected to be lavish. And, coming from Caesar, they were: every foot
soldier of his veteran legions got twenty-four thousand sesterces as his
booty, over and above the two thousand he had received as wages. If you
pay a lot for gratitude, Caesar well knew, it is likely to stay bought. But
his men did love him, and for other, equally compelling reasons: his tre-
mendous daring and military skill, his powers of charismatic leadership.

Mounting in a quadriga or four-horse chariot with his children and rel-

atives around him on horseback, the victorious general would now begin his progress toward the Capitol; riding with him in the chariot would also be a public slave, holding over the victor a gold crown studded with precious stones, and repeatedly intoning the mantra "Remember that you are a mortal man." The processional route ran from the Campus Martius through the Triumphal Gate, to the Circus Flaminius—an anomalous public square in which, despite its name (*circus* = race course), races seem never to have been held, and in which there were no banks of seating for spectators, but where the spoils of triumph were displayed—and thence to the Circus Maximus. Then the procession would wind round the Palatine Hill, along the Via Sacra—the oldest and most famous street in Rome—and thence to the Capitol. In the Forum, he would order some captives of high rank imprisoned and put to death, and then ride on to the Capitol, where further rituals including sacrifices would be performed at the Temple of Jupiter Capitolinus. Julius Caesar's sense of display and drama was so developed that when he walked up the final steps to the Capitol, he had forty elephants deployed to his right and his left, each carrying a torch in its trunk.

Naturally, these long and impressive ceremonies required a grand architectural backdrop. All during his campaigns in northern Europe, Caesar had built nothing; there was no time. But in 55–54 B.C.E., he decided to leave a permanent architectural mark on Rome: a magnificent colonnaded square, the Forum Julii or Forum Caesaris, with a temple dedicated to Venus Genetrix, mythical ancestress of the Julian line, at one end of it. It bordered on the more ancient Forum, which had begun as a general meeting-place and market and had become known as the Forum Romanum, to distinguish it from other existing fora such as the Forum Holitorium (Vegetable Market) and Forum Boarium (Cattle Market). Over the years, a clutter of functions had converged and taken root in it. Lawyers, money changers, and senators mingled in its ancillary buildings, which sometimes served as markets. State archives were held in its *tabularium,* an all-important archive. Shrines were built—a circular Temple of Vesta, the Roman hearth goddess, was attended by six vestal virgins, whose duty was to tend the city's sacred fire. The Forum Romanum also contained the small but ritually important Shrine of Janus, the Roman god of beginnings, whose gates were ritually closed whenever peace in the Roman world was announced.

Julius Caesar's forum was the first of a number of fora to be built next to and north of the Forum Romanum; its successors were the Forum

Augusti, the Forum of Nerva, and the Forum of Trajan. The huge costs of Julius' forum would be met by the sack of Gallic cities and shrines, and of course by the slave trade, which Caesar dominated by now with his prisoners-of-war. The final cost of the land—and only the land—for the Forum Julii is said to have been 100 million sesterces, because every square foot of it had to be purchased from private owners at a time of fierce commercial speculation.

This did not matter to Caesar; he was determined to put his parcel together at any cost, and he did. Inside it he erected a marble temple in a colonnaded square. He filled it with expensive works of art, including paintings of Ajax and Medea by the famous painter Timomachus, a golden statue of Cleopatra, a corselet made of British pearls, and a plethora of portraits of himself. Outside its entrance he is said to have installed the *Equus Caesaris,* another sculptural portrait of himself mounted on a portrait of his favorite horse. Ancient accounts—Pliny, Suetonius—concur that this was a peculiar animal, recognizable by its near-human forefeet. But it is not clear whether it had toes, or just malformed hooves.

He was entirely the master of the Roman Empire now. For twenty years he had been head priest of the state religion, the *pontifex maximus.* It seemed that Caesar could go no higher, except by becoming a deified king.

Even that was on the cards. In 44, his portrait head had begun appearing on Roman coins. Mark Antony (Marcus Antonius, c. 81–30 B.C.E.), a close adherent of Caesar's, tried (but failed) to establish a cult of the living Caesar with himself as its priest. Caesar also inflated the numbers in the Senate with hundreds of patricians and equestrians he personally chose. He appointed many new magistrates, equally obliged to him, and established scores of new Latin colonies outside Italy to reward loyal army men. Buoyed by his successes, feeling invulnerable, he also made a fatal mistake. He dismissed his Praetorian Guard.

Conservatives were waiting in the wings, burning with anger at the sight of Caesar's growing autocracy, and determined to return Rome to its supposedly pristine virtues as a republic. The only way, they reasoned, to be rid of Caesarism was to kill Caesar. They rapidly formed a cabal. Its leaders were Gaius Cassius Longinus and Marcus Junius Brutus.

Cassius had fought on Pompey's side against Caesar's army during the civil war, but Caesar, with his usual magnanimity toward defeated

Roman foes, had pardoned him, raised him to praetor in 44, and then made him consul designate.

Brutus, who led the cabal, was a man of intense probity and patriotism—"This was the noblest Roman of them all"—whom the other would-be assassins thought indispensable to the plan of killing a hero so worshipped by the *plebs.* The fact that he was a usurer—Cicero, whom Brutus had served as quaestor in Cilicia, discovered that Brutus was getting 48-percent annual interest on a loan he had made to a city in Cyprus—did nothing to diminish his reputation. To kill a man who had too much power and abused it was not necessarily repugnant to Romans. They had before their eyes the example of such heroic figures as Harmodius and Aristogiton, the Greek lovers who in 514 B.C.E. assassinated the tyrant Hipparchus and were honored by a statue in the Agora, much copied by Roman sculptors (or Greek ones working for Roman clients). That was how the cabal saw Caesar, and they resolved to kill him, which they did with their daggers on the floor of the Senate House in Rome on the Ides of March 44. Shakespeare has the unprotected Caesar exclaiming *"Et tu, Brute?"* ("Even you, Brutus?"), but his last words were apparently not in Latin. They were Greek—*"Kai su, teknon?,"* "You too, my son?"—as befitted one highly educated Roman patrician addressing another, even at the point of death.

Chaos followed. The assassins left Caesar's corpse where it had fallen on the floor of the Senate House, at the foot of a statue of Pompey. They rushed out into the street brandishing their daggers and shouting *"Libertas!"* and *"Sic semper tyrannis!"* ("Freedom!" "Thus always to tyrants!") The general populace was unconvinced; they milled around, some hysterical with grief and confusion; they drove the conspirators to take shelter on the Capitoline Hill. Meanwhile, Mark Antony, Caesar's consul, seized the dead man's papers, last will, and money, and prepared to speak at Caesar's public funeral. His speech incited the crowd to a frenzy, and the conspirators, who had convinced themselves that they would be hailed as saviors, hurriedly left Rome for the Eastern Provinces of the Empire.

At this early stage of post-Caesarian sorting out, nobody paid any attention to Caesar's only male relative, his grand-nephew, a weedy eighteen-year-old named Gaius Octavius. But it turned out that in his will Caesar had posthumously adopted him as his son and heir, and left him three-quarters of his enormous fortune. Antony, who had usurped

the role of Caesar's executor, flatly refused to give the lad this inheritance and, just as foolishly, refused to pay out the three hundred sesterces Caesar had willed to each and every citizen of Rome. This incredible act of parsimonious folly sealed Antony's fate, depriving him of the goodwill of most Romans.

Meanwhile, barred from access to Caesar's fortune, Gaius Octavius used his own lesser but still-considerable funds to raise a private army from among Caesar's veterans who had been settled in Campania and Macedonia. The name of Caesar was still magical to these old campaigners, and Octavius had inherited its mana. And although he was no warrior with any weapon but his tongue, Cicero attacked Antony with fourteen "Philippic Orations," a title he had borrowed from Demosthenes for the hysterically ferocious speeches he made against the dead Caesar's friend.

Octavius now marched his army of hardened professionals on Rome. At the age of nineteen, he was elected consul—the youngest in the city's history—and thenceforth was styled Gaius Julius Caesar Octavianus: Octavian for short. After a meeting near Bononia (modern Bologna) with Mark Antony and the governor of Transalpine Gaul, Marcus Aemilius Lepidus, Octavian announced that the Second Triumvirate had been formed; this was confirmed by the Roman Senate, which had no choice about the matter, shortly after. The triumvirs would hold office for an initial five years. They would have absolute power over taxation and the appointment of officials, high and low. They would be free to proscribe whomever they wished, and they did so mercilessly—three hundred senators and two thousand equestrians died in the purges, their money and property gobbled up by the triumvirs.

And Cicero paid dearly for his insults to Mark Antony. He had scarcely begun his flight from Rome when a party of Octavian's soldiers overtook him on the Via Appia, in early December of 43 B.C.E. They buried his body but brought his head back to Rome. There are two versions of its fate. "It is said," wrote the chronicler Appian, "that even at his meals Antony placed Cicero's head before his table, before he became satiated with this horrible sight." Another version related that the head was nailed up for all to recognize in the Forum. Fulvia, Mark Antony's wife, pried open its jaws, pulled out the tongue, and transfixed it with her hatpin: a fitting insult, she and others felt, for the organ which had so often and so calamitously libeled her husband.

2

Augustus

Until the advent of photography and then of TV, which effectively replaced them, propaganda statues were indispensable when it came to perpetuating the iconography of leadership. They were produced in mass numbers all over the world to celebrate the virtues and achievements of military heroes, political figures, wielders of every sort of power over all kinds of people. Most of them are wretched kitsch, but not all, and one of history's more successful icons of power is a marble statue exhumed in a villa that once belonged to the Empress Livia, wife of Octavian and mother of the future Emperor Tiberius, near the site of the Prima Porta, one of the main entrances to ancient Rome. It is a portrait of her husband, by that time known as Gaius Julius Caesar Octavius, but known to the world and to history as the first of the Roman emperors, Augustus (63 B.C.–14 C.E.).

The statue is perhaps not, in itself, a great work of art; but it is competent, effective, and memorable, a marble copy of what was probably a Greek portrait in bronze, showing the hero in military dress, in the act of giving a speech either to the state as a whole or, more probably, to his army, on the eve of battle. As an image of calm, self-sufficient power projecting itself upon the world, it has few equals in the domain of sculpture. It does not ask of the viewer any particular knowledge of Roman history. But little is wholly self-explanatory. Take the design on the cuirass he is wearing, which shows—as most literate Romans would have known, though we can hardly be expected to—the recovery by Augustus of one of the army's military standards, captured and taken away by the Parthians on the Eastern frontier in 53 B.C.E.: the cancellation, there-

fore, of an unbearable disgrace. It also helps to know that the little figure of the love god Eros next to Augustus' right leg is there to remind us that his family, the Julians, claimed to have descended from the goddess Venus, so its presence reinforces the belief that Augustus was a living god. The dolphin it is riding refers to Augustus' destruction of Antony and Cleopatra's fleet in the sea battle of Actium.

We may be inclined to suppose that the *Augustus of Prima Porta* is a unique piece, but it almost certainly is not. The Romans reveled in the cloning, copying, and dissemination of successful images—successful, that is to say, especially from the viewpoint of ideology. If we think of this Augustus as an "original," we are probably wrong. All over the Empire, sculptors were busy churning out standardized effigies of Augustus, mostly in marble but some in bronze. The artists were more often Greek than Roman, and their production was organized, as far as one can tell, in efficiently factorylike ways. There was more in common between classical Roman art and the techniques of Andy Warhol than one might at first suppose. A huge empire had to be saturated with images of its deified emperor. As a 2001 study put it, "A recent count of [Augustus'] surviving heads, busts and full-length statues reached more than 200, and recent estimates of ancient production guess at 25,000–50,000 portraits in stone all told."

Augustus (the name is a title bestowed by the Senate, meaning "worthy of veneration," and it carried the implication of numinousness, of semi-divinity) was the son of Julius Caesar's niece, adopted as his own son by Caesar himself. It is unclear what kind of relations young Octavian had with his granduncle, but there is no question that Caesar's influence on him was definitive. In particular, the young man admired Caesar's political and military daring.

He made short work of avenging Caesar's death. The Triumvirate's armies destroyed those of the rebels at the Battle of Philippi in 42 B.C.E. Brutus and Cassius committed suicide.

The triumvirs, now in complete control of Rome, instituted a violent purge against the senatorial and equestrian classes of the state. In the course of this, deep rifts between Octavian and Mark Antony appeared. Their upshot was the brief Perusine War (41–40 B.C.E.), in which Antony mounted an open revolt against Octavian. Archaeologists have unearthed not a few of its relics—stone and lead slingshot balls with rude messages scratched on them: "I'm after Octavian's ass." "Octavian has a limp dick." It was a brutal little war, won by Octavian, who had some

three hundred prisoners of senatorial or equestrian rank sacrificed on the Ides of March at the altar of the god Julius. Antony and Octavian's rivalry was patched up, after a fashion. In the new order of things, Octavian took control of Rome's Western Provinces, while Antony kept power over the Eastern, including, fatally and famously, Egypt.

Now came the diplomatic and military fiasco of Antony's love affair with the last of the Ptolemaic rulers of Egypt, Cleopatra (69–30 B.C.E.). The queen of the Nile had already had a liaison with Caesar (48–44 B.C.E.) and borne him a son. Now she and Antony launched into their famous affair, beginning in 41 B.C.E. It produced twins. The extant coins and other effigies of Cleopatra do not seem to do justice to what those who knew her (especially Antony) considered her irresistible beauty. It may be that Blaise Pascal, many centuries later, was right in observing that if her nose had been shorter the entire history of the world would have been different. But there are some things we will never know.

What is quite certain, however, is that Antony and Cleopatra's obsession with each other had huge political repercussions. It was a godsend to Octavian, who by now wanted to destroy Antony altogether, but held back from doing so because an attack on Antony was likely to be interpreted as an attack on the sacred memory of Julius Caesar. He saw an opportunity when Antony took up with the Egyptian queen, and began promoting the idea that Cleopatra had perverted Antony's Romanness. Cleopatra was the power-crazed Greek strumpet of Egypt, a woman who would stop at nothing in her drive to undermine Roman interests in the Middle East, with Antony as her sex-fuddled dupe. She meant to make it all the way to the Capitol: she intended to run Rome.

Actually, the image of Cleopatra we have inherited was completely misleading, a creation of propaganda and nothing more. She was, if anything, a woman worthy of respect, not least for her intelligence, which went far beyond mere sexual cunning. She had only two recorded affairs with powerful and charismatic men, Caesar and Antony, and children by each, to whom she was devoted. The picture of her as a scheming nymphomaniac is false in every way.

But it certainly served Octavian's purposes. He used it to whip up Roman plebeians and patricians alike to a war frenzy. In the first place, they feared that Cleopatra, through her influence on Antony, would subvert the proper course of Roman politics—and do even more damage if she moved to Rome with him. In the second, they loathed the idea of a woman, any woman, having such political influence.

Thus Octavian was sure of popular support for an attack on Antony which would destroy both him and Cleopatra. The eventual result was the sea battle between the Triumvirate's ships and Antony's, fought in 31 B.C.E., off Actium, south of Epirus in Greece. The sixty ships of Cleopatra and Antony were put to flight by the Roman navy; most surrendered. Cleopatra fled back to Alexandria; Antony, likewise. Both committed suicide, he by running onto his sword, and she—unable to bear the loss of her lover and the prospect of public humiliation in Rome, where Octavian was going to drag her through the streets for punishment—by the bite of an asp, the most famous snake in history.

Octavian went on to Egypt. He entered Alexandria on the first day of August, 31 B.C.E. There, he beheld the embalmed body of Alexander, his hero and model. It must have resolved him even further.

His enemies dead or scattered, his army and navy victorious, Caesar avenged, and the Roman people, weary of war, hoping only for order and an honorable, lasting peace, Octavian now had absolute power over Rome. "He was the first and the greatest and the common benefactor," wrote Philo of Alexandria, "in that he displaced the rule of many and committed the ship of the commonwealth to be steered by a single pilot, himself. . . . The whole habitable world voted him no less than celestial honors. These are well attested by temples, gateways, vestibules, porticoes. . . . That he was never elated or puffed up by the vast honours given to him is clearly shown by the fact that he never wished anyone to address him as a god." Instead, the Romans came up with a new name for him: no longer Octavian, but Augustus.

No such *imperium* as his had ever existed before. Rome now ruled the entire Mediterranean world.

The image we have of ancient Rome comes down to us in a very edited form. Much of the editing has been done by art and artists of later years: think of Nicolas Poussin. This city of the imagination, masquerading as a city of collective memory, is mostly white—the color of classical marble, the stuff we imagine the city made of. (So at the outset we are misled, since the marble most valued by Roman builders to sheathe the brick and concrete cores of their buildings was very often colored.) White cylinders of stone gleaming in the sun, surmounted by capitals, Doric, Ionic, Corinthian, Tuscan, Composite, linked by cornices, architraves, and arches. White ramps, white colonnades, flights of white steps, and white foam from the plashing fountains. White people inhabit this townscape, of course, and they are wearing white togas. There is lots of

air around these dignified Romans. As befits the owners and rulers of the known world, which extended from England to Africa, from the Thames to the Nile, from the Seine to the Euphrates, they are not crowded or hurried. Their gestures are dignified; they have become the statues of themselves. They are full of that very Roman attribute *gravitas*.

If we were to pluck a real Roman from the real Rome of this time, the second century C.E., or from the earlier city of Augustus, and set him down in this handsome and meaningful place, this site of classical order, he might feel out of place.

The real Rome was Calcutta-on-the-Mediterranean—crowded, chaotic, and filthy. A few of its inhabitants might dwell in the palaces we imagine, but most lived in warrens—tall jerry-built tottering blocks of flats known as *insulae* or "islands," which rose as high as six stories and were given to sudden collapse or outbreaks of fire. Building codes did not exist. The poet Juvenal complained, without exaggeration:

> Here we have a city propped up for the most part by slats; for that is how the landlord patches up the crack in the old wall, bidding the tenants to sleep at ease under the ruin that hangs above their heads.

Because the *insulae* were usually built without chimneys, the tenants had to rely on charcoal braziers for warmth in winter, exposing them to death by carbon-monoxide poisoning or accidental fires. Rome had about 1,800 *domus* or single-family dwellings and 46,000 *insulae,* but there was no regulation of the size or human capacity of an "island"—it would hold as many people as a landlord could cram into it. If one thinks of a total population of 1.4 million people in Trajan's Rome, one will probably not be far wrong.

This made Rome a vast and consequential city, but it also condemned most Romans to live in conditions worse than the overcrowding and lack of basic amenities—water, fresh air, sewage services—that typified the worst slums of New York at the height of immigration in the 1870s. *"Terrarum dea gentiumque, Roma,"* wrote the poet Martial, *"Cui par est nihil et nihil secundum"*—"Rome, goddess of lands and peoples, Whom nothing can equal and nothing even approach."

But the goddess stank. These being long before the days of mechanical transport, Rome's streets were laden with the excrement of horses, pigs, cows, dogs, donkeys, and people, ton on ton of it, not to mention the dead babies and the corpses from periodic murders and muggings, and all the kitchen waste. Few facilities existed for collecting and getting rid

of this stuff, not even for dumping it in the Tiber. And the Tiber, one should remember, still served as a principal supply of drinking water for many Roman households. Not until the reign of the Emperor Trajan, in June 109 C.E., did the eight aqueducts which formed the distribution end of the Aqua Traiana, bringing more than 220 million gallons a day of good springwater to the right bank of the Tiber, open for use—and most of that was monopolized by the ground floors of the rich. Only very rarely did an *insula* have rising pipes to bring good water to its upper floors.

Nevertheless, ancient Rome did have one hygienic advantage over modern New York. Like most Roman cities, and unlike modern American ones, it was generously equipped with public toilets. These were not of the sort familiar to modern users. Because the ancient Romans did not have the same taboos about elimination as we do, they did not insist on separate cubicles. The typical arrangement was a long stone bench, pierced with suitable holes. Everyone sat companiably, side by side. Underneath ran a channel of flowing water; and a channel in the floor outside the seat enabled the users to wash their hands when they were finished.

Since municipal trash disposal was as far from Roman expectations as automobiles or video, householders simply threw their rubbish into the street, where it lay and festered and was sometimes partly washed away by rain. At least there were sewers and storm-water channels to carry it off into the Tiber. In fact, the Roman sewer system, which had been under construction since the sixth century B.C.E., was (for all its imperfections) one of the marvels of the world's civic engineering.

Nobody wants shit around. *"Cacator sic valeas ut tu hoc locum transeas,"* reads one of the many graffiti preserved under the ash of Pompeii— "Do yourself a favor by shitting somewhere else." And a city of a million or so people is obviously going to have its problems of sewage disposal. Rome had its system, and it was famous. Its main collector, the Cloaca Maxima (Principal Sewer), began its underground journey through Rome below the Temple of Minerva in the Forum of Augustus, passed between the Basilica Julia and the Temple of Vesta, went under the Arch of Constantine and the Piazza della Bocca della Verita, and discharged its noisome freight into the Tiber just below the Ponte Rotto through an arched opening five meters in diameter. None of the *insulae* seem to have any direct connection through downpipes to the sewers. Now and then, *plostra stercoraria* or shit carts might make an appearance, but not

reliably. The ejection of garbage and waste into the public street usu-
ally happened at dusk. It was one of the drawbacks of ancient Roman
life, especially since (as coarse terra-cotta cost nothing) it was a common
habit to throw out the pot with its contents. Juvenal warned the visitor,
"You are truly negligent and careless if, before leaving the house to go
out to dinner, you don't first make a will," because passersby were so
often brained by falling night-urns. "Very often you might die, for all
the windows open along the streets you travel. Therefore . . . cultivate
within yourself the forlorn hope that the windows will be content to
pour out only the contents of their chamber pots on your head." Roman
law did provide some redress for those injured by chamber pots falling
from on high: the victim should be compensated for his medical fees and
lost work time. But he could not sue the owners or tenants of the *insula*
for disfigurement caused by his wounds, since "the body of a free man is
without price."

The wise night-rambler should wear a padded leather cap to protect
his head, not only against such hazards, but from the assaults of other and
more delinquent Romans. One of these, according to Suetonius, was the
young Emperor Nero, whose sport was to prowl the alleys of his impe-
rial capital with a gang of friends and bash strangers insensible—"He
was in the habit of clubbing people on their way home from banquets,
and if anyone fought back he would beat him badly and throw him in a
sewer." To be mugged and then half drowned in excrement by a prowling
emperor was the kind of fate which not even Georgian London, for all its
bad sanitation and royal absolutism, inflicted on its visitors. But it would
have been hard to tell if your assailant was a Nero or a mere commoner,
since the streets of Rome were unlit and unpoliced. Either you found a
lanternarius or lantern-bearing slave to precede you with a flambeau, or
you groped your way in fear and darkness. And, naturally, the streets had
no numbers or posted names.

The traffic made city life harder still. In 45 B.C.E., Julius Caesar issued
an edict which banned carts, wagons, and chariots (with certain excep-
tions, such as chariots belonging to the vestal virgins or to the winner
of a major race) from driving in the city between sunrise and midaft-
ernoon. This was a masterpiece of bad urbanism, since, although it did
something to make daytime walking and riding in Rome possible, it
immediately diverted all Rome's commercial traffic into the night hours,
depriving most Romans of their sleep. Roman carts had wooden wheels
with iron tires, and the grinding and clanking of their progress over the

ruts and stone pavements raised a din that mingled with the braying and lowing of beasts, the shouts of the carters, the merchants' bellowing quarrels, and the crash and scrape of goods being loaded and unloaded. This went on all night long, and a stone could hardly sleep through it. It would keep a sea calf awake on the bottom of the sea, Juvenal thought. It would give the Emperor Claudius insomnia. Rome, the enemy of repose! And during the day it was little better: the traffic noise was not as bad, but the sound of voices and pedestrian confusion were still unbearable. The only solution, and a partial one at that, was to be rich and ride at ease in a "spacious litter" that one's slaves could hoist above the heads of the madding crowd. In it, one could close the windows and perhaps doze. But on foot, wrote Juvenal,

> the tide of the crowd before me is an obstacle, while the one following behind me like a compact phalanx is pressing at my back; one man elbows you in the side, another strikes you roughly with a cudgel; the next one bashes your head with a board, the next with a barrel. Meanwhile, your legs grow heavy with mud, your feet are stepped on from all sides by enormous shoes, a soldier punctures your big toe with his hobnailed boots. . . .

Before it could flow out of Rome, of course, the water had to flow in. It did so mainly through aqueducts. Eleven of these supplied the city with its drinking and washing water, eight entering by the region of the Esquiline Hill. Four more were added after the popes replaced the emperors, two of them in the twentieth century. No other ancient city had such a copious supply of water, and it earned Rome the name of *regina aquarum,* "the queen of waters." Almost all of them brought in drinkable water, except for the Alsietina, which carried water from the small Lake Martignano; some thirty-three kilometers long, this aqueduct supplied an arena for naval battles which the Emperor Augustus created on the present site of Trastevere. Probably the best water was that of the Claudian Aqueduct, begun by Caligula in 38 C.E. and finished by Claudius in 52 C.E.; certainly the aqueduct whose construction created the most difficulty was the Aqua Marcia, begun in 144 B.C.E. under the praetorship of Quintus Marcius, with a total run of ninety-one kilometers of which eighty ran underground.

Aqueduct maintenance was a never-ending occupation, done in the main by slaves. The channel or *specus* of each aqueduct was constantly being narrowed by the buildup of "sinter," the common German term

for deposits of calcium carbonate ($CaCO_3$), carried in the water and deposited on the channel walls. How fast it built up depended on several variables: the "hardness" or lime content of the water, the texture of the channel (rough surfaces encouraged buildup, which roughened the surface more, increased friction, and so trapped more sinter), and the speed of water flow. Research done on the channel of the great aqueduct at Nîmes, in southern France, indicates that sinter deposits (on both sides) narrowed its channel by forty-six centimeters, or a third of its original width, in two hundred years. This yields a rate of about nine inches per century, which may not sound like much, but over the hundreds of linear miles of the eleven aqueducts that supplied Rome with its water, the tasks of grinding and chipping the sinter away added up, as did the maintenance of the terra-cotta or lead conduits themselves. Besides, four miles out of every five lay underground.

The distribution of water to its end users was done mainly through lead pipes. Lead gave its Latin name, *plumbum,* to those who worked with it, the *plumbarii*—who bequeathed it to their modern successors in England, the plumbers, and to those in France, the *plombiers.* It had large advantages for such work. It was soft, very ductile, and had a low melting point—about 375 degrees Celsius. Best of all, it was common and cheap, being itself a waste product. It had one disadvantage: it was highly poisonous, as the grieving parents of many a Victorian child who chewed too often on his lead soldiers discovered.

Rome used a great deal of silver, which was present in tiny quantities in lead's principal ore, galena (lead sulfide). The galena, when melted, separated into about one portion of silver to three hundred of waste lead. A simple process afforded slaves (who were likely to die of lead poisoning in the end) the means of making lead pipe. Molten lead was flowed over an inclined heatproof surface. When it reached the desired thickness and cooled, the resulting sheet was trimmed and then rolled around a suitable wooden mandrel. Its edges would be soldered together, and the result was water pipe, which usually came in ten-foot or shorter sections.

The fact that Rome's water was delivered through lead conduits gave rise to a persistent myth: that the water was contaminated, and so lead poisoning killed or weakened those who drank it. This cannot have been so, because the water passed through the pipes too quickly (at its fastest, probably at 1.5 meters per second) to acquire any significant toxicity on the way. However, wine was often kept for long periods in jars, or amphorae, whose interiors had been treated with lead-based glazes, so it

may well be that bibulous Romans were affected by it. Probably it was gonorrhea, rather than lead poisoning, that made Romans ill.

How did water move into the city and get distributed? No pressure pumps existed. The entire distribution system for Rome's water, throughout a total 500 kilometers of eleven aqueducts, was gravity-fed, and the feed had to be maintained across great distances: the original source point of Rome's Aqua Marcia was 91 kilometers from the city, and that of the Anio Novus hardly any closer (87 kilometers). Since water will not run uphill against gravity, each aqueduct had to have a very gradual downward slope, continuous throughout its length. That of the Aqua Marcia, for instance, was 2.7 meters per every kilometer. But the natural form of the earth is never a steady, almost imperceptible decline. Consequently, the aqueducts, on meeting a rise, had to go through a tunnel; and when the ground level fell too suddenly away, the channel of water had to be carried above it on arches. Hence the magnificent sight of the tall aqueducts converging on Rome, across the flat wastes of the Campagna—mile upon mile of arches not yet fallen into ruin, imposing their proud rhythm on an otherwise undistinguished landscape, silently beautiful in the golden morning or rosy evening light.

But how to give them the necessary shape, the exact fall needed to convey the precious water into the heart of the city? This was accomplished by surveyors. They did not have modern equipment—the laser levels and theodolites of today's surveyors did not exist. Yet they managed well with what would seem, by modern standards, to be very primitive instruments. The first of these was the *chorobates,* or water level, a long narrow trough (a straight, hollowed-out section of tree trunk would do) which could be propped up on stones and filled with water. Since a still water surface is always horizontal, this gave an excellent reference for sighting along, and when an assistant placed himself some distance away with a vertical, graduated measuring rod which had a movable target, a surveyor with good eyes—Rome had no lenses or optical glass—could readily establish the rise or fall of the land between the two points. It was a clumsy instrument, needing a twenty-foot-long table to carry the trough, but in skilled hands it could plot variations in height with astonishing accuracy. Though no ancient remains of such a device have ever been found, descriptions leave no doubt about its use. Similar surveying principles governed the boring of underground tunnels.

Next in usefulness was the *dioptra,* a flat disc mounted on a tripod, which could be both turned horizontally and tilted in the vertical plane.

Through a sighting tube fixed diametrically across the disc, it could mea-
sure both the height and the bearing of a distant target and was thus the
ancestor of the modern theodolite.

Finally, there was the basic tool that every surveyor had to have, more
for field surveying than for the layout of aqueducts: the *groma,* consisting
of two horizontal crosspieces fixed at right angles on the tip of a pole,
with a plumb bob hanging from each end of the pieces. It was indispens-
able for the other kind of big Roman engineering project as well: the
laying out of roads.

Along the length of the aqueduct, and especially just before it entered
Rome, settling tanks were built: a simple filtration system whereby the
flow was allowed to pause so that particles and debris could sink to the
bottom, there to be cleaned out periodically by the slave maintenance
crews.

The oldest of the aqueducts dated well back into republican days: the
Aqua Appia, sixteen kilometers long, mostly underground, built in 312
B.C.E. and successively restored by Quintus Marcius Rex (144 B.C.E.),
Agrippa (33 B.C.E.), and Augustus (11–4 B.C.E.). It delivered seventy-five
thousand cubic meters of water per day.

The next oldest was the Anio Vetus (272–69 B.C.E.), another mostly
subterranean aqueduct, which took its water directly from the Tiber
above Tivoli, bringing it eighty-one kilometers to Rome and supplying
some 180,000 cubic meters a day.

Rome's need for water increased rapidly in the second century B.C.E.,
as a result of its colonial victories, which increased the population of the
city. This produced the longest of all its aqueducts, the Aqua Marcia,
which ran for 91 kilometers (81 kilometers below ground) and delivered
190,000 cubic meters daily.

Agrippa, builder of the Pantheon, also constructed two aqueducts,
the Aqua Julia (33 B.C.E.) and the Aqua Virgo (so called because its
source outside the city was pointed out to his surveyors by a young girl).
Between them they brought some 150,000 cubic meters a day into Rome.
Two aqueducts started by the Emperor Caligula (the Aqua Claudia in 38
C.E., the Aqua Anio Novus in the same year) had to be finished by the
Emperor Claudius; between them, they gave Rome a further 380,000
cubic meters a day. All in all, the eleven aqueducts provided some 1.13
million cubic meters of water to meet the daily requirements of about a
million people, which averaged out at about 1.13 cubic meters of water
per person per day.

Not all this water was used for drinking, cooking, and washing. Water also had a strong—indeed, essential—decorative and metaphorical aspect in ancient Rome, as it does today. Not every house had a garden, but many did, and those fortunate enough to have one needed a good supply of water for plants, pools, and, of course, fountains. The fountains of Rome, celebrated in numberless paintings and poems as well as in music—one thinks of the charming trills and tinklings of Respighi's *Le fontane di Roma*—have always been a feature of the city and the culture it embodied. Because of the low water-pressure in the days before mechanical pumps, the "abounding glittering jet" that spells "fountain" to us today and was so magnificently choreographed by the likes of Gian Lorenzo Bernini in the seventeenth century was not available in ancient Rome, but a lot of refreshment and relaxation could be had from trickling basins, ornamental pools, shallow waterfalls, and *chasses d'eau*—the most grandiose project of this kind being the celebrated Canopus in the garden of Hadrian's Villa at Tivoli.

All this civic splendor, and much more, depended on a colonial empire which had grown from a small seed in Italy, at the mouth of the Tiber—Ostia, that vital port where the wealth of the growing empire came in and the administrative manpower went out, taken from its original inhabitants in Etruscan times. Now, at the turn of the millennium, its spread was prodigious. In Africa, Rome commanded the provinces of Numidia, Mauretania, Cyrenaica, and Africa Proconsularis. Its African possessions did not supply mineral wealth (that came largely from Spain), but they gave Rome huge supplies of grain and other foodstuffs and, as a bonus, supplied the wild animals for the shows in the arenas. Rome had all of Egypt. Its command of the Iberian Peninsula, modern Spain and Portugal, was divided between the provinces of Tarraconensis, Lusitania, and Baetica. It ruled Gaul (Lugdunensis, Narbonensis, Belgica) and Britain. It had—insecurely, at times—the frontier provinces of Germany and the lands along the natural frontier of the Danube, such as Dacia. It had annexed Greece (Macedonia, Achaea, and Thrace) and much of Asia Minor. Its farthest Eastern Provinces included Judaea, Syria, and Mesopotamia.

At its height, the Roman Empire included fifty to sixty million people—all under the absolute rule of one single man, all members of subject populations: citizens of Rome, but also other Italians; Europeans and Middle Easterners of all sorts, Gauls, Dacians, Armenians, Mesopotamians, Syrians, Africans, Egyptians; Britons, Spaniards, Germans,

and so on, seemingly *ad infinitum.* These formed a vast and bewilderingly complex mosaic of languages, histories, creeds, and customs, some willingly passive to Roman authority, most of them manageable by dint of colonial firmness, and a few—such as the ever-fractious Jews—continually at odds with the system that had taken them over. Some of these peoples had very little effect on the core culture of Rome. Others, notably Greece, not only influenced but transformed it. *"Graecia capta ferum victorem cepit,"* wrote Horace, *"et artes intulit agresti Latio":* "When Greece was taken she enslaved her rough conqueror, and introduced the arts to cloddish Latium."

Almost as soon as he had emerged victoriously from the Battle of Actium in 31 B.C.E., Augustus launched into an ambitious program to restore his city's damaged prosperity. He took advantage of the long-term security of funds and work which his principate—the word given to his rule as *Princeps* or "First citizen," a title Augustus had chosen to avoid the taint of absolutism or kingship—allowed. "Professing himself satisfied with the tribunician power for the protection of the plebs," wrote Tacitus,

> Augustus enticed the soldiers with gifts, the people with grain, and all men with the allurements of peace, and gradually grew in power, concentrating in his own hands the functions of the Senate, the magistrates, and the laws. No one opposed him, for the most courageous had fallen in battle. . . . As for the remaining nobles, the readier they were for slavery, the higher they were raised in wealth and offices.

It was an essential part of Augustus' political genius that, now and over the coming decades of his reign, he successfully maintained the illusion that he was not a dictator, just a savior, the man who had restored the Republic and its primal virtues by handing it back to the Senate, and thus to the people, of Rome.

But it was a fiction—a necessary one. Although Augustus created a charade of restoring the Republic, few Romans now remembered what it had once been. He had no intention of allowing republican chaos to seize the state again. He made a point of consulting the Senate, but the Senate reciprocally made a habit of never defying his will. He kept total command of the Roman army, and of the imperial provinces. He was also *pontifex maximus,* the supreme religious authority of the state.

Augustus was not a consistently great general, but he had his successes. The chief one was the annexation of Egypt as a Roman province

in 30 B.C.E., which gave Rome an unfailing and inexhaustible supply of grain. His armies completed the conquest of Spain. He also had military failures, the worst of which was undoubtedly the destruction of three whole legions in an ambush in the Teutoburg Forest, on the north side of the Rhine. The leader of the German attack, Hermann or Arminius, was one of the geniuses of German military history, his name invoked by every German leader from Frederick the Great through Bismarck to (of course) Adolf Hitler. For a long time after, it is reported, Augustus would beat his head on the wall at night and beseech the gods, "Give me back my legions!"

But, win or lose, the loyalty of the Roman army was always sworn by oath, by each individual, to Augustus personally. He was their paymaster. Their commanding officers were chosen by him, and the head commanders of their campaigns were usually members of his family—Tiberius, Germanicus, or Agrippa. If the soldier lived long enough to complete his term of service (sixteen years, and later twenty), he would expect to be settled on a patch of arable land to complete his life as a farmer, and the matter of what land he received, and where, was decided by Augustus. He was, in short, the soldiers' patron, and they were his clients: an arrangement wholly familiar from civilian life, but transferred with even more stringent bonds of obligation and discipline to the military.

For a few years after Actium, Octavian/Augustus shrewdly passed up the most obvious possibility raised by his victory—to declare himself dictator of Rome and its empire. In 28 or 27 B.C.E., he made a move that seemed to confirm that he was no dictator, but, rather, was acting as the savior of the Republic and its primal virtue, when he formally restored the supreme power to the Senate and people.

In a document titled the *Res gestae* (*Things Done*), whose most complete text is not in Rome but, strange to say, bilingually inscribed in stone on the wall of the Temple of Rome and Augustus in Ancyra (modern Ankara), in Galatia—the original was placed outside his mausoleum in Rome, but written on bronze pillars, so it was "recycled" by later thieves—Augustus set forth this as the first of what he considered the main achievements of his reign. "In my sixth and seventh consulships, after I had stamped out the civil wars, and at a time when by universal consent I was in absolute control of everything, I transferred the management of politics [*res publica*] to the discretion of the Senate and people of Rome. For this service I was given the name 'Augustus' by a decree of the Senate."

This was merely a façade, though; his actual power was near abso-

lute. There was no "permanent revolution," no automatic retention of supreme power—but he was placed in charge of Gaul, Spain, Syria, and Egypt, where most of the legions were stationed, and he remained one of Rome's two consuls, exercising consular *imperium* (either as consul or as proconsul) until his death. To make quite sure that he did not suffer Julius Caesar's fate, he re-created a special elite unit, another Praetorian Guard, for his personal protection.

The bonds of deference and clientship did the rest. Moreover, they did so for a very long time. Just as England in 1900 had many citizens who had turned sixty without ever knowing any ruler but Queen Victoria, crowned in 1837, so at the time of Augustus' death (14 C.E.) countless Roman citizens had never known any form of government other than the stable principate. The management of an empire without Augustus must have seemed to many people hard to imagine, almost a contradiction in terms.

Yet there are some things that not even the most inspired and determined leader can do, and one of the things he failed at—a vital part of his intentions—was his effort to restore ancient Roman virtues by means of legislation. "By new laws passed at my instigation, I brought back those practices of our ancestors that were passing away in our age." He had the Senate pass sumptuary laws limiting extravagance and the gratuitous display of wealth, and he tried to restore what he saw as the diminished *dignitas* of the upper classes by cracking down on the frequency of divorce and adultery among them. He was no puritan, and his own family was certainly no model of virtue—for reasons lost to history, he felt obliged to banish his adopted son Agrippa Postumus (12 B.C.E.–14 C.E.) to the dull Mediterranean island of Planasia, where he was shortly murdered; in 2 B.C.E., he had banished his only daughter, Julia; in 8 C.E., his granddaughter, also named Julia, both for sexual immorality. Apparently, what irked Augustus particularly in his granddaughter's conduct was that, in the course of a wild party, she placed a chaplet on the head of a statue of the satyr Marsyas,* a gesture with pronounced sexual overtones. But Augustus' attempt to legislate his subjects into virtue was, like most such efforts before or since, a failure.

* Whose story is as follows. The goddess Athena had invented the flute, but threw it away because playing it distorted her face. Marsyas found it where it lay, and taught himself to play it. He became so good at it that he had to challenge Apollo to a contest: his flute versus the god's lyre. Inevitably, the impertinent and libidinous satyr lost. Apollo's dreadful revenge was to string Marsyas up and skin him alive. This was always taken as an allegory of the opposition, in art as in life, between sexy spontaneity (Marsyas) and disciplined invention (merciless Apollo).

It was also a small matter compared with his achievements. He re-created the Roman state and its power, refreshed it, and set a pattern of Roman rule that would last some five hundred years. No other states- man of antiquity could have made such a claim. And to the extent that he could set a compelling example through his own way of life, he did that, too. Augustus had none of the obtrusive vices of his successors. He believed in dignity but not pomposity; in ceremony, where necessary and within the limits proper to a chief priest, but not in Oriental showiness, even though he was regarded as a divine being, *Divus Augustus*. Nor was he given to luxurious display, despite his overwhelming wealth. Few later emperors—Claudius and Hadrian being among the exceptions—would show such an understanding of the difference between *auctoritas* (author- itative influence) and *imperium* (command from above).

Augustus was no glutton. He lived, and ate, with moderation. "He . . . preferred the food of the common people," recalled Sueton- ius, "especially the coarser sort of bread, whitebait, fresh hand-pressed cheese . . . and would not wait for dinner, but ate anywhere." In ora- tory, he loathed what he called "the stink of far-fetched phrases." But he "gave all possible encouragement to intellectuals; he would politely and patiently attend readings not only of their poems and historical works, but of their speeches and dialogues; yet objected to being made the theme of any work unless the author were known as a serious and repu- table writer." He also possessed a dry sense of humor, if one is to believe some of the stories about him. He went to a courtier's house for dinner and was served a poor, unelaborated meal. As he was taking his leave, he murmured, "I'd no idea I was such a close friend of yours." Learning of the death of a Roman *eques* who (without anyone's knowledge) had contracted debts of 20 million sesterces, Augustus sent an agent to the auction of the man's property. There, he bought the man's pillow for his personal use. Eyebrows were raised. But, the emperor explained, "The pillow on which he could rest with all those debts must be especially conducive to sleep." And he could take a joke, or so it was said. Back in Rome after his victory over Antony and Cleopatra, he was approached by a man who offered him, for twenty thousand sesterces, a tame raven that had learned to croak, "Hail, Caesar, victor, commander!" Augustus gave him the money, but then a friend of the bird's owner told him that he had a second raven, which he had trained to say, just in case, "Hail, Antony, commander, victor!" The bird was produced. It did indeed hail Antony. Instead of taking offense, the emperor merely told him to

split the money with the friend. He was whimsical with his presents, which might be gold plate or, just as easily, "lengths of goat-hair cloth, or sponges, or pokers, or tongs."

At the top of the social tree, in this newly stabilized Rome, below the emperor himself, were the senators and their families. It was not in Augustus' interest to lord it over them, since that would have diminished his pretense to be *primus inter pares,* first among equals, and increased the risk that disaffected citizens might see him as a king. The senators were traditionally very much an elite, and Augustus was careful to preserve that status for them—even though, under his rule, they had less and less to do. Particularly important for senatorial self-esteem were the magistracies, which they (and they alone) could hold. They were expected to set standards of dignity, and at times compelled by law to do so—no senator could marry an ex-slave, appear onstage as an actor, or (unthinkable liberty!) enter the arena as a gladiator. Property qualifications also existed: in practice, by Augustus' time, there was no senatorship for men who owned less than a million sesterces.

Below the senators were the *equites,* or knights and squires. In earlier days of the Republic, they had been a cavalry force, hence relatively wealthy. This no longer applied, since under the later Republic and the Principate cavalry was supplied by Rome's allied states. But one still needed to be quite rich—400,000 sesterces or more—to qualify as an *eques.*

Then came the plebs, or ordinary people—the majority of Roman citizens. Some were born free, but others were *liberti* or freedmen, former slaves who had been manumitted by their owners. No stigma attached to being a *libertus,* and none to the free children of slaves. On the contrary: it was a matter for congratulation. When the novelist Petronius depicted the freedman Trimalchio in the *Satyricon* flaunting his status, it was not with contempt, still less with hate: Trimalchio might indeed be vulgar, gross, and a bit of a thug, like a goodly portion of the citizens of the Upper East Side today, but he had made it into respectability, and who was going to rebuke a former slave for waving his cash around?

At the bottom of the Roman social order, one comes to the slaves, without whom the society as a whole could not possibly have functioned. Their legal status was simple. They were chattels, things, owned absolutely by their masters, who could buy and sell them as they pleased, and assign them to do any work they wanted.

The fact that slave labor was less efficient than free was well known

to the Romans, because it was the first big thing a slave owner learned. Pliny, for instance, attributed the high food productivity of pre-imperial Rome to its reliance on free workers on farms, and its fall in his own time to the general use of slave labor. "In those days," he wrote, more as a moralist than an economist,

> . . . the lands were tilled by the hands of the very generals, the soil exulting beneath the plowshare crowned with wreaths of laurel and guided by a husbandman graced with triumphs. . . . But today these same lands are tilled by slaves whose legs are in chains, by the hands of malefactors and men with branded faces. . . . And we are surprised that the yields from the labor of workhouse slaves are not the same as from the honest toil of warriors!

Nevertheless, given the choice, what Roman was going to do without his or her slaves? Most slave owners had few, perhaps no more than one or two—just like most landowners in the slave South of America before the Civil War—but the slave populations of some upper capitalist families in Rome were truly impressive. The freedman Gaius Caecilius Isidorus, toward the end of the first century C.E., left 4,116 slaves when he died. More than a few Roman bigwigs owned 1,000 slaves, and the emperor might be served by as many as 20,000. But the statistics are unreliable, especially for the top end of slaveholding. It is conventionally supposed that about one person in three in imperial Rome was a slave.

What did they do? Just about everything. They served, performing an incredible number and variety of tasks and services, which rose almost to a madness of detail in the division of labor. Slaves worked as water carriers, valets, bricklayers, and litter bearers. Their rural equivalents pruned the vines, fed the pigs, sowed and harvested the wheat. They were secretaries, draftsmen, accountants, stone carvers, and teachers. The great man's toilette would be taken care of by the bathing attendants (*balneatores*), the masseurs (*aliptae*), the hairdressers (*ornatores*), and the barbers (*tonsores*). His food would be prepared by pastry cooks (*libarii*), bakers (*pistores*), and other kinds of *coquus* or cook, and served up by the *structores* (majordomos), the dining-room attendants (*triclinarii*), the waiters who carried the dishes in (*ministratores*), and those who took them out again (*analectae*). Before any food was eaten by the owner, it would be tasted, just in case an enemy had reached the kitchen, by the *praegustatores*. At intervals in the parade of dishes, the emperor or aristocrat would be entertained by dancing girls (*saltatrices*), dwarfs (*nani*), and buffoons

(*moriones*). If a slave was the body servant or the secretary of a master, that implied a certain trust, even closeness. It also meant, however, that the slave would be treated as one who had privileged information, which could lead to torture under interrogation.

The living conditions of domestic slaves in prominent households tended to be better than those of farm-labor slaves out in the country, though not always. But they were also unstable and came without guarantees. The law did not recognize that a slave could be punished by loss of status, for he or she *had* no status to lose. The master owned the slave's body and could do as he pleased with it: flog it, fuck it, work it three-quarters to death. The law of deference and obedience (*obsequium*) was made of iron. On the other hand, a slave might sometimes receive a sum of money, known as the *peculium,* from his or her master; this might be saved, and eventually go toward buying manumission. But it was entirely gratuitous, and no slave had a right under law to such *peculia.*

The *peculium* was understood by all involved, slave as well as master, to be a tool for strengthening the bonds of deference and obedience. Sometimes slaves would help one another out, in the face of (sometimes hideously) unjust punishments. The Emperor Commodus, for instance, displeased with a slave bath-attendant who had drawn him too cool a bath, ordered another slave to burn him alive in the palace's furnace. The attendant burned a sheepskin instead, and its smell deceived the emperor.

Almost all slaves were worth something; a slave needed to be very old, incompetent, or mentally dangerous to be entirely worthless. Some of them, of the right kind and properly handled, could make their owners rich. An example was the instructive career of that singular politician, speculator, and slaveholder, Marcus Licinius Crassus (c. 115–53 B.C.E.), who had been, with Pompey and Julius Caesar, a member of the First Triumvirate. Crassus' fortune had largely been made by his pack of loyal and well-trained slaves. Crassus had many silver mines and huge agricultural holdings, but, wrote Plutarch, all that was nothing compared with the value of his slaves, "such a great number and variety did he possess—readers, secretaries, silversmiths, stewards, and table servants. He himself directed their training and took part in teaching them, accounting it, in a word, the chief duty of a master to care for his slaves as the living tools of household management." But the big profits Crassus' slaves earned him were in property. He purchased slaves who were builders and architects. Then, after one or another of the catastrophic fires

that were always breaking out in Rome, Crassus would move in and purchase the devastated sites and burned-out buildings for a pittance, using his enslaved professionals to renovate and build them up again:

> Then, when he had more than five hundred of these, he would buy houses that were on fire and those adjoining the ones on fire. The owners would let them go for small sums, because of their fear and uncertainty, so that the greatest part of Rome came into his hands.

Crassus was also the man who stamped out the great slave rising led by the Thracian gladiator Spartacus in 73 B.C.E., which burst out in Capua and spread like wildfire across Italy. Competent, supremely brave, strong, and humane, Spartacus was a brilliant and charismatic leader who eventually attracted an army of ninety thousand rebel slaves, many of whom were being trained as gladiators by their Roman masters. He and his army had fought and marched their way to Roman Gaul; they conquered several full Roman armies but were eventually destroyed in Lucania, in southern Italy, after their hope of crossing to Sicily failed. Crassus savagely crucified six thousand of the rebels (the unclaimed ones, of course; the rest went back to their owners, for Crassus had great respect for the laws of property) along the Appian Way. Somehow it is difficult to mourn the fact that this supremely brutal real-estate king was captured and killed by the Parthians when they defeated his legions at Carrhae in Mesopotamia, during a failed punitive expedition in 53 B.C.E.

It is conventionally assumed that the coming of Christianity made the lives of slaves easier, but this is untrue. Early Christian emperors did not press for manumission, and fourth-century sermons were not filled with exhortations to Christian slave-owners to set their human property free. Rather, they tended to follow the advice of Saint Paul—slaves should stay put and obediently serve their masters as the good served Christ. Most Church leaders and ordinary pious Christians were slave owners themselves—a fact which was not going to be ignored in centuries to come, in the American South.

Slavery's impact on Rome was too vast to be only economic. It also changed, by steady and irreversible degrees, the nature of Roman education of the young. In the early days of the Republic, this had tended to be amateurish and tradition-obsessed. A child's teacher was his father, the *paterfamilias,* with some input (of an entirely conservative kind) from the mother. The curriculum consisted largely of learning about the national heroes of the Roman past, and the corpus of law known as the

Twelve Tables. The chief skill taught by this conventional education was rote memory, coupled with a strong emphasis on physical culture and basic military knowledge. Plutarch in his *Life of Cato the Elder,* recounts how the father of Cato the Elder, who owned a slave named Chilo, an accomplished teacher of other boys, would not allow his own son to be taught by anyone but himself. "He thought it improper to have his son reprimanded by a slave, or to have his ears tweaked when he was slow in learning; nor would he have him under obligation to a slave for so priceless a thing as education. . . . In his son's presence he refrained from obscene language no less than if he were in the presence of the vestal virgins. Nor would he ever bathe with him." This was just the kind of cold-bath upbringing that the importation of large numbers of Greek slaves was sure to dispel. As education passed into the hands of Greek instructors, its nature changed: it was Hellenized and liberalized. Instead of the rote learning of conservative tribal wisdom, it favored debate and speculation, philosophical argument, sophistry, and the study of literature, both Greek and Latin.

Most of all, it made oratory the chief skill to acquire, the true test of intellectual capability. Cicero describes how his boyhood and early manhood were devoted to learning it in different places and under different masters. First, he "gave myself up wholly" to instruction by Philo, an expatriate Greek philosopher who, with his intellectual friends, had fled from Athens because of the Mithridatic Wars, and settled in Rome. Cicero studied pleading with Molo of Rhodes, another Greek; dialectic, with Diodotus the Stoic, who actually moved into Cicero's house. "The foremost teachers, knowing only Greek, could not, unless I used Greek, correct my faults or convey their instruction." Now it was time to go to Athens, where he studied with the philosopher Antiochus and went "zealously" into rhetorical exercises under the direction of Demetrius the Syrian. Next he traveled through Asia Minor, attaching himself to one teacher after another, starting with "the most eloquent man of all Asia," Menippus of Stratonicea. Such a varied, intense curriculum was, of course, unusual. But under the old Roman dispensation, it would have been unthinkable, because no one would have thought it necessary.

The words "Augustan Age" evoke the name of the poet Virgil as inevitably as the word "modernity" does that of the painter Pablo Picasso. Publius Vergilius Maro, native of Mantua: he was not born in Rome, but few of the writers who created the canon of Latin verse and prose were. Livy came from Padua, Catullus from Verona, Martial from a backwater

in Spain. On his deathbed, Virgil supposedly dictated the epitaph for his tomb: *"Mantua me genuit; Calabri rapuere; tenet nunc Parthenope; cecini pascua, rura, duces."* "Mantua bore me; Calabria took me away, now Naples holds me; I sang of flocks, farms, and leaders." Modest enough, for the greatest poet Rome ever produced.

This was the man whose lifetime (70–19 B.C.E.) and work associate him indelibly with the reign of Rome's first emperor. Sixteen years of his life as a Roman citizen were disfigured by civil war, by the murderous proscriptions that followed the killing of Julius Caesar and the defeat and suicide of Cassius and Brutus at Philippi. And by the time Italy settled down somewhat, there were still the massive expropriations and evictions to contend with: Roman soldiers were rewarded by their masters with land confiscated from those who had owned it in peacetime, and this dislocated the rural society of Italy. Something like a quarter of the good land of Italy is thought to have changed hands in this disastrous way, a trauma reflected in Virgil's first published work, the *Eclogues* or *Bucolics*:

> A godless soldier has my cherished fields,
> A savage has my land: such profit yields
> Our civil war. For them we worked our land!
> Aye, plant your pears—to fill another's hand.

The speaker is the farmer Meliboeus, in Virgil's *First Eclogue:* and he is lamenting his loss of home, forced on him by the great, distant world of politics. *"Tityre, tu patulae recubans sub tegmine fagi / siluestrem tenui Musam meditaris auena: / nos patriae finis et dulcia linquimus arua: nos patriam fugimus."* "Tityrus, here you loll, your slim reed-pipe serenading the Muse beneath a sheltering canopy of beech, while I must leave my home place and the fields I love: we must evacuate our homeland."

His family was moderately well off—well enough, at least, to send him to Mediolanum (Milan) and Rome to be educated in philosophy and rhetoric. It is possible, though not certain, that Virgil's family estates were lost in the massive confiscations that followed the Battle of Philippi in 42 B.C.E., when free land was issued to Octavian's veteran soldiers, but other property was given to him, near Naples, thanks to the benevolent intervention of his well-placed friend Maecenas. He is said to have been worth ten million sesterces when he died, a handsome fortune which can only have come to him in gifts from Augustus.

Virgil was tall, dark, and shy; he seldom went to Rome, preferring rural life. He had weak lungs (having coughed blood for much of his life,

he died at fifty-one, though that was not an uncommonly short life span) and a fine reading voice; he is known to have read the *Georgics* aloud to Augustus for four days straight, taking turns with Maecenas when his throat got hoarse. Everyone praised the expression and dramatic power of his reading. It irked him to be accosted by admirers, and when this happened on the street—as it often did, when the word of his poetic powers and his friendship with the emperor got around—he would hide in the nearest house. In Naples, his modesty of speech and behavior got him the nickname of "Parthenias," "the Virgin." Of course he was no virgin, and his preference was for boys.

How did a poet make a living in ancient Rome? The short answer was: not at all, or else through patronage. This was only the literary extension of one of the most durable commonplaces of Roman life, the relation between the client and the patron in everyday dealings. There was little question—if possible, even less then than now—of a poet's living off his royalties, since no publishing industry existed. Books were made in small numbers, but few people bought them. When Pompeii and Herculaneum were overwhelmed with lava from Vesuvius in 79 C.E., thousands of statues and scores of wall paintings were buried; they have since been found, but all the digging on these sites over the last couple of centuries has exhumed only one private library.

Some poets, at least, already had a degree of financial independence: Horace had enough cash to pay for a kind of university education in Athens, and both Ovid and Propertius were hereditary squires (*equites*), the latter with senatorial relations and friends who were, or had been, consuls. Catullus came from a senatorial family and was not short of money, especially since his family was friendly with Julius Caesar. But for those who were not so luckily placed (and even for those who were, since having well-off relatives does not make a poet rich, even if it gets him dinner invitations), the benign interest of a patron was all.

Patronage was one of the most characteristic institutions, or social habits, of ancient Rome. In early republican times, a free man would seek the protection of a rich and powerful one, to whom he offered his services. In doing so, he became that person's "client." A freed slave was automatically the client of the former owner. The relationship was not exactly contractual, though early Roman law did treat it as legally binding in some circumstances. The client's task was to dance attendance on his patron, come to greet him each morning, be a "gofer," and offer him political support. He would be formally rewarded with a *sportula,* a dole

of food and sometimes cash. Sometimes, but by no means always, the relationship between patron and client would develop into real friendship, but that was hardly predictable, since friendship presupposes feelings of equality, and differences of class were very strong in ancient Rome. Patronage was an arrangement in which power flowed only one way. It survived long into modern times, of course, and particularly in Sicily. A perfect example of its workings was given by one memoirist who in the 1950s observed, in the dining room of a major Palermo hotel, a *pezzo di novanta* (literally, a ninety-pound cannon; or "big shot") walk in, doff his overcoat, and, without looking, drop it behind him, certain that someone would catch it before it touched the floor. Rome's satirists—chiefly Juvenal and Martial—had some bitter things to say about patronage. "A man should possess 'patrons' and 'masters' who does not possess himself, and who eagerly covets what patrons and masters eagerly covet. If you can endure not having a slave, Olus, you can also endure not having a patron." And in fact they had good reasons to be bitter, because the relationship between patron and client had degenerated appreciably under the Empire. The client was now little better than a parasite, a hanger-on. Originally, in Greek, a *parasitos* was merely a "dinner guest," but it went downhill from there, acquiring strong overtones of contempt.

The transaction between patron and poet was not a simple one—not a matter of any poet's offering to sell mediocre panegyrics to any would-be celebrity. Poetasters do not confer everlasting fame; their work dies with them, or (more likely) before. But there was always the possibility that a major poet might confer on his patron *memoria sempiterna,* "undying memory," by praising him in verse. Thus Rome's first major epic poet before Virgil, the Calabrian Ennius (239–169 B.C.E.), wrote in praise of the military achievements of M. Fulvius Nobilior, and is (unreliably) said to have been awarded Roman citizenship for doing so. However, the negotiation over patronage was a delicate matter, and tended to be done through a tastemaker, a middleman, who had the ear of the potential patron and enjoyed his trust. One such person, the most influential one in the so-called Golden Age of Latin writing, was the *eques* Gaius Maecenas, a friend and confidant of Augustus who claimed descent from Etruscan royalty and was also the patron of Horace. It is not difficult to glimpse the fine hand of Maecenas behind Horace's endorsement and celebration of Octavian/Augustus' victory over Antony and Cleopatra at Actium, the famous "Cleopatra Ode," which begins, *"Nunc est bibendum, nunc pede libero / Pulsanda tellus":*

It's drinking-time, comrades, time to stomp the ground with an unfettered foot, to honor with Salian feasts the couch of the gods. Before now it was forbidden to bring out the Caecuban wine [i.e., wine of the best quality and vintage] from ancestral cellars, so long as a Queen, together with her band of men stained with vile perversion, was preparing insane destruction for the Capitol and ruin for our rule, being so abandoned as to hope for anything imaginable, drunk as she was upon sweet fortune. But when scarcely a single ship escaped from the flames it lessened her madness, and Caesar reduced her thoughts to the stern reality of fear. . . .

This was a great poem, but it is also unrestrained propaganda, libel run wild, without a syllable of truth in it.

Maecenas was associated with, and helped promote, the poetry of Propertius and Varius Rufus as well as Horace. But his chief linkage, the one which fixed him permanently in literary history, was to Virgil. He did well by some of his poets; Virgil died rich, Horace received the free gift of a Sabine farm. But Virgil certainly did the most to earn the gifts he received, and became essentially the emperor's mouthpiece. His *Eclogues* are the main source of the pastoral tradition in Latin, and thus in English and French. His *Georgics* set the mode and pattern for didactic poetry, a form abandoned in the twentieth century but of great importance before then. The *Aeneid* was Rome's archetype of the heroic narrative epic. Augustus was extraordinarily lucky to have Maecenas directing his patronage toward Virgil.

In the *Georgics,* Virgil evokes and idealizes the life which, he believes, Augustus is giving back to Italy—simple, direct, close to the earth and to the workings of Nature: pastoral heaven, in short. (The title derives from the Greek word *georgos,* "one who works the soil.") It is a life without ceremony, flattery, formality—and, we see, without intrusive clients:

O happy beyond measure the tillers of the soil. . . . Even if no high mansion with proud portals pours forth from every room a mighty wave of men coming to pay their respects in the morning; even if men do not gape at pillars inlaid with lovely tortoise-shell . . . or at Corinthian bronzes; . . . even if the pure olive oil they use is not spoiled with perfume, yet they enjoy sleep without worry, and a life that cannot bring disillusionment. . . .

Nothing is going to disturb such men; they have found their centers, they enjoy "sleep without worry . . . gentle slumber beneath a tree,"

unmoved by military honors, the threat of "Dacians swooping down from the Danube," the death throes of kingdoms, the haves and have-nots.

> His furrows are ever piled high with harvest and his granaries are filled to overflowing. . . . The pigs return well fed on acorns, the woods produce wild strawberries . . . Meanwhile, sweet children hang about his lips, his chaste household preserves its purity, the cows' udders hang full of milk. . . .
>
> This is the life the ancient Sabines once cherished; so, too, Remus and his brother; thus, surely, brave Etruria waxed strong, and Rome became the fairest thing on earth. . . .

All of this would be echoed by Horace: *"Beatus ille qui procul negotiis, / Ut prisca gens mortalium, / paterna rura bubus exercet suis / solutus omni faenore. . . ."* "Blessed the man who, far from wheeling and dealing, like the first of mortal men, plows his ancestral acres with his own oxen, free from all usury."

The *Aeneid* was the most important long poem to be written in any European language since Homer's *Iliad*. Through it, Virgil achieved an influence over human thought, and the conception of poetry as an art form, that no other writer could claim. Not until Dante, who made Virgil his fictional guide through the Inferno, would any poet rival the imaginative achievement of the *Aeneid*. And of course Dante paid grateful tribute to his guide for showing him what writing could be and do: "Since you my author and my master are / And it was from you only that I took / That lovely style that I am honored for."

Essentially, Virgil wrote the founding myth of the Roman people, setting forth what was expected of their nature and destiny under the guidance of Augustus. Its importance, both as art and as political utterance, was recognized long before it approached completion. "Stand aside, Roman writers; give way, Greeks!" wrote that entrancing love-poet Sextus Propertius, who had been broken financially by the proscriptions of Octavian and Antony. "Something greater than the *Iliad* is being born!"

Virgil freely admits that other peoples, such as the Greeks, are better at certain things than his Romans. "Let others make more lifelike, breathing images from bronze, which they will," he writes. "Others can excel as orators, as astronomers. But, Romans, keep in mind that your art form is government. You must keep men practiced in the habit of peace, be generous to the conquered, and stand firm against the arrogant." For the real Roman, the art of power was what counted.

To show what this means, Virgil will tell the story of Rome's foundation by that man of destiny, the Trojan hero Aeneas, who, with his venerated father, Anchises, and little son Ascanius, escapes from the burning ruins of Troy and, pursued by the hostility of the goddess Juno, after many perilous wanderings by sea, founds the city of Rome, the second Troy, a city destined for an equally mythic greatness. "I sing of warfare and a man at war," the epic begins, or in John Dryden's translation:

> Arms and the man I sing, who, forced by fate
> And haughty Juno's unrelenting hate,
> Expelled and exiled, left the Trojan shore.
> Long labors, both on land and sea, he bore. . . .

In part, the *Aeneid* is an imitation of Homer's *Odyssey*. Aeneas was already a character in the *Iliad*. In some respects, the *Aeneid* is almost impenetrably complicated, but its story may be summarized, in a very simplified form. Setting sail from burning Troy (book 1), Aeneas reaches Carthage, which is not written about as an enemy to Rome, but as a luxurious refuge from the terrors of the sea; it is ruled by the beautiful Queen Dido, to whom he relates, in the manner of Odysseus, the fall of Troy and his voyaging (books 2 and 3). Dido and Aeneas fall in love (book 4), but the gods oblige him to take to the sea again, deserting her, breaking her heart, driving her to suicide, and, not incidentally, providing the substance of later operas. His venerated father dies; Aeneas holds funeral games for him (book 5), sails on, and makes landfall in Italy, where he finds the entrance to the Underworld near Cumae (book 6). There he meets the shade of Dido, who bitterly reproaches him with many curses. Aeneas can think of no justification for his conduct—there is none—and is forced to the lame excuse that he didn't mean it: he left her because Jupiter told him to. There he also meets the shade of his father, who tells him about the destiny of the city he is about to found, Rome.

In book 7, Aeneas reaches Latium and seeks marriage to the Princess Lavinia, whose previous suitor, Turnus, grows furious and, incited by the ever-vengeful goddess Juno, makes war on Aeneas and the Trojans. In book 8, Aeneas acquires celestial armor, including a stupendously elaborate shield made by Vulcan. It is a prophetic object, showing a number of future events involving Rome, including Augustus' victory over Antony at Actium.

After prolonged warfare (books 9–12), Turnus is killed and Aeneas' hegemony over the new Rome is complete.

It is, on one level, a majestically patriotic poem, suffused with an epic sense of scale and destiny. It recounts as its basic theme the establishment of those moral obsessions of ancient Augustan Rome, peace (*pax*), civilization (*mos*), and law (*ius*). *"Tantae molis erat Romanam condere gentem,"* Virgil wrote: "So hard and massive a task it was to found the Roman race." Much the same might be said about the composition of Virgil's poem. Like Shakespeare, Virgil created an extraordinary number of phrases and images that so embedded themselves in the uses of his language that they seem always to have been there: clichés that continually refresh themselves. *"Equo ne credite, Teucri. Quidquid id est, timeo Danaos et dona ferentes."* A real shudder of mystery in the presence of the Trojan horse: "Don't feel safe with the horse, Trojans. Whatever it is, I fear the Greeks, especially when they bring gifts." Or the warning about Hell:

> The road down to that place of damnation is easy, but
> Night and day the gates of Death's dark kingdom lie open:
> But to retrace your steps, to find your way back to daylight–
> That is the task, the hard thing.

The *Aeneid* reverberates throughout with hints and prophecies of Rome's destiny. Aeneas comforts and encourages his exhausted men (book 1, lines 205–10): "We hold our course for Latium, where the Fates / Hold out a settlement and rest for us. Troy's kingdom there shall rise again. Be patient: / Save yourselves for more auspicious days." Aeneas will found the city, and presently

> Happy in the tawny pelt
> His nurse, the she-wolf, wears, young Romulus
> Will take the leadership, build walls of Mars,
> And call by his own name, his people Romans.
> For these I set no limits, world or time,
> But make the gift of empire without end.

In the kingdom of the dead in book 6, Anchises prophesies that "Illustrious Rome will bound her power with earth, / Her spirit with Olympus. She'll enclose / Her seven hills with one great city wall, / Fortunate in the men she breeds." And he instructs his son Aeneas to

> Turn your two eyes
> This way and see this people, your own Romans.
> Here is Caesar, and all the line of Iulus,
> All who shall one day pass under the dome

Of the great sky; this is the man, this one,
Of whom so often you have heard the promise,
Caesar Augustus, son of the deified,
Who shall bring once again an Age of Gold,
To Latium, to the land where Saturn reigned
In early times. He will extend his power
Beyond the Garamants and Indians,
Over far territories north and south. . . .

Thus the growth of empire is foreordained.

After Virgil, the best-known of all Augustan poets, then as now, was Quintus Horatius Flaccus—Horace. (Lucretius was certainly influential, both in Rome and, later, through his influence on Milton; but he was not loved and enjoyed as Horace was.) Horace was five years younger than Virgil, the son of a freedman, his father an auctioneer who had been a slave. His career, up to the time he was noticed by Maecenas and brought into the Augustan circle, had been an uneven one. In fact, he had served in the army, fighting on the side of Brutus and Cassius and with the high rank of military tribune, against the future Augustus at Philippi.

Horace was certainly indebted to Maecenas, but he did not feel a bit inferior to him—rather, he addressed him as an equal, a friend— "Maecenas, son of royal stock / My friend, my honour, my firm rock." A relaxed intimacy seems to prevail between the two men. At one point, in "Epode 14," Horace even refers to an erotic liaison between Augustus and an actor, Bathyllus—a liberty which he could not possibly have taken if a trusting confidentiality did not exist between him and Augustus' friend Maecenas.

He makes a few mistakes at first, overflattering Augustus, attributing a politically unwelcome divinity to him. He follows the Augustan line on sexual immorality and public weakness a little too sedulously for some tastes: "Teeming with sin, our times have sullied first the marriage bed, our offspring, and our homes; sprung from this source, disaster's stream has overflowed the people and the fatherland . . . The young maiden even now trains herself in coquetry and, impassioned to her finger tips, plans unholy amours." But soon the right proportion of praise is found, and in the meantime Horace has developed into a wonderful singer of the light of pleasure and, sometimes, of the remorse which can be the shadow of that sun.

He was short and stout, gray-haired, and a connoisseur of wine, gar-

dens, and conversation. He was urbane, humorous, and without ran-
cor in the face of human folly. If you can judge a man's qualities from
his poetry, he was an ideal companion. He loved the country farm that
Augustus, through Maecenas, had given him: its orchard, its bubbling
spring of water "shinier than glass." He was presumably homosexual. He
never married, and some of his most beautiful verses are addressed to a
Roman youth called Ligurinus. But he certainly had no animus against
the opposite sex, celebrating it in some of the finest lines ever addressed
by a man to a woman, however imaginary:

> *Quis multa gracilis te puer in rosa*
> *perfusus liquidis urget odoribus,*
> *grato, Pyrrha, sub antro?*
> *cui flavam religas comam,*
>
> *simplex munditiis?*

"What slender lad drenched in liquid scents presses against you, Pyr-
rha, under some pleasing grotto? For whom are you binding back your
blond hair in simple elegance?"

Other remarkable poets enjoyed the favor of Maecenas and, through
him, the largesse of Augustus: Sextus Propertius, Tibullus. The characters
from their poetry would recur in English verse up to the nineteenth cen-
tury, thanks to the classical basis of upper-class English education: Prop-
ertius' Cynthia, and the girl whose slave Tibullus declares he is, Delia.

But the most irresistible of these poets, and the "bad boy" of Augustan
writing, was Ovid: Publius Ovidius Naso, born in a valley of the Apen-
nines east of Rome in 43 B.C.E., died in exile on the western Black Sea
coast in the village of Tomi (now Costanza, in Romania), in 17 C.E., his
books having been removed from Rome's public libraries on Augustus'
orders. It might actually have been a lot worse, for he was allowed to
keep his property in Rome. Exactly what Ovid had done to deserve this
punishment—Augustus never banished another writer of quality—is not
really certain, and Ovid himself never did more than hint at it in his writ-
ing, beyond saying that it was caused by a *carmen* (a song) and an *error*
(a mistake). The mistake was probably sexual, and it may have involved
Augustus' wild and sexy granddaughter Julia, who was some twenty-five
years younger than the poet and would herself be banished to a Mediter-
ranean island for immorality at about the same time that Ovid was sent

to Tomi. As for the disapproved song, any number of Ovid's would have fit the bill. "Posterity, recognize who it is you're reading, / the poet of fun, kindness, love," declares his *Tristia* (*Lamentations*), written in exile, to assert his innocence. Witty, fluent, thrice-married, with a worldly charm that shines through every line of his *Ars amatoria* (*The Art of Love*) and his magnum opus, the *Metamorphoses,* Ovid was the first of the great literary *boulevardiers,* and to kick him out to a provincial hole like Tomi, whatever the rustic charms of its landscape and its women, was a terrible waste of life-enhancing talent:

> As I can,
> I solace myself with song.
> There is no-one to listen.
> In pretence I spend the day.
> The fact that I am alive, that I put a firm front on hardship,
> That I look sorrow in the face,
> I owe to poetry. It offers me comfort,
> Rest and remedy,
> It is my guide and companion. . . .
> Our age has produced great poets,
> But my reputation stands,
> There are many I rank above myself,
> But others rank me with them,
> And I *am* the best-seller.

No wonder that he was; no Roman writer, and few later ones, wrote as stylishly about sexual intrigue as Ovid. Here he is giving his advice to a girlfriend:

> And once you get to the bedroom
> Fill it with every delight; let's have no modesty there.
> Once you are out of there, though, abandon abandonment,
> darling—
> Bed is the only place where you can act as you please.
> There it is no disgrace to fling your dress in a corner,
> There it is no disgrace lying with thigh under thigh,
> There it is proper for tongues, as well as for lips, to be kissing,
> There let passion employ all the inventions of love.
> There use all of the words, the helpful cries, and the whispers,
> There let the squeak of the bed appear to be keeping in time.

And husbands, particularly older ones, are there to be cuckolded by their lovelorn, randy wives:

> Tacticians recommend the night attack,
> Use of the spearhead, catching the foe asleep,
> Lovers use them too—to exploit a sleeping husband,
> Thrusting hard while the enemy snores.

Such cheerful promiscuity did not conform to the standards of "family values" that Augustus was determined to reinforce in Rome. Augustus believed in restraint; Ovid did not. Anyone who has ever had hot sex on a hot afternoon is his co-conspirator. In comes his Corinna:

> Sheer though it was, I pulled the dress away;
> *Pro forma,* she resisted, more or less.
> It offered little cover, I must say,
> And why put up a fight to save a dress?
> So soon she stood there naked, and I saw,
> Not only saw, but felt, perfection there,
> Hands moving over beauty without flaw,
> The breasts, the thighs, the triangle of hair.

Ovid's free sexuality certainly contributed to his popularity, and is one of the reasons he is still read today, but the main reason for his influence in Roman times—which rivaled that of Virgil—was that his verse became Rome's main source for Greek mythology. The divinities of Roman religion tended to be nature spirits—Fortuna, Mens Bona—without personalities. It was Ovid who gave the Roman gods faces—and genitals to go with them. He did most to invent the idea of mythology as entertainment, a comedy of manners, full of dramatic or scandalous stories about the gods' doings on Olympus: as Richard Jenkyns observed, "Ovid is nearer to Offenbach than to Homer." He became the favorite and most imitated Latin poet of the Italian Renaissance and was often rendered into English, especially by Chaucer and Spenser. Echoes of him appear in Shakespeare, and one of the greatest lines in Christopher Marlowe's plays, uttered by Dr. Faustus as he awaits damnation, is quoted directly from Ovid: *"O lente, lente currite, noctis equi,"* "Run slowly, slowly, horses of the night."

We know little about Augustus' own sexual predilections. But we do know about some of his tastes in other areas, particularly architecture

and city planning. Literature would ensure some part of his cultural survival, but marble would do so even more solidly.

Augustus had a great enthusiasm for building. He wanted to make Rome unsurpassably beautiful. For that reason, it had to become Greek; but bigger. His famous declaration that he had found a city of mud brick and left it marble was, to a surprising extent, true. The marble was more often a thick facing veneer over common brick than solid masonry blocks, but not always. Much of it was of an intimidating, or inspiring, solidity, of which the extreme example was the enormous Forum of Augustus itself. He fulfilled Julius Caesar's plans for a monumental rebuilding—a creation, really—of the architecturally diffuse heart of Rome, which had been left undone by his murder.

To say Augustus mobilized the Roman building industry is to understate it. He declared he had built (or restored) eighty-two Roman temples alone in one year—many gods, many temples—apart from other structures, and this was no mere boast.

The show material was marble, the best available, from the Luna quarries in Carrara, in the north. Luna marble was the finest available if you wanted perfect whiteness, which Augustus and his builders did. Its whiteness rivaled that of the moon, from which it took its name. Luna marble tended to be very homogeneous and, to the extent that any sedimentary and metamorphic rock can be, free of internal veins and cracks. This reduced the risk that unexpected disfigurements would appear in the whiteness of an architrave or, worse, in the cheek of a Venus or a general. On buildings it was combined with other marbles, whose variety of origins symbolized the vast spread of the Roman Empire, which could bring any kind of stone from anywhere in the conquered world, from Asia, the Near East, and all over the Mediterranean. Pink marble came from the Greek island of Chios; a greeny-blue marble known as *cipollino* from Euboea; yellow from North Africa. There were many others, though not as many as would be exploited by late-imperial designers or, at the extreme, by those of Baroque Rome. The discreet use of bands and veneers of these stones enlivened what might otherwise have been a certain monotony of surface in Augustan buildings.

The best thing about Luna marble, apart from consistency of color, was its firm crystalline structure. This made for an even "grain" in the stone, which in turn favored crispness and depth of detail. And some details of Augustan buildings were very elaborate. The principal archi-

tect and theorist of the Augustan Age was Vitruvius Pollio, who wrote the fundamental text on classical Roman building, the ten-volume *De Architectura* (25–23 B.C.E.)—the only treatise on fine building to survive from ancient Rome. He discussed not only architecture but also town planning, water supply, engineering, and war engines, but his views on architecture, set forth in great detail, lay at the core of European practice for the best part of a thousand years. No actual buildings by him have survived, and practically nothing is known about his life, except that he served Augustus' army as an artillery engineer, designing *ballistae* and siege engines.

Vitruvius was intensely alert not only to the practical aspects of building, but also to its metaphorical content. Thus his disquisitions on the "orders" of architecture and their meanings. Doric, Ionic, Corinthian, Tuscan—each one had its human and divine significance:

> The temples of Minerva, Mars, and Hercules will be Doric, since the virile strength of these gods makes daintiness entirely unsuitable to their houses. In temples to Venus, Flora, Proserpine, Spring Water and the Nymphs, the Corinthian order will be found to have special significance, because these are delicate divinities, and so its rather slender outlines, its flowers, leaves, and ornamental volutes will lend propriety where it is due. The construction of temples of the Ionic order to Juno, Diana and Bacchus . . . will be in keeping with the middle position which they occupy: for such buildings will be an appropriate combination of the severity of the Doric and the delicacy of the Corinthian.

The most prominent of the Augustan "orders" was a new type of capital, known as "Composite," which combined the acanthus leaves of the Corinthian order with the volutes of the Ionic. This hybrid became one of the typical forms of Augustan architecture, but it required rather more skill to carve successfully than most Roman stonemasons had. Greek marble-cutters had to be imported, because Greece trained better stonemasons than Rome in the first century B.C.E.

These Greek workmen did more than carve architectural details. They did statues, too; someone had to churn out all those effigies of the Princeps and his family. This helps account for the fact that the portraiture of the imperial period tends to lack the realistic, sometimes sharply frank likenesses of earlier Roman portraiture. The carvers had never set eyes on Augustus and so had no firsthand idea of what he "really" looked

like, and of course no conception of his personality other than the one diffused by imperial propaganda. But Augustus was a god, and Greek sculptors were well used to depicting gods. This also helps account for a certain sameness in the representations of Augustus throughout his reign and across the Empire.

But more than flood the culture with numberless coins, busts, and statues, the Greeks had a profound and lasting influence on the physical city. Two monuments in Rome itself which clearly showed the continuing Greek influence on Roman art and architecture were the Forum of Augustus, finished around 2 B.C.E., and the Ara Pacis Augustae, dedicated in 9 B.C.E.

In layout, the Forum is entirely Roman, as it should be: a rectangular open space lined with porticoes, in which people met and business was done. One end was closed by a large temple on a high podium, that inheritance from more ancient Etruscan conventions; and there were statues of heroes of the state, including, of course, Augustus himself. But Greek details understandably insinuate themselves. The capitals of its columns are Corinthian; the presence of a line of Caryatids (load-bearing, columnar figures of women) in the upper story of the colonnades is a direct reminiscence of those on the porch of the Erechtheum in Athens.* The scale of the whole complex was immense. The columns of the temple were some eighteen meters high, made of the gleaming white Luna marble from the quarries of Carrara that was Augustus' architectural signature. The flooring of the colonnades, by contrast, which survives only as fragments, was done with the most highly colored marbles in the Empire: Phrygian purple (*pavonazzetto*) from Turkey, Numidian yellow (*giallo antico*) from Tunisia, red-and-black *africano*.

The Ara Pacis Augustae, or Altar of Augustan Peace, is an even more direct quotation from Greek norms and forms. Its purpose is to celebrate the end of conflict and dissension—the settling of the Roman state by its great uniter, Augustus, who is seen as presiding over a Rome that has been reborn from the dissent that finished off the Republic. The altar rises on steps, themselves contained within high screen walls of Luna marble with open entrances on the east and the west sides. On either side of each entrance are mythological panels of carved stone. They depict the spiritual and material benefits of Augustus' reign, and are clearly

* The Caryatids, bearing the architrave on their heads, were emblems of slavery. The city of Caria, in Asia Minor, had resisted the Athenians, and thenceforth its women were depicted as defeated load-bearers.

by Greek artists. One of them, for instance, promises the return of the Golden Age. Here, enthroned at the center of the panel, is *Natura naturans,* Nature being Nature—Mother Earth in her sweetest and most fertile guise, with two infants sporting in her arms. Fruit and flowers surround her, a cow and a sheep lie contentedly at her feet, and she is flanked by two benign nature spirits, representing Ocean and Water. The mood and content are those of Virgil's *Fourth Eclogue,* in which the poet tells of the coming age of Apollo:

> Ours is the crowning era foretold in prophecy:
> Born of Time, a great new cycle of centuries
> Begins. Justice returns to earth, the Golden Age
> Returns, and its first-born comes down from heaven above.
> Look kindly, chaste Lucina, upon this infant's birth,
> For with him shall hearts of iron cease, and hearts of gold
> Inherit the whole earth—yes, Apollo reigns now.
> And it's while you are consul—you, Pollio—that this glorious
> Age shall dawn. . . .

Who is this firstborn child "from heaven above"? It is still a mystery. Christian interpreters after Virgil's death had no doubt that it was the infant Jesus, but the wish was certainly father to the thought: Virgil was not writing Christian prophecy, although many people have wished he was.

Elsewhere on the carved walls of the Ara Pacis, we see Augustus as Aeneas making sacrifice, in his fundamental guise as the peace bringer, establishing the city of Rome, having at last transcended the dreadful conflict and loss of Troy. The lesson is not to be avoided: there is a savior before us, a savior who repeats the primal act of foundation by establishing the Roman state for the future in accordance with its ancient laws and pieties. What is more, the savior's family is and always will be the metaphor of the good state. Such is the "Augustan Peace."

The other Augustan building in Rome that survives, after a fashion, is a parallel to the Ara Pacis—Augustus' own family mausoleum, whose original form has been so broken down over the ages that, apart from its circular form, it is hardly legible. The Augusteum (in which there remains, of course, not a speck of the dead emperor's dust) is really more an earthwork than a building—a big shallow cone, eighty-nine meters in diameter and forty-four high, reminiscent of much earlier Etruscan monuments. The first member of Augustus' family to be interred in it

was probably his favorite nephew, Marcellus, poisoned in 23 B.C.E. by Augustus' third wife, Livia, who wanted her own son Tiberius to inherit the throne. In less ancient times, once the remains of Augustus himself were lost, it acquired many uses, none of them particularly glorious; it was fortified and used as a military base by the Colonnas in the twelfth century, then it was quarried for travertine, and in 1354 the corpse of Cola di Rienzo, mutilated by the daggers of the Roman mob, was cremated in it. Later, it became a huge kitchen garden; later still, when the fashion for things Spanish reached Rome in the nineteenth century, it was turned into a bullring. Not until the 1930s, when Benito Mussolini is said to have contemplated being buried in it, did it regain some of its archaeological dignity—a dignity now hopelessly compromised by the clutter of wastepaper, candy wrappers, empty cigarette packets, and other rubbish left on it by passing Romans.

Augustus' commitment to building was felt with particular zeal at the edges of empire, where such major architecture was less dense. Some of the greatest structures of the Augustan Age are "provincial" in location—far from Rome, but governed by it—and yet as sophisticated as anything in Rome itself. One of the most beautiful of these Augustan monuments is the Pont du Gard, an aqueduct near Nemausus (modern Nîmes) in Provence, with its rhythm of arches spanning a valley; for those who have seen it, and perhaps even for those who only know it from photographs, this huge and exquisitely proportioned three-level structure is *the* aqueduct, the archetype of its genre.

Being a major provincial center, the capital of Gallia Narbonensis, Nîmes also has an amphitheater, seating some twenty-five thousand spectators and built around the end of the first century C.E. The Augustan jewel of Nîmes, however, is the temple honoring Augustus' grandsons, Caius and Lucius Caesar, known as the Maison Carrée or Square House (c. 19 B.C.E.). It is extremely well preserved, probably because it was converted into a Christian basilica in the early Middle Ages. Some of its details, in particular the design of the Corinthian capitals, resemble those of the great Temple of Mars Ultor, dedicated a few years earlier in Rome, and they reflect Augustus' partiality to the Corinthian order. Likewise, the frieze decoration—continuous acanthus scrolls—mimics that of the Ara Pacis. The Maison Carrée had been enormously admired for centuries when it was first seen by an American, Thomas Jefferson, in 1784. He seized on its design as the ideal prototype of dignified official architecture for the new conception of democratic politics which he had the honor to

represent in France: noble and Augustan, yet fine-boned and somehow intimate. Thus the influence of the Maison Carrée crossed the Atlantic, supplying the prototype of the new State House, the capitol of Virginia. It was not a passive copy: Jefferson had to make changes, substituting Ionic capitals for the Corinthian ones, since he feared (no doubt correctly) that local Virginian masons would not be able to carve all those complicated acanthus leaves. But the Virginian capitol, in Richmond, showed, in Jefferson's own words, that "we wish to exhibit a grandeur of conception, a Republican simplicity, and that true elegance of Proportion, which correspond to a tempered freedom excluding Frivolity, the food of little minds." How Augustus himself would have approved!

The first century C.E. also saw the decorative arts flourish in the private sphere. Probably the best paintings were imported from Greece, or done in Rome by Greek artists. There was a strong tradition of easel painting throughout the Greek and Roman world, but we know this only from literary sources—the works themselves, victims of time, have not survived except as fleeting glimpses. There is no sign that Roman walls in Augustus' time had anything comparable in quality or in charged, intricate grandeur to the red-background mural paintings of initiatory scenes in the Villa of the Mysteries in Pompeii, built c. 60 B.C.E.

Little is known of Roman garden design, but it existed, though whatever Augustan gardens there may have been were obliterated long ago by later building. One can infer the character of gardens from what survived in Pompeii—the fishponds and shell grottoes, the paved walks, vine arbors, pergolas, and painted shrubberies. Floor mosaics were popular, whether made of pebbles or of glass tesserae. Middle-class Romans seem to have been excessively fond of kitsch ornamental sculpture, too: the garden of the Pompeiian house of Marcus Lucretius Fronto, if one can judge from photographs, looks like the terrace of Luigi's Pasta Palace in coastal New Jersey, crammed with sculptures that are more like garden gnomes—a Silenus standing in a nymphaeum and pouring water from a wineskin, birds, satyrs, a generic bearded herm, a Cupid riding a dolphin. Some of this stuff may have been inherited, but most of it was undoubtedly turned out in local factories to the householder's order.

Yet, in the midst of all this building, what was the single most important monument built by the Romans, still visible in some part today? We think of "monuments" as vertical, rearing up in stately fashion and visible from a distance. *"Exegi monumentum aere perennius,"* wrote the poet Horace—"I have earned a monument more durable than bronze,"—

meaning the fame of his own poetry. But the greatest of the physical monuments, which occupied the best energies of Roman surveyors, planners, engineers, laborers, masons, and slaves for centuries and made possible the growth and administration of the largest empire the world had hitherto known, was neither a mighty building nor a statue but a thing both ponderously physical and entirely horizontal, and thus, at least from a distance, rather hard to see: certainly invisible, and very hard to imagine, as a whole. This was the enormous road system, without which the Roman Empire could not have existed.

Estimates of its size vary a good deal, depending on how many secondary and tertiary roads are figured in. But it was certainly not less than 80,000 kilometers long, and possibly as much as 100,000 or even 120,000 kilometers, including its many bridges thrown over foaming rivers, culverts above swamps, and tunnels hewn through mountainous rock. It was a stupendous feat of surveying, planning, and labor, and all done without earthmoving machines, graders, or explosives—just hand tools and muscle.

You can no more imagine Roman power without its sustaining road network than you can imagine that of America's empire without radio, TV, telephones, the Internet, and every other sort of electronic communication. It enabled information to pass between distant points faster than ever before in history. To ride across Italy from Rome to Brindisi along the Via Appia took only eight days. The road had its own support system, the ancestor of the garages and rest stops along today's autostrada—workshops and inns, well-equipped stables, vets for the horses. If your vehicle, whose most common type was known as a *carpentum* (whence "car"), threw a wheel or broke an axle along the way, you could call for a mechanic or *carpentarius* (whence "carpenter") to repair it. If carless, the ordinary pedestrian could walk perhaps twenty kilometers in a day. A marching soldier might do thirty to thirty-five.

In the past, other great imperial powers (the Egyptians, and in Persia the Achaemenids) had road systems, sometimes large and well-maintained ones. But either their use was restricted (in Egypt, all roads were royal and off limits to commoners), or they were poorly integrated with existing ports, making the relations of land and sea transport decidedly iffy. The Roman system worked with a smoothness never achieved before in history, and every *civis romanus* (Roman citizen) who had anything to move—an army, a wagon train, a roll of papyrus with an important or trivial message, a basket of melons—had access, either personally or

through his representatives and clients, to it. From the point of view of trade and strategy, nothing like the roads of Rome had ever before been imagined, let alone built. Without the roads, the strategy could not have existed. The administration of so many subgroups within an empire was extremely time-consuming. Speed of communication and accuracy of placement of force were essential. Imperial cohesion, then as now, depended on communication.

The size of the road network, given the labor required to create it, is astonishing now and was almost inconceivable two millennia ago. It encircled the entire Mediterranean Basin; given enough time, a traveler on horseback or in a wheeled vehicle who started out from Rome and headed east through Ariminum (modern Rimini) and Thessalonica toward Byzantium (not yet named after the Emperor Constantine) and crossed into Asia could follow the same road south through Antioch, Damascus, and Gaza and then have before him, still fully paved and serviced, the long westward coastal run through Alexandria, Cyrene, and Leptis Magna that would eventually finish at Banasa, in what is now Morocco. There, he might find himself staring across the narrow strait that divided Spain from North Africa at another traveler who had taken another Roman road west along the bottom of Europe, through Arelate (modern Arles) and Narbo (modern Narbonne), across the maritime foot of the Pyrenees to Tarraco (modern Tarragona), west from there to Caesaraugusta (modern Saragossa), and thence southward to Hispalis (modern Seville) and Gades (modern Cádiz), which gazed on the North African coast. The Roman geographer Strabo believed that more than thirty-five hundred miles of roads had been completed by the Romans on the Iberian peninsula by 14 C.E., and this total would presently rise to some ten thousand.

To the north, the pattern was much the same. The conquered territories carried the mark of their subjugation in the form of Roman roads. One such road linked Mediolanum (modern Milan) to Augusta Vindelicorum (modern Augsburg), and so along the valley of the Rhine to Mogantiacum (modern Mainz) and Colonia Agrippina (modern Cologne). France was webbed with paved routes, from Lugdunum (modern Lyons) to Rotomagus (modern Rouen). And of course the network spread across the Channel to Britannia, thrusting north to link up with Hadrian's Wall, which had been built to frustrate the hostile Scots in 122–125 C.E.

Their construction hardly varied, and it depended entirely on exact-

ingly supervised slave and military labor. First a large trench was dug, six or seven meters wide and perhaps eighty centimeters deep. Both sides of it were lined with *gomphi* or curbstones, and then the roadbed was filled with layers of sand, gravel, and small rocks, well pounded in. The final surface was provided by flat slabs of stone, keyed together. The road builders took care to give the surface a camber, so that water would run off to the sides.

Not all Roman roads were like this. Many were cambered, edged, but unpaved. Some, like the great military road that linked Carthage to Theveste in North Africa, were paved and assiduously maintained. These included the Via Appia between Rome and Capua, and the Via Egnatia across the Balkan Peninsula from the Adriatic to the Aegean—which would be extended to Constantinople. But many roads disintegrated over time, from the stress of wheeled traffic, and would hardly be traceable today but for their surviving milestones, squat cylindrical columns which indicated the traveler's distance from the nearest major city. (The "Roman mile" was about 10 percent shorter than modern ones at 1,620 yards.) Nevertheless, the Roman road system was by far the most elaborate and far-reaching that human ingenuity would produce until the nineteenth century in Europe. Naturally, it long outlasted Augustus' own lifetime and was one of the most valuable parts of the enormous legacy that he left to his successors.

Augustus ruled Rome for almost forty-four years, dying a month before his seventy-seventh birthday. He had what he had asked the gods to send him: a quick and painless death. Though there were rumors that he had died of eating some poison-smeared figs brought to him by his wife, Livia, this was only gossip. The transition of power went smoothly: Livia's elder son by him, Tiberius, was Augustus' main heir and received the *imperium.* No one expected that anyone could measure up to the immense achievements of the Princeps; and, of course, neither Tiberius nor anyone else did so. Dying, according to Suetonius, "finally he kissed his wife with 'Goodbye, Livia; never forget whose wife you have been.'" It cannot have been a much-needed injunction.

3

Later Empire

We are used to thinking of most Roman emperors after Augustus, with the exception (thanks to Robert Graves's sympathetic novels) of Claudius, as beastly degenerates—the proof that absolute power corrupts absolutely. It is not true, but one can understand why so many have imagined it was.

The most prominent offenders were those two reliable crazies Gaius Julius Caesar Germanicus, known as Caligula (12–41 C.E.), and Lucius Domitius Ahenobarbus (37–68 C.E.), or Nero. Caligula got his pet name from the legions—the word roughly translates to "Bootikins"—by wearing tiny versions of the legionaries' combat boots, *caligae,* as a child, when he was the mascot of the Rhine armies, shortly after the death of his much-adored father, Germanicus, in 19 C.E. The one thing everyone knows about him is that he was quite mad and excessively fond of his horse Incitatus (a name which meant, roughly, "Go-Go") . Not only did he give this animal a marble stable, an ivory stall, purple blankets, slaves, and a jeweled collar, but he actually appointed it consul. Or so the story goes. There is, however, no evidence that he made any such promotion. Consul Go-Go may just have been palace gossip of a somewhat recherché sort. Suetonius, our only ancient source on this, merely writes, "It is said that he even planned to award Incitatus a consulship"—and planning something is not the same as doing it. The consul-horse story is likely no more than a variation on one of the twisted jokes Caligula was fond of making, as appears from other examples. One can imagine him losing his temper with the unfortunate Senate and calling its members dumber than his horse.

Can anything be said for Caligula? Probably not much, although the Roman gladiators and their owner-managers were doubtless grateful for his obsessional interest in arena fighting. However, he did make distinct contributions to public works. Realizing that the water supplies of Rome's seven aqueducts were not enough for a growing city, he ordained the construction of two more, the Aqua Claudia and the Anio Novus, though he did not live long enough to see either completed; they were finished by his successor, Claudius. He began a project which (until Claudius finished it) kept thirty thousand men busy for eleven years, leveling and tunneling a mountain to drain the Fucine Lake, in central Italy—a Roman equivalent to the appalling labors to which Stalin's political slaves would be condemned in digging the White Sea Canal.

The least popular of Caligula's additions to Rome would have been the Tullianum, or Mamertine Prison, the oldest in the city, at the foot of the Capitoline Hill. Here, notable captives were incarcerated; this was where Saint Peter supposedly languished in chains (the chains themselves are holy relics, preserved along with Michelangelo's sublime figure of the horned and glaring Moses, gripping the tablets of the Law, in the Church of San Pietro in Vincoli, not far away); in this sad little round room with its domed ceiling, Jugurtha, once king of Numidia, died of starvation in 104 C.E., and the Gallic warrior Vercingetorix, Caesar's chief enemy in Gaul, was beheaded in 46 C.E.

Without question, however, Caligula's most popular contribution to the architecture of Rome was on the Ager Vaticanus, an enormous circus or racecourse known as the Circus of Gaius and Nero. Almost all of it lies underneath the Basilica and Piazza of Saint Peter, for a simple and logical reason: this was the circus where Nero put Christians to death in the spectacular persecution that followed the fires of 64 C.E., for which the members of that sect were blamed. Early Christian tradition also held that it was the site of Saint Peter's martyrdom. Both Caligula and Nero were obsessive enthusiasts for chariot racing, and they competed with the professionals on this track.

The much later Emperor Elagabalus, who reigned from 218 to 222 C.E., drove *in Vaticano*, too, except that his chariot was drawn not by horses but by a team of four elephants, which does not suggest lightning speed, especially since his ponderous *équipe* kept knocking over tombs on the way. Elagabalus lives in legend as the demented homosexual transvestite who once arranged for his guests to be smothered in rose petals, dropped through trapdoors in the ceiling of his palace. His

sexuality made Caligula's seem almost routine, although the two were not dissimilar; Elagabalus surrounded himself with actors, dancers, and charioteers, all seeking to outdo one another in perversity. He was at least bisexual enough to have three wives: Julia Paula (who lasted one year), Aquilia Severa (a vestal virgin, whom he married, divorced, and married again, each time for a year), and Annia Faustina, a relative of the late, great Marcus Aurelius, whom he seems to have espoused for the sake of prestige. She, too, lasted a year.

To make quite sure that he had something for everyone, Elagabalus also caused annoyance to religious conservatives by bringing his own god with him from the East, the black stone of Emesa, itself an object of reverence, representing Baal. Having been proclaimed emperor in 218 by rebellious legions of Eastern troops, he was persuaded by his grandmother—a fearsome old harpy who dominated him completely and, in effect, ran the palace with his mother—to adopt his cousin Severus Alexander as his son and Caesar in 221. Perhaps inevitably, this lad's presence sent Elagabalus into shrieking fits of jealousy: the Western imperial troops liked Severus better than the emperor. Elagabalus planned to have him killed, but the soldiers killed him instead, with his mother. Thus perished the only emperor who gave Caligula some competition as the most dissolute in Roman history.

The personal behavior of both Caligula and Nero fluctuated, according to the rather meager reports it left—mainly in the writings of Suetonius—between the eccentrically aesthetic and the utterly mad, the indulgent and the insanely cruel. Caligula is said to have raped his sister Drusilla, and to have made a habit of public incest with her and two other sisters at banquets, while (one imagines) the less-than-enthusiastic guests stared in glum silence at their roast peacock. He could also be more public in his entertainments. It was Caligula who habitually condemned criminals *ad bestias* (to be devoured by wild beasts in the arena), or had them forced into narrow cages where they were sawn in half—"merely for criticizing his shows [or] failing to swear by his Genius." What made life under Caligula especially difficult was that he expected to be applauded, not just by his courtiers but by the whole Roman public, as a great tragic-comic and sporting personality. Gladiator, singer, dancer, chariot racer, actor: there was nothing he did not excel at. Perhaps there is a touch of Caligula in every showbiz star, but Caligula himself was *all* Caligula, and nobody who outdid him in performance was likely to live long. Besides, he was no fool in literary matters. He might

rave and shout, but he knew all his references. The emperor had a captive audience, and he knew it. To imagine a more modern, though hardly more threatening equivalent, one should perhaps think of Adolf Hitler singing at Bayreuth, with a member of the Gestapo posted behind each seat in the theater.

But some of his efforts at self-dramatization (and they were many) defy any attempt at rational explanation. Suetonius relates how, while on campaign in Gaul, facing the English Channel, Caligula had had his men drawn up in battle array, backed by various engines of war—*ballistae* and the like—pointing at the distant coast of England. He then boarded a trireme and put to sea, for a short distance. Then his warship turned round and brought him back to shore, where he clambered up on its high poop and shouted the order, "Gather sea-shells!" Nonplussed but obedient to their commander-in-chief, his troops did so, filling their helmets and tunics with what Caligula termed "plunder from the sea, owed to the Capitol and the Palace." He then promised every man in his army a bonus of four solidi or gold pieces, though there is no record that this was actually given out. The seashells were dispatched back to Rome as "booty." As Caligula's most recent biographer has written with some understatement, "This episode has provided much grist for the scholarly mill."

It may be that this bizarre incident was nothing more than training maneuvers; but this was winter, the weather and the seas were adverse, and even if Caligula (who was terrified of the sea and could not swim) had not realized it, any of his captains could have enlightened him about the impossibility of launching an invasion of Britain at that time of the year. No matter: he planned an ovation for himself for having invaded Britain, and he even chose some sturdy Gauls to grow their hair long, dye it red, and act like conquered soldiers, which in a general way they were. But it was not enough for Caligula to be fêted and admired as a hero, the conqueror of Germany and Britain. He was determined to be worshipped as a living god. Now, it was true that previous emperors had been seen, and within limits revered, as divine. Virgil included Octavian/Augustus as one of the "gods among us," and it was common in the Greek East of the Empire to pay divine honors to members of the imperial family. But divine homage to living emperors was far less usual in Rome itself than in the external empire, the definition of divinity itself could be rather fuzzy, and in any case some emperors found it excessive, even embarrassing: Tiberius, for instance, refused to allow a temple to be dedicated to himself and Livia in 25 C.E. Dead emperors could be worshipped as

gods and have temples dedicated to their cult, but Caligula was the first (though not the last) to take this a step or two further. According to Suetonius, he decided to live as Jupiter Optimus Maximus on the Capitoline. It was said that he planned to have Phidias' renowned sculpture of Olympian Zeus transferred there as his cult image, presumably given a new head, but was somehow dissuaded; he then had a full-length statue of himself, life-sized, made in gold. Every day the slaves dressed it in a different outfit of clothes from Caligula's extensive wardrobe.

All in all, perhaps the most surprising thing about Caligula's short and demented reign—he died in 41 C.E. at twenty-eight, assassinated by the officers of his own guard, having ruled Rome for not quite four years—was that he managed to last as long as he did. What happened to the seashells is unrecorded.

His successor was a man widely regarded as the family idiot, humiliated and condescended to by his nephew Caligula: Tiberius Claudius Drusus (10 B.C.E.–54 C.E.), known to history simply as Claudius, the last male member of the Julio-Claudian line. But he was popular with the Roman public, and with the army as well; certainly he was much better respected and liked than the repulsive Caligula. Nothing, one might have supposed, prepared him for the *imperium.* He was lame; he drooled and twitched when excited; and some chroniclers, notably Suetonius and Tacitus, treated him as a ridiculous figure, inept and stammering. Some of his traits were consistent with Tourette's syndrome, but this is not easily judged. Moreover, his sexual tastes, compared with those of most Roman emperors, seemed downright eccentric, almost perverse: according to Suetonius, he had no interest in men, only in women. Unfortunately, he had a way of marrying the wrong ones: first a lumpish horse of a creature named Urgulanilla, then a termagant called Aelia Paetina, then his cousin Valeria Messalina, a money-crazed nymphomaniac who, according to the often unreliable testimony of Tacitus, once competed with a prostitute to see which of them could take on the most sexual partners in a night; and finally Agrippina, a descendant of Augustus and the mother of Nero. From childhood on, Claudius was mercilessly bullied and deprecated as a fool by his mother, Antonia, and his grandmother Livia, and this seems to have set a pattern of domination by scheming women which infected his entire married career.

Claudius was fifty years old when Caligula was murdered. In the general confusion that followed the assassination, he ran into hiding behind a door curtain in the palace. One of the Praetorian Guardsmen, Gra-

tus by name, spotted his feet beneath the curtain and pulled him out. Claudius, thinking his last moment had come, clasped the soldier's knees and started begging for mercy—but, to his mingled terror and relief, the soldier bore him off to the palace guards' quarters, where he was acclaimed as the new emperor. He was the first emperor to be proclaimed by the Praetorian Guard rather than the Senate; obviously, the Senate had little choice in the matter.

This may not have been a very auspicious start to his reign, but Claudius proved to be a surprisingly good ruler—much better, certainly, than either his crazed predecessor, Caligula, or *his* predecessor, the mediocre Tiberius, who, after a promising start, with wide military experience on the German frontier, ended his reign as an elderly, cruel debauchee on the island of Capri while leaving the effective control of Rome to his Praetorian captain Sejanus. Claudius, of whom less had been expected, did much more. He considerably enlarged and strengthened the Empire by planting *coloniae,* fortified settlements, in remote zones; such places as Colchester in Britain and Cologne in Germany were originally Claudian settlements. To Claudius belongs the distinction of leading the successful conquest of Britain, which began in 43 C.E. Having captured the British general Caractacus, he spared his life and treated him with unusual clemency. Caractacus was allowed to live out his natural life on land given to him by the Roman state, instead of being garrotted in prison, the usual fate of those who dared lead a resistance against Rome. This, one need not doubt, did wonders for the colonial relationship between the British and their conquerors.

Claudius was a gifted administrator with (as it must have seemed to citizens who had grown used to the arbitrary habits of Caligula) an intense regard for the minutiae of the law. He presided at public trials, viewing his presence there as both a duty and a pleasure, although some of his edicts make strange reading today; one of them, according to Suetonius, promoted unrestrained farting at table as a health measure. In particular, he was committed to programs of public works—the building of aqueducts, the draining of the Fucine Lake. (The latter almost proved a disaster; because of miscalculation by the engineers, the lake waters came rushing out too soon and backed up in a too-narrow sluice, nearly drowning Claudius and his party, for whom a great banquet had been prepared on the bank of the channel.) The Fucine drainage scheme, underwritten by a syndicate of businessmen in return for ownership of the reclaimed land, kept thirty thousand men at work for eleven years,

but is said to have eventually returned a profit. Probably the most important of these works was Claudius' creation of a deep-water harbor at Ostia, complete with a tall lighthouse; this transformed Rome's access to Mediterranean trade, especially during the winter storm season.

His main contribution to popular entertainment was his unbridled enthusiasm for arena fights. Claudius—according to Suetonius, our only source on this—was unusually bloodthirsty, even by Roman standards. If an accused man was to be tortured to extract testimony, Claudius liked to watch. Sometimes, when he had spent the whole morning watching gladiator fights and wild-beast shows, "he would dismiss the audience, keep his seat, and not only watch the regular combats but extemporize others between the stage carpenters . . . as a punishment for the failure of any mechanical device." Nothing survives of Claudius' work as a historian—which is a considerable loss, since he wrote many books about Roman, Etruscan, and even Carthaginian history from sources which were extant two thousand years ago but have now disappeared.

He was gluttonous, and this led to his death. His favorite dish was mushrooms, and at a family banquet his last wife, Agrippina, served him a dish of *funghi porcini* laced with poison. This killed him, conveniently preparing for the succession of Agrippina's son, Lucius Domitius Ahenobarbus, better known as Nero.

Nobody could say that Nero lacked the advantages of education as well as birth.

Coming from Spain, Lucius Annaeus Seneca (d. 65 C.E.) was Nero's tutor, and a stupendously voluble writer; his surviving prose works alone run to over a thousand closely printed pages. He took great pride in his Stoicism, but no Stoic was ever longer-winded or more self-infatuated. He could argue both sides of a case—when Claudius died, it was Seneca who composed the eulogy delivered on him by Nero, his successor, but also Seneca who wrote a satire on the departed emperor, the *Apocolocyntosis* or *Pumpkinification* of Claudius, who was imagined as turning into a dim-witted, sententious vegetable god. Seneca was a hypocrite almost without equal in the ancient world. He sang praises of moderation: "To be a slave to self is the most grievous kind of slavery; yet its fetters may easily be struck off. . . . Man needs but little, and that not for long." Fine words, which, unhappily, bear little relation to the real facts of Seneca's life: he was a mercilessly greedy usurer. Few can have mourned him when, on direct orders from Nero, he committed suicide by opening his veins in a hot bath.

Nero's most notorious act of vandalism was (supposedly) burning much of the city of Rome.

It is not sure that, as legend durably insists, he fiddled while doing so. Though he was a keen amateur musician, his preference was for giving long vocal recitatives, generally of a tragic kind, some of whose titles—though, perhaps mercifully, not their libretti—have been preserved: among these were *Canace in Childbirth, Hercules Distraught,* and *Orestes the Matricide.* In these he would wear the masks of heroes, gods, or goddesses modeled either on his own face or on the features of a current mistress.

Nevertheless, the image of Nero fiddling away while the flames leapt upward has entered the English language (and most others) and is unlikely to vanish soon. Even without the accusations of arson, Nero's treatment of others—including his own family—was, to put it mildly, defective. The list of his victims was long, and it included his mother, Agrippina, with whom he was alleged to commit frequent incest. He had no hesitation in ordering the murder of anyone who displeased him, however trivial or fictional the offense. Not even his wives were exempt: his Empress Octavia, daughter of Claudius and Messalina, died in exile on the desert island of Pandateria in 62 C.E., thus freeing Nero to marry, deify, and then kick to death (in pregnancy) his second spouse, Poppaea, merely because she had dared to complain that he came home late from the races. He had his aunt Domitia Lepida murdered with an overdose of laxative. In all, as Suetonius remarked, "There was no family relationship which Nero did not criminally abuse." He made every effort to mock real family relations by parodying them: thus his obsessive relation with his catamite Sporus, whom he castrated and then married. "The world," remarked Suetonius acidly, "would have been a happier place if Nero's father Domitius had married that sort of wife."

It is said that for his own amusement he launched an attack on several granaries near the future site of his Golden House, knocked down their walls with siege engines, and then had his troops set the contents ablaze. Naturally, he found a public reason for this—slum clearance. The old buildings were decrepit, and he was only finishing off a fire hazard. However, there is no evidence that Nero was personally responsible for the fires that broke out and spread during demolition. They could have been, and probably were, entirely an accident. If Rome was anything like eighteenth-century London—and it was, being overcrowded and a firetrap, filled with tinderbox *insulae,* blocks of flats, which would go up at a

breath and were unprotected by water pumps or safety ordinances—then living in it must have been a constant menace, especially since the reliance on open braziers in cold weather must have filled their rooms with carbon monoxide and further reduced the level of sleepers' consciousness.

Whatever their origin, these fires soon joined up in one continuous blaze, lasted for six days and seven nights, and destroyed not only the rickety *insulae* of Rome's public housing but also numerous mansions and temples dating back as far as the wars against Carthage and Gaul. It started on June 18, 64 C.E., the exact anniversary of the burning of Rome by its Gallic invaders in 390 B.C.E. It did enormous damage, not only to the residential quarters of the Aventine and Palatine hills but also to the Forum itself, most of whose monuments it destroyed. Nero is said to have reveled in watching the fires, and it was rumored that, to celebrate what he called "the beauty of the flames," he donned the costume of a tragedian and proceeded to sing, from start to finish, a lengthy dramatic piece about the burning of Troy entitled *The Fall of Ilium*. This may perhaps have been heartless, but it is hard to think what actions of a practical sort Nero could have taken to extinguish the flames. What could he have done, flouncing around in his fancy dress, except get in the way of the hard-pressed firemen? And what person, emperor or commoner, would fail to get the best vantage point from which to view the irresistible spectacle of a city fire?

This tale is of course the origin of the much-worn saying. According to Tacitus, the fire broke out among the shops of the Circus Maximus and ran through the level portions of the city, which contained no masonry walls to interrupt its spread. It outstripped the puny efforts to control the flames, "so completely was the city at its mercy owing to the narrow winding lanes and irregular streets which characterized old Rome." When the blaze took hold in earnest, Nero was not in Rome, but in Antium (modern Anzio), south of the city. Nothing, it seemed, could contain the flames, but Nero, hurrying back to Rome, threw open the Campus Martius, the public structures of Agrippa, and even his own gardens, and had emergency shelters erected in them. But the effect of such well-meant measures was less than it might have been, because by now the plebs of Rome were convinced of the rumor that their emperor, the deified firebug, was to blame for the destruction of so much of the city.

After this veritable orgy of site clearance, Nero's own idea of a suitable new building was the Domus Aurea or Golden House, a legendary

structure of antiquity of which so little remains that one can only form the haziest idea of its splendors. There had been a huge palace linking the Palatine and Esquiline hills, and when it burned down, Nero had it rebuilt with a statue of himself 120 feet high in the entrance hall (for comparison's sake, Bartholdi's Statue of Liberty in New York Harbor is roughly 150 feet from toes to crown). Behind it, a pillared arcade ran for a mile, flanked, said Suetonius, "by buildings made to resemble cities," and artificial woodlands in which every kind of domestic and wild animal sauntered and grazed at its ease. Inside, the walls of the Golden House earned its name by being both gilded and inlaid with mother-of-pearl and precious stones. Nero's dining rooms had ceilings of ivory fretwork which, on command, released gusts of perfume or rose petals onto the reclining guests. The main dining room, where Nero held his feasts, was circular, and its entire roof, fretwork and all, revolved in a stately harmony with the sky, day and night. "He believed," wrote Suetonius of Nero, "that fortunes were made to be squandered, and whoever could account for every penny he spent seemed to him a stingy miser." Nero's own comment on the Golden House, once it was finished, was merely that now, at long last, he could begin to live like a human being.

Little enough is left of the Domus Aurea, and much of that remains to be excavated. The enormous Baths of Trajan had been built on top of Nero's palace. Unfortunately, most of its valuable décor—the colored marble veneers, the gilded panels, and of course the carved ivory—was stripped and looted as soon as the palace was abandoned; all that remained was the painted plaster on the walls of secondary rooms. But this fascinated the artists who, in the sixteenth century, burrowed down through the baths into the remains of the palace to study them, and it became the basis of whole arrays of playful décor known as *grotteschi*, "grotesques," because they had been found in "grottoes." These would influence European design and décor, especially through the work of Englishmen like the Adam brothers, for two centuries. The foremost exponent of decorations based on the remains of the Golden House was Raphael, who admired and copied them and was followed not only by other artists, but by a horde of intrepid sightseers who braved the subterranean dark with torches, and sometimes left their names scratched on the moldering walls—among them, Casanova and the Marquis de Sade. Raphael would use *grotteschi* for his decoration of the Loggetta in the Vatican (c. 1519), and they gave him a limitless fund of invention and caprice—even though, as the art historians Mary Beard and John Hen-

derson mischievously noted, the subsequent popes were parading about in what were, in effect, copies of Nero's servants' quarters.

Under the original ceilings and beside the Domus Aurea's scented pools, Nero would give himself up (wrote Suetonius) to "every kind of obscenity." These included dressing in the skins of wild animals, and attacking the genitals of men and women who stood helplessly bound to stakes in the imperial gardens. Presumably, it is not possible for one man to practice all the known or imaginable sexual perversions; but Nero clearly had as impressive a repertoire of them as any Roman. And he famously compounded them by fastening the blame for Rome's misfortunes on one particular group. This was the tiny sect known as the Christians, whom Nero persecuted with quite demented severity after the fire.

It had not taken long for the responsibility for the Great Fire that had consumed so much of the city to be assigned, by the plebeians, to the emperor himself. For that reason alone, Nero had to find someone else, another group, to divert the blame for it; and that was the Christians. The historian Tacitus explained why: these Christians were already "hated for their abominations," not only in Judaea but also in Rome, "where all things horrible or shameful from all parts of the world collect and become popular." Those who confessed, on interrogation, to being Christian were convicted "in great numbers"—"not so much of guilt for the conflagrations as of hatred of the human race" and then "mockery was added to their deaths":

> They were covered with the skins of wild beasts and torn to death by dogs, or they were nailed to crosses and, when daylight failed, were set on fire and burned to provide light at night. Nero had offered his gardens for the spectacle, and was providing circus games, mingling with the populace in the dress of a charioteer. . . . Hence, though [the Christians] were deserving of the most extreme punishment, a feeling of pity arose as people felt they were being sacrificed not for the public good but because of the savagery of one man.

As indeed they were. The first representation in art of Christ crucified is a derisive graffito from somewhere on the Palatine Hill, near the Circus Maximus. It shows a crudely scratched figure with a donkey's head, hanging on a schematic crucifix, with a man raising his arms in homage and adoration. A scrawled caption says, "Alexamenos worships his god." The donkey, in popular Roman lore, was an utterly despised animal, lower than a pig. The graffito is no older than the second century c.e.—

which suggests how very slowly the story of Christ's crucifixion seeped into popular awareness. "It is now generally accepted," writes an authoritative scholar of the subject, "that there are no securely datable Christian archaeological remains before the second century or about A.D. 200."

"The blood of martyrs," a famous saying went, "is the seed of the Church." This was indisputably true. How did Christianity manage to detach itself from the peculiar tangle of competing creeds that jostled one another in the fourth-century Roman world? There were mystery cults of varying degrees of eccentricity, drama, and peculiarity. There was Mithraism, a powerful import from the Middle East, which had a strong following among the Roman military. Rome harbored a large minority population of émigré Jews, who of course stood by the tenets of their faith and practiced its rituals. Deified emperors received various forms of devotion. There were cults of Isis, Dionysius, Hermes, Serapis, and the patron of doctors, Asclepius, the human healer transmuted into a god. Often, when the cult of a spring goddess or a fertility god had been established for years, it was merely renamed and began a new votive life. The Christian belief that a god was likely to punish disobedient humans was not, on the whole, a feature of pagan religion. The weight of guilt or sin did not bear heavily on the worshippers. The pagan moral world was in this respect, as in others, a universe away from the spiritual environment of Judaism and Christianity, so largely animated by guilt and the desire for expiation and forgiveness.

But the greatest difference was in ideas of past and future. Roman religion presented its faithful with only the haziest conception of an afterlife. Its dreams of felicity were focused on a long-past Golden Age; perhaps this could be recaptured, but it was certain that the present was a descent from it. Christianity, however, had no powerful notions of lost happiness in an earlier life. What mattered most to the Christian was happiness or anguish after death, both eternal, both irrevocable. With the help of Jesus, the Christian soul had charge of its fate to a degree not imagined by classical religion. Hence the power of Christianity. Now the Christian and pagan paths were about to cross, with totally unforeseeable results.

A visit to the decaying remains of the Golden House of Nero can be disappointing, and there is unlikely to be much to see in another fifty or a hundred years. The most complete Roman building to survive from antiquity, however, was constructed somewhat later, during the reign of the Emperor Hadrian. This is the enormous concrete-and-stone masterpiece of engineering that is the Pantheon.

It was built to replace the original Pantheon, built and dedicated in 27 B.C.E., in the aftermath of Octavian's victory at Actium by Marcus Agrippa during his third consulship. This building burned down, along with others next to it, in a huge fire in 80 C.E. Hadrian had it rebuilt, in its present form, in about 125 C.E. Rather confusingly, it bears on its pediment the legend M · AGRIPPA · L · F · COS · TERTIUM · FECIT, which stands for "*Marcus Agrippa, Lucii filius, consul tertium fecit,*" meaning, "Marcus Agrippa, son of Lucius, consul for the third time, made this." But he did not make it—Hadrian did. Agrippa was long dead (12 B.C.E.) by the time the Pantheon was finished.

The Greek word *pantheion* means "temple of all the gods," which makes the building polytheistic. Cassius Dio, a Greco-Roman senator writing some seventy-five years after the present Pantheon was built, opined, "It has this name . . . because its vaulted roof resembles the heavens."

In the audacity and thoroughness of its engineering, in the grand harmony of its proportions, and in the eloquent weight of history with which it is imbued, the Pantheon is certainly the greatest of all surviving structures of ancient Rome. The Colosseum exceeds it in mass and size, but it is the form of the Pantheon that elicits one's amazement: that huge dome, opened at the top by an oculus which seems not merely to show but to admit the sky, is a landmark in the history of construction and, one might add, of architectural metaphor. Even today, almost two millennia after it was finished, the alert visitor is likely to be struck less by its great age than by its inexhaustible newness. This is truly *Roman* architecture, not Greek. Greek building was a matter of straight posts and straight lintels. The Roman genius was to conceive and build three-dimensional curved structures, of which the Pantheon's dome is the sublime archetype. This could not be done, at least not on a larger scale, in hewn stone. A plastic, moldable substance was needed, and the Romans found it in concrete, whose use was unknown to Greek architecture.

Roman concrete was a structural ceramic which set hard, not from the action of heat (as pottery does in a kiln) but from the chemical interaction of hydrated (slurried or water-saturated) ingredients. Concrete consists of an aggregate (small pieces of hard stone) mixed with a semi-liquid mortar of hydraulic cement, made from a mixture of water, lime, and a crushed volcanic-ash deposit known to the Romans as *pozzolana.* This thick liquid is then tamped into a mold, known as a "form." It may be reinforced with metal rods to increase its tensile strength, although this

was not the Roman practice. Chemical changes in the mass as it dries make it set into a hard, impervious block, whose shape is that of the negative space inside the form. The mold is dismantled and removed; the concrete block remains.

Ancient Roman builders would mix their ingredients, wet lime and volcanic ash, in a barrow, spread this over the rock fragments of the aggregate, and then pound it together well, using a hefty wooden compactor known in English as a "beetle." The less the water, the better the amalgamation of mortar and aggregate, the stronger the result—and it is amazing what Roman builders could do by hand, without mechanical compactors, rotary mixers, or any of today's motorized tools. Vitruvius' *Ten Books on Architecture* (c. 25 B.C.E.) recommended a ratio of one part of lime to three of *pozzolana* for buildings, and one to two for underwater work. *Pozzolana* concrete behaved like Portland cement. It also had the extraordinarily useful merit of drying under seawater, which made it invaluable for maritime structures; the Emperor Claudius had a harbor mole built at Ostia by the simple expedient of using a whole large ship as a form, filling it with *pozzolana,* lime, and water, and then sinking it, so that it set into a (literally shipshape) block.

With concrete, the Romans could build aqueducts, arches, domes, and roads; it opened up means of rapid transport, storage, and defense that had not existed in earlier masonry cultures. Concrete built hundreds of bridges, which gave the Roman army swift access to the most remote parts of the Empire. The stuff of power and discipline, it was ugly and always would be—the brief mid-twentieth-century vogue for *béton brut* produced some of the most hideous, grime-attracting surfaces in all architecture, as a visit to London's Festival Hall will confirm. But it could be rendered with stucco or faced with thin sheets of stone, and it was very strong and cheap, allowing the construction of very large structures. And size—raw, powerful size—had great appeal to the Romans in building their empire, as it would to the Americans in building theirs, two thousand years later.

The Pantheon is circular, and it rests on a ring beam of concrete four and a half meters deep and more than ten meters wide. The drum walls are six meters thick, and solid: the only light for the interior comes from the great oculus in the dome above. The dome of the Pantheon was constructed from concrete elements shaped by wooden formwork. It was not necessary to do this in one continuous pour. What was essential was a complete control of the dimensions of the formwork, which pro-

duced the stepped coffering within the dome; of the angling of the elements, which gave a perfect circular shape to the oculus (8.92 meters in diameter, the edge originally ringed with bronze); and of the varying density of the concrete mix. This last was crucial, because the dome, in the interest of structural stability, had to be lighter at the top than at the bottom; its thickness increases from 1.2 meters around the oculus to 6.4 meters at the bottom, where the base of the dome meets the drum. Moreover, the integrity of the structure depended on using a lighter aggregate at the top—pumice stone and tufa—than the brick and travertine at the base. The builders took care to add the concrete in small batches and tamp it very thoroughly to expel air bubbles and water before adding the next batch. In sum, the construction of this five-thousand-ton dome was a marvel of architectural forethought—what we would call "systems planning" today—and an architectural historian might well long for a sight of the wooden formwork, scaffolding, and shuttering that its construction must have entailed.

The statistics, bare as they are, remain. With a diameter of 43.3 meters, its dome is the world's largest in unreinforced concrete, surpassing the diameter of Saint Peter's cupola by just seventy-eight centimeters. There are larger domes on earth, but they are segmental and reinforced with steel, like the hundred-meter dome of the 1960 Palazzetto dello Sport in Rome. No modern architect would dare to attempt another Pantheon using the same structural principles—nobody would insure it. But the Pantheon has stood for nearly two thousand years and shows no prospect of collapse.

It has, however, endured some damage. Originally, the great dome was sheathed in gilded bronze, all of which was plundered by the Christian (Byzantine) Emperor Constans II in 655 C.E. Pope Gregory III replaced it, more prosaically, with lead sheets a century later. It had long been believed that the Barberini Pope Urban VIII, patron of Bernini, had the bronze beams of its portico removed, melted down, and recycled into the *baldacchino* of Saint Peter's and cannons for the Castel Sant'Angelo. Alas, some historians now doubt this story.

Imperial Rome also gave birth to what must be, bar none, the greatest piece of narrative sculpture from the ancient world. It stands in the remains of the Forum Traiani, Trajan's Forum, rising up as one of the chief landmarks of the city. Much of the sculpture of Trajan's enormous forum was destroyed in Christian times, either burned for lime or taken away to embellish other buildings. Thus several reliefs on the Arch of Constan-

tine (315–16 C.E.), showing battles between Romans and Dacians, were taken from the Forum, altered by inserting portrait heads of Constantine and Licinius, and installed on the arch.

Trajan's Column, on the other hand, is virtually intact. However, it is still impossible to "read" as a continuous story, because of its form: a continuous stone frieze, seven hundred feet long, carved in low relief and wrapped in a spiral around a hundred-foot high vertical cylinder. It is a huge ancestor of the comic strip. Other monuments to this great emperor have disappeared; there was, for instance, in the middle of the Forum of Trajan, a magnificent equestrian statue of the emperor, offered to him by the Senate but later destroyed in one of the barbarian invasions of Rome (or perhaps by the Catholics).

But the column still stands, well preserved. Yet, although it is an astonishingly ambitious piece of propaganda, there is no vantage point from which it has ever been possible to see more than segments of the whole design, and of course (for a spectator at ground level) the detail toward the top tends to vanish in the recession of its perspective, although the artist or artists who designed it made an effort to counteract this by gradually increasing the height of the figures from 0.6 meters at the base to 0.9 at the top. It represents that frustration with narrative sequence which would not be conquered until the invention of the movie camera.

It is carved from seventeen drums of Luna marble. Each drum is about ten feet in diameter and hollow inside, to accommodate a cramped spiral staircase of 185 steps, so that (with difficulty) one can climb to the top; the stair is lit by forty-three small slit windows, which are virtually invisible from the outside. Even though the drums were cut separately, the matching of the figures, and the lack of damage at the joints, make it look like one seamless cylinder.

The sculptors were Roman artisans, many of whom must have been Greek slaves: the scenes are full of figures that descend from Hellenistic prototypes, and Greek-trained sculptors were usually preferred to Roman craftsmen. How many carvers worked on this enormous project is of course unknown, but there must have been many.

Dedicated in 113 C.E., it commemorates Trajan's campaigns in the Dacian Wars on the Danube frontier in 101–2 and 105–6 C.E. For anyone with good binoculars, a sustaining interest in Roman military history, and a crick-proof neck, this is a mesmerizing document, if "document" is the right word for something so big, stony, and solid. Nothing tells us so much about the Roman army at work—not just killing and capturing

barbarians, but marching, bridging, foraging for supplies, maintaining weapons, building camps, listening to the speeches of its commanders, and bearing its standards. Every detail of uniform, armor, and weaponry is correct. So is the depiction of barbarian arms, which are prominently shown as military trophies on the column's rectangular base as well as in the scenes of conflict along the band. Throughout the narrative helix of twenty-six hundred figures there are some sixty Trajans, speaking to the troops, receiving envoys, conferring with his generals, offering sacrifices to the gods. One may also notice a large river-god, the personification of the Danube, blessing the Roman army as it crosses. The dexterity with which this story is unrolled is still as amazing as the clarity of detail with which it is set forth in the stone.

Unfortunately, the bronze statue of Trajan himself which used to stand atop the column was removed and melted down in Christian times, to be replaced in 1588 by one of Saint Peter, who had nothing to do with the Dacian Wars. If you look closely at the base, you can make out another relic of Christianization over the door to the column's interior—the outline of the roof of what was once a tiny church, San Nicola de Columna, recorded in the early eleventh century but demolished by the sixteenth. The main feature of the interior, a gold urn containing Trajan's ashes, was inevitably looted long ago.

Of the phrases that have survived into English from classical Latin, certainly one of the best known stands for social irresponsibility, fatuous hedonism: the public's desire for "bread and circuses." It comes from a satire by Juvenal, launched against the "mob" of his fellow Romans of the first century C.E. Juvenal had seen mob violence directed against Tiberius' right-hand man Sejanus, through his many public effigies:

> The ropes are heaved, down come the statues,
> Axes demolish their chariot-wheels, the unoffending
> Legs of their horses are broken. And now the fire
> Roars up in the furnace, now flames hiss under the bellows:
> The head of the people's darling glows red-hot, great Sejanus
> Crackles and melts. That face only yesterday ranked
> Second in all the world. Now it's so much scrap-metal,
> To be turned into jugs and basins, frying-pans, chamber-pots.
> Hang wreaths on your doors, lead a big white sacrificial
> Bull to the Capitol! They're dragging Sejanus along
> By a hook, in public. Everyone cheers. . . .

They follow fortune as always, detest the victims.
If a little Etruscan luck has rubbed off on Sejanus,
If the doddering Emperor
Had been struck down out of the blue, this identical rabble
Would now be proclaiming that carcase an equal successor
To Augustus. But nowadays, with no vote to sell, their motto
Is "Couldn't care less." Time was when their plebiscite elected
Generals, Heads of State, commanders of legions; but now
They've pulled in their horns; only two things concern them:
Bread and the Games.

"Duas tantum res anxius optat, / panem et circenses"—the public which once cared passionately about serious matters of power and public welfare, such as consulships and the army, now merely longs for two things, bread and circuses. One might suppose this was a poet's license, but it was closer to fact. The Caesars had discovered one of the better aids to governing a large, potentially unruly state, once the capacity for power inherent in citizenship of a republic had been collapsed into the single power of the dictator: keep the citizens diverted, at state expense. The immense political power of amusement, and the social anesthesia it fosters, was something that no one had fully acknowledged before. The Romans would use it to spectacular effect.

To wit, the Caesars underwrote leisure, the blank tablet on which amusement is written. First, they created more public leisure than any state had ever imagined giving its citizens, or ever would. This became addictive. The Roman year was divided into days on which ordinary business could be done (*dies fasti*) and days on which it could not, for fear of offending the gods (*dies nefasti*). As the number of leisure days or *dies nefasti* grew, so the number of *dies fasti* had to shrink. Earlier on, in the time of the Republic, Rome had holidays on which *ludi* or games were held in honor of various gods; the Ludi Romani, lasting two weeks, began in 366 B.C.E., and these were joined over the next couple of centuries by the Ludi Plebei, the Ludi Florales (in homage to the goddess Flora), and various others. In all, there were fifty-nine such holidays. But then, on top of these, one must add the thirty-four days of games instituted on various pretexts by Sulla, and the forty-five *feriae publicae* or general feast days, such as the Lupercalia in February (celebrating Romulus and Remus' nurture by the *lupa* or she-wolf), the Volcanalia in August, and the riotously entertaining Saturnalia in December. Then

there were the various days that Roman emperors designated to honor themselves, or were awarded by an obsequious Senate. All in all, by the reign of Emperor Claudius, Rome had 159 public holidays a year—three a week!—most of which were accompanied by games and shows paid for with public money. And reckoning in the irregular feast days that emperors were apt to decree on the slenderest pretexts, one might not be far off the mark in saying that imperial Rome had one holiday for every day of work.

This may seem an absurd disproportion to modern eyes, and indeed it is, but it kept the plebs in line and had two major side effects. It meant that Rome was perennially short of useful, productive free labor, and this shortfall had to be made up by slaves, the only ones who did not share in the unremitting fun of the festivals; the dependence on slave labor meant that Rome would always lag in certain areas of technology and invention. Second, it meant that the food, handed out by the emperor's minions, was an essential accompaniment to the pacifying distraction of the circus games, since a man and his household must eat whether they work or not. The mob is volatile. A populace that is both hungry and bored is a powder keg, and the successors of Augustus wanted no such risk. At any time there were probably 150,000 people in Rome living on "public assistance," meaning free food and games. To give them a common cause of anger might be politically risky.

In the short run, the addiction to state-sponsored amusement was very effective. "The height of political wisdom," the second-century commentator Marcus Cornelius Fronto called it. "The success of government depends on amusements as much as on serious things. Neglect of serious matters entails the greater detriment, of amusements the greater unpopularity. The handouts of money are less eagerly desired than the shows."

What were these shows? Basically, they were of three kinds: horse races, theater, and, most popular of all, gladiatorial combat.

The horse races were run in "circuses," racetracks specially designed for them. Rome had three principal circuses: the Circus Flaminius, the Circus Gaii ("of Gaius," named after the emperor nicknamed Caligula, who had it built on the site of what is now the Vatican), and, grandest of all, as its name implies, the Circus Maximus. All have since been buried beneath the structures of a later Rome. The form of the circuses never changed, though their sizes did. Two long straightaways formed a rectangle with a half-circle at one end. The strip between them was called the *spina,* or backbone. The public sat on long tiers of raked seats, parallel to

the *spina* and facing it across the track. The Circus Maximus could hold some 250,000 spectators, though estimates vary; it was a gigantic structure, six hundred meters long by two hundred wide, or over a kilometer and a half per lap, of which there were normally seven per race. With a gross area of about forty-five thousand square meters, it had twelve times the area of the Colosseum.

Each driven by a single charioteer, the chariots would thunder around this track. The chariots, the horses, and their drivers were kept in their *carceres,* or starting pens, until the signal was given; then the doors would spring open, and the race would be on. The starting pens were made of tufa, and the posts marking the turning points were of wood. The Emperor Claudius improved on this by having the pens reconstructed from marble and the turning posts from gilded bronze, which gave an even grander aspect to the races. Some chariots were *bigae,* or two-horse rigs; others, *trigae,* three-horse; *quadrigae* (four-horse), and so on up; the most common and popular type of racer was drawn by four horses, but eight-horse chariots were not unknown.

The charioteers commonly began as slaves, and won their freedom through skill and ruthless success on the track. Driving to win in the circus was the most effective way for a fearless, illiterate athlete to rise above the mob and become a hero: a charioteer who consistently won was a star, he had the mob on his side and, besieged by groupies, was enormously rewarded, both in prestige and in cash. Nothing essential would change between the day of the Roman chariot hero and that of the modern stock-car racing star, except of course that two thousand years ago the charioteer did not get to endorse products and had to live on his prize money alone. But this could be enormous. Undoubtedly, the most successful charioteer in history was Gaius Appuleius Diocles, originally from Lusitanian Spain, who competed in more than 4,200 races over a twenty-four-year career and retired in 150 C.E., having reached his early forties and won or placed 2,900 times, amassing 35 million sesterces. Unsurprisingly, no other drivers had the skill, the stamina, or the blind luck to equal this barely credible record. Some did very well: the charioteer Scorpus, for instance, won or placed 2,048 times. But by far the more common fate of the charioteer was to end up in his early twenties dead or a crippled pauper, crushed under the wheels of his opponents.

Theatrical shows were popular with the Roman mob, but their drawing power could hardly compare to that of the circus; the three principal theaters of Rome (the Theater of Pompey, the Theater of Marcellus, the

Theater of Balbus) probably had a combined seating capacity of fifty thousand—huge by modern standards, but nothing like the capacity of the Circus Maximus. The shows they put on tended to be gross, melodramatic, and simpleminded—in the same vein, one might say, as most of the produce on American television today. There was no Roman equivalent to Sophocles or Aristophanes. As Barry Cunliffe points out, "Creative theater in the Greek sense was already dead. Plautus and Terence represent not the beginnings of a new Roman approach to drama and comedy, but the end of the Greek-inspired tradition."

But they were only theater, not reality. The headiest stuff of Roman spectacle, barbaric and frightful and (to us) incomprehensible as it was, were the *munera*, the spectacle of men slaughtering other men in gladiatorial combat in an arena built for that specific purpose. Virtuously, we recoil from the very thought of these dreadful entertainments. We cannot imagine (we say) queuing up to see them. They represent an idea of the value of human life so totally opposed to our own—or what we would like to claim as our own—as to extinguish all comparison between ourselves and the ancient Romans. We good and gentle people do not have such sadistic voyeurism simmering beneath our skins—so we would prefer to think.

But if the existence and popularity of the *munera* are an indication, it is that civilized men (and women, too) can and will do almost anything, however strange and terrible, if they see others doing it and are persuaded of its normality, necessity, and entertainment value. Moreover, Romans took the *munera* as a lavish gift from the Caesars to themselves. A succession of autocrats, starting with Augustus himself and continuing onward through Pompey and Julius Caesar, treated them as the greatest imperial show of all, and hence a great public gift. In his *Res gestae,* list of the things he had done for the state, Augustus recounted, "I gave a gladiatorial show three times in my own name, and five times in the names of my sons or grandsons; at these shows about 10,000 fought. . . . Twenty-six times I provided for the people . . . hunting spectacles of African wild beasts in the circus or in the Forum or in the amphitheaters; in these exhibitions about 3,500 animals were killed." Not to have attended such bloody extravaganzas, not to immerse oneself in the entertainment, would be a sign of base ingratitude. Not that the emperor up in his *pulvinar* (royal box) would have noticed; but your fellow Romans well might, and treat you with derision and contempt for it.

The Romans attributed ancient origins to the *munera*. Many thought

they had begun with the foundation of the city, when such duels had supposedly been fought in honor of the god Consus, one of the primitive forms of Neptune. Probably the first "games" of this kind, albeit on a modest scale, were fought between gladiators in the Forum Boarium (cattle market) in Rome. They soon became extremely popular, and were rapidly enlarged: at the funeral games of the *pontifex maximus* Publius Licinius Crassus Dives in 183 B.C.E., sixty pairs of gladiators fought to the death. A variant on these man-to-man combats was the man-to-beast encounter in which criminals suffered the particular humiliation of *damnatio ad bestias,* condemned to destruction by wild animals. The first example of this practice is supposed to have happened the year after the consul Aemilius Paullus' military victory at Pydna in 168 B.C.E. over the Macedonian King Perseus, when Paullus had his deserters crushed to death by his war elephants.

Amphitheaters appeared wherever cities grew. By the second century C.E., seventy-two were to be found in Gaul, twenty-eight along the towns of Rome's Northern frontier, nineteen in Britannia—a total of some 186 sites throughout the Roman world. By far the largest, and the best known, of these was the Colosseum in Rome.

The Colosseum was originally called the Flavian Amphitheater, the largest example of a type of building peculiar to imperial Rome, used for spectacles and gladiatorial contests in which thousand of men and beasts struggled and died for the entertainment of a mass audience.

The earliest of these amphitheaters dated from 53 B.C.E., and stood in the Forum Boarium, where early "games" had been held in honor of Decius Brutus Scaeva some two centuries before—a link to the gloomy and chthonic ceremonies of Etruscan death. Little is known about either its architecture or the gladiatorial shows it staged. It was presently replaced by the Amphitheatrum Castrense, a three-story oval structure built not far from the present site of Santa Croce in Gerusalemme, a broad oval in plan, with a long axis of eighty-eight meters. At first the Castrense was the only amphitheater in Rome.

But this building, though impressive in size, was completely dwarfed by the arena, which came to be known to all and sundry as the Colosseum. The name does not mean "gigantic building"—it means "the place of the Colossus," a necessary distinction, because the "colossus" in question was an actual statue. It was a portrait of the Emperor Nero, cast in bronze by the Greek sculptor Zenodorus, nude and some 120 Roman feet high

(according to Suetonius), which stood at the entrance to Nero's prodigy of extravagance the Domus Aurea or Golden House, on the side of the Velian Hill. This monster of imperial narcissism hardly outlived its subject. After Nero died, his eventual successor, the Emperor Vespasian, who understandably did not want to be overshadowed by the largest effigy of another monarch in the Roman world, had his artists and engineers convert it into an image of Sol, the sun god, by equipping it with a radiant head-dress, something like the Statue of Liberty's, with seven rays, each twenty-three Roman feet long. In 128 C.E., the Emperor Hadrian had the whole thing moved to a site just northwest of the Colosseum—a square in the street surface, seven meters on a side, marks the spot. Hadrian was no stranger to huge engineering projects—this was, after all, the man who built the Pantheon and his own magnificent villa at Tivoli—but the transfer of Nero's statue was one of his largest. The statue was moved standing up vertically, hauled by twenty-four elephants. This was done around 128 C.E., but after Hadrian died, in 138 C.E., a successor, the deranged, dissolute Commodus, had the head of the Colossus removed and replaced by a portrait of himself, glaring across the city. (There was a strong relation between the arena of the Colosseum and the fantasies of Commodus, who identified with Hercules and was obsessed with being a gladiator. He had been known, among other proofs of skill, to ride around the arena lopping off the heads of terrified ostriches, like some madman in a park decapitating tulips with swings of his walking stick.)

In due course, the attributes of Commodus were stripped from the Colossus, and it became Sol once more. The frequent rituals held to venerate it gradually petered out, and by the end of the eighth century, it was no longer being mentioned, so presumably it had been demolished and melted down for its bronze. It left behind it a famous cliché. The English monk and chronicler (672–735) known as the Venerable Bede, who had never actually been to Italy, wrote, *"Quamdiu stabit Coliseus stabit et Roma; quando cadet Coliseus, cadet et Roma; quando cadet Roma, cadet et mundus"*—"As long as the Colossus stands, Rome will stand; when it falls, Rome will fall, too; when Rome falls, so will the world." This was echoed by many a later English writer, most memorably by Byron in *Childe Harold's Pilgrimage*, transferring the supposedly eternal endurance of the statue to the arena itself:

> "While stands the Coliseum, Rome shall stand;
> When falls the Coliseum, Rome shall fall;

And when Rome falls—the World." From our own land
Thus spake the pilgrims o'er this mighty wall
In Saxon times. . . .

This enormous oval arena stood on a portion—though only a small one—of the site of Nero's Domus Aurea. Its design, like that of the Golden House itself, was accomplished after the Great Fire. It may be that Nero's architects, of whom little is known beyond their names, meant to produce a *cavea,* or internal space, with some eighty regular arched openings, framed by engaged Tuscan, Ionic, and Corinthian columns. It had begun as an ornamental lake, which had been turned into a series of fountains and grottoes, ringed by the Velian, Oppian, and Caelian hills. The idea was to build the largest and most beautiful of all amphitheaters, but it was too grand and time-consuming a project to be carried out by any single emperor. The floor plan was an ellipse, the long axis eighty-six meters long, the short fifty-four meters.

Vespasian (reigned 69–79 C.E.) pushed its construction to the top tier of the second arcade of the outer wall before his death in 79. The Emperor Titus added the third and fourth stories of seating. Domitian (reigned 81–96 C.E.) is said to have completed the topmost story of the amphitheater *ad clipea*—as far up as the emblematic gilded bronze shields that ringed the top story of its exterior. It must have been a formidably impressive sight when finished, although a series of lightning bolts and earthquake tremors damaged it over the years. It was struck by lightning in 217, shaken by the earthquakes of 442 and 470, and seriously attacked by demolishers who were after the massive stonework and marble facings of which the Colosseum was built, material which was later recycled into other buildings of Rome. In the sixteenth century, for instance, the steps of Saint Peter's were built of stone quarried from the Colosseum.

By then, the wreck looked much as it does today, an enormous array of ring corridors. Through these radiated *vomitoria,* or radial corridors through which the audience streamed in and out to take up or vacate their places on the raked seating for the show. Underneath them were the gladiators' cells, the cages for the wild beasts whose deaths were such a popular part of the Colosseum "games," and the elaborate, ponderous stage machinery. Although none of the seating survives, it is clear that the arena itself was an ellipse, floored with heavy planks of wood which were strewn with sand for traction and could be removed for "special effects." What these effects were remains, to some extent, obscure.

The auditorium could hold as many as fifty thousand, and perhaps even seventy-five thousand people, and one has to imagine this mass audience stomping, hollering, and baying for blood; the "games" were the most barbarous form of orgiastic release ever devised, and their addictive power was immense.

All fighters were trained in a *ludus gladiatorius,* or gladiators' school, generally attached to an amphitheater. Each school was organized and run by an entrepreneur known as a *lanista,* sometimes an ex-gladiator himself, a tough and ruthless man who trained up his fighters from the bottom of the heap: from the endlessly replenished supply of prisoners-of-war and condemned thieves and murderers, from slaves, and even from paid volunteers, down on their luck and desperate for cash. Perhaps one gladiator in five was a free man. Gladiatorial fighting in what was called the *hoplomachia* (a Greek term meaning "heavily armed struggle") did at least create the possibility of freedom and reward for a really successful thug, if he won enough fights in the arena. Generally, the gladiator, once downed, would be doomed to die; a dreadful figure symbolically costumed as Charon, ferryman of the dead, or Hermes Psychopompos, carrier of souls, would step forward with a heavy wooden mallet and smash in his forehead. But if the gladiator had killed enough, and the audience and emperor approved with the thumbs-up signal, he might be awarded the *rudis,* or wooden sword, symbol of his favor and manumission. Then he would be allowed to live and be laden with treasure—silver salvers, gold baubles.

One of Cicero's letters to Atticus mentions that in Capua alone there lived five thousand gladiators, and it was from the gladiators' school in Capua in 73 B.C.E. that the Thracian hero Spartacus arose to lead the most dangerous and nearly successful slave revolt in Roman history.

It was necessary, for the sake of dramatic variety, to keep the audience on its toes by having various types or classes of gladiator. One kind fought with sword and full-length shield; another, with a shorter dagger and a round leather buckler. The *retiarii,* their weapons chosen in homage to the god Neptune, carried nets in which they strove to entangle their opponents, and razor-pronged tridents with which to impale them. The custom was to make them fight *murmillones*—netless but wielding swords, identified by fish on their helmets.

It was considered especially piquant to send different kinds of opponents out onto the sands of the arena. One learns, for instance, of "a bold array of dwarves—they give and suffer wounds, and threaten

death—with such tiny fists!" Women, untrained in a gladiatorial school, would be sent out to hack and bash awkwardly at one another on the sands, or be pitted against dwarves—a certain crowd-pleaser.

One also sometimes reads of naval battles fought in arenas specially flooded for the occasion, but if this happened at all it must have been very uncommon. The only well-attested event of that kind in Rome took place in a *stagnum,* an artificial pond, somewhere to the south of what is now Trastevere, where (at the command of Augustus) there was a scaled-down restaging of the Battle of Salamis, involving thirty full-sized biremes and triremes. But although it caused much loss of life, the wretched crews cannot have had much room to maneuver: the pond was only half a kilometer long.

Since the gangs of gladiators were privately owned and hired, they were quite often deployed outside the arena or the training school in street violence fomented by the political ambitions and enmities of their rich masters—becoming, in effect, private armies.

Then there were the fights between man and beast, or beast and beast, known as *venationes.* The former were simulated hunts—except that the animals had no way out, no caves or forests to escape into. They were kept penned and caged below the floor of the amphitheaters and released to come charging up ramps to face the *bestiarii* or animal killers. Outstanding gladiators might win themselves considerable prestige, though not nearly as much as heroic chariot-racers—but a *bestiarius* had none and was regarded as somewhere between a butcher and a common criminal, as indeed he usually was. These entertainments were first presented early in the second century B.C.E. The Roman Empire in Africa furnished its arenas with what seemed, at first, to be an inexhaustible supply of wild animals, captured by intrepid hunters on African deserts and savannas and then shipped back, caged and alive, to be tormented to a pitch of fury and then done to death in the various arenas. Among them were elephants, lions, panthers, tigers, and—unlikely though it may sound—hippopotami, which somehow survived the sea voyage in their cages. (Despite its placid, portly, and waddling appearance, the hippo if enraged is quite fast on its feet and can easily kill a man.) As a result of their use in the arenas, North African elephants became extinct in Roman times. During the opening slaughters of the Colosseum, in 80 C.E., at the behest of the Emperor Titus, some five thousand beasts were killed in a single day, either by human butchers or by other animals.

But not every Roman approved of the *munera.* Some were disgusted

by them and emphatically said so. One such person was Seneca, who described in his *Moral Epistles* how he went to a midday show in the arena and found, "It is pure murder. The men have no protective covering. Their entire bodies are exposed to the blows, and no blow is ever struck in vain. . . . In the morning men are thrown to the lions and the bears, at noon they are thrown to their spectators. The spectators call for the slayer to be thrown to those who in turn will slay him, and they detain the victor for another butchering. The outcome for the combatants is death. . . . And when the show stops for intermission, 'Let's have men killed meanwhile! Let's not have nothing going on!' " Cicero attended a *venatio* and came away feeling distinctly let down. "I . . . saw nothing new in it. The last day was that of the elephants, and on that day the mob and the crowd were greatly impressed, but manifested no pleasure. Indeed, the result was a certain compassion, and a kind of feeling that that huge beast has a fellowship with the human race."

The origins of these games must lie in more formalized human sacrifice, and are lost in antiquity; presumably, they descend from the gloomy funeral customs of the Etruscans—the assumption being that bloodshed reconciles the dead with the living.

There can be no doubt that the Roman public was debased by the gladiatorial shows. How could they not have been? Was any counter supplied by the State? None whatever; but at least the Caesars gave their subjects another, somewhat less murderous source of pleasure: the public baths. These structures did little but good. For most citizens of Rome, private bathrooms were nearly unknown: they were too costly to heat, and their water supply was at best irregular. Public baths, however, were the great amenity of Roman city life. They began to make their full appearance in the second century B.C.E., and in 33 B.C.E., when Agrippa had a census made of the public baths with paid admission in Rome, there were already 170; by Pliny's time, the total was closer to a thousand, many of which were presumably tacky if not outright filthy. But the great imperial bath complexes, whose construction probably began late in the first century B.C.E. and continued into the third century B.C.E., were entirely another matter: huge, splendid, and overwhelmingly popular. Their role as a point of contact between imperial largesse and the desires of the Roman public can hardly be overestimated. The *thermae* were not a mere amenity, but a central element of civilized life in Rome and throughout its empire. One finds, for instance, an edict of Caracalla from 215 C.E., banishing as possible subversives all Egyptians living in

Alexandria except "pig dealers, river boatmen, and the men who bring down reeds for heating the baths."

The first of the baths was created by Agrippa in about 25 B.C.E., near the Pantheon. It had a *laconium,* a dry sweat-bath, and was heavily adorned with works of art, including pictures (both encaustics and frescoes) which were recessed into the walls of even the hottest rooms.

The second great bath complex was the *thermae* built in 62 C.E. by Nero, struck by lightning and burned, and at last finished in 64—just in time for the catastrophic fire that swept through Rome in that year, which it survived. It occupied a site between the northwest corner of the Pantheon and the Stadium of Domitian, now Piazza Navona, and although it has almost entirely disappeared, two gray granite columns from it were used, in the seventeenth century, to repair the porch of the Pantheon, and other *spolia* were cannibalized for later palaces; another column and a piece of cornice were dug out from beneath the piazza outside San Luigi dei Francesi and set up in Via di Sant' Eustachio as late as 1950. None of these fragments give any idea of the scale of the Baths of Nero, whose plan was about 190 by 120 meters.

The third major Roman bath was that of Titus, dedicated in 80 C.E., the same year as the Colosseum, and also built on part of the site of the Golden House of Nero, of which little remains except the brick cores of some columns of its porch, facing the Colosseum.

The fourth, built after 104 C.E. on a huge rectangular section of the burned-out ruins of the Golden House of Nero, 250 meters wide by 210 deep, was the Baths of Trajan. The fifth was officially known as the Baths of Antoninus, although everyone calls them the Baths of Caracalla. They were completed early in the third century C.E., and they are vast, covering eleven hectares. The sixth, the Baths of Diocletian (c. 306), was even bigger, with an area of thirteen hectares. Today its site and vestiges contain a large church, an oratory, and one of the greatest collections of antique art in Italy, the National Museum of Rome. Because of the administrative and fiscal chaos into which so much of the administration of Italian museums has fallen, whole tracts of this notionally sublime collection are closed to the public—for instance, none of the Ludovisi collection, except the Ludovisi Throne itself, is open to view. But it is still extraordinarily rich, not only in sculpture, but also in ancient Roman painting, in which it nearly rivals the unsurpassable collections of the Naples Museum.

The parts of the imperial baths that are still standing have always

afforded inspiration to architects—including, especially, those of the past century. Roman *thermae* supplied the models for those mighty expressions of the mystique of early-twentieth-century American travel, Grand Central Station, and the former Pennsylvania Station (1902–11), by McKim, Mead & White—with its waiting room modeled on the Baths of Caracalla but enlarged by a quarter—demolished in 1963, when, in one of the worst outrages ever inflicted on Manhattan, it made room for the squalid warren that has replaced it. The Baths of Caracalla also furnished the prototype for another nineteenth-century masterpiece in New York—the cool, august spaces of the entrance hall of Richard Morris Hunt's Metropolitan Museum of Art. But the influence of these ancient *thermae* extended well into the twentieth century, and will continue to be felt in the future by any architect who values mass and volume above mere transparency.

A Beaux-Arts architect like Hunt tried to get back to the magisterially pristine form of the Roman baths. Sixty years later, another genius of American design, Louis I. Kahn, was inspired by their state as ruins. The various baths, including those of Caracalla and Diocletian, had been built of concrete and brick, then sumptuously clad in limestone and colored marble. All this surface and carved detail was stripped away after the death of the Empire, and the brick set in to crumble, leaving only the rudiments of architecture behind it: mass, space, light. These were the rudiments Kahn set himself to capture in new structures, and his search for them began in his experience of Roman ruins, particularly the *thermae,* with their giant vaults made possible only by that Roman invention, the poured concrete arch, which generated the vault (if extended) and the dome (if rotated)—so un-Greek, so prototypically modern.

Whatever the architectural differences of individual buildings, the process of bathing—and the divisions of space and use that it implied—hardly varied. Naturally, all the functions of the bath palace had to be grouped under one roof, a huge quadrilateral, with shops and exercise and massage rooms along its outer sides, and the bathing facilities within. The rituals of the Roman bath were, so to speak, processional. On entering, one shed one's clothes in the dressing room or *apodyterium,* stowed them in a locker, and then headed for the *tepidarium* or warm hall, which had on one side the *frigidarium* or cold plunge-bath, and on the other the steam room, the *caledarium.* Next to that was the hot-air sweating room, the *sudatorium.* The necessary heat for this system, which was enormous, came from furnaces stoked with firewood or reeds. One could lose a

lot of weight in such places, sweating out one's surplus fluids. Seneca described (vividly, though perhaps with some exaggeration) what it was like to live over a bathhouse. The grunting and groaning were enough to make him queasy:

> When the stronger fellows are exercising and swinging heavy leaden weights in their hands . . . I hear their groans; and whenever they release their pent-up breath, I hear their hissing and jarring breathing. . . . Add to this the arrest of a brawler or a thief, and the fellow who always likes to hear his own voice in the bath, and those who jump into the pool with a mighty splash as they strike the water. . . . Imagine the hair plucker keeping up a constant chatter in his thin and strident voice . . . [and] the varied cries of the sausage dealer and confectioner and all the peddlers of the cook shops. . . .

The *thermae* were not only for bathing. The larger ones, in Rome, were likely to contain libraries and galleries. Some were so richly endowed with sculpture, both copies and original pieces in marble and bronze, that they were almost museums in their own right: the *Laocoön,* considered by eighteenth-century connoisseurs to be the very quintessence of achievement in classical sculpture, was allegedly disinterred in the ruins of a bathhouse. Probably the presence of such works of art did much to appease the objections of conservative Romans who felt that the athletic prowess celebrated by bath culture was anti-intellectual. The baths rightly inspired civic pride. "With so many indispensable structures for so many aqueducts," remarked Frontinus, "compare, if you will, the idle pyramids or the useless, though famous, works of the Greeks." This was not empty boasting, even though it is unclear why Frontinus should have regarded Greek architecture as useless. Certainly, to a Roman the pyramids of Egypt, those prodigies of stonework with no function beyond the burial of a single man, must have seemed "idle"—the extravagances of religions other than one's own do tend to look that way. But a Roman took great pride in his city's baths. Their size and magnificence did not overpower him—rather the reverse, for they reminded him that he was the reason for the state. In form and meaning, they were the very quintessence of public architecture.

The Emperor Gaius Aurelius Valerius Diocletianus (reigned 284–305), or Diocletian, did much more than build the immense baths in Rome that bear his name.

He was a straightforward soldier from Dalmatia, with little formal

education, not even Roman by ancestry (his original name, Diocles, was Greek), and of the humblest birth. This was a prime factor in his control of the army, and in the army's loyalty to him. The social gap between army officers and enlisted men now yawned; it was not just an inconvenience, as the *social* distance between an officer earl and Tommy Atkins might have been in the British army, but an ever-present danger to the coherence of the Roman forces. The more the army had to fill its ranks with "barbarians" rather than true *Romani,* as it did, the less patriotic ardor it could expect from the men who fought for Rome. At least the line soldiers, knowing that their emperor began as a low-class outsider like themselves, were more likely to stick with him.

He was very pious, devoted to the Roman gods, and this must have caused family stresses when both his wife, Prisca, and his daughter, Valeria, converted, as it was said, to Christianity. He was also imbued with an extreme arrogance, which he regarded as a necessity of power. Augustus had begun the tradition of the Principate, by which the emperor was always *"primus inter pares,"* "first among equals"; he had loathed being addressed as *dominus,* "lord," although in practice his power was absolute. Later emperors observed this formula, with varying degrees of conviction.

The earlier Emperor Vespasian (Titus Flavius Vespasianus, 9–79 C.E.), for example, had viewed the fantasy of the Divine Emperor with a most commendable skepticism, but he was the only emperor to do so. He was a sound, fair, hard-boiled military man, who had won honors under Claudius for his role in the conquest of southern Britain in 43 C.E., and in 66 had commanded three legions in the Jewish War. He loathed pretension and effeminacy, qualities which had not been in short supply under previous emperors. When a dandified young officer, smelling heavily of scent, came to thank Vespasian for his promotion, the emperor brusquely remarked that he would rather he smelled of garlic, and busted him back to the ranks. He also had an ironic sense of humor, and no patience with the mumbo-jumbo of deification—a fact commemorated in his famous deathbed remark, as he was expiring of a fever in 79 C.E., *"Vae, puto deus fio,"*—"Oh, no! I think I am becoming a god!"

Diocletian was not going to be anything but a god. He completed the evolution of the Principate to the Dominate—undisguised, ceremonious, and absolute monarchy; Oriental monarchy, as many thought. The subject, approaching the presence of the emperor, had to prostrate himself and, when he spoke, address him as *dominus et magister*—"lord and

master." As we have seen, there had been moves in this direction made by previous emperors. To be treated as a god on earth—that had been expected by Caligula, Domitian, and Commodus. By the time Diocletian became emperor, there was nothing unfamiliar or freakish about emperor worship, and it meshed perfectly with the great third-century jurist Ulpian's declaration "The emperor is above the laws." Diocletian may have regarded this as entirely benign, a corollary of his belief that, as emperor, he was the *pater patriae,* father of the Roman people. But once you have tasted godhood it is not so easy to de-deify yourself.

However, he was earthbound enough to recognize that the sheer size and complexity of the Roman Empire, and the slow communication this size meant, demanded changes in the administration of its government. He therefore introduced the Tetrarchy, or Rule by Four. It actually began as a diarchy, rule by two. In 285, he designated his lieutenant Maximianus as "Caesar" and put him in charge of the Western half of the Empire, while he kept the East. (Diocletian was worshipped as the earthly incarnation of Jupiter, and now Maximianus became, for religious purposes, Hercules.) In 293, Diocletian appointed two more Caesars: Constantius, father of the future Constantine the Great, who was to rule Britain and Gaul in the West, and Galerius, who got the Balkans in the East. But he had to be sure that ambitious sub-Caesars did not become too powerful, so he split the provinces: divide and rule. There would henceforth be six dioceses in the East and six in the West, divided into about a hundred provinces, each with its own governor. The roster, in its essential features, would last for centuries—it was the basis of most subsequent national divisions.

Inflation was a huge, intractable problem, which Diocletian lacked the economic ingenuity to control. He tried, and failed, to fix prices by issuing edicts limiting both wages and the sale price of every sort of commodity and service. An army *modius* of ground millet, for instance, would cost 100 denarii; a pound of best-quality pork leg, 20 denarii; oysters, a denarius each; and so on. An arithmetic teacher was to earn 75 denarii per month; a carpenter, 50 per day; a scribe, "for second-quality writing," 20 denarii per hundred lines; a lawyer, 1,000 denarii for pleading a case; and a checkroom attendant in a bathhouse, 2 denarii per person. None of this worked; it merely produced a runaway black market.

The Empire's coinage, meanwhile, became so debased as to be almost worthless. Nobody trusted it. There was not enough gold and silver bullion in the Empire to reinstate the currency, and eventually Diocletian

was forced to accept tax payments, and to pay his soldiers, in kind rather than in cash. Nevertheless, there were imperial headquarters to be built for the tetrarchs: in the East, at Nicomedia, Antioch, and Thessalonica; in the Balkans, at Sirmium; and in the North, at Milan, Trier, and York.

One might have thought all this would have distracted the god Diocletian from such matters as a small, peripheral Jewish religion, but far from it. For the first two decades of his reign, Diocletian paid no attention to the Christians; but toward 303, he began to worry about the infiltration of their faith into high places, mainly through the conversion of governors' wives and daughters. It worried him—understandably, in view of his own immense egotism and his piety toward the old gods—that such families were moving away from the imperial cult, especially since some of the more intelligent members of the army high command were becoming Christians, too. This canker had better be excised; even the oracle of Apollo at Didyma, near Miletus, urged the emperor to attack the Church. The result was a fierce renewal of persecution of Christians, designed to force them to accept the imperial cult and worship Diocletian as a god—which, of course, few of them would do. It is not known how many were killed in the "Great Persecution" of 303–13; severe as it was, Christian writers like Lactantius were bound to exaggerate it and to demonize Diocletian, "inventor of wicked deeds and the contriver of evils . . . ruining everything." (One should, perhaps, remember that Lactantius had a bit of an ax to grind. He had been summoned from Africa to teach Latin rhetoric in Nicomedia—an extremely important academic post, given that Nicomedia was scheduled to become one of the new Romes. Then, during the Great Persecution, Diocletian fired him. To lose such a job was a very severe blow that demanded literary revenge, which Lactantius certainly exacted with a bloodcurdling text, *On the Deaths of the Persecutors*.)

There is a temptation—fostered, of course, by pious impulses—to suppose that Christianity had somehow "triumphed" over Roman paganism by the fourth century, completely changing the religious horizon of Rome. Nothing could be further from the truth.

With the establishment of the Tetrarchy, no emperor spent any length of time in Rome. Once the *caput mundi*, it was no longer an effective center of power; its monopoly of power was gone. Perhaps because of this, its pagan institutions continued to flourish. The building of its huge defensive bulwark against barbarian invasion, the Aurelian Walls (309–12 and 402–3), with their fifteen-meter height and their 380 tow-

ers, created what Richard Krautheimer called "the greatest monument of late antique Rome." Any list of the pagan enterprises of Rome in the thirty years before the arrival of its first Christian emperor, Constantine, would need to include the Baths of Diocletian, the Senate House on the Forum Romanum (rebuilt after fire in 283), the Basilica Julia (rebuilt after the same fire), the colossal hall of the Basilica Nova (with its three huge barrel-vaulted niches, built by Maxentius in his six-year reign, 306–12), the apsed hall of the Temple of Venus and Cupid, and much more. Fora, temples, sanctuaries, shrines were constantly being repaired and rebuilt. Through the fourth century, Rome seemed to visitors "an essentially classical, secular and pagan city." The fourth-century gazetteers listed, among its contents, twenty-eight libraries, eleven fora, ten basilicas, eleven public baths, nine circuses and theaters, thirty-six triumphal arches, and forty-six brothels. Even after Constantine's death, the persistence of pagan memory was strong. There may have been a "new Rome" and Constantine would of course change the city, but not so huge a change that it suddenly rendered old Rome itself irrelevant. Cities didn't die at the stroke of a pen. The persistence of pagan memory was too strong for that. Rome remained a stronghold of enlightened paganism, drawn from Gnostic and Neoplatonic philosophies, strengthened by some of the greatest art and literature the world had ever seen, and supported by powerful and conservative local aristocrats. In those decades, to be conservative was to be anti-Christian—indeed, to regard Christianity itself as an intrusive lowbrow sect, not worth a civilized person's attention except as an example of the kind of folly that was coming out of North Africa. If anyone had suggested to such a Roman that, at some future date, this little sect would be larger, richer, and more powerful than any number of Roman Empires, he would have thought the proposal lunatic. And the struggle over that transfer of power would be fierce.

For what could then have been more powerful than Rome? Or richer? The Tetrarchy may have disbanded the central power, but the more wars Rome won, the more its empire expanded, the richer it got: this was inevitable. And the richer it got, the more luxurious its life became. Not everyone's life, obviously; but for the top 5 percent, life took on a character of manic overindulgence and extravagance, unpleasantly reminiscent of the life of the American super-rich today. *"Frangitur ipsa suis Roma superba bonis,"* wrote Sextus Propertius: "Proud Rome is now brought low by her wealth." Pliny the Elder, writing as early as the first century c.e., esti-

mated that at the "lowest reckoning" the expensive imports from India, China, and the Arabian peninsula "drain our empire of 100,000,000 sesterces every year—that is what our luxuries and womenfolk cost us." Granted, Roman writers (just like American ones two thousand years later) were fond of invoking the good old days of the early Republic, when men were men, life was simple, and morality stricter. Why did frugality prevail in olden times? Because, Tacitus explained, we were once all citizens of one city. "Even when we were masters of Italy alone, we did not have the temptations of today. Victories in foreign wars taught us to devour the substance of others, victories in civil wars, our own." Inveighing against recent luxury and decadence, Seneca pulled out all the stops:

> We think ourselves poor and mean if our walls are not resplendent with large and costly mirrors; if our marbles from Alexandria are not set off by mosaics of Numidian stone, if they are not covered all over with an elaborate coating variegated to look like painting; if our vaulted ceilings are not concealed in glass; if our swimming pools—into which we lower our bodies after they have been drained weak by copious sweating—are not lined with Thasian marble, once a rare sight in a temple, or if the water does not flow from silver spigots. . . . We have become so luxurious that we will tread upon nothing but precious stones.

In the view of the historian Livy, writing around the same time, the appetite for debilitating luxury came to Rome from its conquests in the East, and was brought back by the military:

> It was through the army serving in Asia that the beginnings of foreign luxury were introduced into the city. These men brought into Rome, for the first time, bronze couches, costly coverlets, tapestries, and other fabrics, and—what was at the time considered gorgeous furniture—pedestal tables and silver salvers. Banquets were made more attractive by the presence of girls who played on the harp. . . . The cook, whom the ancients regarded and treated as the lowest menial, was rising in value, and what had been a servile office came to be looked upon as a fine art.

What did these Romans eat and drink? The answer is a little disappointing, if your expectations of Roman food are based on the legendary

blowouts recorded in Petronius' *Satyricon* and other accounts of high living. We read of Trimalchio, a former slave grown immensely rich through speculation, entertaining guests in his house in Campania. They are shown a bronze donkey—Corinthian bronze, the most expensive kind—with panniers on its sides, one full of white and the other of black olives. There are silver dishes "laden with dormice sprinkled with honey and poppyseed . . . [and] sausages smoking-hot on a silver gridiron, with damsons and pomegranates sliced up . . ." Each dish is engraved with Trimalchio's name and its own weight, so that all the guests know what it is worth. The *pièce de résistance* is a basket full of straw, with a carved wooden peahen sitting atop it, her wings spread. Two slaves set it down; trumpeters play a fanfare; the slaves rummage in the straw, finding egg after egg. Trimalchio exclaims: "My friends, I ordered peahens' eggs to be set under a hen, and by Jove I am afraid they are half-hatched already; but let us try whether we can still suck them." Each guest is given a silver spoon "weighing at least half a pound," and they start on the eggs, which turn out to be made of "rich pastry." Within, hidden in the yolk, the narrator finds a fine, plump figpecker, a great delicacy then, as now.

This kind of gastro-pornography is what springs to mind when most people today think of Roman food, but it has little to do with what the vast majority of Romans actually ate. Their daily fodder was much more likely to be polenta (a corn porridge, either hot and gloppy or, when congealed, refried in slices), beans, and bitter herbs, with meat (preferably pork) as a rarity, and eggs and an occasional chicken. Most working-class Romans subsisted largely on pulses and bread. A lot of cheese was eaten, and there cannot have been much difference between the *pecorinos* or sheep's-milk cheeses consumed today and those of Roman times. Vegetables, of course, made an appearance, in such forms as a delicious preparation of young zucchini known as *scapece,* which is still served in some Roman restaurants. There would also be fish, though without refrigeration it cannot often have been fresh. The very rich were able to maintain fishponds—there are even horror stories about slaves being fed to their enormous eels. The universal stimulant of appetite was garum, a decoction of rotting fish guts, which seems to have resembled a very smelly and salty ancestor of Worcestershire sauce. Roman households consumed it rather as lower-class Americans today consume tomato ketchup, putting it on everything. We tend to assume that *garum* merely stank of rotten fish, but it must have had a more subtle taste than that.

The potato, the tomato, and all other imports from the undiscovered New World were, of course, unknown. So was sugarcane. When a Roman cook wanted to sweeten a dish, he did it with honey.

Another outlet for Roman wealth and decadence during this time was art. Just as today, the prices of fashionable "fine" art were fantastically inflated: ancient Rome, it seems, had its equivalents to the hysterical, grotesque pricing of Pablo Picasso, Andy Warhol, and Jasper Johns. The orator Lucius Crassus paid an incredible 100,000 sesterces for two silver goblets engraved by Mentor, a famed Greek silversmith, "but he confessed that for shame he had never dared use them." Corinthian bronzes were so prized for their workmanship that they cost whole family fortunes. Pliny reported that one ivory table changed hands at 1.3 million sesterces—"the price of a large estate, supposing someone preferred to devote so large a sum to the purchase of landed property."

Still another was jewelry. The display of precious stones by some Roman matrons was grotesquely excessive, and the matrons themselves were monsters of vulgarity, just like today's. Here was Lollia Paulina, third wife of the Emperor Caligula, whose beauty equaled her vulgarity, "at an ordinary betrothal banquet covered with emeralds and pearls interlaced with each other and shining all over her head, hair, ears, neck, and fingers, their total value amounting to 40,000,000 sesterces, and she herself ready at a moment's notice to show the bills of sale in proof of ownership." By the Tiber as under the lights of Broadway, diamonds really were a girl's best friend. The spread of empire inevitably brought with it an increased supply of luxury goods and precious baubles: emeralds from Egypt and the Urals, sapphires from Sri Lanka, amethysts and diamonds from India. The finest Chinese silk traded for gigantic prices: a pound of silk for a pound of gold was not unknown. Perhaps the favorite Roman jewel was the pearl (margarita), yielded by all Rome's oceans. Naturally, the abundance of precious and semi-precious materials helped create a large class of luxury craftworkers. More relics of their industry would, no doubt, have come down to us if Rome had not so frequently been sacked.

The most spectacularly ostentatious piece of art-stuffed real estate in Roman antiquity—surpassing even the Golden House of Nero—was a villa built for the Emperor Hadrian at Tivoli, twenty miles northeast of Rome. To call it "Hadrian's Villa" seems a complete understatement, since its site was about the same size as central Las Vegas, some three hundred hectares, twice the area of Pompeii. Like some abandoned Mayan city,

Tikal perhaps, it has only been partially excavated, despite the enormous number of statues and other works of art removed (looted) from it over the last few centuries and dispersed to museums in London, Paris, Berlin, Los Angeles, and Saint Petersburg, not to mention Rome itself and, of course, unlisted private collections. Some historians of antiquity think that only 10–20 percent of the full constructed area of the "villa" has been dug up and disclosed, which would make it the biggest unstudied ancient site in Italy or the Roman world.

One particular kind of ancient statue is associated with the villa—the naked, idealized likeness of Hadrian's lover Antinous, the Greek homosexual pinup *par excellence,* whose fetching body and pouting Elvis mouth proliferated all over the Empire after he drowned in the Nile in 130 C.E. But the contents of the villa reflect a general culture of intense imitation in which one version after another of Greatest Sculptural Hits was turned out to imperial order by craftsmen whose sole task was to create a cultural dreamscape: a wondrous Greece re-created in (or just outside) Rome. The idea of "heroic invention," which is the basis of modern worship of the new, did not exist in classical times, and would have been regarded as a zany aberration, not as a sign of excellence. One of the results has been that Roman copies, or (relatively) free variants, of Greek originals have become almost all we know of the original art of Greece; with the exception of a few indisputably Greek-made masterpieces, such as the Parthenon Marbles, Greece is now largely Roman. And because so many "Greek" masterpieces were either made by Greeks in Rome for Roman clients, or made by Romans in Rome, or completed in Rome by local craftsmen after the original block had been roughed out in Greece, the problem of saying anything certain about the origins and nature of classical art objects is usually insoluble. But one thing seems fairly certain. In its quality of sculpture, ancient Rome could never rival ancient Athens. Phidias had many Roman imitators, but there was no Roman Phidias. Most Roman sculpture is, at best, faithfully descriptive—one thinks of the realistic funerary portraits of slightly grim-looking citizens, tight with virtue. Great sculpture, like the panels celebrating Augustus on the Ara Pacis, is very much the exception, and when it occurs one may fairly suppose the authorship of Greek or at least Greek-trained carvers. Virgil was right: the great art of Rome was not sculpting, but ruling.

4

Pagans Versus Christians

It makes little real sense to speak of "the end of the Roman Empire" as though that enormous social structure suddenly came undone or ceased to exist. In forms both powerful and merely vestigial, it continued to provide the framework of international society throughout Europe for hundreds of years. That said, starting with the reign of Constantine, the conflict between the old pagan rule and the new Christian might would slowly erode the Empire's potency.

The first persecutions launched against the Christians by Rome's emperors were relatively small affairs, but none the saner for that. It must seem strange that a city as abundant in sects and cult objects as imperial Rome should have persecuted anyone for holding unorthodox beliefs—there was, one might have thought, more than enough superstition for everyone—but in imperial times that was not how the ruling and priestly classes saw the matter, and for two reasons.

One was that the Christians refused to pay divine honors to the emperor. They would not pray or sacrifice to him as a god. Even a token participation in Roman religious rituals would probably have satisfied the authorities. But to refuse them altogether was an act of defiance. It was resented as a crass form of lèse-majesté. Christians seemed bound together by ties of common belief and worship which had nothing to do with the ordinary relationships between Romans and their gods. Those relationships underwrote the stability of the Roman state. The Christians seemed more loyal to their secret society, which could only mean that they were disloyal to Rome.

The second, related reason was that, after a period of relative indif-

ference, Christianity began to attract hostile and fantastically inflated rumors about the numbers, conduct, and beliefs of its devotees, and the dangers they might pose to an orderly society. They were becoming a more visible sect, which—thanks to its slowly growing popularity among the common folk of the Roman Empire in the third century c.e.—was attracting the kind of hatred that success breeds. Christians had arrived only recently, boasted one of them, Tertullian, "and we have filled everything of yours—cities, islands, forts, towns . . . palace, Senate, Forum. We have left you only the temples." This was an extreme exaggeration. But nearly everything that was said about Christianity in its earliest years was an exaggeration, and nothing more so than the popular notions among pagans of what Christians actually believed and hoped for.

Given the success of Christianity in the coming years, given that this embryonic cult would soon become an all-dominating and world-embracing religion that drove the pagan gods from their sanctuaries and niches, one might have expected a surge of opposition to it right from the start; actually, there was little. If no threat was presumed, Romans tended to be quite tolerant of minority religions, even when the "minority" was large. The Emperor Augustus, for instance, knew that a large tract of Rome beyond the Tiber was owned and inhabited by Jews. Most of these Jews were Roman freedmen, who had been brought to the city as prisoners-of-war and then manumitted by their owners. They did not worship the Roman gods, or perform obeisances at Roman shrines. But because they caused no trouble either in doctrine or in action, Augustus saw that no pressure was put on their synagogues; no Jew was prevented from meeting with his or her brethren for the exposition of the Law—"On the contrary, he showed such reverence for our traditions that he and almost all his family enriched our Temple with expensive dedications. He gave orders for regular sacrifices of holocausts to be made daily in perpetuity at his own expense, as an offering to the Most High God. These sacrifices continue to this day, and will continue always, as a proof of his truly imperial character."*

Christians, few but growing in number, led little-noticed lives in the forest of sects and cults that the decay of "official" Roman religion produced; as a religion, Christianity seemed hardly worth contesting. To most Romans who thought at all about the matter it would have seemed

* Here, the word "holocaust" is given its earlier and correct meaning: a multiple sacrifice and incineration which is pleasing to the Lord, not the mass murder of an unwilling people.

of little consequence, and the idea that the civilized world would before long date its events from the lifetime of a carpenter's son from Galilee would have seemed merely ludicrous.

There is a passing reference in Suetonius's account of Claudius to disturbances caused by Jews in Rome "at the instigation of Chrestus," but it is not at all clear if Chrestus was the same person as Christ. No pagan writer even bothered to attack the ideas of the Christians until 178 C.E. (He was a Neoplatonist named Celsus, and his writings are lost; we only know that he wrote them because a Christian apologist, the Church father Origen, attacked him for them.)

Unrestrained calumnies were let fly against the Christians, "a rabble of unholy conspirators," given to sharing "barbarous foods . . . for the sake of sacrilege," according to the converted Christian writer Minucius Felix. The result of the mere presence, let alone the growth, of Christianity (according to those Romans who disapproved of it) had been general moral decay in the Empire and, everywhere, "a kind of religion of lust." Christians were accused of every sort of perversion and impropriety, including ritually murdering children and eating their flesh—a fantasy which must have arisen from Christ's Eucharistic instructions to his disciples, to eat his body (the bread) and drink his blood (the wine), and to "do this in memory of me." This form of banqueting was "notorious; everywhere, all talk of it." The Christians wanted to bring the end of the earth, moon, and stars with fire, and be "reborn after death from the cinders and the ashes." In sum, the apocalyptic nonsense that anti-Semitism would soon be spouting against Jews was being marshaled by some Romans to incite and justify the persecution of Christians.

Whence such virulence? A reasonable person might have had his reservations about Christian behavior and found reasons to disagree with, even dislike it. But the idea that Christianity wanted to bring about the destruction of the world must seem exotic, or at least a tad far-fetched, to those who think of it as a benign and gentle religion. Others destroy; Christians temper, comfort, and forgive. But it could very well not have seemed so to a Roman in the first century C.E., when confronted by the rhetoric not only of the sect's faithful, but of its founder, the aggressive Galilean Jesus Christ.

Early Christians were not milky-mild or forgiving at all. We know this because we know what they believed, which was what Christ had told them to believe. At the back of all Christian minds lay his injunction to intolerant militancy: "I come not to bring peace, but a sword." The New

Testament's record of early Christian belief is contained in the Acts and the Epistles. They are saturated with apocalyptic rhetoric; some of it, no doubt, garbled and touched up—the New Testament was put together a long time after Christ's death—but without reasonable doubt a fair epitome of what Christ, and the early Christians, believed and said. And (no less important) of what the Romans thought they were saying.

The principal content of these beliefs was that the world was coming to an end. Saint Peter had no doubt about this. "The end of all things is at hand," he announced. "The time is come that judgment must begin at the house of God." This would happen at any moment, because these were "the last days"—a phrase which would be used and reused in Christian eschatology for the next two thousand years. Saint Paul was of a similar view, eagerly awaiting the day "when the Lord Jesus shall be revealed from heaven with his mighty angels, in flaming fire taking vengeance on them that know not God, and that obey not the gospel of our Lord Jesus Christ: who shall be punished with everlasting destruction. . . ."

Jesus' own words on these terrible events to come are recorded in the Gospel of Matthew:

> For nation shall rise against nation, and kingdom against kingdom: and there shall be famines, and pestilences, and earthquakes, in divers places. All these are the beginning of sorrows. . . . Ye shall be hated of all nations for my name's sake. . . . I say unto you, This generation shall not pass, till all these things be fulfilled.

Christians did not believe that such prophecies, promises, and threats were in any way metaphorical. They were truthful in essence, and soon would be in fact as well: not in the distant future, but imminently, within this generation. Rome was doomed to be destroyed in a few years, a few decades at the most. The New Testament had not been written yet, but such beliefs were preached, described, made part of the essential public lore of the new religion and its adherents. To them, it made perfect sense, because it was Revealed Truth. But it also made sense to the Roman authorities, sense of a different kind. It meant that the Galileans *wanted* this promised destruction—as no doubt many of them, being fanatics, did. The radical who dreams of bringing a whole society crashing down on the heads of its inhabitants, who fantasizes about the fiery end of the social order, would become a familiar figure—hero to some, nightmare to others—throughout the twentieth century: the anarchist with the bomb, the Falangist general crying, *"Viva la muerte,"* the Arab teenager

blowing himself and a Jewish school bus to a bloody, smoking pulp for the sake of "martyrdom." There seems to be little room for doubt that a civilized, law-loving Roman might have believed what the Jesus freaks said about the future of history and their mission within it, and concluded that the best thing to do with this hostile though marginal sect was to wipe it out before it spread any further. Of course, the end of the world did not come—a relief to sensible people, though no doubt a disappointment to some loonies. But to threaten it, which was what Rome thought Christians were doing, was—how to put it?—a deeply antisocial act. It made the thought that Christians were motivated by "hatred of the human race" seem quite plausible.

Undoubtedly, the most crazed and sadistic attack on Christians by any Roman emperor was the one launched after the Great Fire in Rome in 64 C.E., when Nero needed a scapegoat for the fire. According to the historian Tacitus, the Christians were already "hated for their abominations" in Judaea. The Jews, particularly the very Orthodox ones, would have liked nothing better than to see them disposed of—to gratify their apparent longing for holy martyrdom. Thus they welcomed their persecution by Nero, even though the need for it did not, according to Tacitus, convince the Romans themselves. They thought it freakish:

> Nero provided his Gardens for the spectacle, and exhibited displays in the Circus, at which he mingled with the crowd—or stood in a chariot, dressed as a charioteer. Despite their guilt as Christians, and the ruthless punishment it deserved, the victims were pitied. For it was felt that they were being sacrificed to one man's brutality rather than to the national interest.

There was no sudden transition between Nero's obsessions and the victory of the Christians—how could there have been?—and yet, if we look back on it, it is surely possible to see in the violence of Nero's attack on the little sect a foretaste of what was to come two and a half centuries later. The epochal event which divided the history of the Roman Empire was a battle won just outside Rome, and fought in 312: the Battle of the Milvian Bridge, which spanned the Tiber.

This battle marked—though of course no one realized it at the time—the end of the old Roman imperial system and the beginning of the Byzantine Empire. It was predicted by a line in Homer cited, with some relish, by the Roman gossip-monger and historian Suetonius when writing of the first-century Emperor Domitian: "Too many rulers are a dangerous thing."

So indeed they proved to be.

Under Diocletian, the unified Roman Empire had split and assumed a new shape: at the dawn of the fourth century, it consisted of an Eastern and a Western empire, ruled by the tetrarchs—not one but two senior emperors, each known by the honorific "Augustus" and supported by his own "Caesar" or junior emperor, making four rulers in all.

The best-known depiction of this odd system was created by an unknown artist in Constantinople, looted by crusaders in 1204, and brought to Venice, where it was built into the façade of Saint Mark's Basilica. It depicts two pairs of tetrarchs, the Augustus and the Caesar of East and West respectively, embracing one another. They are solid, heavy, thick-necked, and shown grasping their swords with their free hands. It is an image of firm—one might say, implacable—loyalty, though there is no indication of their names.

In the spring of 305, Diocletian, the Augustus of the Eastern Empire, as Maximianus was of the Western, had formally abdicated. He now retired to his gigantic palace, whose ruins still stand at Split, formerly Spalato, on the Dalmatian coast. He was succeeded as Augustus of the East by his fiercely anti-Christian colleague Galerius, who had moved up from his previous post as Caesar of the East (and was succeeded in that role by his nephew, Maximinus Daia). Similarly, Maximianus abdicated as the Empire's Western Augustus and was replaced by Constantius Chlorus, up to then the Caesar of the West.

What threw this ponderous imperial game of musical chairs into chaos was that in 306 the barbarian border tribe of the Picts, ancestors of the modern lowland Scots, tried to invade Roman Britain. Constantius Chlorus would not put up with such effrontery and sailed for Britain with an army and his warrior son Constantine, determined to put the Picts down. He managed to do so; but then Constantius himself died, of unknown causes, at York in the summer of 306. This left his heir, the ambitious young Constantine, as imperial ruler of Britain, Gaul, and Spain, with the full rank and title of Augustus; but Galerius, the reigning Augustus of the East, did not want the boy to succeed him immediately. Constantine wrote to him asking to be ratified as the Augustus. Galerius would only give him the second rank, that of Caesar. Constantine accepted this, no doubt reluctantly, though with as much grace as he could muster.

But in Rome, neither the army nor the majority of the people would go along with that arrangement. For reasons too involved to go into here, stemming from their resentment at the prospect of forced tax lev-

ies, they wanted Maxentius, the son of Maximianus, as Caesar. And once Maxentius was installed, he asked his father to come back from retirement and become, once again, the Augustus. Galerius, who wanted the next Augustus to be a military strongman (but not as strong as himself) named Severus, objected to this proposal, and ordered his army to attack Maxentius. They lost; Severus' troops mutinied and killed their leader; and this left Maxentius and his legions in command of Rome. In retrospect, though of course it would hardly have seemed so at the time, the most important thing about Maxentius' power over Rome and its empire was, like that of Diocletian before him, his implacable dislike of the small and still rather marginal sect of the Christians.

Constantine launched himself across the Alps from Gaul, at the head of an expeditionary force numbering some forty thousand troops, perhaps a quarter of his whole army, in the spring of 312. His target was a heavily fortified Rome, where Maxentius had dug in. The cities of northern Italy offered little resistance. Some of them, notably Milan, effusively welcomed Constantine, because Maxentius' occupation of Rome had deprived them of much of their importance and power. As Constantine advanced southward, it became ever clearer that Maxentius was preparing for a siege. But when Constantine's force had come almost within striking distance of Rome, the Romans themselves lost confidence in their ability to resist a long siege; rumor and oracles persuaded them that Constantine was invincible, and so Maxentius realized that he would have to come out and fight, on the north side of the Tiber. The bridges across the river to Rome had all been destroyed, but Maxentius had a new, temporary one created from boats and pontoons where the more solid Milvian Bridge had stood. Across this structure, anchored against the flow of the Tiber, Maxentius and his army marched forth to confront Constantine on October 28, 312.

The result was a disaster, a rout.

In years to come, Constantine gave his version of the Battle of the Milvian Bridge and swore, under oath, that God had granted him a miraculous victory preceded by signs and omens. As he was leading his army south toward Rome, he claimed, he and every man under his command had seen a cross of light shining in the sky, with the words *"In hoc signo vinces,"* "In this sign, conquer." That night, when Constantine was asleep in his tent, Christ appeared to him in a dream, holding that unfamiliar emblem of the cross, and directed him to have new standards made for his army in its form.

What could this really have meant to him? In the early fourth century, most people, Constantine included, had no idea of the symbolism of a cross. He was not a Christian, not yet, but there were some Christians among his advisers, such as Ossius, bishop of Córdoba, and they all concurred in pointing out that the cross was the emblem of the greatest of all gods, and that if Constantine adopted it he could not be defeated. Well, Constantine seems to have thought, try anything once. The pagan standards were flung away, on went the crosses, and soon Maxentius' troops were on the run, in chaos and confusion. The boat bridge disintegrated, and Maxentius himself is said to have drowned under the weight of his armor while trying to get back across the Tiber.

Just before battle was joined, Constantine declared for Christianity. After the Milvian victory in 312, state persecution of Christians in the Roman Empire—torture, murder, confiscation of goods and property—effectively ceased. It was removed from state policy. There would be no more libelous assertions about the new sect, such as had infested the policies of Diocletian, who regarded the cult as treasonous and diabolical and was not above torturing any suspected Christians on unfounded charges of arson, burning them alive, demolishing their chapels.

Constantine ordered that property and wealth confiscated from Christians under Diocletian's mandate should be given back. But it is far too easy, in Constantine's case, to ascribe to pure religious faith what was more like a continuous exercise in realism, carried out by a hardheaded soldier with a polytheistic background. Certainly, he must have ascribed his victory over Maxentius, at least in part, to the intervention of some powerful god. It is always wise, as well as easy, for a winner to declare that God was on his side. But pagan symbols continued to appear on his coinage for twenty years after the Battle of the Milvian Bridge. Constantine was not even baptized a Christian until he was dying, a quarter-century later, in 337. To say that he unambiguously "converted" to a new faith, a new spiritual discipline, is to invoke a myth—however useful this myth became to Christian propaganda, as it assuredly did. What did it mean, to say that Constantine was the first Christian emperor? Not, perhaps, as much as later Christians made out. At this distance, and across such vast cultural differences as those between his time and ours, it is hardly possible to know. Nevertheless, it is clear that there was a marked change in the religious landscape. The recognition of a new tolerance was inscribed in the so-called Edict of Milan, 313, which emerged from a wish of the

now dying Galerius that Christians might be allowed to "again rebuild the houses in which they used to meet." (Christian religious ceremonies were generally not held in churches, but in *tituli* or houses of the faithful—"meeting houses" exactly describes them. Since there were relatively few churches yet dedicated as such, those shrines and meeting places were commonly part of *tituli*; so this law was also an affirmation of personal privacy of worship. *Tituli* were commonly named after the owners of the private property, as in Titulus Ceciliae or Titulus Anastasiae, or the Titulus Byzantii, named after the Roman Senator Byzantius, who gave his house to the Christians as a place of worship. By the end of the fourth century, about twenty-five of these were known in Rome. There may have been more, but they represented in any case a tiny presence of Christians among the forty-four thousand *insulae* or apartment blocks and more than a million inhabitants Rome had in Constantine's time.)

So, after his victory at the Milvian Bridge, Constantine and his co-emperor Licinius met at Milan and issued a declaration that Christians from now on must have complete religious freedom, that they should no longer suffer confiscations, and, as Galerius wished, that their houses of worship, if taken from them, must be restored. This had large cultural as well as religious consequences, because it opened a space in which specifically Christian iconography and symbolic detail could flourish and develop, moving away from, though in many ways building on, Roman prototypes. A vivid example of this process is the sarcophagus of Junius Bassus (d. 359), one of the first Roman patricians to embrace Christianity. In form, it is a pagan sarcophagus. But on its sides, carved in deep relief, are scenes of such biblical events as the sacrifice of Isaac, the trial of Christ before Pilate, and Adam and Eve's shame at their nakedness, replacing such familiar sarcophagus images as gods, goddesses, and battle scenes.

At the very least, Constantine knew he owed Christianity a great deal, since the new god on the cross had clearly overseen his utter defeat of Maxentius and placed him on the imperial throne. He also knew that debts have to be paid, especially when owed to such powerful gods; henceforth, the Christian Church would receive massive underwriting from the Roman state.

First, Constantine wrote to Maximinus Daia, the ruler of the Eastern Empire, pointing out that since Maxentius was dead, and the Roman Senate had now recognized him as the senior member of the imperial college, he had the absolute authority to order Maximinus, his junior, to cease from any and all persecution of Christians within the East, whether

by tax, violence, confiscation, or (God forbid!) martyrdom. Whatever had been taken from them must be given back. They must not be molested in or out of their places of worship.

Constantine had all officials appointed by Maxentius purged, and replaced by Christian-friendly ones. And in a decision whose consequences would echo down the centuries—granting any cultist quack and televangelist in modern America, for instance, openings to huge immunities and profits—he exempted the churches from tax.

Shrewdly, he imposed no penalties on those among his subjects (and there were many, at first) who wanted to continue worshipping the older gods. One does not change the religious practices and loyalties of a whole empire merely by issuing an edict. Instead, he gave Christianity the status of the most favored religion, then let social pressures take their course.

One spectacular sign of the new order was the opening to the young church of Constantine's imperial coffers. This happened most evidently in Rome, where its results could be seen by the largest number of people. What did most-favored status mean unless the emperor disbursed as much on the temples of the new religion as his predecessors had on the old? With Christians among Constantine's advisers as early as 313, the Church was turning into a major political force already, and by acquiring new landholdings, it became an important economic one as well. Constantine turned much of the revenues from Roman colonies in North Africa, Greece, Syria, and Egypt toward underwriting and embellishing the new Christian foundations, perhaps four thousand gold solidi a year, the approximate equivalent in today's currency of twenty-five to thirty million dollars.

With such funds it was possible to build actual churches, not merely to convert private houses to places of worship.

On the east side of the Caelian Hill, by the Aurelian Wall, was a site formerly belonging to an *eques* or knight named Plautius Lateranus; Constantine had acquired it and was determined to build a magnificent church on it, one which would hold two thousand worshippers, as an *ex-voto* to thank Christ for his victory over Maxentius. (Plautius Lateranus had been unwise enough to befriend Constantine's defeated rival Maxentius, and it must have gratified the emperor to demolish the barracks of his horse guards, who had apparently supported him against Constantine.) It was on the edge of the city, though just inside its walls, and this position meant that Constantine did not have to embark on demolitions that would offend the still-pagan elite, whose shrines to traditional gods were crowded in the center of Rome.

This elite continued to matter a great deal in the fourth and on into the fifth century. Christian writers were given to boast that they and their coreligionists were taking over, but nothing is so simple. In the fourth century, Christian buildings were certainly being constructed, but it took centuries for the Pantheon to be rededicated as a Christian church by Pope Boniface IV, in 609, and more than two hundred years went by before the next Roman temple, that of Fortuna Virilis, was Christianized. Why? It is not certain, but pious Christians may have imagined that these buildings were contaminated by a residue of evil spirits. Certainly that was what people believed about the Colosseum. Meanwhile, pagan monuments were being repaired or even newly built—fora, streets, aqueducts, shrines, and even temples. Indeed, to its most sophisticated residents the culture paganism stood for—learned, aesthetically rich, and well embedded—was the only one worth having.

The siting of the Basilica Constantiniana, or San Giovanni in Laterano (as it came to be known, in recognition of the site's original owner), was of both symbolic and political importance, not only because it was the first great Christian church in Rome but also because it declared that the Christians had no ambition to obliterate the more ancient Roman order: coexistence was the watchword between Constantine and the old aristocratic families. San Giovanni in Laterano was and remains the cathedral of Rome (not, be it noted, Saint Peter's, despite what so many tourists think). It is the mother church of all Christendom, and its role is stated in the inscriptions cut not once but twice on its façade: *"Omnium urbis et orbis ecclesiarum mater et caput,"* "The mother and head of all churches of the city and of the world."

It set the archetypal form for Christian churches in the West by adapting, with minimal alterations, a Roman architectural form: the "basilican" plan, so called after the Greek term meaning "royal house": a long rectangular nave, a public space with entrance and apse on the opposite short sides. Side aisles, framed out from the body of the nave, provided space for ambulatories and chapels. This had been adapted from pagan Roman models (the first basilica in Rome had been built by Marcus Porcius Cato back in republican times, in 184 B.C.E.). It served the same type of ceremonies: lines of acolytes, stately processions toward a designated focus, such as are involved in the sacraments of Holy Communion and Confession. The basilican plan lends itself to a clear and strict separation of the celebrant (the priest) from his communicants, as the centralized plan of the Greek rite does not. But the basilican Christian plan was open to a wide

variety of form: it could have several naves (some had as many as nine of these aisles, separated by rows of columns). Rectangular, axial basilicas of this kind were less costly to build than the centrally planned ones, roofed with masonry domes, favored in the East, because they did not require the elaborate curved shuttering needed to construct arches and domes.

It was, by the standards of its time (or any time), an enormous building, with a four-aisled nave ninety-eight meters long and some fifty-six wide. Its main columns were of red granite, and its secondary-aisle columns were recycled from ancient buildings and were of green marble. Apart from the enormous cost of construction, Constantine donated enough sheet gold—all looted long since—to decorate the apse.

This was not Constantine's only ecclesiastical venture in Rome, of course. He endowed what became a private chapel for the devotions of his mother, Helena (250–330), Santa Croce in Gerusalemme, within the Sessorian Palace. In about 326, the future Saint Helena made a pilgrimage to the Holy Land, from which she brought back shiploads of relics, including some tubs of soil from Calvary, and (a considerable engineering feat, if true) the stairs which Christ was believed to have climbed in the palace of Pontius Pilate in Jerusalem.

Some early Christian churches in Rome are almost bewildering palimpsests. A case in point is the Basilica of San Clemente, less than half a mile from the Colosseum. Its existence began in the first century C.E., when it was raised on the foundations of a building—perhaps a warehouse, perhaps an apartment complex—burned out in the Great Fire of 64 C.E. and owned by a consul named Titus Flavius Clemens, a great-nephew of the Emperor Vespasian. According to the Roman chroniclers Dio Cassius and Suetonius, Clemens was executed in 95 C.E. on charges of impiety connected with "godlessness" and Judaism, brought by the Emperor Domitian. Whether this indicated some connection with Christianity is a matter of debate; the pious like to believe it was. What is fairly certain, however, is that by the late second or early third century the dark, dank, cavelike space within the former *insula* had become a Mithraic temple, which was abandoned when, in the fourth century, Mithraism—imported to Rome largely by legions returning from Asia Minor after the campaigns of Pompey*—was outlawed by the now victorious Christians.

* Mithraism was practiced by the pirates whom Pompey suppressed in 67. It took hold in ancient Rome in the first century B.C.E. Its spread was so rapid that the Emperor Commodus was initiated into the cult at the end of the second century C.E., and it was an important factor in the religious initiation of Julian the Apostate, in the fourth century.

Frustratingly little, and from documentary sources almost nothing, is known about this religion. It was a mystery cult that had managed to keep most of its secrets. Mithras, or Mithra, was a god hero who embodied light and truth. His acolytes knew him as, among other honorifics, "lord of the wide pastures," and his central, mythic action was the capture and killing of a wild bull, which he dragged to a cave and then slaughtered. From its blood sprang life and grain. The sacrificing god was known as Mithras Tauroctonos, Mithras the Bull Slayer. The killing of the bull was therefore a highly generative act, and it may be that its memory is preserved, in a much-mutated form, down to the present day in the Spanish cult of the bullfight. This story may descend from the Greek myth of Perseus killing the Gorgon Medusa, and may have originated with King Mithridates VI of Pontus, who was named for Mithras but claimed descent from Perseus.

Mithraism never claimed a mass collective audience such as Christianity acquired. It had no need of huge basilicas—its cavelike gathering places were usually no more than sixty by twenty-five feet. Moreover, the congregation it did have was deliberately restricted. Mithraism was a masculine warrior-cult from which women were strictly excluded. Mithraea (the term for its meeting places) have been found in Rome, about a dozen in all, the largest being the Mithraeum Thermarum Antonianarum, underneath the Baths of Caracalla. The remains of others exist in Ostia, a reminder of how common Mithraic worship was in ports, among sailors and travelers.

There were similarities between the cults of Mithras and of Jesus, but they generally turn out to be superficial, and there is little support for the once-common view that Christianity developed out of Mithraism. Certainly Mithraism was more like Christianity than any of the other Eastern mystery cults that found adepts in Rome. But the two were also very dissimilar. Christianity wanted to spread; one of its main strengths was among women, and the idea of excluding half the human race from the faith would have been incomprehensible to the early Church, whatever its suspicions of the female sex.

Above the lowest, Mithraic floor of the *titulus* of Clemens (or Clemente, as his name is given in Italian) is another level, dating from the late fourth century and clearly associated with Christian worship. Over the centuries, it was adorned with a series of frescoes and mosaics, of which the most beautiful is a depiction of the Tree of Life in its apse—Christ crucified, with white doves roosting on the arms of his cross, and writh-

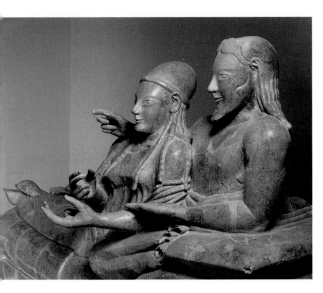

...rcophagus of the Spouses, 6th century B.C.E.
...rra-cotta, 114 x 19 cm.
...tional Etruscan Museum, Rome.

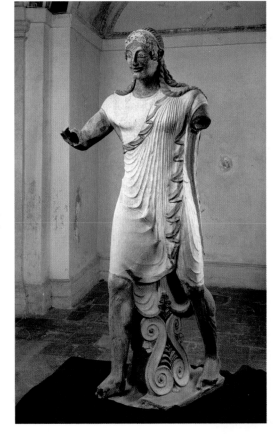

Apollo of Veii, c. 550–20 B.C.E.
Terra-cotta, 174 cm.
Museo Nazionale di Villa Giulia, Rome.

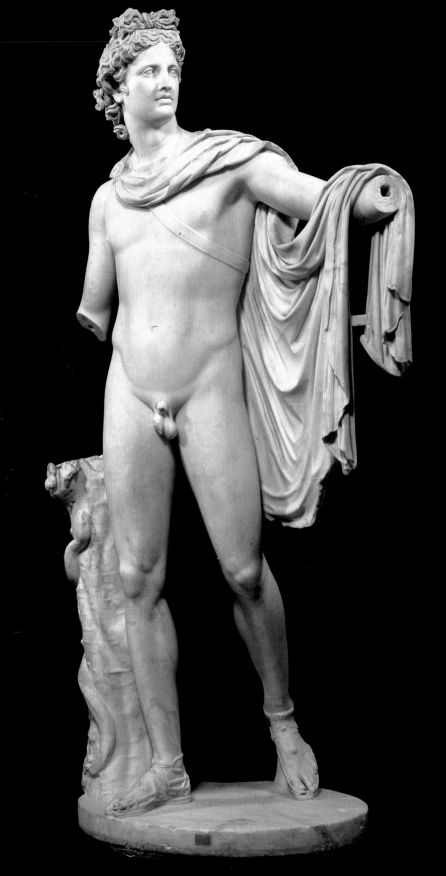

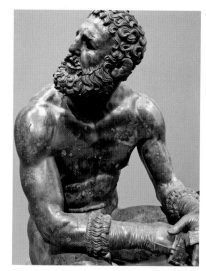

APOLLONIUS
Boxer, 225 B.C.E.
Bronze, 128 cm.
Museo Nazionale, Rome.

Pasquin, 3rd century B.C.E.
Marble, 192 cm.
Piazza di Pasquino, Rome.

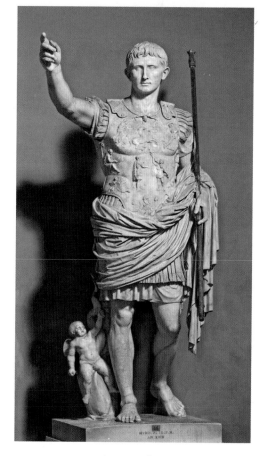

LEOCHARES
Apollo Belvedere, c. 350–25 B.C.E.
White marble, 224 cm.
Vatican Museums, Vatican City.

Augustus of Prima Porta, c. 15 C.E.
White marble, 205 cm.
Vatican Museums, Vatican City.

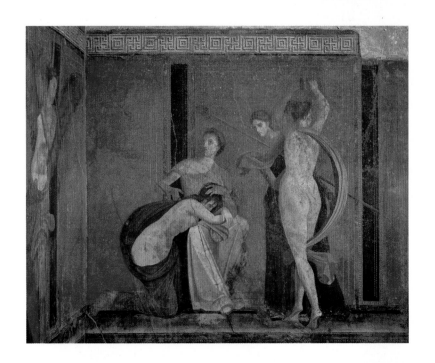

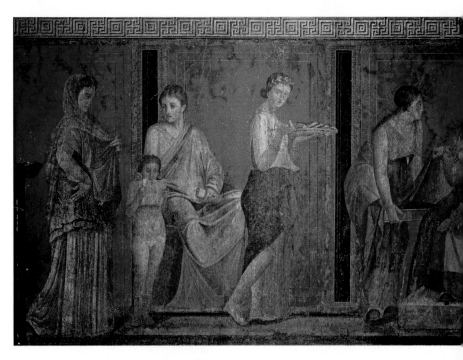

Villa dei Misteri friezes, 1st centur
Fresco.
Pompeii, Italy.

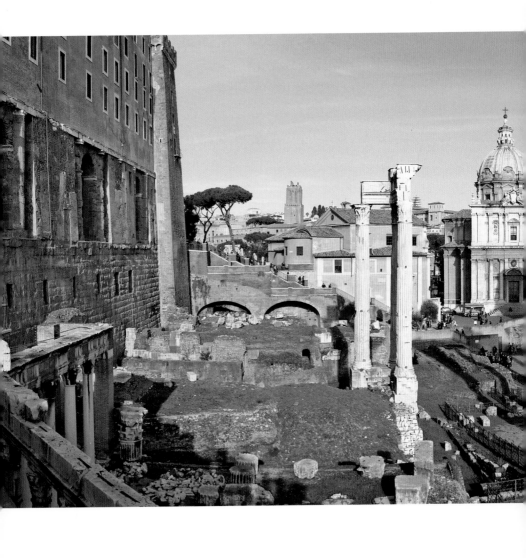

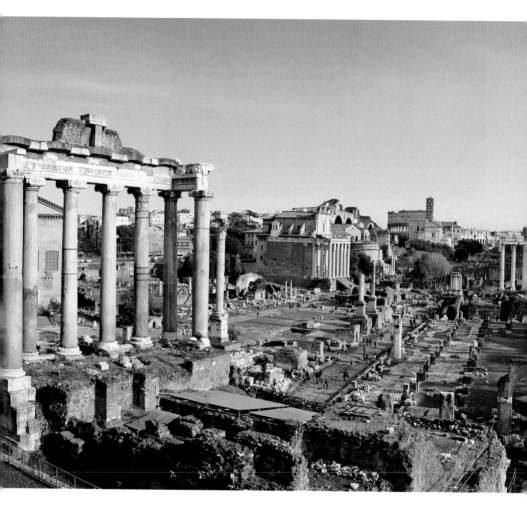

Roman Forum, the judicial and political
center of imperial Rome, 1st century.

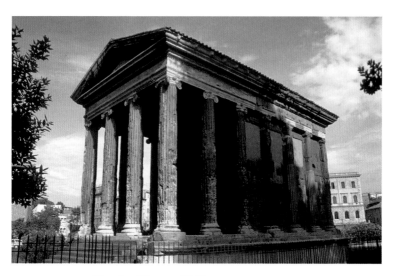

Temple of Fortuna Virilis, 75 B.C.E.
Rome.

Pyramid of Cestius, 12 B.C.E.
Rome.

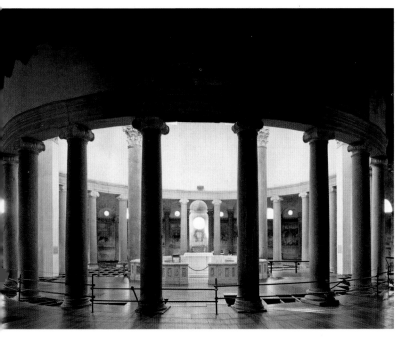

Baths of Caracalla, 212–16 C.E.
Rome.

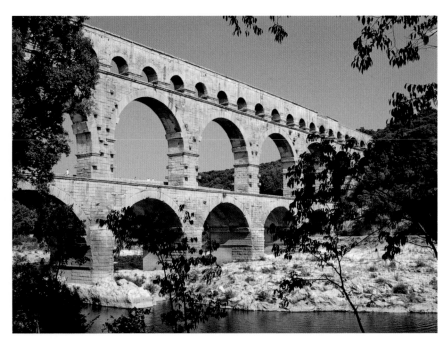

Pont du Gard, 1st century.
Gard River, southern France.

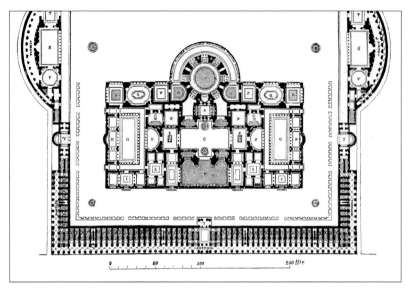

Plan of Santo
Stefano Rotondo,
c. 468–83 C.E.
Rome.

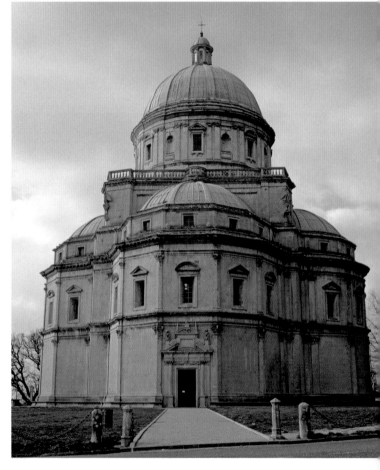

Cola da Caprarola,
Santa Maria della
Consolazione, 1508.
Todi, Italy.

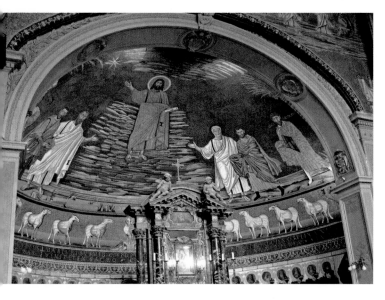

Apse of Santi Cosma e
Damiano, 526–30 C.E.
Mosaic.
Rome.

n Clemente Basilica, 12th century.
osaic.
me.

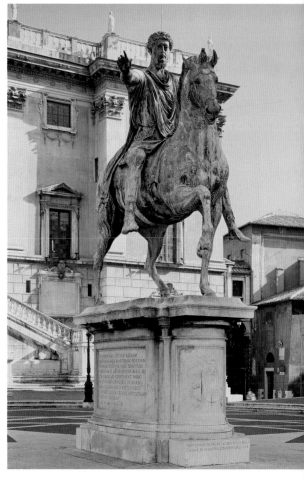

Equestrian statue of
Marcus Aurelius, 176 C.E.
Bronze, 350 cm.
The Campidoglio, Rome.

RAPHAEL
The School of Athens, 1509–10.
Fresco, 500 x 770 cm.
Apostolic Palace, Vatican City.

RAPHAEL
Portrait of a Young Woman
(also known as *La fornarina*), 1518–20.
Oil on wood, 85 x 60 cm.
Galleria Nazionale d'Arte Antica, Rome.

RAPHAEL
The Triumph of Galatea, 1513.
Fresco, 295 x 224 cm.
Villa Farnesina, Rome.

RAPHAEL
The Liberation of Saint Peter from Prison, 16th century.
Fresco.
Stanze di Raffaello, Vatican Palace, Vatican

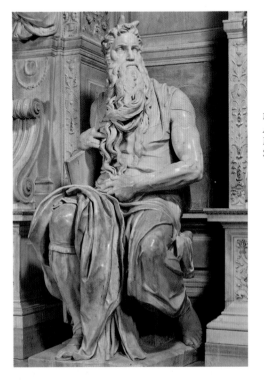

MICHELANGELO
Moses, c. 1513–15.
Marble, 235 cm.
San Pietro in Vincoli, Rome.

MICHELANGEL
Sistine Chapel, 1537-4
Fresc
Vatican Ci

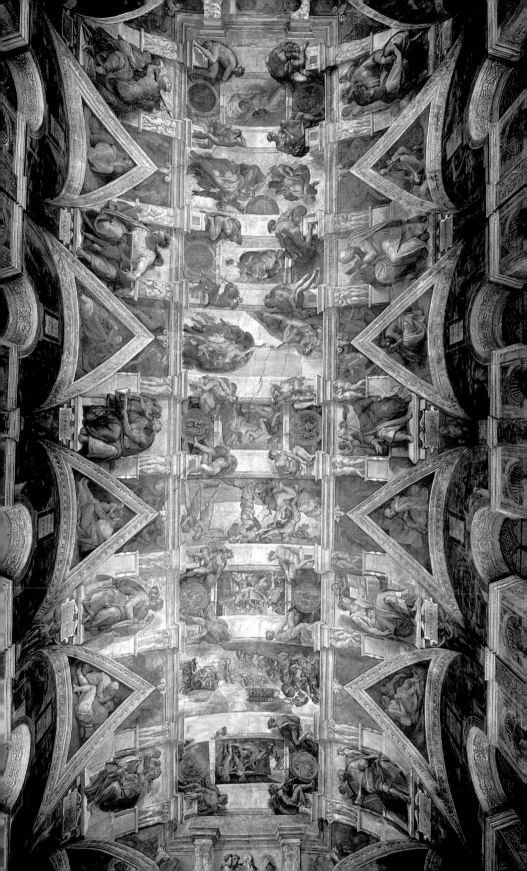

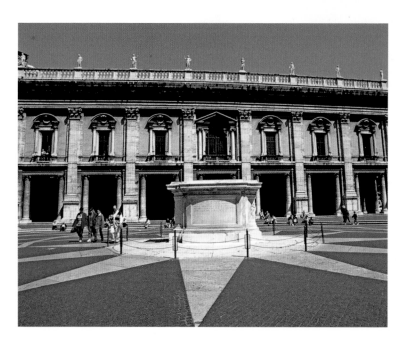

MICHELANGELO
Piazza del Campidoglio, 1536–46.
Rome.

MICHELANGELO
The Last Judgment, 1537–41.
Fresco.
Sistine Chapel, Vatican City.

ing spirals issuing from the base of the tree to fill the gold semicircle of the background. Of all the early Christian monuments of Rome, this twelfth-century mosaic is one of the most decorative and satisfying.

Various legends cling to the church. One is that after Saint Clement, third successor to Saint Peter as bishop of Rome, was flung into the Black Sea in 98 C.E. by the impious Romans with an anchor tied to his neck, his body was recovered by two Slavic saints, Cyril (826–69) and Methodius (815–85), brought to Rome, and buried in the church that bears his name. Another is recorded in a fresco in the nave. It tells how a Roman husband, peeved at his wife's constant attendance at Mass, referred to the clergy of San Clemente's as *fili dele pute,* "sons of whores." Not only is this a surprising inscription to be found anywhere in a church; it is said to be the earliest known writing in vernacular Italian.

Constantine had (why, it is uncertain) a particular devotion to an early Christian martyr named Saint Lawrence (San Lorenzo). This was the deacon who, in the third century, was supposedly roasted to death on a gridiron. (The pious story that he defied his pagan tormentors by exclaiming, after a few minutes had brought him to medium-rare, "Turn me over, I am done on this side," is no doubt apocryphal.) Constantine had Lawrence's grave identified (at least at a guess), and then covered with a handsome silver grating, glorifying the original grill. Then he raised a *basilica major,* complete with inlaid Cosmatesque decoration, to mark the spot.

In a move to expiate the fierce injustices of pagan persecution, he underwrote various martyrs' shrines, of which the most important in terms of its cult power was the Church of the Apostle Peter in the Vatican. There had been a long-standing cult concerning the remains of Saint Peter, martyred in Rome during the persecutions of Nero. There is no proof that the bones in whose honor Constantine had this basilica constructed actually belonged to that apostle, to whom Jesus allegedly entrusted his newborn church. (*"Tu es Petrus, et super hanc petram aedificabo ecclesiam meam."*) The fact that successive rebuildings of Saint Peter's, culminating in the stupendous pile marveled at by today's faithful, are believed to stand above the saint's actual bones proves nothing; the issue, as one Christian historian tactfully put it, is "clouded by confessional loyalties."

Another main recipient of Constantine's civic largesse was Palestine—in particular, the city of Jerusalem. His mother, Helena, like many another woman of humble origins who comes into great wealth and power, was

unrestrained in her largesse; she founded and had built the Church of the Nativity in Bethlehem, dedicated to Mary, mother of Christ, and another church, on the Mount of Olives, to mark the point of her son's ascent into Heaven. But the grandest construction was Constantine's own, designed to mark the special relationship between the emperor and God. On what was believed to be the site of the crucifixion, overlapping onto Christ's tomb, the emperor ordained the construction of a magnificent basilica. This entailed the destruction of a Roman shrine to Venus, and in the course of the work the excavators found a chamber containing not a body (one would certainly not have wanted to find a body, given the dogma of the Resurrection—"He is not here, for he is risen," said the angel) but a quantity of wood, which (of course) could only be the wood of the True Cross on which the Son of Man had expired. Splinters of this timber would fill the Christian world's reliquaries in centuries to come. Those inclined to believe in such things also identified a small stone room, hardly more than a hole, abutting what was rebuilt as an ambulatory, as being the prison in which Christ had been mewed up before his crucifixion.

These links between the New Testament account of Christ's passion and death and the discoverable fabric of the excavated building were tenuous, but they did not deter Constantine's representatives from saying with certainty that the site of the Holy Sepulchre had been found. The work of expanding and ennobling it began almost at once, on Constantine's orders. All who saw it agreed with Eusebius, the bishop of Caesarea (c. 260–340), Constantine's chief admirer and interpreter, in finding the Church of the Holy Sepulchre a building beyond compare, encased in marble and with a coffered ceiling gilded from end to end. Moreover, it contained, in a small side chapel, what was believed to be the actual place where Jesus himself had expired on the cross—the Rock of Calvary. In its original form, the Church of the Holy Sepulchre, when it was formally dedicated in 336 on the thirtieth anniversary of Constantine's coronation as Roman emperor, was the supreme architectural marvel of Christendom, the gold-sheathed and jewel-studded house that testified to the triumph of God.

Unfortunately, little of it remains. In 614, after the Persian conquest of Jerusalem, the Holy Sepulchre was sacked. Some restorations took place over the next few hundred years, but then, catastrophically, the Caliph al-Hakim, a religious fanatic who believed that no Christian institution should be allowed to stand on ground associated in any way with Islam,

ordered the complete demolition of the Sepulchre. But by then there were many other Christian churches in what had been the pagan East, built and supported by funds from the confiscation of temple treasures, and untouchable by any caliph.

Constantine did not, of course, confine himself to church building. He was an indefatigable legislator who also rewrote many of the laws relating to behavior and punishment. Noting that eminent Christians of the past, like Saint Paul, had complained of the obligation to sue one another in pagan law courts over civil matters, he made it legal for them to take their cases out of the hands of civil judges and into the arbitration of bishops, whose verdicts would be final. This greatly increased the Church's power over civil life, as Paul had hoped it would. In the criminal domain, he abolished crucifixion as a punishment, holding that our Lord's manner of death should no longer be the atrocious and degrading thing that pagan Rome held it to be; it was wrong to subject common criminals to what Christianity considered a fearful but now hallowed form of sacrifice.

This was not due to squeamishness. When it came to inflicting pain, Constantine could be as brutal as any other emperor. On the complicated matter of sexual behavior, Constantine's views were so extreme as to qualify as psychotic, and must certainly have seemed so to anyone accustomed to the more relaxed attitudes of pagan family law.

In an edict of April 1, 326, he totally forbade married men to keep mistresses. Only men (husbands, fathers, brothers, or uncles) could bring denunciations of adultery within a family—women never. Rapists and seducers must be burned alive, a punishment which could also be inflicted on any girl who eloped without parental approval, and on anyone who aided the elopement. If a nurse encouraged a girl to take off in this way, her mouth would be forced open so that boiling lead could be poured down her throat. But a girl who lost her virginity to a rapist also deserved punishment; clearly, she had been asking for it—she could have stayed home. Worse, Constantine ordained that, once raped, she must lose the right to inherit property from her parents. This condemned her to the marginal life of a reject, since it deprived her of the dowry without which no man would marry her.

It might seem difficult to reconcile the author of such repugnant statutes with the man often praised for bringing the message of gentle Jesus to a pagan world. But within the soul of Constantine, an innate sadism was looking for an outlet, and found it in the misogynistic lunacies of

Christian asceticism. This can be seen from the wretched fate of Crispus, Constantine's eldest son, by an early marriage. A young married man who enjoyed a brilliant reputation as a military prodigy, and had already served as Caesar to his father's Augustus, Crispus certainly would have succeeded to the imperial throne. But, for reasons which are still obscure, Constantine's newer wife, the Empress Fausta, accused him of violating her. It was her word against his: there was no proof. In an ungovernable rage, Constantine put Crispus on trial, with himself as sole judge, declared him guilty, and had him executed. But then Constantine's aged mother, Helena, who did not believe the story about Crispus and Fausta, seems to have received some persuasive evidence that Fausta had concocted it to cover her adultery with a palace slave. When this was revealed to Constantine, he had Fausta shut in the hot room of the imperial-palace baths, whose furnaces were then stoked so that she boiled to death. Crispus was put to death in Pola. This caused some political embarrassment, and it is probably why Helena went on an ostentatious pilgrimage to the Holy Land in 326, the year Crispus was executed. It cannot have been an easy trip, since she was almost eighty when she set out. But the dowager empress played her role with impressive determination, with her son encouraging her to spend whatever was needed to help people forget the Crispus-Fausta scandal and the delicious gossip it had ignited. It was during this trip that she endowed two churches in Palestine, the one in Bethlehem to commemorate Mary and the nativity of Jesus, and the other dedicated to his ascension into Heaven from the Mount of Olives. She gave generously to whoever approached her on her progress through the Holy Land—soldiers, priests, the poor—and released prisoners from jail and the mines. She acquired enormous and bulky relics, such as the aforementioned stairs up which Jesus was supposed to have climbed in the house of Pilate, and shipped them to Rome. Then, worn out by her travels and benefactions, she died, probably in Nicomedia. Her body was placed in a massive porphyry sarcophagus and carried, under military guard, back to Rome.

As the religious as well as the political leader of the Roman Empire, Constantine inevitably had to deal with matters of heresy. Heresy had not been a problem for the older Roman religions, which left their devotees much freer in their selection of cults and rites than Christians would, or could, ever be. But Christianity was an intolerant religion which placed extreme emphasis on orthodoxy of belief. More and more, bristling phalanxes of bishops and theologians stood ready to do battle over

the smallest inflection, the least quillet of doctrinal meaning. The result was a nightmare of religio-political correctness, in which the stakes were not simply the tolerance or disapproval of others but (it was believed) the soul's prospect of eternity in Hell. This gave a terrible seriousness to theological argument. Ridiculous as many such debates may seem from a twenty-first-century viewpoint (there can be few believers left who care how many angels can dance on the head of a pin), in the fourth century they gave rise to the first Christian persecutions, in which one wing of the faithful tormented and killed members of another over what now look like absurdly minuscule differences of belief.

The first such split was over "Donatism." This heresy had caused a schism in the Church in Africa, which had only slight repercussions in Europe. It arose, quite simply, from the fact that during the persecutions by Diocletian some Christians had knuckled under, denying their faith to save their skins. Now that Diocletian was gone and Christianity had become the state religion, these quislings sought to rejoin the Church and be forgiven. But a strong group opposed this, tooth and nail. To them, there must be no future forgiveness for former collaborators. Their leader was a Carthaginian priest named Donatus. This, one might have thought, could have been resolved at the lower levels of the Church, but it proved insoluble. The emperor himself had to rule on it—and he did, ordering the army to force the Donatists into submission. Thus began the first orthodox, official Christian persecution and martyrdom of "heretic" Christians.

There would be others. The most spectacular, bitter, and bloody of them was the fourth-century Arian persecution, which split the Church down the middle and caused seemingly illimitable suffering to many as Christians rejected, tormented, and frequently slaughtered one another over a single vowel, an extra "o," descriptive of Christ's relationship to God the Father and the Holy Spirit. Was Christ *homoousios* with God the Father (made of the same essence as God, and existing from the beginning of time), or merely *homousios* (similar in essence but not the same, and created after the Father, there having been "a time when he was not")? This seemingly absurd dispute originated in Alexandria, with a highly intellectual priest named Arius (d. 336), who fiercely objected to any prevalent reading of the Scriptures that claimed that Christ was the Son of God, "begotten, not made," sharing the Father's divine essence, and existing for all time. Orthodox Christianity disagreed. It regarded the dogma of the Trinity—God consisting of three persons, the Father,

Son, and Holy Ghost, who form one substance—as a basic and central tenet of faith, which it was heresy to deny. It was this "one substance" clause, as it were, that generated the passion over whether Christ was *homoousios* or *homousios* with his Father. The dogma of the Trinity was a "mystery," not comprehensible through human logic; there were later attempts to rationalize it, though, as when a Victorian cleric argued that one need only imagine a carriage with three persons riding in it—to which another Victorian cleric retorted that one should try instead to envision three carriages with one single person riding in them.

The dispute was settled, after a fashion, when Constantine himself felt obliged to intervene. In 325, he summoned a council of bishops in the city of Nicaea to pronounce on the ideas of Arius. Their verdict, not unexpectedly, was that Arianism was a heresy to be stamped out. This was enshrined in the Nicene Creed, a document repudiating Arius and agreed to, pro forma, by all the bishops of the Catholic Church. Jesus was now officially *homoousios* with his father.

Despite Constantine's gestures toward relative tolerance, by 325 paganism was a lost cause within the Roman Empire. Many of the supporters of Constantine's erstwhile co-emperor Licinius, still a pagan, were killed off after his death. (Constantine was said to have had Licinius himself strangled, though the circumstances remain murky.) Most of the survivors were dismissed. Pagan rituals, such as sacrifice to the gods, divination, or the consultation of oracles, were now banned absolutely. In effect—and luckily for the archaeology of the future—pagans could keep their shrines, temples, and sacred groves, not demolish them, but not worship in them. Constantine made sure that no more pagans, or even those who had recently abjured pagan beliefs, would be appointed as magistrates, prefects, or provincial governors. All preference would go to Christians. But active persecution of pagan religions was not required, since it might provoke violent counter-reactions. Constantine wanted peace, albeit peace only on terms of submission to Christianity.

Apart from Christianity itself, the great beneficiary of Constantine's power was the city of Constantinople, which he founded in 330, not quite a quarter-century after he was proclaimed emperor. To say that Constantinople was in any real sense the "new Rome," replacing the original by a single act of will, is of course a foolish simplification. But Constantine was determined to found a new and great Christian city where he and later Christian emperors could hold their court in an environment not contaminated by physical memories of paganism—no temples to the

gods, no relics of pre-Christian institutions. This ruled out rebuilding the site of Troy, which he seems to have briefly considered for its mythological attractions, but then rejected because he did not want his actions attributed to Homeric inspiration.

On Europe's most southeasterly peninsula, between the saltwater strait known as the Golden Horn and the inlet from the Sea of Marmara called the Bosporus, was a neck of land on which stood the remains of a Greek settlement and the beginnings of a minor Roman city, its origins in the seventh century B.C.E. This city was known as Byzantion. It had obvious strategic and trade advantages. It stood at the intersection of the land route from Europe to Asia and the sea route from the Mediterranean to the Black Sea. It was well placed for self-defense. Most of it was girdled by the waters of the Golden Horn to the north, and the Sea of Marmara to the south. It needed only a wall across its base, between the bodies of water, to make it very difficult to invade. The Via Egnatia linked it to Rome, and from it two other roads led east, toward Asia Minor. The land behind it was indulgent to crops and fruit, and rich in building stone. The sea around it fairly teemed with fish. Aqueducts gave it water, and as soon as serious building work began on the new city, they would be supplanted by many large cisterns, some forty of which survive (and are full of fresh water) to the present day—water palaces, one of which is known to the Turks as "the Cistern of a Thousand and One Columns," which must be close to a factual description.

Here, a new capital could be built—the capital of what would from now on be the Eastern Empire. It would owe a triple allegiance to geography. It lay at the eastern end of the Mediterranean, between the worlds of Rome and the East, right on the borders of Europe and Asia. Yet it fully shared the character of neither. The Asia Minor to which it partly belonged was neither geographically nor ethno-culturally a part of Asia, though it belonged in a sense to the Asian continent. By the same token, the eastern Balkans, on which Byzantion and its territories abutted, were in most senses remote and disconnected from what an Italian, a German, or a Greek would be inclined to call "Europe." Byzantion, no matter how or how far it was developed, was almost certain to be an anomaly to both Europeans and Asians. This suited Constantine very well. He threw the resources of his domain into this project, and the resulting metropolis was naturally named after him: Constantinople.

Less is known of the archaeology of Constantinople than of Rome. There are various reasons for this, but the chief one is that, since it was

conquered by the Muslims in the early Middle Ages, the Turkish authorities have been at best reluctant, and at worst opposed, to having their city dug up in search of Christian remains, at the possible expense of later, Islamic ones. This deadlock is unlikely to be freed in the imaginable future; it would be too unpopular with today's radical or even moderate Islam.

The building of Constantinople, spurred by Constantine's desire for a new capital, went on very fast. In some respects it repeated the layout of Rome, with a central Forum, a Senate House, an Imperial Palace, and a main street, the Mese. Its center was the Hippodrome, where some of the great dramas of the city—political as well as sporting—would be played out after Constantine's death. It did not, however, have a gladiatorial arena, and its churches took the place of temples. Constantine's churches were almost always designed on the basilican plan, which produced a huge, long interior space without internal supports, similar to the basilica he had built in Trier when he was still Caesar there. Their ultimate model was the Roman Church of San Giovanni in Laterano, his vast thanks offering for victory at the Milvian Bridge.

Constantine died in 337 C.E. It is likely, though not certain, that despite his colossal achievements he was afflicted by a sense of failure: having killed his eldest son and likely successor, the gifted Crispus, along with his wife, Fausta, he could hardly have felt wholly fulfilled. He had three other sons, all formally recognized as Augusti: Constantine II, twenty-one years old at his father's death, Constantius II (twenty); and Constans I (fourteen). Deadly quarrels immediately broke out among them. In 340 C.E., Constantine II—who had inherited control of the Western part of the Empire—attacked Constans I, ruler of Italy and Africa. The attack failed, and he was defeated and killed, which placed all the Western Empire (including Britain and Germany) in Constans' hands, while Constantius II controlled the Eastern part. But Constans' rule in the West was so harsh that his troops rebelled—an extraordinarily rare event in the Roman army—and in 350 C.E. he was deposed and killed. After much skirmishing, the officers who had led this revolt succumbed to internal bickering and were finally destroyed by Constantius II, who emerged in 353 as the ruler of a united Roman Empire.

After all this murdering and much more maneuvering, Constantius II found himself seeking a co-emperor: the task of running so vast an empire was more than one man could handle. He found a collaborator, as he thought, in Flavius Claudius Julianus (331–63)—Julian the Apos-

tate—nephew of Constantine. As it happened, Constantius had already arranged, in 337, for the murder of Julian's father and most of his close relatives, sparing Julian (and, for a while, his half-brother, Gallus) only because of their youth. This proved to be a grievous error. Julian had grown up with Gallus, in semi-internment under the thumb of Constantius in the remote provincial village of Macellum, in Cappadocia. Clearly, he was not happy about the massacre of his family (what anguish of survivor guilt did it raise in him?) and he never forgave Constantius for it.

Julian had been raised strictly as a Christian and had even taken lower orders as a *lector* in the church. His eventual "apostasy," his turning away from the Christianity espoused by his egomaniac bully of an uncle, Constantius II, seems to have been a classic example of what can go wrong when beliefs are shoved down the throat of an intelligent, sensitive youth temperamentally unfit to receive or practice them. Constantius II, from the historian Ammianus Marcellinus' account, took orthodoxy to new heights, and was rigidly obsessed with making his godlike stature felt:

> He both stooped when passing through lofty gates (although he was very short), and as if his neck were in a vise, he kept the gaze of his eyes straight ahead and turned his face neither to left nor to right. . . . Neither did he nod when the wheels jolted nor was he ever seen to spit, or to wipe or rub his face or nose, or move his hands about.

This narcissistic and crazed formalist was hardly the kind of person to raise a young intellectual. He demanded from the lad a hostility for all Hellenic culture; and Julian's predictable response was to embrace classical Greece, its art, its philosophy, and Platonic ideals, with enthusiasm. He took up studies in Athens in 355, in his early twenties. He also showed a real and unexpected talent for military command. Also in 355, Constantius II dispatched him to Gaul, to quell dissent among the Franks and Alemanni. Though completely untested in battle, Julian proved highly successful as a victorious general—this also while in his early twenties. So successful was he, in fact, that his troops were more loyal to him than to their remote commander, Constantius. When Constantius wanted to move Julian's legions to fight in a coming Persian campaign, they mutinied and proclaimed him Augustus. Civil war loomed; it was only averted because Constantius unexpectedly died, leaving Julian as emperor—he would be the last pagan emperor of Rome.

To the young Julian, Constantius II's mind-set seemed bigoted and barbaric—as indeed it was. Julian had a deeply religious temperament but not a Christian one. His natural bent was toward what was called "theurgy," the pantheistic mysticism favored by the Neoplatonist philosophers of his time. There were undoubtedly quacks and charlatans among the theurgists, but at least it can be said that they did not have the fanatical character common among the early Christians, and no one was persecuted by them. He believed in the idea of "metempsychosis," proposed by followers of Pythagoras: the direct transmigration of souls, from one body to another. (Julian apparently believed that his body was occupied and, as it were, animated by the spirit of Alexander the Great.)

Theurgy meant, in Greek, "divine work"; it was a kind of mystery religion, part Neoplatonist and part esoteric ritual based on (now lost) Greek texts known as the Chaldean Oracles. The theurgist hoped to learn how the universe worked and then apply its workings to his own advantage. Thus the soul would be purified. It clearly had a powerful appeal for Julian and other intellectuals who wished to preserve some of the character of the old worships. But since the rites of theurgy were understood to compel divine powers and not merely invoke them, it was not always easy to distinguish theurgy from magic. To a polytheist, the magic was white; it depended on a belief in hidden sympathies and affinities between different parts of the cosmos. To Christians, the magic was black, and had to be opposed because it was thought to summon demons. Julian's beliefs, to the extent that they could be revealed to anyone outside his circle of fellow theurgists, struck Christians as being little short of witchcraft.

Just as Constantine had restricted his powerful favors to Christian petitioners, so Julian reserved his for pagans. He would not persecute "Galileans," as he scornfully called the followers of Jesus, but he scarcely tolerated them; he withheld both his respect and his help from them. "When the inhabitants of Nisibis sent to beg his aid against the Persians who were about to invade the Roman territories, he refused to assist them because they were wholly Christianized. He would neither reopen their temples nor resort to the sacred places, and he threatened that he would not help them, nor receive their embassy, nor come to enter their city until he had heard that they had returned to paganism."

In his political views, Julian looked back to an earlier Rome. What he admired was Augustus' conception of the emperor as *primus inter pares,* "the first among equals," a citizen not ostentatiously raised above his fel-

lows, not a despot, and scorning the apparatus of imperial power. "The luxury of the palace excited the contempt and indignation of Julian," wrote Edward Gibbon, "who usually slept on the ground . . . and who placed his vanity, not in emulating, but in despising, the pomp of royalty." He deeply disliked such signs of servility as being addressed by inferiors as *dominus* or "lord." He dressed simply and let his beard grow, which exposed him to ill-tempered satire. After the death of his wife, he is said never to have looked at another woman.

He felt a duty to assert the rights of his adoptive tradition against the arrogant presumptions of the state-sponsored Christians. In fact, because of his commitment to *apostasis* or "standing up" against Christian doctrine, he was known in his time and ever since as Julian the Apostate. Having won the status of official religion to the Roman Empire, the once-marginal sect of Christians went on the attack—and this began even before Julian's ascendancy to Augustus. In the Theodosian Code of 357 C.E., the Emperor Constantius issued bans on soothsayers and astrologers, whose "evil teachings" must henceforth "become silent" and "forever cease." They must all be deported from the city of Rome. Christian punishment for haruspication, the "heinous" ancient Etruscan practice adopted by Rome, seemed to know no limits. But the punishment of those who worshipped traditional gods at their traditional shrines was deliberately and cleverly left to those new fanatics, the Christian masses themselves, who could be relied on to do more damage in their effusions of zeal than need ever be planned by Christian bishops. Posses of hymn-chanting monks, the "black-robed tribe" of whom the traditionalist Libanius, a justly renowned orator and writer (314–93), complained to the Emperor Theodosios, pious drunkards "who eat more than elephants," assailed the unprotected temples with stones and crowbars. "Then utter desolation follows, with the stripping of roofs, demolition of walls, the tearing down of statues and the overthrow of altars, and the priests must either keep quiet or die. After demolishing one, they scurry to another, and to a third. . . . Such outrages occur even in the cities. . . ."

But they were worst in the countryside, where, by ravaging the ill-protected temples, the Christians condemned countless sites to religious and therefore social and economic barrenness. "Temples, Sire," Libanius tried to point out to Theodosius,

> are the soul of the countryside; they mark the beginning of its settlement, and have been passed down through many generations to the

men of today. In them the farming communities rest their hopes
for husbands, wives, children, for their oxen and the soil they sow
and plant. An estate that has suffered so has lost the inspiration of
the peasantry together with their hopes, for they believe that their
labour will be in vain once they are robbed of the gods who direct
their labours to their due end. . . . One god supports the might of
Rome, another protects for her a city under her sway, another pro-
tects an estate and grants it prosperity. Let temples everywhere con-
tinue to exist, then, or else let these people agree that you emperors
are ill-disposed to Rome since you allow her to act in a manner that
will cause her harm.

Constantius II, in his last will, had recognized Julian as his lawful suc-
cessor, and now, with this authority confirmed, Julian set about restoring
the damaged prestige of polytheism.

His first tactic was to reduce the Christian churches' income, so lav-
ishly bestowed on them by Constantine. Large sums had been confis-
cated—or, in plain terms, looted—from the pagan temples and given to
the churches. Julian saw to it that they were given back, along with the
income-earning lands taken by the churches. This could not, of itself,
restore the loss and damage that the pagan religious foundations had
undergone since the conversion of Constantine. But it went some way
to rectify things—if only briefly. Sometimes one detects a heavy-handed,
chortling irony in Julian's abjurations. Thus he took obvious pleasure in
imposing heavy fines on the Christians of Edessa for "the insolence bred
by their wealth," by invoking Jesus' praise of the poor and lowly: "Since
by their most admirable law they are bidden to sell all they have and give
it to the poor so that they may attain more easily to the kingdom of the
skies . . . I have ordered that all their funds that belong to the church of
Edessa . . . be confiscated; this is in order that poverty may teach them to
behave properly and that they may not be deprived of the heavenly king-
dom for which they still hope." And to cancel the Christian laws against
pagan practices, which Julian did, was a great step in the liberal direction.
Julian had little time or respect for Christians, but he was too shrewd a
strategist to persecute them. Instead, he offered toleration to every faith
and cult—especially to "heretics" and to Jews. "I affirm by the gods," he
declared, "that I do not wish the Galileans to be either put to death or
unjustly beaten, or to suffer any other injury; but nevertheless I do assert
absolutely that the god-fearing must be preferred to them. For through

the folly of the Galileans almost everything has been overturned, whereas through the grace of the gods we are all preserved."

His one wholly anti-Christian enactment, which infuriated the "Galileans," was to forbid them to teach the classics in schools, for classical literature was still the basis of all higher education: let them stick to their own beliefs, Julian in effect said, and preach to their own kind about the glories of monotheism, but leave others to teach earlier Roman literature in the polytheistic spirit which originally lay behind it. "I think it is absurd that men who expound the works of [the classic writers] should dishonor the gods whom these men honored. . . . Since the gods have granted us liberty, it seems to me absurd that men should teach what they do not believe to be sound." No Christian, therefore, who presumed to teach grammar, rhetoric, or especially philosophy could be considered a good person, since he was preaching what he did not practice or believe in. He would be a hypocrite and so was bound to corrupt the young, even when he did not want to. If this policy could be carried out, Julian believed, the whole educated elite of the Roman Empire would, within a couple of generations, be pagan once again. Meanwhile, the pedants and monotheists must leave him and his like-minded people alone. "I worship the gods openly, and the whole mass of the troops who are returning with me worship the gods. . . . The gods command me to restore their worship in its utmost purity, and I obey them, yes, and with a good will."

As well as seeking restitution of confiscated pagan land and buildings, Julian worked hard to reassert the independent power of the *curiales,* or city councils (as against the influence of the bishops). This alone, quite apart from his religious beliefs, was bitterly resented by the Christians. He tolerated Christians not because he liked them or respected their beliefs, but because he recognized the truth of the saying that the blood of martyrs is the seed of the Church. He did not want to give the "Galileans" victim status, or do anything that might have aroused sympathy for them. Noting the doctrinal squabbling among Christian clergy and theologians, and the fierce rivalries it caused, he thought it wise to play a waiting game and let the "Galileans" weaken one another. Could this have worked? It is unlikely, but in any case we cannot know, because in 363 Julian was killed, during a campaign against the Persians. A spear thrust pierced his liver. This fatal wound may have been inflicted by a Persian or (possibly) a disloyal Christian in his own army. He was the last pagan emperor, and all his immediate successors did their best to eliminate whatever he might have achieved. Julian's hostility to Christianity

was deeply felt, but it was slight and measured compared with the fury with which Christian emperors after him would persecute intellectual pagans, staging ferocious witch-trials on various concocted pretexts, usually the possession of "wrong" or heretical books.

Julian was succeeded as emperor by the relatively moderate Christian Jovian (331–64). He had reigned for only a year when he died of carbon-monoxide poisoning, from a defective brazier. His ill-educated successor, Flavius Valentinianus (321–75), known as Valentinian, showed tolerance toward pagans but was fatally short-tempered; he lost his temper so completely during a peace negotiation in 375 that he suffered a stroke and died. The throne now passed to his pious and sadistic younger brother, Valens, who instituted a series of purges of real or suspected pagans—carried out with a "monstrous savagery," wrote the fourth-century chronicler Ammianus Marcellinus, that "spread everywhere like a fiercely blazing torch." The record of denunciation amassed by Valens' inquisitors was such that no literate or philosophic-minded person felt safe under his rule, so that "throughout the eastern provinces owners of books . . . burned their entire libraries, so great was the terror that had seized upon all." Merely to be accused of sorcery or un-Christian beliefs led to summary execution; men were maimed, hideously torn with hooks, and dragged off to the scaffold or the chopping block. And, as in Germany a millennium and a half later, "the scene was like a slaughtering of cattle: and

> innumerable writings and many heaps of volumes were brought together from various houses and under the eyes of the judges were burned—being pronounced unlawful, to allay the indignation at the executions, although the greater number were treatises on the liberal arts and on jurisprudence.

But history would soon have its revenge on Valens, and, as many would come to see it, on Rome itself. This revenge erupted from the Germanic people known as the Visigoths, who had settled early in the fourth century in a former Roman province known as Dacia—approximately, modern Romania. These people were invaded soon after by other Germanic tribes, who in their turn had been displaced by invaders from Central Asia known as the Huns. Driven by starvation and deprivation, the Visigoths in 376 petitioned the imperial government in Constantinople to be allowed to cross the Danube and seek refuge in Thrace. Instead of refusing them, the Eastern Emperor Valens made the error of allow-

ing the Visigoths free entry to his territory. His motive was simple and wrong: he thought he could co-opt the loyalty of the new immigrants, and get their warriors into his armies, which already contained numerous Visigoths. He also expected that his own soldiers could get their hands, by cunning fraud if not by violence, on the wealth the Visigoths would bring with them.

So, as soon as they were across the Danube, the Visigoths found themselves in conflict with Roman officials. They were battle-hardened, badly deprived people who realized that the Romans were ready to cheat them blind. So they fought back. In 377, their revolt spread to include other groups, especially slaves. Much to the amazement of imperial officialdom, the rebels forced a Roman retreat.

Valens could hardly believe this, but he resolved to crush the Visigothic rising. And so, on the eastern frontier, near the modern city of Edirne, Turkey, then known as Adrianople, battle was joined. By now the Roman army, once so unified, homogeneous, and dreaded, consisted largely of mercenaries who were not fighting for their homelands. It did not have the *esprit de corps* of former days, and presently an incredulous Roman citizenry would learn that the barbarians had overwhelmed it at Adrianople—the Visigothic victory was so complete that the corpse of Valens could not even be found beneath the heaps of the Roman dead, containing two-thirds of the Roman army and some thirty-five of its senior officers. Fritigern, the Visigothic leader, could not have dared to expect so total a triumph.

The catastrophe at Adrianople shook Roman self-confidence so badly that it has been regarded, ever since, as comparable to Rome's stupefying loss to Hannibal at Cannae, six centuries before.

This did nothing to ease the transition from paganism to Christianity. Most worshippers of the old gods saw no reason whatsoever to give up their faith, and many regarded the new Christians as a pack of arrogant, moralizing primitives. In response, the Christians, emboldened and presumptuously certain that they alone possessed the Truth, could and did behave with an equal high-handedness and violence toward "obstinate" pagans—it was their turn to do some persecuting. There were many cases of this, and some of the flare-ups were deadly. One was the destruction of the Serapeion in Alexandria at the end of the fourth century. This temple, dedicated to the Egyptian god Serapis, was one of the most famed and revered sites of pagan cult in the Mediterranean, and attracted numberless worshippers. It had remained intact and unmolested through

the reign of Constantine the Great. But in 391 it was seized, sacked, and desecrated by a mob of Christians, at the behest of Theophilos, bishop of Alexandria:

> The statues were removed, the *adyta* [secret places where objects used in worship were kept] were exposed; and, in order to cast disrepute on the pagan mysteries, [Theophilos] made a procession for the display of these objects, the *phalli,* and he made a public exhibition of whatever other objects . . . were, or seemed to be, ridiculous.

Offended by this grossly provocative insult, the pagans at the Serapeion attacked the Christians, killed a number of them, and seized the temple. Reprisals were violent and prolonged, culminating in the crucifixion of several Christians and a declaration by the Emperor Theodosius I that the dead Christians were blessed martyrs and candidates for sainthood. Realizing that the next step was likely to be a full-scale attack by imperial forces, the pagans of the Serapeion panicked and fled.

The Serapeion was the best-known but certainly not the only pagan foundation in which this sort of takeover occurred. Strangely enough, at first sight, such conversions were late in coming to Rome itself. The first Roman temple to be converted to Christian use was the Pantheon, which in 609 was finally rededicated as Sancta Maria ad Martyres by Pope Boniface IV. What did this suggest? Only that people tend to be slow in giving up the religions they are used to, and that when a city has a large population of believers—and Rome had the largest—they will be correspondingly slower. For centuries after the death of Christ, Rome would remain a city in which all manner of cults continued to flourish. But now Christianity had taken its majority holder's place in the general repertoire of belief, and nothing was going to dislodge it. From that point on, it could only grow, and, in growing, push out weaker cults whose survival no longer had the mandate of a growing popularity.

5

Medieval Rome and Avignon

Roman Christianity began (largely) as an imperial project. That is to say, it came up from below but was consolidated on high. The first Christian churches in Rome, such as the first Saint Peter's, were paid for by the emperors, notably by Constantine. This was bound to change as the Church accumulated power, prestige, and money—as the political concept we think of as the Papal States replaced the older forms of the Roman Empire, as the Papacy took over from the Imperium. The building that most vividly marks this transition is Santa Maria Maggiore, one of the city's earliest pilgrimage churches, atop the Esquiline Hill. In this undertaking, for the first time, the onus of church building shifted from the emperor to the pope.

Santa Maria Maggiore has been so much restored and rebuilt that almost nothing visible in it today, except for its mosaics, dates from before the Renaissance. The original foundation of the church, however, was made by Pope Liberius in 352–56. It was financed by a childless rich Roman patrician couple, who wished to make a spectacular offering to Mary, the mother of Jesus. Near the site of this church had been a Roman temple dedicated to a goddess of childbirth, Juno Lucina, much frequented by women in late pregnancy; the raising of a basilica to the Christian birth goddess, Mary, in such a spot is one of the direct transferences of pagan into Christian cult in which the early history of Christian Rome abounds. It is also called the Church of Our Lady of the Snow, because of a miraculous snowfall that supposedly took place outside it in August, at the height of the Roman summer, perhaps in 358. In memory

of this supposed event, every year a bagful of white petals is shaken free high up inside the nave and allowed to drift to the floor.

The outstanding works of art in Santa Maria Maggiore are the apse mosaics, depicting the *Coronation of the Virgin,* by the thirteenth-century painter Jacopo Torriti, who had worked on frescoes for the Upper Church of San Francesco in Assisi and came to Rome to work for the Franciscan Pope Nicholas IV in the 1280s. In them, the figure of the Virgin has equal importance and size with that of her Son, Jesus—an iconographic invention which would soon become commonplace, but was not at the time. The chronicler Gregorovius described how the apse mosaic "fills the building with a solemn golden splendour that is more than earthly. When illumined by the sunlight falling through the purple curtains, it reminds us of that glowing heaven, bathed in whose glories Dante saw SS. Bernard, Francis, Dominic, and Bonaventura. Then the spell of the work seizes us with its radiance like the music of some majestic anthem."

This is one of the few mosaic works in Rome that one may compare, in grandeur and intensity, to the Byzantine mosaics in Ravenna. Another is to be found in one of the ancient Roman churches, that of Saints Cosmas and Damian. Its history is actually much older than Christianity, since it was built, in the early sixth century C.E., into and on top of two Roman structures whose remains stood in the Forum of Vespasian. One of these was the Temple of Romulus—not Romulus the legendary cofounder of the city, but one Valerius Romulus, son of the Emperor Maxentius, who died in 309 and was designated a Roman god, with a Roman basilica raised in his honor. The other, adjacent to it, was the Biblioteca Pacis or Library of Peace. Both these sites were given by Theodoric the Great, the Christian king of the Ostrogoths, and his daughter Amalasuntha, to Pope Felix IV (reigned 526–30).

The pope had the idea of uniting the two buildings with a new structure over them, which was dedicated to a pair of Arab Christian doctors, Cosmas and Damian, brothers martyred during the persecutions of Diocletian. The pope seems to have meant it to be a Christian version of, or answer to, the cult of the pagan twins Castor and Pollux, to whom a nearby temple had been dedicated. Fortunately, this radical change did not end in the destruction of the old temple fabric; in fact, the Temple of Romulus, which now serves as a vestibule to the church, compares to the Pantheon as the best-preserved ancient temple in Rome.

The finest thing about the church, however, is the sixth-century mosaic in its apse, depicting the *parousia* or Second Coming of Christ.

In its center, his right arm extended in a gesture of recognition and blessing of the faithful, is Jesus Christ, robed in gold and descending a heavenly stair of many-colored clouds, in whose strata pink and crimson predominate, fading out to silvery gray as the eye moves higher.

It is, almost literally, a stairway to Paradise.

On the right of Jesus is Saint Peter, and on the left Saint Paul, both in white Roman togas; they are ushering the martyrs Cosmas and Damian into his divine presence. The new saints carry martyr's crowns. On the far left is Pope Felix, holding a model of his new church; a figure of Saint Theodore, or more likely the Emperor Theodoric, the donor of the site, appears on the far right. Below this zone, which fills the curving wall of the apse, is a band of mosaic sheep, those ancient symbols of obedience—the flock of the faithful. There are twelve of them, symbolizing the twelve apostles.

Rome has seven chief pilgrimage churches, the greatest of which is the Basilica of Saint Peter, where the apostle and first pope was allegedly buried after his martyrdom. The others are the Basilica of Saint Paul Outside the Walls, San Giovanni in Laterano (the actual cathedral of Rome), Saint Sebastian Outside the Walls, Santa Maria Maggiore (the greatest church dedicated specifically to the cult of Jesus' mother, Mary), Santa Croce in Gerusalemme, and Saint Lawrence Outside the Walls. The "walls" in each case are the Aurelian wall, erected around 271–75 C.E. to girdle the city. Only one of them, Saint Sebastian Outside the Walls, has no works of art of special interest; its attraction—now much diminished, because of the general loss of interest in the cult of relics as distinct from the drawing-power of famous works of art—lay in its relics, among which is a stone carrying the footprints of Jesus, an arrow which once pierced the body of that popular third-century martyr Saint Sebastian, and a fragment of the column to which he was tied while his fellow soldiers, having learned of his Christian conversion, shot at him. Of course, other pilgrimage churches do contain artworks, some of them fine; but the emphasis had always been more on their saintly associations than on their quality, sometimes very slight, as aesthetic objects.

The Church of Saint Lawrence was dedicated to San Lorenzo, the deacon martyred by the Emperor Valerian in the year 258.

Pious legend (no more than that) has it that the Holy Grail, the cup, dish, or chalice from which Christ and his apostles drank at the Last Supper, which had contained the wine converted into his holy blood, passed into Saint Peter's hands and thence to Saint Lawrence's safekeeping, and

that he hid it: in Huesca, Spain, during the third century, according to one version, or in the sanctuary of Montserrat in Catalunya, by another. Yet another version of Grail fantasy has the precious chalice entrusted to the protection of the Knights Templar. A fourth places it in the hands of a noble Irish family, the Dwyers; a fifth holds (insecurely) that it was brought to Lake Memphremagog in Canada a century before Columbus sailed the Atlantic. There are many versions of the post-crucifixion wanderings of the Grail, some pseudo-historical, others openly fictional, all of them absurd.* Several Roman churches are dedicated to Saint Lawrence. The place of his burning is marked by the minor Church of San Lorenzo in Panisperna. His supposed burial spot is commemorated by the pilgrimage Church of San Lorenzo fuori le Mura. The two chief relics of his martyrdom are a gridiron on which he was supposedly roasted (in another Roman church, San Lorenzo in Lucina) and his burned head, kept in a reliquary in the Vatican but not, it seems, regularly shown to the faithful. Considering what this gruesome souvenir might look like after the ravages of fire and time, that may be just as well.

The Roman Church has always had a *tendresse* for early-Christian virgin martyrs, the prettier the better. One of the earliest of them, the most honored, and the only one to have a pilgrimage church dedicated to her, was the fourth-century Saint Agnes, whose faith remained steadfast through trials (inflicted, according to one version, during the persecution by Diocletian, whereas others claim it was that by Decius) that would have sunk any ordinary virgin. She was twelve or thirteen. No sooner had the imperial edict for Christianity been published than she publicly declared that she was a Christian. First the enraged pagans tried to burn her to death, and as a prelude stripped her naked; but she was able to cover her body and hide it from the onlookers with her flowing hair, which miraculously grew to an immense length before the very eyes of witnesses. Then a pagan judge threatened to consign her to a brothel—but when a young man cast lascivious looks on her, God struck him blind. Finally, she was dispatched with a sword. A shrine was built on the place of her martyrdom, on the edge of what is now Piazza Navona. Gradually Sant'Agnese in Agone (as it came to be known) was added to by the faithful, and then by architects working for those papal sponsors the Pamphili family, the greatest of whom was Francesco Borromini.

* Of these the most popular was *The Da Vinci Code* by Dan Brown, a wretchedly ill-written but hugely successful tale in which the holy relic is secreted in a Scottish chapel and under the floor of the Louvre.

Of Rome's seven major pilgrimage churches, the "old" Basilica of Saint Peter was by far the most important. First, and most obviously, it was believed to be the shrine of the Apostle Peter, whom Christ had entrusted with the task of maintaining his Church. Here, from Charlemagne in 800 C.E. onward, emperors were crowned; they were not recognized as emperors throughout Europe unless they had undergone the papal rituals of Saint Peter's. Here, important treaties were signed, sealed, and deposited on the apostle's tomb. Here, Romans and all foreigners went to pray for intercession.

This first Saint Peter's—destined to be torn down in the sixteenth century, and then gradually replaced by the enormous basilica which occupies its site today—was largely built of the pieces of demolished ancient Roman buildings. These recycled fragments were known as *spoglie,* "spoils" or "leftovers," and from the fourth century until the thirteenth, this process of gradually building a new Rome from the recovered, refurbished, and recycled fragments of antique buildings was the biggest single industry the city had. Medieval Rome did not merely rise on the site of ancient Rome; it was, quite literally, made from its remains. The first Saint Peter's was the most important example of this process, but medieval Rome had more than twenty major churches—Santa Maria in Trastevere and Saints Cosmas and Damian being only two of these—built around salvaged Roman colonnades. The two most important of them were Constantine's: the cathedral, San Giovanni in Laterano, and the first Saint Peter's. The Lateran had two sets of recycled columns: some forty big granite ones, each thirty feet tall, in the nave, and forty-two much shorter ones of *verde antico* marble from Thessaly dividing the aisles. Though all vestiges of the first Saint Peter's were lost in the demolition of the church, the architects' records show that its forty-four main columns were recycled shafts of gray and red granite, *cipollino,* and other marbles.

Ancient Roman builders had been fond of using highly colored marbles for their shafts, terminating in white Composite capitals. Color was a sign of preciousness, particularly since colored stone had to be brought a long way; there was none in the environs of Rome. The stone came from all over the Empire: red porphyry from Egypt, green serpentine from Sparta, *giallo antico* from Tunisia, *pavonazzetto* from Turkey. These imports were ostentatiously expensive in ancient Roman times, and hardly any cheaper in medieval Christian times—but the skilled labor force needed to shape them, which no longer existed, was not needed

for these ready-mades. In any case, with the weakening of the Empire and its navy, blocks of exotic stone could no longer be brought to Rome from the outer parts of the Empire, and medieval builders could not have used them. So "found" column shafts had to be employed. Some were exported from Rome to distant parts of Europe. When the Emperor Charlemagne was creating his Palatine Chapel at Aachen in the late 780s, his builders brought luxurious ancient marbles, and in particular whole columns, from Rome and Ravenna. And sometimes, in an effort to assert a more metaphorical connection between the ancient Romans and Charlemagne, they faked it: some of the "Roman" capitals in the chapel at Aachen are actually Carolingian imitations of *spoglia,* made on the spot.

There is no doubt that, for the early-medieval faithful, the presence of ancient Roman columns supporting God's "modern" Roman house signified continuity—the passage of Rome's lost authority to Christianity. It must have contributed powerfully to the sense that the first Saint Peter's was the true center of the true faith.

As a result, a kind of "third Rome"—which to the pious soon became the first Rome—grew up around the pilgrimage church of Saint Peter's. Known as the Borgo, it centered on the Castel Sant'Angelo, that huge, drumlike fortification built around the original tomb of Hadrian. It was defined by the "Leonine walls," a line of enclosure dating from the time of Pope Leo IV (reigned 847–55), which ran from the Castel Sant'Angelo up to a point behind Saint Peter's, turned, and descended to the bank of the Tiber. These defined and sheltered the Città Leonina, or Borgo, consisting of the basilica, the smaller churches, papal apartments, monasteries, living quarters for the clergy, and hostels for pilgrims: a clutter of buildings which, because of their papal associations, enjoyed an ill-defined juridical independence from the rest of Rome which continued until the late seventeenth century. This independence was an origin of what became, by law, the separation of Vatican City (which corresponded, more or less, to the Borgo) as the last vestige of the Papal States.

As early as the ninth century, the Borgo had five hostels for pilgrims, six monasteries to serve these hostels and the basilica, and temporary cells, a warren of them, attached to the basilica for hermits and the poor. But by the thirteenth century, the Borgo had swollen to become the undisputed tourist center of the city—"the Via Veneto of ancient Rome," in Richard Krautheimer's words. It had so many rival inns that their owners competed to steal one another's guests by force, which must have led to some picturesque and noisy squabbles on the piazzas.

Beyond the Borgo were the sectors of Rome known as the *abitato* and the *disabitato*. The *abitato* was where people lived, worked, and worshipped. The *disabitato* was a kind of suburban desert, where nobody wanted to be and invaders came to grief. A chronicler in 1155 recorded how, on the edges of the *disabitato,* half the army of Barbarossa had been killed by "green snakes, black toads and winged dragons . . . whose breath poisoned the air as did the stench of rotting dead bodies."

But the *abitato* was busy, mostly with Christian expansion. By the fourth century, Church revenues from its holdings in North Africa, Greece, Egypt, and Syria amounted to 3,700 gold solidi, roughly $25 million in modern money, every year, and much of this was funneled directly to Rome for its building plans. Thirty-three churches in the *abitato* are mentioned prior to 1050, of which twelve still exist today. Many more would come later.

One of the chief parts of the *abitato,* in the abutment between the Vatican, the Borgo, the Tiber, and the Janiculan Hill, came to be known as Trastevere—the name a compression of *trans Tiberim,* "across the Tiber." By the end of the thirteenth century, it had become the only *rione* (*regione* or district; it was number XIII) on the far side of the river, and it was united to the Borgo in 1585—an administrative gesture which was supposed to reduce, but in fact did not, the Trasteverini's persistent habit of seeing and speaking of themselves as the only true and authentic Romans, and of all other Romans as foreigners. This is embedded in the name of Trastevere's main annual festival, the Festa di Noantri, the "Festival of Us Others." Local pride has always been a big matter in Trastevere, whose inhabitants traditionally resent any effort to horn in on it. A famous example, undocumented but almost certainly true, is said to have been an attempt by Mussolini to intrude upon the procession that accompanied this *festa.* Part of its festivity was a row of pasteboard arches spanning the Via di Lungara, which led to the area's main church, Santa Maria in Trastevere. Advised by his sometimes maladroit propaganda chief, Starace, the Duce was gratified to see that these arches bore patriotic mottoes—"Trastevere, Trastevere, now you shine with a new light / You have the Madonna *and* Il Duce, watching over you!" But, alas for the dignity of the occasion and its propaganda, some Trasteverino got to the arches the night before with a ladder and a paint pot and scrawled on the back of them another message. "*Stanchi di tanta luce . . . ,*" it ran: "Sick and tired of all this light, we want to stay in darkness: tell them all to take it up the ass, the Duce, the Madonna, and the King."

The emblematic figure for Trasteveran dissent and bloody-mindedness was, without rival, the Roman dialect poet Giuseppe Gioacchino Belli (1791–1863). A life-sized stone portrait of him in frock coat and top hat presides over a square in the popular quarter. It was paid for by public subscription—a rare, perhaps unique, indication of a Roman poet's popularity. His following in Trastevere can perhaps be gauged by the fact that the public kept filching the wooden walking stick with which the sculptor had endowed his effigy. (Eventually it was replaced by an iron one, which looked like ebony but was too heavy to steal and brandish.)

Nobody could question Belli's supremacy as *the* dialect bard of the Roman people. Partly because he wrote only in *romanesco,* the Roman language—a parallel tongue to Italian, but difficult for non-Romans to grasp—he has always been the favorite literary son of the city. (Dante may belong to all Italians, but nobody but a Roman owns Belli.) "Infected with clap? Me?" begins one sonnet of 1832, "The Honest Whore,"

> But you amaze me—
> I am as clean as an ermine,
> Look here, how this linen blouse
> Would put a lily to shame with its whiteness!

He wrote with an undeceived pessimism, interlaid with raucous humor, which rose from the lower levels of Roman life. "Faith and hope are beautiful," says a sonnet on the Carnival of 1834, "but in this wide world there are only two sure things: death and taxes." But there is another reason for his popularity, too. Belli's black humor, his spasms of obscenity, his blithely cutting disregard for the proprieties of papal and clerical Rome, all reverberate with the spirit of popular Roman dissent—a spirit in which he alone seemed able to publish. He wrote entirely in terms of Petrarchan fourteen-line sonnets, and produced more than 2,200 of them, which add up collectively to an anti-image of papal Rome—its excesses of wealth and poverty, the decadence of its ecclesiastical rule, its pantomimes of sanctity, the gross superstitions of its faithful. And he came up with burning denunciations of hypocrisy:

> Truth is like the shits—
> When it gets out of control and it runs
> You waste your time, my daughter, clenching your ass,
> Twisting and trembling, to hold it in.

In the same way, if the mouth isn't stopped,
Holy Truth sputters out,
It comes out of your guts,
Even if you vowed silence, like a Trappist monk.

As sometimes happens with those who were radical in their youth, Belli turned conservative later. This master of insult to authority joined the papal government and served it as a political and artistic censor, repressing work by such supposed enemies of religious order as Shakespeare, Verdi, and Rossini. (The official prejudice against Verdi stemmed from the offense taken by some Italian conservatives at the very initials of his name: VERDI could be read, and was, as a disguised form of propaganda for Italian unity under the king rather than the pope—"Vittorio Emmanuele Re d'Italia.")

In the middle of the river, linked to its Trastevere bank by the Ponte Cestio, and to the other side by an ancient (62 B.C.E.) footbridge, the Ponte Fabricio, is the Tiber Island.

Legend (for which there is no historical basis) claims the island began with the Tarquins' grain stores, which, around 510 B.C.E., an indignant Roman citizenry dumped in the river; mud and silt accumulated on these, and presently an island formed. A temple to Aesculapius, god of healing, was built on it at the end of the third century B.C.E. But soon Rome was stricken by a plague against which its medical resources were powerless.

The Sibylline Books were consulted. They directed that the fourth-century effigy of Aesculapius should be removed from its cult center at Epidaurus and brought by ship to the Tiber. The boat grounded on the island, and a giant snake, the incarnation of the god himself, was seen to slither overboard and take up a position on dry land. The plague receded. From then on, the Tiber Island was associated with healing, and hospitals for the sick were built there.

However, if there was any single factor in changing the map and layout of ancient Rome, producing a new, medieval shape for the city, it was the combination of Saint Peter's supposed grave and the Borgo. And added to that were the relics, prime target of faith tourism, which connected to the institution of periodic Jubilees.

The word "jubilee" derives from the Hebrew *yobhel,* meaning a year of special significance in which the *shofar* or ram's-horn trumpet was blown to announce a period of peace and social equality. The Old Testament laid

down that Jubilees were to be commemorated every fifty years, but this was not insisted on by the New Testament. Originally, there was a connection between Jubilees (also known as Holy Years) and pilgrimages to the Holy Land, but after the seventh century the Muslim conquest of Palestine made this all but impossible for Christians. So the idea of the Jubilee became focused on Rome, and the first was announced in 1300 by Pope Boniface VIII (reigned 1294–1303). Boniface had meant there to be a Jubilee every hundred years. But in 1350, Pope Clement VI (reigned 1342–52), exiled in Avignon, shortened the gap to fifty years; and in 1390, Boniface IX (reigned 1389–1404) shortened it once more, to thirty-three years, the length of Christ's life on earth. The humanist Pope Nicholas V brought the interval down again, to twenty-five years. The last Jubilee year celebrated by the Church was 2000. Then there were "extraordinary" Jubilees, outside the normal liturgical calendar. Relics played an important part in all of these, stimulating devotion and strengthening religious fervor.

It is difficult to believe, but hardly possible to exaggerate, what the cult of relics meant for medieval Rome. In Krautheimer's words, it was the relics "that made Rome the glowing center of the 13th-century world, that with the [papal] court made Rome rich by drawing pilgrims to it." Today, millions of people flock to Rome to see—or at least be exposed to—famous works of art. Their fourteenth-century counterparts did not care so much about the art, which in itself was not considered a reason to travel. But as Gregorovius pointed out, in that Jubilee year of 1300, "immense profits accrued to the Romans, who have always lived solely on the money of foreigners." In that holy and hysterical year, at the great pilgrimage Church of San Paolo fuori le Mura, two clerks could be seen standing all day and all night with huge rakes, raking in the coins left by pilgrims. The Florentine chronicler Giovanni Villani thought that 200,000 pilgrims were in Rome at any given moment in 1300, not even counting people who were there on other business or just passing through without religious motives—"and all was well ordered, without tumult or strife, and I can bear witness to this for I was present and saw it." If true, and it probably was, this was an enormous figure. No tourism industry, except in the crudest and least organized form, existed then. There was no system of mass travel. No jumbo jets or hotel chains existed, and there were, of course, no American or Japanese tourists. The population of Europe was far smaller than it is today. Tourism, to borrow the unpleasant term of today's jargon, was solely "faith-based" and undertaken in the hope of benefits in the afterlife. This was the attraction of the "Holy

Year" of 1300. Villani's account makes it clear that large, indeed extravagant, spiritual rewards were promised by the pope. "Within the whole course of this said year to whatever Roman should visit continuously for thirty days the churches of the blessed apostles St. Peter and St. Paul and to all other [non-Romans] who should do likewise for fifteen days, there should be granted full and entire remission of all their sins, both the guilt and the punishment thereof"—after full confession, of course.

These were definitely major benefits, affecting the whole afterlife of the soul.

The relics these pilgrims hoped to see and venerate differed in importance. The main stem of the cult of relics was the remains of early Christian martyrs, whose burial places could be found—or at least were alleged to exist—beyond the walls of ancient Roman cities, and Rome itself in particular. Many of them were exhumed from the catacombs, those underground tunnels full of burial niches in which early Christians interred their dead. (The word comes from the Latin *catacumbae,* meaning "recesses" or simply "holes.")

The persistent myth that these were hiding places for the faithful in times of persecution is picturesque but completely untrue, especially since the pagan authorities would have known where all the tunnels were: nobody could have hidden down there. Even if a person had been executed for treason, it was quite licit for his relatives and friends to bury him—but that burial, like all others, had to be done outside the city walls. Hence, for instance, the burial under Roman law of the dead Christ after his crucifixion in a sepulchre "where none had ever been laid."

Naples, Malta, and parts of North Africa all had Christian catacombs, but the greatest concentration of them was naturally outside the city walls around Rome. Their exploration began with an antiquarian named Antonio Bosio (1576–1629), who nearly got lost forever in the Catacomb of Domitilla, but found his way out and lived to write *Roma sotterranea* (*Underground Rome,* 1634). There may be sixty to ninety miles of these passages, originally containing up to three-quarters of a million bodies, all housed in *cubicula,* or chambers, containing *loculi,* or niches, whose entrances would then be closed by a *tegula,* a stone slab sealed with cement to prevent the stink of putrefaction from getting out.

Occasionally, a Mass or some family ritual would be celebrated in such chambers. A few are sparsely decorated with painted images of a patron saint or a biblical scene. There are, however, no masterpieces in catacombs. It is thought that many of these passages have not been discov-

ered or excavated, but in fact there would not be much point in doing so, since their contents tend to be insignificant: Christians did not believe in burying goods for the afterlife with their dead. Once a passage was filled with tombs, the *fossores* or gravediggers might dig down and open another, lower level; some Roman catacombs have four, five, or even seven such levels, like inertly stacked cities of the dead.

But they were never inhabited, except briefly and for ceremonial purposes, by the living. Strong taboos existed against the pollution of the enclosed area of cities by corpses, but as Christianity took hold there was a stronger and growing demand for martyrs to be shifted into the city, where their remains could be reburied beneath the altars or in the crypts of new (or newly consecrated) churches devoted to their cult. When the Pantheon was rededicated as a Christian church, at the behest of Pope Boniface IV in 609, under the name of Sancta Maria ad Martyres, fully twenty-eight wagonloads of supposed martyrs' bones were reverently dumped beneath its main altar.

Reliquaries became cult centers, and quite rapidly assumed importance in the new configuration of cities as pagan religion was displaced by Christian cult. The old monumental centers—in Rome, for instance, the Capitol—which were heavy with pagan association, were displaced by new basilicas, which turned into episcopal churches, whose special claim to religious importance varied with the relics they contained. And so the significance of the churches was bound to narratives of sacred history, which, in turn, could be read from the importance of the martyrs' relics they housed. The holy martyr had become, as it were, portable, and a part of the body could signify the entire saint. Reliquaria replaced actual burial spots, which meant that a saint could be efficaciously prayed to wherever his remains could be put.

The first man to become the subject of an extensive relic cult was the first Christian deacon and the first Christian martyr: Saint Stephen. Having incurred the wrath of established Judaism, he had been brought before the court of the high priest and elders in Jerusalem, sentenced, and stoned to death. One of the witnesses to his lapidation was Saul, the future Apostle Paul, whose acute feelings of guilt at assenting to it is said to have helped in his later adherence to Christ.

Bits and pieces of Stephen would be revered in churches all around the Mediterranean, but the major ones were concentrated in Constantinople and later migrated to Rome, where they share a tomb with the remains of Saint Lawrence in the pilgrimage Church of San Lorenzo fuori le Mura.

The church in Rome which actually bears his name, Santo Stefano Rotondo, may or may not contain a major relic of him. Built during the pontificate of Pope Simplicius (reigned 468–83), it is one of the few commemorative buildings in Rome (others being the Pantheon and the tombs of the Emperors Augustus and Hadrian, the latter now the core of the Castel Sant'Angelo) with a circular plan. Some antiquarians have argued that this plan was copied from that of the Holy Sepulchre in Jerusalem, but it seems uncertain.

What is quite certain, however, is that Santo Stefano carries, on its walls, the most complete frescoed anthology of scenes of Christian martyrdom ever painted in Italy. The work was done at the behest of Pope Gregory XIII (reigned 1572–85), and it survives as an almost hysterically extreme statement of the values of the Counter-Reformation: by commissioning these encyclopedic scenes of torment and sacrifice, the pope wished, by implication, to draw a parallel between the hostility of Protestantism to the true faith and the heroic resistance of Catholic believers. No work of art in Rome more vividly embodies the didactic style recommended by the Council of Trent, which had been summoned by the Church to define what was, and what was not, tolerable to Catholic orthodoxy.

In its posturing figures, all contortion and clumsy *maniera,* it is a kind of Sistine Chapel for sentimental sadists. Its creator, a Mannerist artist from Volterra named Niccolò Circignani (c. 1530–92), better known as Pomarancio, produced it in the early 1580s—a Herculean labor, twenty-four large panels complete with explanatory inscriptions, including the names of the emperors who ordered the martyrs' torments. It starts, at the entrance, with the crucifixion of Christ and the stoning of Stephen. One then proceeds to every sort of piercing, burning, flogging, skinning, bashing, strangling, drowning, and even cooking in boiling oil, like a Trastevere artichoke. Here is Saint Thecla torn apart by a pair of bulls. Here is Saint Ignatius (an earlier one, not the founder of the Jesuit order) thrown, most satisfyingly, to the lions in the Colosseum. Saints Gervase and Protase are nailed to trees in parody of the crucified God. Saint Eustachius is roasted alive inside a bronze bull. One martyr is crushed under a slab of stone, another is chopped up by heartless axmen. It may be that these scenes of suffering had some real didactic value, for the church was placed under the charge of the Hungarian Jesuits at the end of the sixteenth century, and many a Jesuit was subjected to frightful torments when on missionary duty; perhaps Pomarancio's frescoes prepared them for what was coming. Certainly they are much more vivid

than any dry-as-dust relic of the holy Stephen could ever be. However, time and fading have deprived them of much of their original vividness, which must have been quite lurid; and, given the number of more important works of art in Rome which stand in equal or worse need of restoration, and the very limited money available for this endless task, they are not likely to be restored in the imaginable future.

In a culture which drew no very distinct line between the natural and the supernatural, relics were a powerful instrument of social control, striking awe into the skeptical and the impious. The holiest and rarest relics of all were, of course, those of Jesus Christ himself. The most significant was in Rome: the imprint of Jesus' own face, miraculously preserved on the veil with which Saint Veronica had wiped away his sweat on the way to Calvary. Before this wonderful image preserved by the woman Dante called *"la Veronica nostra,"* faithful pilgrims would throng in obeisance; during the Holy Year of 1300, it was shown to the public every Friday and on all solemn feast days in Saint Peter's, and on one occasion the crush of the faithful crowd was so great that an English Benedictine monk, William of Derby, was trampled to death.

That such a thing could happen today is, to put it mildly, unlikely. Veronica's Veil is still preserved in a reliquary above Bernini's statue of Veronica herself in one of the mighty piers that carry the dome of Saint Peter's, but it is seldom shown, and kept so far from the congregation that no one could tell if the faint marks on it constitute the image of a face. It is said to be even less legible than the now generally discredited "Holy Shroud" of Turin, which bears the supposed imprint of Jesus' body but is probably a fourteenth-century fake. There are a multitude of fabric remnants. At the height of the relic mania, the custom arose of lowering long strips of cloth into a saintly grave; if a piece touched the remains, it became a relic in itself, by holy contagion.

Relics associated with Jesus Christ were, naturally, valued above those of his saints, even if—like the Veil—they were not parts of his body but merely things associated with his suffering and death. The most unwieldy relic may be the one in the Rome's Basilica of Santa Croce in Gerusalemme. It is one of many brought back from the Holy Land by Constantine's mother, Saint Helena, who built a basilica to house them. Its floor was packed with earth that the empress had carted back from the hill of Golgotha, site of Christ's crucifixion. How much earth was involved is not known. A steady trickle of visitors still arrives to view, or at least stand on the presence of, Saint Helena's earth relic.

Her other large souvenir of the Holy Land was brought back in pieces and reconstructed in Rome—the flight of twenty-eight marble steps from the residence of Pontius Pilate, in Jerusalem. Jesus Christ was believed to have walked up these steps on the way to trial and judgment by the Roman procurator, and the Scala Santa or Holy Staircase, as it is known, was reconstructed in Rome in the former papal residence, the Lateran Palace.

How Helena got this enormous cult object from the Middle East to Rome is not recorded, but of course the task, though daunting, would not compare to the logistics of transporting whole granite obelisks from Egypt to Rome in pagan times. The marble steps are now encased in wood, since it would not be right for ordinary human feet to tread on the stones which Jesus' own footprints had sanctified. Glazed peepholes have been cut so that pilgrims can venerate the stains in the marble, left by the blood of Jesus (who had just been scourged at the pillar, and so was leaving spots and smears everywhere).

Large indulgences go to those pilgrims who climb the whole continuous flight of the Holy Staircase on their knees. The future heresiarch Martin Luther is said to have tried, but failed, to do this when he was a young monk, getting only halfway to the top. But in the nineteenth century, when Italy's King Vittorio Emanuele II was about to invade Rome (and thereby begin the process which led to the confiscation of the Papal States), the vehemently conservative seventy-eight-year-old Pope Pius IX managed the climb on his knees—not that it did him or his political future any good. Interestingly, the stairs are still crowded with modern pilgrims, although handrails have been installed on either side for their convenience.

Since Christ ascended into Heaven body and soul, he left behind on earth only one bodily relic, which was surgically removed from him by the high priest of the Temple in Jerusalem when he was an infant. Theoretically, the Holy Foreskin, enshrined in a provincial church not far from Bomarzo, in Latium, ought to be the least contested of all relics, but its unique claim to that title has unfortunately been challenged by another Foreskin, housed in a rival church in the Abruzzi.*

* However, the Chapelle du Saint-Sang (Chapel of the Holy Blood) in Bruges claims to possess a phial containing drops of Jesus's blood, collected by Joseph of Arimathea, which had been given to Thierry, count of Flanders, by the patriarch of Jerusalem in 1149. Other claimants to possession of specimens of this precious fluid are Weingarten Abbey in Germany and the cathedral of Menton in France. One of the rival Crowns of Thorns, acquired by Saint Louis,

But there were, and are, innumerable smaller relics of saints, so many thousands throughout the churches of Rome (and Italy, and the rest of the world) that no effort has ever been made to count them. The most esteemed were bone relics, such as the head (or heads) of Saint Paul. Of course, they are all beyond verification. How does one "authenticate" the holy phial of the blood of San Gennaro, patron of Naples, which is kept in the church named after him and is expected to liquefy each year on the saint's festal day, to the edification of crowds of prayerful worshippers?

Santa Croce in Gerusalemme itself has a whole chapel devoted to relics of Christ's passion. It possesses not one but two thorns from the Crown of Thorns. It has splinters from the True Cross, a piece of the Good Thief's cross, and one of the three iron spikes with which Christ was nailed to his cross. (It is said to be fairly intact, despite the medieval habit of scraping filings from the Holy Nails and incorporating them in minor relics, in order, so to speak, to soup them up, like adding pepper to a cutlet.)

It also has the column at which Christ was scourged, although it might be safer to say *one* of the columns: a thirteenth-century crusader, Robert de Clari, who took part in the sack of Constantinople, mentions being shown Christ's whipping post there in 1204, so either it was in two places at once or there were two columns; perhaps he received a hundred lashes at one and the rest at the other. Santa Croce in Gerusalemme also has the crib in which Christ's mother laid him in the stable at Bethlehem, and (in some ways most wondrous of all) the mummified index finger which Doubting Thomas skeptically poked into the wound left by Longinus' spear in Christ's side.

Among the oddest of these relics is a part of the *titulus crucis,* the label that was affixed to the cross, bearing the legend, in Latin, "Jesus of Nazareth, King of the Jews," in red paint on a worm-eaten wooden plaque. Supposedly, it was purchased by Helena and, after vicissitudes—brought to Rome, hidden from the invading Visigoths, forgotten until the fifteenth century, found in a sealed lead box—became part of the Passion reliquarium. In the cloisters of San Giovanni in Laterano, that ancient pilgrimage church which is the first cathedral of Rome, there is even kept the stone on which the Roman soldiers attending the crucifixion cast dice for his garments.

king of France, and kept in the Sainte-Chapelle, disappeared during the French Revolution and is unlikely to resurface except, perhaps, as a fake of a fake.

Ever since Luther, the matter of relics has been thorny for the Catholic Church. The cult seems so blatantly superstitious, so comical. Yet, within living memory, you could hardly enter an Italian church of any age without encountering scores of reliquaries that contained a profusion of bones, snippets of cloth, vials of dried blood, and other curiosities. Relics were in immense demand in early Christian times, but in a more skeptical age their cult has been greatly reduced. It would probably be fair to say that most people who visit these collections are more interested in their reliquaries, those rhetorically magnificent examples of the metalsmith's art, than in their contents.

There are, of course, numerous competing heads, hands, and legs of the same saint—an apostle, a virgin martyr—but these are the merest fraction of the number of holy relics that used to be displayed in Catholic churches a century or two ago.

We laugh. How superstitious, how easily fooled through an excess of naïve faith, our medieval ancestors and some of their more pious descendants were! But we—or at least some of us—are no better. At the end of the twentieth century, bidders were competing to buy, on eBay, a miraculous (though by then rather stale) piece of bread that some American householder had popped in the toaster and seen come out with the Virgin Mary's face burned on it. On November 22, 2004, an Internet casino called GoldenPalace.com paid $28,000 for this relic—the most expensive slice of toast in history. Miraculous statues of Jesus or Mary, which weep tears or exude blood (but turn out to have cunningly concealed tubes, sacks of red dye, and other handy miracle-aids), periodically turn up in faith-sodden America. No moment in history is free from superstition; and as for the hysteria of relic hunting, what but a sordid and comical piety could have driven wealthy Americans at a Sotheby's auction of Jackie Kennedy's effects to bid for one of her late husband's golf clubs, and for a worn tray on which the drinks of America's Holy Family might have been served at Hyannisport?

The cult of relics gave rise to much swindling and fakery, but holy mementos were not the only things being faked. Forgeries of documents have played important parts in history, and none more so than an imaginative one of uncertain date (probably somewhere between 750 and 850) known as the Donation of Constantine.

What this document, which has been recognized as a forgery since the sixteenth century, attempted to prove and forever ensure was the pre-eminence of religious over secular power. The claim was that it had

been written by the first Christian emperor, Constantine, in the fourth century. It was "discovered"—that is, written—in the eighth century, but it supposedly describes relations between Constantine and Pope Sylvester I (reigned 314–35). Its subject is the extent of papal power over the secular world, which it makes out to be all but limitless. The will of the pope supersedes that of any emperor, writes "Constantine." He can create emperors, and depose them. He has this right because the chief concern of human life is eternal salvation, beside which such matters as the accumulation of wealth and the exercise of worldly power are (relatively) trivial.

Constantine's address, then, is divided into two parts.

In the first, the *confessio,* he recounts how his pagan life ended when he was instructed and baptized in the Christian faith by Pope Sylvester, and how this miraculously cured him of "a horrible and filthy leprosy." Doctors had been summoned but could do nothing. After them came the pagan priests of the Capitol, who recommended a grotesque replay of the Massacre of the Innocents: Constantine must set up a font on the Capitol "and fill it with the blood of innocent children and by bathing in it while it was warm I could be healed." Numerous children were duly rounded up, but when "our serenity perceived the tears of their mothers," Constantine was filled with abhorrence and canceled the project. Now Christ sent Saints Peter and Paul to speak to the still-leprous emperor. They instructed him to seek out Pope Sylvester, who, with his clergy, was hiding from Constantine's persecutors in the caverns of Mount Serapte. "When thou hast called him to thee, he will show thee the pool of piety." Three times immersed in it, Constantine would be cured. And so he was. Constantine was so grateful for this miraculous baptism that he called together all his governors, senators, and officials and ordered, "The sacred see of Peter shall be gloriously exalted above our empire and earthly throne."

How would that be done? As boldly as possible, by the means set forth in the second part of the forgery, the *donatio.* Constantine, instructed by God, confers on the pope as successor to Saint Peter the primacy over the world's four patriarchs, those of Antioch, Jerusalem, Alexandria, and Constantinople. The chief Roman ecclesiastics must have the same honors and rights as the senators, and the pope must have all the same rights as the emperor, including the right to wear a golden imperial crown. But, the forger goes on to recount, Pope Sylvester refused to wear such a crown. The emperor instead bestowed on him a *phrygium,* a tall white

cap of authority—ancestor of the papal miter. He also gave the pope all his Western lands, cities, and possessions, including Rome and its Lateran Palace, as a present (*donatio*), making them "a permanent possession to the holy Roman Church." As a last formality, he officially removed the seat of imperial government to the East, to the capital of Constantinople, since "it was not right that an earthly emperor should have authority [in Rome], where the rule of the priests and the head of the Christian religion have been established by the Emperor of Heaven."

Such are the main clauses of the fictitious "Donation," the most outrageously self-serving secular deception ever foisted on its believers by a Western religion.

It would, however, become the basis for an aggressively expansionist Papacy in the twelfth and thirteenth centuries. Whoever the forger was, he wrote a free ticket to the popes to embark on world dictatorship. The meaning of the Donation is spelled out in a remarkable cycle of frescoes in the small Chapel of Saint Sylvester, part of the larger fortified basilica of the Santi Quattro Coronati, on the heights of the Caelian Hill, not far from the Lateran Palace. Much ancient, medieval, and Renaissance art is political on some level, intent on the promotion and praise of some powerful men and ideologies, while attacking and downgrading others. But few early frescoes are as bluntly, explicitly political as these.

Santi Quattro Coronati, the church of the "Four Crowned Saints," originally celebrated the acts of faith of four Roman soldiers named Severus, Severinus, Carpophorus, and Victorinus, martyred in one of the persecutions by Diocletian for refusing to sacrifice to the god Aesculapius, the Roman name for the Greek god of healing, Asclepius. (If it seems a little excessive, even self-contradictory, to kill men for displaying insufficient reverence for the founder of the art of medicine, then welcome to the oddities of pagan cult.)

These Christian soldiers are not the only ones honored in the basilica, which was built between the ninth and twelfth centuries. It also contains, in a ninth-century crypt under the altar floor, the remains of five Christian-convert sculptors from Pannonia (now mostly in Hungary) named Castor, Claudius, Nicostratus, Sempronianus, and Simplicius, who were put to death for refusing to make a statue of the same god. For many years, the commercial stone-carvers of Rome, especially the ones dealing in recycled ancient marble from demolished buildings, preferred to have their shops near the church of these sculptor-martyrs.

But the art content of Santi Quattro Coronati is chiefly remarkable

for its thirteenth-century frescoes by an unnamed hand, illustrating the Donation of Constantine. We see Constantine recovering from leprosy; Constantine baptized by Pope Sylvester; and, most significant of all, Constantine offering the pope his white *phrygium* of authority and leading the papal horse by its bridle, thus assuming the subordinate posture of a *strator,* a groom. There could be no clearer statement of the Church's belief in the Donation forgery. The emperor must bend the knee—both knees, in fact—to the pope. Religious authority is, and always must be, above the claims of temporal power, which it need not ask for legitimacy.

The pope whose policies and actions were most opportunistically and flagrantly based on this belief was Innocent III (1160–1216). He did more than any other pontiff to shape the politics of Italy, internal but especially external, in the early Middle Ages. He came to the papacy young; with few exceptions, popes tended to be older men, but Lotario de' Conti, son of Count Trasimund of Segni, was voted into the papacy at the age of only thirty-seven, a man brimful of energy, highly intelligent, and completely dedicated to his own conception of the Church Militant.

Such a man was not likely to be content until he had put his own stamp on the mania which seized pious Europeans in the twelfth century, and became the chief voice of that expression of mingled religious zeal and territorial frenzy: the Crusades.

It seems extraordinary, looking back on the Crusades from nearly a thousand years later, that they could ever have been conceived as anything but a mirage, a long bout of collective religious delusion. What good could it do to "free" a portion of the Middle East from its inhabitation by Muslims, for no better reason than that a Jewish prophet had once lived, preached, and died there? But territoriality, especially when conceived in religious terms, heightened by the hope of eternal life and sharpened by xenophobia, is a murderous and intractable passion, and many Christians in the Middle Ages felt it intensely. Crusades were the ultimate form of that fear and hatred of the Other which underlies the sense of racial and religious selfhood, and a man conscious of his honor would have needed an almost superhuman detachment to resist their impulse, once it was roused by preacher and pope.

All over Europe, and not least in Italy, men were seized by a common delusion: that, as Christians, they collectively owned a tract of territory on which none of them had ever lived, that they had an unquestionable right to it because their Saviour had once walked and prayed and died on it; and that the most meritorious of acts imaginable would be to

wrest control of it from nonbelievers, the sons of the Prophet, the Arabs, whose mere presence in the Holy City of Jerusalem defiled that Saviour's memory—despite the fact that the "Holy City" had been in Muslim hands since the seventh century. The Holy Land was defined by certain emblematic sites, closely associated with Jesus. They included, apart from Jerusalem as a whole, the Church of the Nativity in Bethlehem, the Garden of Gethsemane and the Mount of Olives, Calvary and the Holy Sepulchre. Pilgrims had been visiting these since the third century.

So the crusaders engaged in what their enemies would call a *jihad*, a holy war, having trudged, ridden, and sailed thousands of miles under the most adverse conditions to do so. They were fighting not forest dwellers but highly trained, well-armed, and often strategically brilliant armies. Crusaders were both warriors and pilgrims. That double determination was the peculiar strength of their enterprise. Fortified by a sense of their own holiness, bound to one another by the red crosses reverently sewn to their tunics, the Christian soldiers or *crocesignati* talked obsessively about the "recovery" of the Holy Land—in total disregard of the fact that it was never lost, because they had never possessed it, except in collective fantasy. Such was the impetus for the start of the First Crusade (1096–99).

A spontaneous and disorganized parallel campaign in 1096, known as the Peasants' Crusade, miserably failed. But the "professionals" were victorious, taking Jerusalem in 1099.

Encouraged, the papacy gave permission for the Second Crusade (1145–49). It was only a partial success, directed in part against the Muslims who commanded the Iberian Peninsula. These crusaders, led by Alfonso I of Portugal, managed to dislodge them from Lisbon, but the Muslims remained firmly in command of Spain, and in 1187, led by the great general Salah el-Din (Saladin), they recaptured Jerusalem from the Knights Templar.

The Third Crusade (1189–92) was famous mainly for the participation of England's mighty Moor-killer, King Richard I, "the Lionheart," who strove but failed to recapture Jerusalem. Then came the great betrayal of the Fourth Crusade (1202–4), one of the two worst fiascoes of Innocent III's papacy and perhaps of the Catholic Church's entire history.

Innocent never played down his desire to "recover" the Holy Land. Muslim "occupation" of the Holy Places was an unceasing annoyance to him. It provoked him to make the mistake of authorizing a full crusade, the Fourth.

Unfortunately, Italy was neither well placed nor properly equipped to

ship the necessary troops and their supplies across the Mediterranean for such a campaign.

Italy had one Christian naval power, Venice, "Queen of the Adriatic." Approached by the pope, the Venetians agreed to transport the entire army of invasion to the Holy Land, with supplies for nine months, for eighty-five thousand marks. The crusaders—a ragtag assembly of knights and peasants, mainly French, and led by Baldwin of Flanders, Boniface of Montferrat, and Geoffroy de Villehardouin—could not raise this, so another deal was struck. Its essence was that Venice would use the assembled crusading forces to besiege and take Rome's only great rival in the Mediterranean, Constantinople, on their way to the Holy Land. In this way they would finance the whole crusade. Venice would pay for the entire expedition if the crusaders would briefly divert the attack on its way to Jerusalem and conquer the city of Zara, in Dalmatia, on Venice's behalf. They would then go on to take Constantinople and restore the Byzantine Emperor Isaac II Angelus to the throne from which he had been deposed. The man who delivered this proposal, Isaac's son Alexius, undertook to add more men and supplies to the crusading army, bringing its strength to some eleven thousand men, heading for Constantinople in a huge fleet (by medieval standards) of two hundred ships. They were accompanied and directed by the formidable old Doge Enrico Dandolo.

Zara fell easily, and by July 1203, this force was besieging the land walls of Constantinople. Its citizens, all Greeks and Christians, were taken utterly by surprise: it had never been imagined that a huge Christian force, sworn to eject the Muslims from Palestine, would stop off on the way to attack a Christian city—let alone the greatest of all Christian cities after Rome itself.

The outcome was inevitable: by April 1204, the defenses of Constantinople were breached in a climactic attack, and the crusaders surged in, despoiling the churches and palaces, killing the priests, and raping the women. It was the most merciless sack ever inflicted on a Christian city. Baldwin of Flanders was proclaimed emperor, and the Greek Orthodox Church, which had no say in the matter, was finally united with the Roman, under the authority of the pope.

It may be said to Innocent III's (rather limited) credit that he did not authorize, still less organize, this atrocity. He protested against it and even excommunicated those Venetians who had facilitated it. On the other hand, he was not reluctant to see his church benefit from it. He did nothing to force the Venetians to restore their loot to the pros-

trate city. The matchless Greek bronze horses from Constantinople were installed on the façade of Saint Mark's, never to return. Hundredweights of precious stones were lost to the Venetians; many of them may still, a thousand years later, be seen set in the Pala d'Oro, behind the high altar of Saint Mark's. Gold, silver, and bejeweled reliquaries, monstrances, ciboriums, pyxes, patens, and chalices by the ton were distributed to church treasuries all over Europe but especially in Italy. The very icons were torn from the churches and broken up in thousands, burned to extract the precious metal from their gold-leaf backgrounds, which ran down into glittering puddles amid the ash. And nobody knows (though it is not hard to guess) what happened to such things as the high altar of Hagia Sophia, which beggared the descriptive powers of such crusaders as Robert de Clari, an unlettered knight dictating a memoir of the sack years after his return to France:

> The master altar of the church was so rich that it was beyond price . . . made of gold and precious stones broken up and crushed all together, which a rich emperor had made. This table was fully fourteen feet long. Around the altar were columns of silver supporting a canopy over the altar which was made just like a church spire and it was all of solid silver and was so rich that no one could tell the money it was worth.

"Now about the size of the city," recalled de Clari,

> about the palaces and the other marvels that are there, we shall leave off telling you. For no man on earth, however long he might have lived in the city, could number them or recount them to you. And if anyone should recount to you the hundredth part of the richness and the beauty and the nobility that was found in the abbeys and the churches and in the palaces and in the city, it would seem like a lie and you would not believe it.

Neither richness, nor beauty, nor nobility could do anything to deflect the horde of ravening Frankish thugs who stripped Constantinople in the name of Jesus. The city was replete with other wonders, not of an artistic kind. It had a magical tube the size of a shepherd's pipe hanging by the silver portal of Hagia Sophia, "of what material no man knew"; if a sick man put one end in his mouth, "it sucked out all the sickness and it made the poison run out of his mouth and it held him so fast that it made his eyes roll and turn in his head, and he could not get away until

the tube had sucked all the sickness out of him." And of course there were relics in profusion: wonder-working icons, pieces of the True Cross, the iron of the lance that pierced Jesus' side on Calvary, the robe of our Lady, the head of John the Baptist, "and so many other rich relics that I could not recount them to you or tell you the whole truth."

So much has been said about the importance of the Crusades as the collision of two utterly incompatible worldviews that their significance is habitually overblown. In the end, they did not make much difference to either Islam or Christianity, except as largely symbolic events.

The eleventh-to-thirteenth-century assaults of Christian forces were a peripheral affair in the Muslim world, and the Muslim counterattacks hardly menaced the stability of the Christian empire. (The later Ottoman surge against Europe, in the sixteenth century, so memorably beaten back from the walls of Vienna and repulsed by the galleys of Don John of Austria at the Battle of Lepanto, was of course quite a different matter.) Nevertheless, their memory retained enormous rhetorical power, casting the Arabs in European eyes as cruel, barbarous infidels, and the Christians in Muslim eyes as culturally bestial thugs. That is why the Islamic media, to this day, continue to refer to the American armies in Iraq as "crusaders"—not by any means the compliment that the stupider voices of American faith fancy it to be. What gets ignored in this clang and rattle of poisoned stereotypes is the immense cultural heritage shared between Islam and Christianity—though not the Christianity of the ranting American fundamentalist bigots, or the Islam of the murderous lowbrow ayatollahs. As Christians once built Chartres and Saint Peter's, Muslims once built the Blue Mosque of Istanbul and the Great Mosque of Córdoba, the courts and gardens of the Alhambra. Their librarians preserved all that we have of classical drama and philosophy. They created in al-Andalus, the Arab name for Moorish Spain, one of the supreme cultures in world history—supreme, not least, in its tolerance for other faiths and creeds, a tolerance not shared by the anti-Semitic Catholic brutes who did the dirty work of the Reconquista for Ferdinand and Isabella.

Today, Islam's fundamentalist descendants can invent nothing, preserve nothing, create nothing. Comparing them with the remarkable figures of their own history is like comparing some illiterate IRA kneecapper to Seamus Heaney or William Butler Yeats. And it is the same on our side, where the Christian fundamentalists have no sacred art to

show, no writing of aesthetic significance, and little architecture beyond drive-in megachurches.

Next only to the Fourth Crusade, the worst of all exercises in medieval crusading took place inside Europe and was also launched by Pope Innocent III. It was directed, not against the Byzantine Church, not against Saracens and other "infidels," but against Europeans: a heretical religious movement of the French, the Cathars, whom Innocent III and his hierarchy were determined to wipe out by all possible means, by proscription, fire, and the sword.

"Catharism" comes from the Greek root *katharos,* meaning pure—and the Cathars saw purification as their appointed mission in a spiritually fallen world. It was strongest in France, where the tragic and bloody *dénouement* of its growth and repression took place in the early thirteenth century; but at its height, Catharist "cells" grew up all over Europe, including Italy, where they survived until the early 1300s and were experienced, by Rome, as a powerful threat to Christianity itself—as cancerous, potentially, as Stalinist cells in Western democracies were seen to be by the Catholic Church and the U.S. government in the postwar years of Pius XII's papacy.

The first reports of Catharist belief communities actually came from Cologne, in 1143. But France was the stronghold of the cult, and in particular the Languedoc, in the Midi region of southern France, with its strong sense of exception, its remoteness from the great power-center of Paris, its separate language (Provençal, close to Catalan), and its traditions of vehement pietism.

Where did the Catharist faith come from? Because nearly all its "scriptures" and holy books were destroyed, burned along with the Cathars themselves,* it is difficult to be certain about this, but most scholars seem to agree that it was an Eastern import whose roots lay in the Balkans and the Byzantine Empire. It was related to the beliefs of the Bogomils, or "Friends of God," who, being particularly strong in Bulgaria, were also known as the Bougres—whence our durable term of extreme disparagement "buggers."

What did the Cathars believe? This can no more be summed up in

* Among the survivors, which give at least a partial and fragmentary idea of Catharist belief and were preserved by the Catholics as examples of heresy, were *The Book of Two Principles* (an exposition of the Catharist doctrine that the world had two gods, one evil and one good), the *Rituel cathare de Lyon,* and the *Nouveau Testament en provençal.*

a few sentences, or even a single book, than the theology of medieval Catholicism can. Besides, the Catholic effort to extirpate it was all too successful. After the texts were burned, only the merest traces and outlines of their content have remained.

Fundamentally, they thought in terms of a dualist universe ruled by two creative principles, one good, the other evil. The good was entirely spiritual. The evil was material, created by a demiurge whom the Cathars identified with Satan and referred to as the "King of the World," Rex Mundi.

The world we inhabit, including our own bodies, was his product. Sexual procreation, in the Cathar view, was an act of unsurpassed cruelty, since it brought down a helpless and undeveloped soul into a world of utter imperfection.

The great object of mankind's spiritual quest, therefore, was to escape from a hopelessly debased world of substance and material desires ruled by the Devil and his minions, and to enter a world of pure articulate Spirit, beyond desire.

This difficult evolution could hardly be achieved in a flash of insight, or even in a lifetime, although some exceptionally illuminated souls were believed to manage the latter. Generally, it required reincarnation: a second life, and perhaps a third and even a fourth, to achieve the journey toward perfection. Those who did so were known as Perfecti, and were a revered minority within the Cathar cult; they corresponded to the hierarchy of Catholicism (though the Cathars absolutely rejected the idea of priesthood), and were marked by their extreme asceticism. The majority, the rest of the Cathars, the *credentes* or simply "believers," led relatively normal lives in a normal world, farming and trading, but abstaining from meat, milk, cheese, and other animal products, not swearing oaths or engaging in acts of violence.

One might have thought that such mild people presented about as much threat to society as a gaggle of vegans—whose spiritual ancestors, in a sense, they were. But that was not how Rome saw the matter.

The pope and clergy perceived the Catharist doctrine of resurrection as the rankest heresy.

Because the Cathars saw the material world as intrinsically evil, they regarded as a fraud Jesus' coming to earth as the incarnate Son of God. If he was made flesh, he became evil; he became, or was allied with, the creator of material existence, Rex Mundi, and could not be worshipped

as the God of love and peace. To the Catholic argument that he had died to redeem material creation, their response was that, by dying to redeem an evil thing, he was himself evil. (As with many structures of religious "reasoning," once you granted the initial premises the rest made logical sense. That is why Catholic theologians came up with that very useful phrase "a mystery of faith.")

The Catharist doctrine was the polar opposite of what Catholicism taught about Jesus' nature and the supreme value of his sacrifice on the cross. When a Catholic learned that a Cathar despised Christ and held the crucifixion to be of no spiritual value, or that Catharism rejected all belief in Hell and Purgatory, the sacrament of the Eucharist, or the doctrine of the Trinity, he would be horrified. He would think of such ideas as literally diabolic, coming from the Devil. And Catharism's other doctrines aroused an equal hostility. "Resurrection," for instance, meant different things to Cathars and Catholics. To a Cathar, "resurrection" was the means whereby a soul passed from one incarnation to another, in its progress toward perfection. It was essentially the same as the Pythagorean belief in metempsychosis, the transmigration of souls. Whereas to a Catholic it had the narrower meaning of the physical resumption of life after death, emergence from the grave, like that of Jesus or Lazarus.

There were other features of Cathar belief that Roman Catholicism found equally repugnant. In the Middle Ages, before general literacy, and hence before a widespread reliance on written contracts, the swearing of oaths was of paramount importance. But the Cathars regarded oath taking as wrong—the practice came from Rex Mundi, the Devil. They were pacifists and did not believe in war, capital punishment (a most radical departure from medieval norms), or marriage vows. Nor were they at all keen on propagating children; the enormous value placed on sacred copulation and childbirth by the Catholics was not shared by them. And they loathed Roman Catholicism, believing it to be the creation of the Rex Mundi, utterly unworthy of veneration. The cult of relics—old bits of bone, splinters of wood, and scraps of cloth with deluded pilgrims bowing before them—they rightly held to be a sham, merely another form of matter worship. The Cathars had to renounce all aspects of Rome: utterly renounce them, not merely criticize them. Rome was Babylon—hugely rich, corrupt beyond redemption. In fact, the Cathars were so different from Roman Catholics that they positively begged to be stamped out, as in Hilaire Belloc's disillusioned little distich:

Pale Ebenezer thought it wrong to fight,
But Roaring Bill (who killed him) thought it right.

Roaring Bill, in this context, was none other than Pope Innocent III. With the Fourth Crusade of 1204 over, and the treasure houses and reliquaries of Venice crammed with the loot of Constantinople, Christ's vicar on earth now turned his attention to the hapless and heretical Cathars. So determined was the Cathar resistance, spiritual rather than military, that it took the pope's formal crusade, misnamed the Albigensian Crusade though it was not born in and did not attack Albi, twenty years to extinguish it. Yet in the end the job was done; Innocent III's Final Solution to this particular heresy was at last achieved.

But how to raise the necessary papal armies? The Cathars may not have had the riches of Venice. Indeed, most of them had no riches at all, in terms of jewels, gold, or other palpable treasures. But they and their sympathizers in the Languedoc, including many rich nobles, did have land. Innocent III therefore let it be known, and had his preachers declare, that whoever successfully brought a Cathar to trial and thence to death would receive his lands in reward. It was a most effective strategy, because it attracted predatory, land-hungry nobles from the north. Besides, one did not need a huge army to launch an internal crusade. Medieval armies were tiny by modern standards. The pitched battles that determined the fate of whole regimes involved forces that would hardly have made dents in either side today. Ten thousand soldiers, twenty at the most, would more than do.

But the Cathars also had their share of loyal supporters. Weary of the money-grubbing and sexually debauched behavior that they saw everywhere in the upper hierarchy of the twelfth- and thirteenth-century Church, many Catholics stood with the Cathars in a bond of moral superiority. The reputation of the medieval Church in Provence was low, and getting lower all the time.

The Church in the twelfth-century Midi was not entirely discredited by the behavior of its clergy, their love of luxury, their usurious money-grubbing and sexual debauchery. There were always some humble priests, honest bishops, and congregations who valued them. But the moral superiority of the Cathars to the general run of Catholic prelates was no empty claim, and knowledge of it won many converts and tolerant allies for Catharism, doing limitless damage to the Church. Innocent III heard about these doings in Languedoc, of course.

At first, the Church in Rome tried to deal with the Cathars by peaceful persuasion. In the last half of the twelfth century, various missions were dispatched to the Languedoc; all failed. The resolutions of Catholic Church councils—Tours in 1163, the Third Lateran Council in 1179—had negligible effect. The nobly born Domingo de Guzmán, the future Saint Dominic and founder of the religious order that bears his name, began a conversion drive in the Midi, declaring, "Zeal must be met by zeal, humility by humility, false sanctity by real sanctity, preaching falsehood by preaching truth." It had little success, although it was attended by at least one spectacular miracle, sometimes represented in art: locked in a debate between Cathars and orthodox Catholics, the two sides flung their books on a fire; the book of the Albigensians was burned, but Dominic's collection of his writings was spared and floated up above the flames. The mendicant Dominicans whose passion against heresy earned them the name *"Domini canes,"* "hounds of the Lord" (their emblem was a black-and-white dog, duplicating the black-and-white habit of the order, and holding a flaming torch in its jaws), were frustrated by the Cathars' stubborn adherence to their own faith. "In my country," Dominic declared, "we have a saying, 'Where words fail, blows will avail.' "

The blows soon came raining down. In 1208, Innocent III's legate Pierre de Castelnau was sent to meet, and threaten, the most powerful ruler in the Midi, Count Raymond VI of Toulouse. Believing (probably correctly) that the count was soft on Cathars and had been known to shelter them, Castelnau excommunicated him. Vengeance immediately followed: Castelnau was murdered on his way back to Rome, by one of Count Raymond's knights. This left Innocent III no choice, or none that he could see. Exasperated, he called for a full crusade against the Cathars, and land-greedy northern-French noblemen donned their chain mail, saddled their horses, and, brandishing the red insignia of the cross so hated by Arabs and Cathars alike, flocked to the papal banner.

Thus began the Albigensian Crusade, French against French, instigated by an Italian pontiff. Of course, it was not Innocent III's only piece of international meddling: he had received the feudal allegiances of Aragon, Bohemia, León, and Portugal, tampered with the politics of succession in Sardinia, and intervened relentlessly in English affairs, even declaring the Magna Carta invalid. Nevertheless, the crusade against the Cathars joined the Fourth Crusade as the apogee of Innocent's political adventurism, not because he organized it—he did not—but because he gave permission for it.

The pope placed the vanquished territory under the command of a Cistercian abbot, his papal legate, Arnaud-Amaury. He began his crusade in the summer of 1209 by besieging what was supposed to be a Cathar stronghold, the town of Béziers. Béziers also had a Catholic population, who were given the option of leaving the town unharmed. Significantly, few of them did, many preferring to stay and fight alongside the Cathars. One of Arnaud's fellow Cistercians asked his commander how he would tell a Cathar from a Catholic, and the reply became legendary: *"Caedite eos, novit enim Dominus qui sunt eius:"* "Kill them all, the Lord will recognize his own." When the crusaders entered Béziers, where many had taken refuge, they killed some seven thousand people right away, and thousands more later. They were blinded, maimed, impaled, strung up as targets for archers, and dragged behind horses. The town was then gutted by fire. "Today, Your Holiness," the Abbot Arnaud reported with obsequious satisfaction to Innocent III, "twenty thousand heretics were put to the sword, regardless of rank, age, or sex."

This initial slaughter was followed in 1229 by the establishment of the Inquisition throughout southern France. Overzealous thugs interrogated thousands of suspected Cathars, and those who seemed guilty were hanged or publicly burned at the stake. For almost a year, the last redoubt of the Cathars, the almost inaccessible fortress of Montségur (the name means "Safe Mountain") was besieged by troops of the archbishop of Narbonne. It fell in March 1244, and a large massacre followed, in which more than two hundred Perfecti were incinerated on a killing field below the castle, the Prat des Cremats or "Field of the Burned." Though this did not eliminate all the Cathar faithful, it scattered them and broke the back of resistance. The last Cathar leaders, Pierre and Jacques Autier, were executed in 1310.

So the Papacy was well able to repress the challenges of heresy, but for a long period it was obliged to move out of Rome altogether. The "Avignon Papacy," which lasted from 1305 to 1376, began as a temporary exile of papal authority to France, but for a time looked like its complete removal to what some people called a "Babylonian captivity" of the Church.

Its origins lay in an irreconcilable conflict between the French monarchy and Rome's papal authority, whose ultimate source was that hobgoblin of medieval power politics, the spurious Donation of Constantine.

The papal authority involved, at the beginning of the fourteenth century, was the implacably arrogant Benedetto Caetani, who belonged to

one of the more powerful clans of medieval Rome and was elected pope as Boniface VIII in 1294. Boniface believed absolutely in the Donation's dictum that the Papacy ruled over all Christendom, taking precedence over any secular authority, including the king of France. He soon locked horns with that king, Philippe IV, over the issue of tax.

The French state derived no small amount of income from the taxes French feudal lords levied on their clergy. Boniface vehemently opposed this, and in his bull *Clericis Laicos* (1296)* he decreed that no taxation on the Church, its clergy, or its by now immense properties could be levied by any secular authority. (The next year, he wavered a little, granting Philippe IV the right to impose taxes on the clergy in certain emergencies. But this was soon rescinded in the wake of the triumphant Jubilee year of 1300.) Obviously, an expanding church needed every penny of its own money.

Boniface's confidence in defying King Philippe was inflated by the mighty success of the Holy Year he had proclaimed for 1300, in which a total of two million pilgrims inundated Rome; after such a display of faith, it made no sense to ask, "How many battalions has the pope?" Boniface issued two further bulls: *Salvator Mundi,* canceling all privileges issued to French kings by earlier popes, and *Ausculta Fili,* ordering Philippe IV to present himself forthwith to appear before a papal council. Philippe would have none of that: "Your Venerable Stupidity," he wrote back, "must know that we are nobody's vassal in temporal matters." He then issued accusations of simony, sorcery, heresy, and even sodomy against the pope.

This was hardball, and, not to be outdone, Boniface in 1302 issued the bull *Unam Sanctam,* which laid it down as "necessary to salvation that every human creature be subject to the Roman pontiff." Impossible to be more categorical than that, and Philippe's response was in deeds, not words: he dispatched a delegation, which was really a military squad, with orders to bring the pope from Rome to Paris, to answer the king's charges before a French council. He even arranged for the cardinals of that exceedingly powerful Roman clan the Colonnas, who hated the Caetani, to humiliate Boniface. Philippe's men seized Boniface in his residence at Anagni, outside Rome. He died of illness brought on by his apoplectic outrage some weeks later, aged sixty-seven.

* A papal bull, meaning an official declaration of policy from the pope, was so called because of the *bulla* or seal affixed to such documents, affirming their papal origin.

His successor, 1303–4, was another Italian pope, Benedict XI. He was not as tough as Boniface and could not so readily defy the French king. His timidity made him impotent in the face of big Roman clans like the Colonnas. Unsurprisingly, he was poisoned, and in 1305 a new pope had to be chosen. This time it was a French cardinal who took the name of Clement V (reigned 1305–14). This was a political triumph for Philippe and the other French cardinals in the Curia, and Clement found the very idea of moving to Rome repugnant.

For, quite apart from the clan hostilities within the Roman elite, Italy itself was close to civil war. It was being shredded by the deadly struggles between Guelph and Ghibelline. Its greatest writer, Dante Alighieri, called it "the abode of sorrow" and "a place of prostitution."

A country so riven by vicious political factionalism was clearly no safe place for a foreign pope, and no Frenchman could forget the attack on Boniface VIII at Anagni—an act of lèse-majesté that could only have happened with the connivance of the Roman nobles.

So it was quite understandable that the French popes of the fourteenth century refused to hold their court in Rome, and set up their own papacy at Avignon. Avignon was not Italian. But neither was it French. It was an enclave within France, independently papal, like the Vatican today, only much larger.

It ruled the territory known as the Comtat Venaissin. A French cardinal could feel much safer there than in Rome, but still be on papal ground.

It is often imagined that to have a pope living outside Rome was an unusual violation of Church custom. This was not true at all. There were lots of precedents for it.

In the century between 1099 and 1198, the pontiffs spent a total of fifty-five years away from Rome, eight of them in France.

In the two centuries from 1100 to 1304, the popes spent an aggregate of 122 years out of Rome, sometimes remaining in Italy, sometimes not.

Gregory IX (reigned 1227–41) passed more than eight years of his fourteen-year papacy away from Rome. Celestine V never saw Rome at all—elected in 1294, he lasted only five months, then resigned, defeated by the intrigues that swirled around him, thus making *"il gran rifiuto,"* "the great refusal," the abandonment of the papacy, for which Dante placed him in the *Inferno.*

Innocent IV (reigned 1243–54) was elected and consecrated in Anagni

but spent no more than a single year in Rome; Boniface VIII spent far more time in Velletri, Orvieto, or Anagni than in the Lateran Palace.

In sum, the only precedent-breaking aspect of the Avignon Papacy was its length—about seven decades. This filled some observers with alarm and foreboding. Papal withdrawal, said one, could be more economically and spiritually disastrous for Rome than even the barbarian invasions. Ferdinand Gregorovius called the Avignon popes "slaves" of the king of France, and this was not an uncommon view among writers and intellectuals at the time. And yet it would be difficult to maintain realistically that the removal of the Papacy from Rome to Avignon was inherently bad for the Church. In some ways, it even meant its improvement: the Church turned out to be more readily centralized, with a more efficient administration, from Avignon. But the ostentation of papal life there certainly grated on those who did not benefit by it. The poet Petrarch, who lived in Avignon, was horrified. "Here reign the successors of the poor fishermen of Galilee," he wrote to a friend in 1353.

> They have strangely forgotten their origin. I am astounded . . . to see these men loaded with gold and clad in purple, boasting of the spoils of princes and nations. . . . Instead of holy solitude we find a criminal host and crowds of the most infamous satellites; instead of soberness, licentious banquets; instead of pious pilgrimages, preternatural and foul sloth. . . . In short, we seem to be among the kings of the Persians or Parthians, before whom we must fall down and worship. . . .

Though one might take this for the rhetoric of a disgruntled poet, it was close to literal truth. The papal court at Avignon eclipsed most others in Europe by its sheer extravagance. In the Palace of the Popes, a far more imposing building than the old Lateran Palace in Rome, the floors were covered with splendid Flemish and Spanish carpets, and the walls with silk hangings. The popes and their swarms of courtiers ate from gold plate and trays, lidded goblets, ewers, sauce boats, and flagons, using gold cutlery with handles of jasper or ivory. Pope Clement V's stock of plate weighed seven hundred marks or 159 kilos; that of Clement VI, in 1348, weighed almost two hundred kilos. Their clothes were tailored from the richest materials: silk from Tuscany, gold Venetian brocade, white woolen cloth from Carcassonne, linen from Rheims and Paris trimmed with ermine or sable. Fur was used with abandon: Pope

Clement VI had 7,080 ermine pelts in a new wardrobe that included several capes and no fewer than nine birettas (fur-trimmed hats).

Nor did the Avignon popes keep frugal tables. Their feasts were catered on a royal scale which, if anything, surpassed the extravagance of the Burgundian courts. In November 1324, Pope John XXII gave a wedding feast for the marriage of his grandniece, Jeanne de Trian, to the young nobleman Guichard de Poitiers. It is uncertain how many guests were invited, but they were served 4,012 loaves, 9 oxen, 55 sheep, 8 pigs, 4 wild boars, 200 capons, 690 chickens, 580 partridges, 270 rabbits, 40 plovers, 37 ducks, 50 pigeons, 292 "small birds," 4 cranes, and, rather anticlimactically, only 2 pheasants. They also dealt with 3,000 eggs, 2,000 apples and pears, and 340 pounds of cheese, washed down with 11 barrels of wine.

When the guest of honor was a pope, however, these relative austerities were abandoned. The Italian Cardinal Annibale di Ceccano threw a reception in Avignon for Pope Clement VI in 1343. "The meal," he reported,

> consisted of nine courses, each having three dishes. We saw brought in . . . a sort of castle containing a huge stag, a boar, kids, hares and rabbits. At the end of the fourth course the cardinal presented the Pope with a white charger worth 400 florins, and two rings, one set with an enormous sapphire and the other with an equally enormous topaz. Each of the sixteen cardinals received a ring set with fine stones, as did the prelates and the noble laymen.

After the seventh course, a jousting tournament, lances and horses, was held in the dining hall, and dessert followed:

> Two trees were brought in; one seemed made of silver, and bore apples, pears, peaches and grapes of gold. The other was as green as laurel, and was decorated with crystallized fruits of many colors.

The climax of all this jollity took place outside, where the guests were shown a wooden bridge over the nearby river Sorgues. This dummy structure seemed to lead to the scene of further festivities, but once it was thickly crowded with monks, nobles, and other guests, it collapsed and "the artless sightseers all tumbled into the water"—one of those coarse practical jokes of which medieval humor was so fond, like the *giochi d'acqua* (water games) which were among the hazards of Renaissance gardens.

While such things were going on in Avignon, the very opposite was happening in Rome. There, the continued absence of the popes, the Curia, and the general life of the Catholic Church had impoverished the city to wretchedness. Suddenly its main business was withdrawn; or, if not withdrawn, then brought to a near-standstill. The contrast between the misery of the Eternal City and the luxuries of Avignon only got worse as time went by. The withdrawal of the papacy effectively deprived Rome of its chief occupation—the effect was comparable to what might happen to modern Los Angeles if the whole entertainment industry, the production and promotion of movies, TV, pop music, were suddenly wiped out. The economy stagnated, and the population plunged. Grass grew in the streets. No pilgrim was safe. License and disorder reigned. The rivalries fought out between the powerful clans of the city, the lawless aristocrats named Colonna, Savelli, Orsini, Caetani, multiplied in number and violence. Bandits who enjoyed the cynical protection of these big shots could not be controlled; no lawful traveler or trader was safe on a Roman street. It seemed that Rome was going bankrupt and careening into anarchy. Then, as sometimes happens, the fermentation of chaos and greed threw up what appeared to be its own antidote—from below.

His name was Nicola Gabrini, and his origins could scarcely have been humbler. His parents were both Romans: mother a washerwoman, father a small-time tavern keeper, Lorenzo Gabrini. In the usual Italian way, his first name was shortened and attached to his father's, so that he became known as Cola di Lorenzo—Lorenzo's boy Nicola. There was nothing in his background to suggest the powerful and idealizing effect he was destined to have on Rome, and on Italy in general. But Cola di Rienzo had a vision of Rome, of what it had once been and might become again. He yearned for Rome to rise from the squalor to which the disappearance of the popes to Avignon had condemned it, and become once more the *caput mundi,* the capital city of the world.

Cola was born in Rome around 1313, and spent his early years in Asnani. He advanced rapidly, becoming a promising notary, and although he had not traveled, he had read widely in the classics, particularly Livy, Seneca, and Cicero; he studied the inspiring monuments, those traces of Rome's vanished greatness. Enthusiasm is the best teacher, and Cola was filled with it. He had found his life's mission early.

He also had a religious vision, not merely an antiquarian one. He was inspired by religious men he came to know, the *fraticelli* or spiritual brothers who were given to proclaim that the age of the official Church

had come to its necessary end, and that a new age, presided over by the Holy Ghost, was dawning. No doubt this belief was reinforced, for Cola, by a mission on which he had been sent in 1343 to Pope Clement VI in Avignon. There he was able to witness very clearly and with his own eyes the corrupt extravagance of the Avignon Papacy, and contrast it with the brutal and impoverished state of Rome, so weak and so exploited by its own aristocracy.

He returned to Rome in about 1344 and soon gathered around him a group of young, like-minded men, all determined to work for public honesty and social justice. He hated the Roman aristocracy (on principle, but also because one of its members had murdered his brother) and was resolved to lead a revolt against them. The stage was now set for the emergence of the first popular leader the city had had since antiquity.

In May 1347, on Whitsunday, the coup was detonated. Promising a general assembly of citizens on the Capitol, Cola di Rienzo appeared before the crowd, magnificent in full armor, and led a huge procession to the ancient focus of Roman power and Roman rights. He harangued the people—*his* people, it was at once clear—"with fascinating eloquence," on the glorious past, present servitude, and future deliverance of their Rome. He unrolled a series of new and more just laws for the governance of the city. The crowd of Romans acclaimed him as its tribune— *"Nicholaus, severus et clemens, libertatis, pacis, iustitiaeque tribunus, et sacrae Romanae reipublicae liberator"* "Nicola, strict and merciful, tribune of freedom, peace, and justice, and liberator of the sacred Roman Republic." The corrupt nobles simply melted away in fear, leaving the young hero in command of the city and its people.

A honeymoon period followed, but it did not last very long. In July, Cola proclaimed the sovereignty of the Roman people over the rest of Italy and sent letters to all its chief cities, demanding that they send legates to what was meant to be a general congress in Rome, to ratify what he conceived as his dictatorship over the whole peninsula. This was a fantasy. Cola's assumption of national power was taken seriously in some places, such as the Kingdom of Naples. In others it was not: what kingdom with its own traditions was going to bow the neck to Rome on the say-so of one Roman tribune? Nevertheless, later in 1347, the delegates of twenty-five cities did converge on Rome, and stood in homage before Cola. A magnificent procession to the cathedral, San Giovanni in Laterano, was formed, and Cola bathed in the enormous font in which Constantine had been baptized a Christian—a ceremony gravid with the

deepest meaning, signifying, in effect, that Cola had assumed the powers not only of a tribune but those of an emperor. This, he announced, symbolized the "rebirth of Italy," and he audaciously told the papal representative that in future he, Cola di Rienzo, could govern Rome without help (or, as he saw it, interference) from the pope.

No such announcement had ever been made before, and its hubris marked the turning point in Cola's fortunes. The noble families of Rome, which hated him, now had papal approval to stir up trouble afresh. In November, having gathered an army, Cola went to battle with the nobles' forces outside the Porta Tiburtina, and succeeded in killing their ringleader, Stefano Colonna. But he had underestimated Pope Clement, who issued a bull of deposition calling him a heretic and a criminal, even a pagan. On December 15, 1347, the bells on the Campidoglio began discordantly to chime and a crowd assembled, shouting, "*Popolo! Popolo!* Down with the tribune!"

Cola lost his nerve. Fearing a revolt, he fled to Castel Sant'Angelo, shed his insignia, and, in plain clothes, ran for refuge in Civitavecchia, the port on the Tyrrhenian forty miles north. From there, after some delays and confusion, he abdicated his tribuneship, retreated into deeper exile—first to Naples, then in among the *fraticelli* of the Apennines. Among these monastic followers of the pious, radical mystic Joachim di Fiore, he waited out a manhunt by papal troops for two years.

By then he was even more strongly convinced that he had been chosen, not only by the Romans but by the Holy Ghost, to lead Italy back to virtue and toward the unity it had never had. He wrote a plan full of apocalyptic visions for the reform of the Church and the regeneration of the world, and in 1350 presented it to the Emperor Charles IV in Prague, urging him to invade Italy and make Cola the imperial vicar of Rome. Unimpressed, the emperor clapped him in jail, kept him there for a year, and then handed him over to the tender mercies of Pope Clement, who was delighted to have this unstable populist rebel in his clutches at last.

Cola was surrendered to the papal authorities in Avignon in August 1352, tried before a trio of cardinals, and sentenced to death. But he was not executed; he was kept in prison (despite eloquent but vain pleas from Petrarch for his release), and, in another of the dizzying turns of fortune's wheel, he was saved by the sudden death of Pope Clement at the end of 1352. The succeeding pontiff, Innocent VI, who detested the Roman nobles, pardoned Cola, released him, and appointed him senator.

Cola went money-raising in Perugia, one of the cities which had sup-

ported his quest for Rome's *imperium* over Italy. He raised enough cash to hire a force of five hundred mercenaries, and in 1354 he led them in a march on Rome.

At first the populace greeted him as a liberator, but this illusion soon dissolved. Cola's apocalyptic fantasies, nourished in hiding among the monks of the Apennines, had taken him over. His tribune's rule showed signs of increasing tyranny, with arbitrary arrests, executions, and bombastic pronouncements. At last the people who had once adored him had had enough. A mob besieged Cola's palace on the Campidoglio and set it on fire. In disguise, Cola escaped—but he was recognized almost at once, near the top of the great flight of 124 steps that he himself had built up the flank of the Capitoline Hill, leading to Santa Maria in Aracoeli. The mob butchered him with its daggers. It must have been a scene worthy of Sergei Eisenstein. In fact, in his short life and violent death, Cola di Rienzo provided more material for fiction, verse, and drama than any Roman since Julius Caesar. Petrarch addressed one of his most beautiful odes, "Spirito gentil," to his memory. In the nineteenth century he fueled the dreams of republicans and became a Romantic hero, the quintessence of the leader raised from humble origins by a grand fate. To Byron he was heroism incarnate, and he was the hero as well of a novel, no longer read but popular in its day, *Rienzi: Last of the Tribunes* by Edward Bulwer-Lytton. Richard Wagner wrote an opera about him, *Rienzi* (1840). Indeed, one might almost say that he was commemorated not only in art but in real life. The twentieth century would produce in Rome the man who seemed, in so many ways, the only successor to Cola di Rienzo: Benito Mussolini, another "vertical invader" from the lower classes, who would convulse all Italy with his apocalyptic dreams of a historical revival centered on Rome.

6

Renaissance

The overwhelming fact about architecture—the built, manmade environment—is that it tends to be the first thing you see in cities. It gives them their character. It is a thing in the world, irrefutably present, not an illusion like painting. So when we mention the word "Renaissance," it is the architecture that comes to mind as the most potent symbol of that spirit of rebirth that swept European culture starting in the fourteenth century. Architecture refers, first and foremost, to large manmade things which afford shelter and gathering places to social groups and have a clear-cut political intent behind them. At the same time, the origin of these things, their roots, are often deeply buried and obscure. No single person "invented" Gothic architecture, and we will never know who was the first to lay a horizontal tree trunk across the tops of two vertical ones. But there has never been much dispute about who was the "father" of Renaissance architecture. He was Filippo Brunelleschi (1377–1446), the son of a Florentine notary, who was (in Vasari's words) "sent by Heaven to invest architecture with new forms, after it had wandered astray for many centuries."

The new forms, of course, were old forms: those of ancient Rome. This picture of Brunelleschi as a savior sent from on high to redeem the art of building and rescue it from the barbarous, pointy-arched Gothic squalor into which it had fallen may seem, to put it mildly, a little simplified today—but, as far as the sixteenth and seventeenth centuries were concerned, it was the plain and only truth. Everything Brunelleschi designed and built, from the Ospedale degli Innocenti and the Pazzi Chapel to

the immense octagonal dome of Santa Maria del Fiore, the cathedral that dominates the city, was done in his native Florence. But many of their prototypes, the structures and remnants by which his architectural thought was stimulated, were in Rome. Brunelleschi was no copyist, but he was wide open to inspiration from the remote past. The great dome of ancient Rome, the Pantheon, is not like Brunelleschi's dome on Santa Maria del Fiore. It is a structure that relies entirely on mass, whereas Brunelleschi's dome is a highly sophisticated framework covered with a membrane. Nevertheless, Brunelleschi derived his language of building *all'antica* from Rome, and part of the excitement his buildings still transmit comes from the rapturous sense of making the old new which accompanied his discovery of ancient architecture in Rome.

Curiously, although early humanists had talked quite a lot about the physical antiquities of Rome, none of them seem to have made a concentrated effort to examine and record the ruins before Brunelleschi. Ancient Roman texts, inscriptions, and manuscripts, eagerly sought and examined by literary humanists, were of course a different matter.

Little is known about Brunelleschi's early life, but certainly he did not begin as an apprentice architect. Though his father expected him to be a civil servant like himself, the son showed early artistic ambitions, enrolling in the Arte della Seta, the Silkworkers' Guild, among whose members were goldsmiths and bronze workers. He had a vocation for work in gold and semi-precious metals, diligently turning himself (wrote his first biographer, Antonio Manetti, 1423–97) into "a perfect master of niello, enamel, and colored or gilded ornaments in relief, as well as the cutting, splitting, and setting of precious stones. Thus in any work to which he applied himself . . . he always had wonderful success." In 1398, he was recognized as a master goldsmith. His first important building, the Ospedale degli Innocenti, or Foundlings' Hospital, in Florence, was paid for and commissioned by the goldsmiths' guild in 1419 and finished around 1445. With its long portico of round arcades carried on eight-meter-high Corinthian columns, it was the first clear echo of classical Roman architecture in Florence. It had resulted from a study trip Brunelleschi had made with his friend the sculptor Donatello to Rome, after they had both been narrowly defeated by Lorenzo Ghiberti in the competition for the design of the east doors of the Baptistery of Florence Cathedral. Manetti has the disappointed Brunelleschi reflecting, "It would be a good thing to go and study where sculpture is really good," and so, around 1402–4:

He went to Rome, for at that time there were plenty of good things that could be seen in public places. Some of the things are still there, though few. Many have since been stolen . . . by various pontiffs and cardinals, Romans and men of other nations. While looking at the sculpture, as he had a good eye and an alert mind, he saw the way the ancients built and their proportions. . . . He seemed to recognize quite clearly a certain order in their members and structural parts. . . . It looked very different from what was usual in those times. He proposed, while he was looking at the statues of the ancients, to devote no less attention to the order and method of building.

It must have been one of the great dramas of discovery in art's history, a Quattrocento buddy movie: Brunelleschi and Donatello, one at each end of the measuring string, flushed with effort and determination, clambering over the ruins, chopping aside the entangling bushes and creepers, measuring heights, widths, and spacings, tirelessly noting inscriptions, discovering a lost Rome. It requires a real effort of imagination to envisage what Rome looked like in those far-off days. The Forum was a kind of wilderness with ruins, commonly referred to as the Campo Vaccino— the Cow Pasture—which it actually was, with animals grazing about. Shops, restaurants, workplaces—forget them. One traversed the place by stumbling hither and thither. Nothing was self-evident, as Roman ruins are today. The city was a jumble of fallen old columns and ruinous early walls, collapsed vaults, broken arches. The Roman natives who saw them at work on their quest for "the excellent and highly ingenious building methods of the ancients and their harmonious proportions" thought they were nothing more than crazy treasure-hunters—which in a sense they were. "Neither was bothered with family cares because neither had a wife or children. . . . Neither was much concerned with how he ate, drank, lived, or dressed himself, provided he could satisfy himself with these things to see and measure."

In this way, the bones of the Eternal City surrendered their secrets to Brunelleschi and Donatello, even though the latter, wrote Manetti, was not much interested in architecture as such: "Together they made rough drawings of almost all the buildings in Rome. . . . They had excavations done in order to see the joinings of the parts of the buildings, and whether those parts were square, polygonal, or perfectly round, circular or oval. . . . From these observations, with his keen vision, [Brunelle-

schi] began to distinguish the characteristics of each style, such as Ionic, Doric, Tuscan, Corinthian, and Attic, and he used these styles . . . as one may still see in his buildings."

A powerful aid to doing this was the new system Brunelleschi was working out for representing solid objects in depth, known as linear perspective, which relies upon the fact that objects seem to get smaller the farther they are from the viewer's eye. If a reliable way could be found to create this illusion by constructing it on a flat plane, such as the surface of a panel or a sheet of paper, then it would be possible to represent the world and its contents, such as buildings, in a coherent and perceptually accurate manner. Brunelleschi's systematic researches were taken up by another architect—though he was much more than that—Leon Battista Alberti (1404–72). Showing the world in this way enabled the artist to give his scenes a new credibility, with what seemed to be real people moving in real space, and even, startlingly enough, showing real emotions to one another. Wrote Alberti in a 1435 treatise on painting:

> I like to see someone who tells the spectators what is happening there; or beckons with his hand; or menaces with an angry face and with flashing eyes so that no one should come near; or points to some danger or marvelous thing there and invites us to weep or laugh together with them.

In Alberti's eyes, perspective was not merely a means toward illusion—it was a tool of empathy. It helped give painting, and its representation of architecture, the dignity of a "liberal art" and raised both above the domain of mere craft.

Truth of representation, allied with a scientific and pragmatic fascination with the forms of antiquity—such was the beginning of Renaissance architecture. Its canonical early buildings were raised not in Rome but in Florence; yet they would not have existed without the examples of Roman antiquity, as interpreted by Brunelleschi and Alberti.

Alberti's likeness was cast in a bronze medal in 1454–56 by the sculptor Matteo de' Pasti. On one side is a profile portrait of Alberti, a strikingly handsome man of fifty. The reverse shows his *impresa* or heraldic device, a flying eye with flames bursting from its corners, carried on wings, like Jove's thunderbolt—speed and acuity of perception. Around it is a laurel wreath, declaring his certainty of success. And below, the motto QUID TUM, "What next?" It is a declaration of man's faith in the future, in the power of human invention. Nobody could have deserved it more than

Leon Battista Alberti, for, if anyone gave meaning to the term "Renaissance man," it was he. He was architect, theorist, sculptor, painter, archaeologist, and writer; his subjects included such matters as cryptography and family ethics, as befitted someone used to the close-knit and often secretive world of Renaissance courts. He contributed much to the use of vernacular Italian, as distinct from Latin, in prose writing. He composed the first Italian grammar. He wrote treatises—the first since Vitruvius in antiquity—on architecture, painting, and sculpture. Moreover, he is said to have been an outstanding athlete, and he even wrote a treatise on horses, *De equo animante.* He designed some of the most beautiful and visionary buildings of the fifteenth century: in Florence, Palazzo Rucellai (c. 1453) and Santa Maria Novella (1470); the Tempio Malatestiano (1450) in Rimini; commissioned by Lodovico Gonzaga, the churches of San Sebastiano (1460) and Sant'Andrea (1470) in Mantua. But in Rome itself, he did nothing except restoration. His literary masterpiece was the ten books of *De re aedificatoria,* the first comprehensive treatment of Renaissance architecture ever published, and the first treatise written on classical architecture since antiquity. Its effect on architects—at least on those who had Latin, since Alberti did not write it in vernacular Italian—was as wide and fundamental as Vitruvius' had been. Indeed, it has a serious claim to be the most influential text on architecture ever written.

Although he did not build in Rome, Alberti had great influence there, and his medium for it was the pope, Nicholas V (1397–1455). Born Tommaso Parentucelli, this new pope, who ascended the papal throne in 1447, four short years after Alberti had settled in Rome as a member of the court of Pope Eugenius IV, was a humanist like Alberti, and had been his friend since their university days in Bologna. Both men in earlier years had served the Florentine grandee Palla Strozzi as a tutor. Vasari affirmed that Nicholas had "a great, resolute spirit, and knew so much that he was able to guide and direct his artists as much as they did him."

Just how this translated into practice is not certain. Without doubt, Nicholas V and Alberti talked often and long about architecture and town planning—so long and so often that the pope became the natural person to whom Alberti would dedicate and present *De re aedificatoria.* "By God!" Alberti wrote at one point. "I cannot but rebel sometimes when I see monuments, which even the wild barbarians spared for their beauty and splendor, or even time itself, that tenacious destroyer, would willingly let stand forever, falling into ruin because of the neglect

(I might have said the avarice) of certain men." And to mitigate this constant erosion of Rome's historical fabric, he began to collect all the knowable facts about the city's monuments and to present them in a way that made preservation possible, if not easy. His friend the pope was all in favor of that work of memory.

Unlike many of his predecessors—all of whom were of course literate, but some not much more than that—Nicholas V was a ravenous bibliophile. "He searched for Latin and Greek books in all places where they might be found, never regarding the price," wrote Vespasiano da Bisticci (1421–98), who would have known, being the principal bookseller of Florence.

> He collected many of the best scribes and employed them. He brought together a number of learned men and set them to produce new books, and also to translate others not in the libraries, rewarding them liberally. . . . Since the time of Ptolemy there had never been collected such a store of books.

Nicholas's book-collecting enthusiasm formed the basis of the Vatican Library, and cost a fortune. Thus he became "the ornament and the light of literature and of learned men, and if after him there had appeared another Pope following in his footsteps, letters would have achieved a position worthy of them." This did not happen, because later popes did not entirely share Nicholas's bibliomania. But even his library building was quite modest compared with his architectural enterprises. Vespasiano da Bisticci remembered how Nicholas "used to say that he would like to do two things, if ever he had the money: form a library and build, and he did both during his pontificate."

The formation of the library was quite gradual. In the mid-fifteenth century, it consisted of only 340 volumes, two in Greek. Modern scholars point out that Nicholas V was the first pope to give the formation of the papal library a high priority, but by 1455 its collection amounted to no more than 1,160 books; there were others in Italy the same size or bigger. The honor of being the true founder of the Vatican Library as an institution, therefore, goes to a later pope, Sixtus IV, who was lucky enough to have the scholar Bartolomeo Platina as his librarian (1475–81). Later expansions, particularly that of Leo X in the sixteenth century, would far surpass that. Yet Nicholas certainly had the vision of a library for the Vatican, "for the common convenience of the learned," and nobody could accuse him of stinginess. He even carried a bag with hundreds

of florins in it, which he would give away by the handful to people he thought deserving.

Leon Battista Alberti he thought particularly deserving. Alberti stood out for two reasons.

First because, in addition to his other writings, he composed a *Descriptio Urbis Romae*, a *Description of the City of Rome*, which covered the main buildings of antiquity and the principal churches built during the Christian Era, along with the city walls and gateways, the course of the Tiber, and other matters. This was a huge step up from what had been the only guidebook to the antiquities of Rome, the legend-infested *Mirabilia*, or *Marvels*, of the Eternal City, a text infested with hearsay and extreme inaccuracies. Alberti's guide became a much-needed prelude to the Jubilee year of 1450 which Nicholas had just announced. "There was not the least remain of any ancient structure," Alberti would write with pardonable pride, "that had any merit in it, but what I went and examined, to see if anything was to be learned from it. Thus I was continually searching, considering, measuring, and making draughts of everything I could hear of, until such time as I had made myself perfect master of every contrivance or invention that had been used in those ancient remains." It is probably no exaggeration to say that Alberti ended up knowing more about ancient Roman building than most ancient Romans had.

The second reason lay in the pope's own archaeological interests. In addition to all his other talents, Alberti had the novel distinction of being the world's first underwater archaeologist. The object of his search was an ancient Roman galley from the time of Trajan, which 1,300 years before had sunk, presumably during a *naumachia*, a mock naval battle, to the muddy floor of Lake Nemi. Its location was known because it kept fouling fishermen's nets. But nobody had figured out a way to raise it, and without underwater goggles divers could not see more than a vague bulk looming in dark water. Commissioned to do so by Cardinal Prospero Colonna, Alberti brought it up with grappling hooks, cables, floating barrels, and winches. Only the prow came clear of the water before the hull broke in half and sank again, and Alberti was able to observe—the first account of ancient Roman naval construction—that it was built of pine and cypress "in an excellent state of preservation" and covered with tar-soaked linen, which was then sheathed in lead secured by bronze nails.

Although this feat must have caused a good deal of buzz and flutter in court circles, what most cemented Alberti's position as Nicholas V's

adviser on building was his large and ever-growing knowledge of architecture, its theory, practice, and history. In addition, he had no illusions about whom he was designing and, if possible, building for. "Do everything possible," he exhorts the reader,

> to obtain commissions only from the most important people, who are generous and true lovers of the arts. For your work loses its value when done for persons of low social rank. Can't you see the advantages to be had in the furthering of your reputation if you have the support of the most influential people?

Moreover, "the safety, authority, and decorum of the state depend to a great extent on the work of the architect." With the patronage and encouragement of Nicholas V, Alberti became the successor to Brunelleschi, with the difference that he was also the first architect of the Renaissance papacy. (Brunelleschi, despite his great influence on other architects, did not design for popes.) Certainly, though Alberti believed in the supremacy of Roman norms and forms, he also believed strongly in individual taste and would never have considered imposing a strict, formulaic canon of beauty. A building might well have the proportions of a human being, but what kind of human?

> Some admire a woman for being extremely slender and fine shaped; the young gentlemen in Terence preferred a girl that was plump and fleshy; you perhaps are for a medium between these two extremes, and would neither have her so thin as to seem wasted with sickness, nor so strong and robust as if she were a Ploughman in disguise, and were fit for boxing: in short, you would like her such a beauty as might be formed by taking for the first what the second might spare. But then, because one pleases you more than the other, would you therefore affirm the other to be not at all handsome or graceful? By no means . . .

It seems fairly certain that Alberti had the strong hand in crucial restorations of a dilapidated Rome, although we do not know how many. Nicholas had ambitious plans for the city's renovation. One of the keys to it was the aqueduct of the Acqua Vergine, which had been so important to the water supply of the ancient city. Now tracts of it had fallen in, and much of the rest was blocked by sinter or accumulated lime deposits. Those who lived in districts once served by the Acqua Vergine were obliged to drink the filthy water of the Tiber, teeming with bacteria.

Prompted by Alberti, Nicholas V ordered a complete rerouting of the aqueduct, entering Rome near the Porta Pinciana and finishing at the Campo Marzio in three outlets called the Fontana di Trevi, designed by Alberti but later to be demolished and replaced by Nicola Salvi's enormous stone festivity, into which Anita Ekberg waded for Fellini's camera and generations of tourists threw their coins.

Alberti oversaw the restoration of the Ponte Sant'Angelo, which brought traffic across the Tiber to the Castel Sant'Angelo, formerly Hadrian's Tomb. He was also busy restoring ancient and infirm churches for Nicholas V, such as Santo Stefano Rotondo, the circular church with its majestic ring of internal columns erected in early Christian times.

Nicholas V had no doubts about the importance of architecture—a new architecture, one which would center and stabilize the faith of Christians. In 1455, he declared:

> To create solid and stable convictions in the minds of the uncultured masses there must be something that appeals to the eye. . . . A popular faith sustained only on doctrines will never be anything but feeble and vacillating. But if the authority of the Holy See were visibly displayed in majestic buildings, imperishable memorials . . . belief would grow and strengthen like a tradition from one generation to another, and all the world would accept and revere it.

But the great work on which Nicholas V and Alberti hoped to embark was the replanning and construction of Saint Peter's, the navel of Christianity. By the fifteenth century, Constantine's original basilica was in poor repair, and Alberti saw that whole sections of it had to be rebuilt. "A very long, big wall," he noted, "has, very unadvisedly, been built over a number of large voids," with the result that the buffeting of north winds over the centuries had pushed it six feet out of plumb—so that any extra pressure or subsidence could bring it crashing down. Alberti recommended that the whole wall be bound in with new masonry, and Nicholas ordered that more than two thousand cartloads of building stone be quarried from the Colosseum and brought to the site of Saint Peter's. But the gigantic task of rebuilding the old Constantinian basilica was not achieved; the pope died, and the responsibility for the great church passed into other and even more ambitious papal and architectural hands.

The architectural ones were those of Donato d'Angelo (1444–1514), commonly called Bramante—a nickname that meant "Ardent" or

"Intensely Desiring." (His maternal grandfather had been nicknamed Bramante, too: perhaps intensity was a family trait.) He was a farmer's son, born in a village of the Papal States near Urbino. He undoubtedly witnessed the construction of the Ducal Palace, and he would have had some contact with artists who attended its highly cultivated court at the invitation of its ruler and patron, Federigo da Montefeltro, including Alberti and such figures as Piero della Francesca. He was one of a constellation of early-Renaissance figures who were born in or around the 1440s—Perugino, Botticelli, Signorelli, and, in 1452, Leonardo da Vinci. Later, when he moved to Milan, he came to know Leonardo, but how well one cannot say. Probably a small book on ancient Roman architecture that appeared anonymously around 1500 and was dedicated to Leonardo was by Bramante. Certainly both men worked for the Sforza court in Milan in the 1490s. Presumably Bramante got his introduction to Duke Ludovico through his aunt Battista Sforza (d. 1472), who had married Federigo da Montefeltro. Bramante was to spend more than two decades in Milan, doing some building for Duke Ludovico Sforza. He did not become a star there; as an outsider to the city, he did not secure the big commissions. However, he did design the church of Santa Maria presso San Satiro, and was involved with the design of the Milanese monastery and church of Santa Maria delle Grazie, where Leonardo painted his disastrously ill-preserved *Last Supper*—that now almost vanished icon of the High Renaissance. Bramante designed a tribune at the end of the nave which was originally meant to be a mausoleum for the Sforzas.

Bramante's move to Rome we owe to political history. When the French armies marched into Milan in 1499, they expelled the duke and dislocated the city's cultural life entirely. They also perpetrated what is doubtless one of the greatest crimes against art ever committed; Leonardo's clay model for the giant bronze horse which was to be the monument to Gian Galeazzo Sforza, Ludovico's father, ignominiously fell to pieces after the French crossbowmen used it for target practice—a great loss indeed. Bramante and the bitterly frustrated Leonardo, were among the figures who left for Rome, and Milan's loss was very much Rome's gain. Like any other architect of talent, Bramante was soon absorbed in the grandeur and purity of its ancient structures.

Quite soon, Bramante's obvious talents would be snapped up by one of the great "building popes" of the Renaissance, Pope Julius II. But he designed several nonpapal buildings first, and the most significant of them was hardly bigger than a summerhouse—a diminutive domed circular

temple in the courtyard of the Spanish Franciscan convent and church, the Tempietto of San Pietro in Montorio, up on the Janiculan Hill. This may have been inspired by the ancient Temple of Vesta in Rome. The sixteen columns of its outer ring are all Doric, the order considered most suitable for commemorating robust and virile heroes, which Peter, no plaster saint, certainly was. Bramante worked to a modular scheme originally set out as a recipe for internal harmony by Vitruvius—all the chief dimensions, such as the diameter of the interior, are multiples of the column diameters. The *tempietto* is the first completely Doric building of the Italian Renaissance, as another pioneer architect, Sebastiano Serlio, pointed out: "We should give credit to Bramante, seeing that it was he who was the inventor and light of all good architecture, which had been buried until his time, the time of Julius II."

Julius II was the name taken, at his election to the papacy by the College of Cardinals, by Giuliano della Rovere (1443–1513). This impatient, bellicose, and thunderously energetic man was the greatest patron of art the Roman Church had ever produced, and he would remain so until the partnership of Urban VIII Barberini and Gian Lorenzo Bernini more than a century later. His architect was Bramante, his sculptor Michelangelo, his painter Raphael.

This trio formed, without much question, the most remarkable body of artistic talent ever assembled by a single European man.

Raphael frescoed his suite of private papal apartments on the second floor of the Vatican, the chief one of which was known as the Stanza della Segnatura because in it Julius signed his name to essential documents. Some think that Julius himself, rather than Raphael, chose the narrative of images for these rooms.

As for Michelangelo, Julius was by far the most important, if difficult, client he ever had—just as Michelangelo was the most difficult and important artist Julius had ever employed. The sculptor embarked upon a colossal and never-to-be-finished project for Julius' tomb in the Church of San Pietro in Vincoli. He very reluctantly frescoed the ceiling and end wall of the chapel in the Vatican which, having been built by Julius' uncle Pope Sixtus IV (reigned 1471–84), was known as the Sistine, and later decorated the Pauline Chapel, also in the Vatican, with scenes of the conversion of Saint Paul and the crucifixion of Saint Peter.

And Bramante—an aging man when he came into Julius' employ, more than sixty years old—took on the Herculean task of finishing the work Alberti had started, creating a new symbolic center for Christian-

ity by demolishing Constantine's Basilica of Saint Peter and building an entirely new one. It would be the biggest church in the world.

That Julius II was a monster of will and appetite has never been in doubt. You could not defy him with much hope of survival, let alone success. He was known to his court and the rest of Rome as *il papa terribile*, the terrifying pope—or, if you wanted to shift the meaning an inch or two, the dreadful father. He did not call himself Julius for nothing. His model was antiquity's Julius the First—the all-conquering, all-seeing, all-remembering, and godlike Julius Caesar, conqueror of Europe and remaker of Rome, *Roma triumphans,* the city around which the rest of the world turned. Julius II was determined to restore, not just superficially refurbish, the scope of the Catholic Church's political power, which had suffered all-too-apparent losses through the translation of the Papacy to Avignon.

For this, it was necessary to expand the Papal States, an effort which could be tried by diplomacy but only underwritten by military force. Thus Julius II became the first and last pope to lead an army from horseback, wearing plate armor. (His papacy also brought the foundation, on January 21, 1506, of the Swiss Guard, who today are merely pushy Vatican cops with flapping yellow uniforms but in the sixteenth century were a serious force of halberdiers dedicated to protecting the person of the pope—an ecclesiastical Praetorian Guard.)

Much of the money for his military enterprises came from Italy's textile industry. The dyeing of cloth requires a fixative, which in the sixteenth century was a mineral, alum. Most alum had come from Turkey, but large deposits of it were to be found north of Rome, in an otherwise unremarkable spot named Tolfa. The mines of Tolfa, with their virtual monopoly on the mineral, rose with the textile trade and so were a large source of income for the Papacy.

In 1503, when Julius was elected pope, the city of Rome was in difficult straits. In some respects it hardly functioned at all as a city—it lacked a strong central government and was divided up into quarrelsome and isolated districts, run in an improvised way by the entrenched heirs of medieval clans. It was plagued by crime, particularly in the dock areas of the Tiber, the Ripa and the Ripetta, where trade was dominated by mafiosolike thugs. Some banks had closed, unable to hold up against the creeping devaluation of the currency. The price of corn had doubled. The ancient system of water supply was near collapse, despite Nicholas V's earlier efforts to fix it. There were frequent outbreaks of plague. Some

riverside parts of Rome had turned malarial—even Julius II had a bout of malaria, though not a grave one.

Against this background, Julius' actions, even if resented by many Romans, made considerable sense. He stabilized the price of bread by setting up public bakeries. He brought in cheap grain from Sicily and France, he prohibited immigration, tightened the screws of tax collection and confiscated the estates of several immoderately rich cardinals who had conveniently died. They were replaced by newly appointed cardinals, all friends of Julius, who were also rich but could be relied on to obey him. And of course the Church was directed to wring every penny it could from the sale of indulgences, that abusive and superstitious practice by which the faithful could supposedly buy remission from Purgatory in the next life by giving hard cash to Rome's agents in this one. "When you open your purse strings and the cash bell rings, the soul flies out of Purgatory and sings." Disgust at the indulgence trade would be one of the forces that drove the Protestant Reformation, but at first the Catholic hierarchy did not realize how furious an industry it was growing to be. Thanks to these emergency measures, the papal treasury, which had about 300,000 ducats in 1505, rose to 500,000 in 1506.

Julius was lucky to have a close friend and astute money manager in the Sienese papal banker Agostino Chigi (1466–1520), recognized as the wealthiest merchant banker in Europe, who had more than a hundred offices spread from Cairo to London and at one point held the papal tiara in pawn as security on his loans.

Thus Julius was able to indulge his appetite for Caesarian glory. This became especially clear after the papal armies annexed Bologna and expelled its Bentivoglio rulers in 1507, when an imperial procession exactly reminiscent of the original Caesar's triumphs was arranged for him in Rome; along streets flanked by cheering crowds, he rode under triumphal arches to the Capitol. In 1504, a new and revalued silver coin bearing his portrait and known as the "giulio" was minted in his honor. The following year, Julius II commissioned from Michelangelo an enormous figure of himself, which was mounted on the façade of the Bolognese Church of San Petronio, but three years later, when his forces lost control of the city, this bronze giant was torn down, broken up, and recast as cannon. But by then Julius' attention was preempted and occupied with other projects by Michelangelo, as well as by Raphael and Bramante.

Architecture took first place. Through new building on a grand scale,

Julius intended to renovate the "decorum" of Rome, returning the city to the grandeur and authority its ancient buildings had once conferred on it. Julius Caesar had given Rome a renewed spiritual center through his constructions. Julius II would do the same, by rebuilding Saint Peter's on a hitherto unimagined scale.

In 1505, Bramante began a series of additions to the Vatican Palace: the terraces of the Belvedere Courtyard. These were private, of course—indeed, so much so that they were designed to be seen from one main vantage point, the window of the pope's study, the part of the papal apartments overlooking the downhill slope toward the Tiber known as the Stanza della Segnatura. Modeled on the huge imperial palaces of antiquity—Nero's Domus Aurea, Hadrian's Villa—they would tell the visitor that a new Catholic and papal Rome comparable in every way to the old imperial and pagan Rome was on its way. Naturally, Julius wanted this gigantic affair—a hundred meters wide and three hundred long, with its stairs, ramps, formal gardens, arcades, fountains, nymphaeum, and open-air theater—to be finished tomorrow, if not yesterday. It would have the most impressive and precious collection of antique sculpture that existed: the *Apollo Belvedere,* the *Laocoön,* the *Belvedere Torso* were all there. The words of Virgil's Cumaean Sibyl, warning off the ignorant—*"Procul este, profani"* ("Begone, you uninitiated")—were cut into the stone of the spiral staircase ramp near the sculpture court. You could ride a horse up this ramp. Its architrave bears on a series of columns, which get slenderer and more refined as one ascends: the Tuscan order at the lowest level, giving way to the Doric, and then to the Ionic, and finally the Composite.

The fresco of Parnassus was painted on the north wall of the Stanza della Segnatura, above its window. The view from the window was of a part of the Vatican Hill traditionally considered sacred to Apollo. Another part of its mythic history was that Etruscan priests used to watch for auguries and make prophecies (*vaticinia*) from this spot. Hence the name "Vatican" for the general area. The Apollo was installed on the Belvedere as an act of naming, not so much the sculpture as its site. Having Raphael's fresco of Apollo and the Muses right at the spot from which one observed the distant sculpture of Apollo confirmed the mantic tradition of the place, and this was enriched by the further myth that Saint Peter had been crucified there.

The Belvedere, with its size and levels, could almost be a town in itself, and certainly Bramante's town-planning ambitions, though never

fulfilled, were part of his reputation in Rome. Two years after his death, a writer named Andrea Guarna put Bramante in a comedy titled *Scimmia* (*The Monkey*). He dies and arrives at the gates of Paradise, telling Saint Peter—the original pope, one should remember, the prototype of Julius II—that he will not come in unless he is employed to rebuild the whole place:

> I want to get rid of this hard and difficult road that leads from earth to Heaven; I shall build another, in a spiral, so wide that the souls of the old and the weak can ride up it on horseback. Then I think I will demolish this Paradise and make a new one that will provide more elegant and comfortable dwellings for the blessed. If you agree, then I shall stay; otherwise I shall go straight to Pluto's house, where I shall have a better chance of carrying out my ideas. . . . I shall make an entirely new Hell and overturn the old one.

Neither Bramante nor Julius hesitated to get rid of old buildings, however venerable, if these got in the way of their plans. It is no surprise that one of the architect's nicknames was "Bramante Ruinante," Bramante the Wrecker. This was used a lot as he prepared to undertake the biggest project of his life, perhaps the biggest project of any architect's life (unless you count later mile-high skyscrapers in Arab sheikhdoms or mega-airports in China): the design and building of the new Saint Peter's Basilica.

Both the pope and the architect believed, with good reason, that the old building, erected in the fourth century by Constantine, would no longer do. In the reign of Nicholas V (1447–55), a survey had shown its walls were tottering out of plumb, and there was a real danger that an earthquake tremor (to which Rome, in the fifteenth and sixteenth centuries, was more prone than it is today) would bring the whole thousand-year-old fabric down. Both men were conscious of their own mortality, and in fact would die within a year of each other, Julius in 1513 and Bramante in 1514. If history were to remember them as the authors of this colossal enterprise, they would have to hurry. Moreover, they needed to move the project as far along as possible, so that the next architect and the next pope would be stuck with their conception, unable to make radical changes.

Unfortunately, since Bramante did not run an architectural office in the modern sense, there are practically no written or drafted records of how ideas might have passed to and fro between him and Julius, and the

only firsthand record of Bramante's intentions is a drawing known as the "parchment plan," now in the Uffizi. It shows a central dome and two domed chapels, forming a Greek cross, though of course with no indications of size. But there were strong motives for making the basilica enormous, and one can imagine Julius and his architect discussing how, now that Constantinople had fallen (in 1453) to the Turkish infidel and Hagia Sophia had become a mosque, the largest dome should be the center of Christendom. The questions raised by the demolition of a building as venerated as old Saint Peter's would be silenced by the phrase inscribed on a medal depicting its intended elevation: TEMPLI PETRI INSTAU-RACIO. *Instaurare* meant "to restore," "to make new"; the pope and the architect could say that they were only "restoring" the ancient fabric, though of course they were replacing it altogether.

Bramante's inspiration for the new church was essentially Roman, not Florentine. That is to say, it was modeled on the gigantic bath complexes of ancient Rome and, like them, made of concrete and brick, with various facings of marble and limestone. As built, the basilica is 218.7 meters long, its main nave being 26 meters wide and 46 high from floor to roof. The transept is 154.8 meters long. The whole fabric contains 46 altars. It covers an area of 5.7 acres. None of these raw figures gives more than a faint impression of the vastness of a building that can, if the congregation is packed in, hold up to 60,000 people (though not comfortably). For comparison, the Duomo in Milan can hold about 37,000. Saint Peter's dome is the tallest in the world—448 feet from the floor to the top of the external cross on the lantern. In diameter, it is fractionally smaller than the ancient dome of the Pantheon and Brunelleschi's "modern" dome of Florence Cathedral. The tradition that it is built on top of the actual site of Saint Peter's tomb is only that—a tradition, for which there is no compelling historical or archaeological evidence.

Not the least impressive aspect of the cupola was its lighting, splendid and theatrical. Today it is done with electric floods and spots, but from the Seicento to the end of the nineteenth century it was achieved (on special occasions, such as the *festa* of Saint Peter) with a superabundance of several thousand lamps, lanterns, and torches, all of which, on the orders of a theatrical maestro, would be lit simultaneously. Everyone who saw this, before the age of electricity, was astounded by its grandeur. Goethe, who witnessed it, recorded, "If one reflects that, in that moment, the great edifice serves only as the frame of a fantastic orgy of light, one can well understand that nothing else like it can be found in

the world." Rome's vernacular poet Giuseppe Belli echoed this astonishment in a sonnet he wrote in 1834:

> *Chi ppopolo po' èsse, e cchi sovrano,*
> *Che cciàbbi a ccasa sua 'na cuppoletta*
> *Com' er nostro San Pietr' in Vaticano?*
> *In qual antra scittà, in qual antro stato,*
> *C'è st'illuminazzione bbenedetta*
> *Che tt'intontissce e tte fa pperde er fiato?*

"What people, and what sovereign, / Have in their home a little dome / Like that of our St. Peter in the Vatican? / In what other city, in what other country, / Is there this blessed light / That stuns you and takes your breath away?"

The design of the basilica was heavy with liturgical symbolism. Thus (to take only one instance) the early drawings for the church specify twelve doors, alluding to the twelve tribes of Israel and to the twelve apostles. The most essential thing about it, from both Bramante's and Julius' viewpoint, was that it should be based on "perfect" geometrical forms, the square (symbolizing, among other things, earth) and the circle (the heavens), one inscribed within the other. It was not built that way, but in another building by Bramante—not in Rome—one can get some idea, on a smaller scale, of the general effect. This is the far smaller pilgrimage Church of Santa Maria della Consolazione, built on a hillside below the town of Todi, in Umbria. Its dome rises from a drum which in turn rises from a square block, from which grow four polygonal apses, each roofed with a half-dome. There is no town around it; it simply emerges from the earth, flooded with light inside. No mosaics, no statuary, no gilt, no marble: only strong, ideal geometrical form. To have such an interior to oneself, in the light of a spring morning, is to grasp a fleeting sense of what Dante meant— *"luce intellettual, piena d'amore"*: "the light of the mind, suffused with love."

The construction of Saint Peter's took 120 years and lasted for the lifetime of twenty popes. When Bramante died in 1514, he was replaced by Giuliano da Sangallo, Fra Giocondo, and Raphael. Sangallo and Fra Giocondo both died the next year, which left Raphael as the master architect until he, too, died, in 1520.

Antonio da Sangallo now took over the revision of the design, and stayed with it until his own death in 1546, by which time Michelangelo—

old, reluctant, and increasingly infirm—was handed the enormous task. By then Sangallo had built the crossing piers that would support the dome, and vaulted some of the arms of its immense Greek cross.

But the dome itself did not exist yet.

Michelangelo's first step was to cancel Sangallo's plans altogether and tear down whatever structures by Sangallo he did not like.

He wanted to revert to a Bramantean purity, and in a famous letter he sent to the Fabbrica, or Office of Works, of Saint Peter's, he wrote, "Any who have deviated from Bramante's arrangement, as Sangallo did, have deviated from the truth."

Sangallo had cut off all the light from Bramante's plan, or so Michelangelo thought, creating dark corners where nuns could be molested and false coiners could do their nefarious work. In the evenings, when the basilica had to be locked up, it would take twenty-five men to clear out anyone hiding inside. And so, "Winning [the commission for Saint Peter's] would be the greatest loss to me, and if you can get the pope to understand this you will give me pleasure, because I don't feel well." It was no use. Having no choice, Michelangelo accepted, full of misgivings, in 1547. He sent off to Florence for clay and wooden models of its Duomo. These became the first inspiration for the double-shelled cupola of Saint Peter's raised on its sixteen-sided drum. It had come nowhere near completion before Michelangelo died, in 1564. It was eventually finished by Giacomo della Porta in 1590; his design had a somewhat more pointed, upward-reaching quality than Michelangelo's hemispheric outer dome.

Meanwhile, Raphael had been at work inside the Vatican.

Raphael was born in 1483 in Urbino, which, though small, was no cultural backwater. His father, Giovanni Santi, was a painter, attached to the court of its duke. The first duke, the *condottiere* Federigo da Montefeltro, had been ennobled by the pope—Urbino was part of the Papal States—and, largely thanks to him, the town had become what W. B. Yeats would later call "That grammar school of courtesies / Where wit and beauty learned their trade / Upon Urbino's windy hill." As the gifted son of a court artist, Raphael was raised in an environment where polished manners, tact, and all-round *gentilezza* counted immensely; this place, this tiny social world, was to be the model for Baldassare Castiglione's classic manual of behavior, *The Book of the Courtier* (1528). So, although Raphael did not get a top-flight education as a humanist scholar—his Latin always seems to have been a little shaky—he did receive one in

the manners and skills of a court artist. Moving gracefully in high circles was never to be a problem for him, as it often was for other Renaissance painters. Other artists, as Vasari pointed out, might be hampered by "a certain element of savagery and madness, which, besides making them strange and eccentric, had . . . revealed in them rather the obscure darkness of vice than the brightness and splendour of those virtues that make men immortal." Not Raphael.

Of his precocity there was never any doubt. Right from the start, as his earliest surviving drawings (done when he was sixteen or seventeen) amply show, Raphael's hand was both brilliant and disciplined. He was apprenticed to the studio of one of the best-known and most successful painters in Italy, Pietro Perugino (1450–1523). According to Vasari, young Raphael imitated Perugino's style, in all its elegance and sweetness, so closely that their paintings could hardly be told apart; "his copies could not be distinguished from the master's originals." What made him more than an epigone of this fine but provincial artist was a sojourn in Florence, where "he changed and improved his manner so much from having seen so many works by the hands of excellent masters, that it had nothing to do with his earlier manner; indeed, the two might have belonged to different masters."

Clearly, the road pointed toward Rome, where, thanks to Julius' patronage, a new interest in painting, as in architecture, was simmering. It is not known how word of Raphael's existence reached Julius II's ears. Perhaps Bramante, who came from the same part of Italy, recommended him. In any case, by 1508 the young painter, now in his mid-twenties, had been summoned to Rome and given the difficult and prestigious job of decorating the papal apartments in the Vatican Palace. From then until his death, he would be occupied with this commission, which required him to hire more and more assistants, including Giulio Romano—who would presently transfer what he had learned from Raphael about architectural design to Raphael's Villa Madama, in Rome, and about fresco to his own gloriously eccentric masterpiece for the Gonzagas, the Palazzo del Te, in Mantua. Giulio Romano was often accused of vulgarity, but in his hands in Mantua this became a virtue; since he could not incorporate his life-affirming coarseness into Raphael's rooms for the pope, it went instead into the Mantuan frescoes, some of which fairly burst with stylish libido, and the enjoyably pornographic prints he made as illustrations to the work of the bawdy writer Aretino. It hardly surfaced in his Roman work.

The first room Raphael addressed in the Vatican Palace was the pope's library and office, the Stanza della Segnatura. The themes he chose, or was given, were those appropriate to Theology, Poetry, Jurisprudence, and Philosophy.

"Poetry" called, of course, for a scene of the gathering of ancient and near-contemporary genius on Parnassus, grouped around an Apollo, who is making music below his emblematic laurel tree. At the top are his agents, the nine Muses, the Greek deities of astronomy, philosophy, and the arts. The daughters of Jupiter and Mnemosyne, they are Calliope (Muse of the heroic epic), Clio (history), Euterpe (lyric poetry and flute music), Terpsichore (dance), Erato (erotic poetry), Melpomene (tragic drama), Thalia (comedy), Polyhymnia (mime, sacred poetry, and agriculture), and Urania (astronomy). Ancient poets in the fresco include Homer, Virgil, Sappho, Propertius, Horace, and Tibullus. Among the more modern writers, some of whom were Raphael's contemporaries, are Petrarch, Ariosto, Sannazaro, Boccaccio, and of course Dante. It is an anthology of what a person would need to have read before he could call himself civilized.

Traditionally, and rightly, *The School of Athens,* representing "Philosophy," is the grandest of the four compositions in the Stanza della Segnatura. The arch of the wall opens out into a perspective series of further arches: we seem to be in a majestically vaulted but unfinished architectural space. Blue sky can be seen through its gaps, suggesting that the building is the new Saint Peter's, of which Raphael was now the supervising architect. To a sixteenth-century visitor seeing this image for the first time, it would have suggested a pristine Rome, being rebuilt and restored—just what Julius II wanted his papacy to suggest.

It is filled with figures, explaining, arguing, reading, or writing. At their center, the vanishing point of the perspective, two men are advancing toward us. The one on the left, in the red garment, pointing upward, is Plato, indicating to his listeners, and to us, that the source of all ideal form is to be found in the heavens. He is holding a copy of his late work the *Timaeus,* which was devoted to natural science and sought to describe the relationship between gods and man in the world. The world, the *Timaeus* asserts, is eternal, because it is subject to eternal laws. Next to him, Aristotle, in the blue cloak, contradicts this; he points downward, to the earth, indicating that true knowledge is to be found empirically, in the world as it is and its contents as they are. He carries a book inscribed ETH[IC]A—the *Nicomachean Ethics,* regarded by Christianizing human-

ists of the day as the summit of Aristotle's thought. Each man has his eager group of listeners and disciples. The heroes of thought are sometimes given the faces of Raphael's contemporaries. Plato, for instance, has the archetypal-sage features of Leonardo da Vinci.

Raphael wanted his fresco to represent not the physical production of books, but the processes of thinking that go into them and undergird their arguments—along with the buzz of discussion that thought produces. If one man is writing something down, another is reading it over his shoulder. *The School of Athens* is often taken for an image of "classical" composure, but in fact it is almost as animated as a battle piece, crisscrossed with vectors of agreement, exposition, and surprise. In the right foreground is a knot of figures watching a savant with protractors, drawing a geometrical figure on a tablet. He represents Euclid, demonstrating one of his theorems. But his face is that of Bramante, in whose buildings geometry played so large a creative role. In a corresponding position on the steps to the left is Pythagoras, busily writing in a book. Solitary, sitting apart, wrapped in a keep-away melancholy (the saturnine artist in contemplation), is Michelangelo, his pencil poised over a page. What is he thinking about? We don't and can't know—but we know what Raphael has been thinking about, and that is the permeability, the exchange value, of thought itself. And surely he could think about that, and find such a fluid, continuous embodiment for it, because he could draw on the help and interpretive support of the humanists in and around Julius II's court. Perhaps such a painting as *The School of Athens* could be called, in that sense, a collaborative work of art. Other painters worked under Raphael as painting assistants on the Stanza della Segnatura, but who worked with him in deciding its cast of characters and implied themes?

The theme of Raphael's frescoes in the Stanza d'Eliodoro is broadly political. They represent God's way of protecting His Church from various possible threats.

Is its wealth threatened? Then the would-be thief has to consider a once-obscure incident related in the Apocrypha (2 Maccabees 3), where the larcenous general Heliodorus has been planning to loot treasure from the Temple of Jerusalem. We see him sprawling, blinded, and furiously attacked by two spectacularly beautiful youths while a horseman sent by Heaven tramples him down. From the left, this scene is watched by Julius II seated in a litter, which is borne by an entourage that includes likenesses of Raphael himself and his assistant Marcantonio Raimondi.

Is there concern or skepticism about the truth of dogma? Then the visitor must consult Raphael's fresco of *The Mass at Bolsena,* where we see a priest celebrating Mass; it is the climactic moment of the ceremony, the consecration of the Host, when, at the words *"Hoc est enim corpus meum"* ("This is indeed my body"), first uttered by Christ at the Last Supper, the bread—so Catholics are required to believe—is transformed into the veritable flesh of Jesus. This Mass in the lakeside town of Bolsena, north of Rome, had a skeptic in its congregation who was unsure about the Transubstantiation, and to convince him God caused the Host in the priest's hands to bleed Jesus' own sacred blood. Raphael has this event watched by the kneeling figure of Julius II, who never saw it but wished to emphasize his devotion to the Eucharist.

Thirdly, is the seat of the Church, Rome itself, in danger of invasion? Raphael symbolizes this in *The Meeting of Leo the Great with Attila,* the least inspired and satisfactory of the four scenes, in which we see Attila the Hun and his barbarian hordes reeling back from the walls of Rome at a mere gesture from Pope Leo I. Raphael's figure of this pope is a portrait of the tenth Leo, Giovanni de' Medici.

Finally, is the person of the pontiff in danger? Then the viewer must consider the fourth wall of the Stanza d'Eliodoro, with its fresco of *The Liberation of Saint Peter,* Raphael's superb night-piece of the saint incarcerated in the darkness of the Mamertine Prison in Rome, glowing like a firebrand beside the shiny black armor of his guards. The sense of life restored, the contrast between the vitality of the saint and the moribund, beetlelike quality of the guards' bodies, shows how carefully Raphael must have taken note of similar contrasts between the risen God and his slumbering captors in earlier paintings of the Resurrection of Christ. This must have been the last fresco of Raphael's that Julius could have seen; he was painting it in 1513, the year the pope died.

The work of frescoing the *stanze* continued well past Julius' death and was still absorbing Raphael while he worked as papal architect on Saint Peter's. The clearest reference to the new pope, Giovanni de' Medici, who took office as Leo X, is quite indirect: it shows a miracle performed by his namesake, an earlier Pope Leo, the Fourth (reigned 847–55), who miraculously extinguished a fire that threatened to destroy Saint Peter's along with all the buildings of the Borgo. In the so-called Stanza dell'Incendio, in the fresco *Fire in the Borgo,* he appears as a small, distant figure making the sign of the cross on a balcony, near the vanishing point of the composition. Unless you look for him, you hardly know he is there, but the clue

is given by the distant, agitated women beseeching him from below his balcony. The emphasis of the fresco is on the frantic Romans in the foreground, scurrying to and fro, disoriented by the threat of the blaze. The fire rages on the extreme left. On the right, one sees a crowd of women carrying pots of water to put out the flames. There, in the foreground, is a strong young man carrying an older one piggyback, accompanied by a boy: a direct reference back to images of Aeneas accompanied by his son Ascanius and carrying his old father, Anchises, away from the flames of Troy, on their way to found Rome. A mother hands her swaddled child over a wall, into the receptive arms of a helper; a naked man hangs by his fingertips from the wall, about to drop to safety. (This is a fairly operatic moment, since it would clearly have been just as easy for the naked man to scoot around the end of the wall. But that would have deprived Raphael of the pretext to paint that magnificent body, muscles tensed at full stretch.)

In the years during which he worked on the *stanze,* Raphael did not limit himself to fresco. He also had a large output of portraits and devotional paintings. His portrait of Baldassare Castiglione is to be ranked with Leonardo's *Mona Lisa* as one of the suavely inventive masterpieces of that genre. His most popular religious paintings were of the Madonna and Child, usually with the infant John the Baptist. One typical complaint about Raphael concerns these images, which remained steadfastly popular from the sixteenth to the nineteenth centuries and influenced generations of artists, down to Ingres, who wrote, "We do not admire Rembrandt and the others at random; we cannot compare them and their art to the divine Raphael." The group of German artists in Rome who called themselves the Nazarenes (Overbeck, Pforr, and others) venerated the early more than the later Raphael. Others thought him sentimental, stereotyped, and oppressively masterly; nineteenth-century English artists like Millais and Holman Hunt called themselves "Pre-Raphaelites" because they wanted to paint as though he had never existed.

But today it is difficult to have more than a glancing acquaintance with Raphael's devotional easel paintings without succumbing to their charm, and then realizing what unsurpassed mastery lies behind them. No matter how often one sees Baby Jesus and infant Baptist playing together, however strongly one may react against the repeated theme—the prophetic Baptist showing the little Saviour a stick, or wand, with a crosspiece which Jesus eagerly reaches out for, since it is a prefiguration of the cross on which he will die—the sheer beauty and fluency of the painting gets

you every time. "Immortal," "divine," "perfection"—such words, which Raphael's work evoked from earlier admirers, may die on our modern (or "postmodern") lips, but their memory cannot be entirely effaced.

And certainly no need to be rid of it was felt in the early sixteenth century. Raphael was the ideal secular as well as religious painter, faultless in his production, his meanings always clear as springwater, his saints holy, his men noble and thoughtful, his women desirable, his technique impeccable. What other artist could have painted two little angels like Raphael's into an Assumption of the Virgin, giving them an enchanting air of childish detachment while not distracting at all from the majesty of the event? The answer is: none. Nobody had a word to say against him except the notoriously prickly Michelangelo, who learned that Bramante had let Raphael into the Sistine Chapel for an early, unauthorized look at its first completed ceiling section when its scaffolding was dismantled in 1511. "Everything he knew about art he got from me," the titan grumbled, though serious enmity did not persist between them.

Raphael never let a client down, and among his clients were some of the most powerful men in Italy. Apart from the pope, his chief patron was the papal banker Agostino Chigi, for whom he painted two chapels in the churches of Santa Maria del Popolo (Chigi's own burial chapel) and Santa Maria della Pace. For Chigi he also painted his only major mythological subject, a *Triumph of Galatea* (c. 1511–12), frescoing it on a wall of Chigi's Villa Farnesina in Rome. Where did this delectable sea nymph come from? Possibly, indeed quite probably, she is a portrait of Chigi's mistress. In the myth, Galatea was uncouthly loved by the monstrous Cyclops Polyphemus, in the *Odyssey.* (Polyphemus himself is depicted in a nearby fresco in the villa, by Sebastiano del Piombo.) She escaped from him over the sea, in a boat drawn by two dolphins, and in Raphael's version of the event one sees that one of these charmingly stylized marine mammals is chewing up an octopus, a "polyp," in its sharp jaws—a sight which Raphael no doubt remembered from a visit to a fish market, but which equally alludes to the defeat of Polyphemus. Nereids and other sea deities sport around her, putti flutter in the sky above. Galatea herself is enchantingly pretty, surfing along in graceful *contrapposto,* but she may not have been directly painted from a living model: "To paint a beauty, I should have to see a number of beauties, provided Your Lordship were with me to choose the best. But in the absence of good judges and beautiful forms, I make use of an idea which comes to my mind."

By then Raphael was famous throughout Europe, and so esteemed in

the papal court that the pope's treasurer—Leo X's chief minister, Cardinal Bernardo Bibbiena—actually offered his niece to the painter in marriage. Even more remarkably, the painter politely refused. There seem to have been two reasons for this. The first was that Raphael's life was full of other women, notably La Fornarina, who was his adoring mistress for years. If his portrait of her (c. 1518) in Rome's Galleria Nazionale is truthful, which presumably it is, and correctly identified, which it may not be, one can well understand why he might not have wished to switch. The second reason is said to have been more practical: there was a possibility that Leo X might make him a cardinal, an office to which married men could not be raised. If that had happened, Raphael would have been the first and only artist in history to receive the red hat for making art. But neither that nor the marriage took place: in 1520, at the excessively young age of thirty-seven, Raphael died—as a result, some said, of a fever caused by a particularly energetic night of love with La Fornarina, "the Baker's Daughter," his delicious black-eyed woman of the people from Trastevere. He was buried in a niche in the Pantheon: the epitaph cut on his tomb slab was an elegant distich by his friend the poet Pietro Bembo: ILLE HIC EST RAPHAEL, TIMUIT QUO SOSPITE VINCI / RERUM MAGNA PARENS, ET MORIENTE MORI. "The man here is Raphael; while he was alive, the Great Mother of All Things [Nature] feared to be outdone; and when he died, she, too, feared to die."

The frescoing of the *stanze* was one of the two chief achievements of Julius' patronage. The other, it goes almost without saying, was the employment of Michelangelo Buonarroti. It was for Julius that Michelangelo, sometimes with the deepest misgivings and resentments, frescoed the ceiling of the Sistine Chapel, producing what remains the most powerful—if not in all ways the most likable or even comprehensible—series of images of the human figure in the whole history of European art. It would be followed, more than twenty years after Julius' death, by the *Last Judgment* on the altar wall of the chapel, conceived by Pope Clement VII late in 1533, commissioned by Pope Paul III Farnese in 1534, started as cartoons in 1535 and as fresco in 1536, and finally unveiled to very mixed reactions in 1541.

In between these fell the tragic debacle of Julius' tomb, Michelangelo's obsessive project. It was to have been a sculptural block about twenty-four by thirty-six feet, and thus with a "footprint" of over seventy square meters. It was designed to be on three levels, containing some forty-seven marble figures. It would have been in Saint Peter's,

where, since Bernini had not yet appeared, it would have been the greatest sculptural project of the Christian world. And, Michelangelo being what he was, maker of the colossal *David* in Florence, it would have been entirely the work of one man. Ascanio Condivi, who knew Michelangelo and wrote his life, relates:

> All around about the outside were niches for statues, and between niche and niche, terminal figures; to these were bound other statues, like prisoners . . . rising from the ground and projecting from the monument. They represented the liberal arts, and likewise Painting, Sculpture, and Architecture . . . denoting by this that, like Pope Julius, all the virtues were the prisoners of Death, because they could never find such favor and nourishment as he gave them.

This was never achieved. Julius II died in 1513, but none of his successors was able, or willing, to support the project. Before long it was relocated, in a much-diminished form, to Julius' former titular church in Rome, San Pietro in Vincoli. Though it contains one tremendous finished sculpture for the tomb, the *Moses,* Julius II's final resting place does not even remotely resemble in scale, size, site, or imagery what Buonarroti had in mind. Julius himself had undermined Michelangelo's chances to complete it, by ordering him to paint the Sistine instead. Paul III had ruined them by insisting that he lay down hammer and chisel to paint the *Last Judgment.* Then there were the architectural projects for the Medici, such as the Laurentian Library and the façade of San Lorenzo, the Medici church in Florence. A man, even if that man is Michelangelo, can only do so much.

The Sistine Chapel was so called because it had been built thirty years before Julius' papacy by his uncle Pope Sixtus IV (reigned 1471–84). Its architect was the otherwise unremarkable Giovannino de' Dolci. Its walls were frescoed by some of the greatest Quattrocento artists, including Luca Signorelli, Sandro Botticelli, Domenico Ghirlandaio, and Bernadino di Betto, better known as Pinturicchio; but nine out of every ten people who visit the Sistine go there only for the ceiling.

The layout of the Sistine reflects a particularly medieval conception of world history. It was believed, in the Middle Ages, that humanity's past divided into three sections or epochs. The first was the story of the world before God gave the Law to Moses. The second was the Law as laid down to Moses. The third, life since the Law, centered on the birth and life of Christ: the period of the New Testament. Sixtus IV's artists had

illustrated the third part and some of the second. However, this left the first untouched, and so it was to Michelangelo that Julius II entrusted the task of illustrating, on the ceiling, the epic narrative of the Old Testament.

The ceiling was blank, or almost. The only decoration on it was a uniform coat of ultramarine blue, dotted with golden stars. It was enormous, forty and a half meters long and fourteen wide, and every inch of it had to be painted by Michelangelo. The contract to paint the vault was drawn up and signed in May 1508, and the work was finished in October 1512—a little more than four years, which included an interruption of close to a year, between 1510 and 1511. Considering that all, or nearly all, the painting was done by Michelangelo and not delegated to assistants, as Raphael might have done, this represented an astounding speed of execution. Of course, he did have assistants—carpenters to erect the high scaffolding and the ladders, studio men to grind the colors and mix the plaster, laborers to carry the paints and buckets of water up the ladders to the top of the scaffold, *stuccatori* to apply the wet plaster to the ceiling, and assistants to help hold the cartoons or design drawings in place while their lines were transferred to the plaster, whether by scratched-in marks from a stylus or by "pouncing" lines of powdered charcoal dots through holes pricked in the paper. No one man could have done all that donkey work. The conception of the grand design must have been formed by conferring with others, chiefly Julius II and whatever clergy and theologians he might have brought in—not many, one suspects.

But all the rest—which is to say, about 95 percent of the actual work, all the painting of more than ten thousand square feet of ceiling—was done by Michelangelo alone, and the more one knows about the technique of *buon fresco*, as this kind of painting was called in his native Florence, the more astounding the achievement of the Sistine becomes.

An artist could not just paint his design on a hard, dried plaster surface. That invited disaster, and when even an artist as skilled as Leonardo da Vinci tried it with the *Last Supper* in Milan, disaster obligingly came. The reason is that no wall made of bricks, mortar, and plaster is ever completely dry and impermeable. Waterborne salts work their way in from outside and destroy an oily paint film lying on top of plaster inside. This does not happen, or not as gravely, when the colored pigment is integrated with the plaster, and such is the essence of *buon fresco*. For the paint to be integrated with the plaster, it must be applied while the plaster is damp—ideally, two or three hours after the laying of the *intonaco*,

as the fresh lime plaster is known. Then the two form an indissoluble chemical bond when they dry.

But fresco has its peculiarities, and the chief one is that it has to be done piecemeal. The artist must complete painting a section of the *intonaco* before it dries. If the pigment is put on dry plaster, as it sometimes has to be for retouching and correction, it is said to be done *a secco* and lacks the durability of true fresco. However, not all pigments are suitable for fresco, because some—particularly the blues and greens, such as ultramarine and malachite—are vulnerable to the alkaline action of the lime. These were used *a secco*. The preferred fresco pigments included the ochers, brown and yellow earths, hematite reds, umber, burnt sienna, ivory black, and vine black. The borders of each section must therefore be planned, like a large jigsaw. Each is limited to the work that can be done in a single day. The patch of each day's surface was known as a *giornata,* and it is easy for a trained eye, close up, to follow the outlines of each *giornata* and thus reconstruct the order in which the fresco was done. If repair work is needed, as it sometimes was, it was done by brushing water-based paint onto the now dried *intonaco.* A further complication is that in fresco colors do not dry the way they look when wet—a problem that does not arise with oil paint or watercolor. Pigments with a green or black hue dry lighter, whereas iron-oxide pigments dry darker; matching up wet and dry demands from the artist the most acute powers of visual memory.

It is not known exactly how the narrative of the ceiling was composed. Michelangelo undoubtedly had input from others (especially the pope) in doing it. (He claimed he invented it all, but he was given to claims like that.) The basis of the vault we see now is nine scenes from the book of Genesis, framed in fictive (painted) stonework, running crosswise between the long walls. They begin at the altar end of the chapel with three scenes of cosmic creation, *The Separation of Light from Darkness, The Creation of the Sun and the Moon,* and *The Separation of Land from Water.* Then follow three more: *The Creation of Adam, The Creation of Eve,* and *The Temptation of Adam and Eve* combined in one panel with *The Expulsion from the Garden of Eden.* Finally, one sees *The Sacrifice of Abel* (or perhaps that of Noah), *The Flood,* and *The Drunkenness of Noah,* complete with the ancient patriarch's eldest son committing what had become known as the Sin of Ham—not overindulgence in *prosciutto crudo,* but gazing upon his inebriated father's nakedness.

Gazing on masculine nakedness was, of course, Michelangelo's unwav-

ering obsession. On the painted stone frame surrounding these scenes sit the *ignudi,* the beautiful naked youths who have no part in the biblical narrative but are purely the invention of the artist, and make up the grandest anatomical repertoire in Western art. They serve to hold up garlands and painted bronze medallions. The spandrels of the chapel hold mighty figures depicting those who foretold the coming of Christ to the ancient Gentiles (the Sibyls) and to the ancient Jews (the Prophets). They alternate down the walls: the Libyan Sibyl, then Daniel, then the Cumaean Sibyl, then Isaiah, and so on. It seems, the more one looks at this huge vocabulary of human form, that Michelangelo did more than any artist before him to give posture and gesture their utmost eloquence. Here is the Libyan Sibyl, arms spread wide to hold open her enormous book, showing her back but looking over her shoulder. Here is the figure of Jonah, just released from the mouth of the whale—which is actually more the size of a large tarpon—leaning back and gazing upwards in astonishment at a sky which he never thought to see again. Goethe, after visiting the Sistine, wrote that no one could have any idea of what a single individual could accomplish on his own unless he had stepped inside this huge hall. It is still true, and no other work of art can deliver that.

The effort of painting the ceiling, lying on his back, was brutal and interminable, even for a man in his mid-thirties in peak physical condition. Michelangelo wrote a sardonic sonnet about it, addressed to his friend Giovanni da Pistoia. "I've grown a goiter at this drudgery," it begins,

> The kind wet cats get in the Lombard swamps
> Or in whatever country the things live—
> My belly's rucked up underneath my chin,
>
> My beard points up, my memory hangs down
> Under my balls, I've grown a harpy's breast,
> And all the while my brush above me drips,
> Spattering my face till it's an inlaid floor.

He feels crippled, permanently deformed—"I am recurved like a Syrian bow"—and his thinking is distorted:

> A man shoots badly with a crooked gun.
> And so, Giovanni, come to rescue me,
> Come rescue my dead painting, and my honor—
> This place is wrong for me, and I'm no painter.

The Sistine ceiling is almost all body, or bodies; the only sign of a nature that is not flesh is an occasional patch of bare earth and, in the Garden of Eden, a tree. Michelangelo was not even remotely interested in landscape; in this respect, as in many others, he was completely the opposite of Leonardo da Vinci. The human body, preferably male, its structure, musculature, and infinitely diverse postures, framed all the expressive powers he wanted to use. A dumb *tree?* A patch of unconscious *grass?* A wandering, arbitrarily shape-shifting *cloud?* Forget it. None of these, in Michelangelo's eyes, had the grand complexity, the sublimely purposeful integration, of the human body, created in God's own likeness. Leonardo might suspect that universal laws lay hidden in the behavior of water pouring from a sluice gate into a still pond, but such speculations were of no interest to Michelangelo.

Twenty-one years after the ceiling was complete, in 1533, Michelangelo began work on his fresco for the altar wall of the Sistine, and this time the work contained nothing but bodies (though there is a small patch of water, representing the river Styx, at the bottom). The subject of this monumental muscle-scape was the Last Judgment. It is a huge creation, and he took eight years over it, finishing it in 1541, at the age of sixty-six—almost twice the age he was when he began the Sistine ceiling.

Politically, a great deal had happened in Italy in those twenty-nine years, and the most traumatic event of all had come in 1527, with the Sack of Rome. Barbarians and other enemies had got as far as the walls of Rome in previous years, but none had actually succeeded in breaching them on a large scale. The Sack of 1527, however, was almost another Cannae in its traumatic effects on Roman self-possession and self-confidence.

Europe had now become an immense cockpit in which national factions were battling it out for international dominance. Long and inconclusive wars (1526–29) were fought in Italy between the troops of the self-styled Holy Roman Emperor Charles V and the hodgepodge alliance of France, Milan, Florence, and the Papacy. There is considerable truth in the saying that the Holy Roman emperor was neither holy, nor Roman, nor in any real sense an emperor. Nonetheless, Pope Clement VII had thrown his lot in with Charles so as to avert France's defeat at the hands of Charles's army. But the imperial forces did defeat the Franco-Florentine-papal alliance—only to find there was no money to pay the troops their promised fee. Frustrated, the imperial forces mutinied and forced their commander, Charles III, duke of Bourbon, to lead them in an attack on Rome. Rome was a fat, rich city, full of treasure;

so it was assumed. The army of the Holy Roman emperor contained a substantial number of Lutheran sympathizers, grimly delighted at the thought of attacking the throne of the Great Whore of Babylon, the Catholic Church; and, whatever their religious views, all thirty-four thousand soldiers wanted their promised back pay. So they marched south, spreading rapine and chaos as they went, and arrived beneath the Aurelian walls of Rome in early May 1527.

The city was not strongly defended. It had better artillery than its attackers, but only five thousand militia and the small papal force known as the Swiss Guard. Duke Charles III died in the attack—the great goldsmith-sculptor Benvenuto Cellini, never averse to self-promotion, claimed to be (and possibly was) the marksman who shot him. With him died the last possibility of restraint on the imperial invaders, among whom were fourteen thousand fearsome German *Landsknechte,* thirsting for blood, sex, and gold. The Swiss Guard was cut down almost to the last man on the steps of Saint Peter's—out of its five hundred members, only forty-two escaped and, with commendable bravery and guile, managed to smuggle Pope Clement VII by a secret corridor out of the Borgo and to precarious safety as a prisoner in all but name in the Castel Sant'Angelo. About a thousand defenders of the city and its churches were summarily killed. Then the sack began.

Before long, it was for the living in Rome to envy the dead. Priests were dragged from their sacristies, savagely humiliated, and put to death, sometimes on their own altars. Hundreds of nuns were gang-raped and then killed, starting with the younger and more attractive ones. Monasteries, palaces, and churches were gutted and torched, and the higher clergy—including many cardinals—had to pay heavy ransoms to the implacable soldiers. Some of the minor scars of these days can still be seen today: in one of Raphael's *stanze,* a mutineer left his scratches on the fresco of Heliodorus. The chaos went on for weeks. The Emperor Charles V was unable, and not altogether willing, to stop his troops. Not until June 6, after a month of unremitting plunder and rape, did Clement VII formally surrender and agree to pay a ransom of 400,000 ducats for his own life.

It was spared, but there was no way to restore the prestige of his papacy, or the sense of inviolability that went with Rome's position as *caput mundi.* If God had allowed this to happen, what reliance could be put on Rome's supposedly divine mission? In minds all over Europe, the Sack of Rome was an omen, joining in terrible synergy with the Refor-

mation, which was by now a ten-year-old movement with undeniable staying power. God was abandoning the city; had already abandoned it, perhaps. A judgment had fallen. This was the end of the Renaissance papacy in Rome, that short and glorious thing. And although Michelangelo, who witnessed these things, was not given to writing about current events, it is surely not wrong to see in the titanic pessimism of the Sistine *Last Judgment* some character of response to the sacking of the helpless city six years earlier. Possibly, indeed probably, the image of Charon, the diabolic ferryman, whacking the terrified souls out of his boat with his oar, harks back to some moment Michelangelo had witnessed when a gleefully ruthless *Landsknecht* was driving a gaggle of helpless citizens out of their shelter with stabs and swipes of his halberd.

The wall of figures is huge; it is also almost unbearably claustrophobic, because there is no "space" in the ordinary sense of the word: no landscape or skyscape in which you can imagine your own body moving. It is packed almost to immobility with enormous bodies. Its actors are vehemently corporeal, and yet not of this world. We see, as we have seen in other Last Judgments, the division of the damned from the saved, the former going down to Hell, the latter rising to glory under the aegis of Judge Jesus. And yet there is something disquietingly irrational about the scene, if something as huge and dispersed as this can rightly even be called a "scene." Why does Jesus look more like a relentless Apollonian Greek god than the "normal" judge and Saviour of other Last Judgments? Why does Jesus' mother crouch so submissively by his side, as though terrified by the revelation of her son's capacity for wrath against sin? Perhaps both are related to the line of Dante's which had probably inspired Michelangelo before, when he carved the adult and supremely beautiful dead Christ lying in his mother's lap, *Figlia del tuo figlio, Daughter of Your Son.* But why does Saint Bartholomew, customarily depicted holding up his own skin (which was flayed from him in his martyrdom), hold up a human skin whose collapsed face is unmistakably that of Michelangelo himself? And why on earth did Michelangelo give the blessed Bartholomew the face of that most unsaintly writer, the satirist and pornographer Pietro Aretino, whose collection of sexual "postures," illustrated by Giulio Romano, was one of the repressed classics of High Renaissance titillation? These and a dozen other questions rise unbidden whenever one enters the chapel and gazes at its altar wall, and they bring with them the thin thread of possibility that they could be answered,

at least partly, if only one could see Michelangelo's work as it had been when his brush left it.

In the meantime, both the ceiling and the *Last Judgment* had been condemned to woeful indignities. Some popes later than Paul III quite vehemently disliked it. Paul IV (reigned 1555–59) called the *Judgment* "a stew of nudes," meaning "stew" in the Renaissance sense of a public bath, a *stufato,* a whorehouse. Another Medici pope, Pius IV (reigned 1559–65), ordered that some of the figures be made decent with painted loincloths; this task was assigned to a good painter, Daniele da Volterra, who ever after was known as *il braghettone,* the trouser maker. Clement VIII (reigned 1592–1605) wanted the whole thing whitewashed over, but fortunately was dissuaded by his clerics.

No art-interested person who was in Rome in the late 1970s and early '80s is likely to forget the passions roused by the project of cleaning the Sistine. Lifelong friendships were broken; the field of discussion, usually a relatively tranquil one, was swept by hails and cross-fires of moral disagreement.

The argument tended to revolve around one central question: was the grayness, the almost monochrome character of so much of Michelangelo's coloring, deliberate or accidental?

There is always a certain resistance to cleaning any beloved work of art. The thought of damage, the natural fear of radical change, combine in what sometimes amounts to an anguished conservatism. And sometimes it is not a bit unreasonable: those who remember certain paintings in London's National Gallery, before the director Sir Philip Hendy's restorers were unleashed to use their swabs and solvents upon them, bitterly recall that they were not merely spruced up but skinned alive. The puritanical belief that cleanliness is next to godliness, that the more you take off the closer to the original truth you come, was still very strong in some quarters of the picture-cleaning trade in the late 1970s, and in the early 1960s it was virtually a dogma. The reduced color of the Sistine ceiling seemed to accord very well with the belief that Michelangelo was primarily a sculptor, a man who naturally thought in terms of monochrome substance. People didn't want to think that the grayness which lent the figures a marmoreal grandeur, even as it deprived them of detail, was just dirt, soot, and centuries of grime.

Elaborate explanations were devised by the anti-cleaning faction, which, it is only fair to say, included some of the most distinguished

art historians in Italy and elsewhere. The most popular idea was that Michelangelo, disliking the relative brightness of the Sistine frescoes, had applied an *última mano,* a "final touch," in the form of a darkening and unifying wash of pigment and animal glue-size. Obscure and ambiguous ancient texts about the use of *atramentum,* a dark tonal wash, in antique painting were resurrected to suggest that Michelangelo had used it, too.

Glue there certainly was, and dark-wash pigment, too. But Michelangelo did not put them there. They were later accretions. The pigment was mostly airborne soot, from hundreds of years of burning candles. (Before the age of electricity, the Sistine was lit by large, stout candles, smoking away on an internal ledge below the level of the frescoes. They were not beeswax, which burns relatively cleanly, but the kind of black gunk you get on a barbecue from grilling chops.) And the glue was animal size, much of it also applied long after Michelangelo's death by intrusive conservators who sought to bring up the higher tones in the frescoes by darkening the lower ones. The net result was a messy obscurity. Various attempts were made over the years to clean some of the film of dirt away, but none succeeded.

If you wanted to know what colors Michelangelo really preferred in a painting, it made sense to look at his one surviving complete easel picture, the *Doni Tondo,* or *Holy Family* (c. 1504). Bright, singing colors—*colori cangianti,* as they were called, the hues of shot silk, the crinkled sky-blue of Mary's skirt, the opulent yellow of Joseph's garment, the general clarity of light—none of this looked remotely like the colors of the Sistine ceiling. Inevitably, when the ceiling was cleaned in 1999 and colors similar to those of the *Doni Tondo* began to appear, there were cries of protest from art historians who felt that Michelangelo had been traduced: the "new" colors were those of later, Mannerist art, characteristic of artists like Pontormo or Rosso Fiorentino. The obvious deduction from this should have been that the bright *colori cangianti* of Mannerism had been copied from the Michelangelo of the Sistine, by artists who regarded Michelangelo as the ultimate guide and wished only to follow him in homage, when they flocked to the Sistine to see his new work. But critics of the restoration were determined to put the cart before the horse.

Seeing the Sistine frescoes in their renewed state a decade later, one can only guess what the hysteria of opposition had been about. They can now be seen in their full plenitude of color, and it is one of the world's supreme sights. At this point I should perhaps confess a bias: working for what was then a major American magazine, *Time,* I was lucky enough

to get extended access to the *ponte* or moving bridge between the Sistine walls on which the cleaners worked, and spent the better part of three days up there, with my nose a couple of feet from the fresco surface, seeing the way Michelangelo's color was coming alive once more after so long a burial under waxy residue, and how the forms were being reborn. This was a privilege, probably the most vivid one I had in a fifty-year career as an art critic. It left me in no doubt that the Vatican team's meticulous high-tech efforts, inch by inch, were as great a feat of skill and patience as John Brealey's magnificently discreet cleaning of Velázquez's *Las meninas* in Madrid, and that an enormous cultural truth, once obscured, was now coming to light.

Michelangelo's frescoes are, of course, a magnetic point of concentrated attraction for visitors to Rome—so much so that it is no longer possible to appreciate them in peace, thanks to the intolerable jam-packed year-round crowds. Michelangelo's Roman architecture is, however, a different matter. Its chief undertakings were three: the reform of the Capitol, complete with its bronze of Marcus Aurelius on horseback; the design of the grandest palace in Rome, Palazzo Farnese; and the development of the Basilica of Saint Peter's.

Sometimes, while he was working on the *Last Judgment,* Michelangelo was approached in the hope that he would turn to public-architecture projects. With the *Judgment* finished, and the Paoline Chapel behind him, he was relieved to give himself over to architecture, and the first of the schemes in which he immersed himself was the redesign of Rome's mythic and historic nucleus, the Capitol (in Italian, Campidoglio). The need for a renewed Capitol had become clear in 1536, nine years after the Sack of Rome, when the victorious Charles V made a state visit to the still horribly scarred Rome, and Pope Paul III realized that, although temporary processional arches were run up to greet the emperor along the old Roman route of triumph, there was no great central piazza for a reception ceremony.

The Capitoline Hill, with all its historical associations, seemed suitable, and in 1538, Paul III ordered the bronze statue of Marcus Aurelius on horseback to be moved from its site outside the Lateran to a new spot on the Capitol. The pope thought, wrongly, that it was a statue of the Emperor Constantine, hence Christian. It was a fortunate mistake, since only the fact that all Romans in the Middle Ages had assumed it to be Constantine (or, later, the Christian Antoninus Pius) had protected it from being demolished and melted down as a pagan monument. Michel-

angelo, interestingly enough, opposed placing the Marcus Aurelius on the Capitol—we don't know why—but, fortunately for Rome, the pope overrode him. He was made an honorary citizen of Rome in 1537, and, flattered by this compliment, he pressed ahead with ideas for the Capitol. He designed an oval base for the statue, which he surrounded with an oval pavement, replacing the amorphous piazza in front of the Palazzo del Senatore. He put in two symmetrical staircases on the face of that palace, and designed a fine wide stepped ramp, the *cordonata,* linking the piazza to what is now the level of Piazza Venezia below. So the visual axis of the *cordonata* runs through the Marcus Aurelius and up to the junction of the twin stairs on Palazzo del Senatore. Now the statue needed a new architectural environment. To one side of it, built on the ruins of what was once the Temple of Jupiter, was the fifteenth-century Palazzo dei Conservatori. Michelangelo gave it a new façade, with powerful full-height Corinthian pilasters, and on the other side, facing it, he built the matching Palazzo Nuovo, now the Capitoline Museum, which holds its prodigiously rich collection of Roman antiquities.

In this way, Michelangelo created one of the greatest urban centers in the history of architecture; only a few others in Italy, such as Piazza San Marco in Venice and the Piazza del Campo or shell-shaped piazza in Siena, compare to it in spatial beauty, and none can approach its phenomenal richness of art content. Nothing could rival it, or ever will. Its effect on visiting aesthetes was summed up in a much later drawing by the neoclassical artist Henry Fuseli, who had moved to Rome for an eight-year sojourn in 1770. It showed a figure, head buried in his hands in despair, seated before the enormous marble foot and hand of Constantine; this is still on the Capitol. Its title is *The Artist in Despair over the Magnitude of Antique Fragments.* This emotion was often felt, and by many; but not by Michelangelo. Raphael was the more enthusiastic preserver of the two.

Through his short life, Raphael actively promoted the preservation of Rome's innumerable ancient ruins and monuments. A report on their decay was submitted to Julius II's successor, Leo X, who in 1515 appointed Raphael to be prefect of the antiquities of Rome. This did not give Raphael the power to block the plunder of ancient marble. Rather the reverse—it put him in charge of gathering ancient material to be used in building the new Saint Peter's. So there is something hypocritical about the lamentations in the report. It is not clear who compiled and wrote it. Unsigned, it has been ascribed to Bramante, Raphael, the

writer Baldassare Castiglione, and others. Since a draft copy of the report written in Baldassare's hand was found in the Castiglione family library, and since Raphael (1483–1520) was not only the architect-designate of Saint Peter's and the chief adviser on aesthetic matters to Leo X, but also an intimate friend of Castiglione, it is likely that the two men wrote the report together.

The author(s), says the report, have been all over Rome, looking, drawing, measuring, and it has been a decidedly mixed pleasure: this knowledge of "so many excellent things has given me the greatest pleasure; on the other hand, the greatest grief. For I beheld this noble city, which was the queen of the world, so wretchedly wounded as to be almost a corpse." In Rome, antiquity had been mercilessly despoiled by the Romans themselves, the fine stone of the ruins looted, the columns felled and carted away, the marble statues and friezes burned for lime, the bronzes melted down. This had been going on for hundreds of years, without hindrance from pope or Senate. The Romans had done more damage to Rome than the worst barbarian invasions. Compared with them, "Hannibal would appear to have been a pious man." "Why should we bewail the Goths, the Vandals, and other perfidious enemies of the Latin name, when those who above all others should be fathers and guardians in defense of the poor relics of Rome have even given themselves over to the study—long study—of how these might be destroyed and disappear?" This Ubuesque project of demolishing the ruins, this relentless urbicide, was Rome's biggest, almost its only, industry.

> How many pontiffs, Holy Father, who have held the same office as yourself, though without the same knowledge . . . have permitted the ruin and defacement of the ancient temples, of statues and arches and other edifices that were the glory of their builders? How many allowed the very foundations to be undermined so that *pozzolana* [volcanic ash] might be dug from them, so that, in but a little time, the buildings fell to the ground? How much lime has been burned from the statues and ornaments of ancient times?

This piecemeal destruction of the city by its ignorant developers was "the infamy of our times," an atrocious historical castration. Raphael and Castiglione knew very well whom they were pleading to. He was Giovanni de' Medici, successor to the mighty Julius II, the last layman to be elected pope, the second son of Lorenzo the Magnificent of Florence, then only in his early forties.

He had received a good humanistic education at Lorenzo's court in Florence, from such luminaries as Pico della Mirandola, Marsilio Ficino, and the poet Angelo Poliziano. Both in Florence and in Rome, he had been immersed in art and literature; his reverence for the classical past was thoroughly instilled, not just an affectation or a pseudo-intellectual quirk. Moreover, he did not have automatic respect for the opinions of earlier popes, especially on such matters as architectural history.

"Since God has given us the papacy," Giovanni de' Medici famously remarked after his election as Leo X, "let us enjoy it." He set out to do so, and he did. Venice's ambassador to Rome, Marino Giorgi, wrote that Leo was "a good-natured and extremely free-hearted man, who avoids every difficult situation and above all wants peace. . . . He loves learning; of canon law and literature he possesses remarkable knowledge." He had a menagerie of pets, including a tame white elephant. He was, according to the 1525 testimony of the historian and politician Francesco Guicciardini, an active and unembarrassed homosexual, "exceedingly devoted—and every day with less shame—to that kind of pleasure which for honor's sake may not be named." And he was culturally serious. Leo X restored the University of Rome, which had fallen on hard times during the pontificate of Julius II. He increased the salaries of its professors, expanded its faculties, and underwrote a Greek printing press, which created the first Greek book to be published in Rome (1515), an important step in the implantation of humanistic ideas in the city. He gave papal secretaryships to scholars and poets, such as Pietro Bembo and Gian Giorgio Trissino.

All this cost money—a great deal of it. Leo X badly depleted the papal treasury in two or three years. Naturally, it embarrassed him, as Christ's vicar on earth, to find himself presiding over a city as miserably shorn of its ancient glory as Rome had become. The Church needed defenses, of which new buildings were the manifest and concrete proof. Julius II and his architect Bramante had begun to replace the old Saint Peter's with a vast new basilica, and now Leo X set out to double its size, a thing unheard of in the previous history of Christianity. Much of the time these expansions were chaotic, since new popes tended quite often to allow the projects of those before them to lapse. The military, political, architectural, and artistic ambitions of successive pontiffs drove the Papacy into long spasms of bottomless debt, causing inextricable woes to its bankers. Leo X was certainly not exempt from these financial horrors, and his short-term palliatives for them were a disaster for the Church. He

was one of the most feckless spenders in the history of the Papacy. One cannot help liking him for his attachment to the fine arts, especially for his encouragement of literature and scholarship. But the Church needed a more restrained man, and restraint was not a virtue Leo X understood. He needed immense sums, not only to support his luxurious tastes, but to finance large projects, of which the largest was building the new Basilica of Saint Peter's. He therefore opened the door to one of the worst rackets in ecclesiastical history: the large-scale sale of indulgences.

When not enough cash was flowing in from it, Leo sold (to selected buyers, of course) the prestige of association with the Papacy. He invented all manner of new papal offices, and sold them to the highest bidders. It was reliably estimated that when Leo died more than two thousand people were paying for offices he had created, generating a capital value of three million ducats, which yielded the pope 328,000 ducats a year. Cardinals' hats were commonly sold, and this caused the higher levels of the hierarchy to silt up with avaricious crooks. Leo was even reported to be pawning and selling some of the artistic contents of the Vatican—furniture, plate, jewels, and works of art.

It is not certain that Leo X fully understood the determined anger propelling the epic change in the history of ideas and of worship that was about to rock Europe; there could hardly have been two more dissimilar men than the Medici pope and the German monk named Martin Luther who, in the fourth year of Leo's papacy, on October 31, 1517, nailed his ninety-five theses to the church door in Wittenburg. Luther was a deeply educated man, but he had none of the hedonistic delight in culture that animated Leo. In no way could he have been called a sensualist, which Leo in all respects was.

The indignation and disgust this caused among the faithful was to be one of the prime causes of the Reformation, in which for doctrinal reasons the epochal split between Catholicism and Protestantism took root. But at the same time that Leo was disposing so recklessly of such magnificent works of art, he was acquiring others, notably books and manuscripts for the ever-growing Vatican Library. In the process, the pope who gave rise to the Reformation was also fostering a new intellectual elite: the Roman humanists.

7

Rome in the Seventeenth Century

Y ou cannot imagine modern Rome without the changes that a single pope, Sixtus V, imposed on it in the sixteenth and seventeenth centuries.

Because of his patronage of titans like Michelangelo, we are naturally inclined to think of Julius II as the supreme "building pope" of the sixteenth century. And so he was, in a sense—but if the scale of Sixtus V Peretti's changes to the urban structure of Rome is not appreciated, one is fated to misunderstand the city. It was Sixtus V who laid the groundwork of Baroque Rome, the city whose exoskeleton the visitor sees today but is apt to take for granted.

He was elected pope in 1585, inheriting a chaotic city riddled with crime, close to bankruptcy, and dotted with half-abandoned ruins. In the apogee of its imperial years, Rome held over a million people. Now it had possibly twenty-five thousand, and probably fewer. The economic depression of the fourteenth century, forced on Rome by the Great Schism that drove the city into a plunge, had turned Rome into a veritable ghost town with monuments.

The seven main churches of Rome were foci for a steadily increasing flow of religious tourism, which, unlike later and more exploitive forms of mass tourism, did little for the city's general economy. True, every year the number of pilgrimages by the faithful increased. But the connective tissue between them—the living body of the supposedly Eternal City—seemed to be shriveling at an alarming rate. One project of renewal stood out: Michelangelo's masterpiece of urban design, the remaking of the Capitol, which had been accomplished in the 1540s—long before

Sixtus V's papacy. But too little had been built anew, and the order on which Rome depended for its continued civic life had disappeared, replaced by a chaos reminiscent of New York City in the 1970s or Washington, D.C., in the 1990s. Some people believed the bandits had taken over. One estimate said there were twenty thousand of them, about one for every law-abiding citizen. This hardly seems plausible, but certainly the crime rate had increased beyond computation.

Such a crisis cannot be averted by one person. Yet it cannot be defeated without strong leadership, either—without a ruthless intensity of will that committees cannot usually summon. But, as sometimes happened, the crisis called forth the man—a cleric who, in the closing years of the sixteenth century, became pope and thus took over Rome and its administration. He was Felice Peretti, Cardinal Montalto, a Franciscan who had been elected pope by the conclave that followed the death of Gregory XIII, and had assumed the papacy under the name of Sixtus V.

He was a farmer's son, born in Grottammare, an obscure *paese* near Montalto, in the Papal States. It was said that as a boy he had been a swineherd, which may easily be true. He rose rapidly within the Church as a Minorite friar, becoming the rector of successive convents in Siena (1550), Naples (1553), and Venice (1556). He was appointed counselor to the Inquisition there a year afterward. Fierce and fanatical Inquisitors were no novelty in Venice, but even there Peretti seems to have been abnormal in his zeal, and by 1560 the Venetian government demanded and got his withdrawal.

In 1566, Pope Pius V made him a bishop; in 1570, he took the cardinal's red hat. Fifteen years later, he was elected pope. He was said to have entered the chamber of the electoral conclave on crutches, feigning extreme infirmity. No doubt he hoped this would improve his chances of being elected as an interim, short-term pope. The instant his election was confirmed by the white smoke rising from the chimney, he flung the crutches away, to stand before the assembled cardinals erect and fairly bristling with vitality. The story is untrue, but *"se non è vero,"* as the Romans habitually say, *"è ben trovato,"*—"if it's not true, it ought to be."

In some respects, Sixtus V was a terrifying figure; in others, an ignorant one; and in all ways, formidable. But he could never be reproached for either indecision or lack of creativity. The atmosphere of reform that seized the Church had brought forth a man whose belief in authority, especially his own as pontiff, was absolute. However, being a man of iron will, he was not inclined to listen to those he considered his

inferiors—which meant anyone else in the One Holy Roman Catholic and Apostolic Church. This showed in all his actions, from city planning to Biblical scholarship.

In the late 1580s, Sixtus took charge of publishing the "Sixtine Vulgate," or official Latin text of the Bible. This was a religious necessity, because it would give Italians the definitive printed form of the fundamental text of Christendom, protecting it from heretical incursions like Lutheranism.

But Sixtus did not take kindly to editors. He saw them as quibbling nuisances, and brusquely ignored their suggestions. This edition, published in 1590, became a bibliographic rarity, because it was so full of mistakes that it had to be suppressed—after his death, naturally.

Nothing like that happened with his plans for Rome itself. Thinking holistically, on a citywide scale rather than just building by building, Sixtus transformed the shape of Rome.

But first he had the crime problem to deal with.

"*Non veni pacem mittere,*" he told a fellow cardinal who congratulated him on his election, "*sed gladium*": the words of Christ, "I come not to send peace, but a sword."

The papal blade first swung, with deadly effect, at Rome's population of thugs and thieves, who found themselves arrested, beheaded, garroted, or hanging from gibbets and the Tiber's bridges. Sixtus V emphatically did not believe that citizens had the right to bear arms. What he did believe in was judicial terror. When four innocuous youths with sheathed swords were seen following one of his papal processions, he had them summarily executed. This policy was so effective that before long the Papal States were considered the safest domain in Europe. Sixtus celebrated this achievement by having a medal struck with his face on one side and on the other a pilgrim sleeping beneath a tree, with the motto *Perfecta securitas.*

In case villains tried to get away, Sixtus was the first to arrange for extradition treaties with neighboring states. No ruler was going to risk papal displeasure by ignoring them. If the death penalty could improve civic order, it could also do wonders for moral order. Among the actions Sixtus declared punishable by death, apart from theft and assault, were abortion, incest, and pedophilia. Theoretically, these had carried the death penalty before, but Sixtus made it absolutely mandatory and without exceptions. Lesser crimes, such as failing to keep holy the Sabbath day, were punished by condemnation to the galleys. (The Papal States

still had a modest-sized fleet, though its ships were probably used less for warfare than for the punishment of sinners at the laboring oar.) Rome was swarming with prostitutes, who had scarcely been disturbed by previous papacies; Sixtus had them banned from major thoroughfares during daylight hours, and from all Roman streets after nightfall. He meant it, too: if a girl was caught plying her trade in the wrong place or out of hours, she would be branded on the face or breasts.

With crime and vice under some kind of control, Sixtus next turned his attention to the planned but unfinished urban work of Gregory XIII. This pontiff had already made his own changes to the city. A Holy Year was scheduled for 1575. It would bring many pilgrims to Rome, multiplying the circulation problems. By way of preparation for this, Gregory had cleared a wide street called the Via Merulana, running from Santa Maria Maggiore to the Lateran. He also revised the building codes, to encourage larger and more impressive civil structures.

But this was small stuff compared with the projects Sixtus V now embarked on, through his architect-in-chief, Domenico Fontana (1543–1607).

Much earlier, in 1576, Fontana had designed a huge (and ever-expanding) villa on the Quirinal for Sixtus, the Villa Montalto. He advised the pope on the restoration of one of the most beautiful early churches in Rome, the fifth-century Santa Sabina, with its twenty-four matching Corinthian columns recycled from some ancient pagan temple. He designed a large but undistinguished building to house what is now a great collection, that of the Vatican Library (1587–90), and chose the painters who frescoed it with such scenes as the Cumaean Sibyl presiding over the burning of the Sibylline Books.* Sixtus was not in favor of keeping the palace of San Giovanni in Laterano, parts of which dated from the sixth century, and which until the fifteenth century had been the chief papal residence. Pope Nicholas V had moved out of it and into new quarters in the Vatican. Since then, the old building had decayed through neglect, and much of it was uninhabitable, certainly not pope-worthy. Sixtus

* The Cumaean Sibyl was the most famous of that sisterhood. Her prophecies and oracles, filling nine volumes, were offered to the last king of Rome, Tarquinius Superbus, at a high price. He refused; the Sibyl burned three of the books and offered the remaining six to Tarquin at the same price. He refused again; she burned three more of them and offered the remaining three to Tarquin, who finally bought them. These *Libri Sibyllini*, filled with prophecies and advice on how to avert divine anger, were entrusted to the care of patricians. The Sibyls came to be thought of as equal to the Old Testament prophets and figure as such in Michelangelo's Sistine Chapel.

decreed that it should be razed to the ground, and in its place Fontana built a new Lateran Palace, which was finished in 1588.

The particular concern of Sixtus V, though, one which amounted almost to an obsession, was the shape and circulation of the city of Rome itself. It was not enough for the pope to ban all overhanging wooden structures on its streets, though he did. The streets themselves needed radical surgery. In the end, Sixtus either paved or resurfaced about 120 streets in Rome, and laid out some ten kilometers of new roads within the city.

The city maps from earlier in the sixteenth century show its seven pilgrimage churches: San Giovanni in Laterano, San Pietro, San Paolo Fuori le Mura, Santa Maria Maggiore, San Lorenzo, Sant'Agnese, and San Sebastiano. Meandering between them were roads, most of which were mere cattle paths. This messy informality offended the pope's sense of order. In future, straight streets would join up at focal points, in orderly progressions. For instance, he directed the layout and construction of avenues that linked Santa Maria Maggiore directly to the Lateran Palace, and the Lateran with the Colosseum. A wide, handsome street named the Strada Felice (after the pope's own name), and later renamed the Via Sistina, was driven three kilometers from Santa Croce in Gerusalemme, on to Santa Maria Maggiore, and so to Santissima Trinità dei Monti. No existing building impeded the clearance of these avenues. If anything was in the way, down it came. The pope had an unquestioned right of eminent domain on secular as well as ecclesiastical buildings, and he exercised it without restraint.

Nor did he have the slightest regard for the classical monuments. Sixtus V was a man of superficial culture, never inhibited by humanistic reverence for the Roman past, or even the memories of the Renaissance. His predecessor, Gregory XIII, had set up ancient statues on the Capitol; Sixtus objected to this, saying that they were no more tolerable than any other pagan idols, and had them carted off. He told one of his courtiers that this gave him particular enjoyment because he had dreamed that Gregory XIII, whom he hated, was suffering in Purgatory. He took pleasure in spending the recorded sum of 5,339 scudi on destroying the ruins of the Baths of Diocletian. Without a qualm he demolished the remains of the magnificent façade of the Septizodium of the emperor Septimius Severus (dedicated in 201 C.E.), so admired by fifteenth- and sixteenth-century artists, and had its *spolia* of precious marble dispersed through the city as part of his own building projects. He wanted to see

the four-sided arch of Janus Quadrifrons, in the Forum Boarium, demolished, so that his court architect, Fontana, could use its marble to make a base for the obelisk in front of San Giovanni in Laterano, and gave orders for the destruction of the tomb of Caecilia Metella, even though it was well outside the city limits. He also thought the Colosseum should be turned into a wool factory to increase employment in the city. This latter plan was going forward, but on Sixtus' death, in 1590, it was dropped. So (luckily) was another and far worse idea of his, which was to tear down a whole section of the Colosseum to make way for a new, straight avenue connecting the Campidoglio to San Giovanni in Laterano.

When the question arose of what to do with the two great antique columns of Rome, those of Trajan and Marcus Aurelius, Sixtus went right ahead without regard for the original meanings of these monuments, installing a statue of Saint Peter (cast from the bronze of ancient statues melted down) on top of Trajan's Column and one of Saint Paul on that of Marcus Aurelius. In dedicating the statue of Peter, His Holiness explained that such a monument as Trajan's could only become worthy to bear the effigy of Christ's vicar on earth if it was rededicated in the cause of the Catholic Church—an astonishing piece of casuistry.

The truth was that Sixtus V, like many another man of unbridled power, believed more in the future than in the past, because the future could be shaped but the past could not. At his core he simply did not see why the remains of a defeated paganism should be allowed to impede the progress of a living, triumphant faith. He was in that respect an ideal pope for the Counter-Reformation. Everything that was built, restored, carved, or painted under his papacy had to exemplify the power of the Church Triumphant. If a fountain was to be designed, its subject could no longer be the pagan Neptune surrounded by sea nymphs and Tritons. It would have to be Moses striking the rock, releasing the gushing water of faith.

Water was a prime metaphor of devotional art by now. Much of Fontana's work depended on his construction of a new aqueduct, which, in homage to the pope's birth name of Felice Peretti, was known as the Acqua Felice. "Happy Water," indeed. Until then, new building in Rome had mostly been confined to the low-lying areas along the Tiber. The Acqua Felice entered Rome higher up its hills, finishing at Piazza Santa Susanna, by the Baths of Diocletian, the present site of the Museo delle Terme. This wider distribution of precious water opened up much more of the *disabitato,* the "abandoned" or "empty" tracts of the city, for devel-

opment and occupation. Naturally, it was much easier to build on empty land than to "do an Haussmann" and have to demolish and clear every site first.

So there was always work, but the one project by which Fontana is remembered, and which gave him a deserved immortality as an engineer, was moving and re-erecting the obelisk of Saint Peter's, that huge spike rising from what would become the heart of Christianity.

Sixtus V had a vast liking for obelisks, and Rome had more of them than any other European city—thirteen, to be exact, all except one either broken or lying prone, or mostly both.* His enthusiasm was satirized by one of the acrid couplets that made the rounds during his papacy:

> *Noi abbiamo basta di guglie e fontane:*
> *Pane vollemo, pane, pane, pane!*

> We've had it up to here with obelisks and fountains:
> It's bread we want, bread, bread, bread!

These angry rhymes were known as "pasquinades," because they were traditionally affixed to a worn antique statue named, since time immemorial *Pasquino.* Rome had a number of such "talking statues," which served as vents for civic annoyance at a time when Romans had no access to any press. Another was a female bust, now rather battered, known to Romans as *Madama Lucrezia,* attached to the wall of the Palazzetto Venezia, next to the corner of the Basilica di San Marco, the church of Rome's Venetian colony. But the most famous pair of talkers were *Pasquino* and his old friend *Marforio. Marforio,* an ancient river god, used to be at the entrance of the Mamertine Prison, but then he was moved up to the Capitol and is to be found reclining at the entrance to the Capitoline Museum. *Pasquino* is in the little piazza named for him, the Piazza di Pasquino, behind Piazza Navona. *Marforio* would speak (through a placard), and *Pasquino* would reply (or vice versa), and their dialogue, usually in a dialect incomprehensible to the non-Roman, was one of the great comic acts of Rome.

Pasquino, like *Marforio,* is ancient: a worn and beaten classical torso of Menelaus from the third century B.C.E. dug up during the repair of an adjacent street. It was installed in its present place by a cardinal in 1501. The name is supposed to have come from a tailor in a nearby shop who was dangerously free with his impertinent criticism of the papal govern-

* It is thought that there had once been more than forty; the fate of the rest remains unknown.

ment. But there are so many legends about *Pasquino*'s origins that it is probably impossible to disentangle the true one.

In any case, one day during the reign of Sixtus V, *Pasquino* was seen wearing a horribly filthy shirt. Why, *Marforio* wanted to know, did he wear such a stinking rag? Because Donna Camilla has become a princess, came the answer. Donna Camilla, the pope's sister, in her humbler days had been a washerwoman, but had just been ennobled by His Holiness.

There was a limit to what great figures would endure from *Pasquino*, and this crossed the line. It got to the ears of Sixtus V, who let it be known that, if the anonymous satirist owned up to writing it, his life would be spared and he would receive a present of one thousand pistoles in cash. But if anyone else found him out and denounced him, the writer would be hanged. Naturally, the nameless graffitist—for who was going to turn down such a reward?—confessed. Sixtus V gave him the money and spared his life, but unsportingly added, "We have reserved for Ourselves the power of cutting off your hands and boring your tongue through, to prevent your being so witty in the future." But nothing would shut *Pasquino* up; he had a hundred tongues and two hundred hands. The very next Sunday *Pasquino* was seen draped in a still-wet freshly laundered shirt, set to dry in the sun. *Marforio* wondered why he couldn't wait until Monday. "There's no time to lose," said *Pasquino*, thinking of His Holiness's taxation habits. "If I stay until tomorrow perhaps I'll have to pay for the sunshine."

The obelisks of Rome were souvenirs of the Empire's conquest of Egypt, and most of them had been brought to the city in imperial times. Ancient Egypt had three basic commemorative forms: the pyramid, the sphinx, and the obelisk. But the task of moving an obelisk (never mind a sphinx or a pyramid) across the Mediterranean was hardly less daunting than making the thing to begin with, which was difficult enough—indeed, insanely so—and could only have been undertaken by a theocratic anti-state like ancient Egypt.

All known Egyptian obelisks came from the same quarry—a deposit of extremely hard and fine-grained syenite, a rock similar to granite, at Aswan, below the first cataract of the Nile. It lay seven hundred miles from Alexandria and five hundred from Heliopolis, where the biggest concentration of finished obelisks stood.

The tools of ancient Egypt were very simple. No stonecutting saws or explosives, of course; no steel; and for moving the heavy blocks of syenite, once they were free of the quarry, only the timber lever, the

roller, the inclined plane, the wedge, palm-fiber ropes, grease, and limitless manpower. Human muscle, at least, was not in short supply, and it was preferred to animal traction, since the fellahin could obey orders a team of oxen would not understand. Egypt had about 11,500 square miles of inhabitable terrain, and a population, in pharaonic times, of perhaps eight million people, a density of some seven hundred per square mile—six times more than China's or India's then.

The task of cutting out the granite block for an obelisk was simplicity itself—tedious, infinitely laborious simplicity.

You and other slaves marked the intended line of cleavage in the granite by gouging a channel for its full length, about two inches deep and two wide. Into the bottom of this channel you drilled a line of holes, each about three inches in diameter and six inches deep, spaced some eighteen inches apart.

You and your fellow slaves now had two choices.

The first was to hammer a wooden plug into each of these holes and then fill the channel with water, which other slaves would have brought in skins from the nearby Nile. If, despite the evaporative power of the Egyptian sun, the wood was kept soaked long enough, the plugs would swell and, with luck, cause the whole mass to crack away from its matrix.

The second choice was to build a fire the whole length of the channel and keep it burning until the rock was piping hot, then sweep away the ash and embers and quickly douse it all with cold water, which (with luck) would also crack the granite.

No tools for work on the obelisks have ever been found, except a single bronze chisel at Thebes. Iron tools, if they existed at all, have entirely disappeared, rusted away (some think) by the highly nitrous Egyptian soil. Possibly the chisels had diamond teeth. For the long and arduous task of smoothing the faces of the obelisks, there must have been abrasives of some kind—emery, corundum, or even diamond dust. The main ingredient, of which ancient Egypt was never short, was limitless amounts of human labor.

How the obelisk got its final sculptural shape, with the "pyramidion" or point on top of the shaft, is not known. It cannot have been done with abrasives—there was too much rock to remove—but trying to split the waste rock off accurately at sixty degrees on all four faces must have been, to put it mildly, chancy.

Nevertheless, it was done, and now came the problem of getting the thing to its intended site. But this was not a matter to deter a really serious

pharaoh. In the nineteenth dynasty, about 1400 B.C.E., Rameses II had a nine-hundred-ton effigy of himself dragged 138 miles from its granite bed to the *memnorium* in Thebes, on some kind of enormous sled, with obedient Egyptians pouring oil on the sand in front of its runners to reduce friction and thousands of other Egyptians hauling on ropes. The obelisk's granite bed was not so far—at least, not unthinkably far—from the Nile. The best guess is that the Egyptians built a dry dock on the bank of the river, at low water. Inside this, a transport barge was constructed. Now the obelisk would be dragged from the quarry to the dry dock on a massive timber sledge, an operation requiring perhaps fifty thousand men in double or quadruple lines, and miles of palm-fiber rope.

Thus the obelisk would be loaded slowly, slowly into the barge, there to wait for the great event, the annual inundation of the Nile. This would raise the laden barge, which then, with great luck and skill, would be floated down the river to a place as close as possible to the obelisk's appointed site. There, the patient Egyptians would run through the whole process again, this time backward, building another dry dock, securing the barge in it, waiting for the Nile water to recede, dragging the obelisk from the barge and the embankment to its eventual pedestal, and raising it vertical.

How this might have been done was entirely conjectural, and so it had to be reinvented again and again. First the ancient Romans, of the time of Cleopatra and Ptolemy, had to reinvent it, no doubt with a great deal of subservient Egyptian help. Then, more than a thousand years later, the Italians had to invent it once more, since there were no records of the original moves.

Of the ships that brought the obelisks to Rome, not a trace remains. It is presumed that they were enormous galleys, each custom-built, quinqueremes with at least three hundred oarsmen, and that the prone obelisk was ballasted with many tons of wheat or dried beans in sacks packed around it to prevent it from shifting, since any instability in so immense a load would have rolled the ship and sent it to the bottom at once. (Underwater archaeology has found an amazing variety of objects in ancient wrecks, including what some presume to have been a primitive ancestor of the computer off the island of Antikythera—the "Antikythera Mechanism"—but no obelisk so far.)

Once the ship and its cargo had reached Ostia, the entire process had to be repeated in reverse: the dry dock, the sledge, the hauling, and the inch-by-inch journey to Rome. Some obelisks, at least, were raised verti-

cally on their bases in the Circus Maximus and elsewhere, but it is not known how. Most of them were broken into several pieces, either by toppling over in unrecorded antiquity, or by damage from earthquakes or ground subsidence as they lay prone.

There was, however, one perfect unbroken obelisk still standing in Rome in the sixteenth century. The largest intact one outside Egypt, it dated from the nineteenth dynasty, about 1300 B.C.E., and had been brought to the Eternal City on the orders of none other than Caligula, having been raised first at Heliopolis. Caligula decreed its transport to a site on Nero's Circus, which, more than a thousand years later, turned out to be the back of the old Saint Peter's Basilica. It was a tapering granite shaft, eighty-three feet and one inch to the tip of its pyramidion, weighing 361 tons. On top of the pyramidion was a bronze ball, which nobody had ever opened; it was reputed to contain the ashes of Julius Caesar.

Pope Sixtus V had often looked at the obelisk from afar, and was not satisfied. It should not be behind the new Basilica of Saint Peter's, which was then nearing completion. It must be moved to the front. A simple matter of civic punctuation—shifting the exclamation point in the sentence. A great piazza would be made in front of the new Saint Peter's (and so it was, years later, to the designs of the as yet unborn Gian Lorenzo Bernini). Let the obelisk be brought round and planted *there,* plumb in the center, to the wonder of pilgrims now, the edification of the faithful in centuries to come, and the eternal memory of Pope Sixtus V.

But—the age-old problem—how to move it?

The pope appointed a commission to look into the problem. Through 1585, some five hundred experts from all over Italy and as far afield as Rhodes, which had had previous experience with colossi, were consulted. Some were for transporting the obelisk prone, others for doing it standing upright, and at least one proposed, for inscrutable reasons, moving it at an angle of forty-five degrees. Some wanted to move it horizontally and then turn it upright by means of a gigantic half-wheel to which it would be fixed. Others proposed raising it off its pedestal with wedges. Scores of solutions were proposed, most of which looked ineffective and some downright lethal.

Before too long, Sixtus V wearied of looking at these notions, and appointed the man he had had in mind all along: his own architect, Domenico Fontana. The hitch was that Fontana was only forty-two, and therefore seen by some papal officials as too young and inexperienced.

So the commission appointed a watchdog: the distinguished Florentine architect Bartolomeo Ammannati, who was seventy-four and had to his credit a number of architectural masterpieces, such as the courtyard of the Palazzo Pitti in Florence; the Ponte Santa Trinità, spanning the Arno; and the Villa Giulia in Rome.

Ammannati was an outstanding architect, but he was hardly needed, since Fontana was the greater engineer. What Fontana proposed was to set one pair of massive timber pylons on each side of the obelisk. Each of the four pylons would consist of four vertical members, each ninety-two feet long, made of twenty-by-twenty-inch timber lap-jointed securely together with one-and-a-half-inch thick iron lag-bolts and iron bands. The timber balks were brought from twenty miles away. Ropes would run over pulleys at the top of the pylons and be secured to the obelisk, which was to be padded with straw and then encased in two-inch-thick planks for its whole length, to give it some degree of protection—though if it dropped nothing could save it from shattering. These cables would connect to eyebolts fixed to iron bands clasping the sheathed body of the obelisk. The cables would run to windlasses on the ground, turned by horse-powered capstans, like the capstans used to raise the anchors of ships. Fontana calculated the gross weight of the obelisk, its armature, and metal lifting bolts at 681,222 pounds. A capstan powered by four horses, he figured, could lift fourteen thousand pounds. So he would need forty capstans to lift vertically 80 percent of the obelisk's weight—the remainder being done by five massive timber levers. If the obelisk began to tilt, it would initiate a catastrophe, slipping sideways to the ground, so the most exquisite care was going to be required to keep the tension equal on all those forty cables, fanning outward to the capstans around the obelisk. Winching in the cables required pulleys based on ship's tackle, but of a huge size never used on a ship—scores of double-sheaved pulley blocks, iron-bound, with a two-to-one ratio, the largest of them five feet two inches long. The cables themselves were each 750 feet long, three inches in diameter, and spun in an especially large ropewalk at Foligno, with a breaking strain (Fontana figured) of fifty thousand pounds. This was the largest order of equipment the Italian maritime industry had ever known. But, then, nothing like this had ever been tried in the history of Italian civil engineering. It was going to need almost unheard-of care and coordination, which Fontana proposed to achieve with a system of sound signals—a trumpet to start each capstan pull, a bell to end it.

First the obelisk must be raised from its base, and then swayed down

prone on the enormous carriage and rollers on which it would be dragged from the rear of Saint Peter's to the site in front. Then the pylons and capstans must be brought round, rerigged, and used to stand the prodigious block of stone vertical again and gingerly lowered onto a base which had been prepared for it in front of the basilica.

Sixtus V issued lengthy and detailed orders that no one "shall dare impede, or in any way molest the work." This meant invoking eminent domain over everything that lay along the route of the obelisk: if there was a house in the way, down it would go. The whole operation, which took days and consumed the labor of nine hundred men and some 140 horses, was watched by most of the population of Rome—who were kept back by a security fence and had been warned, in no uncertain terms, that anyone who made a noise or spoke a word would be instantly put to death. Nobody uttered a peep.

However, it became part of the folklore of this tremendous operation that, at a certain point, the ropes carrying the obelisk began either to fray from the load or to smolder from the friction. Disaster stared Fontana in the face. Legend has it that the day was saved by an iron-lunged Genoese sailor named Brescia di Bordighera, who broke silence by bellowing, *"Acqua alle funi"*—"Water on the ropes!" Far from punishing the man for breaking silence, the pope, when he realized how the sailor had saved the project, rewarded him with blessings and annuities.

Unfortunately, the story seems not to be true. Neither Fontana, who kept a log of the lowering, moving, and raising of the obelisk, nor anyone else who was there mentions the sailor and his saving cry, and it would hardly have been possible for anyone to find or bring the necessary water to Piazza San Pietro in time.

When the obelisk was vertical, Sixtus V could not contain his joy, crying in triumph, *"Cio che era pagano ora è l'emblema della cristianità"*—"The thing that was pagan is now the emblem of Christianity." And that was the point: to Sixtus, the moving or "translation" of this and other obelisks, achieved with such immense, concerted effort and determination, symbolized the work of the Counter-Reformation, the reunification of the Church, the defeat and pushing back of heresy.

The pope showered Fontana with honors.

The bronze ball was opened, and it contained no trace of Caesar; it was quite empty. So much for superstition.

The Vatican obelisk and the Acqua Felice were the most spectacular projects that Sixtus' papacy contributed to the fabric of Rome, but not by

any means the only ones. An even bigger obelisk had been lying in three pieces near the cathedral, San Giovanni in Laterano. Originally commissioned by the Pharaoh Thutmose III, it was removed to Alexandria by Constantine in 330 c.e., and then transported to Rome by Constantius II in 337 c.e. and set up in the Circus Maximus. It was 105 feet high—fully twenty feet taller than the enormous Vatican one—and weighed 510 tons. At Sixtus V's behest, Fontana managed to raise it, and repaired it so well that today its seams can be seen only if you look closely. He took charge of a third obelisk, which had also served as a marker in the Circus Maximus, and moved it to the Piazza del Popolo, where it still stands. Compared with the Vatican and Lateran obelisks, this was almost child's play—a mere seventy-eight-footer, 263 tons. Finally, he had the obelisk that lay in four pieces on the Via di Ripetta, on the west side of the Mausoleum of Augustus, excavated and set up anew behind the apse of Santa Maria Maggiore, in Piazza Esquilino. This was completed by the end of 1587.

This example was followed by several later popes, so that within a century a dozen obelisks were standing in Rome. The chief obelisk-pope, after Sixtus, was Pius VI Braschi, who had three erected during his twenty-four-year pontificate (1775–99). The first was put up on the Quirinal, between its huge white marble statues of the horse-taming Dioscuri, Castor and Pollux. It, too, came from the Mausoleum of Augustus, where it had been found in the sixteenth century, reburied (it was a massive obstacle to riverside traffic on the Via di Ripetta), exhumed again in three pieces, and, under the direction of the architect Giovanni Antinori, set up in 1786 in front of the Quirinal Palace. The second was installed at the top of the Spanish Steps, outside Santissima Trinità dei Monti, in 1789. The third, extracted from Augustus' Mausoleum and known (for its ancient use as a gnomon on the enormous sundial) as the Obelisco Solare, went in five pieces to Piazza Montecitorio and was reassembled by Antinori; it still stands there today, in front of the Palazzo dei Tribunali. Augustus had brought it back from Heliopolis, in Egypt, where it had been made for the Pharaoh Psammetichus I.

So Sixtus V's obelisk raising was by no means unique. How, after inheriting a bankrupt papacy, could this manic-impressive pontiff keep up the rhythm of building public works that he insisted on? By the sale of offices, by the establishment of new *monti* or public loans (a money-raising device first employed by Clement VII in the sixteenth century), and above all by ferocious taxation. All this created a glut in the papal *fiscus,* which, like some omnipotent Scrooge McDuck, he pre-

ferred to keep in bullion and specie in giant iron-ribbed coffers (still to be seen, but gaping empty) in the Castel Sant'Angelo. In these money boxes he hid three million scudi in gold and 1.6 million in silver, the biggest mass of cash in Italy, one of the biggest in Europe. In fact, his accumulation took so much cash out of circulation that it created severe economic problems for the Roman economy; money could not circulate as before, and so business stagnated. Either Sixtus was unaware of this, or he did not care about it. The public display, the rhetorical obelisk, was the thing.

In most respects his politics, particularly in the field of foreign policy, were a mess. He was given to grandiose fantasy. Wasn't he God's vicar on earth? He would conquer Egypt, he would bring the Holy Sepulchre to Italy, he would annihilate the Turks. He renewed the excommunication of Queen Elizabeth I of England, and agreed to give the Spaniards a large subsidy for the Armada which would conquer England—not, however, to be paid until the Spanish forces had actually landed, which of course they never did, so that their providential wreckage and dispersal by a storm in the Channel saved him a million crowns.

But the rethinking and rebuilding of Rome around those exclamation marks of the obelisks, the re-creation of the expanse of the city as a pattern of rhetorical circulation—that was something new, worthy of another Caesar: and all done in five years of an incredibly short, obsessively active papacy. A fair epitaph was pronounced on him by the nineteenth-century vernacular poet Giuseppe Belli (1834):

> *Fra tutti quelli c'hanno avuto er posto*
> *De vicarj de Dio, non z'è mai visto*
> *Un papa rugantino, un papa tosto,*
> *Un papa matto, uguale a Papa Sisto.*

> Among all those who have held the place
> Of God's vicar, there had never been seen before
> Such a quarrelsome, tough, crazy
> Pope as Pope Sixtus.

Nor would there ever be again. A visitor from Mantua, Angelo Grillo, reported, "Such is the newness of the edifices, the streets, piazzas, fountains, aqueducts, obelisks, and other stupendous marvels which Sixtus V of glorious memory embellished this old city" that he could hardly recognize the place he had left ten years before. Later popes would build,

but not with such a commitment to reorganize the basic pattern, the manifest sense of space, that was Rome. In a sense, the "building popes" of the Baroque era stood in the shadow of Sixtus' obsession with the city as a pattern of movement and coordinated public declamation, not just a collection of separate monuments. So the visitor to Rome feels gratitude to this man, so inventive, so tyrannous, and so dreadful in different ways. Yet few could be surprised to learn that a statue of him, erected in his honor on the Capitol when he was alive, was torn down by the common people of Rome—the "rabble"—as soon as the breath was out of his body. They must have felt a right to smash it, since it had been put up with the tax money Sixtus extorted from them.

And what of his early seventeenth-century successors? How did they change the appearance and layout of Rome? Very considerably, though perhaps not as radically as terrible Sixtus.

The greatest scheme was the one accomplished during the pontificate of Alexander VII Chigi (reigned 1665–67)—the rebuilding of Piazza del Popolo, which lay just inside the Porta del Popolo, one of the chief entrances to Rome. "Popolo" does not carry some proto-socialist implication; in the Middle Ages, *populus* was a politically neutral term, meaning simply "parish."

Alexander VII cleared the way for his urban desires by reviving the Congregazione delle Strade, the planning commission for Rome, which had fallen into disuse. He gave it the authority to demolish whatever it wished, whenever it saw fit. This was a powerful license. It enabled him, for instance, to get rid of the Arco di Portogallo, which, by constricting the Via del Corso, caused endless traffic jams.

What Alexander favored was generous squares approached by wide streets (no more medieval crimps and doglegs) marked out by distinctive buildings, fountains, and groups of statuary: these he called *teatri,* "theaters," and certainly Piazza del Popolo showed what he meant. It was the first part of Rome that most arriving foreigners saw, and it deserved special treatment. Gian Lorenzo Bernini had designed the gate with the Chigi star carried proudly above it, and at the other end of the piazza now rose twin churches. Designed by the architect Carlo Rainaldi in 1661–62 and finished by Bernini and Carlo Fontana in 1679–81, these frame the entrances to the trident of streets (Via del Corso, Via del Babuino, Via di Ripetta) that plunge away into the core of Rome, and heighten the sense of anticipation that has already been raised by the Porta del Popolo. Everyone who sees them from the piazza, unless forewarned, admires

them for their symmetry. In fact, they are not symmetrical, being built on different-shaped sites. Santa Maria in Montesanto (on the left, looking from the piazza) stands on a longer triangular slice of ground than its companion. It therefore has an oval dome, whereas Santa Maria dei Miracoli has a circular one. But nobody notices this (at first) from the outside, and the illusion of symmetry is perfect until you look closer.

Rome of the Counter-Reformation—the late sixteenth and early seventeenth centuries—did not offer much work to great Italian-born painters, though it incubated some extraordinary expatriates. There were, however, several outstanding exceptions, some of whom (chiefly Bolognese painters in Rome) affirmed the classical tradition, though another seemed completely to subvert it. The first of the classicizers was Annibale Carracci (1560–1609), along with his brother Agostino Carracci (1557–1602). They were native Bolognese, and a third painter-member of the Carracci clan, their cousin Ludovico (1555–1619), chose to spend his life in Bologna and never painted in Rome. Both Agostino and Ludovico were fine painters, but the genius of the family was undoubtedly Annibale.

How powerfully inventive he was can best be gauged by a visit, if it can possibly be arranged, to the state rooms of the Palazzo Farnese. Generally, this used not to be possible, since the palace, originally built by that arch-nepotist Alessandro Farnese, the future Pope Paul III (reigned 1534–49), and without much doubt the most sumptuous palazzo in Italy, became the French Embassy, and access to it used to be so unbelievably restricted that even its courtyard, the combined work of Antonio Sangallo and Michelangelo, was open to the public for exactly one hour a week, between 11 a.m. and noon on Sundays. As for the state rooms, forget it. This meant that one of the supreme works of seventeenth-century Italian painting could only be known by the visitor to Rome, and imperfectly at that, from reproduction. Fortunately, these conditions have now relaxed somewhat, and guided tours are offered. They should not be missed.

Alessandro Farnese (this, one must remember, was before he became pope, though it is unlikely that his proclivities changed much after his election to the Fisherman's Chair) decreed that its subject should be the Power of Love, and earthly rather than divine love at that. To call such a theme inappropriate for a future pontiff would be a mistake: he had been made cardinal by the Borgia Pope Alexander VI, whose mistress was Alessandro Farnese's sister, Giulia Farnese. Moreover, he had four illegitimate children of his own, plus an unknown number of by-blows.

Thus Annibale Carracci set out, with tremendous zeal and brio, to cover the twenty-meter barrel vault with frescoes representing the Triumph of Love as symbolized by the cavortings of Bacchus and Ariadne—a surging, tumbling apparition of scenes from Ovid's *Metamorphoses,* a veritable firmament of classical flesh, anchored in references to Raphael's Loggia Farnesina and the *ignudi* of Michelangelo's Sistine ceiling, but as pagan as the art of painting could imaginably be. Annibale, a superb draftsman, was one of the greatest reinventors of the nude body that has ever existed, and the Farnese ceiling is virtually the last full-strength appearance of the classical impulse, at its outer boundaries of ambition, in Italian art. If one wants to see the other extreme of Annibale Carracci's work, it, too, is in Rome, in the Galleria Colonna: the much earlier and more social-realist portrait of a worker tucking into his lunch of beans and onions, while clutching a bread roll and returning your gaze with a glare of feral possessiveness, mouth open, frayed straw hat on: *The Bean Eater* (c. 1583). It, too, is a masterpiece, though of a very different sort. Presumably it would be difficult, for today's dinner guests in their *fracs,* glancing up from their plates of *foie gras en gelée Lucullus* at the tumultuous joys of gods on the embassy ceiling, to connect the two. It is sad to know that Farnese paid Annibale Carracci so stingily for his four years' inspired labor on the Farnese ceiling that the artist slid into depression, took to the bottle, and died at the early age of forty-nine, reduced at last (one supposes) to eating beans.

The other major Bolognese artist working in Rome in the first part of the seventeenth century was Guido Reni (1575–1642). There can be few painters in history whose careers show such a spectacular rise to the heights of reputation, followed by such a plunge to the depths. For more than a century after his death, connoisseurs, tourists, and other artists considered him to have been angelically inspired, as famous, in his way, as Michelangelo, Leonardo, or (for that matter) Picasso. Percy Bysshe Shelley, who died in Italy, thought that if some cataclysm overwhelmed Rome, the loss of Raphael and Guido Reni would "be alone regretted." Unquestioned geniuses, such as Gian Lorenzo Bernini, thought he painted "pictures of Paradise" and took his work for a model, and other artists were unstinting in their praise. As well they might have been: as his allegorical frescoes in the Palazzo Rospigliosi-Pallavicini in Rome, such as the Raphaelesque *Aurora* (1614), amply demonstrate, Reni at his infrequent best had an exquisite sense of style. In the eighteenth and early nineteenth centuries, his big altarpiece of the Trinity in Santis-

sima Trinità dei Pellegrini was considered one of the sights of Rome, a mandatory spectacle for the serious young artist. But by 1846, in *Modern Painters,* John Ruskin was attributing to Reni "a taint and a stain, and jarring discord . . . marked sensuality and impurity." Fifty years later, Bernard Berenson declared, "We turn away from Guido Reni with disgust unspeakable"—not that it took so very much to disgust that severe and fussy aesthete. The nadir was reached fifty years after that, when you could easily get a ten-foot Reni (if you wanted it, which few did) for under three hundred dollars at auction.

What happened? A tectonic shift in taste. The Victorians did not mind sentimental high-mindedness, just as long as it was not hypocritical, and hypocrisy was the charge made, more and more often, against Guido after his death. He was proud, he said, of being able to "paint heads with their eyes uplifted a hundred different ways," but this did not seem a virtue to later generations—not, at least, one that outweighed Reni's manifest vices, the saccharine of his expressions, the self-repetition, the overproduction.

Moreover, his personal life was disastrous, a swamp of neuroses. Reni had the misfortune to be a gambling addict, always badly in debt, and turning out masses of hackwork to stay afloat. It has been surmised, no doubt rightly, that his gambling was inspired by masochism—losing was a form of self-flagellation for the sin of being alive. Since debts had to be paid, he kept an enormous studio—at one point, his biographer Malvasia noted with some amazement, Reni employed some two hundred assistants. At the same time, he was socially inept, agonizingly aware of his poor education (which hampered him as a history painter and made him hopelessly awkward with sophisticates and scholars), and an extreme closet-case. It was commonly assumed that he lived and died a virgin. He was not only a daily churchgoer but morbidly superstitious. Women terrified him—he suspected them all of being witches, a suspicion they could only allay if they showed themselves to be the Virgin Mary, a hard thing to prove—and he could not bear it if anyone except his own mother touched his laundry.

Yet, for all that, he was capable of extraordinary things. Perhaps his greatest painting was done in 1618–19, not long after leaving Rome for his native Bologna, and now in the Prado. This is *Atalanta and Hippomenes.* In the myth, Atalanta was a swift-running huntress who was determined to keep her virginity and refused to mate with any man who could not outrun her in a footrace. Nobody could, until she was chal-

lenged by Hippomenes, who had been provided with three golden apples by the interfering goddess Aphrodite. At intervals in their race, Hippomenes would drop an apple, which Atalanta could not resist; picking them up delayed her so much that she lost both the race and her virginity. Reni's vision is of two superb nudes that fill the picture space to the exclusion of everything except empty earth, bare sky, and a plain horizon line. But there is little doubt about its subliminal meaning. Hippomenes is well ahead of Atalanta, who is greedily stooping for her second apple. His gesture toward her, however, is one of repulsion and banishment; he is fending off all possibility of contact with her, even though his victory in the race will, according to the myth, entitle him to claim her. He is racing for a prize that he does not desire. It would be hard to think of a more direct statement of homosexual repulsion (within the bounds of decorum) than this.

The word "radical" became so comically overused in the late twentieth century that it has been worn to near-complete vacuity. But there were times (now long gone) when it could (with due caution) be applied to things that happened in the arts. One such time was the early seventeenth century in Rome, and such an event was the appearance in Rome of a young painter named Michelangelo Merisi, known by the name of his birthplace, the northern Italian town of Caravaggio, where he had been born in 1571. There was no reason to suppose that anything of promise, let alone of transforming importance, would come out of a backwater like Caravaggio. It had produced no artists, had no intellectual life, and could boast no aristocratic collections for a young painter to admire or copy. Yet Michelangelo Merisi was a genius, and he possessed what all who knew him agreed was *uno cervello stravagantissimo*, a really weird turn of mind. What form did the weirdness take? In a word, realism. Caravaggio was not even faintly interested in the tricks and tropes of Mannerist painting—the elongated bodies, the balletic twisting and posturing, the arty metaphors and elaborate *concetti*. Roman painting in 1592, the year Caravaggio got there, had a great past but a mincing present. Much of it was as fatuous as the stuff that would come to be praised as "postmodernism" there (and in New York) four centuries later: pedantic, clever-clever, garrulous, and full of weightless quotation. He wanted to see reality head-on, and paint it that way, direct from life, with the maximum impact and sincerity, down to the last callused foot and dirty fingernail.

This ambition, which seems admirably natural today, earned him

much finger-wagging: he was called an "anti-Michelangelo," as though that meant "anti-Christ"; an evil genius, a concocter of overpeppered stews, and so forth. But Caravaggio's work really did turn the history of European painting around. For a time, one had practically no choice but to be a Caravaggista. France, Holland, Spain, Germany, and of course Italy itself were all subject to his influence. When he was born, almost all painters in Europe worked under the classicizing idealism of Michelangelo. Forty years later, after his early death, their descendants with equal unanimity were painting Caravaggios, neither classical nor idealistic. Scratch almost any seventeenth-century artist and you will find traces of Caravaggio: Rembrandt, Seghers, and Honthorst in the Netherlands: Velázquez and Ribera in Spain; Georges de La Tour and Valentin de Boulogne in France; and a dozen more, omitting the scores of mere imitators.

There are two reasons why the hunger in Caravaggio's eye, the desire for complete and unidealized human truth, had such a powerful effect in its time, the early seventeenth century.

The first was a general one: all over Europe, people were getting tired of the euphemism that tends to accompany abstraction. One sees this, for instance, in theater: how the powerful and wrenching scenes of the Jacobean "revenge" dramatists entranced their audiences:

> Tear up his lids,
> And make his eyes like comets shine through blood;
> When the bad bleeds, then is the tragedy good.

Or think of the fearful scenes in *Lear*—cold Goneril insisting that her father be blinded, not just put out of his misery by hanging—or in *Titus Andronicus*. Obviously, the language of horror and dramatic extremity was not invented by seventeenth-century artists and writers, but it moved to the forefront of their imaginations, whether for titillation or for religious revelation, and thus became one of the main ingredients of Baroque art. Then one must add the fact that, horror or not, seventeenth-century Europeans were getting a lot more interested in the pragmatic and the factual. Fewer angels with gauzy wings; not so much disembodied spirituality. Instead, direct appeals to the senses of smell, touch, hearing, and to the actual look and feel of a world which, after all, God had created. If a painter set before a viewer an image of high, transcendent artificiality, it might not affect his beliefs. But an image which came out of the real world and referred dramatically back to it, one which inhabited the same kind of space as the viewer, which was

subject to the same kind of feelings—that was more convincing. Such was the opinion of the Council of Trent, which resolved to find ways of making the doctrines of Roman Catholicism more vivid and direct to an unsophisticated public. The object of art would be not to out-argue Luther, not to win theological debates, but to assure the faithful of the Truth by means of a superior intensity, a more palpable truth of events and emotions. And that, his patrons soon realized, was where Caravaggio came in.

He certainly did not please everyone, but nobody could say he went unrecognized. "In our times, during the pontificate of Pope Clement VIII," begins a diatribe by the sixteenth-century painter and theorist Vicente Carducho (1570–1638), an Italian who had moved to Madrid,

> Michelangelo Caravaggio rose in Rome. His new dish is cooked with such condiments, with so much flavor, appetite, and relish, that he has surpassed everybody. . . . Did anyone ever paint, and with as much success, as this monster of genius and talent, almost without rules, without theory, without learning and meditation, solely by the power of his genius and the model in front of him? I heard a zealot of our profession say that the appearance of this man meant a foreboding of ruin and an end to painting. . . .

Though he finished as a sublime religious dramatist, Caravaggio began as a painter of benign nature. Granted, the worm is in the bud sometimes—Caravaggio's early still-lifes often show overripe, embrowned fruit—but the Caravaggian cave of darkness was not invented overnight. His early Roman works, such as the exquisite *Rest on the Flight into Egypt* (1594–95), are evenly and crisply lit, in a way recalling the High Renaissance painters Lorenzo Lotto and (more distantly) Giorgione. Mary, bent sleepily over her infant, is a beautiful redhead (presumably Caravaggio's girlfriend at the time), and the elderly Saint Joseph holds up a score, from which the angel is playing soothing music on his fiddle as the mother and child doze.

Such works made him popular with the upper ranks of Roman collectors. They included Cardinal Francesco Maria del Monte, who owned eight of his paintings, and the discerning and deep-pocketed Marchese Vincenzo Giustiniani, who had fifteen.

Because of their even lighting and elegant variety of color, we are apt to think of these early works as "untypical." By his early thirties, though, Caravaggio's essential character as an artist was formed. Its prime ele-

ment was his mastery of gesture. Caravaggio saw things and set them down with uncanny accuracy: how people move, slump, sit up, point, and shrug; how they writhe in pain; how the dead sprawl. Hence the vividness of Abraham's gesture in *The Sacrifice of Isaac*, as he pins his wailing son down on a rock like a man about to gut a fish. In *The Supper at Emmaus*, the characters seem ready to come off the canvas as Christ makes his sacramental gesture over the food (an ordinary Roman loaf); and the basket of fruit, perched on the very edge of the painted table, is ready to spill its contents at one's feet. And the cramped little Cerasi Chapel of Santa Maria del Popolo, for which Caravaggio painted a *Conversion of Saint Paul* and a *Crucifixion of Saint Peter* (1600–1601), is so small that it is impossible to get a distance from the paintings: they are almost pressed against you, like bodies in a crowded room, and you cannot believe this effect is not deliberate. This is particularly true of the figures of Peter and his three executioners; they form a powerful X of flesh and dun-colored cloth, the faces of two executioners hidden from us completely, and the third turned away in shadow. Only Peter (who was crucified upside down, according to pious legend, because he did not think himself worthy to die in the same way as the Messiah) is fully visible—that strong old man's body reflecting the light, those eyes staring in anguish at the iron nail driven through his hand and into the wood. These are not invented or imagined figures; they have a tremendous physical presence, and one is left in no doubt that the stories about Caravaggio's way of working—that he found his models among the people on the streets, and painted them just as they were—are basically true. He clearly went to great lengths to arrange the directional lighting in his dark studio. But not much else is known about his way of working, because not a single attributable drawing by Caravaggio has survived. Perhaps he destroyed them all, or they were lost in one of his many moves between one improvised studio and the next, one city and another. But there is also the possibility, which one cannot reject out of hand, that he did not make any: that he drew directly on the canvas, without planning things first.

Naturally, this risky and exalted spontaneity—unlikely as it seems, and out of kilter with "normal" studio practice—seems to fit the picture of Caravaggio that his way of life offers, from what we know of it. He died of a fever in 1610, at the age of thirty-nine, in Porto Ercole, then a malarial Spanish enclave on the coast of the Maremma, north of Rome. The last four years of his life were one long flight from police and assassins;

on the run, working under extreme pressure, he left altarpieces—some very great, and none mediocre—in Mediterranean seaports from Naples to Valletta to Palermo. He killed one man with a dagger in the groin during a game of tennis in Rome in 1606, and wounded several others, including a guard at Castel Sant'Angelo, and a waiter, whose face he cut open in a squabble about artichokes. He was sued for libel in Rome and mutilated in a tavern brawl in Naples. Saturnine, coarse, and queer, he thrashed about in the etiquette of early Seicento Rome like a shark in a net. But the vivid piety of his work after 1600 was fundamental to Baroque painting, and he will always be remembered as one of the essential figures of Roman art on the verge of the Counter-Reformation.

The others were largely foreigners, drawn into the irresistible orbit of the world's art capital. While he was being fêted during an unproductive visit to Paris (see page 296), the great Baroque sculptor and architect Gian Lorenzo Bernini was shown the work of a number of French painters. They did not impress him. To the old maestro's implacable eye, they seemed small fry—hacks and bores, capable of an uninteresting decorum at best. There was, however, one artist whose works had been collected by Paul Fréart (1609–94), the sieur de Chantelou and steward to Louis XIV. This was Nicolas Poussin. To him, Bernini responded strongly, looking long and carefully at his paintings and exclaiming, at last, *"O il grande favoleggiatore!"*—"Oh, the great storyteller!" (except that *favola* suggests a kind of moral weight that goes beyond mere anecdote, into serious allegory). Later, again to Chantelou, Bernini would point to his own head and say admiringly that Poussin was an artist "who works from up here."*

It was true; and one reason for its truth was Rome. Poussin was the father and first great practitioner of French classicism. He lived most of his working life in Rome, and left it only with the greatest reluctance. In cultural terms, everything north of Rome was merely a colony—especially France, the second-rate power he came from. "We are indeed the laughingstock of everybody, and none will take pity on us," Poussin morosely wrote of the French, in a letter from Rome in 1649. "We are compared to the Neapolitans and shall be treated as they were."

For him, Rome and the countryside around it were, above all, the terrain of thought and of memory. The thought was not abstract; it was

* Paul Fréart was chiefly remarkable for accompanying Bernini on his visit to France, and reporting copiously on the sculptor's reactions to French art and his views on sculpture.

grounded in observation. The memory combined deep feeling about the observed, natural world with a kind of poetic erudition which was rare enough in the seventeenth century and is even less common in the culture today. William Hazlitt put his finger on it when he compared Poussin to John Milton. Poussin, he wrote, "was among painters (more than anyone else) what Milton was among poets. There is in both something of the same pedantry, the same stiffness, the same elevation, the same grandeur, the same richness of borrowed material, the same unity of character." Looking at certain Poussins, where a sturdy figure in a plain-colored garment is walking through a leafy landscape, you cannot help remembering the last words of "Lycidas," as the shepherd takes the rural path, having sung his song, "With eager thought warbling his Doric lay": "At last he rose, and twitched his mantle blue: / Tomorrow to fresh woods, and pastures new." Everything about Poussin's landscapes is ordered and coherent, but nothing in them is abstract; they are the "Fair champain" of *Paradise Regained,*

> Fertil of corn the glebe, of oyl and wine,
> With herds the pastures throng'd, with flocks the hills,
> Huge Cities and high tower'd, that well might seem
> The seats of mightiest Monarchs, and so large
> The Prospect was, that here and there was room
> For barren desert. . . .

What Poussin offers above all is the earthiness of the world he creates, and of the men, women, and children who work, embrace, play, and doze in it. This is not an abstract world of lifeless marble. You can imagine yourself desiring its inhabitants as flesh, not as idealized stone: the long-thighed shepherdess who leans forward with her shepherd companions (who clearly cannot read, either) to peer at the inscription *Et in Arcadia ego* on a forgotten sarcophagus in the woods, with a skull on top of it to remind you that the *ego* in Arcadia, the self, is the inexorable presence of death; or the ravishingly beautiful figure of the goddess Diana to whom the infatuated Endymion, kneeling, declares his love. "This young man has the inner fire of the devil," wrote one of Poussin's Roman acquaintances, and in fact it was his vitality, breathing his life into his reimagining of the Antique, that distinguished his work from all other archaizing painting that the seventeenth century produced in Rome. Even the play of children, watched by nymphs while charging at one another on goat-back, has a certain chivalric intensity, though it is at the

same time a parody of knightliness. This landscape lives and breathes, and looks as though nothing trivial can happen in it. His goddesses and nymphs have not dropped from Olympus; they grow up out of the earth. They carry their archaism like a bloom, so that there is more sexual tension between the white goddess and the kneeling shepherd in *Diana and Endymion* (1628), than in a hundred Renoirs. This tension, for him, is part of classicism. "The beautiful girls you will have seen at Nîmes," he wrote to a friend in 1642, "will not, I am certain, delight your spirits less than the sight of the beautiful columns of the Maison Carrée, since the latter are only ancient copies of the former." It is an enchanting conceit, yet more than a conceit: the idea that the ancient orders of architecture were "copies" of the ideal proportions of the beautiful human body was deeply embedded in Poussin's thinking, as it was in the ideas of many connoisseurs. This humanized ancient architecture and emphasized its relation to the present. And it emphasizes one's feeling that the women drawing water from a well in a Poussin have a relationship to the architecture behind them which is not simply formal, but, in some historical way, spiritual.

In *Landscape with Saint Matthew* (c. 1640), we see the evangelist surrounded by ruins—fallen column, broken entablature—writing down the words of a visiting angelic being on a sheet of paper: its subject is the same as the Caravaggio in San Luigi dei Francesi, the dictation to Saint Matthew of his Gospel. But in its companion piece, *Saint John writing the Apocalypse on the island of Patmos*, Poussin produced what could almost amount to a self-portrait, sitting among the mighty ruins of antiquity, sketching their geometrical fragments (prism, cylinder, with an obelisk and an intact-looking temple in the background), quite like himself encountering, in real life, the Roman ruins of the Campagna. Wherever else he may be, he is not where he was born. He is where fate and the necessity of his own art have obliged him to go. He was the model expatriate. This was the story of Poussin's life.

He was born near Les Andelys, a provincial market town on the Seine in Normandy, in the vicinity of Rouen. Not much is known about his childhood, except that it clearly included some instruction in the classics, without which he could never have developed his enthusiasm for ancient Rome and its culture. Around 1612, he left home for Paris, and from there he is known to have made one unsuccessful attempt to reach Rome, defeated by illness and poverty (he got as far as Florence, but had to turn back). But then, in Paris, he had the good luck to meet the Ital-

ian poet Giambattista Marino (1569–1625), who was impressed by some drawings young Poussin had made for him on themes from Ovid's *Metamorphoses* and invited the budding artist to come to Rome with him. No urging was needed. In 1624, Nicolas Poussin arrived in Rome and began to make acquaintances whose regard for his work would stand him in excellent stead. One was Francesco Barberini, nephew of Urban VIII. The other was Cassiano del Pozzo, the Barberinis' secretary, a man of singular connoisseurship and some scientific knowledge.* Poussin's main job in Rome, before his pictures started selling, was to draw records of classical sculpture for del Pozzo. This gave him excellent access to private collections, and the time to develop a repertoire of figures that would fill his work in years to come. The two men arranged for Poussin his first big commission, though a very uncharacteristic one—an altarpiece for Saint Peter's done in 1628, the *Martyrdom of Saint Erasmus,* an early saint who suffered disembowelment, his guts wound out on a windlass. In the painting, which is mercifully short of blood, Erasmus' intestines look like a long string of thin *luganiga* sausage. This would be one of Poussin's very few images of a human being in extreme pain. Its only competitor is the anguished face of a woman in *The Massacre of the Innocents,* which Francis Bacon thought was the most awful depiction of grief in all Western painting. Poussin was certainly able to paint extremes of human feeling, but he wisely kept them under control and used them only where they counted most.

Poussin devoted his early years in Rome to studying ancient architecture, drawing the live model (in the studios first of Domenichino and then of Andrea Sacchi), and making measured drawings of Roman statues and reliefs. But his work as a history painter came into full focus in the 1630s with two magnificent compositions, each depicting a heroic or tragic moment from the Roman past. The first was *The Destruction of the Temple at Jerusalem,* commemorating the Emperor Titus' sack of the Holy of Holies. (There goes the seven-branched candlestick with the soldiers, presently to be carved on the Arch of Titus in Rome.) The second was *The Death of Germanicus.*

Germanicus Julius Caesar, conqueror of Germany, was sent to command Rome's Eastern Empire and died in Antioch in 19 C.E., poisoned on the orders of his adoptive father, the Emperor Tiberius—so it was

* As a result of Cassiano's instruction, Poussin became the illustrator of a later edition of Leonardo's work on optics.

believed—by a jealous Roman governor. He soon became an archetype of the Betrayed Hero.

In Poussin's picture, the hero lies ashen and dying beneath the frame of a blue curtain, which suggests both a military tent and a temple pediment. On the right are his wife, women servants, and little sons; on the left, his soldiers and officers. The common soldier on the far left weeps inarticulately, his grandly modeled back turned toward us. Next to him, a centurion in a billowing red cloak starts forward: grief galvanized into action in the present. Then a gold-armored pillar of a general in a blue cloak (adapted from an antique bas-relief) projects grief forward into the future by swearing an oath of revenge. We do not see the man's face or its expression, which is Poussin's way to suggest that this death is not a private issue but one of history itself. The target of this socially ascending wave of resolution is not only Germanicus' exhausted head on the pillow but his little son, whose blue cloak matches the general's; the women suffer and can do nothing, but the boy learns, remembers, and will act.

In 1629, Poussin moved in with the family of a French cook in Rome, Jacques Dughet, who cared for him during an infection of syphilis which would last the rest of his life. In the end, Poussin was so afflicted by the tremors brought on by the advanced stage of this disease that he could no longer paint with any confidence; in 1658, aged sixty-four, he apologized in a letter to Chantelou for not writing a separate letter to his wife "because my trembling hand makes it difficult for me. I ask her pardon." But there remained to him another twenty years of uninterrupted creativity. Poussin was lucky in being one of those men who did not care much about the social world. Selected friendships, such as his relationship with Chantelou in Paris, mattered greatly to him, but not the world of courts, whether royal, noble, or papal. A story went the rounds of how his friend and patron the Cardinal Camillo Massimi visited him in his modest house in Via del Babuino and wondered how Poussin managed without servants. "And I pity Your Eminence," retorted the painter, "because you have so many." "He avoided social gatherings as much as he could," recalled one of his friends, the connoisseur André Félibien, "so that he could retire alone to the vineyards and most remote places in Rome. . . . It was during these retreats and solitary walks that he made light sketches of things he came across."

Poussin was quite often accompanied on these walks by another French expatriate in Rome, Claude Lorrain (1604–82). The two men shared a passion for ideal and classical landscape, but were otherwise unlike each

other; Poussin, compared with Claude, was a positively scholarly painter, well acquainted with classical poetry and philosophy, whereas Claude's knowledge of ancient Roman and Greek culture was relatively thin. He was less educated than Poussin partly because he came from a lower social level—his parents were of peasant stock, smallholders from the village of Champagny in Lorraine. He was not interested in allegory or the illustration of myth: Poussin was the *favoleggiatore,* not Claude. And this was just as well, since he did not have a jot of Poussin's aptitude for painting the human body, and hence not much gift for narrative.

Claude's observation of trees, earth, water, and especially of light was exquisite, rapturous; the figures in his landscapes (and convention demanded that they should be there) were conventional at their infrequent best and, at their more usual worst, looked like spindles or slugs—a fault shared, not incidentally, by Claude's great follower, J. M. W. Turner. No matter: Claude's mastery of, and inspiration within, the conventions of ideal pastoral landscape (some of which he invented) were so great that he became a model for several generations of painters, and the visitor to Rome is still likely to catch brief glimpses of Italy through Claudeian eyes.

Claude came to Rome as a teenager, possibly as early as 1617. He seems to have had no artistic training in his native France, though it was often said that he had been a pastry cook—indeed, he is sometimes credited with having learned the technique of puff pastry, *pâte feuilletée,* in Rome, and introducing it to France; this is possible, but undocumented. His first known training with a painter was in the studio of a German artist in Naples, Goffredo Wals. He did not stay there long, and soon was back in Rome as a studio assistant to the Italian landscapist Agostino Tassi. In 1625, he returned briefly to France, to work for a minor court painter named Claude Deruet. But by 1627, or even a little earlier, Claude was back in Rome. He would remain there for the rest of his life, never revisiting France or traveling elsewhere in Europe, always at the same address, in Via Margutta off Piazza di Spagna, the haunt of foreign artists in Rome. Everything about his life was low-key and modest. He scrimped and saved. He never married; and of his love life, if he had one, nothing is known. Even though he was modest, hardworking, and probably rather a bore when he was away from the easel, Claude's career was steadily successful; he sold nearly everything he painted, and at his death there were only four unsold paintings left in his studio. He was not interested in social climbing in the "great world"; the world could find its way

to him, and it did, reliably and regularly. In fact, by the mid-1630s he was so popular that he was plagued by fakers, Roman artists who saw in the manufacture of "Claudes" a useful supplement to their modest (or non-existent) incomes. The trademarks of a Claude were, at a certain level, easy to mimic: the parallel planes of the landscape, the luminous ultramarine skies (no cheap pigments for the maestro, only the very best), the feathery *repoussoir* trees framing a distant view of water or a Roman ruin—the Colosseum and the cylindrical tomb of Caecilia Metella, displaced, were particular favorites with collectors. To safeguard his own rights in his own work, Claude came up with the practice of making records of his paintings—drawings of them in their finished state, which he annotated and bound in an album called the *Liber veritatis,* or *Book of Truth.* Whatever was not in the book of truth was, by definition, false. In fact, Claude did not copy all his work in this way, and that led to some acrimonious disputes about the authenticity of perfectly genuine paintings—but the *Liber veritatis* was the first effort an artist ever made to keep a catalogue of his own work.

Claude's career exemplified the fact that no foreign artist could really consider himself a finished man unless he had studied and worked in Rome, though of course the lengths of apprenticeship to the great city varied. So many flocked there, from practically every country in Europe, that it would be pointless to try to list them all. The chief ones will have to do. From Spain, they were Jusepe de Ribera (1588–1652) and Diego Rodríguez de Silva y Velázquez (1599–1660).

Ribera, a brilliantly gifted realist painter of humble origins (he was the second son of a Valencian cobbler), was inspired by Caravaggio, whom he may have met in Naples. His most Caravaggian traits were his precise draftsmanship, unideal street-life models, and intense lighting, with faces and limbs plucked from surrounding darkness by brilliant shafts of light, in the manner of Caravaggio's *Calling of Saint Matthew* in San Luigi dei Francesi. Though he passed almost all his working life as an expatriate in Naples, where he was affectionately known as *lo spagnoletto* (the little Spanish guy), Ribera spent several early years in Rome, 1611–15, living with a bohemian group of Spanish and Dutch expats around the Via Margutta.

His main surviving early work there was an extraordinary series symbolizing *The Five Senses. Sight,* for instance, is a portrait of an introverted-looking thinker, no doubt one of Ribera's friends, holding a Galilean telescope, with a pair of spectacles and a mirror on the table

before him. Earlier and more genteel painters might have symbolized *Smell* with flowers and flasks of perfume, in the hands of a nymph; Ribera painted a ragged and none-too-clean old man, who certainly stank, holding a split onion near his face. His opposite, however, is *Touch,* which one identifies at once with the cultural life of Rome—a well-kempt and decently barbered dealer in a brown jacket, his eyes closed in thought, running his discerning fingers over an antique head.

There is a certain family resemblance, caused by a common Caravaggian realism, between early Ribera and early Velázquez. That, and Spanish blood, was all the two men had in common, and it is doubtful that they met more than briefly in Italy, if at all. Ribera by nature was a democrat and a populist, whereas Velázquez was a gifted courtier and a crushing snob. (In person, that is. Both painted low-life figures, common workers, bravos, and tavern inhabitants, since the rich enjoyed seeing pictures of the poor on their walls in the seventeenth century, just as they would in the twentieth century with Blue Period Picassos.)

Velázquez was undoubtedly one of the greatest geniuses who ever held a brush, but he might have given up painting altogether for the sake of the right title. He was stiff, reserved, extremely conscious of lineage and protocol, religiously observant to a fault (you needed to be, for the right cardinals to give you the right commissions), and obsessed with winning membership in the noble Order of Santiago—a distinction he finally obtained, after years of lobbying, in 1658, only two years before his death, having tried throughout his life, without success, to prove that his family was of noble origin. In his self-portrait at the easel in his climactic masterpiece, *Las meninas,* he is wearing the red cross of Santiago on his tunic. Membership in this exalted order entailed proving his *limpieza de sangre,* purity of blood—no Arabs or Jews allowed. He cannot have been an easy man to know. His contemporaries admired and respected more than liked him. But of his qualities there was little doubt: one of Italy's leading artists, Luca Giordano, called his work "the theology of painting," the highest imaginable praise.

Velázquez was born in Seville and spent most of his career in Madrid, in the service of King Philip IV. He was apprenticed to a mainly religious painter, Francisco Pacheco (1564–1644), for six years. As an artist, Pacheco was a distinctly minor figure, but he knew a great deal about art theory and Christian iconography, which he imparted to the young Velázquez. As for his painting, its qualities were perhaps best summed up in a *boutade:*

> Who painted you thus, O Lord,
> So dry and so insipid?
> Some may say it was True Love—
> But I can tell you Pacheco did it.

Pacheco had a wide acquaintance as a portraitist among the upper crust of Seville, and this gave his student his first involvement with society. His apprenticeship ended in 1617, and Velázquez, now licensed to work as an independent painter, celebrated by marrying Pacheco's daughter Juana and setting up his own studio. What earned him the most kudos in these early years, however, was less his portraits than his *bodegones,* or genre paintings—the word *bodegón* originally meaning a rough eating house offering the simplest of meals and wine. *Bodegones* were not considered a very serious form, but it was young Velázquez, above all, who made them so, by turning them into a vehicle for the most detailed and exquisitely recorded perceptions of substance and human character. There is no more beautifully painted glass of water in European art than the one the old man is passing to the boy in *The Waterseller of Seville* (c. 1617–19), nor has a terra-cotta water urn ever been painted with more enraptured and sober attention. It may be that these early Velázquezes bear a debt to the early works of Jusepe de Ribera, but the debt is more like a compliment. When a new Habsburg king, Philip IV, ascended the throne of Spain in 1621, it was almost inevitable that young Velázquez, who had already found favor with his grand adviser Gaspar de Guzmán, the count (later duke) of Olivares, should have been on track to become the Pintor del Rey, to which office he was raised in 1623.

To be the King's Painter in seventeenth-century Madrid was not only a singular honor, but an extraordinary advantage. It gave Velázquez unlimited access to one of the greatest collections of painting in Europe, formed by the dispersal of the royal collection of the English King Charles I after he was beheaded by Oliver Cromwell—this collection was a veritable storehouse of Titian, Rubens, and other masters. Since Spain had no public collections and would not until the formation of the Prado in 1819, and since common painters had no access to the palace or the Escorial, this gave Velázquez the edge over practically every other painter in his country, and he made the fullest use of it—quite apart from the social advantages that went with being Pintor del Rey. Then, when Peter Paul Rubens arrived at the Madrid court from the Netherlands and Rome in 1628, an even wider world opened before the

enraptured eyes of the thirty-year-old Spaniard. Rubens (who seems to have painted a number of his Madrid commissions in Velázquez's studio) urged him to go to Rome, the center of the world, and of course Velázquez needed little urging. Letters of release and introduction were arranged, and in 1629 Velázquez set off for Italy: Venice, Ferrara, Bologna. But the key destination was Rome, where Velázquez stayed for a year with the Spanish ambassador, the count of Monterrey. On this first visit, he came as a young painter, albeit a brilliant one. On his second visit to Rome, twenty years later (1649–51), he arrived as an established and, as it were, absolute master.

What did Velázquez get from Rome that Spain could not have given him? A sense of pictorial possibility and sheer skill: no painting in Spain could rival in confidence, range, and pictorial imagination what Italian art from the Renaissance on—Michelangelo, Raphael, Veronese, Titian, Caravaggio, the Carraccis—magnificently embodied. Then there was the Antique as well, the ancient statues which Velázquez was not there to copy, but which fortified his sense of possible continuity with the long past. There were no Roman paintings that look like Velázquez's *Surrender of Breda (The Lances)* (1635), and yet he could hardly have managed that theater of expression, that complex composition in deep space, and that inspired frieze of twenty-four vertical lances (their rhythmic beat broken by just three oblique ones) without knowing and internalizing the achievements of Roman art. For an ambitious artist with the skill and determination to work out its lessons, seventeenth-century Rome was indisputably the school of the world. It gave great liberties and opportunities to artists. For instance, in Velázquez's case, it encouraged a figure painter to paint naked women. This practice, if not unknown in Spain, was very rare, because of the ignorant moral hostility of the clergy; as for the clientele, they could not display nudes on their walls, for fear of obloquy. But there was no risk attached to painting the female nude in Italy, and somewhere among the horde of potential models who hung out for hire around Piazza di Spagna, Velázquez found the girl whose slender, lovely body was destined to become one of the most celebrated in art history, and the first recorded nude by a Spanish painter: the pensive mirror-gazing subject of *The Toilet of Venus,* or *The Rokeby Venus* (c. 1651). Rome also presented Velázquez with the opportunity to create one of the most mesmerizing and inquisitorial images of human power ever put on canvas. This, of course, is the 1650–51 portrait of Pope Innocent X Pamphili, which still hangs in its cubicle in Palazzo Doria, above Piazza

Navona. Such is the nature of late-modernist fame that, by now, prob-
ably most people who are aware of this painting know about it through
the "screaming pope" versions of it done by Francis Bacon. These are
among Bacon's best work, but they do not come near the original (which
is of course not screaming: of all men, the one least likely to scream,
even privately, is this Pamphili). Indeed, one is sometimes tempted to
say that very few portraits, if any at all, approach Velázquez's pope—even
Innocent X himself, on seeing it finished, is said to have called it "too
truthful," and when one confronts its steely, interrogatory glare, it is all
too easy to know what he meant.

The fourth great seventeenth-century expatriate to work in Rome
was not a Spaniard but a Fleming, originally from Antwerp: Peter Paul
Rubens (1577–1640). In terms of versatility, influence, and sheer histori-
cal and mythical power, there has never been another artist to touch
Rubens, and it is likely that there never will be. In his energy and his abil-
ity to fulfill great public roles, he puts every twentieth-century painter
in the shade. We are apt to regard Picasso's *Guernica* as a very impor-
tant piece of public art, and so it is—for its time. But it is alone in
Picasso's work, whereas Rubens, the greatest Northern painter associated
with the Counter-Reformation, could and did turn out such utterances,
usually of a religious sort although sometimes descriptive of politics, on
the grandest scale and with an eloquence and formal beauty that leave
Picasso far behind him. This kind of painting, with such ambitions for
the languages of paint, is simply no longer possible; its use has been
subverted by the decay of religion, the distrust of politics and politicians,
and the evaporation of belief in authority that characterize our own age.
There can never be another Rubens, because the intellectual and ethical
backgrounds to his work, not to mention the educational systems and
reverence for historical prototypes that supported and infused it, no lon-
ger exist. Nor can they be willed into being. The enormous fish has no
water to swim in, and the estuary is dry.

There is no doubt that Rubens got his sense of the public role of an
artist from a long visit to Italy and, in particular, to Rome. He made his
first visit there at the end of 1601, when he was serving at the court of
Vincenzo Gonzaga, duke of Mantua. In that northern city he had already
been able to study the late King Charles I's collections of Renaissance art.
Presently the collection was relocated to Spain, where Velázquez got to
study it, and where Rubens would later be able to renew his acquain-
tance with its Titians, Tintorettos, Veroneses, and other High Renais-

sance masterpieces now relocated to the royal collection in Madrid. On his first trip to Rome, and during a later sojourn there in 1606–8, Rubens was able to study the chief works of the Grand Manner, all of which were there: Michelangelo's Sistine frescoes, Raphael's Vatican *stanze*. Their impact on him was immeasurable, and it was increased by the fact that the ancient Roman marbles, which had served these earlier artists as authoritative sources, were also there for Rubens to study and copy, side by side: the *Belvedere Torso,* the *Laocoön,* and lesser but still instructive works such as the *African Fisherman* (then thought to be a carved marble figure of the dying Seneca). Thanks to the wholly privileged position of the Church, the greatest collections of such antiquities were in the hands of wealthy clerics: the huge room in Palazzo Farnese, for instance, whose ceiling Annibale Carracci had frescoed, was crammed with ancient statues, and Cardinal Alessandro Farnese had already opened this collection of antiquities to scholars and selected artists (not yet a general public) in 1589. In an age before public museums, this situation was tailor-made for Rubens, who used all his powers of charm, talent, and ingratiation to get access to such aesthetic treasures and draw them, accurately, fast, and from every angle. He made hundreds of such drawings, which served him as memory aids—these being the days before photographic reproduction—and furnished the basis of many of his own figures and compositions to come. Rubens would never cease to be a student of the art of the past, and drawing was his medium of study. To copy a work was to absorb it; to internalize it; to assimilate its DNA. This process is almost lost to us today, in an age of mass mechanical reproduction.

On this early visit, Rubens did not leave many works in Rome. He was not yet well enough known to get big commissions there, although he did an altarpiece for the Church of Santa Croce in Gerusalemme, commemorating the Empress Helena's acquisition in Jerusalem of the relics of the True Cross and the Holy Staircase contained in the church itself. But the experience of Rome, and in particular the sense of an immense sacred and aesthetic history transmitted through the ancient fabric of the city to the present day, would never leave him: it remained one of the basic messages of his art, the old vigorously underpinning the new. There was no artist who gave one a stronger sense of continuity in art than Rubens in Rome.

8

High Baroque (Bernini, Borromini, Etc.)

The Catholic Church, faced with the stresses of the seventeenth century, responded with brilliant skill and energy. It marshaled its forces in defense of its own dogmas and powers, and the visual arts were one of the theaters in which such marshaling took place. This was part of the ideological and imaginative thrust known as the Counter-Reformation. Never, not even in the Middle Ages, had so much been expected of architects, sculptors, and painters in defense of Catholic belief. If one had to choose a single sculptor-architect who completely embodied, in his person and his work, the spirit of the Counter-Reformation, there could only be one candidate. He was Gian Lorenzo Bernini (1598–1680). Across a long and prodigiously fecund working life, Bernini epitomized what it could mean to be a Catholic artist in the fullest sense. "Inspired" is a word that should be used with caution, but there is no more fitting adjective for Bernini. Not only was there no angle between his beliefs and those of the royal personages and Catholic hierarchy for whom he worked; he drew an extreme stimulus from them, taking an unfeigned joy in satisfying their doctrinal requirements. He was the marble megaphone of papal orthodoxy in the seventeenth century. If you cut stone and worked in the seventeenth century in Italy (and elsewhere in Europe, too), you worked in the shadow of this Roman prodigy. It was really as simple (but as complex) as that, and there have been few artists in European history who defined their age and their spiritual environment as completely as Bernini did. If we look back on him from a century whose defining cultural characteristic

is doubt, it seems hardly credible that a man of such skill and *certezza* could have existed. But he did, and he found the right patrons to match his genius.

The presence of Baroque art is so massive now, so powerful in our reading of European culture, that it might always have been there. But it was not. "Baroque" was a term of abuse, and the work it denoted was considered vulgar, hateful, and (despite its technical skill) inept, right through the eighteenth and nineteenth centuries. Colen Campbell (1676–1729), the Scots protégé of Lord Burlington, whose *Vitruvius Britannicus* was such a strong influence on British architectural taste, saw the period as a descent from the heights of Palladian genius into "capricious ornaments, which must at last end in the Gothick":

> I appeal to the Productions of the last Century: How affected and licentious are the works of Bernini and Fontana? How wildly extravagant are the designs of Borromini, who has endeavoured to debauch Mankind with his odd and chimerical Beauties, where the parts are without Proportion, Solids without their true Bearing, heaps of Materials without Strength, excessive Ornaments without Grace, and the Whole without Symmetry?

Nor did the succeeding two centuries bring much change of heart or opinion. For indignant Ruskin, to whom Gothic was the sublime mode for religious architecture, Baroque was merely "the flourishes of vile paganism." Charles Dickens, visiting Rome in *Pictures from Italy,* found Bernini's Baroque monuments "intolerable abortions," "the most detestable class of productions in the whole wide world." The 1911 edition of that style bible of English architectural history, Banister Fletcher's *History of Architecture on the Comparative Method,* gave the whole seventeenth century thirty lines of text: writers on the Baroque were apt to content themselves with the mere exercise of stamping on its grave. It represented, wrote Fletcher,

> an anarchical reaction [to Palladio]. Sinuous frontages and a strained originality in detail are characteristic. . . . Ornamentation is carried out to an extraordinary degree without regard to fitness or suitability, and consists of exaggerated and badly designed detail. . . . Maderno, Bernini and Borromini are among the more famous who practiced this debased form of art.

Such a picture of Baroque achievement, particularly in Rome, is unrecognizable today. Tastes change, as a matter of course; but in the case of seventeenth-century building and the reactions to it, we might be looking at a different world—and in a real sense, we are. Where the Ruskins and Campbells saw disordered heaps of ostentation, a gratification of the lust for pomp without reference to true religious feeling, we are more likely to see the last great universal language of spirituality. The reasons for this begin and end with Bernini (1598–1680).

Bernini had his training in the studio of his sculptor-father, Pietro Bernini, a Florentine Mannerist artist of some achievement who worked in Naples and settled in Rome, the art world's center, around 1606 to work for Pope Paul V. His earliest known independent works belong to childhood: a small group of statues of the goat Amalthea suckling the infant Jupiter, done with the complex realism he must have learned from the Hellenistic marble carvings he saw in Rome, and from his father's imitation of them—all those tangles of matted goat hair, done with such relish!—dates to about 1609, when he was eleven. He was hardly more than a boy when his work first came to the attention of Cardinal Maffeo Barberini, who saw his carving of the *Martyrdom of Saint Lawrence,* being grilled to death over hot coals and rising marble flames but looking fairly composed about it. It is said (*se non è vero,* etc.) that the twenty-year-old sculptor arranged a mirror and then put his leg into a fire, the better to see the anguish on his own face—although the expression of this Lawrence does not look unduly agonized. Or was it just that Bernini was unusually stoic? Probably not.

It was through Barberini that one of Rome's foremost art collectors became aware of young Bernini's work. This was Cardinal Scipione Borghese (1576–1633), nephew of Pope Paul V, connoisseur of antiquities, *bon vivant,* and man of enormous wealth. He was the pope's secretary, and, to all intents, he ran the Vatican government. He held a host of official positions, most of which returned him serious money; by 1612, his annual income was said to be a huge 140,000 scudi.

Pederasty in seventeenth-century Rome was a crime which, at least in theory, carried the death penalty. There is no doubt about Scipione Borghese's homosexual proclivities, but he was protected—indeed, armor-plated—by birth and wealth. He surrounded himself with *fanciulli* or pretty boys, and there is little doubt that the homosexuality of the great realist Caravaggio, whom Borghese was one of the first to encourage, was a prime reason why early Caravaggios like the *Sick Bacchus,* the

Boy Bitten by a Lizard, and other works entered Borghese's collection. These pouting pieces of rough trade, with their lumberous dark eyes and hair like black ice cream, were clearly much to the cardinal's taste.

His collection of ancient sculpture included some of the most admired pieces in Europe, such as the *Borghese Gladiator* (c. 100 B.C.E.), which Bernini strove to emulate. It was clear to Borghese that Bernini, hardly out of his teens, was a maestro in the making. And Borghese was not the kind of collector who would wait for, or be denied, anything that took his imperious fancy (one of his more odious actions was to confiscate more than a hundred pictures from the Cavaliere d'Arpino, a feeble Mannerist painter whose claim to distinction was to have taught Caravaggio for a while, for not paying his taxes). Borghese started amassing Berninis, and secured some of his best early works: among them, a life-sized figure group of Aeneas and his little son, Ascanius, fleeing the burning city of Troy, carrying his aged father, Anchises, who himself carries the *penates* (household gods) of their lost home. This is a transcription in stone of Virgil's lines from the *Aeneid:*

> "Then come, dear father. Arms around my neck:
> I'll take you on my shoulders, no great weight.
> Whatever happens, both will face one danger,
> Find one safety. . . .
> Father, carry our hearth-gods, our Penates.
> It would be wrong for me to handle them–
> Just come from such hard fighting, bloody work–
> Until I wash myself in running water."

This sculpture, the spiraling movement of its bodies so strongly indebted to the great Mannerist sculptor Giambologna, was designed for Scipione Borghese's new villa at the Porta Pinciana in Rome, where it still stands. So was the extraordinary *Pluto and Persephone* (1621–22), in which the imposingly muscular figure of the king of Hades is seen carrying off the helpless daughter of Zeus and Demeter to be his prisoner and bride in the Underworld: a girl snatched, in Milton's lines, from

> . . . that fair field
> Of Enna,* where Proserpin gathering flours
> Herself a fairer Floure by gloomie Dis
> Was gather'd, which cost Ceres all that pain
> To seek her through the World. . . .

* Etna, in Sicily.

Persephone shrieks in vain; she struggles and wriggles helplessly, enticingly; we even see the marble tear on her cheek, and the yielding flesh of her thigh as Pluto's fingers sink implacably into it. It is an extremely sexy sculpture, and should be, since its subject is a rape; Scipione Borghese possessed an unsurpassed collection of antique Roman erotica, with which the young sculptor must have been happily familiar. The extraordinary character of this sculpture lies in a mastery over carving which transcends the puritanical mantra of modernism about "truth to material," as though there were only some things that could legitimately be done with wood or stone, and to go beyond them were a sin. Bernini leaves you in no doubt that stone can represent anything if the shaping hand is skilled enough. Is it wrong for it to look as though it were modeled rather than carved? Assuredly not, the marvelous surfaces and textures of Pluto's and Persephone's bodies tell us. Is the effect a lie? Of course, but art itself is a lie—a lie told in the service of truth.

The showpiece of Bernini's early virtuosity is, however, the *Apollo and Daphne,* commissioned by Scipione Borghese after he gave the *Pluto and Persephone* to the pope's nephew to curry favor with the pontiff. It is a sculptural illustration of one of the more beautiful and poignant moments in classical poetry, which occurs in book one of Ovid's *Metamorphoses.* Apollo has encountered the nymph Daphne, daughter of the river-god Peneus. The love-god Cupid, witnessing this, fires two arrows from his bow; one sharp and tipped with gold, which pierces Apollo's vitals, and the other blunt and lead-tipped at Daphne, who at once becomes unreachable by love. Apollo is now compelled always to pursue Daphne, who is likewise doomed always to flee. "But the marriage torches / Were something hateful, criminal, to Daphne," who entreats her father to "Let me be a virgin always. . . ." Apollo, of course, has other ideas. She runs,

> But Apollo,
> Too young a god to waste his time in coaxing,
> Came following fast. When a hound starts a rabbit
> In an open field, one runs for game, one safety,
> He has her, or thinks he has, and she is doubtful
> Whether she's caught or not, so close the margin,
> So ran the god and girl, one swift in hope,
> The other in terror, but he ran more swiftly,
> Borne on the wings of love, gave her no rest,
> Shadowed her shoulder, breathed on her streaming hair,

Her strength was gone, worn out by the long effort
Of the long flight; she was deathly pale, and seeing
The river of her father, cried "O help me,
If there is any power in the rivers,
Change and destroy the body which has given
Too much delight!" And hardly had she finished,
When her limbs grew numb and heavy, her soft breasts
Were closed with delicate bark, her hair was leaves,
Her arms were branches, and her speedy feet
Rooted and held, and her head became a tree top,
Everything gone except her grace, her shining.
Apollo loved her still. He placed his hand
Where he had hoped and felt the heart still beating
Under the bark; and he embraced the branches
As if they still were limbs, and kissed the wood,
And the wood shrank from his kisses, and the god
Exclaimed: "Since you can never be my bride,
My tree at least you shall be! Let the laurel
Adorn, henceforth, my hair, my lyre, my quiver:
Let Roman victors, in the long procession,
Wear laurel wreaths for triumph and ovation. . . ."
He said no more. The laurel,
Stirring, seemed to consent, to be saying *Yes.*

This, one might have thought, would have been an impossible thing to illustrate with sculpture. Sculpture—at least until Bernini—always depicted achieved actions and complete states. Nobody had tried to illustrate in sculpture things in transition, to convey what was incomplete or in the very process of change. Yet in *Apollo and Daphne* we do see the change from girl to tree happening before our eyes; the bark enveloping and encasing her lithe body; softness giving way to ligneous toughness; movement turning into rootedness. Moreover, the sculpture seems to defy what we know is a chief property of stone: its brittleness. How on earth (one wonders), through what preternatural skill, did Bernini manage to render those brittle stalks and thin, freestanding blades of laurel leaf in marble, without snapping them off? It must have been done with rasps, drills, and abrasive; a hammer blow, the touch of a chisel, would have ruined any of them. And once a leaf was broken, there were no adhesives like epoxy capable of mending it in the

early seventeenth century. No sculpture, one feels, could be riskier. Of course, one's admiration of Bernini's technique is not confined to enjoying its Last-Supper-carved-on-a-peach-stone virtuosity, which has always been considered to go beyond mere skill. There is no feeling that he has achieved such effects by some sort of trickery or legerdemain. They are there, factual, and it was not magic that put them there. And the rendering of emotion and expression rivals the intensity of the work of the painter Guido Reni, the Italian artist whom, we know, Bernini greatly admired. In years to come, Bernini's work would deepen and acquire a wider emotional resonance. It, and he, would mature. But already, in his twenties, he showed himself capable of producing one of those works of art that seem to enlarge the scope of human possibility. Anyone who thinks of the young Picasso as a prodigy should reflect on the young Bernini, and be admonished. There was no twentieth-century artist, and certainly none of the twenty-first century, who does not look rather small beside him.

He was a man of the utmost concentration and energy. Even in old age (and he lived to eighty-two), Bernini was quite capable of working on a marble block for seven or eight hours at a stretch. This vitality, which he never lost, combined with astonishing executive powers. He ran a very large studio, and had to, because of the number of commissions in sculpture and architecture, for the highest levels of government and religion, that he confidently undertook and completed. He was by far the most influential sculptor in Rome, or in the seventeenth-century world. Bernini was to become the supreme artist of the Counter-Reformation in sculpture and architecture, as Rubens was in painting.

And, like Rubens, he was a man of strong and deep religious conviction. It is not, of course, true that to create important works of religious art one must be pious. Still less is it true that an artist's personal piety underwrites the quality of his art as art—much of the world's vilest, most sugary religious kitsch has been deeply felt and produced by honest and morally impeccable people. But there have been cases, uncommon but real, when deep religious impulses lend an authentic intensity of spiritual feeling to depictions of the Crucifixion and the Resurrection, one which detachment or agnosticism cannot provide. Bernini's was such a case.

The event that set the seal on Bernini's growing success came on August 6, 1623, with the election of Maffeo Barberini as Pope Urban VIII. Barberini (reigned 1623–44), a Florentine, was a man of the most unbridled political ambition. Indeed, his papacy reached the high-water

mark of the extent and power of the Papal States within Italy. It would hardly have been possible for him to remain aloof from politics, not only because the Papacy ruled Rome but also because his reign coincided with twenty-one years of the Thirty Years' War.

But the patronage of art was also, for him, as important as the prosecution of war. He built extensively in Rome, and some of the results were glorious in their extravagance—notably his own residence, Palazzo Barberini, on the Quirinal (Via delle Quattro Fontane 13). Its initial design—a villa with wings extending into the garden around it—was done by Carlo Maderno; later, the work, interrupted by Maderno's death in 1629, was taken over by Bernini and Francesco Borromini. Its façade derives, in its essentials, from that mighty prototype of Roman Baroque palaces, the Palazzo Farnese. If he had built nothing else, Maffeo Barberini would deserve a place in architectural history for this private home, but of course he did much more. He was determined to leave a great indelible mark on Rome; like many before him, he chose to do so through its principal church, Saint Peter's. The man who would do this for him was young Bernini. On the very day of his election, Urban is said to have summoned the sculptor and declared: "You have the great fortune to see Cardinal Maffeo Barberini Pope, Cavaliere; but ours is much greater to have Cavaliere Bernini alive in our pontificate." Or words, at least, to that effect. Later, Urban would write of his artist, "Rare man, sublime artificer, born by Divine Disposition and for the glory of Rome to illuminate the century."

Bernini was only twenty-three when he was made a *cavaliere*, a papal knight. This honor was merely a formal recognition of what everyone who had seen his early sculptures already knew: that, of all the stonecutters and bronze casters working in Europe, Bernini was the most skilled, the most inventive, not only in his technical mastery of materials, but in his astonishing ability to create a *concetto* or "concept" of sculpture. This gift went far beyond the ability to carve a strong Hercules or a desirable Venus, which was (relatively) easy. It had to do with inventing an entirely new kind of drama from posture, gesture, and expression. It ensured Bernini his first papal commissions, of which the principal ones had to do with Saint Peter's. In fact, for the half-century after 1623, hardly a year would pass in which Bernini would *not* be involved in the decoration of this prodigious basilica, and it was Urban who brought him into it as the master of papal works, starting with an enormous monument right below the dome, over the (supposed) burial spot of the Apostle Peter.

This was the *baldacchino,* or altar canopy. It can never be overemphasized that the shared project of Bernini and Urban VIII was to display to the world the triumph of Catholicism over Protestant heresy, and give unforgettable visual form to the tenets of the Counter-Reformation. The canopy was the first icon of this: a huge, exuberant declaration of the belief that Saint Peter, Christ's vicar on earth and first in an unbroken line of popes, lay buried *here* and nowhere else, that the only true version of Christianity was *his* faith and that of his successors, not (perish the thought!) Martin Luther's. It marks the foundation stone of the Church: *"Tu es Petrus, et super hanc petram aedificabo ecclesiam meam,"* Christ is recorded as saying, punningly, to Peter: "You are Peter, and on this rock I will build my church." These words are inscribed around the drum of the crossing, above the *baldacchino,* in letters five feet high.

The baldachin would have to be huge. In the vast space of that nave, under such a dome, seen from the distance of the entrance (the nave is 218.7 meters long), anything less than huge would look as trivial and incongruous as a beach umbrella. Obviously, one could not use a real canopy, figured silk supported on poles. The size of the thing would have been too great for any kind of cloth, which would have perished anyway. So the canopy must be rigid, made of metal. The correct metal would be bronze. But a structure so large, with its superstructure of volutes and its twenty-meter-high twisted columns (of the type known as "solomonicas," from the belief that spirally twisted columns were used in Solomon's Temple in Jerusalem), would require enormous quantities of this metal. Where would it come from? Where, but another church? Urban VIII gave Bernini leave to strip the ancient bronze cladding from the portico of Santa Maria Rotonda, the new name of the Pantheon, which had been adopted and reconsecrated for Catholic rites and was the property of the Holy See. From this and other sources of recyclable bronze, Bernini got the metal to make the *baldacchino,* with enough left over to cast some cannon for the Castel Sant'Angelo. This made some Romans indignant, though in truth, even if it would obviously have been better to have both, it would be difficult to claim that the exchange of the Pantheon's bronze for Bernini's baldachin was anything but a net gain.

The *baldacchino* is the world's first incontestably great Baroque monument. No wonder Bernini's enemies derided it (behind his back, of course) as a "chimera"—it fell into no agreed category of décor, sculpture, or architecture. It still strikes the viewer with awe, through the richness and complexity of its detail no less than its astonishing size—the

largest bronze sculpture in the world. But is it sculpture? Or metallic architecture? Manifestly, both. As a work of propaganda it has few rivals elsewhere in the fine arts. It is propaganda not only for Catholic doctrine and Catholic archaeology, but for Maffeo Barberini himself. The bronze bees that are crawling everywhere on it, giant insects the size of starlings, are the heraldic *api* of the Barberini family. The recurrent suns and the laurels that twine the massive corkscrew columns are, likewise, Barberini emblems. *L'église, c'est moi.*

Maffeo Barberini's papacy had been a fairly long one—twenty-one years, from 1623 to 1644. It cannot be called a financial success; he practiced nepotism on too gigantic a scale. When he came to the throne, the papacy was sixteen million scudi in debt, and Urban took only two years to run that up to twenty-eight million. By 1640, the debt stood at thirty-five million, so that the interest payments on it alone consumed more than four-fifths of the annual papal income. His political adventures tended to be quite disastrous: Urban was the last pope to go to war in the hope of expanding papal territory, and he always lost his battles. Nor was his scientific sense much better. He vigorously opposed Galileo's heliocentric theory of the universe, the belief that the earth went round the sun and not vice versa, and summoned him to Rome in 1633 to make him recant. He also—to descend from the serious to the absurd—issued a papal bull, in 1624, that made smoking tobacco punishable by excommunication. The reason was that when smokers sneezed their convulsion resembled orgasm, and this struck Urban as a mortal sin of the flesh.

Bernini far outlasted his patron in life, and glorified him after death in a tomb which occupies one of the most honored spots in the basilica, enthroned and wearing the papal tiara (bareheaded was more normal in tomb sculpture). Nobody can miss the encompassing gesture of benediction with which he faces the viewer, but people do not always notice Bernini's attribution to him of eternal life: three bronze Barberini bees, which have flown out of the sarcophagus and are heading upward, in illustration of Virgil's lines from the *Georgics* describing the immortality of those cooperative insects: "There is no room for death: alive they fly / To join the stars and mount aloft to heaven."

Nowhere could Bernini's diplomatic skills have been more evident than in his handling of the transition of power, after Urban VIII's death, to the new pontiff, Giovanni Battista Pamphili, who succeeded to the Fisherman's Chair in 1644 and reigned for eleven years under the name of Innocent X. Though Bernini would spend a few years out in the cold, he

bided his time; his sheer talent and unrivaled ingenuity would ensure his return to favor. Innocent had a visceral loathing for his predecessor, who had left the Papacy heavily depleted—patronage of one's own family, as Urban practiced it, was a most expensive hobby.*

Innocent's acute dislike extended to the recipients of Urban's largesse, of whom the most conspicuous was Bernini. The great sculptor was detested by most artists and architects in Rome, since nothing breeds envy more than extreme success. It was therefore with an overwhelming sense of relief and *Schadenfreude* (that useful German word that has no exact English equivalent but means roughly "pleasure in the misfortunes of others") that the Roman cultural world not only saw him fail, but saw the pope do nothing to rescue him.

The stumbling block was a design he made in 1637 for bell towers on the façade of Saint Peter's. Apparently, Bernini did not design a strong enough footing for them; the ground was more weakened by subterranean streams than the architect realized. Soon after it was built, cracks appeared in the left tower. To the unrestrained delight of his enemies, including his arch-rival Borromini, Bernini's towers had to be demolished. Because of Innocent X, it was politically safe for anyone to be as nasty about Urban VIII's once-omnipotent protégé as he liked. For the first time in his life, Bernini was out in the cold. From the point of view of his prosperity, this demotion from the exalted status of papal architect hardly mattered—there would be enough commissions from rich but lesser patrons to keep him busy through Doomsday. Still, losing the pope's favor was a severe blow, one that the great man could not accept.

And Innocent meant business. Once his mind was made up, he did not easily relent. Urban was hardly cold in the magnificent tomb Bernini had made for him in Saint Peter's when Innocent X brought suit against his relatives, the Cardinals Antonio and Francesco Barberini, for misap-

* This went both ways, for the Barberinis disliked the Pamphilis as much as the Pamphilis the Barberinis. In about 1635, the pope's brother, Cardinal Antonio Barberini, had commissioned a painting for the Church of Santa Maria della Concezione, the home church of the Capuchin monks, with whom his career had begun. It was by one of Rome's most esteemed painters, Guido Reni—a fact which guaranteed that every sophisticate in the city would come to see it. Its subject was the warrior archangel Michael with his sword, trampling underfoot a rebel demon whom he is casting down from Heaven. The prostrate and humiliated demon had the unmistakable face of Giovanni Battista Pamphili, the future Pope Innocent X. Despite the future pontiff's rage at this insult, the Capuchins hung on to their altarpiece, and it is still there—though nowhere near as well known as the other portrait, of an older Innocent X, by Velázquez, the "screaming pope" frequently copied by Francis Bacon, which remains in its cubicle in Palazzo Doria on the Pamphilis' family square, Piazza Navona.

propriation of public funds. They fled to France and took refuge under the powerful wing of Cardinal Mazarin, leaving financial chaos behind them; Innocent promptly confiscated their property.

He was also as given to meddling in the affairs of other countries as his medieval namesake Innocent III: but this was still normal for a powerful sacro-secular state like the Papacy. One should not forget that the Papacy still ran the civil and political government of Rome. Its affairs were not only those of the Church, but of the state. The Church *was* the state. An extreme case of this meddling was Ireland. During the Civil War (1642–49) in England and Ireland, the pope dispatched a nuncio—an ecclesiastic diplomat—Archbishop Giovanni Rinuccini, to Kilkenny with a huge sum of money and ten tons of the best gunpowder. Though he declared, and with sincerity, that he meant to sustain the king, his purpose was to help the Irish Catholics throw off the Protestant yoke of England, restoring confiscated property to the Irish Church and the rights of Catholic worship to the Irish people. It went badly awry; instead of gaining its lost rights back, Ireland got the "accursed butcher" Oliver Cromwell, who invaded with his New Model Army and in what could euphemistically be called a "police action" mercilessly crushed the rebellion and ensured more than three further centuries of bloodshed between Catholics and Protestants within long-memoried Ireland—"much hatred, little room," in W. B. Yeats's pregnant words. Archbishop Rinuccini was recalled by Innocent in 1649, his gunpowder wasted.

Preoccupied with his political adventures, Innocent X had little or no time for Bernini, who bided his time and worked on more private commissions. The greatest of these was the Cornaro Chapel, in the Church of Santa Maria della Vittoria, the work which signaled a new and audacious development in the sculptor's thinking. This is the project which brought together sculpture, scenography, narrative, and architecture in a way which had never been done or even attempted before—a hinge point, not only in Bernini's career, but in the history of seventeenth-century art.

It was a memorial, commissioned by the Venetian Cardinal Federigo Cornaro (1579–1653), patriarch of Venice, to commemorate both himself and his family. The saint it glorifies is Saint Teresa of Ávila (1515–82), the holy Spanish woman, founder of the Carmelite Order (to whom the church belongs) and teacher of Saint John of the Cross, whose copious writings include a vision of Divine Love, manifesting itself in the form of an angel with a spear. Her description of this vision has often been quoted, but it is worth repeating not only for its classical importance in

the canon of mysticism but also because Bernini followed it to the very letter and clearly, as a most devout Catholic, believed every word of it, striving to make it as concrete as sculpture could be:

> He was not tall but short, and very beautiful; and his face was so aflame that he appeared to be one of the highest rank of angels, who seem to be all on fire. They must be of the kind called cherubim. . . . In his hands I saw a great golden spear, and at the iron tip there appeared to be a point of fire. This he plunged into my heart several times so that it penetrated to my entrails. When he pulled it out, I felt that he took them with it, and left me utterly consumed by the great love of God. The pain was so severe that it made me utter several moans. The sweetness caused by this intense pain is so extreme that one cannot possibly wish it to cease, nor is one's soul then content with anything but God. This is not a physical but a spiritual pain, though the body has some share in it—even a considerable share. . . . If anyone thinks I am lying, I pray God, in his goodness, to grant him some experience of it.

In Bernini's sculpture, Saint Teresa is levitating, borne up on a marble cloud. Only three parts of her body are visible: her face, one bare foot, and a single nerveless hand. The rest of her is a mass of drapery, a near-chaos of folds and pleats, beneath which no sign of the body's form is discernible. All is agitation, the swirls and crumples of marble cloth standing as signs of the intense emotion caused by the vision's arrival. Her mouth is open, moaning; her heavy eyelids are lowered, stressing the internal power of her vision. Discreetly but without ambiguity, Bernini shows us a woman in orgasm—"If that is divine love, *eh bien,*" said a worldly French diplomat on catching sight of *The Ecstasy of Saint Teresa* for the first time in the 1780s, "I know it well." (So, it should be added, did Bernini; he had an earthy-looking mistress named Costanza Bonarelli, whose bust he carved, voluptuously parted lips and all.) Compared with Saint Teresa, the angel is all unitary force, rising vertically beside her, his face a study in benign masculine sweetness, his eyes fixed on her as he draws back the spear to plunge it, once more, into her welcoming flesh. (His left hand, touching the saint's disordered garment, is a superbly ambiguous touch: it could be seen as gently lifting the cloth to expose flesh which he can see but we cannot, or else as raising the whole body of the saint, weightlessly, upward—a reminder of the levitation Saint Teresa said she had undergone.)

The space of the chapel, which is in the left transept of Santa Maria della Vittoria, is quite shallow. Its focus is, of course, the marble group of Teresa and the angel. This is framed inside a niche, a sort of proscenium with a pediment that breaks forward on a curve and is framed on each side by a pair of darkish-green Breccia Africana columns. The dark surround makes the white figures of angel and saint even more apparitional, especially since they are lit from above by a source we cannot see. In a chimney or light well that is hidden from view, light cascades from a yellow glass window. (At least, it used to; the glass is now so dimmed by dust and pigeon droppings that the Carmelites had to install an electric bulb to replace the sun.) The "real" light falls on fictitious light—a burst of gilded sun rays, fanning down behind the figures.

On the side walls of the chapel are two symmetrical niches, designed in false perspective to give the illusion of deep space running back. In them are seated white marble effigies of eight members of the Cornaro family: Cardinal Federigo, the donor, with his father, the Doge Giovanni Cornaro, and six earlier Cornaros, all cardinals, too—a conclave of pious family power, spanning several generations. Leaning forward in fascination at the miracle before their eyes, they turn to one another, talking and arguing (or, since this is a church, whispering in awe) about it and its meaning; their astonishment parallels our own and increases it. This was the largest and most complicated essay in group sculptural portraiture (individual lifelike portraiture, not merely figure groups) ever done. And it reminds the viewer, as so much of Bernini's work does, that he had a background in theater: he relished designing stage setups, theater sets, and special effects like floods and sunrises, though we have little idea of how realistically they might have worked. We do know that they impressed and likely fooled the audience.* No wonder the Cornaro Chapel keeps its magic of illusion even in an age of photography and film, and retains its talismanic power as a mixed-media masterpiece, melding sculpture, theater, architecture, and colored marble surfaces in an inspired unity, a "total work of art" that Wagner might have dreamed of.

Nobody of Bernini's genius can remain out in the cold in an age of public patronage for very long, and certainly Bernini did not. His res-

* Paul Fréart, sieur de Chantelou, who was *maître d'hôtel* for Louis XIV and closely accompanied Bernini on his visit to that monarch in France in 1665, recalled that Bernini had written several comedies for the stage, which "caused a great stir in Rome because of the decorations and the astonishing contraptions he introduced, which deceived even those who had been forewarned." See Elizabeth Gilmore Holt, *A Documentary History of Art,* vol. 2, p.125.

toration to papal favor came through the very pontiff who had revoked it: Innocent X Pamphili. No great Roman family was more bound up with an architectural feature of Rome than the Pamphili clan with Piazza Navona. It was "their" square—actually, an elongated horseshoe which almost exactly followed the track of the ancient Stadium of Domitian, which lay beneath it. Because footraces had been held in this stadium in ancient times (it was not a venue for either chariot races or the murderous rites of the gladiators), it was relatively short and lacked a central divider or *spina*. A place of intense physical striving, it had become known as the Circus Agonalis or *platea in agone,* which became changed by Roman dialect into "Piazza Navona." A grand open space, ringed with palaces, closed at one end by the unwieldy bulk of Palazzo Doria, it had been distinguished by the pilgrimage church of Sant'Agnese in Agone, built on the presumed site of the holy child-virgin's martyrdom, a Roman brothel. It was a modest church in its first form, but that would presently change by the orders of various members of the Pamphili family. In 1652, Innocent X decreed a total rebuilding of Agnes's little shrine. This work was entrusted to Innocent's architect Girolamo Rainaldi. He had designed the Pamphili Palace next door, and he would work on Sant'Agnese until 1653, shortly before his death, when the project was taken over by his son Carlo. But in 1653 the work on the commission was also joined by Francesco Borromini, the depressive genius who was Bernini's chief rival. He redesigned the façade of Sant'Agnese as a concave oval curve between bell towers on either side. The church façade one sees from the piazza, therefore, is a palimpsest of three architects' work: Borromini up to the cornice, then a classical pediment by Bernini (1666), and finally the dome and the upper parts of the campanili by Rainaldi. It is a horse made by committee.

Nevertheless, the piazza had evolved into one of the greatest festive precincts in Rome, frequented alike by the grandees taking their evening *passeggiata,* and every kind of jongleur, contortionist, pickpocket, pimp, tart, hawker, and gawker, whose descendants still throng the square as the day's light is fading. In a superb demonstration of civic theater, there was until the end of the eighteenth century a custom of flooding the piazza with water, through which processions of horse-drawn carriages would festively parade round and round—a spectacle painted more than once by such artists as Hubert Robert. It must have been quite a sight, though prolonged immersion in water cannot have done much good to the wooden chassis and spoked wheels of the *carrozze.* But sometimes

a Roman has no choice but to cut a *bella figura,* even when his carriage warps. Piazza Navona in the Baroque era was a center for street theater, replete with processions and ceremonies such as the Giostra del Saraceno, a jousting contest in which the target of the riders' lances was an effigy of a Saracen mounted on a pole. But none of these delights of the *effimero barocco* (temporary Baroque) could compare to what Innocent X, through the ministrations of Bernini, made of the piazza.

At the beginning, the pope did not mean to use Bernini at all. Piazza Navona was the Pamphilis' backyard, their family precinct, and Innocent X was determined to convert it into a permanent memorial to his reign—the greatest public square in Rome. He saw to it that every sculptor-architect of proven quality in Italy was invited to submit designs for the remodeling of Piazza Navona—with the single exception of Gian Lorenzo Bernini, who, being so conspicuously the favorite of the detested Barberini, was disqualified.

At first it looked as though Borromini was going to win the commission: it was he who conceived the idea of a sculptural centerpiece for the square, a great fountain outside Sant'Agnese, with figures representing four rivers and, perhaps, symbolizing the four quarters of the known world. He also devised a scheme for a new aqueduct which would bring enough water for the fountain. Project models would be displayed to Innocent, and he would choose.

But, unknown to Borromini and everyone else, including the pope, Bernini's friend Prince Niccolò Ludovisi had briefed the great sculptor on the situation and recommended that he make his own model, some say of silver; it would be secreted in a room where the pope would see it. Bernini chose the theme of the four rivers, too—no doubt Borromini never forgave him for this plagiarism—and proposed to add an Egyptian obelisk, which Innocent X had previously seen lying in five pieces on the *spina* of the Circus of Maxentius, out on the Via Appia. If Sixtus V could have his obelisks, so could Innocent X.

But it was necessary to give it a more grandiose and memorable setting than other obelisks, and Bernini proposed that it should be moved and reassembled to stand on the fictive mountain of travertine where the statues of the four rivers were ensconced. These rivers were the Nile, the Plate, the Ganges, and the Danube. Each of the rivers would represent one of the world's four then known continents—Africa, America, India, and Europe—respectively, identified by allegorical figures and implications: a lion for the Nile, a pile of riches for the Plate (representing

the promise of the New World), a man holding an oar for the Ganges, and a papal coat of arms for the Danube. The whole thing would be an astounding *coup de théâtre:* that giant spike borne up on a rough arch of rock, standing on a void above water—an image of the world, *imago mundi,* without parallel in earlier sculpture.

On top of the pyramidion would be a bronze dove, the *stemma* of the Pamphili as the bee was of the Barberini, proclaiming to the world the triumph of Christianity (the Holy Ghost, which a dove also symbolized) over Egyptian and all other paganism, and the happy identification of that same Holy Spirit with the Pamphilis in general and this pope in particular.

Then came a further level of meaning: the traditional form of Paradise contained, at its center, a fountain, and from it sprang the four rivers that irrigated the four quarters of the world—the Gihon, the Pison, the Tigris, and the Euphrates. Bernini's design alluded to this, too, thus implying that the Pamphili pope was in charge of Paradise, and, in a theological sense, its actual gatekeeper.

The model was finished; Prince Ludovisi arranged for it to be set in a room in Palazzo Pamphili through which Innocent always passed on his way from dinner. He was on his way with his brother cardinal and his sister-in-law, Donna Olimpia, when it caught his eye.

> On seeing such a noble creation and the sketch for so vast a monument, [he] stopped almost in ecstasy. . . . After admiring and praising it for more than half an hour, he burst forth, in the presence of the entire privy council, with the following words: "This is a trick of Prince Ludovisi. It will be necessary to employ Bernini in spite of those who do not wish it, for he who desires not to use Bernini's designs must take care not to see them." He sent for Bernini immediately.

And so Bernini's design for the Fountain of the Four Rivers went ahead.* Begun in 1648, it was finished in 1651, thanks to a cast of skilled assistants working to his designs—on a project like this, Bernini was

* It is not known what happened to the silver model. It may have ended up in the possession of the formidably avaricious Olimpia Maidalchini, who had been married to Innocent's late brother and now, in her widowhood, was believed to have become Innocent's mistress, wielding great influence over him. She was respected and disliked in Rome, both for her ruthlessness and for her sexual power, which led to her nickname, "Olim Pia," roughly meaning "Formerly Virtuous." Certainly she would have been a useful and receptive person to bribe with a silver *bozzetto.*

more the master of works than the carver, although he reputedly did the horse, the palm tree, the lion, some of the rock, and possibly the bizarre hybrid creature next to Francesco Baratta's figure of the river Plate, which looks like nothing that ever lived but was meant to be an armadillo, an animal so exotic that neither Bernini nor anyone else in Rome had ever seen one or even an engraving of one. Bizarreries and jokes were designed into the stone: Antonio Raggi's figure of the Danube is holding up its hand, allegedly to shield its gaze from the unwelcome sight of Borromini's façade of Sant'Agnese. Because the source of the Nile was unknown, the figure of it, carved by Giacomo Fancelli, has a head swathed in cloth—but this blindfold was also said (falsely) to protect the Nile against a glimpse of Borromini's work.

The reassembly and erection of the obelisk was a major enterprise: not, perhaps, as monstrous as Fontana's task in shifting the obelisk of Saint Peter's for Sixtus V, but attended by great engineering problems. It is a gigantic spike balanced above a void. Bernini constructed the base from travertine, apparently solid rock but carved to simulate "natural" stone, an arch. One can see right under and through it, from one side of the piazza to the other. This was the new base of the obelisk. One can but guess a connection between the emotional effect that the collapse of the bell tower at Saint Peter's must have had on Bernini, and the daring with which he set up the obelisk over the void at the center of the Four Rivers Fountain. Let the public and the papacy see, he in effect declared, what I can do! Let them know that the bell-tower fiasco was not of my own making! And then one realizes something else. This spike over a void within the "legs" of an arch—what is it but a prefiguring of the feat Gustave Eiffel would bring off two and a half centuries later, in steel and in Paris, with his celebratory tower? Was this where Eiffel got his first idea for the structure which, at the end of the nineteenth century, would be identified more than any other with modernity? Tantalizing, but impossible to know.

The Four Rivers was by far the most elaborate, ambitious, and delightful fountain Bernini contributed to Rome, but of course it was not the only one. His earliest was possibly the "Ship" or Barcaccia in Piazza di Spagna. It may have been designed by his father, Pietro, who was the official architect of the Acqua Vergine, the aqueduct through which its water came; but the son seems to be the more likely author. Created in 1627–29, it takes the low water pressure in that area and turns it to

advantage: the motif is a marble ship half sunk in a pool, dribbling rather than exuberantly spouting water from its gun ports. It may be that it has a political reference, since the patron who commissioned it was Urban VIII, who at the time was conspiring with France and Spain to launch the seaborne invasion of Protestant Britain—the very attack that would end in the ignominious destruction of the Spanish Armada. With consummate hypocrisy, Urban penned a distich which was engraved on the fountain and, in translation, reads, "The ship of the Church does not pour forth fire, but sweet water, by which the flames of war are extinguished."

Bernini had a hand in the original design of the Trevi Fountain, but it was not started by him, and it fell to Nicola Salvi (1697–1751) to build it in the mid-eighteenth century. The commissioning pope was Clement XII Corsini (reigned 1730–40). The fountain occupies one whole flank of Palazzo Poli. It is huge—twenty meters wide and twenty-six high. Its central figure, by Pietro Bracci, represents the sea god Neptune, riding on an enormous shell drawn by sea horses and guided by two Tritons. These in turn are flanked by allegorical figures of Abundance and Healthfulness, in praise of the benefits of papal government. It owes at least some of its popularity, not so much to its grandiose and congested design, as to that hardy perennial of 1950s sentiment, the movie *Three Coins in the Fountain*—that, plus the iconic sight of the young blonde bombshell Anita Ekberg wading stalwartly in it in Fellini's *La dolce vita*. There is an urban myth which says that if you stand with your back to the fountain and toss a coin over your shoulder into the pool, your return to Rome will be guaranteed. The other, and perhaps more attractive, legend of the fountain holds that if a lover drinks a cup of its water in the presence of his beloved, he will never be able to get her out of his heart. Presumably this story is connected to the source of the fountain's water, which used to be known as the Acqua Vergine because its upwelling, some miles away, was pointed out to ancient Roman water-seekers by a young girl.

The Bernini fountain that remains an outstanding favorite of the Romans themselves is the Triton Fountain, in Piazza Barberini (1642–43), outside the Barberini Palace, itself partially the work of Bernini. If the Trevi Fountain is the most grandiose in Rome, the Triton Fountain is surely the most graceful and, if one may use the term, the most epigrammatic. In the middle of a geometric pool, four head-down dolphins bear up, on their tails, a gigantic scallop shell which has opened its ribbed

halves, like a book, to reveal a Triton blowing his conch. The "music" one expects to come from a conch is a vertical blast of water, glittering in the Roman sunlight. It is a fabulous *concetto,* scarcely diminished even by the parked cars that cluster around it, the *avvocato* Agnelli's hogs at a trough.

Italy was the only country in which Bernini's genius was able to spread its wings. The French King Louis XIV had him invited to Paris, and (cautioning His Majesty not to speak to him about small projects) the sixty-six-year-old culture hero actually made the long and arduous trip to discuss a possible rebuilding of the royal Palace of the Louvre. Nothing came of this except some drawings and a magnificent, complex marble portrait bust of Le Roi Soleil, which survives and remains in France. Bernini took a sardonic pleasure in seeing people flock to view him as though he were a traveling elephant.

The visit also gave rise to a tremendous display of the old maestro's bad temper, when he heard the architect Claude Perrault, Bernini's eventual successor as *architecte du roi,* commenting to Chantelou on a possible flaw in Bernini's design for pavilions. The two men were speaking French, of which Bernini hardly spoke a word. Nevertheless, he thought he understood, and flew into a towering rage.

He wanted Perrault to know, Bernini said, that in the matter of design Perrault was not worthy to clean the soles of his shoes. That his work had pleased the king, who would be hearing about the insult personally. "That a man of my sort," he fumed on, "I, whom the Pope treats with consideration and for whom he has respect, that I should be treated thus! I will complain of it to the King. I shall leave tomorrow. I do not know why I should not take a hammer to the bust after such an insult. I am going to see the Nuncio." Eventually, the great man consented to be soothed with apologies, and he never listened to a French official again. The point was taken. He retired, victorious, to Rome.

The size of Bernini's huge output in Rome defies short summary, and so does its "mood," if that is the word. Bernini could be very funny in his unofficial work, as in his pen-and-ink caricatures of Vatican notables, which were not made for public display. The much-loved elephant of Piazza Minerva, bearing an obelisk on its back, shows his humorous fantasy at full stretch. In the seventeenth century, an elephant, in Italy, was a veritable apparition, a rarity seldom seen. The very name of the animal was a synonym for the bizarre, the unexpected, and (sometimes) the menacing—hadn't Hannibal used the great beasts to crush the Roman armies at Cannae?

But apart from three other churches,* the stairways, fountains, portrait busts, chapels, palaces, and tombs, Gian Lorenzo Bernini's enormous reshaping of Rome centers on the greatest basilica in Christianity, Saint Peter's. You cannot imagine this complex without Bernini and his powers, not only of architecture, but of stagecraft—not that the two are readily distinguished. Bernini was responsible not only for much of the church and its contents but for its link to the Vatican palaces, in the form of the so-called Scala Regia (1663–66). Before he installed this staircase, the passage between church and palace had to be negotiated by a flight of cramped steps up and down which the pope was carried, at some risk, on a litter. Bernini had this steep and undignified incline demolished and replaced it with a new stair, which had a break near the bottom. This point, at which one turned through ninety degrees left to ascend the last and longest run of stairs, he marked with a huge sculpture of the Emperor Constantine on his rearing warhorse, stricken with his vision of the cross—"Conquer, in this sign," promising victory over Maxentius at the Milvian Bridge.

But now he had to resort to a perspective trick. The walls of the basilica and the palace were not parallel. They converged toward the top of the stairs. Bernini therefore introduced, on either side of the stairs, a run of columns which create a diminishing tunnel-vault, getting smaller as your gaze travels up, giving the impression that the walls do not converge.

Of all the Berninian features of Saint Peter's—the altar that carries the Cathedra Petri or Apostolic Throne, the *baldacchino,* the numerous papal tombs and figures of saints, the nave decorations, the twin fountains on either size of the central obelisk†—the one that absolutely typifies Baroque grandeur, that "stands for" the size and inclusiveness of the seventeenth-century Church, is of course its piazza. Saint Peter's Square, which is not a square but a colossal oval colonnade, "pulled apart" in the middle, has been known to hold the tens of thousands of people who flock there to receive the papal blessing, and is justly regarded, even by some Protestants, as the very epicenter of Christianity—a pair of immense arms, Bernini himself said, reaching out from the façade in a gesture of embrace to the world.

* All belonging to the period of Alexander VII's pontificate: Sant'Andrea al Quirinale (1658–70), San Tommaso Villanova at Castel Gandolfo (1658–61), and the Chigi Church of the Assumption at Ariccia (1662–64).
† One designed by Carlo Maderno; the other, its twin, by Bernini.

It is the greatest anthropomorphic gesture in the history of architecture.

It is also the stripped-down essence of Baroque, for it carries little of the elaborate detail and décor usually associated with Baroque design. Its columns—284 of them, in four rows—are austerely Tuscan, not the more florid Corinthian one might expect from Baroque. Its frieze is unbroken Ionic, without sculptural ornament, though there are some three hundred sculptures—more than a lifetime's work, one might have thought, even for Bernini's corps of assistants—along the edge of the roof. But in the vast spaces and distances of the piazza, these cause no visual congestion. Some critics have said, truthfully enough, that the piazza pays no compliment to the enormous façade of the basilica, by Carlo Maderno, that closes it off. The front of Saint Peter's is too wide for its height—some 115 meters broad. The loss of Bernini's bell towers caused this disproportion. It is a flaw, admittedly, but a small one in the context of a scheme so gigantic both spatially and conceptually.

Bernini's rival architect in the formation of the Baroque style in Rome, his prodigious contemporary Borromini, did not build as much as Bernini, and he was not a sculptor; but his relatively small output of buildings is so concentrated, so inventive, as to set him alongside Bernini as one of the heroic figures in architectural history. Moreover, it should be recalled that Bernini was not an architect to begin with, and much of what he learned about the design of buildings was acquired, usually without acknowledgment, from Borromini. It would be hard to find two architects of comparable talent who were, psychologically and temperamentally, less like each other. Borromini's life ended in a way utterly unlike the sense of fulfillment conveyed by Bernini's death; at the age of sixty-eight, harried by jealousy and an irascible sense of failure, he wrote out his will by candlelight and then gave himself what he hoped to be a truly Roman exit, falling on his sword. Botched and painful, it was neither a quick nor an easy death, just a tragic one.

That he was a misfit genius of the first order cannot be doubted. Melancholic by nature, he went to extremes in admiring Michelangelo's penchant for solitude and for *terribilità*. In a Rome where sexual morality among men was notoriously lax, he had a reputation for strict and extreme chastity, focusing only on his work and never indulging in stray affairs. He made a point of always dressing in funereal black, Hamlet-like, in the Spanish way. In another architect, this might have been a sign of dandyism; one may be fairly sure that in Borromini it was not. It was

more like penance, or perhaps indifference, to fashion in an intensely fashion-conscious cultural capital. Borromini was never popular with everyone in his own lifetime. His contemporary Giovanni Baglione, a priggish but influential figure, denounced him as "a most ignorant Goth and corrupter of architecture, and the infamy of our century."

The innovations of detail and planning he wrought into his buildings were paralleled in the way he presented their designs to clients. Thus Borromini was the first architect to use the graphite pencil rather than ink-and-wash in his presentation drawings. Moreover, he seems to have regarded these drawings as ends in themselves, finished works of art, rather than merely indications of what structures and finishes would be. He liked to call his drawings his "children" and often refused to be parted from them by sending them to competitions—"sent begging into the world" was his phrase for this.

Borromini's origins were humble. He was the son of a builder, born in Bissone, on Lake Lugano. The apprenticeship of a manual worker started early, and when he was only nine years old, his father dispatched him to Milan to learn the basics of stonecutting on the decorative details of the city's cathedral, then under construction. He was a thoroughly skilled *scarpellino* or stoneworker when, in 1619, he moved to Rome and found work on the construction site of Saint Peter's, to whose official architect, Carlo Maderno, he was (very distantly) related. At first he carved decorative details; then Maderno and others saw that he had talent and facility as a draftsman.

He was developing a very wide knowledge—probably wider than that of anyone in his generation, including Bernini—of the history of architecture, both ancient and modern. He absorbed and venerated old Roman building, but also studied sixteenth-century masters, from Bramante and Raphael through to Palladio and Vignola—and, especially, Michelangelo, whom he called "Prince of Architects" and revered almost as a god.

This made him extremely valuable to the better-connected but perhaps somewhat less studious Bernini, who, only a year older than Borromini, was engaged in the first big project of his fast-track career, the *baldacchino* for Saint Peter's. At that early stage, Bernini had no architectural experience, and he had to rely on Borromini, whom he hired to do all the working drawings for the baldachin, along with the designs for some of its details, such as the bronze vine leaves and the four marble column bases with their complex Barberini shields and heraldic bees. It is

likely, too, but undocumented, that Borromini designed the baldachin's dynamic top, the four bronze volutes that so successfully replaced Bernini's original idea of semicircular ribs. If so, this could have been the seed of the painfully frustrating rivalry that Borromini felt toward Bernini for the rest of his life: the volutes are a much-admired stroke of architectural genius for which he got no credit.

Borromini's relations with Carlo Maderno, however, remained good, and they led to his work on Palazzo Barberini (1628–32), one of the archetypes of the grand Roman Baroque palace. Maderno also hired Pietro da Cortona and Bernini as codesigners, and the questions of who designed what and when are too complicated and uncertain to resolve easily or briefly. Maderno died in 1629, leaving the job to the three younger architects—a troika which seems to have been plagued by disagreements, hardly a surprise given how strong-willed each member was. Before long, Borromini left.

His first solo, independent commission came in his mid-thirties, in 1634, through the good offices of Cardinal Francesco Barberini. This was a monastery and church for the Discalced (or Barefoot) Trinitarians, an offshoot of the well-established Trinitarian Order, which had originally been formed in 1198 with the object of rescuing Christian captives from the Muslim "infidels." The Barefoot Trinitarians tried to set an example of reform through austerity—one might almost say that they stood in the same quasi-fanatical relation to the original order as Borromini did to Bernini. They had little money and few means of raising it. But their superior, Padre Giovanni della Annunziazione, became confessor to Barberini, who happened to be very rich.

This was just as well, since the austere Discalced Trinitarians badly needed funds and a strong contact with the papal court. The friars had been horrified when Borromini presented them with his first drawings for the church and monastery that became San Carlo alle Quattro Fontane, and they complained that they had wanted something that cost about a fifth as much. Eventually, a compromise was reached, brokered by Cardinal Barberini, who presumably gave money for its construction—though it is not known how much.

What they got in return was one of the most radical and daring small buildings of the Roman Baroque. Despite the shortage of funds, Borromini was able to develop and keep the three key elements of his project: the plan, the dome, the façade.

The plan became almost immediately famous, and architectural vis-

itors to Rome kept begging for copies of it (which they did not get, because Borromini did not trust them). It had begun as a central-dome church with four crossing piers. Because the site was long and narrow, that configuration was squeezed, and the circular dome became an oval. This produced the further sensation that the walls were going in and out, "breathing," almost like a live creature with lungs.

The dome is coffered. Its interior is very deeply shaped, the pattern produced by a series of interlocking hexagons and crosses that seem to recede from your eye as your gaze travels toward the center of the dome, which is marked by an emblematic triangle representing the Trinity, after whom the order is named—Father, Son, and Holy Spirit. This is an optical illusion: the geometrical figures are getting smaller, but the dome is not getting deeper. Nevertheless, the spatial effect is very powerful. Borromini delighted in such tricks of false perspective: there is another, smaller one in Palazzo Spada—the palace in Piazza Capodiferro, near Palazzo Farnese—which he redesigned for Cardinal Bernardino Spada in 1652, consisting of an illusory Doric colonnade which, because of the sharply decreasing size of its framing pillars and the slant of its floor, seems to be twenty meters long, though its actual length is only 8.6. This "Prospettiva," as it was known, was (and is) one of the most charming minor sights of Rome. But when you catch sight of it and see how it works, it is immediately readable as a trick, and it may have had a deliberate allegorical meaning: just as its size is an illusion, so, too, is worldly grandeur. No such ironic meaning attaches to the dome of San Carlo alle Quattro Fontane.

Then there is the façade. Borromini is said to have talked wistfully about creating a façade from a single molded sheet of terra-cotta, and the front of San Carlo suggests this unachieved idea. It ripples and bulges—in, out; in, out. Actually, not all of it is by Borromini. The lower half was done before he died, in 1667; the upper, posthumously, by followers of Bernini, whose ideas are somewhat passively applied in the oval medallion supported by angels above the entablature. What Borromini himself might have done with this upper façade, had he lived, is anyone's guess.

Fortunately for the modern visitor, though, he was able to complete the cupola of the church that is generally regarded as his masterpiece, Sant'Ivo alla Sapienza (1642–60), the chapel of the University of Rome. This quite small building, whose walls appear, when one first sees them, to be almost fluid, in continuous motion, is one of the most inventive in Italy—or in the world. It is a marvel of space-shaping, based on a hexag-

onal plan with sharp cutouts and lobes that form a steep tent from which light pours into the nave below. In the words of the architectural historian Rudolf Wittkower, "Geometrical succinctness, and inexhaustible imagination, technical skill and religious symbolism, have rarely found such a reconciliation." The geometry, imagination, and skill are self-evident; the religious symbolism of Borromini's *concetto* is perhaps less so. It may be that the geometry of the plan refers to the Star of Solomon, the king whose proverbial wisdom chimes with the idea of the building as the church of *sapienza* (wisdom). The most striking feature of the church is its lantern, whose top Borromini designed as a spiral that corkscrews into three full turns counterclockwise—a wonderfully dramatic climax to the building, flamelike and aerial. Various interpretations of its symbolism have been made, none of them entirely convincing; but as an expression of sheer architectural brio, there is nothing quite like it in Rome.

An age of great and mobilized spiritual awakening stands a good chance of producing strong and effective religious art, impelled by remarkable personalities—remarkable not so much for their piety as for their intelligence and militancy. So it was with Baroque Rome; the energy of its art and architecture was equaled by that of its outward thrust in conversion and theology. The Protestant Reformation awoke the Roman Church and gave it a new, fiery *raison d'être.*

The most powerful force in the Roman Catholic recovery, the essential militant group produced by the Church in its fight against the Lutheran heresy, was the Society of Jesus—otherwise known as the Jesuits. This order of secular priests grew from a tiny nucleus—at first, two Basques, later to be canonized as Saint Francis Xavier and Saint Ignatius Loyola. Both were missionaries, one inside Europe, the other in the Far East. The one who took Europe as his field was the founder of the society, Ignatius Loyola. The nature of the Jesuits cannot be grasped without their shared conception of discipline, and that discipline depended on the military background of their founder, Ignatius, the thirteenth and last child of the lord of Onaz and Loyola, in the Basque province of Guipúzcoa.

Loyola's family was military, both in origins and in practice. They were border chieftains—tough, violent, merciless to their enemies, endowed with an iron loyalty to their friends and allies. Two of Ignatius' brothers were killed fighting for Spain against Italy, one in the *conquista* of America. The young Loyolas of Ignatius' generation were obsessed with the projects of conquering the New World for Christ and, in the Old World, of driving the *moros,* the occupying Arabs, from Spain and restoring the

primacy of the Christian faith to the peninsula. They were enthusiasts—or, not to mince words, fanatics—who completely shared the belief that religious and national feeling were, and ought to be, the same. In their eyes, there was little difference between the messages of early chivalric novels like *Amadis of Gaul* (the first book of knight-errantry printed in Spain) and the worship of the Virgin Mary. The corollary of this assurance, the certainty that Spain's supreme projects were the expulsion of the Jews followed by the eradication of the Moors, was a fanatical belief in the sword of the conquistador. This belief lent a nobility to the profession of arms that is difficult to appreciate and impossible to share in another culture more than four centuries later.

Ignatius of Loyola felt it to the extreme. Almost from childhood, he saw himself as a soldier. He was never to write a memoir of his life, but his "confessions," dictated after 1553, ignored his youthful years, merely saying, "Up to twenty-six years of age, he was a man given to the vanities of the world and his chief delight was in martial exercises with a great and vain desire to gain honor."

What he gained was not just honor, but disaster and an atrocious degree of suffering that changed his life. In 1521, the duke of Nájera, viceroy of Navarre, was embroiled in a war of secession against the French, who had territorial claims on that part of Basque Spain. Ignatius went to fight for him, but a French cannonball smashed both his legs—the right femur almost irreparably. Taking chivalrous pity on him, the French shipped him on a litter back to his native ground in Azpeitia, fifty miles away, where a long and grindingly difficult convalescence began. At first there seemed to be only two prospects for Ignatius: to die in agony from infection, or to survive as a helpless cripple. But he was a singularly tough and determined man, not to say a lucky one. When it became apparent that his injuries, if allowed to heal "naturally," would leave him crippled for life, Ignatius submitted to having his leg broken and reset. This butchery took place at the family home in Azpeitia, and was followed by equally horrendous sessions in which the newly fractured leg was stretched—at Ignatius' own insistence—in an improvised rack, so that both limbs would set to more or less equal lengths. How could he have endured it? One would need to be another Ignatius to know.

Without anesthetics, antibiotics, or any of the drugs modern medicine takes for granted, the sixteenth century was an age when pain would be almost insuperable. Not only that, but Ignatius had to endure the knowledge that the active life of a knight-errant was now closed to him.

A lesser man's resolution might well have buckled under the stress of such disappointment, but nothing could dissuade the crippled cavalier from his ambition to make a pilgrimage to Jerusalem. Before that could be done, Ignatius' soul must be cleansed, and he set out to achieve this by going first to the ancient pilgrimage center of Montserrat, in Catalunya, home of the cult effigy of the Black Virgin, at whose altar he left his arms and armor, and thence to Manresa, a backwater village where he spent a year in fasting, prayer, and deprivation.

Ignatius' self-mortification was not as extreme as the punishments inflicted on themselves by certain medieval mystics, such as Henry Suso, who recounted (in the third person, as was customary) how

> he secretly caused an undergarment to be made for him; and in the undergarment he had strips of leather fixed, into which a hundred and fifty brass nails, pointed and filed sharp, were driven, and the points of the nails were always turned toward the flesh. He had this garment made very tight and so arranged as to go round him and fasten in front, in order that it might fit the closer to his body. . . .

Ignatius did not need to go to such masochistic extremes because his doctors, such as they were, did that for him. Nevertheless, he cut a very strange figure in Montserrat and Manresa. He threw away his clothes and donned prickly sackcloth. He grew his hair into a long, matted thatch; his fingernails turned into an animal's claws; he begged, stank, starved himself, and kept strange hours at night. He spoke of his desire "to escape all public notice," but he was becoming one of the grotesques of the street. Gradually, these hippielike eccentricities abated, leaving behind a residue of strict self-denial in which there was no room for frailties and eccentric behavior. Ignatius had little in common with such saints as Francis of Assisi, who shrank from cleaning his sheepskin out of tender pity for Brother Louse, or the obese theologian Saint Thomas Aquinas, who endearingly had a piece sawn from his dining table to make room for his Falstaffian belly. His mind was fixed on missionary work, and this entailed different disciplines from those of the contemplative orders—especially, learning about the languages and customs of the very foreign cultures in which he and his fellow priests would be working.

The product of the soldier-saint's hard time in the outer desert was a small but immensely influential book, the *Spiritual Exercises* (published 1548). This was the manual for all those who wished to take the road of submission to Ignatian rule, a discipline that few at first could contem-

plate adopting but that later became the essence of Catholic revival and recruitment. Of all the Spanish Catholic texts that sought to open a passage away from the world and to prepare the soul for its encounter with God, this was by far the best-known and most influential. Its strength lay in its relentless single-mindedness. "Carefully excite in yourself a habitual affectionate will in all things to imitate Jesus Christ," Ignatius wrote:

> If anything agreeable offers itself to your senses, yet does not at the same time tend purely to the honor and glory of God, renounce it and separate yourself from it for the love of Christ. . . . The radical remedy lies in the mortification of the four great natural passions, joy, hope, fear, and grief. You must seek to deprive these of every satisfaction and leave them, as it were, in darkness and the void.

Ignatius' *Exercises* were a long and precisely divided feat of the imagination. First, the soul must be driven into repentance by the fear of Hell. This must go on for a week, at whose end the now terrified and malleable soul will be ready to receive enlightenment. Progressive stages follow, and their sequence amounted to an intense form of self-therapy, which would remain central to Jesuit practice for centuries to come. To see its effect on the humbled, sensitive, and impressionable young mind, one need only read the description of the "retreat" suffered and finally embraced by the Jesuit student Stephen Dedalus in Joyce's *Portrait of the Artist.* Once an initiate had undergone this, there would be no turning back. Here is Ignatius' description of the meditation on Hell, the fifth exercise of the first week:

> The first point will be to see with the eye of the imagination those great fires, and the souls as it were in bodies of fire.
> The second to hear with the ears lamentations, howlings, cries, blasphemies against Christ our Lord and against the Saints.
> The third, with the sense of smell, to smell smoke, brimstone, refuse, and rottenness.
> The fourth, to taste with the taste bitter things, such as tears, sadness, and the worm of conscience.
> The fifth, to feel with the sense of touch how these fires do touch and burn souls.

Each sense is mobilized, one by one. In this way, Ignatius insisted, the utmost concreteness of feeling would be given to spiritual experience. There would be nothing abstract or hypothetical about it. Part of the

discipline was learning to defy the evidence of one's own senses, should obedience make that necessary. Then, gradually, step by step, the novice is moved through repentance to hope, and from hope to desire of the joys of heaven and of union there with God: but each of these stages must be fully visualized, imagined in completeness. The *Exercises,* as one priest-psychologist put it, created a "regressive crisis, with its concomitant dissolution of psychic structures and the weakening of repressive barriers," whose product was "a new identity."

The whole process, from entry to the final emergence as a future Jesuit priest, took some twelve years—and in addition to the usual priestly vows of poverty, chastity, and obedience, the Jesuit had to take further vows of obedience to his superiors in the Papacy, making it incumbent on him to go and work at the task of evangelical conversion anywhere in the world, if the pope so wished. It was a somewhat frightening responsibility, because in the sixteenth and seventeenth centuries the world was a huge, hostile, and little-known place, and the small corps of Jesuits was spread thinly in it. But this corps grew slowly and steadily. At Ignatius' death in 1556, there were 958 members of the order; seventy years later, some fifteen thousand; by 1749, 22,500. It was an order highly conscious of its elitism, both intellectual and in terms of class. Other orders of priests could, and did, focus on recruiting the poor. But there is little doubt that, just as the intellectual elitism of the Jesuit missionaries underwrote their enormous success in the highly class-conscious society of eighteenth-century China, so their stoicism and military toughness enabled them to withstand and survive the terrible sufferings visited on them by the savage tribes of North America. They were the commandos of the Church Militant.

The order won official recognition from Pope Paul III in 1540. Once papal approval was secured, the Society of Jesus had to have a home church in Rome, and it had to be splendid, which meant money. Fortunately for the Jesuits, the man who volunteered the cash was Cardinal Alessandro Farnese, who became Pope Paul III and, during the fifteen years of his pontificate (1534–49), showered money on his own family and its projects. He also did great things for the city itself: he spent huge sums on repairing the damage inflicted on Rome by the disastrous 1527 sack of the city, directed the creation of Piazza del Campidoglio, and instructed Michelangelo to move the ancient bronze rider statue of Marcus Aurelius there, thus creating the most spectacular and influential urban scheme of the sixteenth century. But there is little doubt that the long-term effect

on the Church of his recognition of the Jesuit Order at least equaled his urbanistic projects in importance. The Jesuits already favored their own architect, the otherwise unremarkable Giovanni Tristano (d. 1575), who had designed their college in Rome in 1560. But for the mother church something much grander in spirit was called for, and the chosen designer was a favorite of Cardinal Farnese's, Giacomo Barozzi da Vignola (1507–73), who had entered papal service in the 1550s, designing a stream of projects for Rome and the Papal States. The greatest of these was the Villa Farnese at Caprarola (1559–73), which began as a five-sided stronghold but morphed into a grandiose country house, a hilltown in its own right, with magnificent approach ramps. There were smaller secular buildings, some of them masterpieces, such as the twin-pavilioned Villa Lante at Bagnaia.

But his most important church, paid for by Alessandro Farnese, was done for the Jesuits: Il Gesù, the Church of Jesus (1568–75), which (as the evangelical order of the Ignatians spread) provided a model for numerous—though usually more modest—Jesuit structures throughout the world. It was also the first church to take the name of Jesus himself.

The main requirement of Jesuit churches, faithfully carried out by Vignola and every designer after him, was that the ceremony of the Mass should be plainly seen, and that the priest's sermon, carrying the evangelical word of the Church into battle against the claims of Reformation heresy, should be distinctly heard, everywhere in each building. This had not been easy, or even possible, in older church layouts. The work of the Jesuits centered on preaching. So the Gesù had to have a large nave to fit in as many celebrants as possible, with unimpeded views of the main altar, and clear lines of sight and hearing to the main and side pulpits. It would not need crossing spaces—shallow side chapels would be better than transepts. The Gesù's nave is some seventy-five meters long, and it had three main chapels: on the right, that of Saint Francis Xavier, a memorial to Ignatius' missionary partner, who carried the Catholic message to the Far East and was the means by which Catholic doctrine and theology entered China, where he died in 1552; at the apse end, that of Saint Robert Bellarmine, the great Counter-Reformation theologian who died in 1621; and on the left, indispensably, the Chapel of Saint Ignatius himself, built to the designs of the Jesuit artist Andrea Pozzo and containing a bronze urn which holds Ignatius' remains. If one thinks of the soldier-saint as a puritanical opponent of lavishness, which he certainly was when alive, it is a good idea to see what became of him in

death: this is one of the most costly and extravagant tombs in all Rome. Its columns are entirely sheathed in blue lapis lazuli, and a globe of this rare and semi-precious stone, the largest in the world—"blue as a vein on the Madonna's breast," in Robert Browning's words—surmounts the whole confection. It was for this reason that the grand duke of Tuscany suggested that the Jesuits' motto, whose initials are IHS, ought to be rendered *Iesuiti Habent Satis,* "The Jesuits have got enough."* One vividly realizes what Goethe meant when he wrote (in Regensburg, 1786, on his way to Rome):

> I keep thinking about the character and the activities of the Jesuits. The grandeur and perfect design of their churches . . . command universal awe and admiration. For ornament, they used gold, silver and jewels in profusion to dazzle beggars of all ranks, with, now and then, a touch of vulgarity to attract the masses. Roman Catholicism has always shown this genius, but I have never seen it done with such intelligence, skill and consistency as by the Jesuits. Unlike the other religious orders, they broke away from the old conventions of worship and, in compliance with the spirit of the times, refreshed it with pomp and splendour.

Across the ceiling vault of the Gesù spreads the overwhelming rhetorical utterance of Giovanni Battista Gaulli's *Triumph of the Name of Jesus,* 1678–79. Gaulli was born in Genoa, but he came to Rome early, before 1658, and worked there for the rest of his life, very much under the spell of Bernini, who connected him to influential patrons like the Pamphilis. His *Triumph* reminds one how fatuous the Victorian and modernist objections to Baroque art as "too theatrical" are. One might as well decry theater itself as "too theatrical." Theater, on this ceiling, is of the very essence: emotion and seduction on the grandest scale, achieved through a billowing range of bodily contortion, facial expression, and gesture.

The ceiling falls into three zones, distinguishable but not sharply divided. At the center, the glowing apex, divine light streams from Christ's monogram, the "IHS." Around it is a mass of clouds upholding the heavenly blessed, the Communion of Saints, drawn in toward it like filings to a magnet. Some of them are allowed to spill over, across the painted architectural frame, into "our" space. Then, at the bottom of this enormous cartouche, we see the damned and disgraced falling in

* It is actually an abbreviation of the Greek form of the name of Jesus.

a torrent out of the sanctifying presence of Christ's name. As befits their earthly status, these are the most solid bodies of all, not transfigured by light like the saints, but writhing, toppling, and (in some cases) clutching the emblems of their sins—Vanity has a peacock; the head of Heresy teems, like Medusa's, with snakes.

The Baroque ceiling painting that rivals Gaulli's masterpiece is also in Rome, and it, too, was dedicated to the founder of the Jesuits. It is by Andrea Pozzo, in the Church of Sant'Ignazio. Its theme is *The Glory of Saint Ignatius Loyola and the Missionary Work of the Jesuit Order* (1688–94). It represents Ignatius entering Paradise. This enormous fresco in the nave vault, spilling over tracts of fictional architecture which in turn can hardly be told from the real architecture of the church, joins with Gaulli's work to sum up the rhetorical grandeur of painted Baroque illusion. If one is standing on the right "viewing spot" (considerately marked by a metal disc in the floor) and looking up at the perspective convergence of the ceiling, it is only with difficulty that one can tell where the walls of the nave end and the ceiling begins. The barriers between illusion and reality are down, and it takes a strenuous effort of the will and imagination to raise them again. It was important to have no visible break between what was happening in the sky and on earth: a seamless transition between the two meant a continuity which was both a promise of transcendence and a threat of failure. The walls seem to stretch up so far that they become misty in the open sky; the space between them is filled with a whirling gyre of figures, enacting a sort of spiritually drunken ecstasy. In these ceilings, Bernini's sculptural achievements in the Cornaro Chapel are equaled in the art of painting. Pozzo would go on to do other schemes for Jesuit churches, in Trento and Montepulciano and even as far afield as Vienna, but Rome remained his base, and none of his later works surpass his frescoes there. Between them, Pozzo and Gaulli represent the furthest stretch of the art of Baroque mural painting in Rome. But when the great age of foreign cultural tourism opened in Rome, after 1700, this was not what *i milordi inglesi,* the French connoisseurs, or the Russian princes were going there to study and appreciate. They were in full pursuit of the Antique, and of the seemingly lost authority of ancient Rome.

9

Eighteenth-Century Rome, Neoclassicism, and the Grand Tour

The modern traveler, gazing through his little porthole at the procession of the Alps below, glancing irritably at his wristwatch to see whether his flight is going to be thirty or forty minutes late into Fiumicino, can have no idea of what the trip from London to Rome meant in the late eighteenth century—that heyday of the Grand Tour.

It was trying, dangerous at times, protracted, and above all unpredictable. All travel was for the rich. There was no such thing as "mass tourism," for the simple reason that the masses had not yet learned to move, to go abroad for holidays or education, or even to imagine visiting Europe. The idea of "going abroad" for relaxation was not yet invented. Abroad was bloody, and foreigners were bastards. In 1780, most English people lived within a social radius of fifteen or twenty miles from their birthplaces, and the English Channel was a barrier to further exploration. The Englishman in the English street did not think of going to France; the French, most of the time, were despicable enemies, and would remain so for decades yet. Spain was simply not to be imagined—a country of misery, with a language none could speak, bravos who would slit your belly as soon as look at you, and oily, filthy food that none could digest. A pretty fair summation of English attitudes to the European foreigner was given by Thomas Nashe in *The Unfortunate Traveller* (1593), that masterpiece of abusive, inventive xenophobia:

> Italy, the paradise of the earth, and the epicure's heaven, how doth it form our young master? It makes him to kiss his hand like an ape, cringe his neck like a starveling, and play at hey-pass, re-pass, come

aloft, when he salutes a man. From thence he brings the art of Atheism, the art of epicurising, the art of whoring, the art of poisoning, the art of Sodomitry. . . . The better sort of men, when they would set a singular mask or brand on a notorious villain, do say that *he hath been in Italy.*

Still, Italian tourism by England's rich and notable was not, strictly speaking, an invention of the period in which it first flourished, the eighteenth century. Sir Thomas Hoby (1530–66), for instance, intrepidly made an Italian tour in his late twenties, when he was rich and vigorous enough to defy the swarm of Italian crooks, footpads, delators, and church spies that beset him.

But in those early years, English travelers in Italy tended not to be welcome, especially outside the great centers of sophistication, because they were assumed (correctly, as a rule) to be heretical Protestants. The Italians they were likely to deal with abhorred the Reformation; they themselves, with every parallel reason, feared the Inquisition and its arbitrary power to throw strangers into dungeons without *habeas corpus*. To go there at all in Elizabethan or early Jacobean times, one needed a travel pass from the English Privy Council, and these were not lightly given out. Generally, English travel was confined to northern Italy: Venice, Padua (whose university accepted foreign Protestant students, as no other academic institution in Italy would), and Vicenza. Rome, being the capital of the Papal States, was much more difficult; a prolonged stay there was always expensive and fraught with administrative obstacles. And forget about Naples, that enormous den of thieves and religious fanatics. All in all, one needed to be rich or very determined, preferably both, to confront the difficulties of Italian tourism, and the awareness of this took centuries to fade, even though it lost its primal Elizabethan virulence.

Someone who signed himself "Leonardo," one of a group of English poetasters called the "Della Cruscans," issued a warning against Italy in the late eighteenth century, when the Grand Tour had become an institution. For the peninsula offered an even worse threat to moral rectitude than it did to physical safety, no matter what its cultural benefits might be:

> But most avoid Italia's coast,
> Where ev'ry sentiment is lost,
> And Treach'ry reigns, and base Disguise,
> And Murder—looking to the skies,

While sordid Selfishness appears
In low redundancy of fears.
O what can Music's voice bestow,
Or sculptur'd grace, or Titian glow,
To recompense the feeling mind
For BRITISH virtues left behind?

Such people feared that not all the art on the Continent, no matter
how good it was, could make up for Italy's contagious lack of moral fiber
and common decency. Fortunately, most of those who could afford the
trip ignored these late-Puritan misgivings, and went anyway. You didn't
have to be all that interested in art, either. So it was with the biographer
of Samuel Johnson, James Boswell, for whom Italy was mainly a field
for sexual tourism, like Thailand today. Boswell was quite undeterred by
the pox, although, as one travel book remarked, "A great many of our
gentlemen travelers have reason enough to be cross on account of some
modish distemper the Italian ladies may have bestowed upon them with
the rest of their favours." "My desire to know the world," he confided to
his journal, "made me resolve to intrigue a little while in Italy, where the
women are so debauched that they are hardly to be considered as moral
agents, but as inferior beings."

But to know that world—that was the problem. It is hard today even
to imagine the difficulty of access that Italy presented in the eighteenth
century. There were two ways of getting to it: by sea, and across the Alps.
Both took weeks, which (depending on the weather) could lengthen into
months, especially with stops to examine works of art. The sea route
entailed an overland crossing through France to the Mediterranean, then
a coast-hugging progress to the Franco-Italian border, and then a slow
descent south through Genoa, Lerici, and thus to the Campagna and to
Rome. John Mitford (1748–1830), later Baron Redesdale, described part
of the sea passage he made in 1776:

From Genoa the Lerici travelers usually pass in a felucca to avoid
the fatigue of a mountain journey along roads where only mules can
keep their feet. These Mediterranean vessels are not formed for bad
weather and they are manned by no very skilful mariners. Scarcely
ever an oar's length from the shore they creep under the rocks,
and trembling at every wind are always afraid to hoist a sail. If the
wind is very fair, eight hours will carry the felucca from Genoa to
Lerici. But if the wind is the least contrary, or if it is so slight that

these timorous seamen do not trust a sail, twenty hours' rowing will hardly suffice.

If the sea tourist suffered boredom, discomfort, and seasickness, the land traveler might have worse problems, for he had as a rule to negotiate the Alpine pass of Mont Cenis. This was so steep and tortuous, and the road surface so blocked with ice and snow, that no horses could drag the coach over the pass. The vehicle then had to be dismantled at the foot of the incline, and the horses sent on, unencumbered. The wheels, axles, and all components of the coach, along with the tourists' luggage, would then be loaded onto mules and sent ahead. At the Italian side of the pass, on the flat, where it was safe to do so, the coach was reassembled and the portmanteaux, crates, and everything else reloaded. And what of the passengers, who had been carried up the steep slope in chairs on poles? Thomas Pelham, in 1777, reported (a little surprisingly), "As to our own person there is neither danger nor inconvenience: it was so hard a frost that when we came to the top of the mountains we left our chairs and descended in sledges, which though very trying to the nerves was not unpleasant. It was the clearest day imaginable and the view beyond description."

The delays must have been irksome, and there were occasional sorrows: Tory, Horace Walpole's pet spaniel, was eaten alive by a wolf on his Alpine crossing. Surely not all tourists who attempted the Mont Cenis pass can have had the phlegm or adventurousness of a Pelham; but it was too late to retreat, Italy beckoned, and this was the only way to the land where lemon trees bloomed.

"I have not read the Roman classics with so little feeling," declared the eighth duke of Hamilton, "as not to wish to view the country which they describe and where they were written." This was at least part of the essential motive with which the Grand Tourist, recipient of a classical education, set out. Would the trip make it all worthwhile—the rigors of life at an English public school, the flogging, the fagging, the bullying, the hours spent construing Cicero and Virgil? Probably it would; but not always in the expected way.

Few visitors failed to be thunderstruck by the density of Rome's Settecento cultural milieu. "As high as my expectation was raised," ran one typical reaction, that of the English tourist Thomas Gray writing to his mother in 1740, "I confess that the magnificence of this city infinitely surpasses it. You cannot pass along a street but you have views of some

palace, or church, or square, or fountain, the most picturesque and noble one can imagine."

Of course, it mattered very much whom you knew, or had introductions to. Though some exalted Englishmen complained of the dearth of social life to which they had access—compared with the heady whirl of cities like Venice or Milan—there were certainly hosts aplenty. Many of the continental aristocrats who came to Rome in the eighteenth century were taken in hand by the city's French ambassador, Cardinal François-Joaquin de Bernis, who entertained them most lavishly. In the papal Jubilee year of 1775, the visitors to Rome included Charles Theodore, the elector palatine; the princes of Brunswick; the earl of Gloucester and brother of George III of England; Archduke Maximilian of Austria; and innumerable lesser nobility. Up to 1775, there was a steady stream of exalted foreign visitors to Rome, but in the last quarter of the century it became a flood. It was Bernis's firm conviction that the way he entertained his guests ought to be a direct reflection of the *gloire* of the king he represented, Louis XVI. His embassy, near Piazza di Spagna, was the center of feasts so extravagant they confounded their guests, even those who were quite accustomed to shows of abundance; and when the cardinal's staff handed out the epicurean leftovers at the back door, even the commoners of Rome were left in no doubt about which was the premier Catholic power of Europe. This variation on the spectacle of Roman charity was repeated by other noble houses, on a lesser scale, throughout the city. Unsurprisingly, Bernis later complained that the cost of being Louis XVI's ambassador had nearly bankrupted him.

This mania for high-priced private and official entertainment meshed with Rome's insatiable desire for public extravagance. No Italian city, except possibly Venice, loved a parade or a ceremony as much as the papal capital, or staged as many. Just as in Caesar's day, Rome and everyone in it, from its cardinals down to the raggedest urchin, was addicted to its Carnival, its *feste,* its holidays, cavalcades, illuminations, and processions, not forgetting its huge firework displays and distributions of free food and wine to the poor. These were the points at which entertainment crossed with official life, including the still extremely vigorous life of religion and the all-reaching power of the Papacy. When a newly elected pope took office, he would enact the ritual of the *possesso,* the "taking possession" of Rome, with a long cavalcade from the Church of San Giovanni in Laterano (the cathedral of the city), through the Capitoline Hill—re-enacting, in effect, the route of ancient Roman military

triumphs. In the basilica, he would affirm his spiritual leadership of the Church; on the Campidoglio, where the leading magistrate gave him the keys of Rome, his political power over the city.

A more regular event, the "Chinea" ceremony, staged every year but abandoned in 1787,* was eagerly awaited. This was the day when the feudal dues of the Kingdom of Naples, a fief of the Papacy through most of the eighteenth century, were paid to the pope. They came as a bag of gold carried by a white donkey, the *chinea*. The money would be accepted by papal representatives and handed over in Piazza Santi Apostoli, in front of a stupendous piece of pasteboard architecture, vulgarly known as the *macchina* or "contraption," designed by a leading architect and paid for, traditionally, by the Colonna family.

At first it was difficult for a visiting *inglese* to grasp how very essential an aspect of Roman (and, more generally, Italian) life was the profusion of servants in the houses of the rich. Private property in England was more private than here. The English lord had his dependents, and some hangers-on, but as a rule nothing like the number of accepted parasites that swarmed around the noble Roman household and were taken with equanimity as part of the cost of blue blood. It was common for a wealthy aristocrat—a Corsini or a Borghese, an Odescalchi, a Chigi, or a Colonna—not even to know how many domestics he employed, or what they did. Rome was Europe's capital of the bow, the scrape, and the extended palm. The visitor was expected to distribute *mancie* (small tips) to everyone for everything, and often, it seemed, for nothing. This was profoundly unfamiliar and, for the foreign visitor, annoying. The Romans themselves saw it differently: giving to importunate beggars, after all, fulfilled Christ's injunction to care for the poor.

The foreignness of Rome was vividly felt in the position and conduct of its clergy. Both politically and socially, the Rome encountered by the well-off visitor was ruled by that clergy: rich, respected, feared, constantly lobbied and supplicated, and active in all its grades, from priest to monsignor to bishop to cardinal. No other society in Europe, not even France's, could show such an influential religious power group, or one so obsessed with matters of age and rank. Or, for that matter, so given to partying. Today the presence of a cardinal in full rig would put a damper on most parties. Not in eighteenth-century Rome, where the hierarchy of the Catholic Church loved to gossip, drink, and gamble,

* The year in which Naples refused to continue to accept its status as a papal fief.

though not (one presumes) dance; in 1729, Cardinal Alessandro Albani caused a delicious scandal by losing the huge sum of two thousand scudi at cards one evening in the palace of the princess of San Bono. It was assumed, however, that to become a cardinal was to be raised to the summits of wealth. Hence the bizarre custom by which, when news of a new cardinalcy got around, the favored cleric would hurry to empty his house of all his furniture and valuables. Otherwise, there was a good chance that the Roman mob would sack it. Some of the hierarchy were skeptical about themselves and their position, and Goethe related a story about the same Cardinal Albani, who had been present at a seminarists' meeting where poems had been declaimed in their various national languages. It was, Goethe wrote, "another little story to show how lightly the sacred is taken in holy Rome: One of the seminarists turned towards the Cardinal and began in his foreign tongue with the words 'gnaja! gnaja!' which sounded more or less like the Italian 'canaglia! canaglia!' The Cardinal turned to his colleagues and said, 'That fellow certainly knows us!' "*

Even if one did not have access to a great household, so much of Rome's life went on in public places—the piazzas with their cafés, *trattorie,* markets, and ever-refreshing fountains—that it hardly mattered. Bed, undoubtedly, was the poor man's opera, but just walking and sitting outside was his theater, and a Roman or a *straniero* could slake his curiosity about life and art merely by poking his nose out the door. You didn't soon forget what you saw in Rome. Thirty years on, a friend of Goethe's named Hofrath Meyer was still talking with delight about a shoemaker he had seen there, beating out strips of leather on an antique marble head of an emperor that stood before his door.

There would have been memories, new knowledge, and perhaps, for the more assiduous traveler, a journal to keep. That feeling about the ancient past—"Heroes have trod this spot—'tis on their dust ye tread," in Byron's words, from *Childe Harold's Pilgrimage*—might still be running strong in the minds of aristocrats who started off as ignorant as colts. Of poets, too, and everyone in between, not to mention some who were both, such as Lord Byron. Probably the most beautiful poetic image of the Colosseum written by any foreigner came from his pen, when he described how, at night, the stars seen through the arches of the Colosseum glittered "through the loops of Time." His friend Percy Bysshe Shelley, when he arrived there in 1818, found that it was chief

* *Canaglia* means, approximately, "scum" or "dirty mob."

among "the miracles of ancient and modern art" that exceeded all comparison, all expectation:

> The Coliseum is unlike any work of human hands I ever saw before. It is of enormous height and circuit, and the arches built of massy stones are piled on one another, and jut into the blue air, shattered into the forms of overhanging rocks. . . . The copse-wood overshadows you as you wander through its labyrinths, and the wild weeds of this climate of flowers bloom under your feet. The arena is covered with grass, and pierces, like the skirts of a natural plain, the chasms of the broken arches around. But a small part of the exterior circumference remains—it is exquisitely light and beautiful; and the effect of the perfection of its architecture, adorned with ranges of Corinthian pilasters, supporting a bold cornice, is such as to diminish the effect of its greatness. The interior is all ruin.

As a good anti-clerical, Shelley was distressed to see the Arch of Constantine nearby, built to commemorate "the Christian reptile, who had crept among the blood of his murdered family to the supreme power," even though it was "exquisitely beautiful and perfect." To him, the identification of Roman ruins blotted out everything else. "Behold the wrecks of what a great nation once dedicated to the abstractions of the mind! Rome is a city, as it were, of the dead, or rather of those who cannot die, and who survive the puny generations which inhabit and pass over the spot which they have made sacred to eternity. In Rome, at least in the first enthusiasm of your recognition of ancient time, you see nothing of the Italians."

Modern Italians did not, would not live up to the image of their ancestors that was part of the traveler's baggage. "There are two Italies," wrote Percy Bysshe Shelley,

> one composed of the green earth & transparent sea and the mighty ruins of ancient times, and aerial mountains, & the warm and radiant atmosphere which is interfused through all things. The other consists of the Italians of the present day, their works & ways. The one is the most sublime & lovely contemplation that can be conceived by the imagination of man; the other the most degraded, disgusting & odious.

Nothing was entirely predictable. Little about Rome could be discovered without being there: "Only in Rome can one educate oneself for

Rome," declared Johann Wolfgang von Goethe. "What the barbarians left, the builders of modern Rome have destroyed." This was a prophetic utterance, even truer today, more than two centuries after his arrival in 1786, than it was then. "Nothing here is mediocre, and if here and there something is in poor taste, it too shares in the general grandeur."

How one remembered it afterward was another question. One's memories of Rome were necessarily a kind of artifact. Probably no visitor could have seen what he or she expected. For some, the city was a guaranteed disappointment. Some Protestants were automatically skeptical. To Sarah Bentham (Jeremy Bentham's widowed stepmother, who died in 1809), the city did not arouse hope as one approached it; seen from the Campagna it "appeared to be situated in a desert." And once you entered the Eternal City,

> The streets are narrow, dirty and filthy. Even the palaces are a mixture of dirt and finery and intermixed with wretched mean houses. The largest open places in Rome are used for the sale of vegetables. The fountains are the only singular beauties. . . . Rome has nothing within, nor without its walls, to make it desirable for an English person to be an inhabitant.

On top of this, one had to count the distaste that some English visitors felt for the prying, denunciation, and bigotry of Roman Catholic rule, and the contrast it made with the relative frankness and freedom of England. The oppression was real enough, though some *stranieri* laid it on a little thick. The English expatriate Sacheverell Stevens, who lived in Rome for five years (1739–44), wrote in his introduction to *Miscellaneous Remarks Made on the Spot on a Late Seven Years Tour* (1756) that he hoped to "plainly shew under what a dreadful yoke the wretched people of other nations groan, their more than Egyptian task masters having impiously robbed them of that glorious faculty of their reason, deprived them of their properties, and all this under the sacred name of Religion." One surpassingly zealous Scots Presbyterian actually tried to convert Pius VI during a ceremony at Saint Peter's, at which Dr. John Moore, physician and cultural adviser to the duke of Hamilton, was also present. "O thou beast of nature," cried this fanatic, on being presented to the pope,

> with seven heads and ten horns! thou mother of harlots, arrayed in purple and scarlet, and decked with gold and precious stones and

pearls! throw away the golden cup of abominations, and the filthiness of thy fornication!

The pope's reply (if indeed he made one) was not recorded. This unruly Protestant fundamentalist was seized by the Swiss Guards and briefly jailed. But then the pope not only had him released, but thanked him for his good intentions and paid for his return passage to Scotland.

From the confusing wealth of images and experience that the gentleman tourist would encounter on his way to Rome and in the Eternal City itself, there were basically three kinds of souvenir that he could bring back to his London house or his country seat, proof that he had made the instructive pilgrimage and passed through history's great finishing school.

He could purchase examples of the Antique—a cinerary urn or a kylix, cameos, and pieces of ancient sculpture (among which there were almost bound to be fakes, though they could well include a modern piece in the best classical taste, by Antonio Canova or one of his many imitators). The greatest collections of antiquities in Rome were usually in the hands of royalty or the Church, but adroit middlemen could sometimes pry them free. The Giustiniani collection of ancient art was sold to the earl of Pembroke in 1720, the statues and vases amassed by the Odescalchi family went to the king of Spain in 1724, and the antiquities purchased by Cardinal Polignac in Rome were bought as a block by Frederick of Prussia in 1742.

The two leading English purveyors of fakes (or "optimistic restorations," as they might be called) to the British were Thomas Jenkins and James Byres.

Jenkins (1722–98) was an intriguing, almost protean figure: salesman, tomb raker, cicerone, banker, dealer. With a past as a painter, he had more than enough connoisseurship to realize he had little future as one. He had come to Rome in 1752, and wasted no time making friends in high places. Through his friendships in Vatican circles (which included two popes, Clement XIV and Pius VI, and were cemented by his role as an unofficial British representative to the Holy See) he was able to move into the higher reaches of both Roman and tourist society. By the 1760s and 1770s, he had formed a considerable clientele from the visiting English gentry, who loved Jenkins to show them the sights of Rome (about which, to be fair, he knew a lot more than most Italian

"bear-leaders") and trusted him to find them fine antiquities—which were not always so very fine.

It was impossible to enjoy any standing as a connoisseur in Georgian England without a collection of old marbles. So Jenkins employed several Roman sculptors to carve them, and to give them an antique patina with the help of tobacco juice. In 1774, he even helped form a consortium to dredge the bed of the Tiber for antiquities. But he also dispersed whole ready-made collections of impeccable genuineness, such as (in 1785) the whole Villa Montalto-Negroni collection. Very large shifts in Roman ownership took place in the Settecento. In 1734, Clement XII bought some four hundred Roman sculptures, mostly busts, from that indefatigable collector Cardinal Alessandro Albani; these became part of the nucleus of the Capitoline Museum, the only museum in Rome at the time that was open to the general public, and for that reason a unique educational resource for the scores and then hundreds of young artists who were flocking to Rome to study the Antique. It was difficult, and usually impossible, for a young unknown sculptor to get access to the treasures of nobly owned palazzi—thus the advantage for painters such as Velázquez and Rubens in gaining access to the great royal collections—and this lent even greater importance to the Capitoline Museum. And the number of foreign artists struggling to get to Rome was constantly growing. For them, the Grand Tours of others were an important career filter. If a British sculptor met another Briton in Rome, it was more likely that this traveler would be there to look at art, and thus receptive to the work of the newcomer.

Jenkins's specialty, other than marble, was ancient gems and cameos, both real and fake. The fake cameos were made in a *bottega* set up in a nook within the Colosseum, at the time a favored location for rough-and-ready workshops and boutiques. Unfortunately, his flourishing career was cut short by Napoleon's invasion of Rome in 1796. Because Jenkins had quasi-diplomatic status without diplomatic immunity, and greatly feared what the French might do to him, he had to run from Rome, leaving all his property behind.

What Jenkins was to sculpture, James Byres (1734–1817) was to painting. To him belongs the honor of having spent several weeks in 1764 guiding the historian Edward Gibbon, future author of *The History of the Decline and Fall of the Roman Empire,* around the Eternal City. He offered the best-known course in the appreciation of antiquities; it lasted

six weeks and was thought by all who took it to be rewarding if very hard work.

As dealers, Byres and Jenkins were not in competition, since Byres was mainly concerned with paintings. He did, however, manage to acquire and resell one of the most famous objects now in England, the antique Roman cameo-glass vessel from Palazzo Barberini known as the Portland Vase, which passed through Sir William Hamilton's hands and from him to Margaret Bentinck, duchess of Portland, in 1784. His most outrageous coup was to fraudulently extract one of Poussin's greatest masterpieces, the group of seven canvases constituting *The Seven Sacraments,* from the Bonapaduli collection in Rome, export them to England classified as copies, and sell them as the originals they were to the duke of Rutland for two thousand pounds.

There were paintings, drawings, and prints to be bought, and many a great English collection began with things brought back from Milord's Grand Tour: Raphael, Michelangelo, and Titian if possible—which it seldom was—but plenty of other masters appealed to the taste of the eighteenth century as hardly less estimable: Veronese, Guido Reni, the Carraccis, and Domenichino. Grand Tourists did not buy "primitive" art; the products of the early Renaissance did not appeal to them, and Gothic painting seemed positively barbarous, wooden, inexpressive. They responded to the grand and suave eloquence of the sixteenth and seventeenth centuries, and to the beautiful, fleshy girls masquerading as Madonnas and saints that it so often described. But it would be quite wrong to suppose that English tourists were the only ones buying. Rome attracted connoisseurs and collectors from everywhere, and it was a competitive business. The Holy Roman Emperor Joseph II vied with Catherine II, empress of Russia, and Augustus III, king of Poland, who were in competition with Prince Nicholas Yussupov and the Grand Duchess Maria Feodorovna of Russia. Rome had a booming, open market for paintings, more than for antiquities, and it was served by (among others) expatriate artists doubling as dealers. It was the Scottish painter Gavin Hamilton, for instance, who purchased in Rome what became two of the greatest treasures of the National Gallery in London: Raphael's *Ansidei Madonna* in 1764, and Leonardo's *Virgin of the Rocks* in 1785.

However, the Roman painters most admired in Italy in the eighteenth century were not necessarily the ones most eagerly snapped up by English and other Grand Tourists. The arch-example was probably Carlo Maratti

(1625–1713), whose grand classical style of decoration, intimately linked to the doctrinal and emotional requirements of the Catholic Church, did not travel well in more Protestant latitudes. But Maratti's success in Italy was huge. His mythological and religious work energized young painters all over Europe, and he served seven popes. The death of Bernini in 1680 left Maratti as the unchallenged leader of the Roman school of art. The major Roman churches for which he painted altarpieces include Santa Croce in Gerusalemme, Santa Maria sopra Minerva, Santa Maria della Pace, Santa Maria del Popolo, and a dozen others, including Saint Peter's Basilica itself. His fame and influence were so great that he was widely known as the "Roman Apelles," after the Greek painter of the fourth century B.C.E. with the reputation as the greatest painter of antiquity. And yet, a century after his death, this vastly influential virtuoso had sunk with hardly a trace; there has never been a retrospective of Maratti in a modern museum, an extraordinary omission.

A Grand Tourist's second choice of memento was somewhat more modest. Rome was already making tourist souvenirs. They were, of course, more palatable than the trash stamped out in Asian sweatshops (the Vatican naturally prefers to call these "workshops" or "studios") for today's tourists: phosphorescent plastic rosaries, gummily smiling aluminum pope-medals, three-inch-high replicas of the Capitoline she-wolf. Nevertheless, the eighteenth-century versions had a slightly industrial character, though this would only have been noticed if you lined them up next to one another.

Various studios made small bronze replicas of famous statues, the *Apollo Belvedere* or the *Laocoön;* the best-known of these was run by the sculptor Giacomo Zoffoli. Giovanni Volpato, a ceramicist of high reputation (and a friend of Canova's), did porcelain objects, to a high standard of finish. Cork models of ancient buildings, precise in scale, were made by the firm of Giovanni Altieri—the British architect John Soane bought several of these.

The part of this memory trade that verged on real art was the making of micro-mosaics. The Vatican had employed a small army of mosaicists for the decoration of Saint Peter's. But when their employment waned, the mosaic workers, expert in their trade, turned to producing tiny, portable mosaic images for the visiting milords. The virtuoso of these *mosaicisti in piccolo* was Giacomo Raffaelli, who composed his diminutive architectural views, landscapes, and even copies of famous paintings in near-microscopic tesserae made from *smalti filati,* glass threads colored

with various metal oxides and rendered opaque with oxide of tin, then cut into pinheads. There might be more than 1,200 of these tesserae to the square inch. You could have a brooch with the whole Colosseum on it (microscopic gladiators might cost extra), or a snuffbox with a view of the Forum on its lid, all in imperishable glass.

The third choice, open only to, and all but obligatory for, the rich, was to commission paintings, possibly of Italian landscape scenes but certainly of oneself, with or without one's family. These were true acts of patronage, not just of souvenir purchase, and the chief recipient of these commissions among British landscape artists was a Welshman named Richard Wilson (c. 1713–82).

Wilson's father, a clergyman, had given him a most thorough education in the classics, particularly in Latin poetry; he knew, and could quote by heart, long tracts of Horace and Virgil. This meant that most of the places he was likely to paint, and that his clients were likely to have visited—Lake Nemi, for instance, haunt of the Sibyl; or the waterfalls near Tivoli, where later he would enjoy a contemplative and jolly picnic with the earls of Thanet, Pembroke, and Essex, travel companions in Rome—were in a literary sense familiar to him before he set eyes on them. The fact that he shared such a background with them made his mellow paintings all the more agreeable to his educated English patrons, who regarded him as the Claude Lorrain of England.

But whether or not he brought back a classical landscape of the "holy ground" which he had trod, by the real French Claude or the "English Claude," the Grand Tourist was almost bound to have his portrait made there. It would be set in a vista of the Eternal City, with the Colosseum or the Castel Sant'Angelo (always favorites, because easily identified) in the background, pointing with a pink and didactic hand at some exemplary work from the glorious Roman past—the *Borghese Gladiator*, perhaps, or the *Dying Gaul*, the *Belvedere Torso*, or the *Laocoön*. See! This is what I have seen, and in some sense appropriated! And, just as I have returned with this painting, so I have come back with the knowledge of the cultural setting that it implies!

The maestro of such transactions, the first choice for the foreigner seeking to have his Roman portrait done, was the son of a goldsmith, Pompeo Batoni (1708–87). Born in Lucca, trained in part by his meticulous father, he had moved to Rome in 1727 to study painting, and almost from the beginning of his Roman life he showed a large and ever-growing talent for copying antique statuary. This in itself might have been enough

to earn him a steady income from selling his beautiful and highly finished drawings to rich English visitors, who wanted to take home reminders of the classical masterpieces they had seen in the Vatican and elsewhere in Rome. But Batoni also had strong ambitions to be a painter of religious and historical subjects, and such appetites could only be satisfied by working for the Church. At first, his ecclesiastical work brought him unremitting success. His subject paintings were popular with the *inglesi,* and, more important, Pope Benedict XIV appreciated him and saw to it that he received commissions for some of the greatest churches in Rome, among them Santa Maria Maggiore (1743). What should have been the early apotheosis of his career came in 1746, when he was commissioned to paint a *Fall of Simon Magus* for the altar of Saint Peter's itself.

Batoni had labored on this enormous project, the most important that a painter in Rome—or, indeed, anywhere in Italy—could have been offered, for almost ten years. And it defeated him. The Vatican meant to have his oil painting executed in mosaic, because canvas, given the unexpected dampness of the air inside the basilica, succumbed to mold; but a temporary crimp in the papal income prevented that, and, to Batoni's intense disappointment and chagrin, the giant canvas was moved to the Church of Santa Maria degli Angeli, where it remains.

For any ordinary artist this would have been a prestigious spot, but Batoni was not an ordinary artist, and he felt the loss of a place of such honor as Saint Peter's very keenly—so bitterly, in fact, that he gave up his ecclesiastical work altogether and resolved, from then on, to concentrate on the more profitable field of portraits of the visiting nobility and gentry. He worked with such speed and virtuosity that by the time of his death he had painted some two hundred of these affluent tourists, most of whom were already peers or would presently inherit a title. He was to Italy what the great portraitist Sir Joshua Reynolds was to England. Reynolds, it seems, detested his Italian rival. Batoni was doomed in advance, Reynolds declared in his Fourteenth Discourse, written after Batoni's death: "However great their names may at present sound in our ears, [they] will very soon fall into . . . what is little short of total oblivion." Reynolds did not believe that *De mortuis nil nisi bonum.*

He was right about most of the painters he mentioned—who today remembers Imperiale, Concha, or Massuccio?—but wrong about Batoni, although he was nearly right about him, too, since Batoni's name was on the verge of disappearance by 1800. Most of the men who had bought his work were dead, and those who remained were old. Their heirs thought

the ancestral portraits old-fashioned and banished them from positions of honor in the sitting room to dark landings on the stairs. Few other people saw them, because the portraits had never been exhibited: they had gone straight from the maestro's studio in Rome to their owners' walls, and there had been no intervening exhibitions in which a public might have had the chance to see them. Hence, although he had many clients in Britain, his public was never large enough to make him popular. So even today (or perhaps especially today) Batoni's work has the charm of the unfamiliar. Admittedly, some of it looks routine, although one ought to be alert to its very real charms—the delightful palette which seems to preserve the complete freshness of encounter with a living creature, the fluent and ever-accurate drawing, and the wholly delectable polish. Because the human subjects are so long dead, we can no longer appreciate the lifelike qualities that earned them such praise. Yet there are Batonis that compel not only by their immense skill but by a certain oddity—their theatrical faithfulness, it seems, to the self-confidence of the upper-class Briton abroad among the foreigners.

The outstanding, though by no means the only, one among these is his portrait of a Scots aristocrat, Colonel William Gordon. It is almost a definition of what used to be called the "swagger portrait." There is the noble laird, leaning on his ostentatiously drawn sword. (And why would a tourist be pulling out his sword in Rome?) He is swathed in yards of his family tartan, which becomes a bizarre sort of Caledonian toga. He looks as though he owns the place and is getting set to defend it against Italians.

The subject of the best of all the foreigner-in-Italy portraits, however, was neither rich nor titled, nor English, nor was he painted by an Italian. The symbolic, over-life-sized portrait of Goethe in the Roman Campagna (1786–87) was by Wilhelm Tischbein (1751–1829). Tischbein and Goethe were long-standing friends, and their meeting in Rome was deeply stimulating for both men. Born in 1749, Johann Wolfgang von Goethe was a German literary celebrity at twenty-four, the prodigy of Frankfurt am Main. Within a year or two, his reputation had spread throughout Europe. As Nicholas Boyle points out in the first volume of his magisterial biography, Goethe wrote in *Faust* "the greatest long poem of recent European literature. . . . Goethe was not just *a* poet—for the whole Romantic generation in Germany, England and even France, he was *the* poet. . . . He affected all subsequent notions of what poets are and poetry does." But his previous works had already cemented his repu-

tation, and since he had at last fulfilled a lifelong desire by making the journey to Rome, this was seen by Tischbein (and other German cultural expatriates who were already installed there) as a very consequential act even before all its literary results were apparent. This has to be remembered when one looks at Tischbein's portrait. At the time of his arrival in Rome, Goethe was a little older than most members of the vigorous colony of German artists there: he was thirty-seven, Tischbein thirty-five, and none of the others past forty. Apart from Tischbein, his closest artist friend in Rome was the abundantly gifted and celebrated Swiss painter Angelica Kauffmann (1741–1807), who lived with her husband, Antonio Zucchi, in a studio at the top of the Spanish Steps, on the Via Sistina. With her, Goethe had many illuminating talks about art.

Tischbein painted him at full length. Goethe's energy was boundless, his thirst for historical understanding through art and architecture unquenchable, and the resulting image conveys both. Shaded by a wide-brimmed artist's hat and wrapped in a voluminous white cape—which looks appropriately like a toga but subliminally conveys the thought of the inspired prophet, although it was only a practical garment—Goethe reclines amid the overgrown relics of the Campagna. His gaze, at something out to the right which we do not see, is strong and reflective. His right hand, his writing hand, is emphatically in view. He is not pointing at a famous work of art, as Batoni's clients were apt to do in their pseudo-proprietary way. The circular tomb of Caecilia Metella on the Appian Way rises in the distance. It was a favorite of both Tischbein and Goethe, and of Byron, too, who wrote of it in *Childe Harold's Pilgrimage;* his hero sees it, approaching Rome:

> There is a stern round tower of other days,
> Firm as a fortress, with its fence of stone,
> Such as an army's baffled strength delays,
> Standing with half its battlements alone,
> And with two thousand years of ivy grown,
> The garland of eternity, where wave
> The green leaves over all by time o'erthrown;—
> What was this tower of strength? within its cave
> What treasure lay so lock'd, so hid?—A woman's grave.

In the foreground is a fragment of ancient bas-relief, a fallen composite capital, and the clutter of stone blocks, which may be the pieces of a toppled obelisk, on which Goethe is taking his ease. Rather, the ancient

vestiges that surround the poet are painted as part of his natural environment of thought and reflection. They are not potential "souvenirs." And the bas-relief (as Nicholas Boyle pointed out) has a quite specific meaning in relation to Goethe's own work. It depicts the "recognition scene," from *Iphigenia,* whose dramatic adaptation Goethe was then writing; and its marble block is overgrown, or crowned, with ivy, symbol of immortality.

"I shall never rest," Goethe declared in a magnificent passage, written in Rome in June 1787, "until I know that all my ideas are derived, not from hearsay or tradition, but from my real living contact with the things themselves. From my earliest youth, this has been my ambition and my torment." In this spirit he approached the enormous bulk of the city and its antiquities.

And so Rome took time. Not only for Goethe, but for any serious visitor. "It is as impossible for a person to dash through it," noted Charles Cadogan in 1784, "as it is for him to fly." To set his impressions in order, get smooth access to collections, and have the whole confusing panorama of ancient Rome explained to him, the Grand Tourist would need help. It could be at hand in the form of a guide or "bear-leader"—a traveling tutor, preferably English, experienced in antiquity, who might be found living as an expatriate in Rome but was more likely to have been brought over in the tourist's party. Some of them were harmless clergymen of no high distinction, but Thomas Pelham retained no less a figure than Anton Mengs to show him around Rome, and men as eminent as Thomas Hobbes and Adam Smith were also well known as bear-leaders—in fact, guiding the bear cubs, as the young and the rich were known to the Italians, was practically the only way an impecunious intellectual could afford to get to Italy himself. One of the most popular guides to the city was the great German art historian Johann Winckelmann, "than whom no one has greater skill in antique statues" (said Edward Wortley Montagu). He was besieged with requests for such services from bigwigs on the Grand Tour. Goethe observed his happy relations with ordinary (and less ordinary) Romans, but:

He experienced considerable pain at the hands of visitors from abroad. To be sure, nothing is worse than the ordinary tourist in Rome. In any other place, the traveler can go his own way; however, those who fail to do as the Romans do are a horror to the true Roman.

Such provincial sightseers—narrow-minded, unobservant, always in a hurry, arrogant—Winckelmann cursed more than once and repeatedly swore never again to act as their guide, only to relent on the next occasion. . . . Yet he also benefited considerably from serving as a guide to persons of position and reputation.

Some of the bigwigs, particularly the English, disgusted him: Frederick Calvert, Lord Baltimore, appeared in Rome with a harem of eight women, some of whom were stout and others thin; the fat ones were fed sour food, and the thin a meat-and-dairy diet. Winckelmann, a fastidious homosexual, found both them and their master repellent. The duke of York, George III's brother, seemed to be "the greatest ass I know, no credit to his rank or country." Naturally, the scholar kept these opinions to himself. He did a little bear-leading, but others did a lot, and without these guides, the novice—as a friend wrote to the painter George Romney—would not be ready for the shearing; he would walk through whole palaces of pictures

> [like] an upholsterer through the Vatican. They have been told of the *gusto* of the antique, but where to find it, or how to distinguish it, they know no more than their mothers. Virtu however is to be purchased, like other superfluities, and in the end their *Cicerone* lays them in for a bargain, perhaps a patchwork head of *Trajan* set upon a modern pair of shoulders, and made up with *Caracalla's* nose and *Nero's* ears. . . . Home they come privileged *Virtuosi,* qualified to condemn every thing that their own countrymen can produce.

Some Grand Tourists collected on a huge scale. Richard Boyle, third earl of Burlington, who presided over the Palladian "Revival" in England, was a shining example of what intelligent patronage—allied, in his case, with equally intelligent collecting—could do. The "Apollo of the Arts," as Horace Walpole called him, collected on a lavish scale during two Grand Tours of Italy, the first in 1714–15, the second in 1719. Burlington came back from his second tour of Italy in 1719 with no fewer than 878 pieces of luggage, crammed with works of art. He bought with the utmost discrimination, finding, for instance, more than sixty original drawings by Palladio, together with prints and rare books of the master's work, during his sojourns in Verona and Vicenza. Lord Burlington was one of those exceptionally rare talents who could have altered the history of architecture as patrons, but who did so instead as geniuses of creative

design in their own right. By involving himself directly in architecture as a designer rather than simply as a patron, he shifted the social relation in England between patron and artist. And certain of his buildings, such as his own Palladian villa, Chiswick House, or the grandly pure Assembly Rooms in York, are of a near-minimalist intensity which exceeds most of their Palladian prototypes.

Among the materials Boyle brought back from Italy would certainly have been various editions of the Roman etchings of Giovanni Battista Piranesi, printmaker extraordinary and architect manqué. No artist has ever done more to record the posthumous image of a great city than this Venetian brooding on the ruins of Rome. In effect, he created and re-created the Eternal City and its obsessively present antiquities for a mid-eighteenth-century public, ruin by ruin, almost stone by stone. In the course of a working life of forty or so years, Piranesi made etchings of every kind of structure in Rome: amphitheaters, baths, churches, monasteries, bridges and arches, fora, piazzas and freestanding columns, perspectives of streets, gardens and grottoes, obelisks, mausoleums, aqueducts, fountains, ruined temples, tombs, theaters, villas and palaces both abandoned and lived-in, sewers, and crematoria.

The writer and connoisseur Horace Walpole urged artists to "study the sublime dreams of Piranesi, who seems to have conceived visions of Rome beyond what it boasted even at the meridian of its splendour":

> Fierce as Michelangelo, and exuberant as Rubens, he has imagined scenes that would startle geometry . . . He piles palaces on bridges, and temples on palaces, and scales heaven with mountains of edifices. Yet what taste in his boldness! What grandeur in his wildness!

He reproduced inscriptions that had been chipped and worn to near-illegibility by the gnawing of time, *tempus edax*. He designed tripods, urns, trophies, shields, imaginary armor, lamps, marble maps, Egyptian-style beds, Etruscan-style candlesticks, and yawning, cavernous Roman fireplaces. He did huge decorative initials: a letter "V" made of sections of lead piping leaning one against the other, a "D" featuring the Roman *lupa* glaring toothily at the reader from inside its curve. He created a set of clocks, and another of designs for sedan chairs and coach doors, as well as some Egyptian Revival decorations (which featured sphinxes, vultures, and a Nile crocodile but, alas, were destroyed long ago) for the inside of the Caffè degli Inglesi, and a set of haunting *capricci* showing the gloomily enfolding spaces of imaginary prisons, which for many

people remain his supreme imaginative achievement and had more effect on writers than any etchings of the eighteenth century. He also designed elaborate furniture, nearly all of which has since disappeared—the sole apparent survivor being a carved and gilt side table from the Quirinal Palace in Rome, designed for one of his principal patrons, the Cardinal and future Pope Clement XIII, Carlo Rezzonico, which ended its travels in the Minneapolis Institute of Arts.

Piranesi died in 1778, at the relatively advanced age of fifty-eight. He left some 1,024 engraved images, an output unrivaled by any other graphic artist of his age. More than seven hundred of his preparatory drawings also survive. But there is only one building standing in Rome that he designed and built: the church and headquarters of the Knights of Malta, on the Aventine Hill. For a man who styled himself a "Venetian architect," it must have been something of a disappointment to have built only one building. Yet, in the end, his colossal output of prints and drawings had more effect on the experience of architecture, on what many people expected of that art, than anything he could have achieved with real buildings. Their effect was powerfully felt all over the Western world, in structures as far apart from one another as John Soane's Bank of England (1798) and Benjamin Latrobe's Baltimore Cathedral (1805–18). His prints could and did travel everywhere, with an ease that no actual building could possibly rival. These "buildings I never saw," as the great English designer Robert Adam wrote in 1755, "are the greatest fund for inspiring and instilling invention in any lover of architecture that can be imagined." In them, memory, fantasy, and scholarship all combined to produce a parallel Rome, in many ways as actual as the city itself: a Rome that was both permanent and forever lost. This must have consoled Piranesi for his lack of built buildings. This hugely ambitious artist re-created not only a city, but several ages of it.

Which is not to say that his instincts about its past were necessarily right. Piranesi managed to convince himself that the root of all classical architecture, Greek as well as Roman, was actually Etruscan. He even compared Etruscan buildings to the architecture of the Egyptians. (Of course, Piranesi had never been to Egypt.) He never wavered from this belief, which had no shred of evidence to support it. He had studied the Roman systems for water distribution and sewage removal, starting with the Cloaca Maxima. Knowing that the Etruscans had been experts in drainage, he wrongly supposed that they were masters of the same kind of massive tunneling and vaulting that the Romans had developed. He

imagined Etruscan architecture as massive, stonily articulated, vast in its spaces and recessions—all qualities which, he believed, lay at the root of Roman building. Actually, though some Etruscan temples and sacred spaces were artificial caves hollowed out of bedrock (the soft and easily cut tufa), those that were built—such as the Portonaccio Temple in Veii, from the sixth century B.C.E.—were made of timber and mud brick and bore no resemblance at all to Piranesi's massive fantasies.

Born in Venice in 1720, Piranesi was the son of a mason, and he grew up fascinated by the question of where the roots of classical architecture in Italy lay. One should remember that Venice was the only major Italian city that, because of its watery site among the lagoons, had no Roman-era building and therefore no Roman ruins; this must have immensely increased the impact of the Rome that young Piranesi saw when he went there for the first time. This happened when he was aged twenty, and a draftsman on the staff of Marco Foscarini, the Venetian ambassador to the court of the new pope, Benedict XIV. Piranesi already had an enthusiasm for antiquity. It had been nurtured by his older brother, Angelo, a Carthusian monk who had encouraged him to read Livy, Tacitus, and other historians of Rome.

There were large and magnificent buildings in Venice, but none of them were Roman at all, let alone Roman on the scale of the Baths of Caracalla or the Colosseum or Flavian Amphitheater. Moreover, because Venice (like its cradling sea) was flat, Piranesi grew up without seeing anything like the tumbled, precipitous palimpsest of seven-hilled Rome, with its gigantic overlay of columns, fallen cornices, collapsed vaults, and ancient excavations. Its imaginative impact on him would be immense, and it would liberate his imagination. It would encourage him to turn big things into titanic ones. "These speaking ruins," he would write, "have filled my spirit with images that accurate drawings, even such as those of the immortal Palladio, could never have succeeded in conveying."

These images were often intensely theatrical. There is no evidence that Piranesi, as has sometimes been said, ever actually worked with the chief stage designer of Italy, the Venetian Ferdinando Galli da Bibiena (1657–1743), but he certainly knew Bibiena's work—as who in Venice did not?—and he did an apprenticeship with two somewhat less celebrated Venetian stage designers who worked in a similar mode, Giuseppe and Domenico Valeriano. He also became an expert in the dramatic use of angular perspective, under the tutelage of an engraver, Carlo Zucchi.

Venice was the natural home of such exercises, which went by the name of *capricci,* and were the stock-in-trade of earlier painters who clearly had an impact on the young Piranesi, such as Canaletto and the Tiepolos. So one will find his views of ancient Rome populated by the figures of people scattered among the ruins—ragged, gesticulating, tiny people, very different from the more elegant and composed travelers to be seen in other "views" of Rome, sometimes troglodytic, as if they had just crawled out of holes between the rocks. These contributed to the impression given by Piranesi's later collections of architectural and topographic prints, such as the four-volume *Le antichità romane* (1756)—that the Rome whose remains he was etching had indeed been the creation and home of earthly giants, a titanic but now vanished race whose like would not come again, sublime in ambition and unlimited in scope of grandeur.

Piranesi was lucky to reach Rome when he did. Any talented artist would have been. It was a clearing house of ideas, a place where one went to learn, irrigated by the talent of scores of foreign artists (John Flaxman, Henry Fuseli, Angelica Kauffmann, Anton Mengs, Pierre Subleyras, Claude-Joseph Vernet), Italian ones (Marco Benefial, Pietro Bianchi, Giuseppe Cades, Pier Leone Ghezzi, Corrado Giaquinto, Benedetto Luti, Giovanni Pannini, Francesco Trevisani), British architects (William Chambers, Robert Adam, George Dance, and John Soane), and cultural theorists (notably Johann Winckelmann), and hundreds of intelligent tourists from all over Europe, some highly cultivated and others eager neophytes.

Among the former, Piranesi found a professional context. In the ranks of tourists, he found an abundant market. Chipped marble heads and Ionic capitals were not easy to carry back from Italy, but sheets of paper were, and large numbers of Piranesi prints from his major series (the *Antichità romane,* the *Della magnificenza ed architettura de' Romani,* and all the other series he made, not forgetting his fanciful studies of chimney ornament and of designs for vases, candelabra, and gravestones) found their way back to England, where they were pored over and used as inspirational models by dozens of architects. True, it was sometimes difficult to mimic Piranesi's effects in the materials of the real world. The layers of massive, rusticated stones in his view of the understructure of the Castel Sant'Angelo seem to be bulging, extruding their very substance under the weight of the primeval masonry above. However, the care which Piranesi brought to depicting his Roman-ruin architecture is so dedicated as to

challenge belief. In some of the plates, which purported merely to depict the technical aspects of ancient building, he was able to invest tools and techniques—like the lifting tackle for large masonry blocks—with the drama of the technological sublime, a project dear to the heart of other eighteenth-century figures. At the same time, fantasy ruled the world given by other prints. Thus, when he rendered the Pyramid of Cestius, in reality quite a small and almost delicate affair (as pyramids go), and erected near the Porta Ostiensis in memory of a man about whom almost nothing is known, he gave it an Egyptian scale and mass.

In making his Roman ruins look like chasms and cliffs of stone, Piranesi was protecting the Roman genius for mass from dilution, as he saw it, by Greek artificiality. Much of this was fiction, of course. There could be little in the world—not even the Roman part of it—quite like those disturbingly congested perspective views of the Via Appia in its heyday, stretching away in a surreal perspective, crammed cheek by jowl with statues, tombs, sarcophagi, urns, and obelisks. No wonder such things would become a rich source of plunder for later and lesser artists—Eugene Berman and Salvador Dalì—seeking to project a disquieting dreamworld of never-never architecture.

Making large etchings is an expensive business, and to do it on a Piranesian scale required large financial support. The patron from whom Piranesi expected most was a young Irishman: James Caulfeild, first earl of Charlemont, to whom he wrote in 1757, "I believe I have completed a work which will pass on to posterity and which will endure so long as there are men curious to know the ruins which remain of the most famous city in the universe." Charlemont seemed to Piranesi like a good potential patron; he was rich (though not, as it turned out, as rich as the artist supposed), and in 1749 he had set up an academy, though a short-lived one, for British artists in Rome to study antiquities, about which he was passionately enthusiastic. It looked a splendid idea, both to him and to Piranesi, to have his noble name attached to such a turning point in archaeology as the *Antichità romane*. But, unfortunately, Charlemont had no idea—and since he was an amateur without earlier experience of publishing, how could he?—of the overwhelming mass of work and expense in publishing the four volumes and more than 250 plates of the *Antichità*. He had supposed he would be paying for a single volume about tomb chambers, and now he was faced with the cost of this mammoth work, all of it, the fruit of more than ten years of study and meditation. Not only did Piranesi plan to show all of ancient Rome above

ground: his engravings would also show what was hidden—the foundations and footings, the drainage conduits and water-supply systems. Poor Charlemont had something much simpler in mind, and much more salable: picturesque *vedute* of the Eternal City. Not surprisingly, his resolution buckled, and he dropped the project altogether, fleeing back to the British Isles. This was the greatest disappointment of Piranesi's life, and he never really got over it, even though he was able to find other supporters for the *Antichità*. Perhaps he would have killed the traitorous, chickenhearted Charlemont (as he now thought of his ex-patron) if he could have gotten away with it, but he did not have the chance, and so he had to be content with a kind of *damnatio memoriae*. His title page had originally carried a rather fulsome dedication to James Caulfeild, inscribed on an ample plaque surrounded by attributes of antique ruin. Piranesi now removed Caulfeild's name from the plate. This was in imitation of the Roman Senate, which after 203 C.E. had erased the once-honored but now disgraced name of Geta from a dedicatory inscription on the arch of Septimius Severus in the Forum Romanum.* Presumably Caulfeild would have recognized this insult, even if few others did.

One area of Piranesi's output departed into pure fantasy, and has always seemed separate from his archaeological and view-making work. This is the series of fourteen plates known as the *Carceri d'invenzione* or *Imaginary Prisons,* which first appeared in 1745 and were reissued in 1760. Unlike all his other work, as their title implies, these are not based on any known buildings. They are emanations of the artist's mind, and right from the start it was recognized that they had little relation to real architecture. What they depict, essentially, are limitless underground chambers with no exit, the space knitted together, but never resolved, by ramps, stairs, bridges, galleries, catwalks, vestibules, and arches that all assert a powerful presence but actually lead nowhere. They seem self-replicating, and this was what spoke, with peculiar directness and vividness, both to Samuel Taylor Coleridge, sunk deep in his own laudanum addiction, and to his friend Thomas De Quincey, an addict as well. When Coleridge eloquently described the *Carceri* to De Quincey, they did not have copies of the *Prisons* to hand. But Coleridge thought

* Publius Lucius Septimius Geta (b. 189 C.E.) was the younger brother of the Emperor Caracalla. The two hated each other to the point where their palace in Rome had to be physically divided. In 211 C.E., Caracalla had Geta stabbed to death—in his mother's arms!—and tried to have his memory obliterated by having his portraits defaced and removing his name from all public inscriptions—the *damnatio memoriae,* Rome's last and worst insult to the dead.

that these strange and paranoid imaginings recorded "the scenery of his own visions during the delirium of a fever." De Quincey seemed to recognize them, too, from Coleridge's vivid account of the "Gothic halls," the wheels, cables, pulleys, levers, and racks. And he recognized some of the features of his own opium hallucinations. "With the same power of endless growth and self-reproduction did my architecture proceed in dreams."

In one sense, these images hark back to his earlier years as a student of stage design. Prison scenes were common and popular in the eighteenth century and through into the nineteenth, as an acquaintance with Beethoven (*Fidelio*) or Puccini (*Tosca*) reminds us. Many artists designed prison sets, whose towering arches and claustrophobic, vast-space, no-exit qualities all suggest affinities with Piranesi's dream prisons. What had been palatial now turns penal. Huge spaces had in the past been taken to magnify their inhabitants' importance, in a world of wealth, power, and privilege. But now in the very different world of the *Carceri,* magnitude reduces man to a crawling, suffering insect.

In all their oppressive power, the *Carceri* had a strong appeal for writers, particularly for English Romantics. One of the first to set out his response to them was William Beckford (1760–1844), the dilettante who, fabulously wealthy from inheritance in the slave trade and the sugar business, had taken his Grand Tour in 1780. When he was in Venice, his gondola floated him under the Bridge of Sighs. "I shuddered whilst passing below," he would recall later.

> Horrors and dismal prospects haunted my fancy upon my return. I could not dine in peace, so strongly was my imagination affected; but snatching my pencil, I drew chasms and subterraneous hollows, the domain of fear and torture, with chains, racks, wheels, and dreadful engines in the style of Piranesi.

Memories of Piranesi's *Carceri* would infest Beckford's imagination for years to come, pervading the landscapes of his novel *Vathek* (1786). They were filled with a fear of vastness and indeterminacy—the *Carceri* could not be reconstituted in the mind's eye as real, architectural space, betokening security. This, of course, was what gave them their grip on the dreaming mind. In the 1960s, when the "drug culture" was looking for antecedents to its often obsessive interest in hallucination, efforts were made to find a parallel between Piranesi's carceral visions and the visions caused by pot or LSD. It was argued, or at any rate suggested,

that the connecting thread may have been attacks of malaria, caught by Piranesi while sketching aqueducts and ruins in the mosquito-infested Campagna outside Rome: a common treatment for malaria was large doses of the opiate laudanum. But this is unprovable, and probably has more to do with the atmosphere of the 1960s than that of the 1740s.

There were several reasons why such images might have caught the attention of a liberal-minded public. The whole issue of imprisonment—of crime and punishment, of what could deter the errant soul from sin—was much to the fore in English literary thinking around the turn of the nineteenth century. What was an appropriate architecture, a "speaking" architecture, that would make a building truly carceral and would distinguish itself from other structures not designed to punish, intimidate, reform? George Dance the Younger (1741–1825) seems to have extracted part of his answer from the ideas of Piranesi, whom he met in Rome in 1763, and whose *Carceri* he undoubtedly saw. In 1768, after he got back from Rome, Dance was given the job of rebuilding London's main prison, Newgate Gaol. This task occupied him for the best part of seventeen years. It was hardly a coincidence that Dance's design for Newgate, dreadful though it may seem today, emerged just as the movement for penal reform in England began to stumble into life, urged along by its pioneer, John Howard, with his monumental report on punishment, *The State of the Prisons in England and Wales* (1777). We do not know if Dance read this tome, but its message was certainly in the air among the enlightened and reasonably Whiggish Englishmen whose values George Dance esteemed. Dance did not wish to create a jail along the traditional English lines—a sump of misery and social chaos, without decent ventilation, lighting, heating, sanitary provisions, or even segregation of the sexes. In the "new" Newgate, he paid some attention, within a tight budget, to all of these matters, supplying such necessities of overcrowded life in a cold climate as stoves and privies. The walls of Newgate had to be blind, with no openings through which prisoners might conceivably escape to or even glimpse the world outside. In this, the design showed some debt to the claustrophobic spaces of Piranesi's prisons.* Further

* However, the main influence on Dance here was Italian but not Piranesian. Its source was the massive rusticated stonework of Palladio's Palazzo Thiene in the center of Vicenza, which Dance had seen on his tour and now adopted for his imagery of impenetrability and retribution: the heavy stones deliberately used as emblems of the weight of sin and crime on the crushed human conscience.

touches were directly taken from the *Carceri,* such as the festoons of carved stone chains over the prison's entrance.

It was the custom among successful architects to hire assistants and apprentices, as lawyers took articled clerks. For four years, 1768–72, Dance employed a young assistant who was to change the language of English architecture, largely as a result of his visit to Rome and the influence of Piranesi. He was John Soane, to whom Dance was a "revered master."

Some architects come from a background of wealth and relative ease, but in the eighteenth century few did. Certainly Soane did not. He was the son of a bricklayer, always short of money, proud of his craft background, which gave him confidence in his own building, but socially insecure when dealing with his "betters." The degree of that insecurity can be sampled, if not judged, from his change of name. His father's name was "Soan"; the son added a terminal "e" because it seemed classier. Thenceforth he would always be referred to as "Soane," and he would not be drawn into any conversations about his background, becoming irritable and touchy whenever social position came up in conversation. He even went back over his own early drawings when he could get at them, and "corrected" the signatures.

Soane, with the backing of the architect William Chambers, who was the Royal Academy's influential treasurer, was awarded a traveling studentship which would finance a three-year tour of Italy. It was a well-timed stroke of fortune. His tour was not "grand," but his sojourn in Rome put him in touch with other Englishmen who were Grand Tourists and would become his clients and colleagues in years to come. Among them was Thomas Pitt, cousin of England's future Prime Minister William Pitt. Soane loved Italy so much that every year he celebrated March 18 as the day on which, aged a hopeful twenty-four, he set out in 1777 for the wondrous South. It was not his birthday. But it was the day of his professional birth, which counted for rather more. It was just around the time that Thomas Pelham was writing home to complain about the surfeit of English tourists he encountered in Rome. The Eternal City had, he wrote, "too great a resemblance with [Brighton], being crowded with about seventy English visitors." (Crowded! Just as well, perhaps, that Pelham was not granted a prophetic vision of English package tourists harried along in their thousands from bus to museum to Michelangelo to pizza bar two centuries later.)

Soane quickly found lodgings in Rome and made the Caffè degli Inglesi—in Via Due Macelli, on the south side of Piazza di Spagna, rendezvous of foreign artists and intellectuals—his postal address. With his friend Thomas Hardwick, another postulant architect, he started measuring Roman buildings, both ancient and more recent: the Pantheon, the Temple of Vesta, Santa Maria Maggiore, Sant'Agnese fuori le Mura. And, as Chambers urged, he looked up Piranesi, with whom he began a steady friendship.

But it was Soane's misfortune—which at first he mistook for good luck—to spend part of his tour with Frederick Augustus Hervey, later bishop of Derry and presently to become the fourth earl of Bristol. This culturally literate but deeply unpleasant cleric regarded Soane as part servant, part pet, and as a reputable creative figure only from time to time. When the two men were exploring the ruins of the Villa of Lucullus, south of Rome, Derry turned to Soane and announced that he wanted to see designs made for a "classical dog kennel, as I intend to build one for the hounds of my eldest son." Instead of treating this dotty idea with the repudiation it deserved, for no English architect with a sense of his own future was likely to want to spend his time housing dogs, even for a noble bishop, poor Soane—whose embarrassment at his own humble origins had not equipped him for dealing properly with the rich and titled—took the bishop seriously, went off, and drew up designs for a kennel in the ancient Roman taste, decorated with every sort of doggy detail that his febrile imagination could muster. To Soane's mortification, it was never built. Nor was anything else he proposed for Derry. The bishop had capriciously half-promised that Soane would get more serious work at his seat, Downhill, building for people rather than animals, when they got back to Ireland. Soane impulsively cut short his Italian trip by almost a year, went to Ireland at his own expense, and spent a month there measuring and sketching. But nothing came of it; Derry dismissively dropped the idea, and the bitter disappointment this caused Soane was to skew his relations with clients for the rest of his life.

Soane was not the only person made miserable by Hervey's egocentric and brutal behavior. The earl-bishop's wife, Elizabeth Hervey, was reduced to what her husband unkindly called a "majestic ruin" by his vile moods. She described herself, in a sad letter to her daughter in 1778, as "almost such a skeleton as Voltaire . . . wizened like a winter apple."

Fortunately, however, Hervey was by no means the only person with whom Soane was significantly involved in Rome, and others were more

seriously helpful. To a great extent, Soane's tastes, and his way of displaying them as a collector, were formed by his acquaintance with the Roman cleric Cardinal Alessandro Albani (1692–1779). Albani was very much the child of privilege. He had been born in Urbino, and his uncle Giovanni Francesco Albani became pope (as Clement XI) in 1700. To the young man's mortification, this uncle had so sharply attacked the nepotism widespread in the papal court that he was unable to do much for his own relatives, including Alessandro. The young man showed promise as a linguist, a student of the classics, and a horseman; the last talent recommended him (since nepotism was not yet quite dead, this being Italy) to be made a colonel of the Papal Dragoons. Clement XI died, nepotism was given full revival, and Innocent XIII bestowed the cardinal's red hat and tassles on Alessandro at the age of twenty-nine. (It was possible to be made cardinal without being a priest first.) His nominal task in Rome was to look after the interests of its German community as "Protector of the Holy Roman Empire." But his main interest was a peculiarly rapacious form of archaeology; it was even said that when the catacombs were being opened, and the pious nuns were sieving the dirt inside them for anything that could be called, however optimistically, a relic of an early Christian saint, Albani was right at their backs, snatching any cameos, intaglios, coins, rings, or other antique tidbits that might turn up. His position in the Vatican meant that he could indulge his acquisitive passions to the full, and deal without restraint. When Soane and Albani met, the cardinal had only a year to live, could barely walk, and was as blind as a mole—but there was Albani's enormous, eclectic, and ruthlessly acquired collection, begging to be imitated. Rivaling it became one of the central passions of Soane's later life, when he became an avid collector himself.

In addition to sponsoring neoclassicist theory and practice—Anton Raphael Mengs painted an enormous and frigid *Parnassus* for His Eminence's library, considered then and ever since, though not always with undiluted admiration, to be among the key works of neoclassicism—Albani was a formidable collector of antiquities. His palatial villa on the Via Salaria was stocked with bronzes, marbles, coins, and other *tesori dell'arte antica* raked in from the excavations that were going on around Rome and, in particular, from Hadrian's Villa at Tivoli. Soane visited Albani whenever he could wangle an invitation, and since Albani's hospitality to young foreigners was cast wide there were many invitations.

Having Albani for a model might not seem realistic for a bricklayer's

boy whose career was only just opening, but in 1784 Soane married, and richly. The bride was the niece of a wealthy English builder and property speculator. From then on, Soane would never be less than comfortable. Not only could he pick and choose between projects, but he could make his own private museum, like a (less generously endowed) Cardinal Albani.

This is the wondrously diverse accumulation of architectural fragments, plaster casts, Greek and Etruscan vases, cinerary urns and other antiquities, prints, paintings by Hogarth, Turner, Fuseli, and a host of others, architectural drawings, cork models, and other delights, such as the ponderous alabaster sarcophagus of the Egyptian King Seti I, all acquired by Soane over the years, which makes a visit to his house in Lincoln's Inn Fields such an adventure. No other museum in the world conveys such a powerful feeling of passing through the convolutions of another person's brain. It is the polar opposite of those boring epics of standardized taste that so many museums, especially in America, have become.

In terms of Soane's career prospects, the most generous new friend he made in Rome was Thomas Pitt, the future Lord Camelford. With Thomas's cousin William Pitt's backing and encouragement Soane, whose surname now had its "e," was appointed surveyor (or chief architect) to the Bank of England in 1788. This put him, at the age of thirty-five, in charge of the much-needed redesign of the building, one of the most important in the city.

There are certain forms beloved by Soane that you can recognize, instantly, as coming from Piranesi's version of the ruins of Rome. One of these is the segmental arch that seems to rise from ground level, rather than being borne up on columns—a form which is all curve, no springing. Low, and giving an impression of primeval weight, it derives from the actual Roman arches that Soane had observed and drawn, half buried in the earth. It is an extremely powerful shape, and Soane used it as the main motif in the new bank rotunda—a ring of windows, providing the top lighting he so prized. Soane was so enamored of this effect that he actually commissioned the painter Joseph Gandy (1771–1843), a visionary illustrator of architectural themes who often did renderings for Soane, to create a painting of the rotunda of the bank (1830) as a ruin.

Robert Adam (1728–92) was, with William Chambers and John Soane, the most influential British architect of the late eighteenth century. Born in Fifeshire, the son of a leading Scots architect, he was not rich, but

ANNIBALE CARRACCI
The Bean Eater, 1583–90.
Oil on canvas, 57 x 68 cm.
Galleria Colonna, Rome.

ANNIBALE CARRACCI
The Triumph of Bacchus and Ariadne, 1597.
Fresco.
Palazzo Farnese, Rome.

CARAVAGGIO
Rest on the Flight into Egypt, 1597.
Oil on canvas, 135.5 x 166.5 cm.
Galleria Doria Pamphilj, Rome.

CARAVAGGIO
The Calling of Saint Matthew, 1599–1600.
Oil on canvas, 322 x 340 cm.
San Luigi dei Francesi, Rome.

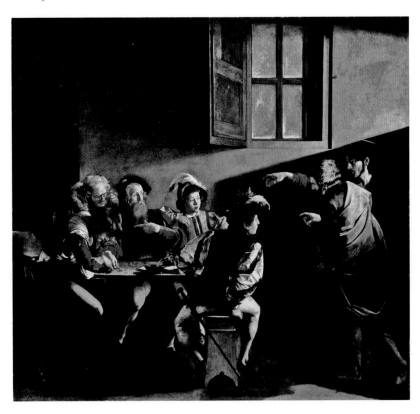

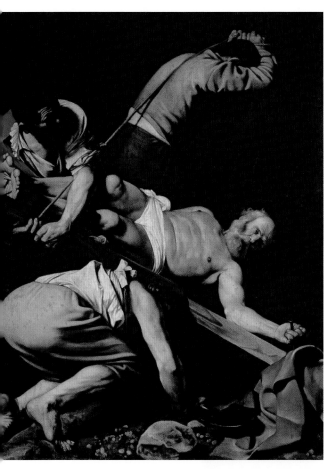

CARAVAGGIO
Crucifixion of Saint Peter, 1601.
Oil on canvas, 230 x 175 cm.
Santa Maria del Popolo, Rome.

STEFANO MADERNO
Martyrdom of Saint Cecilia, 1600.
Marble.
Santa Cecilia in Trastevere, Rome.

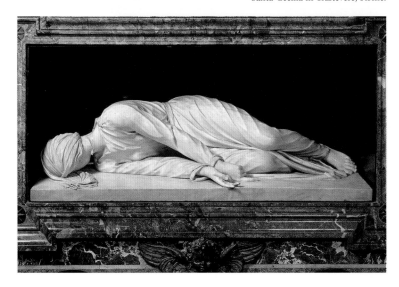

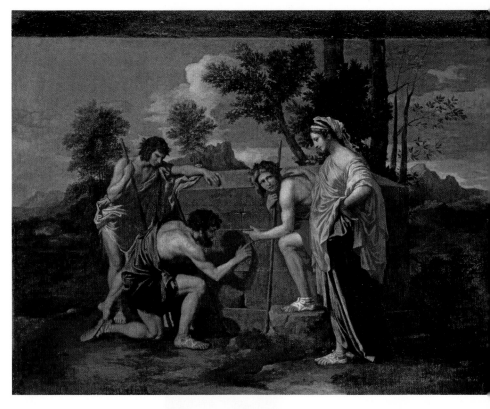

NICOLAS POUSSIN
Et in Arcadia Ego, 1637–38.
Oil on canvas, 121 x 185 cm.
Musée du Louvre, Paris.

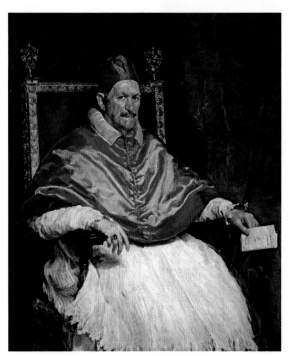

DIEGO VELÁZQUEZ
Portrait of Innocent X, 1650.
Oil on canvas, 119 x 114 cm.
Galleria Doria Pamphilj, Rome.

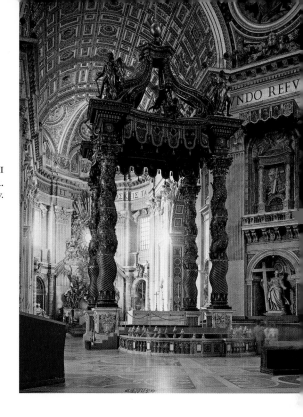

BERNINI
Baldachin of Saint Peter's Basilica, 1623–34.
Vatican City.

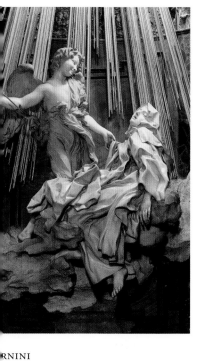

BERNINI
Apollo and Daphne, 1624.
Marble, 243 cm.
Galleria Borghese, Rome.

RNINI
e Ecstasy of Saint Teresa, 1647–52.
rble, 150 cm.
ta Maria della Vittoria, Rome.

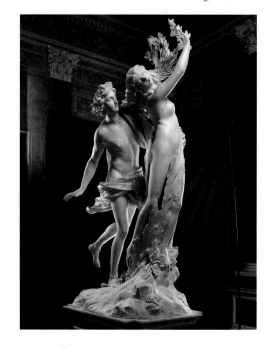

BERNINI
Fontana dei Quattro Fiumi, 1651.
Rome.

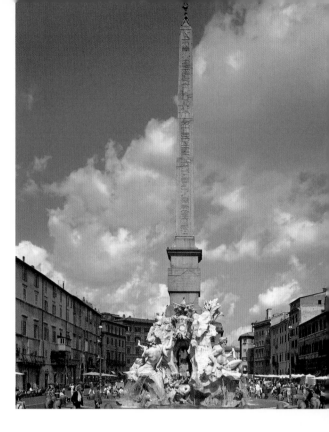

BERNINI
Saint Peter's Square, 1656–67.
Vatican City.

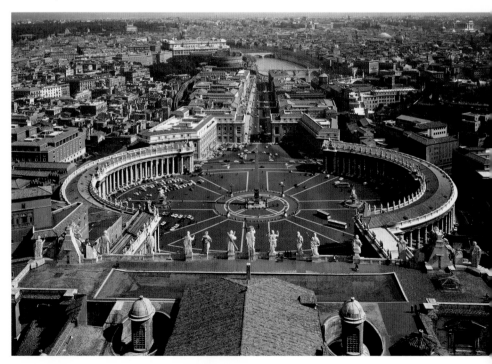

BORROMINI
Sant'Agnese in Agone, 1653–57.
Rome.

GIOVANNI PAOLO PANNINI
*Preparations to Celebrate the Birth
of the Dauphin of France*, 1729.
Oil on canvas, 110 x 252 cm.
Musée du Louvre, Paris.

BORROMINI
Sant'Ivo alla Sapienza,
1642–60.
Rome.

PIER LEONE GHEZZI
Dr. James Hay as Bear Leader, c. 1704–29.
Pen and ink on paper, 36.3 x 24.3 cm.
British Museum, London.

GIOVANNI
PAOLO PANNINI
*Interior of Saint
Peter's, Rome*, 1731.
Oil on canvas,
145.7 x 228.3 cm.
Saint Louis Art Museum,
Saint Louis, Missouri.

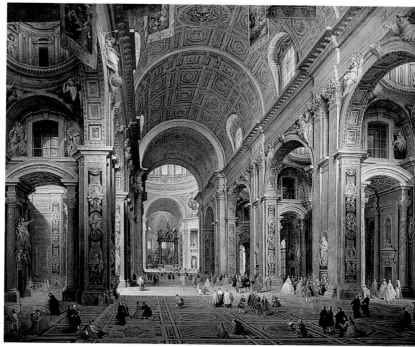

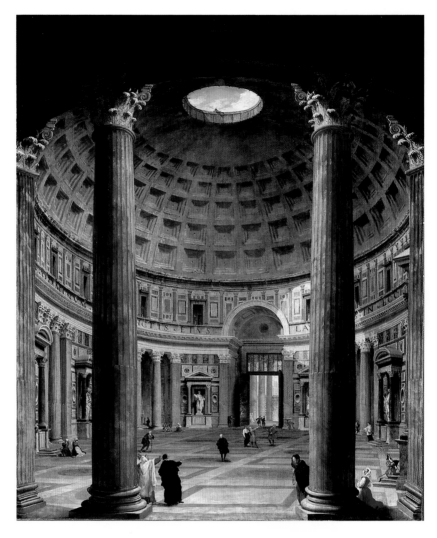

GIOVANNI PAOLO PANNINI
Interior of the Pantheon, 1734.
Oil on canvas, 144.1 x 114.3 cm.
Samuel H. Kress Collection,
National Gallery of Art, Washington, D.C.

GIOVANNI BATTISTA PIRANESI
The Prisons (Carceri), 1745–61.
Etching, 77.79 x 51.43 cm.
Los Angeles County Museum of Art,
Los Angeles, California.

ANTON RAPHAEL MENGS
Johann Joachim Winckelmann, 1755.
Oil on canvas, 63.5 x 49.2 cm.
Metropolitan Museum of Art, New York.

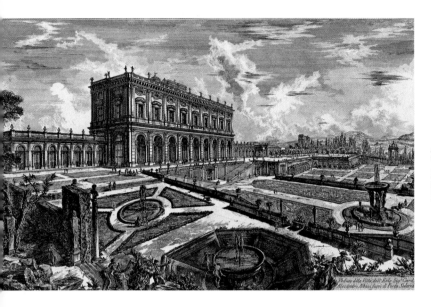

HENRY FUSELI
*The Artist Moved by the
Grandeur of Ancient Ruins*, 1778–80.
Red chalk on sepia wash, 105.4 x 90.2 cm.
Kunsthaus, Zurich.

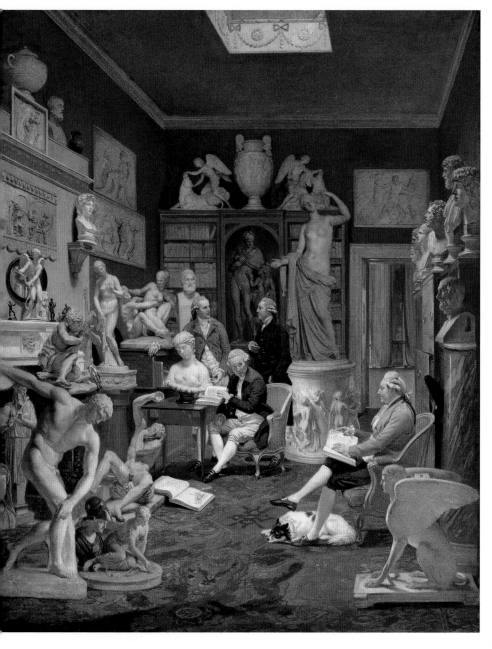

JOHANN ZOFFANY
Charles Towneley and His Friends in the
Towneley Gallery, 33 Park Street, Westminster, 1781–83.
Oil on canvas, 127 x 99.1 cm.
Towneley Hall Art Gallery and Museum,
Burnley, Lancashire, England.

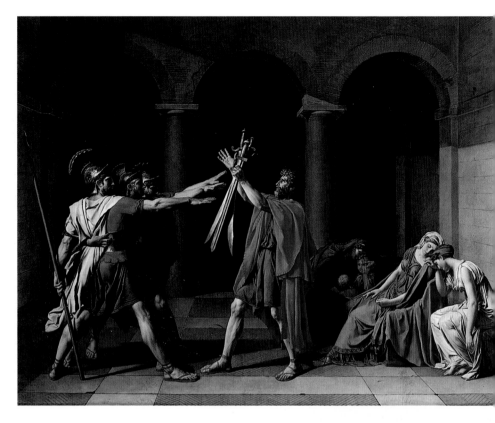

JACQUES-LOUIS DAVID
Oath of the Horatii, 1784.
Oil on canvas, 326 x 420 cm.
Musée du Louvre, Paris.

JOHANN HEINRICH
WILHELM TISCHBEIN
*Goethe in the Roman
Campagna*, 1786–87.
Oil on canvas, 164 x 206 cm.
Staedelsches Kunstinstitut,
Frankfurt am Main.

JOHANN HEINRICH
WILHELM TISCHBEIN
*Johann Wolfgang von Goethe
at the Window of His Dwelling
on the Corso in Rome*, 1787.
Watercolor, 30.2 x 19.6 cm.
Freies Deutsches Hochstift,
Frankfurt am Main.

MCKIM, MEAD & WHITE
Pennsylvania Station, 1910.
New York, New York.

he managed to embark on a medium-grand tour to Europe, sharing expenses with his friend Charles Hope, younger brother of one of his father's main clients, the earl of Hopetoun. They embarked in 1754, and traveled together through Paris, the south of France, and central Italy. It was there, in Florence, that Robert Adam met the slightly older man who would prove so decisive to his career, a Frenchman who, he wrote, "has all these Knacks, so necessary to us Architects." This was Charles-Louis Clérisseau (1721–1820). In the course of his immensely long life, Clérisseau did not put up many buildings, though he did collaborate with Thomas Jefferson on the Virginia State Capitol, based on the Maison Carrée in Nîmes. His fame came from his drawings: he produced an enormous corpus of gouaches and watercolors of ancient, Renaissance, and Baroque Roman monuments, both real and imaginary. He had, Adam wrote,

> the utmost knowledge of Architecture, of perspective & of Designing & Colouring I ever saw, or had any conception of; he raised my ideas, He created emulation and fire in my Breast. I wished above all things to learn his manner, to have him with me at Rome.

The wish was granted. In Rome, Clérisseau became Adam's teacher and cicerone. His other guide was Piranesi, whom Adam met, came to know, and believed to be the only Italian "to breathe the Antient Air." Adam did not emulate the dramatic massiveness of Piranesi's visions of ancient Rome, but his work, even at its most delicately articulate, was never spindly or effeminate, and he sometimes borrowed decorative details such as those in Piranesi's engravings of chimneypieces.

He did not confine himself to houses, either. A grand master of design, he filled them with furniture (chairs, chimney boards, tables, escutcheons, doorknobs, chandeliers, carpets) and ornamented their walls and niches with painted "Etruscan" designs and quasi-Pompeiian grotesques whose twining imitated the *grotteschi* he had seen in Rome. All this was done with a consummate precision and light-handedness, not to say lightheartedness. Though he was so successful in business that he had to employ a small army of assistants and draftsmen to satisfy the demand, there is hardly such a thing as a dull or self-repeating Adam design for anything. "We flatter ourselves," he remarked in the introduction to his *Works* (1773–78), "[that] we have been able to seize, with some degree of success, the beautiful spirit of antiquity and to transfuse it, with novelty and variety, through all our numerous works." This is of course

true of the greatest Adam buildings, such as Syon House, Osterley Park, Kenwood House, and Kedleston; but its spirit informs all of Adam's work, and makes it perhaps the most refined and complex architectural response to Rome built anywhere in England, or even in Europe, in the eighteenth century.

At the time when the influence of Rome on foreign architecture was reaching its eighteenth-century meridian, the impetus of building in Rome itself had slowed considerably. There were no popes cast in the Baroque mold of architectural ambition. In fact, the whole eighteenth century saw the creation of only one scheme that compared to the vast projects of an earlier Rome under Sixtus V, Julius II, or Alexander VII. This was the three-flight stairway connecting the floodplain of the Tiber below to the system of streets laid out by Sixtus V above, rising from Piazza di Spagna with its Bernini ship-fountain to the triumphant, climactic surge of the Church of Santissima Trinità dei Monti and its attendant obelisk. Rome, being a city of hills, is also a city of steps and ramps, but the Spanish Steps are the grandest and most spectacular of all its staircases—its only rival being the flight of steps down the side of the Campidoglio that connects Santa Maria d'Aracoeli to Piazza Venezia. The Spanish Steps were constructed between 1723 and 1726 to the designs of Francesco de Sanctis (c. 1693–1731), the very young architect of the French Minims who owned the whole hillside down from the church, and it was his only major work in Rome. The commissioning pope was Innocent XIII. It grew out of an unrealized project of Gian Lorenzo Bernini's, who in the 1660s was thinking of a monumental ramp to connect the Piazza di Spagna below to the church above, including an equestrian monument to Louis XIV as its centerpiece. For various political reasons, this was not carried out. The division of the stairway into three major flights and three landings refers to the Trinity (Father, Son, Holy Spirit), after which the church at its summit is named.

The Spanish Steps are the only great rococo monument in Rome, and, in fairness, they should not be called Spanish at all, but French. (They got the name from the building at number 50 on the piazza, which was and is the Spanish Embassy to the Holy See.) The French Minims controlled and supplied the funds to build the staircase, and de Sanctis had worked for them since 1715. This masterpiece, however, finished the architect's career. In 1728, defective engineering combined with freakishly heavy rains caused the upper part of the stairs, linked to the Viale

del Pincio, to collapse; and although repairs were made, and the disaster was not de Sanctis's fault, he got no more projects in the city he had so unforgettably embellished.

Today most visitors to this part of Rome have little or no interest in the Spanishness of the Spanish Steps. They—or, rather, their flanking buildings—have other claims on one's attention. Two of the greatest English poets of the nineteenth century are associated with them. In a tiny museum room with a view in the Casina Rossa, as the building at 26 Piazza di Spagna is called (for its color), the poet John Keats lived for a time, and died at the age of twenty-five in the evening of February 23, 1821; his gently smiling death mask is preserved there, along with a lock of his hair and a carnival mask worn in Venice by his fellow poet Noel, Lord Byron. English doctors had sent Keats to Rome, hoping it would cure his tuberculosis, but it did not. He was buried in the Protestant Cemetery not far from the Pyramid of Caius Cestius, in a tomb which bears the famous inscription "Here lies one whose name was writ in water." His friend Percy Bysshe Shelley lies nearby, in the "New Cemetery" of non-Catholics, along with August, the only son of Goethe (1789–1830), and the Marxist political theorist Antonio Gramsci.

The flood of information about ancient art, of archaeological discovery, of new specimens, fragments, and entire masterpieces that was appearing every month from the plum pudding of Italy was bound to produce its interpreters. The leading one—the man who revolutionized archaeology by creating a framework in which antiquities could be classified by style and time of origin—was Johann Joachim Winckelmann (1717–68).

To the extent that Winckelmann is read at all today, it is by scholars of the discipline of art history, not by art scholars. The almost papal influence and prestige his writings acquired in the eighteenth and early nineteenth centuries have evaporated, but his position as one of the "fathers of art history" is secure and presumably always will be. "Winckelmann must be regarded as one of those who developed a new organ," wrote Georg Hegel, "and opened up fresh perspectives in the world of art." Goethe regarded him as hardly less than a moral hero. "While the characters of many men, and especially of scholars, tend to disappear from view as we look at their achievements, the opposite is true of Winckelmann: everything that he produces is great and remarkable because it reveals his character." To see that character in action, in all its fervent enthusiasm

for the Greek ideal, one should consult his famous dithyramb on the marble statue known as the *Apollo Belvedere,* "the most sublime of all the statues of antiquity":

> An eternal spring, such as reigned in the blessed Elysian fields, clothes the attractive manliness of full maturity with delectable youth, and plays about the majestic frame of his limbs with soft tenderness. Pass with your spirit into the kingdom of incorporeal beauties and try to become a creator of a heavenly nature, to fill your spirit with beauty that rises above nature: for there is nothing mortal here, nothing that human appetite demands. No veins, no sinews, heat and stir his body. . . . His delicate hair plays about the divine head, like the slender and waving tendrils of a noble vine, stirred, as it were, by a soft breeze; it seems to be anointed with the oil of the gods. . . . My breast seems to dilate and swell with reverence. . . . How is it possible to describe it?

It sounds faintly ridiculous now. One doubts the truth of such ecstasies. It might not have been entirely possible, but many a visitor to the Vatican Belvedere, where the *Apollo* stood (enclosed in a kind of wooden sentry box to protect it from unauthorized eyes), tried very hard. To see the *Apollo* was considered both a privilege and a high point of one's Roman visit, and Winckelmann, in his position as librarian to Cardinal Albani (whose near-total blindness had not impeded his appointment as head of the Vatican Library), was the gatekeeper of such occasions. When the painter Benjamin West came to Rome, its *cognoscenti* were agog with curiosity about what the American's reaction to the *Apollo* would be. Not a few supposed that, being American, he was some kind of Noble Savage complete with feathers, and were politely surprised to see before them a young Philadelphia Quaker. Thirty carriages had followed him and Winckelmann to the Vatican. The marble deity stood revealed; West exclaimed, "My God, a young Mohawk warrior!" Winckelmann was thrilled; this could only confirm his argument that the Greek masters had created archetypes of mankind, true across all cultures.

Winckelmann was a cobbler's son from the provincial town of Stendal who, by dint of fierce application, studied Greek, Latin, medicine, and theology at the universities of Halle and Jena. He taught classics and became a librarian. By 1754, he was involved as a librarian with the court of Augustus III, elector of Saxony, and began—while having seen, as yet, very little of classical art beyond some engravings—to develop his

theories about the relative merits of Greek art, which he regarded as the supreme aesthetic achievement of mankind, and Roman art, which to all intents he dismissed as a corrupt imitation, unworthy of its Greek prototypes. His library work in Dresden brought him into contact with the man who changed his life, the papal nuncio to the court of Saxony, Count Alberigo Archinto. It happened that Archinto, mortally bored with what he regarded as his "Babylonian exile," had a friend at court—the papal court, far away in Rome. This was Cardinal Passionei, scholar and *secretarius brevium,* in charge of the promulgation of all papal briefs, who (by a nice coincidence) was looking for a librarian who could set in order his collection of 300,000 volumes. Archinto recommended Winckelmann to him. Passionei responded favorably, and offered the young German aesthete a room in his own palace in the Vatican. Winckelmann realized that this kind of offer would not be made twice. Everything was drawing and pushing him to Rome, the center of the world's art.

For convenience, and to show his sincerity, Winckelmann underwent conversion to the Roman Catholic faith, a move which horrified his Lutheran associates but opened to him a far wider field—of clerical contacts, of collections, of access of every sort—than he could ever have had as a mere Protestant neophyte, a naïve heretic in the Eternal City. Lutheranism would do nothing for a man whose obsession was with antiquity. Rome and its clergy could do everything. Winckelmann had no family ties that could impede a conversion to Catholicism. His beloved mother was long dead; his father had succumbed to epilepsy in 1750. Winckelmann also knew very well that, without firsthand contact with Rome, an immersion in antiquity far deeper than anything he could scratch together by looking at engravings in books, he would never win recognition as an *Aufklärer,* a wise and enlightening connoisseur. Expatriation or obscurity, go or die: there was no other choice, he would go to Rome. But before he went, he would write.

His first attempt at art criticism rested on wobbly foundations. Published in 1755, the year he left for Rome, *Gedanken über die Nachahmung der griechischen Werke in der Malerei und Bildhauerkust (Reflections on the Imitation of Greek Works in Painting and Sculpture)* was his effort to enshrine ancient Greek art at the topmost and purest pinnacle of taste. It suffers, in retrospect, from the fact that Winckelmann at the time literally did not know what he was talking about. He had scarcely seen any Greek art; he had only read about it, and seen a few engravings. But this was also true of his own readers, and it made very little difference;

the essay was an immediate success. One phrase from it in particular became a standard utterance in the presence of the Ideal, a motto of neoclassicism: the characteristic of high Greek sculpture was *"eine edle Einfalt, eine stille Grosse"*—"a noble simplicity, a calm grandeur." This essay later became the basis of his most influential and elaborate work, his *Geschichte der Kunst des Alterthums* (*History of Ancient Art*, 1767).

Winckelmann was chiefly responsible for implanting the modern belief that later classical art, Greek and Roman, was a degenerate form of the "pure," early-Hellenic tradition. There were no limits to his admiration for Hellas. "Our race is not likely to produce as perfect a body as the *Antinous Admirandus*, nor can our ideas conceive anything beyond the superhuman and harmonious proportions of a god as they have taken shape in the *Apollo Belvedere*. Here is the consummation of the best that nature, art, and the human mind can produce. I believe that imitating the Greeks can teach us to become wise more quickly . . . They have marked for us the utmost limits of human and divine beauty." This, Winckelmann believed, was partly because the Greeks had achieved a sort of genetic transcendence, expressed in the "great care" they took to "have beautiful offspring." They sought to avoid any distortion of their own bodies; Alcibiades "refused to play the flute in his youth because it might distort his face, and the Athenian youths followed his example."

In the true and exemplary art of Greek antiquity, Winckelmann saw the refutation of much of his own age and its cultural expressions. Modern artists had gone off the rails, and the Baroque filled Winckelmann with disgust. Among his contemporaries, "especially the famous ones" (meaning the school of Bernini), admiration was reserved for "exaggerated poses and actions, accompanied by an insolent 'dash' that they regard as spiritedness. . . . Their favorite concept is 'contrapposto,' which for them is the essence of everything that makes for artistic perfection. They want their figures to have souls as eccentric as comets." Since *contrapposto*—the depiction of a standing figure with most of its weight reposing on one leg—was an absolutely fundamental device of classical Greek art later than the archaic, one may well wonder what Winckelmann thought he was getting at.

Nevertheless, it was really Winckelmann who invented the idea of stylistic development within antiquity, a master story of rise and decline. He was also the first writer to create a sexual narrative within his subject. Winckelmann was homosexual—when his friend Casanova interrupted him in mid-grapple with a servant one Roman afternoon, he unconvinc-

ingly explained that he had undertaken this sexual adventure in the interests of research, since he wanted to know what it was that the ancient Greeks had liked so much. But his yearning, lip-smacking descriptions of the ideal Greek body obviously come from deeper sources; and his descriptions of the canon, in which (for instance) the left testicle is always larger than the right, are permeated with desire.

Unfortunately, his sexual passions not only supplied fuel for his art interpretation, they led to his death. In the spring of 1768, after a meeting with the Empress Maria Teresa in Vienna, he was passing through Trieste on his way back to Rome when his eye was caught by a pockmarked young hustler on the waterfront, by the name of Francesco Arcangeli. Winckelmann made the classic mistake of boasting to Arcangeli about his exalted friends in Rome, and showing him some valuable medals the empress had given him. They were both in Winckelmann's room, number 10 in the comfortable Locanda Grande, when Arcangeli turned on Winckelmann, tried to choke him with a cord, and then repeatedly stabbed him.

Few sexual encounters between foreigners and natives in Rome had such drastic outcomes, but it need hardly be emphasized that prostitution was one of the most commonplace and visibly eternal aspects of the Eternal City. For the visitor, its very air was saturated with sex, offered, bought, paid for, and consummated. If you were male and could manage a trip to Rome without getting laid, this could only be because you did not want sex. The frequency with which tourists indulged their tender passions is certainly hard to gauge, since letters home do not always describe it—sex with Italian strangers, socially high or low, was not the first thing you would tell the family about—and diaries were often censored and tampered with by the travelers' descendants. But the availability of Italian women—not only professionals, but more or less respectable married ones as well—was a well-known fact among English travelers. "If Italy don't spoil his Chastity and Germany his Sobriety, I flatter myself he will preserve the character he sets out with, as an honest worthy young man," wrote Sir George Oxenden of his son Henry (1721–1803). Few Grand Tourists could have been unaware of the major punishment of vice, death by venereal disease, or of the painful and usually ineffective treatments eighteenth-century medicine reserved for the pox. Among others, Charles Howard, Viscount Morpeth, succumbed to it in Rome in 1741 in his early twenties, necessitating a by-election in Yorkshire.

The perils of vice had been a well-known feature of Rome since antiquity, when prostitutes were called *lupe* or she-wolves, perhaps in homage to the original *lupa* who suckled Romulus and Remus, and brothels—particularly dense in the area of the city known as Suburra—were known as "lupanars." We owe one of our commonest sex terms to the humble environment in which so many of the street girls traded; they offered sex out of doors, in the arches or *fornices* of the city; hence "fornication."

There were myriad steps between this commonplace rutting and the much more costly engagements offered by quality ladies—between the ordinary work of the whores (*puttane,* from which comes the name of the delicious *pasta alla puttanesca,* a simple dish using olives, anchovies, and onions, easily prepared while in between clients) and that of the *meretrici* or, at the top, of the *cortigiane,* the courtesans, who could expect to be escorted out on ceremonial occasions and receive a place at table—and even enjoyed real social and political power. Such women counted nobles, prelates, and even cardinals among their clientele. The scale of their income was recognized by realistic and heavy taxation, which at times became necessary to the income balance of the Roman state. Some even endowed their own churches. Areas of the city were set aside for them, not only in life, but in death as well; a favored spot for the burial of ordinary whores, in unconsecrated ground, was by the wall known as the Muro Torto, at the ancient entrance to the Villa Borghese. This practice fell into disuse, perhaps because the hookers' cemetery ran out of space.

An effort was made in September 1870 to systematize the sex trade in Rome by the introduction of *casini* or "closed houses"—so called because their blinds and shutters were kept closed, by law—in a very limited number of locations. By 1930, there were nineteen of these highly ordered and state-supervised brothels, with strict rules: the client had to be able to show his age (the prescribed minimum being eighteen years, three months, and a day), and could only enjoy the services of the sex workers between 10 a.m. and midnight, never staying the night. Naturally, the actual business done in these places was only a fraction of the whole prostitution industry of Rome, but one had to start somewhere.

Any great society like Rome's, at almost any time, is bound to have its sex goddesses who are not, in fact, prostitutes: women famed for their beauty and desirability who are known to everyone but are not in the trade at all. Rome, of course, had several, and the most famous of them is commemorated in a statue. Her marble effigy reclines in its own cham-

ber in the Villa Borghese, queening it over all the rest of the women (except Bernini's) in the building. This is Antonio Canova's full-length, semi-nude, reclining marble portrait of Maria Paolina Bonaparte (1780–1825), the sister of Napoleon who, renowned for her beauty, had married Prince Camillo Borghese. It is one of the absolutely iconic images of woman in Western art, as justly celebrated in its way as the *Mona Lisa,* and not without a parallel mystery of expression, which is hinted at in its title, *La Venere vincitrice, Victorious Venus.* This is a masterpiece at the end of a tradition which runs from the earlier reclining nudes of Titian and Giorgione to Jacques-Louis David's slightly later portrait of Madame Récamier.

That Antonio Canova was the last of the line of great and generally admired Italian sculptors, the eighteenth-century successor in fame and reputation to Gian Lorenzo Bernini in the seventeenth century, without rivals in his lifetime or successors after his death, can hardly be doubted today. His very presence in Rome, and his art's relation to Roman proto-types, seemed to confirm that the city had kept an undiminished vitality as a center of the world's culture. His success as a professional artist was on an almost Berninian scale, even though, unlike Bernini's, his architec-tural ambitions were modest and he built nothing in Rome and only one major building outside it—but the work kept pouring from the studio, and the commissions kept pouring in. No Italian artist since Bernini had the relations Canova enjoyed with the great and the good of his day: with the popes he served, depicted, and memorialized (Clement XIII, Clem-ent XIV, Pius VII); with bankers and politicians; with princesses and other powerful women; with every sort of foreigner.

Canova never married and had no children. He may have been homo-sexual, but there is no real evidence for that: only the famous but rather ambiguous story about Paolina Bonaparte, who, on being asked if she had never felt some *frisson* of anxiety being naked in the studio with the maestro for so many hours and days, retorted, "With Canova there was never any danger." More likely, he was one of those artists whose entire libido is subsumed in his creativity, leaving no room for the distraction of sexual expression.

This could not have meant that he was an introvert, or in any way a selfish man. Rather the contrary: he had a large and thoroughly deserved reputation for generosity. A tireless worker in the studio, he also spent large sums of his own earnings giving support to other, less successful Italian artists, including students, and on the commendable project of

keeping Italian art in Italy, defending it against the merciless suction of foreign capital. He constantly visited archaeological sites (Naples, Paestum, Pompeii, Pozzuoli), acquired Roman antiquities for the Vatican museums, and did his best to stem the export of works of art. He was helped in this difficult and distracting task by Pius VII's appointment of him as *ispettore generale* of antiquities and fine arts for the Papal States, which gave him the power to block foreign sales of significant artwork. In 1815, after the fall of Napoleon, it was Canova who went to Paris to earmark for return the major works of art the French had abducted from Italy and the Papal States during the Napoleonic Wars, an essential part of Italy's cultural patrimony that included the *Apollo Belvedere* and the *Laocoön.*

Canova had never been to Greece, but that did not imply that he was ignorant of classical Greek sculpture. Some was to be seen in Italy, and though little of that was in Venice when he was a young artist, he eagerly drew and imitated the plaster casts of ancient Greek sculptures assembled there in Palazzo Farsetti by Filippo Farsetti, a Venetian collector who wanted to provide his city's young artists with a sense of quality. His reputation as *the* authority on ancient sculpture was such that the English government brought him to London to certify the Phidian origins of the Elgin Marbles from the Parthenon. Critics who were against their purchase (often out of venomous dislike of Lord Elgin, masquerading as a desire for economy) wanted to dismiss them as vulgar Roman copies from the age of Hadrian, not even Greek, let alone by Phidias. Canova's opinion as the greatest living sculptor was rightly thought to be decisive: he thought the marbles genuine, "stupendous and unforgettable," and said that any attempt at restoring them, even to touch them with a chisel or a rasp, would be "sacrilege."

Among the English *milordi* in particular, Canova had an immense vogue. Although nobody could mistake one of his carvings for an ancient marble of the kind he sometimes indirectly quoted, English connoisseurs and collectors credited him with the authority of the best Greco-Roman antiquity. The Hanoverian King George IV bought his work, and as prince regent presented him with a diamond-studded snuffbox bearing his royal portrait in miniature. Canova did not take snuff. He was urged to try a pinch, and on opening the box the sculptor found a five-hundred-pound banknote in it. And in the early nineteenth century, a pound was very much a pound.

Canova designed a cenotaph for the Stuarts in Saint Peter's, which

Stendhal, no less, thought was the touchstone of one's appreciation of sculpture—if it left you cold, you had no feeling for the art. Practically every English or European writer of note was deeply affected, sometimes even shocked, by encountering his work. "The devils!" William Wordsworth exclaimed on catching his first sight of Canova's entwined lovers, *Cupid and Psyche.* But the overwhelming feeling it induced was nostalgia—a kind of longing for an imagined Golden Age of antiquity, when emotions, whether of patriotic valor, of piety, or of young love, were pure and unsullied. A partial list of the well-known English writers who found themselves stirred to the marrow by Canova would include Keats, Coleridge, Thomas Moore, the Brownings, and, of course, Byron. "Italy has great names still," Byron wrote in the preface to Canto IV of *Childe Harold's Pilgrimage* (1818), "Canova, Monti, Ugo Foscolo . . . will secure to the present generation an honourable place . . . and in some the very highest;— Europe—the world—has but one Canova." If one added the French, German, Russian, and of course the Italian ones, the list would be even longer and more eminent. Small wonder that collectors all over Europe, from the Devonshires at Chatsworth in England to Russian royalty in Saint Petersburg, competed to possess his work and vied to pay the highest prices for it.

He was tirelessly and exuberantly inventive, creating entire new conventions for such constantly worked-over problems as the design of tombs. As a funerary sculptor and an interpreter of myth in stone, nobody in his time could approach him. He was, for instance, the first artist in modern times to find something fresh in one of the most ancient of all commemorative forms, the Egyptian pyramid, that symbol of grief, permanence, and transcendence. The finest of Canova's pyramidal tombs (1798–1805) is in the Augustinian Church in Vienna, and contains the ashes of Maria Christina of Austria. In the tombs of the past, figures had been included or integrated with the structure. Canova had the simple but brilliant idea of detaching them so that they move, as it were, from our space into the domain of death; they form a procession of young and old mourners toward the dark doorway which contains the corpse invisibly, and swallows up the visible living. Canova was thinking of the pyramids of Egypt, but even more of the Pyramid of Cestius, which he had seen so often in Rome.

No artist who came later, with the single spectacular (though very different) exception of Auguste Rodin in France, achieved Canova's measure of fame and influence in his own lifetime. He was, and still is, the

only sculptor in all history to have a monument erected to him while he was still alive.

After his death in 1822, all this fell apart. The reaction against him began in England, with John Ruskin, who fulminated that the demand for Canova's work only went to prove the decadence of the upper classes—cold, overidealized, boring. By the twentieth century, good taste had come to neglect or even to despise him utterly, and the praises heaped on him in earlier times looked like so much fustian, the products of some kind of collective delusion against which modernism, fortunately, had inoculated most of us, leaving only reactionaries to admire his like. Nobody seemed to be speaking up for him, even in his native country, whose unrivaled culture hero he once had been. Its most powerful art critic, Roberto Longhi, let fly at "the funereal blunders of Antonio Canova, the stillborn sculptor whose heart is buried in the church of the Frari, whose hand is in the Accademia and the rest of him buried I know not where."* We critics all make mistakes, but this was an extreme one; one may or may not share Canova's idealism about the body—he was perhaps the last great sculptor to share implicitly Spenser's belief that "Soule is Forme, and doth the Bodie make"—but there is hardly a "funereal blunder" anywhere in his large and immensely refined output.

If ever an artist appeared at the exact moment when his society most needed him, he was Antonio Canova. He was the last of a line of geniuses who redefined the art from the late fourteenth century, through Andrea Pisano in the late Middle Ages, to Donatello in the Quattrocento, to Michelangelo in the High Renaissance, and Bernini after them. But after Canova there would be no more such figures.

Inevitably, one's feelings about the singularity of Canova are increased by his isolation within his moment in Italian cultural history; aside from him, that history, at the start of the nineteenth century, was at a low ebb—the lowest it had ever reached, though not as debased as it would be by the start of the twenty-first. Italy's long-lasting cultural primacy, especially in the plastic arts (painting, sculpture, architecture), was a thing of the past. There were no Italian writers who could be even fleetingly compared to Dante; Alessandro Manzoni, the future author of *I promessi sposi,* had not yet appeared, nor had the romantic genius of

* This refers to the reverent dismemberment of Canova's body for burial. Most of his body was interred in his own museum-mausoleum in Possagno, his birthplace in northern Italy. However, his heart was placed in the monument to Canova in the Church of the Frari, Venice; and his amputated right hand is in an urn in the Accademia di Belle Arti, Venice.

Giuseppe Verdi emerged to vitalize Italian music. The situation of the arts in Italy echoed, broadly speaking, the miseries of politics: almost all authority gone, almost all power in the hands of foreigners, most conspicuously Napoleon.

The heyday of the Grand Tour was well and truly over by 1800. The French Revolution broke out in 1792, and it had immediate repercussions on continental travel, especially for the English. The threat of French naval action against Rome and Naples was taken very seriously. Britain entered the conflict in 1793; no Englishman now could contemplate a journey across France, and although it would perhaps have been possible to plan a trip to Italy by the sea route through the Bay of Biscay and the Straits of Gibraltar, the fear that the French might get complete control of the Mediterranean and thus be able to interdict British shipping going either way was a powerful discouragement to civilian travel to Italy by sea.

The spectacle of the Terror made matters worse. Who, for the sake of culture, was going to risk leaving his head in a basket at the foot of the guillotine? The Grand Tourist's noble and illustrious contacts on the Continent were being killed or forced to flee. British diplomats were being withdrawn. Banking was in chaos. Access to Italian monasteries, nunneries, and academies closed down. The art market collapsed in the face of massive confiscations; Lord Derry's large collection of antiquities, for instance, which had imprudently been left in storage in Rome, was simply seized by the French as French loot; portable ones, such as the *Laocoön* and the *Apollo Belvedere,* were taken to Paris (whence Canova would retrieve them in due course); immovable ones, like murals, were rendered harder to get to. The French occupied Rome in 1798 and founded the Roman Republic; Pope Pius VI went into exile (in France) in 1799. The entire cultural world of Europe, in short, was in upheaval and shock.

10

The Nineteenth Century:
Orthodoxy Versus Modernism

Deep change in Italy was set off by Napoleon when he invaded the north in 1796. Napoleonic ideas never found a following among the illiterate peasantry who made up most of the Italian population, which certainly had no say in how it was governed. But Buonaparte could challenge the authority of royalty and the Papacy and not look like a foreign intruder, because, on the simplest level, he was of Italian blood—or could plausibly claim to be, since his native Corsica had been Italian territory right up to the moment Genoa sold it to France, less than three decades before, in 1768.

At this time, there was no sense in which Rome could have been called the political "capital" of Italy, except that the Papacy was based there. Italian politics had no capital. The whole country was crippled by what it called *campanilismo,* the bewildering profusion of municipalities, local centers of power. A traveler descending the river Po had to traverse no fewer than twenty-two customs barriers, submitting to search and the payment of imposts at each stop. No common currency existed: in Piedmont one paid in lire, in Naples with ducati, in the Papal States with scudi, in Sicily with oncie. Exchange rates fluctuated, often at the whim of whoever was manning the customs and excise barriers. Merely to say *"sono italiano"* was to invite mirth or, more likely, incomprehension. One was Roman, Neapolitan, Sicilian—not Italian. But Florentines despised Venetians, who loathed Neapolitans, who felt nothing in common with Abruzzesi, who looked down their noses at Sicilians, who resented any imputation that they might be from the mainland across the Strait of Messina.

The result was that, although the tiny minority of Italian highbrows and *literati* were able to feel various cultural bonds in common—such as sharing the homeland of Dante or Michelangelo—this was much less of an option for the illiterate or the culturally indifferent who made up most of the population. Moreover, the situation placed great importance on local dialects, which were immensely varied, and whose differences all but guaranteed cultural disunity. So, understandably, the Code Napoleon, the uniform legal system the conqueror sought to impose on Italy, though attractive to a few educated Italians longing for good, responsible government, was met with disdain by the masses, who did not believe that such a government could exist. Besides, they had become used to and even protective of the patchwork of ill-framed laws that defined their civic lives.

Nevertheless, Napoleon went right ahead with his plans. On taking charge of a conquered Italy, he proceeded to depose all its kings except those of Sardinia and Sicily, whose kingdoms, protected by the British navy, were able to keep their independence. He was determined to cancel the powers of the great landowners and the Catholic Church, which, working together, provided the utmost resistance to his rule. To the impotent horror of Italian conservatives, Napoleon evicted the pope from Rome and took over the temporal power of the Church, dissolving the Papal States as a political entity. At a stroke of his pen, he reduced the number of Italian states to three—Piedmont, Naples, and his own conquered territory, including the former Papal States, which he renamed the Cisalpine Republic. Little by little, French revolutionary ideas began to take hold in Italy.

But they hardly had the time to fix themselves there. Napoleon was defeated at Waterloo in 1815, and with his fall the Congress of Vienna immediately set about reassigning the states of Italy to their former rulers. The Bourbon monarchs reclaimed Naples and Sicily (the so-called Kingdom of the Two Sicilies). Austria recovered her former possession Lombardy, and was given Venetia as well. The Grand Duke Ferdinand III, brother to the Austrian emperor, was restored to his dominion over Tuscany. And, most important of all, the central states of Italy reverted to the Papacy. Meanwhile, that formidable exponent of counter-revolutionary tactics, Prince Metternich of Austria, who had some seventy thousand men within the "quadrilateral" of central Lombardy, made a military alliance with Naples, whose object was to maintain indefinitely Austria's "right" to interfere in Italy. For him the very term

"Italy" had no meaning; it was, he memorably said, merely a "geographic expression."

Thus Italy was, if anything, even more disunited than she had been before Napoleon's invasion. It was a situation bitterly lamented by her writers and intellectuals, including the poet Leopardi (1798–1837):

> I see the walls and arches, O my Italy,
> The columns and the images, the solitary
> Towers of our ancestors,
> But this I do not see:
> The glorious laurels and the swords they bore
> In ancient times. . . .
> Who brought her down to this?—and what is worse,
> Both her arms are bound about with chains . . .
> Weep, for you have good cause, my Italy.

By the early nineteenth century, Rome was swarming with foreign artists; despite Napoleon's invasion, the city had come to be regarded, once again, as the world's school. Several of these expatriates rivaled the native Italians not only in reputation, but in the demand for their work: if you could not secure a piece by Canova, for instance, a very good neoclassical sculpture by the Danish sculptor Bertel Thorvaldsen (1770–1844) was an acceptable replacement and could well be available.

Thorvaldsen, who spent most of his working life in Rome, first went there on a scholarship in 1797 after entering the Royal Danish Academy of Fine Arts at the precocious age of eleven.

It was not always easy, at first sight, to distinguish Thorvaldsen's mature work from Canova's. The subjects were much the same, drawn from Homeric poetry and Grecian antiquity in general: Thorvaldsen's over-life-sized *Jason with the Golden Fleece* (1803–28) produced many similar commissions—*Ganymede, Hebe, Apollo,* and so on. He was also a prolific and fluent portrait sculptor—Byron's letters reveal how eagerly he was waiting for Thorvaldsen to complete his bust and that of his adored Venetian mistress. Canova's sculptures had more surface polish, and Thorvaldsen's tended to be matte, but this difference was sometimes reduced or even abolished by overenergetic cleaning. Most of his major sculptures found their way to his native Copenhagen, where, emulating the example of Canova's museum at Possagno, he endowed his city with a large and comprehensive collection of his own work. Nobody could have

accused this Dane of a hampering modesty: one of his larger self-portrait sculptures represented him as Thor, the thunder god.

Not the least aspect of Thorvaldsen's sojourn in Rome was his support of other expatriate artists, mainly from the North, whose work he thought significant. He was particularly attracted to the work of the so-called Nazarenes, a group of young Germans who had set themselves up in Rome—a nickname they were given by more skeptical Germans in Rome for their demonstrative piety. He bought their work in some quantity, forming the city's most important collection of modern works of art in Rome. The Nazarenes' chief figures were Joseph Anton Koch, Peter Cornelius, Wilhelm Schadow, and their leader, Friedrich Overbeck (1789–1869). The chief literary influence on his and his friends' work was an essay by the German cultural ecstatic Wilhelm Wackenroder, *Outpourings from the Heart of an Art-Loving Monk.* In it, as the title suggests, art was discussed as a holy activity akin to prayer, leading to an unshaken belief in divine nature. Other artists and writers might feel they were part of the great movement toward the secularization of culture which was under way throughout Europe at the end of the eighteenth century, but Overbeck and his friends in Rome did not, and wished only to oppose and reverse it. They felt their duty was to create a revival of religious art in Germany and, spreading outward from there, throughout Europe. Religion, Overbeck came to believe, was the true foundation of art. Merely secular painting was culturally impotent. This was the basis of the revulsion he felt at the wholly secular, classicizing teaching methods of the Vienna Academy, which he attended from 1806 to 1809. But the starting place for this belief's assimilation into visual culture, he concluded, would have to be Rome, that mighty capital of past religious imagery. Other young artists he came to know at the academy felt the same, and just as warmly; among them were Ludwig Vogel, Franz Hottinger, and Franz Pforr.

Together they formed a small confraternity they called the Lukasbruder, or Brothers in Saint Luke—the Apostle Luke, said to have painted the Virgin Mary from life, being the patron saint of artists.

The past artists they most admired and sought to imitate were Italians of the early Renaissance, particularly Masaccio and Fra Angelico. These, the "Lukes" believed, were more sincere and naïvely truthful in their responses to Nature and to religious faith than any painters of the Baroque or neoclassical persuasion. Baroque artists were coarsened by the rhetoric of their style; neoclassical ones, by an excessive refinement

and the traces of paganism. It was hardly surprising that the ideas of the "Lukes" would presently cross to England and find strong echoes in the work of the Pre-Raphaelite Brotherhood.

"Art is to me," declared Overbeck, "what the harp was to David. I use it on every occasion to utter psalms in praise of the Lord." But what had become of this sacred impulse, once so general among painters? It had irreversibly declined, wrote Franz Pforr in Vienna. Not all the art that was being made in Rome was "sacred" or even Christian-religious in its general themes. Neoclassicism itself worked against so narrow a definition of the artist's role in Rome, and it tended to contradict exclusively religious, or even primarily moral, readings of art and its functions—simply by holding up pre-Christian themes as desirable ones. In times gone by, "few men can have had so strong an influence upon morality and virtue" as artists. But now, in these fallen times, it had declined and could only be brought back with difficulty.

> When we consider the ends for which [art] is now used, one can only deplore that its decay is so very general. Formerly the artist tried to charm the spectator into devotion by representing pious objects, and to induce him to emulate the noble actions he depicted; and now? A nude Venus with her Adonis, a Diana in her bath—toward what good end can such representations point?

Both Pforr and Overbeck found the classical past, as promoted at the academies, not only irrelevant to the present but even slightly disgusting to a good Christian soul. "Why do we seek subjects so distant from our interests," Pforr demanded, "why not instead those that concern us? In the old Israelite stories we find more material than anywhere else." Overbeck was saying the same, in more high-flown accents of faith.

It seemed to them that there was only one place where such desires could be satisfied, where a young German could complete his religious and artistic education; Rome, just by virtue of being a religious capital, would provide the balance the young Germans sought between stylistic tradition and living faith. Overbeck and Pforr longed to immerse themselves in it, not for the ancient marbles (they had seen quite enough of the academy's plaster casts of those) but for the accumulated deposit of Christian belief the city represented. The very name of Rome spoke to pious young Germans like these with an intensity and promise that no other place could offer. They were determined to move there. And so, in May 1810, Overbeck and Pforr, along with Hottinger and Vogel, left

Vienna for the Holy City. They entered Rome a month later, scarcely stopping to look at anything on the way.

The city at the time was still occupied by the French, who had closed and secularized a number of its religious institutions. One of these was the Irish-Franciscan monastery of Sant'Isidoro, up on the Pincio, above Piazza del Popolo. The Napoleonic occupation had driven its monks out, and the four youngsters, with minimal bargaining, got a lease on rooms there. Wackenroder had written about the monastic ideal of an artist's life, and where better to live it than in a real, if admittedly disused and rented, monastery? The pattern of activity was to work all day in one's cell and then meet up in the refectory at evening, to argue, confess, and carouse. Many bottles of Frascati were consumed and then smashed. Soon the group became known as the Fratelli di Sant'Isidoro, a nickname given special point by their way of dressing in cowl-like hats and monkish habits; the street where the monastery stood became the Via degli Artisti.

Their group was quite short-lived. Seeing themselves as missionaries, bent on converting the "heathens" of art, they sought to establish the primacy of religious art as it once had been, before art lost its purity to secularism and academic thinking. Fra Angelico, early Raphael, and such Northern masters as Dürer and Jan van Eyck: these were their heroes and touchstones. Later, Overbeck would produce a large painting for a German client, *The Triumph of Religion in the Arts,* accompanied by a lengthy written explanation of how "true art" had petered out with the Renaissance, featuring some sixty portrait-heads of approved artists. Other young Germans would presently join this Roman nucleus of the Nazarenes. One was Julius Schnorr von Carolsfeld (1794–1872), son of a German history painter, who applied to Overbeck for admittance to the group, was accepted, and wrote his delighted thanks: "You have judged me worthy to join your glorious ranks as a brother. Thus take me into your arms! My being is now tied to yours!"

Some of these artists, including Carolsfeld, were deeply influenced by the German practice, strong among the expatriates in Rome, of painting what they called "friendship pictures," portraits of themselves and their German friends far from their native homes but locked in the fealty of common interest, a mutual loyalty sanctified by its enactment in the Holy City. One eloquent example among many was Wilhelm Schadow's *Self-Portrait with Brother Ridolfo Schadow and Bertel Thorvaldsen* (1815).

Wilhelm and Ridolfo were the two sons of the eminent Berlin sculp-

tor Johann Gottfried Schadow (1764–1850), who, as a friend of Canova's, had made the decisive pilgrimage to Rome and converted to Catholicism in 1785. Going to Rome themselves, the brothers swore to each other that "they would rather stay dead in Rome than return unknown to their home city." Wilhelm's painting shows the taking of this oath. On the right, Wilhelm, with his palette and brushes, solemnly shakes hands with Ridolfo, who is holding his stonecarver's hammer. Between them, the Danish sculptor Thorvaldsen, rests his left hand in comradely style on Wilhelm's shoulder, his firm gaze fixed on Ridolfo. Between the Dane and the young German, linking the figures in the group, is the marble carving which won Ridolfo his early reputation in Rome, the *Sandalbinderin,* or *Girl Fastening her Sandal.* It had been much admired for its truth and sincerity by Overbeck and other Nazarenes.

Overbeck refused to paint or even look at the female nude. To do so, he thought, was immoral. This shifted the terms of allegory; an earlier artist might have painted "Italy" as a splendid naked nymph, but Overbeck would not. The painting that most expressed the Nazarenes' feelings about Italy was probably the pair of fully clothed figures by Overbeck depicting the cultural union of Italy and Germany. Blonde Maria and dark Shulamit. The left-hand figure, crowned with a wreath of olive and bending attentively toward her companion, is "Italia," and the landscape behind her is that of Italy: rolling hills, a rural *casa colonica.* The one on the right, who bends eagerly forward, holds Italia's hand, and whispers lessons about painting and morals to her, is "Germania," with her rosebud chaplet, her plaited braids, and the German city-on-the-hill with its medieval spire in the background.

Overbeck firmly maintained what he held to be his duties as an artistic and moral teacher. Basically, he believed that nothing good had happened since the Renaissance—he must have viewed the monuments of Baroque Rome with horror—and so he missed out on the powerful spirituality of the newer art made by such Italians as Bernini in the seventeenth century. But he did not have much opportunity to do public art in Rome. His biggest commission came from Pius IX: it was a scene of *Christ Evading His Pursuers on the Mountain near Nazareth,* an allegory of the imprisonment of Pius VII by Napoleon, painted on one of the ceilings of Palazzo del Quirinale—a devout but insipid work at which few visitors, if any, look today. The Nazarenes certainly left an impression on Roman art, but it did not prove to be deep or lasting; meanwhile, the cultural energies of Italy had shifted almost entirely to the sphere of poli-

tics and its contentions. Pius IX, in particular, was so preoccupied with trying to hold on to his domains in the Papal States that he had little time for being an art patron. But in Germany, Overbeck's influence, and that of the Nazarenes in general, was widespread.

Interestingly, it also spilled into one area of French painting. The French had rarely been influenced by stylistic events in Germany, but in a city bustling with so many foreign artists, it was bound to happen and did, because of one major French artist who was resident there. The oldest of the various foreign academies in Rome was that of France; it had been instituted in 1666, under Louis XIV, impelled by Colbert and Charles Le Brun. In a very short time it had acquired great prestige, and its *pensionnaires* (the painters, sculptors, and musicians whose talent, officially recognized by the Prix de Rome, had been rewarded with a stipend from the French government and a spell on its premises) were considered to have made an important start to their public careers. In 1806, the brilliantly talented young painter Jean-Auguste-Dominique Ingres was awarded a *pension* from the academy and settled in Rome. The academy had been located in Palazzo Mancini, in Via del Corso, but in 1803 one of the great sites of Rome became available to the French government, which bought it: the Villa Medici, at the head of the Spanish Steps. This became Ingres's studio and home for much of the rest of his life. The nineteenth century was an exceptionally rich period in the history of the French Academy in Rome. Among its *pensionnaires,* apart from Ingres, were the architects Baltard and Garnier, the sculptor Carpeaux, the composers Berlioz, Bizet, and Debussy. Ingres worked there as a *pensionnaire,* staunchly defending the classical tradition that surrounded him in Rome, from 1806 to 1820, and after a return to Paris he came back to Rome again in 1835, now as the director of the academy in the Villa Medici. In this position, as the grand cham of French art teaching, the paladin of the classical style, he exerted an incalculable influence on thought and practice in French art. He was not a man prone to self-doubt, and one of the pictures he was proudest of was his first official commission in Rome since the fall of Napoleon in 1815—*Christ Giving the Keys to Saint Peter* (1820). It depicts the moment at which Christ entrusted the future of his newly formed church to the first of the line of future popes, Saint Peter, who kneels at his feet and looks up at him; Christ, too, is looking up, but to his Father in Heaven, while with his left hand he points to the keys in Peter's hands, the power to open or close the doors of salvation, which he has just passed on to his succes-

sor. Everything about this image, but especially its almost stonily firm construction and its powerful sense of hierarchy, points to the origins of at least some of Ingres's ideas in Nazarene painting—hardly a surprise, since the monastery where Overbeck and Cornelius had been working was next door to the Villa Medici.

All this artistic flourishing took place against a turbulent political landscape. Especially post-Napoleon, Italy was considered so hopelessly divided that it could barely have been called a single country at all. "We have no flag, no political name, and no rank among European nations," lamented one of the patriots whose efforts would eventually bring its unification about, Giuseppe Mazzini (1805–72), who had been born and raised in Genoa, then under the rule of the French Empire, being part of the Ligurian Republic.

> We have no common center, . . . no common market. We are dismembered into eight states—Lombardy, Parma, Tuscany, Modena, Lucca, the popedom, Piedmont, and the kingdom of Naples—all independent, without any alliance, with no unity of aim and no organized connection between them. . . . There are eight different systems of currency; of weights and measures; of civil, commercial, and penal legislation; of administrative organization; and of police restrictions. They all divide us and make us foreign to each other as much as possible.

As Mazzini was coming of age, there was a slowly growing current in the direction of change. What growing numbers of Italians—liberals, intellectuals, dissenting patriots, anti-imperialists who resented the rule of Austria—looked toward and longed for was a *risorgimento,* or "resurgence," that would unify Italy as an independent country, free of Austrian influence. Of course, Italy never had been unified; it was always a patchwork of post-medieval entities, its dominant unit being the Papal States, whose size, wealth, and centrality gave enormous political power to the pope as a temporal ruler.

At first, the main revolutionary action came from a secret society called the Carbonari, or Charcoal Burners. They were originally centered in Naples, from about 1806 onward, and they were hailed as brethren by all Italians of a radical disposition, as well as by such foreigners as Lord Byron, who called them his "cronies" and generously gave them rooms in his residence in Ravenna in 1821. "My lower apartments are full of their bayonets, fusils, cartridges, and what not. I suppose that they consider

me as a depot, to be sacrificed, in case of accidents. It is no great matter, supposing that Italy could be liberated, who or what is sacrificed. It is a grand object—the very *poetry* of politics. Only think—a free Italy! Why, there has been nothing like it since the days of Augustus."

The Carbonari were fiercely persecuted: to be caught meant jail or death, and often these amounted to the same thing, since the usual jail was the dreaded Spielberg Fortress in Moravia, by all accounts the most miserable sort of place imaginable. (One unfortunate Italian writer named Silvio Pellico, arrested in 1820 for a trivial offense, wrote a book about his treatment there, *Le mie prigioni* [*My Prisons,* 1832], which was said to have damaged Austria more than a lost battle.) But sometimes they were executed right away in Italy, with hardly more than the semblance of a proper trial.

This was the fate of two such dissidents in November 1825, Angelo Targhini and Leonida Montanari. They had long been cooking up plots against the papal government of Leo XII Sermattei della Genga (reigned 1823–29), being fiercely opposed to the continuation of that pope's absolute power in the Papal States. One can hardly blame them. Leo XII was one of the vilest reactionaries ever to occupy the Fisherman's Chair. Not only did he insist that all court proceedings of the Papal States be conducted in Latin by ordained priests; he forbade Jews, especially those in Rome, to own property, and ordered that they sell their possessions without delay and attend Christian catechism. Their only recourse was to emigrate from the political control of the Church—to nonpapal states, such as Lombardy or Tuscany. All charitable institutions in the Papal States were put under direct Church supervision, as were all libraries and, of course, schools. The pope's neurotically suspicious dread of enemies only made the enmities, and his reaction against them, worse. If a dressmaker designed low-cut or in any way revealing dresses, she would be excommunicated. If her clients wore them, the same applied. Papal fear of unorthodoxy led to a system of denunciation, torture, and arbitrary arrest for imagined doctrinal crime beside which the excesses of the Inquisition paled. And it often ended in death for the suspects.

So it was with the unfortunate Targhini and Montanari, whose paths in Rome had crossed with that of a papal double agent named Spontini. On finding out Spontini's real mission, which was to entrap Carbonari, Targhini enticed him onto a dark Roman street and stabbed him in the chest. The blow was not fatal, but in the denunciations that followed it, both Targhini and Montanari were condemned to death. Papal law

decreed their beheading. They declared their innocence and impenitence right up to the last moment.

The pope, as monarch of the Papal States, had his very own *boia* or executioner—a functionary named Mastro Titta, who later (without the least trace of remorse) wrote his memoirs. Targhini and Montanari were beheaded on Piazza del Popolo in November 1825.

The Carbonari had unofficial enemies, too. The Sanfedisti, a secret society supported by nobles and peasants alike, took an oath "not to spare anyone belonging to the notorious gang of liberals, regardless of his birth, lineage, or fortune . . . and to spill the blood of the infamous liberals to the last drop, regardless of sex or rank." The Sanfedisti were an Italian equivalent of such hysterically rightist Spanish terror organizations as the Exterminating Angels. But their membership came nowhere near that of the Carbonari, of whom there were claimed to be between 300,000 and 1 million. The loathed *sbirri,* or political police, could not field a fraction of that. Nevertheless, Mazzini, who had joined the Carbonari in 1830, estimated that his home district of Lombardy contained 300 police agents, 872 gendarmes, 1,233 police guards, and a swarm of semi-official delators, all of whom reported back to Vienna. In 1830, while in his mid-twenties, he was arrested and locked up without trial for conspiring against the Piedmontese state. When his father protested to the governor of Genoa, he was told, "Your son is a man of some talent, and he is too fond of walking by himself at night deep in thought. What on earth has he to think about at his age? We do not like young people to think unless we know the subject of their thoughts." Mazzini was then clapped behind bars in the Savona Fortress.

He was freed in 1831, but offered the unappetizing prospect of what amounted to permanent house arrest in a provincial town. Instead, he chose exile, moving to Marseilles, where he started a society called La Giovane Italia (Young Italy), whose political program was based on the creation of a free Italian republic by the merger of several states. It had some success in the next few years, claiming sixty thousand adherents by 1833—not enough to convert all Italy, but certainly enough to perturb the government of Savoy, which ruthlessly clamped down on the young movement, sending twelve of its members to the gallows. Mazzini's best friend, Jacopo Ruffini, killed himself. Mazzini, tried and convicted *in absentia,* was forced into exile in London; from there he sent out a stream of letters and pamphlets to other countries—Germany, Poland, Switzerland—urging the creation of independence movements

by national youth. He even tried to foment one among army cadets in Turkey, known, prophetically, as the "Young Turks." From their ranks, Kemal Atatürk, the future Westernizer of Turkey, would eventually arise.

Mazzini theorized and argued incessantly, but he never led a militant revolt. His hopes for a continuous ignition of riots proved delusive. Every insurrection failed. Austrian police power was too strong. Centralization on Austria was so extreme that, at one point in the 1840s, worn-out police boots had to be sent to Vienna to be repaired. Nevertheless, through the 1830s and 1840s, brush fires of dissent kept flaring up across Europe, demanding local constitutional rather than Austrian colonial rule. Their emblematic focus was Italy. In 1846, a Roman pamphleteer complained about unrestrained police power. "The police can imprison a man, banish him, confine him to a district, rob him of office, forbid him to carry arms or to leave his house at night. They open his letters in the post and make no effort to conceal it. They can invade his house, close shops, cafés, and inns, and fine us at their pleasure." In Rome, political suspects (and it took very little to qualify as one) were confined to their houses from sundown to morning. They were also obliged to take the sacrament of confession once a month, and of course what they told the priest under the seal of the confessional was routinely disclosed to the authorities as part of the "special surveillance of the class called thinkers." Most foreign books were proscribed or placed on the Index, the banned reading list; even private reading groups on economic theory were banned, and old or dying persons were refused absolution by their priests unless they betrayed their friends and relatives.

The Italian liberals and nationalists struck back as best they could, sometimes with ingenuity; thus, in January 1848, the protestors staged a civil-disobedience strike in Lombardy, which consisted of citizens collectively refusing to smoke or play the state lottery; this caused grievous embarrassment to Austria through loss of income, both the lottery and the tobacco industry being state monopolies. Pro-constitutional revolts and demonstrations broke out in Tuscany, Naples, Sicily, and Milan. But serious, open conflict did not come until the appearance of Giuseppe Garibaldi.

Garibaldi had been born and raised in Nice (Nizza), then a part of the Kingdom of Savoy, with a large Italian-speaking population. He took naturally to the sea and was working as a merchant-marine captain when, laid over for a few days in 1833 in the Russian port city of Taganrog, he made the acquaintance of a political exile from Italy, Giovanni

Battista Cuneo. Cuneo, a follower of Mazzini, was a member of the illicit Giovane Italia, and he soon converted the young Garibaldi. From now on, the sea captain would be dedicated to the vision of an Italy free from Austrian control. It made him feel, he said, "as Columbus must have done when he first caught sight of land."

He met Mazzini in Italy, joined the Carbonari, and rather prematurely agitated for insurrection in Piedmont. This merely made him a marked man—one more malcontent on the police lists. A Genoese court tried him *in absentia.* He fled from Italy to Marseilles. From there, Garibaldi wandered.

His peregrinations took him to Brazil, where he fell in with a republican uprising over meat taxation. The Brazilian gauchos, who regarded themselves as the backbone of the country, had come to resent bitterly the high taxes imposed on the sale of *charque,* Brazilian dried and salted beef, a staple food. Feelings ran so high that a minor civil war known as the Guerra dos Farrapos, the "War of Tatters," broke out; the *farrapos* were the rebels, and Garibaldi, scenting an invigorating conflict in the making, joined them in 1839. During the war, Garibaldi met and fell in love with a very brave and spirited woman, Ana Ribeiro da Silva, known as "Anita," who fought right next to him in a series of engagements. It is said, though it is not certain, that Anita invented what became the Garibaldian uniform of red shirt, poncho, and wide beret—the red cloth coming from a factory in Montevideo, Uruguay, which had originally been contracted to sell it to the cattle slaughterhouses of Argentina. Some believe that this gaucho outfit was the origin of the use of red as a sign of revolution, which would later pass to Russia and the Bolsheviks.

In 1842, the pair sailed on his ship to Montevideo, where they raised an "Italian Legion" to support the Uruguayan liberals in a civil war against the conservative *caudillo* Juan Manuel de Rosas. But the situation in Italy moved steadily to the forefront of his concerns; revolution was in the air all over Europe, he was Italian and not South American, and his duties as an insurgent were owed to Italy, not Uruguay.

Garibaldi's mind was made up by the mistaken news that the recently elected pope, Pius IX, was apparently a liberal and sympathetic to reform. This was given credibility by the fact that, in 1846, the pope had granted amnesty to all political prisoners in the Papal States.

In 1847, Garibaldi wrote a letter to the papal offices offering "to shed our blood in defense of Pius IX's work of redemption." The next year, he sailed back to Italy with sixty men, a fraction of his legion. He offered

their support to the king of Sardinia-Piedmont, Charles Albert, who had just granted a constitution to Piedmont, but soon he was to transfer his allegiance to the more promising Milanese, who in March, after five days of struggle against the Austrian occupation, had expelled the Austrians from their city. Venice, too, rose against its Austrian overlords and proclaimed a republic. Likewise, the Papal States—to the horror of Pius IX—declared for republicanism.

Now Garibaldi, encouraged by the ever-premature Mazzini, moved down to Rome with the hope of taking military charge of it. In November, Pius IX fled south from Rome to Gaeta. But this was not a victory for Garibaldi. Louis-Napoleon, the future Napoleon III, was determined to restore the pope and his temporal power, thus safeguarding the Papal States. He dispatched an army to throw Garibaldi out of Rome. At first, this force, though larger than Garibaldi's, failed at the very gates of the city, in April 1849. But then French reinforcements arrived, and after a four-week siege, they forced Garibaldi and the republican army into retreat. Under a hastily negotiated truce, he led his men—by now around four thousand in number—out of Rome, on July 2, 1849. His idea was to keep up the pressure on Rome, guerrilla-style, from strongholds in the Apennines. "Wherever we are," he announced with impressive defiance, "there Rome will be." When this did not work, the refugee army began heading for Venice, but most of its strength was eroded on the way; by the time its remnants reached San Marino, only 250 men were left, and the ever-courageous Anita had died near Comacchio on the retreat. Her death could only make her widowed husband more determined for victory than ever, although some years passed before he had another chance.

Meanwhile, the French army entered Rome and re-established the military and political power of the pope. After brief sojourns in New York (1850), Peru (1851), and even Australia (1852), Garibaldi bought land on the Italian island of Caprera, north of Sardinia, and settled down to farm. This was merely an interlude. In 1859, he was made general in a war of independence launched by Sardinia against the Austrian government, leading a force of "Alpine Hunters" to harass the Austrians in the mountains.

He won Sardinia's independence in 1860, the year Piedmont was able to assimilate several northern duchies—those of Tuscany, Modena, Parma, and the Romagna. The next in line, in the sights of Italian nationalists, was to be the Kingdom of the Two Sicilies, comprising southern mainland Italy (its center, Naples) and the island of Sicily itself, ruled by the

Neapolitans. Garibaldi by now was quite resolved that the only hope for unification would be monarchy under Vittorio Emanuele.*

From Genoa, he planned an attack on Sicily and Naples, with the backing of Prime Minister Cavour, to be carried out with the covert support of the British. In May 1860, an expedition on two steamships set sail from near Genoa, carrying a thousand volunteers under Garibaldi's command.

The expeditionary force, under the name of I Mille (Italian for "The Thousand," volunteers drawn mainly from Lombardy and Venetia, otherwise known as the "Red Shirts"), landed at Marsala, in western Sicily, where Garibaldi announced that he was setting up a dictatorship over all Sicily in Vittorio Emanuele's name. The Mille won their first battle, against a two-thousand-man detachment of the Neapolitan army, at Calatafimi, in mid-May. Now Sicilians, previously uncommitted, began to join them—there were even desertions *en masse* from the Neapolitan army. Soon the Mille had increased to about four thousand men. Garibaldi laid siege to Palermo, Sicily's capital, and at the end of May his forces took the city. Other victories followed—Milazzo, Messina. By the end of September, resistance to Garibaldi in the Mezzogiorno had all but collapsed; Garibaldi's troops had crossed the narrow strait to the Italian mainland and occupied Calabria, against the advice of Cavour but to the delight of Vittorio Emanuele II. Louis-Napoleon's forces, which had been propping up the papal territories, now let the Piedmontese army come through from the north to lend decisive support to Garibaldi. Francis II, king of the Two Sicilies, was forced to leave his throne in Naples, transfer to the fortress of Gaeta, and eventually to seek exile in friendly Austria. In October 1860, a plebiscite formally confirmed the annexation of the Kingdom of the Two Sicilies to that of Sardinia, at which point it collapsed. The new Kingdom of Italy—an entity which at that point excluded Rome—was established in March 1861, with Vittorio Emanuele II as its king, proclaimed in Turin by the first Italian Parliament; Garibaldi handed over authority for southern Italy to the new king. He retired to his farm on the island of Caprera, a national hero, and declared himself ready to leave the rest of the work of unification to Vittorio Emanuele.

* Victor Emmanuel II (1820–78), eldest son of Charles Albert of Sardinia and Maria Theresa of Austria, had assumed the throne of Piedmont-Sardinia in 1849, following the abdication of his defeated father.

This did not happen, because many, in some places most, southern Italians refused to acquiesce to rule by Piedmont. More than half the national army of 120,000 men had to be sent, an army of occupation in all but name, to the Two Sicilies to repress the discontents of former Bourbon subjects. The strong Catholicism of southern peasants supported every kind of opposition to the new regime. At first the southern clergy supported the papal officials against Vittorio Emanuele—they were particularly incensed by new laws nationalizing church property. They angrily resented all efforts to strip the Papacy of its temporal possessions. When their efforts to frustrate the new policies failed, they resorted to encouraging "brigandage," which southerners merely saw as an expression of their territorial rights. Priests in their sermons openly referred to the brigands of the Mezzogiorno as their brothers. They preached that the Virgin would be bound to perform the miracle of driving the Piedmontese and their "usurping king" back where they belonged, to the north.

Many of the discontented southerners managed to take ship for America. The brigands who stayed mutated, in large part, into the Mafia, which could never have become such a strongly self-protective society without the repressions of Vittorio Emanuele II and the Piedmontese. The defiance of such repression was summed up in the practice of *omertà*, "manliness," or the code of silence—keeping one's mouth shut, never blabbing to strangers or, especially, to the *sbirri* or political cops, and above all never testifying to higher authority in court against anyone who was accused of anything at all. Cala Ulloa, the Bourbon who acted as "Prime Minister" of the Neapolitan government in exile, spoke in 1863 of the "rigorous and pitiless enforcement of martial law." The Piedmontese, however, "have kept Naples under martial law for six months; and Neapolitans are treated by them not as people fighting for their independence, but as slaves who have revolted against their masters."

Moreover, the pope in Rome would not get out of the way of unification. He was determined to hold on to the Papal States and viewed any effort to absorb them into a united single country of Italy as an atrocious trespass on his God-given rights. Garibaldi, however, living on his island, was determined to take Rome. So was Cavour, who in a speech in 1861 declared: "Rome is the only city in Italy with more than merely local memories. . . . Rome, Rome alone must be the capital of Italy. . . . We must go to Rome, but on two conditions: we must go there in agreement with France, and the true independence of the Pontiff must not be less-

ened. We must go to Rome, but civil authority must not extend its power over the spiritual order."

By now there seemed to be only three possible solutions to what had come to be known as the "Roman Question." Either the whole territory of what had been the Holy See would be reconquered by foreign troops and held for the pope, as they had been before 1849; or the pope's total loss of these dominions would be agreed upon; or a small amount of the former papal territory surrounding Rome would be assigned to the pope and protected by foreign troops. This last, with France as occupying guarantor, was now the case. The first was clearly impossible, and the second would never have met with Pio Nono's agreement.

In 1862, Garibaldi and his Red Shirts tried to assail Rome, but were beaten back before their march really got under way, although Garibaldi himself was shot in the foot. In 1864, the "September Convention" extracted an agreement from Napoleon III to withdraw his troops from Rome within two years. However, the people of Rome did not, as the republicans expected, rise against the pope. Instead, they fortified the French and papal armies. As a result, Garibaldi and the Red Shirts were beaten back at the Battle of Mentana, in 1867, in which six hundred Italian volunteers died. Once again, a march on Rome had been defeated. But the cause of Italian unification was not. In 1870, war broke out between France and Prussia, and the French armies were defeated at Sedan. This meant that the French forces had to be withdrawn from Rome, and in September 1870 the troops of Italy marched in and took their place. At long last, Rome became the capital of an Italy united under its new king, Vittorio Emanuele II.

Few Italians and no one outside of Italy seem to have regarded the new king as any kind of political genius. "Lazy, uncouth, jealous, petty, and boisterous," was a commonly echoed judgment, and British Foreign Minister George Villiers opined, "Vittorio Emanuele is an imbecile; he is a dishonest man who tells lies to everyone, he will end up losing his crown and ruining both Italy and his dynasty." He was certainly philo-progenitive. In addition to the eight children he had by his cousin Maria Adelaide of Habsburg (1822–55), he had several by various mistresses, two by his *maîtresse en titre,* or chief mistress, Rosa Teresa Guerrieri, two by Laura Bon, two by Virginia Rho, and various daughters by others less remarked. He was a decent patriotic man who seems to have deserved his popular nickname of *il re galantuomo,* "the gentleman king," but he left little trace of wit or thought behind him.

He did, however, strongly believe that Italy ought to be one country, with himself as its king, wily architect of unification Cavour as its prime minister, and the Papal States—along with the temporal, if not the spiritual power of their ruler, Pius IX—reduced to a cipher.

It would be idle to suppose that such political events were directly reflected in Italian culture, particularly in painting in Rome; it was mainly writers who got stirred by them. However, there was a rhyme, though not a causal connection, between what happened in nineteenth-century Italian painting (some areas of it, at least) and what was brewing in politics. But what was happening in art, for a change, did not start in Rome.

In the mid-nineteenth century, a group of ten or so artists formed in Tuscany. Their meeting place was the Caffè Michelangiolo in Florence, and their shared interest was in landscape. They were all opposed to the formal teachings of the Florentine Accademia delle Belle Arti and, in a general way, they supported Italian unification, as most young artists naturally did—Italian unification symbolized Italian freedom, a freedom they wanted every part of. After 1799, when Napoleon invaded Tuscany and expelled Austrian Grand Duke Ferdinand III, the official style of art in Florence was neoclassical in the French manner: David and later Ingres (who worked and taught in Florence from 1820 to 1824) were its models, and its seat was the academy. The chief ornament of this institution, who specialized in imperial commemoration, was the laborious history painter Pietro Benvenuti (1769–1844), whose biggest work for Napoleon was a painting of his victory at Jena in 1806, *The Oath of the Saxons* (1812). But younger artists were not so interested in replicating these neoclassical "machines." Gradually, the conviction grew among them that what counted more was direct truth to tone, expressed in chiaroscuro—the relations of light and darkness, described in tonal relationships of increasing clarity and simplicity, as seen in quite ordinary things. Because the painters—whose major figure was Telemaco Signorini (1835–1901)—expressed these relationships in terms of broad strokes and patches, they became christened (by a hostile critic, of course) Macchiaioli, or Splotchers.

It would be wrong to think of these young artists as provincials. They were not displaced Impressionists, but different kinds of painters entirely. Some of them visited Paris and were well aware of Impressionist developments; they also drew some of their impetus from photography, which in the 1860s was coming strongly into its own as a source for both urban and landscape painting. (The Florentine photographic firm

of Alinari Brothers, which supplied mementos and records to the once again increasing flow of tourists, saw its first developments in the 1860s.) Signorini went to Paris in 1868, '74, '78, '81, '83, and '84, partly to visit other painters (he counted Degas among his particular friends), and displayed a quite precocious modernity after a trip to Ireland with his painting *Leith* (1881), which is dominated by a huge theatrical poster glued to the wall of a general store—Pop Art long before its time. Nevertheless, there is nothing to suggest that he or any of the other Macchiaioli were impelled by political feelings to paint what was local or modern into their views of Italy. Some of them did enlist to fight for their belief in Italian unification; and Silvestro Lega (1826–95) painted squads of unification sharpshooters leading captives to imprisonment in Garibaldi's war against the Austrians in 1859. For the most part, though, politics came second to art.

The longest-lived and most prolific of the Macchiaioli was Giovanni Fattori (1825–1908). More than eight hundred oil paintings by him are known, most painted after 1861, and they all show a consistent, stubborn attachment to nature. But they have very little to say on Rome itself: Fattori's chief subject was rural, the landscape of the Maremma, to the north of the city. This was yet another instance of how far-reaching and vivid changes, even convulsions, in a society's political opinions may produce very little direct reactions in what its painters do.

But it is sometimes otherwise in architecture. Vittorio Emanuele II, the gentleman king, died in 1878 and was succeeded by his son, Umberto I. Spurred by Umberto's filial piety—an emotion not always so easy to tell apart, especially in Italy, from costly and displaced narcissism—the Italians now proceeded to plan and build the largest and most stupefyingly pompous memorial ever dedicated to a national leader in Western Europe. It is all the more remarkable because the late nineteenth century was a period of almost complete barrenness for Roman architecture. Apart from the monument to Vittorio Emanuele II, practically nothing that was built in Rome in the latter half of the nineteenth century repays more than cursory inspection. This monument is by far the largest act of architectural commemoration ever accorded to an Italian ruler, or indeed to an Italian of any kind, since the days of Julius Caesar. Nothing raised in memory of Dante, Michelangelo, Christopher Columbus, or any other world-changing Italian comes even close to competing with it in size or visibility. There are not many parts of Rome from which it cannot be seen, and few over which its white mass does not appear to loom—a

singular disproportion, given the personal mediocrity of the man it so crushingly celebrates.

It is 443 feet wide and 230 feet high, chopped and gouged with utter ruthlessness and a complete disregard for context into the flank of what had so long been regarded as one of Rome's most sacred ancient spots, heavy with history—the hill on which the Capitol stood, surmounted by Michelangelo's piazza with its statue of Marcus Aurelius, gazing down upon Piazza Venezia. Visually, it completely obliterates everything else on that hill. It is safe to say that, a hundred years later, it would have been quite impossible to clear the space for even a chicken coop there against the protests of conservationists, but the question hardly mattered then. The late nineteenth century was not the late twentieth and, in any case, Italians then had a more exalted idea of the importance of their own recent history than they do now.

Dozens of medieval buildings, and even some ancient churches, were accordingly flattened to make room for this cyclopean monster. Work on it began in 1884 and continued long past the death of its architect, Giuseppe Sacconi, in 1905; it was inaugurated in 1911 but not deemed completed until 1935. By then, Benito Mussolini—a man of pronounced architectural enthusiasms—was the absolute ruler of Italy, but Il Duce seems not to have interfered with Sacconi's almost insanely florid designs. They perfectly illustrate Alexander Pope's line on the new-rich lord's estate: "Lo, what great heaps of littleness abound!" The building contains the Tomb of the Unknown Soldier, complete with eternal flame, a body selected from a dozen equally anonymous and unrecognizable ones at the war's end by a bereaved Italian mother from Gradisca d'Isonzo. It also houses the Museum of Italian Unification, full of the clutter of busts, documents, maps, and weapons that one would expect to see there. School parties visit it from time to time, and some of the more energetic tourists manage the climb to the curved colonnade that crowns the enormous edifice, but it is not one of the more crowded institutions of the city—or one of the more beautiful, as some of its nicknames remind you. It has been variously known as the *macchina scrivere,* "the typewriter," for its resemblance to a vintage writing machine; as the *zuppa inglese,* "English soup," the common name for a cream-and-cake trifle; and the *torta nuziale,* or wedding cake; as the "false teeth," an allusion to its ever-dazzling whiteness; and, most popular of all, as the *pisciatoio nazionale,* or national urinal.

Not only is the national urinal the largest structure in Rome, its mate-

rials are absurdly conspicuous. Nothing can make it fit in. The general color of Roman buildings is ivory to buff to terra-cotta: the warm hues of tufa, brick, travertine, and other local materials. The stone of which the Vittoriano was made is not local at all. It is *botticino,* a corpse-white marble imported by rail and wagon, at great expense, from geologically distant Brescia. Neither in design nor in material does the typewriter look Roman, and in point of fact it is not. It is Greco-Teutonic. Its architect was certainly Italian, but his inspiration was the German architect Leopold von Klenze (1784–1864)—the obsessive and more than slightly bizarre neoclassicist who was court architect to Ludwig I of Bavaria. The origins of its style are political, and they lie within the Triple Alliance of the 1880s. In this treaty between Germany, Austria-Hungary, and Italy, which lasted until the outbreak of World War I, each Great Power member promised to support the others if one was attacked. The general Italian public was unenthusiastic about this. After all, Austria had been the proven enemy of Italian independence: it had shown itself to be a fiercely colonialist power.

Nevertheless, the white-column Greek-revival style of Klenze spread across Europe. Not only did he do the Glyptothek (sculpture museum) and the Alte Pinakothek in Munich, but he was commissioned by Nicholas I of Russia to design the New Hermitage in Saint Petersburg, and by Ludwig I's son Otto to make designs for the reconstruction of Athens, including the restoration of the Acropolis, so catastrophically damaged in 1687, when a stray Venetian mortar shell blew up the Parthenon, which was being used as an ordnance dump by the Turks.

Klenze provided a convenient—in fact, a virtually mandatory—template for a neoclassical building that sought to prove Italian links to the classical past. One of his favorite buildings was the second-century-B.C.E. Hellenistic altar at the Greek colony of Pergamon (modern Bergama) in Turkey, with its huge stone frieze of the Battle of the Giants, which had been torn asunder and looted by German archaeologists in the nineteenth and early twentieth centuries and shipped, section by damaged section, to Berlin. It consisted of a lower podium, which carried a 113-meter (371-foot) sculptural frieze of the battle between the gods and giants described in Hesiod's *Theogony;* on top of this massive base was an open colonnade.* The distant descendant of this weighty and magnificently deco-

* The narrative of gods versus giants probably symbolized the Pergamene conception of its own dynasty defending the Hellenic ethos against "barbarian" invaders from the North.

rated building was the speaking tribune Albert Speer designed for Adolf Hitler, facing the Zeppelin Field at Nuremberg (which mercifully lacks Nazi versions of the mighty Pergamene sculptures).

One of Klenze's adaptations of this Pergamon scheme was the U-shaped Ruhmeshalle (1850) in Munich, where he had built other Hellenic-style buildings in a lifelong effort to satisfy the insatiable Grecomania of his monarch. From this, with added memories of the Pergamon altar itself, Sacconi derived his design for the Vittoriano, which was even bigger than the Pergamon altar—some seventy feet longer in plan. Its main difference in layout from both the Pergamene original and Klenze's Ruhmeshalle is that its crowning colonnade is curved on a concave arc, not straight. It is liberally, indeed fulsomely, endowed with sculpture: not only a ten-meter figure of the Emanuele on horseback,* not only two victory goddesses driving quadrigae, but dozens of white bas-reliefs in *botticino* symbolizing the various districts and cities of Italy now united by the great political event, together with swags, cartouches, eagles, and other celebratory props. They remind the visitor how many skilled sculptors were working in Italy at the turn of the century, and how forgotten they all are—a lesson for today. Who now remembers those once-noted regional sculptors—Emilio Bisi, who did *Lombardy;* Italo Griselli (*Tuscany*), or Silvio Sbricoli (*Abruzzo*)—all contributed to what Sacconi called "the Valhalla of the Gentleman King"? The answer, alas, is nobody, just as nobody will remember most of our own contemporary art when it ceases to be contemporary.

The Vittoriano is also an anti-monument. It celebrates the first king of a united Italy, but, by implication, it marks the end of the temporal power of the Papacy. The last pope to wield this power, in its full measure, was Pius IX, and he was also the longest-reigning pope in the history of the Catholic Church: elected in 1846, he occupied the Fisherman's Chair until his death in 1878. Few popes came anywhere near this record, and none equaled it; they were usually men in their sixties when their reigns began.

Born Giovanni Maria Mastai-Ferretti, Pius IX began his papal incumbency as a liberal—or so many Catholics thought. Thus he showed sympathy—though not too much of it—for nationalist feeling in Italy, as long as it did not threaten the papacy or its holdings; he encouraged

* There are photos of the sculptors who worked on the project crammed, rather uncomfortably, around bottles of vermouth inside the cavernous belly of the horse, like tipsy Greeks approaching Troy.

the drafting of a constitutional framework for Rome, and freed a number of political prisoners who were under indictment from his predecessor, the ultraconservative Gregory XVI.

But such sentiments were not to last. Like many another powerful figure in that mid-century of vehement anti-clericalism, he began as a (relative) progressive, to the dismay and suspicion of the neighboring Austro-Hungarians. Though he did not encourage Protestantism, at least he did not denounce its faithful, and even allowed them to worship according to their own rites in the Holy City. He showed a serious interest in social reform within his own fief, Rome, where he began a program of street lighting and even established the first railroad, sometimes riding in public view in his own papal carriage—that ancestor of the modern "Popemobile." He even went to America before his election and was the first pope to have crossed the Atlantic, also visiting some of the South American republics as an assistant to the apostolic nuncio—a gesture that would pay dividends in the later American loyalty to Roman Catholicism. The figures speak: in 1846, there were some seven hundred Catholic priests in North America; by 1878, the country had six thousand.

Nevertheless, before long he began a shift that would take him far to the right. Political feelings in Italy and across Europe in 1848, the "year of revolutions," were too heated for him to do otherwise. There was nothing opportunistic about this. He genuinely felt the world was slipping away from the stability of the Faith, and felt impelled by conscience to oppose it. In France, there had been an uprising of the workers followed by the abdication of Louis-Philippe—who died the next year—and the election of Louis-Napoleon as president of the Republic. Revolution in Vienna had forced the resignation of Metternich. In Prague, Czech nationalist revolts were repressed by Austrian troops. Sardinia declared war on Austria. The nationalist Lajos Kossuth rose to power in Hungary.

Most pregnant with direct menace from the pope's viewpoint, however, revolt broke out in Rome. Pius IX's premier, the liberal Pellegrino Rossi, chief minister for the Papal States, was murdered in November on the stairs of the Vatican's exquisite Palazzo della Cancelleria, supposedly by medical students who had practiced on a corpse laid out for dissection in order to find exactly the right spot to strike for the jugular vein. The usually reliable Swiss Guards laid down their halberds, leaving the pope essentially unprotected in a Europe of growing nationalism—a barely credible thought, but a fact nonetheless, to which the pope responded by

going into exile. Garbed as an ordinary priest, he fled south to Gaeta, a fief of the Kingdom of the Two Sicilies, under the aegis of Ferdinand II.

The pope's departure ignited general rejoicing in Rome: a Roman Republic was proclaimed early in 1849, and huge firework displays lit up Saint Peter's Square on, of all blasphemous dates, Good Friday. Looting and vandalism of papal property followed. Pius responded from the safe distance of Gaeta by excommunicating everyone who had been involved in these outrages and by affirming his devotion to the Madonna, who, he believed, had saved his life. More to the practical point, the new French president, Louis-Napoleon, who had assured Pius of his unwavering support, sent French troops to Rome and crushed the embryo republic. They would remain there, as a peacekeeping force in support of Pius IX, for twenty years, causing a steady simmer of resentment among Italian nationalists, both in Rome and outside it.

It is sometimes thought that Pio Nono's pursuit of dogma was aimed to combat and reduce the effectiveness of non-Catholic belief. But it was not—not chiefly, anyway. Its main target was "liberal" opinions held within the Church itself. Nobody who was not a scrupulous Catholic already was likely to care deeply about a detailed, nitpicking document like the Syllabus of Errors, or to regard it as anything but a long list of ecclesiastical complaint and, indeed, desperation. Rather, it was a charter for what came to be called "ultramontanism."

Ultramontanism, meaning literally "adherence to ideas promoted on the other side of the Alps," referred to the geographical location of Rome as against the rest of the Catholic Church, and particularly in contrast to "Gallicanism," or things happening in France, which denoted non-Roman practices of other churches and the (in Pius' view) woeful tendency, verging on sinfulness, to give more importance to the traditions and opinions of national governments, national churches, and local hierarchy than to Rome. The ultramontane Catholic was strict, reflexively obedient, and in all things a dogmatist: an unwavering follower of Pio Nono. To him (or her), the views of national governments did not matter a straw compared with the eternal Truth embodied in papal policy. Thus it would not count if some national government—Ireland's, say, or Germany's—wished, under a grant of Catholic emancipation, to veto some episcopal appointment if it thought the candidate politically undesirable; a more flexible church could put up with that. Not now. Not any more. In particular, the astonishingly ill-timed Syllabus of Errors was aimed at what Pio Nono and the papal curia saw as the bale-

ful and enduring effects of the French Revolution, which had happened half a century before.

What were these "errors"? About eighty were listed. Some were of the most fundamental kind. It was an "error" (number 55) to think that "the Church ought to be separated from the State, and the State from the Church." It was an "error" to think that "the marriage tie is not indissoluble" and that civil authority had the right to grant divorces (number 67). It was an "error" to suppose that people who came to reside in some Catholic countries had the right to "enjoy the public exercise of their own peculiar worship," and that was as true for Baptists as for Mohammedans or, for that matter, fire worshippers. It was an "error" to hold that the Church lacked the power of "defining dogmatically" that its religion was the only true religion, or that it needed the "permission and assent of the civil government" to exercise its authority. And so on, for many clauses and many pages. The capstone was undoubtedly the last, number 80, which in simple purblind majesty pronounced that there was no way in which the Roman pontiff "can, and ought to, reconcile himself and come to terms with progress, liberalism, and modern civilization."

It is not often that one can say an official document gets everything wrong, but the Syllabus of Errors came as close to that exalted state as anything set forth by the Catholic Church since the death of Luther. To call it antediluvian is to understate its impact. It set Catholic orthodoxy in antagonistic relation not only to the cautiously growing liberalism of the *Zeitgeist*, but also with the contrary findings of science and recent philosophy from which it would take the Church generations to recover. Indeed, some would say, in light of the notorious conservatism of the present Pope Benedict XVI, whose habit is to attribute "virtual infallibility" to all papal utterances, that it has not recovered yet, and that the harm done by the syllabus was permanent.

Inevitably, many Catholic moderates saw it as a blow against the Church's "ablest and most eloquent defenders," who now, in the words of Odo Russell, the English government's representative in Rome, could "no longer speak in [the Church's defense] without being accused of heresy. . . . Silence and blind obedience must henceforth be their only rule of life." Many believed the pope had placed himself "at the head of a vast ecclesiastical conspiracy against the principles of modern society," which was indeed true. The French government, whose troops alone stood between the pope and the forces of the Risorgimento, banned the syllabus. "If we do not succeed in checking this senseless Romanism,"

wrote Archbishop Dupanloup of Orléans, "the Church will be outlawed in Europe for half a century."

People embrace religions with special fervor when they yearn for clear ideological security, and the effect of Pio Nono's definiteness was to make the Church more popular, not less, not only in Italy but in the rest of Europe, and in both North and South America. Religious bodies, both clerical and lay, expanded; the missionary scope of the Church, in Africa and Asia, increased. Pio Nono created over two hundred new bishoprics. The life of the Church in France, where it had been devastated by the Revolution, dramatically revived, producing the long outburst of faith and worship that led to a rash of church building and the growth of such popular Marian miracle cults as that of the healing spring at Lourdes. Given the choice, many people prefer forthright expressions of faith, however irrational and superstitious they may seem, to the qualified utterances of more cautious moral theology, and this received full scope from the papacy of Pius IX, whose syllabus condemned rationalism, socialism, and liberalism of all kinds. A lot of people hated him, but he was still an enormously popular pope. You knew where you stood with him when you were making the sign of the cross.

This helps explain the otherwise puzzling enthusiasm among Catholics for Pio Nono's views and teachings on the subject of the Virgin Mary, Christ's mother, and the prestige her cult enjoyed in Catholic worship during his reign. Little attention was paid to her, or her myth, by the early church. There is ample evidence for the historical existence of Christ. For that of his supposedly virgin mother, though, there is practically none. Obviously Jesus had a mother of some kind, but we know next to nothing about her, and her cult in the Catholic Church—including her much-invoked and incessantly lauded virginity, in all its stark unlikeliness—is an accretion for which there is no real Biblical sanction. "Mariolatry," the cult of the Virgin, is basically a variant—though a much-inflated one—of ancient cults of the Mythic Mother that long preceded Christianity. She first appears, in art, in third-century-C.E. catacomb pictures of the Annunciation and the Adoration of the Magi. These represent an effort to Christianize an existing pagan deity—Cybele, who had been worshipped originally in Asia Minor, but whose cult as the mother of the gods was brought to Rome in the early third century B.C.E. By imperial times, it had grown into a yearly celebration, linked to that of Isis, the Egyptian goddess of fertility, who had her own temple on the Campus Martius. From there it was

only a short step to the worship of Mary as the real mother of the god Jesus. This was reinforced by the supposed discovery in the Holy Land of an actual portrait of Mary painted by the Apostle Luke, patron saint of artists. This precious artifact, the so-called Hodegetria, was probably destroyed by the Turks in the 1453 Siege of Constantinople, where a special church, the Hodegon, had been built for it. (There were no physical relics of the Virgin Mary, since according to doctrine she had been "assumed" in her entirety into Heaven, so the Hodegetria was the closest thing to a sacred relic of her the Church possessed. Copies were made of it, one of which is in the Pantheon in Rome.)

Five years after the Syllabus of Errors was published, at the end of 1869, Pio Nono convened the assembly of bishops known as the First Vatican Council. Its purpose was to defeat the "Gallicists" by centralizing power and authority in the hands of the pope and the papal curia, and in this it was spectacularly successful. The big question being decided was papal infallibility. Could the pope, speaking *ex cathedra* ("from the throne," meaning with the full official weight of his position, on vital matters of dogma), actually err? Or would God intervene to prevent him from doing so? When the votes were counted, God was clearly in favor of "inerrancy," though not without a lot of heavy politicking from the pope and his curia. Pio Nono bullied the bishops relentlessly. Some 350 of the eight hundred or so bishops attending the council meetings were financially dependent on the Vatican, and they were told in no uncertain terms that any dissent from Pius IX's line would bring a complete cutoff of funds. There was no secret balloting. One French delegate, Bishop Félix Dupanloup, confided to his journal, "I'm not going to the council any more. . . . The falsity, vanity, and continual lying force me to keep my distance." The modern Catholic theologian Hans Kung, who was appointed official theologian for the Second Vatican Council in 1962, thought that the First Council "was so severely compromised" that its infallibility doctrine was null. "Painful and embarrassing as it may be to admit, this council resembled a well-organized and manipulated party congress rather than a free gathering of Christian people." Kung would argue that the pope got infallibility translated into dogma for four reasons. "Pius IX had a sense of divine mission which he carried to extremes; he engaged in double dealing; he was mentally disturbed;*

* "Mentally disturbed" is perhaps too strong, though the pope did suffer from a well-attested and much-discussed affliction: epilepsy.

and he misused his office." Ludicrously but unsurprisingly, the Church in 1979 banned the impeccably scholarly Kung from ever teaching theology in its name.

It says much about Pio Nono's priorities that, having forced through the vote on papal infallibility, he should only have made one other infallible utterance, and that it concerned the Virgin Mary. This was in 1854, when he defined the dogma of the "immaculate conception"—the belief that Mary, as perfect mother of the Redeemer, had been conceived without the burden of "original sin." That inheritance of collective guilt for the fall of Adam and Eve, which the sacrament of baptism was believed to lift from every human soul, had never been laid upon her; she was a completely innocent being, as befitted the mother of God. Needless to say, this was pure fantasy, as statements about those of whom so little is known are apt to be. Nevertheless, it became, and remains, Catholic dogma, and a column commemorating it was raised in Piazza di Spagna. Later, Pius XII, another committed Mariolater, would go further and define, as dogma, the belief that Mary had been saved from earthly corruption by being "assumed," taken up body and soul, into Heaven. Perhaps she was, but so far the sight of those pristine blue robes in outer space has eluded the world's observatories. (One assumes the robes would be there; the image of a naked virgin in perpetual orbit is hardly thinkable.)

The life and actions of Pius IX confront the church historian with an apparent paradox, for, despite his innate and growing conservatism, Pius IX's papacy marks the beginning of a modern church: he successfully negotiated the difficult passage of the Church away from temporal power toward purely spiritual dominion, and did so without loss of institutional dignity. For this he was hated in some quarters—during his burial services, a rabble of Italian nationalists tried, but failed, to seize his body and throw it in the Tiber. (This was by no means the first time that such violent disrespect had been thrust on a dead pope. Long before, when papal elections had been more nakedly in the hands of rival factions, the badly decayed corpse of Pope Formosus [reigned 891–96] was disinterred and pulled from his coffin; the fingers with which he had given so many blessings were chopped off; he was dragged through the streets, pelted with ordure, and flung in the river; not content with this, the Roman mob threw his successor, Stephen VII, into prison and strangled him there.)

No such violence was inflicted on Pio Nono. He had enemies, of course, but was still much beloved and badly missed by most Italians,

and by non-Italian Catholics as well. There had been a strong popu-
lar move to persuade him to institute constitutional government in the
Papal States, but it had come to nothing—Pius held out for the uncon-
ditional restoration of papal rule. If there was one principle on which his
secular power was set, it was that constitutional government would never
be allowed in the *papato*, the "popedom" or in the Papal States. Pius'
personal following was such that he could do whatever he wanted. He
died "in the odor of sanctity," as the phrase went, leaving behind him an
incalculably more popularized church.

In some ways, the man who did most as pope to carry on Pio Nono's
legacy was his successor's successor, Pius X, a realist who recognized that
further recriminations between the Church and the Italian state were
going to produce very little for either side. He stopped publicly call-
ing the state a usurper of the Church's rights (though what he privately
thought of the matter is unknown). Giuseppe Melchiorre Sarto (1835–
1914) was a man of humble origins, one of ten children fathered by a
village postman in the Veneto. By no stretch of the imagination could
he have been called an intellectual, but this proved not to matter much,
and may even have been an advantage: he had a sure instinct for religious
populism, and used it to the full. He saw himself as a "pastoral pope," in
direct contact with his flock. He was, in fact, a sincerely charitable man;
when a disastrous earthquake hit Messina in 1908, he opened the doors
of the Vatican to its homeless victims, putting the secular government of
Italy to shame. Perhaps his most famous saying was "I was born poor, I
have lived poor, and I wish to die poor."

Pius X's special mission, as he saw it, was to expand the living church
by recruiting the devotion of children, through participation in the
sacraments. In a pastoral letter written as patriarch of Venice, he com-
plained, "God has been driven out of public life through the separation
of Church and State, now that doubt has been raised to a system. . . . He
has even been driven out of the family, which is no longer consid-
ered sacred in its origins." The remedy for this was divine obedience.
"When we speak of the Vicar of Christ, we must not quibble. We must
obey; we must not . . . evaluate his judgments, or criticize his directions,
lest we do injury to Jesus Christ himself. Society is sick. . . . The one hope,
the one remedy, is the Pope." He wanted Catholic doctrine to impose
conformity on the Church, and he would have nothing to do with "mod-
ernism," meaning any kind of synthesis between late-nineteenth-century
currents of thought and the supposedly immutable teachings of the

traditional church. The only theology eligible to be taught in Catholic schools and seminaries was that of the medieval philosopher Thomas Aquinas. Hence he would not back the nascent Catholic Action movement, a society of lay Catholics attempting to propagate Catholic influence on society, because even that suggested too much independence by the faithful. Theological debate within the Church was stifled until the reign of Pius XII, when it began to make a shy and tentative reappearance.

In the past, children had been ten to twelve before making their First Communion and lisping out the record of their tiny sins to the priest in the confessional. Pius X decreed the lowering of this age to nine or even seven, thus replicating the traditional boast of the Jesuits, "Give me a child until he is seven, and I will give you the man." Boys at their First Communion must wear sashes and rosettes; girls, white dresses and veils. It was a very popular "reform," increasing the sacramental theater of childish faith and pleasing all devout parents. It also increased the frequency with which Catholics went to Confession, a necessary prelude to Holy Communion.

Pius X, like his namesake Pio Nono, saw no reason to accommodate simple faith to scientific theories, or to Biblical interpretation. He made his views, and the conservative policy of his church, clear in 1907 in an encyclical letter, *Pascendi Dominici Gregis,* and the decree *Lamentabili,* and the effects of his conservatism would be felt by the Church for some fifty years, right through the papacy of Pius XII. The use of the Index of Forbidden Books now became common, indeed general, throughout the teaching and administration of the Church. All in all, Pius X's papacy spelled hard times for Catholic intellectual life. The threat of excommunication hung menacingly over it. "Liberal Catholics are wolves in sheep's clothing. Therefore the true priest is bound to unmask them. The Church is by its very nature an unequal society. The hierarchy alone moves and controls. . . . The duty of the multitude is to carry out in a submissive spirit the orders of those in control."

Pius X urged his flock to "be proud" of being called "papists, retrogrades, and intransigents." He refused to accept France's 1905 Law of Separation between church and state—which eventually deprived the French Catholic Church of all government funding, and ended with an official diplomatic break between the French government and the Vatican. His chief intellectual foe within the Church was Father Alfred Loisy, principal theologian at the Institut Catholique in Paris, whose widely cir-

culated book *The Gospel and the Church* argued that the findings of radical Biblical criticism dissolved the Protestant threat to faith by dismissing Biblical literalism as merely naïve, because they implied that there was no getting back behind the tradition of the Church to an "unmediated" Christ.

He did, however, spell certain liturgical reforms which the Church needed. Italian church music had been invaded by opera, stressing bravura passages and ensemble instrumentation. Pius would have none of this secular stuff, and in 1903 he called for a return to the ancient tradition of plainsong and the classical polyphony of the Counter-Reformation, especially in the *Kyriale, Graduale,* and *Antiphonary.* Pius favored a return to Gregorian chant. He also explicitly forbade women to sing in church choirs.

This was all very well, and he backed it up with a program of restoration of dilapidated churches—always a problem in the Eternal City, which by now was beginning to seem not very eternal—that did little but good.

Initially, he even forbade Italian Catholics to vote, on the grounds that the Italian state, being secular, had made the pope a "prisoner in the Vatican," and that to vote at all for a secular state which had confiscated the enormous papal domains would be to acquiesce in it. But later, when it became obvious that neither Victor Emmanuel nor any elected Italian politicians who valued their votes were going to tolerate backsliding on the issue, this was relaxed. From now on, the size of the papal domains would remain tiny—although the numerical size of the Catholic Church would be enormous, and ever-growing.

This softening on the voting issue did not imply a softening in papal doctrine. In 1907, Pius X formally condemned some sixty-five propositions regarding the nature of the Church and the divinity of Christ as wrong and heretical, and soon afterward compelled all priests to take a sacred oath against modernism in general. "Modernism" was an extremely wide-ranging term. As understood by Pius X and his curia, it meant any effort to square the ideas of more recent philosophers, such as Immanuel Kant, with the traditional teachings of the Church. Such attempts were viewed with horror by theological traditionalists like Pius X, because they implied that the Church's teachings on faith and morals were neither eternal nor immutable. Gradually the battle lines between church orthodoxy and modernism were firming up.

11

Futurism and Fascism

Poets have seldom had political influence. There were few exceptions to this in the twentieth century. In England, none, except Rudyard Kipling. In America, none at all. In Russia, one might mention Vladimir Mayakowsky. But the outstanding figure in this regard was Italian: a bizarre, hyperactive, and fantastically egotistical writer named Gabriele D'Annunzio (1863–1938), a man hell-bent on turning himself into a living legend, and one who succeeded, though most writers who try it fail.

He had been born in Pescara, on the Adriatic coast, and raised in the Abruzzi, then a brutishly backward part of Italy, with a tiny educated elite and an illiterate, superstitious majority of peasants. This seemed to be the eternal order, and contempt for the masses was to be the mainspring of D'Annunzian politics. His father, Francesco Paolo, was an intelligent, loathsome bully, whose contempt for the underdog was fully inherited by his son. The world, he wrote, was divided into masters and slaves, with nothing in between:

> To the superior race, which shall have risen by the pure energy of its will, all shall be permitted; to the lower, nothing or very little. The greatest sum of well-being shall go to the privileged, whose personal nobility will make them worthy of all privileges. The plebeians remain slaves, condemned to suffer. . . .

All his life, D'Annunzio would be pursued by the specter of his own provincial origins and by that of his piggish father's sexual opportunism: sex wasn't real sex unless it was also rape. He married young, but almost

as soon as he got to Rome, in 1881, to seek his literary fortune, he dumped his Abruzzese wife in favor of a string of socialites, whores, *principesse*, and actresses, culminating in his prolonged affairs with the two most famous tragediennes of the day, Sarah Bernhardt and her Italian rival, Eleonora Duse. (The wife would presently commit suicide by jumping from a window.) His bed-hopping was ruthless. There was nothing modest about the transfiguration D'Annunzio expected of his sex life: "The work of the flesh is in me the work of the spirit, and both harmonize to achieve one sole, unique beauty. The most fertile creatrix of beauty in the world is sensuality enlightened by apotheosis."

D'Annunzio practiced most kinds of writing, with increasing public success. He started publishing his juvenilia—verses and short stories—when he was sixteen; to get publicity for his first book of verses, he sent the newspapers a fake report of his own death in a fall from a horse. He wrote a series of novels, beginning in 1889 with *Il piacere* (*The Child of Pleasure*), followed in 1891 by *L'innocente* (literally "the innocent one," but appearing in English translation as either *The Victim* or *The Intruder!*), *Giovanni Episcopo* (1892), *Il trionfo della morte* (*The Triumph of Death*, 1894), *La vergine delle rocce* (*The Virgin of the Rocks*, 1896), and *Il fuoco* (*The Flame of Life*, 1900). Most of these were best-sellers in Italy, and some in France, where D'Annunzio had also developed an avid following. He was constantly in trouble with the Italian clergy, building a hypnotic reputation as a decadent and a sex maniac, which did his sales no harm at all. *Il fuoco* was a *roman à clef* based on D'Annunzio's scandalous and hugely publicized love affair with Sarah Bernhardt. Bernhardt had also prompted him to turn to the theater, with noisy if variable success. His two great dramatic hits, *La città morta* (*The Dead City*, 1898) and *Francesca da Rimini* (1901), were written for her as their tragic heroine.

In addition to the plays, the novels, and several collections of lushly decadent and hortatory verse published around the turn of the century, D'Annunzio collaborated with the composer Claude Debussy on a musical play, *The Martyrdom of Saint Sebastian*, and even wrote a screenplay for a silent movie based on *Salammbo*, Gustave Flaubert's lurid novel about the fall of Carthage. He also has the distinction of being the only poet in history after whom an airport is named—the Gabriele D'Annunzio Airport, in Brescia.

His poems had their moments, but most were of an old-fashioned sort, echoing English writers like Swinburne, Rossetti, and Keats, and tailor-made for the *fin-de-siècle* fascination with erotic necrophilia:

> As from corrupted flesh the over-bold
> Young vines in dense luxuriance rankly grow,
> And strange weird plants their horrid buds unfold
> O'er the foul rotting of a corpse below . . .

You would hardly guess that such sticky period pieces were written by a contemporary of Pound and Eliot. A little of this stuff went a long way, even in the 1890s, and most of it is so overdone in its theatric "decadence" as to be barely tolerable, even in Italian, a century later. D'Annunzio was addicted to aesthetic posturing; the aesthete-hero of his novels was invariably a projection of himself into the domain of fiction, with all its room for exaggeration. Andrea Sperelli, the protagonist of *Il piacere*, the novel D'Annunzio published at the age of twenty-six, is the young embodiment of Art for Art's Sake. "Art! Art!" he sensitively rants to himself.

> This was the faithful Lover, ever young, immortal. This was the Fount of pure joy, forbidden to the multitude, conceded to the elect; this was the precious sustenance that made man like a god. Having set his lips to that cup, how could he have drunk at any other?

What moved D'Annunzio into the full Italian limelight was not his writing alone, with its relentless emphasis on self-gratification at any cost to others, but his singular aggression and personal bravery. This included a real understanding of mass media and what they could do for a career. D'Annunzio wrote, and was written about, everywhere: he was the only Italian writer, other than the Futurist Filippo Marinetti, who could make headlines in London and New York as well as Rome or Milan.

Whatever one might say about the qualities of his verse—and some of it, allowing for the conventions of the time, was passably good, although the prose strikes a modern eye as unreadably florid and self-regarding—there is no doubting his ardor and toughness as a man. As soon as World War I broke out, D'Annunzio quit Paris—where he had gone partly in pursuit of Sarah Bernhardt, and partly to escape his growing legion of creditors—and returned to Italy, where he agitated ceaselessly in articles, verses, and speeches for Italy's entry on the side of the Allies. He believed that war would rehabilitate his country in foreign eyes: that Italian aggression would cancel his homeland's annoying image as the mother of waiters, tenors, and ice cream vendors. He learned to

fly, lost an eye in a landing accident, and reached the climax of his aeronautical career in August 1918, when, with considerable bravery—one should remember that the thing was done in a biplane with an open cockpit and no parachute—he led a squadron of nine fighters from the Eighty-seventh Squadron on a seven-hundred-mile round-trip flight from an airfield near Venice to drop propaganda leaflets on the city of Vienna. The Austrian capital had no anti-aircraft guns, but the *volo su Vienna* was still a spectacular achievement that cemented the poet's reputation in Italy as a daredevil, one of the heroes of the early age of Italian aviation.

By the war's end, D'Annunzio was seen by his own countrymen (and swooning countrywomen) as a modern *condottiere*, with wings and a Fiat aero-engine instead of a horse. This matched his own opinion of himself: totally without modesty, he was a relentless tuft-hunter, a chaser of awards, citations, and medals for bravery, which he sought (and got) not only from Italy but from other Allied countries as well. He briefly heightened this reputation by actually capturing some territory; D'Annunzio's nationalist feelings, like those of many Italians, were offended when at the Paris Peace Conference it was proposed that the ethnically Italian northern city of Fiume be handed over to a newly formed political entity, Yugoslavia. He therefore recruited two thousand hard-core nationalist irregulars, Italian citizens of Fiume, and forced the withdrawal of the British and French occupying forces that were in control of the city.

The Italian government, however, refused to accept Fiume and demanded that D'Annunzio and his men surrender. This the poet refused to do. Instead, he declared that Fiume was now an independent state, a sort of Monaco-on-the-Adriatic, ruled and led by himself. He ran it as a military dictatorship, and during this time he invented and put to use a number of devices that were later adopted by Mussolini and the Italian Fascists, ranging from black shirts to forcing dissidents to drink castor oil as a humiliating punishment. Eventually, the Italian government, vacillating, weary of D'Annunzio's strutting but uncertain what to do about a national poet-hero, set up a naval blockade. Matters grew tenser by the month. At one point, D'Annunzio had Fiume declare war on Italy, one of the more splendid examples of a mouse that roared in modern European history. Fiume even issued postage stamps with his head on them and the motto *Hic manebimus*—"Here we shall stay." Finally, at the end of 1920, the Italian government had no choice but to accept the

declaration and commence a naval bombardment of Fiume, taking care to inflict as little death and damage as possible.

It was all diplomatically resolved in the end. Fiume, no longer a city-state, remained Yugoslavian and then was absorbed into Croatia (it is now known as Rijeka). D'Annunzio went back to his home on Lake Garda and resumed his literary and erotic careers. He never again went into formal politics, though he campaigned vigorously from the sidelines and behind the scenes. But this activity was somewhat curtailed by injuries after he fell, or was pushed, from a window in 1922. The legacy he left was one of political theater, but it was powerful and became more so when it was taken up by Benito Mussolini. It was D'Annunzio who first made popular the Roman salutes, the black shirts, the speeches from the balcony, the marches and "oceanic" demonstrations that we associate primarily with Il Duce—a title, not incidentally, that the poet wanted to reserve for himself. He was the first writer, one might say, to grasp the relations between crowds and power. This would make him a valuable role model for the young Mussolini after the war. D'Annunzio's main theater was Rome, where he showed an unfailing gift for stirring up street riots and demonstrations against Italy's prime minister, the cautiously neutralist Giovanni Giolitti, with inflamed and inflaming speeches about how the time for words had gone, the time for action arrived. This, too, would be noted and copied by Mussolini. Did more cautious souls object to these hot harangues? *"Me ne frego,"* was D'Annunzio's response: "I don't give a toss." It became one of the nationally popular catch phrases of Fascism.

D'Annunzio was himself not a Fascist. He was close to leading anti-Fascists and, in 1922, was better known to many Italians than Mussolini himself. He had the dirt—which never became fully public, but always threatened to—on the 1924 assassination of the socialist deputy Giacomo Matteotti, who had attempted to annul the elections won by Fascism because of their voting irregularities. D'Annunzio was greatly admired by the Fascists for his choreography of demonstrations and crowd scenes. Mussolini begged him to help Fascism, but all he got in reply was a letter reproving him for stealing D'Annunzian ideas.

It was hardly a surprise, therefore, that Mussolini, after he came to power, treated this national icon with kid gloves. If you have a rotten tooth, the Duce explained, you either pull it out or fill it with gold; D'Annunzio had to have the second treatment, for otherwise he might

become too dangerous. Mussolini got the king to give D'Annunzio the title of "Principe di Montenevoso," the Prince of Snowy Mountain, which of course the poet lost no opportunity to flaunt. Mussolini publicly financed a magnificent edition of D'Annunzio's writings, promoted by the government, on which the poet was paid a 30 percent royalty, earning a million lire a year from 1924 to 1938—a time when a lira was still a lira. And he gave D'Annunzio a villa on Lake Garda, Il Vittoriale degli Italiani, which became a memory palace of D'Annunzian achievement, narcissism, and, above all, kitsch. It can still be visited, and, for its spooky, vulgar intensity, it deserves to be. From the ceiling of a music room is suspended the fragile biplane in which D'Annunzio made his celebrated flight over Vienna, dropping leaflets in the summer of 1918. Its other exhibits include the *Puglia,* a torpedo cruiser on which D'Annunzio had once patrolled the Dalmatian coast, which was moved intact to dry land, to the cypress gardens overlooking the lake. From time to time, her bow guns used to be fired, in salute to the poet's genius. They no longer are, because after nearly a century they (like his verses) have run out of ammunition.

In the gloomy and pretentious spaces of the Vittoriale, D'Annunzio conducted the last, rather sordid and perfunctory affairs of his long amatory career. Women were still falling over one another to reach his bed. It never occurred to D'Annunzio that men should not live off women. Bernard Berenson, who knew D'Annunzio somewhat, liked to tell the story of a silver-haired, highly respectable, and immensely rich American woman of advancing years who, seized with the desire to add D'Annunzio to her conquests, let the poet know (through a go-between) that she would pay most generously for a night with him. The poet's response was to ask, "Is she white all over?"

The D'Annunzian style strongly affected both Futurism and Fascism. Futurism was a culture-bound movement with pretensions to affect everyday life. Its leader was Filippo Tommaso Marinetti—"the caffeine of Europe," as he liked to style himself. He was born in Alexandria, Egypt, in 1876. His father, Enrico, was a successful corporate lawyer who lived with, but never married, his mother, Amalia Grolli. Unlike most of the poets, musicians, and artists in his circle, he was never short of money. For him, private income meant freedom, as it does for most people lucky enough to have one: he never had to swerve from the self-appointed mission of changing the world merely in order to earn a crust, and his attacks on middle-class complacency were made all the bolder by his own

class security. As the ringmaster of cultural novelty in Europe, he needed to be everywhere—not only Rome, where he and his family kept a large apartment, but Paris, Saint Petersburg and Moscow, Zürich, Berlin, London, and especially Milan, his chosen home. Such mobility cost money, and Marinetti was one of the few modernists—certainly the only Italian one—who had plenty of it.

He had been schooled by Jesuits, which may well have contributed to his sense of confident exception. This was confirmed when his Jesuit teachers expelled him for cultural rowdiness: he had been passing around copies of Zola's realist novels.

Another factor which seems to have put him at an angle (as one may mildly call it) to middle-class assumptions was his affiliation with Africa, through his Egyptian childhood. Marinetti deeply wanted to be seen as an exotic, and he played it up. *"Vulgare Greciae dictum,"* Pliny the Elder had written in his *Natural History, "Semper aliquid novi Africam adferre"*: "It is commonly said by Greeks that something new is always coming out of Africa." This could well have been Marinetti's motto, and it explains the frequent references to the prowess of "Negroes" (as he called Africans, in the usage of the day) in his writings. Africans were imagined as tough, energetic, fearless, and never at a loss when it came to surprising and disconcerting Europeans. They were, in that sense, natural avant-gardists, which was how Marinetti saw himself. Unlike Picasso, Matisse, or Derain, he was never influenced by the "primitive" art of Africa. He was a writer and performer, not a painter. It is quite possible, though, that there was a link between the languages and chants of the Dark Continent, as imagined by Marinetti and other intellectuals, and the nonsense onomatopoeia of "words-in-freedom" that was to become an important part of Marinetti's poetic strategies. Like some other Europeans who wanted to display their difference from the common herd, he liked the bone-in-the-nose, ooga-wooga picture of African savagery.

His father sent him to Paris to study for his *baccalauréat,* which he got in 1893. Then he came back to Italy and enrolled in the Faculty of Law at the University of Genoa, from which he graduated in 1899. But he was never to practice law. Instead, he lived the life of a young literary *flâneur,* writing poems, essays, plays, and, with increasing regularity and skill, practicing journalism in Italian and French. More and more, he gravitated toward literary and artistic circles in Rome, Turin, and Milan.

The movement called Futurism was launched with an essay written in French by Marinetti and published, as befitted its international intent,

in Paris in 1909. From then on, the production of manifestos was going to be Marinetti's chief art form: nobody in the European cultural world, except for D'Annunzio, had a stronger instinctive talent for publicity or could excel him at hectoring.

Certain images recur in his work, and in that of his fellow Futurists. They are almost all mechanical, and polemically modern. "The world's magnificence," he wrote,

> has been enriched by a new beauty: the beauty of speed. A racing car, whose hood is adorned with great pipes, like serpents of explosive breath—a roaring car that seems to ride on grapeshot, is more beautiful than the *Victory of Samothrace.*

For many people, this is now true. At the very least, it is not difficult, more than a century after this manifesto was written, to find both the sculpture and the machine beautiful, though not in the same way. But in 1909, such sentiments seemed, to cultivated Europeans who read them, blasphemous and almost diabolical—they amounted to a contradiction of the "proper" order of aesthetic experience, because the car was not beautiful *at all,* whereas the sculpture was *nothing but* beautiful.

The car, object of what one writer called "autolatry," was the prime Futurist icon, the emblem, the spectacular object of desire. The only thing that compared to it was the airplane, then (in 1910) in its very early, pioneering stage of development, the Wright brothers having achieved heavier-than-air flight under power in 1903. The airplane of early Futurist dreams was merely a Blériot monoplane, of the kind that had recently made it across the English Channel. Trains and fast motorboats also figured, but they never approached the automobile, whose rapid progress under personal control (or lack of it) seemed to Marinetti and other Futurists to confirm the belief of Henri Bergson (1859–1941), one of their favorite philosophical writers, that reality was in constant flux: car travel presented the driver and passengers with one level of experience rapidly overlapping another, so that the total impression had more to do with *collage* than with a static view. Consequently, Futurist writing and painting, when it turned to cars, was always highly personal—the "I" is in the driver's seat—and invariably centered on exhilarated feelings of directional energy and rapid change. Needless to say, this arose at a point in history, around the first decade of the century, when the roads were clear of other cars and that emblem of automotive culture, the traffic jam, did not yet exist. What can it have been like to drive a fast car around an Ital-

ian city, at night, in those days before the invention of the traffic light? Marinetti's first Futurist manifesto tells us his version, in a stream of Mr. Toad–like rantings.

It is 1908. He has been up late into the night with two friends, auto-maniacs like himself, bloviating about life and culture, when they hear "the famished roar of automobiles." " 'Let's go!' I said. 'Friends, away! Let's go! . . . We're about to see the Centaur's birth and, soon after, the first flight of Angels! . . . We must shake the gates of life, test the bolts and hinges.'" This kind of rodomontade would rank high on anyone's list of Invocations That Were Probably Never Invoked (though, with Mari-netti, it is hard to be sure): in any case, they are soon down at their cars, the "three snorting beasts, to lay amorous hands on their torrid breasts." Off they go, vroom-vroom, in a sort of mechano-sexual delirium. "Like young lions we ran after Death. . . . There was nothing to make us wish for death, unless the wish to be free at last from the weight of our cour-age!" But, alas, some cyclists appear, blocking the road; and Marinetti and his leonine friends have to avoid them. His car plunges upside down into a ditch, baptizing Marinetti in sacramental filth. "O maternal ditch . . . Fair factory drain! I gulped down your nourishing sludge; and I remembered the blessed black breast of my Sudanese nurse. . . . When I came up . . . from under the capsized car, I felt the white-hot iron of joy deliciously pass through my heart!"

There is more, much more, in this vein; no one could accuse Marinetti of terseness. One can have a certain sympathy with the annoyed Italian writer who, when asked if he didn't agree that Marinetti was a genius, retorted, "No, he's a phosphorescent cretin," but in fact he was less than the first but a good deal more than the second. Sometimes he could be perfectly idiotic, as in his call to glorify war, "the world's only hygiene," along with militarism, and patriotism; or in his ludicrous exhortations to fill the canals of Venice with the rubble of its demolished palaces. "Let's Kill the Moonlight" was the title of one of his more famous anti-romantic manifestos. And he positively loathed John Ruskin's views on art, nature, and (inevitably) Venice. He asked his English audience in a speech at the Lyceum Club in London in 1910:

When, when will you disembarrass yourselves of the lymphatic ideology of that deplorable Ruskin. . . . With his morbid dream of . . . rustic life, with his nostalgia for Homeric cheeses and legend-ary wool-spinners, with his hatred for the machine, steam power,

and electricity, that maniac of antique simplicity . . . still wants to sleep in his cradle and feed himself at the breast of his decrepit old nurse in order to recover his thoughtless infancy.

This must be one of the stupidest diatribes ever launched against Ruskin, but perhaps its defects are ascribable to the limitations of Marinetti's English. Though he was certainly no feminist, he said he stood for "the semi-equality of man and woman and a lessening of the disproportion in their social rights," which put him ahead (or semi-ahead) of most Italians. He had an acrid realism, sometimes, which contained some hard nuggets of truth: he wanted to see

> Disdain for amore (sentimentality or lechery) produced by the greater freedom and erotic ease of women and by the universal exaggeration of female luxury . . . Today's woman loves luxury more than love. A visit to a great dressmaker's establishment, escorted by a paunchy, gouty banker friend who pays the bills, is a perfect substitute for the most amorous rendezvous with an adored young man. The woman finds all the mystery of love in the selection of an amazing ensemble . . . which her friends still do not have. Men do not love women who lack luxury. The lover has lost all his prestige.

Sad, perhaps, but indisputable. Marinetti was an enthusiastic womanizer; if you believe his account of adventures among the beauties of Moscow and Saint Petersburg on a Russian lecture tour, he was an irresistible sex god. The preferred attitude of Futurism toward women in general was to see them as primordial forces rather than rational beings. "Let every woman rediscover her own cruelty and violence that makes them turn on the defeated," exhorted a Futurist manifesto in 1912. "Women, become once more as sublimely unjust as every force of nature!" There were, of course, no woman artists in the band of brothers who enlisted their talents around Marinetti's peculiar charisma.

As he aged, Marinetti drew closer to the big movement that was developing in Italy: Fascism. Of course, he would not have seen it that way: rather, his view was that the Fascist leaders, including Mussolini himself, drew closer to him, needing the inspiration that only he personally and Futurism in general could provide. In 1918, the political party Marinetti founded, the Partito Politico Futurista, merged with Mussolini's Fasci di Combattimento. Mussolini himself did not have strongly partisan views on visual arts other than architecture, but he was certainly not going

to echo the psychotic hatred of modernism as a Jewish plot that animated Hitler and his cultural lieutenants. He never showed any interest in importing Nazism's exhibition "Entartete Kunst" ("Degenerate Art") to Italy, or encouraging his own people to construct and curate an Italian equivalent. The reason was simple: Mussolini, at first, was not anti-Semitic, and in any case (as he put it in 1923*), with regard to art, "the State has only one duty: not to undermine art, to provide humane conditions for artists"—in short, to get out of the way. Hitler might loathe Futurism, but how could Mussolini do so? Marinetti succeeded in persuading Mussolini not to import the "Entartete Kunst" show to Italy. He also protested, successfully at first, against the copying of Nazi cultural anti-Semitism by Italian Fascists. As the twenties moved on, Marinetti became more tolerant still: he accepted election to the Italian Academy, tried (but failed) to have Futurism declared the official state art of Italy, took a hand in promoting religious art, and declared that Jesus Christ had been a Futurist—which, given Jesus' more excited and apocalyptic predictions about the transformation of human life in the world to come, may not have been so far off the mark. And no one could say Marinetti himself did not want to practice what he preached: the man who praised war as the world's necessary hygiene volunteered (but was not accepted) for active service in World War II, when he was past sixty.

Of the artists associated with the Futurist group and promoted by Marinetti, the most talented were three men: the painters Gino Severini (1883–1966) and Giacomo Balla (1871–1958), and the sculptor-painter Umberto Boccioni (1882–1916).

Along with these, one should probably include a fourth, a musician whose work can no longer be assessed because the special instruments for playing it have long disappeared: Luigi Russolo (1885–1947), who was the spiritual ancestor of such eccentric modernists as the English composer Cornelius Cardew. Russolo's belief was that nonmusical sounds, as from industry, machines, or traffic, could have as much aesthetic value as traditional sounds made by stringed or wind orchestral instruments; his specialty was constructing what he called *intonarumori*, "noise machines." At this first concert, at the Gran Teatro del Verme in Milan in 1914, eighteen of these devices were divided into howlers, cracklers, gurglers, thunderers, hissers, exploders, buzzers, and crumplers. Under

* While opening an exhibition of the Novecento (twentieth-century) Italian Group, organized by his mistress, the freelance curator and art dealer Margherita Sarfatti.

a hail of vegetables from the indignant audience, they played three of Russolo's compositions, including his *Convention of Automobiles and Airplanes.* Other recitals, evoking an equally gratifying anger, were given in London and Paris. Russolo pronounced himself "satiated" by Beethoven and Wagner; now, he said, "we find far more enjoyment in mentally combining the noises of trams, backfiring motors, carriages, and bawling crowds than in rehearing, for example, the *Eroica* or the *Pastoral.*" Unfortunately, none of Russolo's noise machines have survived, and we have only the sketchiest idea of what sounds they may have produced.

Gino Severini was the creator of one of the major Futurist icons, the congested, jazzy, frenzied panorama of nocturnal pleasure, *Dynamic Hieroglyphic of the Bal Tabarin* (1912). Giacomo Balla, who taught painting to both Severini and Umberto Boccioni, was quite widely recognized as an artist by the time he joined the Futurists, and he gave the movement its most popular image, the disarmingly humorous *Dynamism of a Dog on a Leash* (1912). This must rank high among the few core-modernist paintings that are good for a laugh and which almost everyone can recognize—the charming vision of a dachshund, tail a-wag and little legs going frenetically, trotting along the pavement at the feet of its owner. The paintings Balla laid most store by, however, were those of a speeding car. Some were very big—*Abstract Speed* (1913) is fully eight feet wide—and they are suffused with the bellowing romanticism of Marinetti's first manifesto, full of force lines and violent, dynamic curves.

Such work was greatly indebted to photography. The main inspiration was the work of Étienne-Jules Marey (1830–1904), the French scientist who has the strongest claim to be the father of modern cinema. Eadweard Muybridge, to study the movement of humans and animals, had set up a battery of cameras side by side in order to capture isolated phases of movement as single images. Marey, on the other hand, used film strips so as to capture on one negative the successive movements of a subject seen from a single point of view by one lens which followed its trajectory. This, not Muybridge's sequences, was the true ancestry of the movie camera.

Boccioni's is an instructive case, because his best-known (and best) surviving work, *Unique Forms of Continuity in Space* (1913), is a striding sculpture based upon the very one Marinetti thought inferior to a racing car—the ancient Greek *Victory of Samothrace.* Its flanges and scooped-out hollows obey Boccioni's conviction that "Sculpture must

make objects live by rendering their extensions in space sensible, systematic, and plastic, for no one can imagine that one object ends where another begins. . . . The pavement can rise up onto our table . . . while between your house and the other your lamp spins its web of plaster rays." But it also illustrates the fact that it is very difficult, and for most talents impossible, to create a work of art that is 100 percent new in the way the Futurists prated about novelty. Everything has precedents, and their presence does not reduce the intensity of a work of art. Boccioni made at least a dozen sculptures in the same vein which suggest this kind of interpenetration of object and surrounding space. Old photos suggest they are among his most beautiful and complex works, but nearly all of them were destroyed by rain when they were carelessly left outside after his posthumous retrospective of 1916–17. They instinctively accept what contemporary physicists such as Einstein had come to perceive as the truth, however esoteric it might seem at first: that matter is, ultimately, energy. Part of the sculptor's task was to find solid form in which this could be symbolized.

Boccioni despised most contemporary sculpture as derivative, dull, and coarse—"a spectacle of barbarism and lumpishness." But he made exceptions, chiefly for the Italian sculptor Medardo Rosso (1858–1928), "who tried," he argued, "to enlarge the horizon of sculpture by rendering into plastic form the influences of a given environment and the invisible atmospheric links which attach it to the subject." Unlike more highly regarded sculptors of the time, with passéist influences—Constantin Meunier (Greek), Antoine Bourdelle (Gothic), and Auguste Rodin (Italian Renaissance and especially Michelangelo)—Rosso was "revolutionary, very modern, more profound, and of necessity restricted." Unfortunately, his attachment to light Impressionist modeling "deprives his art of any mark of universality," but he is much more than a start toward what Boccioni calls "a sculpture of environment."

Boccioni was a painter (not "too"), and he struggled to create images of "universal vibration" which took Impressionist light beyond its normal descriptive aims. He learned much about this from the pointillist paintings of Georges Seurat and Paul Signac. Signac was especially congenial to the Futurists, because he was an anarchist, a foe of all established orders, hence an ally of Marinetti's ideas of overthrow and radical change. Some of Boccioni's paintings, conceived in terms of "divisionism" (as the dot painting that derived from Seurat and Signac was called in Italy), appear

to be deliberate illustrations of passages from Marinetti's Futurist manifestos. "We will sing of great crowds excited by work, by pleasure, and by riot; we will sing of the multicolored, polyphonic tides of revolution in the modern capitals. . . . " And there was Boccioni's *Riot at the Galleria* (1910), with its jagged confusion of figures struggling under the blinding glare of a café's glass doors. Boccioni's masterpiece in this divisionist vein was a canvas of industrial work, *The City Rises* (1910–11), originally titled *Work,* inspired by the sight of heavy industrial construction on the outskirts of Milan. The painting is dominated by an enormous red horse, seemingly half dissolved into flakes and smears of light. The blue hitching horn of its harness rises up aggressively to center the composition. The draft horse strains forward against its hauling cables, as do the human workers that it dwarfs, with the kind of exaggerated effort that will become a commonplace in strip cartoons; its point of departure in "fine art" is probably Tintoretto's *Raising of Lazarus* in Venice.

Futurist architecture had been imagined, but the only Futurist architect who mattered built nothing. His work survives solely on paper: in the small, beautifully rendered drawings he made for architectural projects that existed in his head but had no commissioning client. Antonio Sant'Elia was born in 1888 and, having bravely volunteered to fight in the war which Marinetti and his friends had exalted as "the world's only hygiene," was killed in an Austrian attack at Monfalcone, in northern Italy, in the summer of 1916; he was twenty-eight years old, and his death may be numbered among the culturally unhealable losses of that conflict, along with those of Franz Marc, Umberto Boccioni, August Macke, Henri Gaudier-Brzeska, Guillaume Apollinaire, Wilfred Owen, and a host of others whose names can never be known because they died too soon for their talent to have a chance to make a mark.

Even the efforts to commemorate Sant'Elia failed. He was buried in a cemetery which he had designed for his unit, the Arezzo Brigade; it no longer exists, and his grave is lost. The Futurist painter Enrico Prampolini and the chief architect of Fascist high modernism, Giuseppe Terragni, joined to design a monument to him, and to the dead of World War I, in the cemetery at Como. (Terragni's canonical building, the Casa del Fascio, is also in Como, though after World War II it was shorn of the portrait of Mussolini which adorned its façade.) The monument is based on Sant'Elia's own designs for larger structures (powerhouses, apartment blocks, and factories), but done at a puny scale, far too small to achieve much impact. For those who have studied Sant'Elia's original drawings,

many of which are only a few inches square, it does not matter; since those structures never existed, these drawings are his monument, and a most effective one.

A lot of ingenuity has been expended, mostly by Italian critics, to dissociate Sant'Elia's ideas from those of Marinetti, and one can easily understand why: Marinetti's tolerance for Il Duce, which sometimes approached the level of an intellectual love affair (though a doomed one, in the end), besmirched his postwar reputation and tended to hurt that of his associates. But Sant'Elia was killed before Mussolini's ideas were even born, and long before Marinetti's semi-conversion to them took place in the 1930s. Nothing suggests that Sant'Elia harbored the totalitarian ideas of Fascism, or expressed them in his architecture—though the designs were certainly meant for mass use and occupation. If anything, he was a young socialist. (It is still common for some critics, residually enthralled by the promises of radical socialism, to prefer its ideology to that of Fascism—even though the left, when it achieved power, could be and was as brutal to aspirations of freedom as the right.)

What Sant'Elia and Marinetti had in common was an ecstatic sense of the possibilities of the modern city—a mighty switchboard of information, manufacture, and perception, a social turbine hall, humming away, almost without human interference. To look at the multilevel cities Sant'Elia imagined, with their vast stepped skyscrapers, aerial terraces, bridges, and overpasses, is to see the excitement of a supposed future applied to architecture:

> We must invent and rebuild the Futurist city like an immense and tumultuous shipyard, agile, mobile and dynamic in every detail; and the Futurist house must be like a gigantic machine.* The lifts must no longer be hidden away like tapeworms in the niches of stairwells; the stairwells themselves, rendered useless, must be abolished, and the lifts must scale the lengths of the façades like serpents of steel and glass. The house of concrete, glass and steel, stripped of paintings and sculpture, rich only in the innate beauty of its lines and relief, extraordinarily "ugly" in its mechanical simplicity . . . must soar up on the brink of a tumultuous abyss: the street will no longer lie like a doormat at ground level, but will plunge many stories down into the earth, . . . linked up for necessary inter-

* Compare Le Corbusier's famous somewhat later characterization of a house as *une machine à habiter.*

connections by metal gangways and swift-moving pavements. *The decorative must be abolished.*

It is unlikely that even Sant'Elia himself could have said what went on in those buildings, space by space, function by function. They are like the cinematic dreams of Fritz Lang—*Metropolis* raised to a high level of aesthetic sophistication. But they pack a romantic wallop, as visionary architectural designs can—and there had been nothing as potent, in Italian architecture, since the (equally unbuilt) fantasies of Piranesi. Perhaps, if they had been built, they might not have lasted well. On the other hand, their erosion and decay might not have displeased the Futurists, who liked the idea of temporary architecture anyway, because it accorded with their love of speed and impermanence. They distrusted "massive, voluminous, durable, antiquated and costly materials." They hoped to see architecture as a "rigid, light and mobile art," in Umberto Boccioni's words—although the buildings in Sant'Elia's drawings often look as solid as Egyptian mastabas. In 1914, Sant'Elia declared in a manifesto* that "the decorative value of Futurist architecture depends solely on the use and original arrangement of raw or bare or violently colored materials"—and such materials, as one knows from Le Corbusier and his "Brutalist" offspring, get very grotty very quickly. But since they existed only on the utopian space of paper, this could not be put to the test. Their extrusion into the world of built architecture was not foreseen by Sant'Elia, who had long been dead when it happened, and it would undoubtedly have repelled him. The ideas—at least, his ideas for the single building—were taken over and given a glitzy, theatrical form by two American architects in the 1970s and 1980s—Helmut Jahn with his skyscrapers in Chicago, and John Portman, the architect-developer of huge hotels with see-through glass-pod elevators zipping up and down, making a drama (which quite soon gets tedious, even for the tourists in the lobby) of vertical circulation.

Painting, sculpture, poetry, theater, and architecture were not the only arts that attracted Futurist attention. Because Futurism was meant to be all-embracing, a template for the life to come, it should also—Marinetti insisted—embrace food. Food was not "subsidiary." The Futurist, not to coin a phrase, was what he or she ate. To start with, this required a

* Though there is some debate about the exact extent of his authorship and the names of his collaborators, if any, the content of the 1914 *Manifesto of Futurist Architecture* could not have existed without Sant'Elia.

new use of language, one which was fully Italian and not "corrupted" by linguistic borrowings from elsewhere. What most Italians called a *sandwich,* for example, became in Futurist-speak a *traidue* (between-the-two). There would be no more *bars;* they would be replaced by *quisibeves* (here-one-drinks), and staffed not by *barmen,* only *mescitori* (mixers); what they mixed were not *cocktails* but *polibibite* (multiple drinks). If the Futurist wished to hop in his roaring, rampaging, bellowing, farting, prophetic six-cylinder Fiat and take his girl for a spin in the countryside, they would eat not a *picnic* but a *pranzoalsole* (meal-in-the-sun).

But Marinetti and (probably to a lesser extent) his brothers in Futurism were not content with mere shifts of vocabulary, which, in any case, never took hold in Italy or anywhere else (much the way not many people are heard ordering "freedom fries" today). They wanted to change the Italian diet by eliminating *pastasciutta* from it—all forms of macaroni must go and never come back. A more doomed and futile enterprise could scarcely be imagined. Pasta is a sacred food throughout Italy. In Rome there is even a museum of pasta, dedicated to the hundreds of varieties of it, from angel-hair strands to big sheets for *timballi* of the kind so lovingly described by Giuseppe di Lampedusa in *The Leopard,* from pinhead-sized semolina pasta to floppy pouches designed to contain ricotta, spinach, or purées of chicken in *balsamella.* It is the universal democratic food *par excellence,* as pizza and hamburgers are in America.

The very idea of launching an attack on a substance so bound up with Italy's self-image must have seemed like a kind of cultural suicide. But Marinetti hated pasta. He thought it made Italians gross, lazy, complacent, stupid, and, worst of all, unfit for combat. The mayor of Naples could and did go on record as saying that the very angels in Heaven ate *vermicelli al pomodoro,* but that cut no ice with Marinetti. "Since everything in modern civilization tends toward elimination of weight, and increased speed, the cooking of the future must conform to the ends of evolution. The first step will be the elimination of pasta from the diet of Italians."

His hatred of pasta came from his army service on the Austrian front. "The Futurists who fought at Selo, on the Vertoibizza . . . are ready to testify that they always ate the most awful pasta, delayed and transformed into a cold, congealed mass by the artillery barrages of the enemy, which separated the orderlies and the cooks from the warriors. Who could have hoped for hot pasta *al dente?*" Wounded at the Case di Zagora in the May 1917 offensive, he was brought down on a stretcher to Plava, where

a soldier cook gave him "a miraculous chicken broth . . . [although] terrible Austrian shells were crashing down on the battalion kitchen and smashing his stoves. Marinetti had his first doubts then on the suitability of pasta as a food for war." He had observed that the bombardiers, who were firing their mountain howitzers against the Austrians, never touched the ignoble stuff. Their usual sustenance was "a lump of chocolate smeared with mud and sometimes a horse meat steak, cooked in a frying pan that had been washed out with eau de cologne." Chocolate, eau de cologne, horse meat: already the elements of Futurist recipes, which depended so heavily on discord, on the flight from traditional harmonies, were assembling as substances of "heroism" in Marinetti's mind.

In an interview he gave sometime later to an Italian journalist, Marinetti railed against pasta. "Ugh! What piggish stuff, macaroni!"

> To get the message across, paintings, prints, photographs, and everything that happens to depict it must vanish from our houses; and publishers must recall their books from the shops to subject them to rigorous censorship, deleting without pity. . . . In a few months just hearing its name spoken—macaroni, ugh!—people will throw up. The task is colossal. To destroy something only one hand is needed to light the fuse, but to rebuild it [as a cuisine adapted to our times] thousands and thousands of hands are necessary.

Another journalist, writing in the French newspaper *Comoedia* in the early 1930s, echoed Marinetti by blaming *pastasciutta* for the "languid sentimentalism" with which "eternal Rome, from Horace to Panzini, has defied the passing of time":

> Today we need to remake the Italian man, for what point is there in having him raise his arm in the Roman salute if he can rest it without effort on his bulging stomach? Modern man must have a flat stomach. . . . Look at the Negro, look at the Arab. Marinetti's gastronomic paradox aims at education.

So what would Italians of the future actually eat? "This Futurist cooking of ours," trumpeted Marinetti, "tuned to high speeds like the motor of a hydroplane, will seem to some trembling traditionalists both mad and dangerous; but its ultimate aim is to create a harmony between man's palate and his life. . . . Until now men have fed themselves like ants, rats, cats, or oxen. Now, with the Futurists, the first human way of eating is born."

Thus the "Aeropainter" Fillia (the pseudonym of the Torinese art-ist Luigi Colombo) proposed what he termed "Aerofood." The diner is served from the right with black olives, fennel hearts, and kumquats; to his left, a waiter places a rectangle made of sandpaper, silk, and velvet, which he strokes as he eats, enjoying the contrasts of taste and texture. As he eats, waiters spray the back of his neck with a *conprofumo* of carna-tions while, from an unseen source in the kitchen, the violent roar of an aircraft motor (*conrumore*) and some musical accompaniment by Bach (*dismusica*) are heard. Thus all the diner's senses will be mobilized, to ecstasy. Another invention of Fillia's was a dish called "the Excited Pig": a crazed phallic pun consisting of a whole salami, skinned, standing erect in a dish containing very hot black espresso mixed with "a good deal of eau de cologne." A third was titled "Hunting in Heaven." Slow-poach a hare in *spumante* mixed with cocoa powder. When the liquid is absorbed, dunk the creature in lemon juice, and serve it in a "copious" *salsa verde* based on spinach and juniper, decorated with silver pellets suggestive of huntsmen's shot. The artist Enrico Prampolini, also an Aeropainter, came up with an elaborate proposal for a dish he called "Equator + North Pole." Poach an "equatorial sea" of golden egg yolks, from which will rise a cone of stiffly whipped egg white; bombard the peak of the cone with slices of black truffle "shaped to look like black airplanes." This sounds, at least, conventionally edible, unlike the sexual-metaphor dish proposed by the very minor Futurist art critic P. A. Saladin, "ManandWomanat-midnight." Make a large pool of red *zabaglione*. Arrange on it a "nice big onion ring," transfixed by a stalk of candied angelica, and two candied chestnuts, presumably symbolizing the midnight lover's *coglioni*.

These dishes, and quite a few others of equal weirdness, appear to have been served at Futurist soirées, in Rome and elsewhere, organized by Marinetti. It is not known how well they were liked, and one may presume that not a few passéists among the invited guests may have sighed for a nice bowl of *spaghetti alla Bolognese*. Nevertheless, the Futur-ists briefly had their own restaurant, though it was in Turin: the Santo Palato, or Holy Palate, at 2 Via Vanchiglia. It did not last long, but it served such post-industrial delicacies as "Chickenfiat"—a large fowl, first boiled, then stuffed with steel ball bearings, sewn up and roasted "until the flesh has fully absorbed the flavor of the mild steel balls." It was served garnished with whipped cream, and preferably handed around by "the woman of the future," who would be bald and wearing spec-tacles. Though the Holy Palate was not a commercial success, Marinetti

kept it going for a while to make a point. Its supreme dish—which was also served at Futurist dinners in Rome—was called "sculpted meat," *la carne scolpita*. This was a large cylindrical rissole of minced roast veal, stuffed with eleven kinds of cooked green vegetables. Something must have stuck it together to prevent slumping (perhaps a very stiff bécha-mel?), but we are not told what. It stood upright on a plate, supported by a ring of sausages which rested, in turn, on three golden spheres of chicken meat, and was crowned with a layer of honey. It claimed to be "a symbolic representation of the varied landscapes of Italy."

Just as Futurist efforts to reform the language of food had resulted in substituting lengthy polysyllables for short words, so the food itself had become absurdly elaborate, far beyond the reach of any domestic kitchen, and none too edible in any case. And yet, if one reads its descriptions, it does seem to have something in common with the crazier fantasies of extreme New Cuisine, as practiced by such celebrity cooks as the Cata-lan Ferran Adrià. Gustatory fantasists like Fillia represented an absurdist revolt against the vernacular food-philosophy of the great normalizers of Italian cuisine, such as Pellegrino Artusi, whose book *Science in the Kitchen and the Art of Eating Well* had gone through numberless editions by then and was regarded as the bible of authentic cooking.

One may well ask, what part did the city of Rome play in the develop-ment of Italy's one and only important modern-art movement? In fact, a very important one. To Futurists, it represented the Enemy—historical consciousness, and all that was summed up in the term "passéism," wor-ship of the past. The Futurists hated the place for its immense authority, its age and continuity, and of course for its beauty, which they were most reluctant to recognize. Of course, to rail against the long achievements of thought, feeling, and technique that were summed up in the monuments of Rome was inevitably to look like a beetle whining about a pyramid: it was going to stay in the way, so get used to it. But they could indulge their fantasies. One Futurist publication ran a drawing of what Piazza di Spagna might look like without such passéist encumbrances as Bernini's Barcaccia Fountain—in the background, the familiar shapes of Santis-sima Trinità dei Monti and the obelisk above the familiar three-stage rise of the Spanish Steps; in the foreground, an ugly blank piazza full of electric streetcars and overhead wires. This was supposed to be Progress.

Of all places on earth, Rome was the one where operatically phrased invective against the past sounded tinniest. The *Manifesto of Futurist Architecture* said its authors (mainly Sant'Elia, with input from Marinetti

and probably Boccioni) would "combat and despise" all classical architecture, along with "the embalming, reconstruction, and reproduction of ancient monuments," all perpendicular and horizontal lines, all cubical and pyramidal forms. That more or less took care of everything from the Etruscans to the Vittorio Emanuele monument—2,500 years out the window. No wonder Marinetti and his allies preferred the industrial cities of the north, Milan and Turin.

If Cola di Rienzo, in the fourteenth century, was the first proletarian to rise to great political power in Rome, then Benito Mussolini in the twentieth century was the last.

The parallels between the two men are irresistible: the humble working-class origins, the force of character and oratorical power, the belief in oneself as the chosen figure of destiny. Cola was obsessed with the belief that the ancient glories of the Roman Empire could be reincarnated in him and revived under his rule. So was Mussolini, on an even more grandiose scale. Both men had strong charisma and called forth surging, weeping extremes of fanatical loyalty from their massed followers.

Both regarded themselves, and were for a time seen by their fellow Italians, as inspired tribunes of the people, although Mussolini (astutely, for his own political purposes) refused to promote the kind of class hostility to the rich and titled that marked Cola's politics, because that idea reeked of communism and he needed the support of the rich and powerful.

Each had his intellectual allies and supporters: Cola had the (episodic) backing of the greatest of Italy's humanist writers after Dante himself, Petrarch; and whereas no Italian writer of that stature was at work in the 1920s and '30s, Mussolini had a mentor and literary figurehead in Gabriele D'Annunzio. Both came to sticky ends: Cola lynched by a mob under the shadow of the Ara Coeli in Rome, Mussolini shot by communist partisans and strung by the heels from the awning of a gas station in Milan. And although there is little doubt that Cola (in his less spiritually exalted moments) was a nicer guy than the ruthless and staggeringly narcissistic Mussolini, the two men incarnated a style of operatic, self-dramatizing populist leadership that still seems peculiarly Italian and, truth to tell, still makes many Italians feel nostalgic.

Benito Amilcare Andrea Mussolini was born under the sign of Leo on July 29, 1883, in Dovia di Predappio, a small village in Emilia-Romagna. His father, Alessandro Mussolini, was a blacksmith and a committed anti-clerical socialist. His mother, Rosa Maltoni, was a schoolteacher. He

was the eldest of three children. His names bore a heavy load as political emblems: "Benito" after the Mexican radical Benito Juárez, "Amilcare" from an Italian socialist, Amilcare Cipriani, and "Andrea" from another Italian socialist, Andrea Costa. Predappio only figures in Italian popular culture because Mussolini was born there, and various *canzoni* on the later left stemmed from that:

> *Se Rosa, illuminata de alma luce,*
> *La notte in cui fu concepito Il Duce,*
> *Avrebbe, in lo fabbro predappiano,*
> *Invece della fica, presentato l'ano,*
> *L'avrebbe preso in culo quella sera*
> *Rosa soltanto, ma non l'Italia intera.*

"If Rosa, lit up by divine light / The night The Leader was conceived / There, in the forge at Predappio / Had presented her anus instead of her twat / The one who got it up the ass would be / Just Rosa—not the whole of Italy."

Young Benito helped his father in the forge; just as there had been nothing false about Adolf Hitler's claims to have served devotedly and bravely at Ypres, so Mussolini's frequent accounts of being a son of the working class were quite true. Just as his father was a passionate socialist, so the son was stubbornly rebellious and a sometimes violent delinquent at his priest-run boarding school. One gesture that made him particularly unpopular with the local citizens was to station himself in plain view outside the village church in Predappio and pelt its worshippers with stones as they filed out after morning Mass. He was bright, his grades were good, but because of his surly and easily inflamed temper, he had difficulty finding and keeping work as a schoolteacher when he graduated. In 1902, he moved to Switzerland, with no better luck. His adherence to socialism and his general rowdiness caused him to land briefly in jail, and finally to be deported as an unemployed alien. Back in Italy, he at last fetched up in journalism in 1908, editing the Trento Socialist Party's newspaper, *L'avvenire del lavoratore* (*The Worker's Future*). Trento was under the control of Austria-Hungary, which did not take an indulgent view of either Mussolini's anti-clericalism or his choleric attacks on Austrian royalty. Eventually, Mussolini was deported from Trento, back to Italy proper, where he got a writing and editing job with the socialist newspaper *Il popolo*, followed by another with the more leftist organ *Avanti!* But, despite his opposition to the war with Austria,

Mussolini was called up by the draft in mid-1915. In all he served about nine months under fire in the trenches, until he was severely wounded by an accidental mortar-bomb explosion and, in 1917, invalided out of active service.

It took the Great War to disabuse young Mussolini of his father's dreams of socialism. This catastrophically divisive conflict, this huge international machine for the production of corpses, had put paid to the ideals of voluntary class cooperation across national boundaries that had suffused the socialism of a previous generation. There would be no peaceful *internationale* in the bright future. Instead, there would be struggle, unremitting and pitiless, whose result would be the abolition of the idea that class war could or should define society's shape. "Socialism as a doctrine was already dead," Mussolini later wrote. "It continued to exist only as a grudge." What could Italy raise in place of this unrealizable dream? An authoritarian system that would unify the country as ancient Rome had once unified it.

Some of the raw material for such a system already existed in Italy, and in fact had been created by the war. It consisted of the *squadristi,* or returned soldiers, the army veterans who could be expected to respect Benito Mussolini as a former comrade-in-arms. They had fought on the winning side, that of the Allies against the Germans, but this could not wipe out the sufferings they had undergone, their dislike of those who had opposed the war (which included most socialists), their contempt for noncombatants—still less the feeling that they had been short-changed in the peace. The solidarity of men-at-arms, in an army drawn from all classes of life, far outweighed the socialist rhetoric of class solidarity.

Mussolini started assembling such an elite. For the workers, he promised a minimum wage, more power for industrial labor unions—which was quick to disappear once Mussolini was firmly in the saddle—and more rights for women. For bosses and bankers, who feared the communists and socialists more than any other groups, he offered protection from the Red Menace. This was a shrewd and essential move, since it ensured that he could appeal to them for financial support, just as Hitler could in Germany. The emblem of the party was the ancient Roman *fasces,* the bundle of rods bound together around an ax that had been carried as a sign of strength and unanimity by the Roman lictors—hence the term *fascismo.* The strong arm of the party was organized by Dino Grandi, an army veteran whose groups of *squadristi,* identifiable by their quasi-military *camicie nere,* black shirts, made them increasingly feared

and obeyed throughout the Italian cities and even, by the late 1920s, in country villages. The Fascists refused all alliances with existing parties of the left, and of the right as well. Wisely, they always declared their own uniqueness and independence. They were the *terza via,* the "third way," toward national self-sufficiency. Not surprisingly, this group, small at first, swelled into a full-fledged party, the National Fascist Party, within a couple of years, and in 1921 its leader, now known to more and more of his adherents simply as Il Duce, won official standing by being elected to the Chamber of Deputies. In this and the Fascist rule that followed, Mussolini was greatly helped by the man who would become, in effect, his minister of propaganda and chief image-counselor, Giovanni Starace, appointed in December 1931.

Starace was to the Duce what Goebbels was to Hitler, and just as active in terms of inventing a ruling style. It was he who conceived and organized the "oceanic" demonstrations of tens of thousands of Romans in Piazza Venezia, beneath the Duce's speaking balcony with its hidden podium; he who instituted the "salute to the Duce" at all Fascist meetings, large or small, whether Mussolini was present or not; he who abolished the "insanitary" handshake in favor of the "hygenic," snap-to rigidity of the arm-out, Roman-based Fascist salute. He even stood at rigid attention, heels clicked together, when speaking to his leader on the phone.

And he made sure that the orchestrated cheers of the crowd were directed only to Mussolini: "One man and one man alone must be allowed to dominate the news every day, and others must take pride in serving him in silence." Under Starace, uniforms multiplied into a veritable cult; some leading Fascists were required to have ten or even twenty, without a thread of gold braid missing. (This afforded great contrast to British modes of diplomatic dress, which featured the chalkstripe double-breasted suit and the much-ridiculed rolled umbrella *à la* Chamberlain.) In launching the movement which became known, in 1921, as the National Fascist Party, the Duce hinted privately to socialists that he would support them if they were ready to back his brand of populist dictatorship—a lie, but a welcome one to them. Meanwhile, Mussolini and his men hugely inflated the numbers involved in the 1922 March (or Train Ride) on Rome to 300,000 armed Fascists, of whom, they claimed, three thousand paid for their fervor with their lives. The king was deceptively told that the army was outnumbered by Fascist militiamen and could not possibly defend Rome.

From this point on, there was no stopping either the Duce or Fascism. They took over and reaped all the credit. The 1930s seemed to millions of people, and not just to Fascists, miracle years for the image of Italy in general and Rome in particular. Catalyzed by the sensations of Futurism, Fascism seemed really to have taken off, in all areas. Faster, higher, farther! Italy had the world's fastest seaplane, the supremely elegant Macchi MC 72. Lindbergh had flown the Atlantic, but the gifted pilot Italo Balbo, a brute in some respects though indisputably a brave and gifted pilot, leading a squadron of nine twin-engine seaplanes, flew it twice, in 1931 and 1933, between the lagoons of Orbetello, north of Rome, and Lake Erie in Illinois. In 1931, Italy launched the world's fastest transatlantic passenger steamer, the *Rex*. The prestige of Italian cinema seemed likely (at least to the Italians) to be overtaking that of Hollywood, and in 1932 the first Venice Film Festival was held. In 1934, Italy won the world soccer championship, and the playwright Pirandello, an undoubted Fascist in his idiosyncratic way, was awarded the Nobel Prize. The enormous Italian boxer Primo Carnera, the King Kong of the ring, won the world heavyweight championship by beating the American Jack Sharkey in 1933. (Boxing, one should remember, was then widely rated by Italians even higher than soccer; Mussolini called it an "exquisitely Fascist means of expression.") Guglielmo Marconi's inventions in radio and wireless telegraphy were eclipsing those of Thomas Edison. The new models of Italian machinery—both office and domestic—coming off the drawing boards of Necchi and Olivetti were having their impact on a growing world market.

Perhaps none of these events was quite as epochal as the ever-growing Fascist propaganda machine made them out to be, but together they contributed to a sort of collective exaltation, close to national hysteria. Once, there had been England. Then there was America. And now the technological genius of Italy apparently ruled. It was no longer the land of old canvases, moldy domes, and chipped statuary. It was the country of the Future, presided over by a man who was, in Italian eyes, hardly less than a demigod, a modern successor to the ancient Roman god-king Augustus. The most extreme fantasies of Marinetti and the Futurists, thanks to Il Duce, seemed to be coming true in Fascism. It even had a leader who could vaunt his athletic prowess. The newspapers and magazines of Italy were enlivened by photographs of Mussolini and the officers of his *Bersaglieri* actually jogging, a sight which would not be repeated for another half-century, and in America—though a big differ-

ence was that Il Duce jogged in full uniform, wearing riding boots and an officer's cap, accompanied by brother officers carrying swords and wearing medals gained in the war against the Ethiopians. The Fascists understood media and propaganda, too. Any country that threatened sanctions against Italy for its bellicose policies against Ethiopia, and later Republican Spain, might be ridiculed with such images as a poster of a small naked boy pissing on the word "sanctions." "Better one day as a lion than a hundred years as a sheep," ran a much-cited slogan, but the lion's day was expected to last forever. "If you eat too much, you're robbing your country," proclaimed a poster that showed a slim, determined cop tapping a greedy diner on his shoulder.

A tough, slender, muscular Italy was part and parcel of the new national image promoted by the Abyssinian (also known as the Second Italo-Ethiopian) War. Behind the uniforms, the slogans, and the taste for violence, what did Fascism actually stand for? Was it only another name for social delinquency, as softies and lefties claimed? Mussolini, with some help from his co-author Giovanni Gentile, addressed the question in an entry for the *Italian Encyclopedia* in 1932. First and foremost, it had to be understood that Fascism was not a pacifist movement, seeking an end to aggression. Quite the opposite. "Fascism . . . believes neither in the possibility nor the utility of perpetual peace. . . . War alone brings up to its highest tension all human energy and puts the stamp of nobility upon the peoples who have courage to meet it. All other trials are substitutes." That was what Marinetti had been writing a quarter-century before: war as race hygiene.

Fascism conceives of the state as absolute, the individual as relative. And so it can have no traffic with the "Liberal State," which feebly exalts "all useless and possibly harmful freedom." The meaning and utility of freedom can only be decided by the state, never by the individual citizen. Fascism consecrates the idea of empire. Its growth is "an essential manifestation of vitality, and its opposite a sign of decadence. Peoples which are rising, or rising again after a period of decadence, are always imperialist; and renunciation is a sign of decay and of death." So it was with Italy, which was rising once more "after many centuries of abasement and foreign servitude."

If this rhetoric might seem cloudy, one could always try the aging Marinetti's descants on "Fascist poetry," written by way of an introduction to a 1937 anthology assembled by a Sicilian bard, *Il Duce and Fascism in the Dialect Songs of Italy:*

Just as religious poetry, martial poetry, etc., are not resolved in an assiduous exaltation of war or the Church, Fascist poetry is not to be explained as poetry in praise of Fascism. On the contrary . . . Fascist poetry is that which frames itself in the historical climate created by the Revolution and which means, prefigures, or explains the unifying political, moral, and economic ideas of the Fascist Corporate State, always constructing (or demolishing to construct), never turning back. . . . Fascist poetry is thus construction, construction of the Fascist spirit, which is realized in the fervor of fecund work, in human acts of salvation, material or spiritual, always altruistic and, whenever possible, universal. It is a poetry which turns against the orgiastic, the dionysiac, the pessimistic, against everything depressing, mortifying, and harmful to the individual as to the collective. It expresses the special state of grace indispensable to the politico-social intuition of the historical moment we are passing through. . . .

All was now as limpid as the bed of the Tiber.

Fascism's way forward was the way backward—to an idealized, purified version of ancient Rome, and, equally, because it stood for the Future, it had to have the young, who were the bearers of the Future, on its side. Because it needed to enlist the young, it demanded martyrs and heroes. Fascism was a youth movement, above all else—a fact of which it was not considered proper to remind the young public, in the heady 1960s, with their insane admonitions to trust no one over thirty.

The totalitarian regimes of the last century had young men martyred for their virtuous loyalty to the Cause, like the child saints of earlier Christianity. The Nazis had Horst Wessel, a young Nazi activist supposedly killed by communists and the author of a hugely popular song, that of the Sturmabteilung or Brownshirts, which became Germany's national anthem: *"Die Fahne hoch, die Reihen fest geschlossen,"* "Hold high the Flag, tightly close the ranks!" A Nazi-fomented legend had it that Wessel wrote both music and words, but in fact the tune came from a German naval song of World War I. The Stalinists had a repellent teenage ideologue who rose to cult status by denouncing his own father to the secret police for the crimes of disloyalty and deviationism, whereupon the outraged father killed the son; there used to be a bronze statue of this unsavory young martyr in Moscow, but it was torn down after *perestroika.*

Italian Fascism, which counted so much on its appeal to youth, had its own historical boy hero, too, although not much is known about him. Indeed, there is some doubt whether he actually existed, at least in the form Fascist propaganda gave him. His name was, or was said to be, Giovan Battista Balilla: the last name meant "Little Boy" and was allegedly the nickname of a pre-teen youth named Perasso. Supposedly a Genoese, he met his martyrdom during a revolt against the Habsburg forces that occupied Genoa during the Austrian occupation of 1746—a rising he allegedly started by throwing a rock at some Austrian artillerymen who were struggling to move a cannon stuck in a muddy street.

Many hymns were written by Fascist poetasters to the memory of this semi-legendary child, who came to symbolize Italian victories in World War I, so precious to Fascist hearts, and the future of Fascism itself, so dear to their hopes. He figured in illustrations, on posters, in murals (though of course nobody knew what he looked like, which hardly mattered, since nobody knows what Jesus looked like, either). He was the model for masculine Fascist youth. A typical effusion, which won a bronze medal at the Italian Song Festival of San Giovanni in Rome, in *Anno XII,* was included in *Li Gioielli d'Italia,* a collection of verse by the Roman dialect poet Pietro Mastini:

> *Bocce di rose*
> *Fiori Italiani*
> *Future spose*
> *Madri domani*
> *E pe la fede*
> *Che sempre brilla*
> *L'avrai da vede*
> *Quanti Balilla!*

"Mouths of roses / Italian flowers / Spouses of the future / Tomorrow's mothers / And for the faith / That always shines / You will see before you / So many Balillas!"

This child martyr was rewarded with a special distinction: lots of machinery bore his name. A popular line of low-cost autos—Italian equivalents to the German Volkswagen, though hardly as well engineered—was named after him, and so were several submarines. Mussolini appointed a former *ardito,* Renato Ricci, to create an Opera Nazionale Balilla, intended to train Italian youth "from a moral and physical point of view," and Ricci went to England to seek out the founder of the

English scouting movement, Robert Baden-Powell, whose ideas were a more peaceable model for this militaristic movement of teenagers. Their essential beliefs were summed up in the "ten commandments" of the Fascist militia:

1. Remember that those fallen for the Revolution and for the Empire go before your columns of march.
2. A comrade is a brother to you: he lives and thinks with you, and you will have him at your side in battle.
3. Italy must be served everywhere, always, with all your means; with work and with blood.
4. The enemy of Fascism is your enemy: give him no quarter.
5. Discipline is the sun of armies; it prepares and illuminates the victory.
6. If you go to attack decisively, victory is already in your grasp.
7. Total and mutual obedience is the legionary's strength.
8. There are no great or small matters; there is only duty.
9. The Fascist revolution has counted and still counts on the bayonets of its legionaries.
10. Mussolini is always right.

This last phrase, *"Il Duce ha sempre ragione,"* pervaded all Italy and her African colonies. Painted on walls, chiseled in stone, chalked on blackboards, even laid out in pebbles in school playgrounds by Ethiopian peasants, it was the unvarying leitmotif of Fascism, and the vestiges of it were still to be seen in parts of rural Italy up until the late 1960s.

Because a militarized state must have soldiers, Fascism placed great emphasis on the Italian birthrate. In this, if not in everything else, it found common ground with the Catholic Church, which was stonily opposed to any form of contraception. Each year, one of the many ceremonies under the Duce's balcony in Piazza Venezia (which had replaced the Capitol as the emblematic center of Italian politics, and where huge "oceanic" demonstrations of loyalty to Mussolini were convened by his minister of propaganda, Starace) was held to honor the country's ninety-five most prolific mothers, assembled with their squalling offspring. Naturally, this spectacle gave rise to a good deal of chaffing (though actual satire on fecundity was banned): a cartoon in 1930 showed three flustered but resolute fathers racing toward the finish line of a track, each pushing a baby carriage jammed with dozens of infants, all egged on by their wives with cries of *"Forza, Napoli!" "Spingi, Milano!"*

and *"Presto, Roma!"* Mussolini's own view was that Italian families should expand to eight, a dozen, or even twenty children: brave cannon fodder for the Empire to come. Each heroically fertile mother was awarded five thousand lire and a medal. Other inducements to enlarging the Italian family were devised and tried, as part of the general Fascist application of military techniques of control to civilian life. Thus, in 1926, the Duce introduced what amounted to a concealed tax on bachelors, by assessing them at a higher tax level than married men with children. Top posts in education and the civil service were also reserved for such married people. Women, on the other hand, were dismissed from state jobs unless they were war widows. Information on birth-control techniques, other than the ever-unreliable *coitus interruptus,* was banned, though condoms remained on sale, since these reduced the spread of venereal disease. "There are 400 million Germans," Mussolini declared in a speech on Ascension Day, May 26, 1927, "two hundred million Slavs, and the target for Italians by 1950 is 60 million, over the present 40 million. If we become fewer, gentlemen, we shall not build an empire, we shall become a colony."

Though he had been born in the provinces, Mussolini when he came to power wished only to imagine himself as a Roman. That had not always been so. Though he never made much of a song and dance about his Predappian origins, unless rhetorical purposes required that he present himself aggressively as a man of the people, when he was a young socialist Mussolini deplored Rome as "a parasitic city of landladies, shoeshine boys, prostitutes, and bureaucrats." But quite soon, as the ideas of what was to be Fascism took form in his imagination, so did the necessity of Rome's rebirth. Previous Roman emperors had been born and raised in distant places like Spain and North Africa, and there was no possible reason for a young man from Predappio not to consider himself as fully Roman as any of his ancient forerunners. Discoursing on architecture to a German journalist named Emil Ludwig in 1932, the Duce observed, "Architecture is the greatest of the arts, for it is the epitome of all the others." "It is extremely Roman," Ludwig agreed. "I, likewise," the Duce exclaimed, "am Roman above all." The issue of *romanità,* Romanness, was at the very core of the ideology and self-definition of the Fascist state. Fascism viewed Rome as the center of the world. It had been before; now, in its present and future-bound incarnation, it must be again. "Rome is our point of departure and reference," Mussolini declared:

It is our symbol and, if you wish, our myth. We dream of a Roman Italy: that is to say, wise, strong, disciplined, and imperial. Much of what was once the immortal spirit of Rome rises again in Fascism: the *fasces* are Roman; our organization of combat is Roman; our pride and courage are Roman; *civis Romanus sum.* It is necessary now that tomorrow's history, the history we fervently wish to create, should not be . . . a parody of the history of yesterday. The Romans were not only warriors but formidable builders who could challenge their time.

Mussolini thought of himself as a builder, too, mainly and always. The poet Ezra Pound paid tribute to this in 1935: "I don't believe any estimate of Mussolini will be valid unless it *starts* from his passion for construction. Treat him as *artifex* and all the details fall into place. Take him as anything save the artist and you will get muddled with the contradictions." Il Duce was repelled by the idea of treating Rome just as a museum. It had to show its capacity, not just for commemorating the past, but for continuous life in the present and expansion into the future. Anything less would amount to a silent admission that, in Shakespeare's words in *Julius Caesar,* Romans now

> Have thews and limbs like to their ancestors;
> But woe the while! our fathers' minds are dead,
> And we are governed with our mothers' spirits. . . .

Not the least achievement of Fascism, in the face of the hitherto overwhelming power of the Papacy, was its agreement or "concordat" with the Vatican. Benedict XV had already lost an enormous slice of Italy by surrendering the Papal States. Now, after much bargaining with Mussolini, his successor, Pius XI, found his dependencies reduced to an area one-eighth that of Central Park in New York—a mere 108.7 acres, the size of Vatican City. There were, of course, concessions along with that, such as control over Castel Gandolfo and the Lateran, recognition of canon law as binding alongside of the law of the state, an independent post office and radio station, church control of all Catholic marriage, the teaching of Catholic doctrines in state schools, the placing of crucifixes in all classrooms, and financial compensation to the Papacy of 1.75 billion lire. Better still, Mussolini did God's work (as the Church saw it) in suppressing both Freemasons and communists, sworn enemies of the

Church. Pius XI therefore spoke openly (against the advice of his more moderate lieutenant, Cardinal Gasparri) of the Duce as "a man sent by Providence," and unambiguously told the lower clergy of Italy to encourage their congregations to vote Fascist, which they duly did. This seemed so threatening to the priest-leader of the moderate Catholic Partito Popolare, Don Luigi Sturzo, that he fled to London and remained there.

The most far-reaching of Pius XI's utterances, however, was not on his relations with Mussolini, though these became thornier as time went by. Nor was it even on the "concordat" or Treaty of 1933, which he signed with Adolf Hitler—an ultimately fruitless deal brokered by Eugenio Pacelli, the future Pius XII. It was his encyclical *Casti Connubii* (1930), forbidding artificial contraception by married couples on pain of mortal sin. Naturally, this was very much to Mussolini's taste, but its long-term effect was to drive the hitherto faithful away from the Church.

The reglorification of imperial Rome, and its new linkage to Fascism, required two strategies: excavation and preservation of the ancient past, and the vigorous building of new Fascist structures. Mussolini did not much care about what lay between the ancient and the recent. He was not a friend of medieval, Renaissance, or Baroque building, particularly since, despite his diplomatic overtures, he disliked the Catholic Church.* Consequently, large amounts of this "intermediary" city would be demolished if there was a likelihood of laying bare some traces of authentic Roman antiquity below them. This happened with his first large site-clearing, that of the Largo Argentina,† originally part of the southern Campus Martius. A sixteenth-century church, that of San Nicola de' Cesarini, stood there—but underneath its foundations, archaeologists perceived the ruins of four ancient temples, which dated, they believed, from republican times. Excavation, and the demolition of the church, did indeed disclose these much-battered remains, and in the absence of other evidence about them it was supposed that all four were on the line of the start of most Roman triumphal processions and had been paid for by victorious generals—which ones, it is not known. Nor is it known which gods the temples might have honored. But this association with Roman triumphs, however unclear, naturally would have had

* Mussolini's father had never allowed him to be baptized. Later, for the sake of good relations with the Church and his pious voters, he was; but he was never a believer.
† No reference to the South American country. The name came from the Latin name of the diocese, Argentoratum. Fascist work on the site began in 1926.

great appeal to Il Duce. "I would feel myself dishonored," he declared, "if I allowed a new structure to rise even one meter here."

What he particularly despised, for symbolic rather than aesthetic reasons, was the Rome of the Risorgimento, the architecture of the half-century between 1870 and his own accession to power in 1922—except for the Vittorio Emanuele monument, which he saw as politically untouchable, since much depended on amicable relations between Il Duce and the king, Vittorio Emanuele's son.

Mussolini regarded the nineteenth-century unification of Italy as incomplete at best, and at worst a sham. How could Italy be called "unified" when it was managed by so many local governments, still so hobbled by *campanilismo,* without the central authority provided by Fascism? He would change all that. Throughout the 1920s and the '30s, Mussolini drew all the main functions of government together in his personal grasp.

In October 1922, Mussolini and his growing force of National Fascist Party followers staged a *coup d'état.* They assembled at the Florence railroad station, boarded a train, and got off in Rome, where they headed for the Parliament. This train ride was designated the "March on Rome," though nobody went on foot. To walk all that way would have been too tiring, sweaty, and protracted. The idea of such a march did not come from Mussolini, either; it was initiated, but never organized, by D'Annunzio, who wanted to start it in Trieste with his own men. Supported by the business class and the military, Mussolini was recognized by King Vittorio Emanuele III, and the weak but elected prime minister, Luigi Facta, was ousted.

Italy now had as its prime minister a bellicose man of the people who nevertheless rejected the idea of class war and had nearly all Italian businessmen, and the aristocracy as well, strongly behind him. A minority of socialists and liberals boycotted Parliament, without effect: the king was afraid of political violence from the *squadristi.*

Mussolini's Fasci di Combattimento became part of Italy's armed forces, the Milizia Volontaria per la Sicurezza Nazionale (MVSN). They were now untouchable. In 1923, his Acerbo Law turned Italy into a single national constituency; the result was that, in a 1924 election, the Fascists took some 64 percent of the vote. It was after this probably rigged election that socialist deputy Giacomo Matteotti tried to have the results thrown out and was murdered by a *squadrista* named Amerigo Dumini,

who did several years' jail time but ended up being supported for the rest of his life by Mussolini and the Fascist Party. Matteotti's demise caused some weak protest, but nothing came of it; this spelled the end of opposition to Mussolini, and the beginning of his absolute control over Italy. Throughout the rest of the 1920s, Mussolini devoted himself to creating a police state, with himself in charge of foreign affairs, colonies, defense, corporations, and internal order.

Naturally, he took personal charge of cultural censorship, vetting up to 1,500 plays a year (or so his staff claimed, though it seems hardly credible given the rest of his agenda); among the banned dramas were Machiavelli's *Mandragola,* Rostand's *Cyrano de Bergerac,* and Shaw's *Caesar and Cleopatra.* Nobody but the king could remove him. In 1928, further parliamentary elections were abolished, and all parties other than the Fascists outlawed.

Meanwhile, the Duce began his expansion of Italian power in *mare nostrum,* "our sea," the Mediterranean. And, even as he brandished his Roman gladius at Corfu, Albania, the Greek islands, and Libya, Mussolini made enormous and unceasing efforts with Fascist propaganda within Italy.

The great propaganda event of the early thirties was the MRF, or Mostra della Rivoluzione Fascista, which took place in Rome on the tenth anniversary of Mussolini's accession to power, 1932. Its venue was the old 1883 Palazzo delle Esposizioni, which was given a new façade featuring four thirty-meter-high aluminum columns in the form of the *fasces,* designed by the architects Adalberto Libera and Mario de Renzi. Its theme was how Fascism had united, not divided, the Italian people; how it had prevented class war.

The traditional liberal view is that Fascism was irrevocably opposed to whatever was new or progressive in Italian culture. This became iron doctrine after Italy lost World War II, because most Italians by then wanted only to forget about Il Duce and the miseries of his and Italy's defeat. "Where there was culture it was not fascist," wrote the Italian intellectual Norberto Bobbio, "and where there was fascism it was not culture. There never was a fascist culture." Such a virtuously anti-Fascist view was as perniciously foolish as the cultural doctrines of Fascism itself. Fascism gave hope to millions of people, among whom were a number of artists and architects, who fancied (in the words of the architect Terragni) that it was "the hallmark of the new age. . . . The harmony which made the Greece of Pericles and the Florence of the Medici great must illuminate

the age of Fascism with equal intensity." Not only was there a Fascist culture; many of the most gifted Italian painters, sculptors, and architects believed wholeheartedly in it and worked devotedly to realize it. Even Giorgio Morandi, the best painter Italy had in the 1930s—and, some would say, the best in the whole twentieth century—sincerely thanked Mussolini for the interest he had taken in his work, of which Il Duce had bought several examples. "It gives me great pleasure to recall His Excellency Benito Mussolini. . . . The great faith I have had in Fascism from the outset has remained intact even in the darkest and stormiest of days." This should hardly be taken as a general endorsement of all the Duce's political actions from the recluse of Bologna, who was indifferent to public life and knew little about politics. True, Morandi never did any official artworks of the kind that Fascism commissioned from the likes of Corrado Cagli, Achille Funi, or Mario Sironi—tablescapes of dusty bottles, however beautiful in themselves, were unlikely to raise consciousness about Italy's heritage or future. Also among the Italian artists who worked, directly or indirectly, for Il Duce were the sculptors Marino Marini and Lucio Fontana, the painters Giorgio de Chirico, Carlo Carrà, Enrico Prampolini, and Emilio Vedova. The MRF made quite lavish use of some of the best of these. Nobody could say that de Chirico's classical groups of dream struggle were among his best work—*pittura metafisica* belonged to the teens of the century and was well in the past—but other artists honored Fascism with convinced and eloquent installations. The architect Terragni, for instance, did the room dedicated to the so-called March on Rome.

But Giorgio de Chirico was the artist most representative of the turmoil of nostalgia kicked up by the modern invocation of imperial Rome, which showed itself most vividly in architecture. He was greatly admired by many Fascists, even did occasional commissions for the Fascist Party, but always indignantly denied that his work had any connection to Fascist ideology. He was also one of the last genuinely influential painters Italy produced in the twentieth century. Though his influence, at least in his later years, fell mainly on other Italians, at the outset it was international, since his work had once been a major factor—some would say a determining one—in the development of Surrealism in Paris.

Giorgio de Chirico was not, by origin, Italian at all, as the French "de" in his name (rather than "di") indicates. He got quite offended if called "di" Chirico. He was born in 1888, and raised in the town of Volos, Greece, where his father was a railroad planner and engineer. Neverthe-

less, the most crucial encounters of his early development took place in Paris, and most of his working life was passed in and identified with Rome, where he had a magnificent studio high on the side of the Spanish Steps with an encompassing view of the piazza and its Berninian ship fountain, *La Barcaccia,* below. (Of all the urban studios that have been inhabited by modern artists, de Chirico's was perhaps the most enviably sited.) He was truculent about his attachment to Rome. He wanted, he said in his absurdly egotistical memoirs (1962), "to remain and work in Italy and even in Rome. Yes; it is here that I want to stay and work, to work harder than ever, to work better than ever, to work for my glory and your damnation."

The note of anger was unforced. De Chirico loathed the art world, which he believed had deliberately misunderstood and traduced him for its own gain and self-gratification. He had a bad temper and an inexhaustible supply of grudges. That art world, in his eyes, was synonymous with Paris and its artists, "that group of degenerates, hooligans, childish layabouts, onanists and spineless people who had pompously styled themselves *surrealists* and also talked about the 'surrealist revolution.' " The Surrealist painters, of course, were the modernists who derived most from de Chirico, who most admired his early work, but, because of their contempt for his later, pseudo-classical work, had become his ferociously rejected and disowned children. Chief among de Chirico's villains was the Surrealist leader André Breton, "the classic type of pretentious ass and impotent arriviste," closely followed in vileness and treachery by the poet Paul Éluard, "a colorless and commonplace young man with a crooked nose and a face somewhere between that of an onanist and a mystical cretin." (If de Chirico disliked you, he never forgave or forgot, and you would know it soon enough.) This pair and their associates in Surrealism (Yves Tanguy, René Magritte, Max Ernst, and Salvador Dalì, the Catalan for whom de Chirico cherished an especial contempt and hatred) had all been inspired by the early "metaphysical" paintings he made, up to 1918 or thereabouts, which turned the image of the city (chiefly Ferrara, where he lived from 1915 to 1918, and Turin, whose towers regularly appear in his paintings) into one of the emblematic sites of the modernist imagination. Its elements click into place as de Chirican property as soon as they are named: the piazza, the hard dark shadows, the statue, the train, the mannequin, and of course the arcades.

Many of them are drawn from memories of real places where de Chirico had lived; they are not inventions, and this only adds to their

imaginative power. The town of Volos, for instance, was cut through by a railway; hence the recurrent train and its puffs of smoke. But since de Chirico's father was also a railroad engineer, the train is also a deeply paternal image, and this lends extra meaning to a railway-station painting like *The Melancholy of Departure* (1914): melancholy because the father-train is leaving, abandoning the young, insecure son to his fears. De Chirico found the epitome of strangeness in classical architecture. It was summed up in the arcade—that receding array of dark arches, that shallow screen. "There is nothing like the enigma of the Arcade, which the Romans invented," he wrote:

A street, an arch—the sun looks different when it bathes a Roman wall in light. And there is something about it more mysteriously plaintive than in French architecture, and less ferocious, too. The Roman arcade is a fatality. Its voice speaks in riddles filled with a strangely Roman poetry.

De Chirico cited three words "which I would like to be the seal of every work I have produced: namely, *Pictor classicus sum*"—"I am a classical painter." The thought was anathema to the Surrealists, who took unrestrained pleasure in attacking de Chirico for his later work, in which he celebrated the classical world and completely shied away from those elements in his style that were called proto-Surrealist. There were no boundaries to Surrealist hostility, and none to the anger with which de Chirico responded to it. Modern art, de Chirico insisted, was now in a state of utter decadence. It had fallen for two reasons. First, it had surrendered to Parisian-style modernism instead of keeping to the real track, which in de Chirico's belief ran from the Old Masters through the artists who had nourished de Chirico himself, the Northern painters like Arnold Böcklin. "If some day someone institutes a Nobel Prize for provincialism, silliness, xenophobia and masochistic lust for *La France Immortelle*," de Chirico wrote, "I am convinced that this prize would be awarded to the Italy of today."

Second, painting had forgotten its own basic techniques. Other artists might look back to past painters: Picasso to Ingres, Léger to Poussin, and any number of Italian painters to Masaccio, Piero della Francesco, or Lorenzo Lotto. But what de Chirico proposed was not a mere "looking back," it was a restructuring of art in terms of ancient, now ignored techniques that must somehow be reinvigorated and recovered. And this was not fated to happen, especially not in the terms of gladiator battles and

classical façades that came, more and more, to define the subject matter of de Chirico's later painting.

And there was a further complication. De Chirico refused to believe what was an article of faith among the Surrealists and most other foreign admirers of his work: namely, that he had been a better painter in his youth, and that the so-called *pittura metafisica* that he produced up to about 1918 was the real, essential de Chirico, whereas the later work was either cynical self-copying sold as "original," or obvious pastiches of older forms of art de Chirico admired—Raphael, Titian, and so forth. To make things worse, de Chirico had no inhibitions about selling his later pictures as pre-1918 originals, backdated. Italian art dealers used to say the Maestro's bed was six feet off the bedroom floor, to hold all the "early work" he kept "discovering" below it. There are, for instance, at least eighteen copies of *The Disquieting Muses* (1917), all painted by de Chirico between 1945 and 1962.

Large marketing efforts have been made to set late de Chirico on an equal footing with the early work, but so far they have been unsuccessful, as indeed they deserve to be. By far the best painter directly associated with Fascism was Mario Sironi, who after the fall of Mussolini would pay dearly for his favored role in the movement. A leading member of the Novecento group, which had assembled around Mussolini's art-curating mistress, Margherita Sarfatti, Sironi had rebelled against liberalism, declaring the fine arts to be "a perfect instrument of spiritual government," and wholeheartedly placing his work at the service of the Fascist revolution. It ought to be "intentionally anti-bourgeois." Early in his career, just after World War I, Sironi painted dark, harsh landscapes of industrial Milan, which (consciously or not) reflected Mussolini's early socialist ideas. After Fascism took hold in Italy, Sironi kept stressing that he wanted to be seen as "a militant artist, that is to say, an artist who serves a moral ideal and subordinates his own individuality to the collective cause." He wished to leave aside the easel picture and devote himself to large-scale murals and installations. A truly Fascist art, he insisted, was a matter of style in which "the autonomous qualities of line, form, and color" manipulated reality into "the medium of political efficacy. . . . Through style, art will succeed in making a new mark on popular consciousness." Distinctions between high and low culture must go. Sironi hoped that his style, with its archaic monumentalism of rough-hewn forms and its occasional references to ancient Roman bas-reliefs, would play a part in shaping "the collective will through

myth and image," and this equation of formal order with political order became part of the official ideology of Fascism. This idea of "militant idealism," strongly espoused by Mussolini's first minister of education, Giovanni Gentile, became official ideology during Fascism's first decade, the 1920s and early 1930s.

For the Mostra della Rivoluzione Fascista, Sironi designed four powerful galleries around Fascist themes. Perhaps the most moving display was the *"sacrario dei caduti,"* the "holy room of the fallen," where, in a dim religious light, the names of the Fascist dead were unrolled while a voice murmured, *"Presente, presente, presente,"* and the party's anthem, "Giovinezza," softly played on hidden, ambient speakers.

For the Fascist faithful, this was a guaranteed emotion-jerker. All visitors were taken to it, especially the VIPs: the records of the MRF contain the names of, among others, Franz von Papen, Josef Goebbels, Hermann Göring from Germany, Ramsay MacDonald, Austen Chamberlain, Anthony Eden, and Oswald Mosley from England, and the king of Siam. Eden noted in his journal, "I did not find the place congenial and I did not want to be uncivil to my hosts, so I was glad when the embarrassing ordeal was over." Nevertheless, he felt it was "less dragooning and pervasive than Nazi rule in Germany." Though it may not have been congenial to foreigners like Eden, it was a smashing popular success with the Italians themselves, particularly since the Fascist authorities organized mass visits to it from all over Italy. These enabled citizens who had never been able to leave outlying hometowns like Grosseto or Acquapendente to get to Rome for the first time. Eventually, some four million visitors came by train and bus to the Mostra della Rivoluzione Fascista, and its run was extended by two full years.

A central idea about art and its purposes was enshrined by the MRF, and its main promulgator then and afterward was Mario Sironi. Late in 1933, Sironi joined with three other Italian painters, Massimo Campigli, Achille Funi, and Carlo Carrà, to produce a manifesto about the future of art in Italy. "Fascism is a way of life: it is the very life of Italians." Art must serve the interests of Fascism—but how? Sironi had nothing but contempt for the vacuous propaganda paintings of German National Socialism. He wanted to see a bony, structural art which would nevertheless have the possibility of wide popular appeal. It would do this by reviving Renaissance ambitions: in the tradition of Italian mural painting of the fifteenth and sixteenth centuries; some revival might take place beyond what was offered by the format of the easel painting. He longed

for a collective, community-based art that would unfold on great public walls, under the aegis of the Fascist Party. This would be done in terms of the sober, dark, uningratiating style that Sironi had made so much his own. Its hallmark would be a purposive seriousness, for Sironi had joined with other Fascist-inspired Italian painters, such as Carrà and Funi, in denouncing all that was less than serious and public. Art must speak directly to the Italian people. "We are confident that in Mussolini we have the Man who knows how to value correctly the strength of our world-dominating Art."

It did not dominate the world—there was little chance of that—but it was certainly not as negligible as anti-Fascist feelings made it seem later. Sironi's allegiance to Fascism counted badly against him after Italy lost the war and Mussolini's day ended. Perhaps this was inevitable, but it was certainly not a fair aesthetic judgment. The political beliefs of an artist are no secure basis for judging his, or her, art. What does anyone care, today, about the political convictions of the artists who carved the bulls of Babylon or painted the Madonnas of Siena? It was all very well to deprecate Sironi after the fall of Mussolini for lending his indisputable talents to the promotion of Fascism, but what is one to say of Russian Constructivist artists, like Vladimir Tatlin or El Lissitzky, who wanted to see their work take its role in a national chorus of propaganda-by-monument, whose chief—indeed, only—patron was the new communist state? There was something very unseemly about the pleasure which the party hacks and communist sympathizers of the Italian art world took in Sironi's fall, and in the zeal with which they trampled on his postwar reputation. Marxism-Leninism, followed by Stalinism, murdered, imprisoned, and exiled millions of Russians, smashed the fragile Russian traditions of free speech, and brought illimitable misery to their country and, later, its satellites. If the political allegiances of an artist like Sironi were to be held against him, what could be said against those of one like Tatlin, who labored to serve the Revolution? The answer, as it emerged after World War II, was: nothing. Radical Russian artists who proclaimed their adherence to the deadly fantasies of the Revolution were unanimously forgiven for having been on the "right" side, the side whose adherents helped destroy Fascism. Indeed, given the dreadful censorship that descended on their work from Stalin, they were exalted by liberal opinion on this side of the Iron Curtain: too much so, given the interests they aspired to serve.

In 1931, Mussolini's government set forth a master plan for the remak-

ing of Rome. It followed the main lines of a speech Il Duce had made six years before. Its purpose, he announced, was to reveal Rome as a "marvelous" city, "vast, ordered, powerful, as it was in the first Augustan Empire":

> You must continue to liberate the trunk of the great oak from everything that still smothers it. Open up spaces around the Mausoleum of Augustus, the Theater of Marcellus, the Campidoglio, the Pantheon. Everything which has grown up in the centuries of decadence must be swept away. In five years, from Piazza Colonna, across a great area, should be visible the mass of the Pantheon.

The key to Mussolini's intentions—clarifying the "true" urban meanings of Rome—was to recover what Mussolini took to be the city's true urban purity: that of the Age of Augustus. By exposing and glorifying what was left of the architecture of the glorious principate, he would present himself as the new Augustus Caesar and show Fascism to be the revival of empire. To emphasize this message, a triumphal avenue, to be called the Via dell'Impero, would link Piazza Venezia—where Mussolini's state offices and apartments were now installed—to Ostia and the sea. This specially leveled avenue, seven hundred meters long and thirty wide, would be Rome's parade ground. It was somewhat contradictory, since its creation entailed covering up large tracts of recently excavated imperial Roman fora. But, as the Duce put it, "Rome now has at its center a street truly designed for its great military parades, which until now have been confined to the periphery or the countryside."

The "revival" of the Roman Empire was celebrated in popular song:

> *Tornan colonne ed archi*
> *I ruderi gloriosi, come un giorno. . . .*
> *Dal Campidoglio, fiera, libera l'ale*
> *L'aquila augusta e bronzea*
> *Della Roma imperiale!*
> *Fremon le vecchie mura*
> *Del Colosseo. . . .*
> *Un osanna levano di ardore:*
> *Risorgi, o Roma eternal,*
> *Torna il littore.*

"Columns and arches come back / To the glorious ruins, just as before. . . . / From the Capitol, the august bronze eagle / Of imperial

Rome, proudly spreads her wings. . . . / They shake, the ancient walls / Of the Colosseum. . . . / They utter a Hosanna of ardor: / Rise up again, eternal Rome, / The Lictor returns."

In the north of the city, a giant development of housing, sports arenas, and new roads would grow, to create a gateway to the modern city; it became known as the Foro Mussolini. The southern road to Rome along the Via del Mare would support what was, in essence, a second city, a mass of architectural display, to be known as the EUR, or Esposizione Universale di Roma, which the Duce wanted to open in 1942 with what he called an "Olympics of Civili-zation." This immense reshaping of the Eternal City would far exceed, in scale, the efforts of any earlier emperors or popes since Augustus' time. Through it, Rome would "reclaim its Empire," as a patriotic hymn put it:

> Roma revendica l'Impero
> L'ora dell'Aquil sono,
> Squilli di trombe salutano il vol
> Dal Campidoglio al Quirinal,
> Terra ti vogliamo dominar!

"Rome reclaims its Empire / The hour of the Eagle has struck / Trumpet blasts salute the flight / From Capitol to Quirinal / Earth, we want to dominate you!"

Many of the new buildings of Fascism were, in essence, quite modernist. They had little to do with the stripped-down Doric, neoclassical manner favored by Hitler through his court architect, Albert Speer. They used curtain walls, floating cantilevers, and other attributes of the so-called International Style, which had gathered momentum in Germany and the United States. Some of them, such as the Casa del Fascio (1932–36) by Giuseppe Terragni in Como, were quite Miesian in spirit.

The most vivid and memorable of the new buildings of Fascism was the so-called Square Colosseum, the severely arcaded multistory building which formed the central motif of EUR. If any building can be called the logo of Fascist architecture, it is this one, in all its polemical purity—the "Palace of Italian Civilization." It was much hated in the aftermath of the 1939–45 war, but now there are signs that it is enjoying renewed favor as a landmark and period piece, a situation helped by the fact that it carries no bellicose or excessively nationalist inscriptions—the frieze of letters around the flat roofline praised the peaceful achievements of Italian civilization-makers, explorers, artists, scientists, saints, poets, sailors,

but not soldiers. Its main architect was Ernesto La Padula (1902–68), who survived the war but never got a chance to design another official building. His collaborators were Giovanni Guerrini and Mario Romano.

The sculptor Aroldo Bellini was charged, in 1934, with the task of making a gigantic portrait sculpture of Il Duce, a hundred meters tall (as high as the lantern of Saint Peter's), which would completely dominate the city from the skyline. This monster was never finished, though its head was completed. The largest of all Fascist sculptures, it was even expected to house a permanent museum of Fascism.

The grandest Fascist monument, like the grandest monument of ancient Rome, was a road—or, rather, two roads. One was the Via del Mare; the other the Via dell'Impero, linking the Colosseum to the Vittorio Emanuele monument, which became the chief parade-ground for Mussolini and his *squadristi*. The obvious comparisons that all Mussolini's town-replanning projects would have to sustain was with Albert Speer's efforts for Hitler, and nobody would be more conscious of this than the Führer himself, who had met up with the Duce in Venice in 1934 and was scheduled to make a mighty state visit to Rome in the spring of 1938. It was essential for the Duce to cut a *bella figura* when Hitler arrived, and in February 1938 the dictator made a circuit through Rome to inspect his public works. He started at sites near his political center, Piazza Venezia: Capitoline Hill, the Palatine, the Circus Maximus. He thought with glee of how impressed Hitler would be. He looked with pride at the great expanses swept clear, "formerly suffocated by . . . hovels and alleys." At his orders, the previously congested site of the Circus Maximus had been cleared of all its shacks and later buildings: nothing was showing except pure ancient Rome. At the far end of the Circus Maximus stood his new Africa building (now the United Nations' FAO offices, whose Fascist architectural origins few remember) and the ancient Obelisk of Axum, brought from Ethiopia after his victories there the year before. As he was driven along the new Via dell'Impero, linking central Rome to the sea, he watched the ancient buildings, now cleaned up, roll by: the Theater of Marcellus, the Arch of Janus Quadrifrons, the temples of Vesta and Fortuna Virilis. He thought about how the partly finished Via dell'Impero would soon link Rome's center with the sea, and with the site of the planned EUR complex, whose opening was scheduled for 1942, the twentieth anniversary of the March on Rome. And already, he reflected, his great capital was filling with Fascist buildings: stadia, schools, post offices, and apartments of every kind. It was enough

to warm the cockles of any dictator's heart, and in fact many of these structures are still in use, though under other names. One of the few masterpieces of rationalist Fascist design, in what was then known as the Foro Mussolini, the 1934 Casa delle Armi or Fencing Academy by Luigi Moretti (1907–73), became a *carabinieri* barracks and had a short afterlife as the site of the heavily secured maxi-trials of the Red Brigades. The new Fascist Via del Mare was reborn, after the war, as the Via del Teatro di Marcello—despite the obvious wish of Italy to erase Mussolini from collective memory, this name remains on the commemorative obelisk of the Foro Mussolini, now the Foro Italico. The Piazzale dell'Impero is filled with skateboarders today—a use Fascism had never contemplated. It is full of mosaics showing Fascist imagery and slogans: "Many enemies, much honor," "Duce, we dedicate our youth to you," and, inevitably, "Better one day as a lion than a hundred years as a sheep." Mosaics still show the founding of Fascism after 1919, the March on Rome, the Lateran Accords with the Church, and the conquest of Ethiopia. Quite rightly, the postwar authorities of a more democratic Rome have not tried to efface these; instead, others were added after Mussolini's death to celebrate the fall of Fascism in 1943, the national referendum to abolish monarchy in 1946, and the inauguration of the new Italian Republic in 1948. Some Fascist monuments had already disappeared; several giant heads of the Duce remain in subterranean storage in Rome, and only the head of a colossal bronze statue of Fascism, 150 feet tall, survived long enough to be melted down for scrap; on the other hand, sport being theoretically apolitical, about sixty giant stone athletes in the Stadio dei Marmi at EUR are still standing on their original bases. Via Adolfo Hitler, which still ends at the Ostiense Station, was tactfully renamed the Via delle Cave Ardeatine, in memory of the massacre of anti-Fascists which took place in revenge for the blowing up of a squad of marching Nazis. After the war, the Tiber's Ponte Littorio was renamed, in honor of the murdered socialist deputy, the Ponte Matteotti.

There was a certain community of language between Nazi and Fascist works of visual art, but in ideology aspects of Fascism differed crucially from Nazism: it is a common mistake to suppose that they were essentially the same because of later political alliances between the two. The main issue was that of race. Hitler, one need not stress, was completely obsessed by his desire to "free" the world of Jews. He saw Jewry as the chief evil in German and world society. Even as the battle for a defeated Berlin was entering its last phase and the Russian shells were thundering

down on the Chancellery, Hitler's thoughts continued to be of the Final Solution.

Mussolini, on the other hand, was no racialist, and anti-Semitism did not enter his politics either in theory or in practice. "Race! It is a feeling, not a reality," he declared in 1933. "Ninety-five per cent, at least, is a feeling. Nothing will ever make me believe that biologically pure races can be shown to exist today. . . . National pride has no need of the delirium of race." He pointed out that Jews had lived in Italy since the time Rome was founded, which was true but would have been an inconceivable remark for Hitler to make about Germany. The National Fascist Party contained Jews—one of them, Ettore Ovazza, ran a Fascist newspaper, *La nostra bandiera,* specifically edited to maintain that Italian Jews were patriotic Italians and could continue to be under Fascism. Certainly, Mussolini had political prisons, some of intolerable severity. But they were never designed, as the German concentration camps were, to annihilate whole social groups, whether Jews, or Gypsies, or homosexuals. His *squadristi,* or Blackshirts, could be and often were brutal to "outsiders" and anti-Fascists, but their violence was not designedly anti-Semitic—although it would be naïve to imagine that there was no anti-Semitism in Italy, or that it did not come out in blows and shouted insults when some wretched opponent of the regime was being forced to drink castor oil mixed with gasoline (a favorite Fascist torture) or to chew up and swallow a living toad.* A lot of this would change later, as Hitler's influence over Mussolini increased in the late thirties. In *A Manifesto of Race,* issued in 1938, Mussolini copied Hitler's Nuremberg Laws, stripping Italian Jews of their citizenship and their access to the professions. But at the beginning, at least, the new Caesar was no more prejudiced against Jews than the old ones had been. Good Fascists could be compared to the Jews, and vice versa, without loss of dignity.

Poets, writing about the March on Rome, frequently and unblushingly compared Mussolini to Moses leading the chosen people into the Promised Land.

Hitler, of course, had other ideas. The comparisons of Mussolini to Moses dropped off sharply after May 1938, when a train containing the Führer and his staff pulled into the Ostiense Station in Rome, bringing Hitler on his state visit. Mussolini's *funzionari* had gone to much trouble

* I shall never forget how, forty years ago, I told a young Australian actress of my acquaintance about this Fascist practice. "Oh, darling," she exclaimed, "the poor toad!"

over Hitler's arrival. They even saw to it that the last few miles of railroad track into the station were lined, both sides, with a Potemkin village of stage sets facing inward to the train, filled with enthusiastically cheering Romans. This was greeted with a *pasquinato* which ran:

> *Roma di travertino*
> *Rifatta di cartone*
> *Saluta l'imbianchino*
> *La sua prossima padrone.*

"Rome of travertine / Remade in cardboard / Salutes the house-painter / Its next master."

The mass media of Italy, which were tightly controlled—one needed a state-issued license to practice as a journalist of any kind, even a fashion reporter, under Mussolini, and he personally appointed all editors—greeted the arrival of the Führer with an automatic ecstasy. A good, though minor, example was a cartoon in whose first panel we see a Nazi officer (no mustache, so he cannot be Hitler himself) throwing a Nazi salute at the Capitoline she-wolf and her two foundling babies, Romulus and Remus. In the second panel, the she-wolf, overcome with doggy joy, has come down from her pedestal and is fawning all over the Nazi, while the temporarily abandoned but delighted infants are returning the salute and calling "Heil Hitler!"

It is impossible to say what effect Hitler's architectural opinions may have had on Mussolini's changes to Rome. In some respects, especially at the end of the 1930s, the two men thought so much alike that there is no disentangling their ideas. However, one project in particular which Mussolini inflicted on his capital stands out for its Hitlerian character of axial straightness and dumb clarity. This was the approach avenue to the Piazza San Pietro, Bernini's overwhelmingly rich symbolic site in front of the basilica. Before Mussolini, the visitor coming from the Tiber approached Saint Peter's along the Spina dei Borghi, or Spine of the Borgo, a pair of more or less parallel roads that ran into the piazza but did not open up the view of the basilica in a suitably spectacular way. But in 1937, the year before Hitler's first visit to Rome, Mussolini decided to convert this comparatively gradual revelation into pure, one-point-perspective melodrama. Whether he planned to impress Hitler with this is hard to say; on balance, it seems likely. The result was a giant avenue in the manner of Albert Speer, driving straight for the Vatican Obelisk, Maderno's façade, and the dome. Surprise, once so vital a part of the approach to

the great basilica, was now eliminated. The name of the avenue, the Via della Conciliazione, commemorates the 1929 agreement under the Lateran Treaty, whereby the Vatican—hitherto opposed to Fascism because of Il Duce's anti-clerical bias—recognized the Fascist government of Italy while Fascism granted the Vatican complete territorial independence. This would permanently shape relations between Italy's church and state, whose "conciliation" the new avenue symbolized.

In the process of the reconciliation of art and state, every dialect bard from Lake Como to Capo Palinuro, it seemed, was busy telling Italian children to emulate their savior:

> . . . *anima pura*
> *Va a scola, studia tantu e 'mpara,*
> *E vera fede au nostru Duce giura.*

"Pure soul, go to school, study hard, learn, and pledge true faith to our Duce."

The Duce's appearance evoked paeans of awed praise from dialect poets all over Italy. Here is a Nando Bennati, writing in Ferrarese dialect, around 1937, addressing his leader simply as *"Lu!"* or "You!":

> *La testa, un toc 'd nugara dur massiz,*
> *Taia con al falzzon, cla met i sguiz*
>
> *La front spaziosa larga, ch'fa da ca*
> *A un gran zzarvel, cal pesa purassa;*
>
> *Il zzid come d'arc ruman antig,*
> *Che, se il sa sbassa, a trema i so amig;*
>
> *Du' oc' chi fora come du' guciun*
> *E i lez tut i pensier, cattiv o bun;*
> *Al nas come un bec d'aquila, ch'al s'mov*
> *Par sentr' in tl'aria s'ag fus quell ad nov;*
>
> *La vos la tocca come 'na frusta*
> *L'ariva in tl'anima come'na stilta—*

"The head, a hard and massive nut / Hewn with a pruning hook, which makes one shudder / The high wide forehead, which is the home / Of a large and weighty brain / The eyebrows, like two ancient Roman arches / Which, if lowered, make even his friends tremble / Two eyes which project like two spikes / And read all thoughts, good and bad /

The nose like an eagle's beak, which moves / To sniff the air, and see if anything new has come— / The voice that strikes like a whip / And pierces the soul like a dagger-stab."

And so on, for several verses, until the moral is spelled out: *"Bisogna obbidirgli e dir ad si!"*—"We must obey him and say yes!"

Not only was Mussolini returning the state to its primal dignity, but he was seen as the man to save Italy from shortages, the one who gave back to Italian food its primordial and sacramental character. Such was the content of *la battaglia del grano,* the Battle for Grain, launched by Mussolini in the thirties. The Battle for Grain, which depended on farming the land exposed by the draining of the Pontine Marshes—one of Mussolini's most widely hailed projects—was only a partial success and did not live up to its propaganda. Nevertheless, it was constantly saluted by now forgotten Roman Fascist bards like Augusto Jandolo in such poems as "Er Pane," "Bread," published in 1936:

> *Ricordete ch'er pane va magnato*
> *Come si consumassi un sacramento*
> *Co l'occhi bassi e cor pensiero a Dio.*
>
> *Er Duce ha scritto: "Er pane*
> *A core de la casa,*
> *Orgoio der lavoro*
> *E premio santo alle fatiche umane."*
> *Bacelo sempre, fiio, perche in fonno*
> *Baci la terra tua che lo produce,*
> *C'è sempre intorn or ar pane tanta luce*
> *Da illuminacce er monno!*

"Remember that bread is to be eaten / As one takes a sacrament / With lowered eyes and a heart thinking of God. / The Duce has written: Bread / Is the heart of the house / The pride of work / And the sacred reward of man's labor. Always kiss it, my son, because in fact / You kiss your land that produces it— / Such light always surrounds bread / As can light the world!"

Even D'Annunzio was moved to write an ode in praise of *parrozzo,* the coarse farmers' bread of the Abruzzi, and dedicate it to his own baker, Luigi d'Amico. However, the bread that resulted from the *battaglia del grano* was often very poor, if one is to believe a famed pasquinade that appeared during the campaign. Some nameless wit hung a rocklike

Roman austerity loaf on a string around the neck of a statue of Caesar in the Via dell'Impero, with a message attached:

> *Cesare!*
> *Tu che ci hai lo stommico di ferro,*
> *Mangete sto pane di l'Impero!*

> Caesar!
> You who have an iron gut,
> Eat this bread of the Empire!

Rebuilding this empire was a dream of Mussolini's, but an impossible one. The main stage for his imperial ambitions was Africa; but too many of the Great Powers already had colonial stakes there. Even Italy had its little bits of Africa—since 1882, Eritrea; and Italian Somalia since 1889. However, they were divided by the independent state of Ethiopia, otherwise known as Abyssinia, with whose ruler, Haile Selassie, the Duce had signed a nonaggression pact. But with Mussolini, some pacts were made to be broken, and this was one of them. Italy, it transpired, had been stockpiling ordnance in an obscure oasis named Walwal, which was clearly on Ethiopian territory. A skirmish developed between Ethiopian forces at Walwal and some Somalis attached to the Italian army there; about 150 Ethiopians, it was alleged, were killed by the tanks and aircraft of the Italian-Somali allies. From there the situation worsened, amid Italian claims and counter-claims, until soldiers from Italian Eritrea were on full war footing with the unfortunate Abyssinians. They did not declare war; that formal declaration was left to the Abyssinians, who made it in October 1935. The contest was hopelessly unequal: machine guns, bombers, and mustard gas against half-naked tribesmen armed with bolt-action rifles. Mussolini sent in 100,000 Italian troops commanded by General Emilio De Bono. De Bono was soon replaced by a more ruthless commander, Marshal Pietro Badoglio. They overran Abyssinia, and even emphasized their complete victory with such propaganda gestures as building, with army labor, a colossal stone-concrete-and-earth portrait of mighty Mussolini as a sphinx, rising from the sand, which today survives only in official newsreels.

In May 1936, the Italian forces entered the capital, Addis Ababa; Emperor Haile Selassie, Lion of Judah, fled into exile. The Ethiopians claimed that they lost half a million men in the war; this was probably an exaggeration, but they were dreadfully mauled. Neither side was inno-

cent; both had resorted to torture of prisoners and other war crimes. But there was no doubt which the aggressor was. Italy emerged from this colonial adventure with no credit, and Abyssinia—whose emperor was eventually replaced on his throne by British forces during World War II, which broke out shortly after—with very little. To underscore their victory, the Italians sent to Abyssinia a cast of the Capitoline she-wolf, complete with Romulus and Remus. It was installed outside the train station in Addis Ababa, replacing a figure of the Lion of Judah with Solomon's crown on its head, given by a French railroad company to the negus of Abyssinia, which went to Rome as a souvenir of victory. But after the Allies entered Rome in 1944, the displaced figure of the Lion of Judah, which had been standing in a city park, had mysteriously vanished. Someone had shipped it back to Haile Selassie.

Now Mussolini, realizing that his Ethiopian adventure was not going to earn him credit from England or France, who had their own colonial stakes in Africa, threw his weight behind Franco's Nationalists in the Spanish Civil War. In July 1936, he sent a squadron of Italian planes to Spain to fight for Franco. Naturally, this endeared him, to some extent, to Hitler. He accepted Hitler's annexation of Austria in 1938 and his seizure of Czechoslovakia the following year. It did not mean that Italy became a smoothly working or passive ally of Nazi Germany. It did, however, prepare the way for the Patto d'Acciaio or Pact of Steel, an alliance of "friendship" between Germany and Italy. There was not much, however, that Mussolini could offer Hitler in the way of practical support—his arms supply was too thin. So, when the German invasion of Poland brought a declaration of war from England and France, thus opening World War II, Mussolini—at the strong insistence of Italy's King Victor Emmanuel—stayed nonbelligerent. This was short-lived. Mussolini soon became convinced that Hitler would win quickly, and sent his Tenth Army under the command of General Rodolfo Graziani to attack the British forces in Egypt. This proved a costly fiasco and ended with the British defeat of Italian forces at El Alamein. Now the Germans sent the Afrika Korps to North Africa, Germany attacked the Soviet Union and dragged Italy with it, and Italy committed the grave but probably unavoidable error of declaring war on the United States. Now the descent began in earnest. Allied bombing was pulverizing the cities, factories, and food supplies of northern Italy. Coal and oil started to run out. Even pasta became a black-market rarity.

At the end of April 1945, Mussolini and his mistress Clara Petacci were

captured by Italian communist partisans as they were fleeing north to Switzerland, hoping to fly from there to Spain. They were taken before they left Italy, at the village of Dongo, on Lake Como. They and their fifteen-man entourage were said to have been carrying huge amounts of cash with them. Nobody knows for sure what happened to this money, but the suspicion has always been that it went straight into the Communist Party's coffers; for this reason, the CP headquarters in Rome has, ever since, been known as "Palazzo Dongo."

April 28, the day after their capture, the Duce and his party were driven to the nearby village of Giulino di Mezzegra and shot to death. In a moving van, their corpses were taken south to Milan and dumped in Piazzale Loreto, where partisans strung them upside down on meat hooks from the awning of a gas station—in the past, Fascists had done the same, in the same place, to partisans—to be ritually execrated with stones, vegetables, spittle, and curses. After a long game of hide-and-seek with the Duce's corpse, it was at last interred in the cemetery of his birthplace, Predappio, where it continues to be visited by respectful pilgrims to this day.

In the end, what is one to make of Mussolini? He was a narcissistic tyrant; that goes without saying. But he was certainly not a figure of unmitigated evil, like Adolf Hitler. One cannot imagine a new Hitler arising in Germany, but a new Mussolini in Italy is neither a contradiction in terms nor even unimaginable. As Martin Clark put it, "Mussolini's legacy is a real challenge to contemporary Italian society because his values, though politically incorrect, are so widely shared." It has to be granted that there was nothing phony about his beliefs and convictions. His character was, of course, histrionic; but of how many popular leaders can this not be said? Perhaps histrionic talents are essential for political success. Colorless and clerkly figures do not rise to supreme office, though they make the life of spectacular ones easier. To a great extent, what you saw with Mussolini was what you got. The Italians admired his courage, which was not in doubt. He was clearly not in politics for personal gain; he cared nothing for money or domestic comfort. They liked his forthrightness and his willing, indeed eager, acceptance of risk. He had no middle-class background; he was wholeheartedly patriotic and genuinely male—there was nothing forced or mendacious about all those photos of Il Duce striking attitudes on top of tanks or showing his belligerent profile to the lens. The English might mock them; the Italians did not. Hollywood, in the genius of Charlie Chaplin, might set Jack

Oakie to play him as "Benzino Napaloni" in *The Great Dictator*—but it was not a caricature that has ever played well in Italy.

He believed he had a medium's relationship to his country, instinctive and infallible—and much of the time, at least, he was right. "I did not create Fascism. I drew it from the Italians' unconscious minds. If that had not been so, they would not all have followed me for twenty years—I repeat, *all* of them." This enabled Mussolini's charismatic mix of presidential omniscience and theatrical posturing to work. To dismiss him as a buffoon, a swollen bullfrog on horseback, as Anglo-American propaganda constantly tried to, is seriously to underrate him. He understood the uses of the media, and grasped them extremely well, at least as well as Winston Churchill; he was particularly well aware of the potential of film as propaganda. In this respect, he was ahead of his time, and his career pointed ahead to such image managers as John Kennedy and George W. Bush—but most of all as the immensely rich and sexually flamboyant mediacrat who, through his control of national television, is still the dominant figure in Italian politics, Silvio Berlusconi.

12

Rome Recaptured

The capture of Rome, Italy's capital, from Fascist hands was a long time in preparation. It could not be done by direct attack from the North. All previous assaults on Rome, dating back to the time of the Gauls, had come from there. But the German forces made that impossible. It was becoming clear, by 1943, that the burden of keeping the Allies out of Italy was going to fall, more and more, on the German rather than the Italian forces—and on the repulse, which ultimately proved impossible, of a sea-and-air invasion across the Mediterranean from North Africa.

Mussolini and Hitler, together, had committed Italy to full partnership with Germany in the world war. There is no doubt of the mutual fascination that existed between the two men. It had been in place, and strengthening, ever since Mussolini paid his state visit to Germany in 1937 and was confronted by the full strength of Nazi theatricals—no man as narcissistic as Il Duce was going to be unmoved by the sight of an avenue lined with likenesses of himself and of Roman emperors.

Yet there was no prospect that the partnership of Italy and Germany in a world war could be an equal one. The Italian economy could only support a tenth of Germany's military expenditure (in 1938, $746 million, as against Germany's $7.415 billion). Its production of war materiel was small compared with Germany's, despite all the bluster Mussolini and his propagandists made about it. Italian immigration to the United States between 1918 and 1938 had been heavy, and the reduction of Italian manpower accordingly large—a problem which obviously could not be solved in the short term by any number of appeals to population growth.

And the worst problem of all, from the Axis's point of view, was the difficulty of getting ordinary Italians to hate Americans and the British. The Allies had fought the Italian army in North Africa in early 1943, and the results were not encouraging for Italy; by May 1943, according to John Keegan, the number of Italians who had become Allied prisoners in the African wars over Mussolini's "empire" exceeded 350,000, more than the total garrison assigned to Africa at the beginning. The Allied victory in North Africa was now absolute and irreversible, and this meant that the whole Italian coast was faced, across an intervening sea, by hostile forces, deployed from Casablanca to Alexandria. What Churchill had memorably called "the soft underbelly of Europe" was now open to attack from sea and air as it had never been in previous history.

Moreover, the royal house of Italy, with most of its ruling aristocracy and officer class, was wavering in its loyalty to Il Duce. Hitler was well aware of this, and he felt, correctly, that "in Italy we can rely only on the Duce. There are strong fears that he may be got rid of or neutralized in some way. . . . Broad sectors of the civil service are hostile or negative toward us. . . . The broad masses are apathetic and lacking in leadership." So they were, and they became more so after the unwelcome news of Operation Husky, the code name for the Allied landings in Sicily—the prelude to Operation Avalanche, a full assault on the Italian mainland. This was a crucial event for Italy's ruling class. It persuaded them to change sides, without telling the Germans. The Italian troops facing the Allies crumbled, and Badoglio, their commander, had opened negotiations with the Allies, all the while declaring that, as prime minister—for Mussolini had now resigned his office—he was unshakably loyal to Hitler. After an uncomfortable meeting with King Victor Emmanuel, who had demanded his resignation, Mussolini was banished to an improvised succession of islands off Italy's west coast, ending at a hotel atop the Gran Sasso peaks in the Apennines. From there, a few weeks later, he was "rescued" on Hitler's orders by a formidable duel-scarred SS commando named Otto Skorzeny, who came winging in with a tiny Storch spotter plane, scooped up Il Duce, and flew him off to a reunion with Hitler, and refuge, of a sort, in the tiny town of Salò. Here, he was to reign briefly as head of a puppet regime, the Italian Social Republic. Such was the terminus of Il Duce's political career.

The first stage of the Allies' thrust into Italy was a success. The central target of the Allies' enormous armada was the ancient port town of Gela—where, according to legend, the Attic playwright Aeschylus

had been killed by a falling tortoise, dropped from the beak of an eagle. Much more than tortoises came hurtling down on Gela's Axis defenders: waves of bombers, parachutist drops, and naval guns with which the three-pronged assault of Patton's Seventh Army pressed home its attack, out of a limpidly clear July morning. It took the troops of Husky just thirty-eight days to win back ten thousand square miles of Sicily from the Axis, fighting with desperation uphill most of the way. By the end of it, half a million Germans were dead, and when the Allies reached Messina, the northeastern tip of Calypso's blood-boltered island, the correspondent Alan Moorehead gazed over the narrow strait to the mainland and reflected, "One was hardly prepared for its nearness. . . . When one looked across at that other shore, the mainland of Europe, the vineyards and village houses were utterly quiet and all the coast seemed to be gripped in a sense of dread at what inevitably was going to happen."

What happened, starting in early September 1943, was Avalanche, the Allies' mass landing at Salerno. By now the Italian forces had caved in, and all the fighting devolved on the Germans, who held on with the grimmest determination—a determination matched only by that of the invading Allies.

After the hails of fire that had engulfed southern Italy during the Allied crossing from Sicily, after the bitter yard-by-yard struggle up the "boot" of Italy toward Rome, after the long and murderous transit through Salerno, the "bitchhead" (as the troops named it) of Anzio, and the terrors of the long assault and counterassault on the venerable fortress and Abbey of Monte Cassino, established in the sixth century by Saint Benedict, the actual fall of Rome, in June 1944, came almost as an anticlimax to the Allied army. As the army approached the city, few shots were fired. Rome was almost empty of Germans but full of Romans, all of whom miraculously ceased to be *fascisti* when the first American tanks came rolling over the Tiber bridges; the plug had been pulled, and the enemy was draining north, to make its stands above Rome, north of the Tiber.

If Allied bombers had been set loose to attack the city, they could have produced a devastation without limits. Given the Allies' air superiority, it would not have been difficult to do to Rome what the British had already done to Dresden. But the American high command had to reckon with the reactions of the millions of American Catholics if the American forces were seen to be bombing the pope, even if their target was Mussolini. In late June of 1943, General Marshall had allowed that "it would be a tragedy if Saint Peter's were destroyed," but Rome still contained a

target of high strategic importance: not only was it the capital of Fascism, but through its enormous Littorio marshaling yards passed most of the rail traffic headed south.

Accordingly, Roman Catholic pilots and bombardiers were given the option of not taking part in the planned raid on the yards. Navigation maps highlighted the Vatican and other historic sites. But there was a limit to what a huge bombing raid could avoid. Five hundred B-26 bombers carrying some thousand tons of high explosive headed for Rome from bases in North Africa. There was a kind of miracle in the fact that they nearly all hit their designated railway targets. Only one church of historical value was hit: San Lorenzo, a fourth-century structure, was virtually demolished by a single thousand-pound bomb, but has since been rebuilt.

Though thousands of men had been killed on their way to Rome, few Allied soldiers died in Rome itself. The Germans, or nearly all of them, had pulled out in front of the advancing troops. The Allies had suffered 44,000 casualties since the invasion of mainland Italy had begun on May 11: 18,000 Americans (including 3,000 killed), 12,000 British, 9,600 French, and nearly 4,000 Poles; German casualties were higher, estimated at 52,000. Now General Mark Clark, who had long been obsessed with the capture of Rome, found his conqueror's way through the city to the foot of the Capitoline Hill, up Michelangelo's Cordonata, to the doors of the Campidoglio. Relatively few Romans turned out in the streets to watch Clark's progress through the open city on June 4—all were afraid (needlessly, as it turned out) of being caught in the crossfire of a last-ditch stand by the Nazis as they left. But there was no "last stand" by the Germans as they quit Rome.

Recovery from the Fascist occupation was slow and incomplete. The end of World War II also marked the end of all possibility of Rome's recovery at the head of the static visual arts; culturally, if not dead, Rome was certainly crippled. It is depressing, but hardly unfair, to admit that, by the beginning of the 1960s, Rome, the city that had produced and fostered so many geniuses in the visual arts across the centuries, had none left—not, certainly, in the domains of painting, sculpture, or architecture. None of the painting or sculpture made in Rome since World War II even begins to measure up to the grandeur and energy of earlier work done by Roman artists or to work commissioned by Roman patrons. As for another Raphael or Michelangelo rising in Rome, or a Caravaggio, forget it: there are quite simply no candidates.

What caused this situation? It is impossible to say. Cultures do grow old, and sometimes one of the ominous signs of this can be their frustrated desire to look young. Why it happens may be long debated but remains a mystery. It happened with Roman architecture: one cannot point to a single architectural project built in the Eternal City in the last hundred years or more which could justify comparison to, for instance, the Spanish Steps, let alone Piazza Navona. The sorry truth is that whole cultures, like individual people, do run down; with age, their energies gutter out. They have a collective life, but that life depends entirely on the renewal of individual talent from decade to decade. The mere fact that they once produced extraordinary things guarantees nothing about their futures—otherwise, one could have expected something memorable from (say) Egypt or Mayan America over the last few hundred years.

This is what happened to Rome. The great city gradually ceased to be a place from which one could expect major painting or sculpture to emerge. And in fact no one was watching, because it was simply assumed that the resources of Rome could never be exhausted, and so could be taken for granted. This was not a sudden implosion, but a slow leakage. What Rome had to offer the artist was no longer what the artist necessarily wanted. Who was going to learn about abstract art, the orthodoxy of the postwar years, by looking at Canova and Bernini? The more Rome was visited, the more it was locked into the itinerary of mass tourist spectacle, the less useful it seemed to become to the artist. There had been no doubting the necessity of Rome to the artist in the seventeenth century. Certainly many nineteenth-century French artists could not define themselves or their work without the supreme example of Rome before them, whatever their differences might be among themselves: one need only think of painters who used to be treated as complete opposites, like Ingres on the one hand and Delacroix on the other. But the position of Rome became more debatable, and its strength corroded, as Paris took over as the center of Western art in the nineteenth century. There was, for instance, no Roman equivalent to Manet, and neither Rome nor the prototypes it offered played any significant role in the development of Impressionism or later forms of modernist art, except for Italian Futurism. Then came the twentieth century—and New York, with its even vaster imperial pretensions. In the process, as the Great Tradition of classicism faltered and died, the wonders of Rome slowly became culturally optional.

To a degree not imagined before, Rome had simply run out of major

painters, and the artists it did have were running out of energy. Not much of the art made in Rome between the war and the present seems headed for survival.

Giorgio de Chirico may have been the best-known and (at least for his early work) the most esteemed Rome-based Italian painter of the twentieth century, but there is little doubt who was the most popular in Italy. He was Renato Guttuso (1911–87), a much younger man than de Chirico and his opposite in every way. De Chirico's work showed not the least trace of contemporary social interest or awareness; he was entirely focused on nostalgia for a vanished antiquity. Outside the studio, he took no part at all in politics. Guttuso, on the other hand, was an ardent communist from his youth, defiantly joining the Fascist-banned PCI (Italian Communist Party) in 1940 and never deviating from his anti-Fascist beliefs. From 1943 on, he was an active anti-Nazi partisan, and the risks he ran from the occupying Germans were real. He saw his work as part of the Italian resistance to Nazism, and to the power of the Mafia. This put him in a good position to be seen as a culture hero, untainted by Fascist sympathy, in the eyes of younger leftists even before the Allied victory in the war and the fall of Mussolini. After 1945, when an artist's wartime political allegiances were a big factor in his postwar reputation, Guttuso's name became all but unassailable—any demurral from its pre-eminence was taken, in leftist circles, as a politically motivated assault from the nostalgic right. Guttuso was the only Western artist, other than Picasso himself, who was treated reverentially as an ally and model by official cultural circles behind the Iron Curtain, in the 1950s and after, so much so that he was given the Lenin Peace Prize in 1972, the Soviet equivalent of the Nobel (though never accorded such importance in the West). He shared this honor with La Pasionaria of Spanish Civil War fame (Dolores Ibárruri, 1964) and the Italian sculptor Giacomo Manzù (1965), whose specialty, other than lecturing anyone within earshot about the inequalities of the world, was making harmoniously conical effigies of cardinals and designing monumental doors (1964–67) for the Basilica of Saint Peter.

Guttuso constantly spoke of himself as a Sicilian peasant. "Sicilian peasants . . . hold the primary position in my heart, because I am one of them, whose faces come before my eyes no matter what I do." This in fact was rather a stretch; he was indeed Sicilian (from the ruinously depressed, Mafia-ridden town of Bagheria, not far from Palermo), but he was from the middle class, was married to a Roman contessa, Mimise

Bezzi Scala, and the sales of his paintings made him one of the richer men, and certainly the richest artist, in Italy. Nevertheless, no modern artist could claim to have done more to illustrate the harshly insular, stress-laden, and almost furiously vivid conditions of Sicilian peasant life, before, during, and after the Nazi occupation. Guttuso's best paintings tended to carry a freight of desperation; very much under the influence of Goya, they commemorate revolt against intolerable human conditions. Sometimes they quote and imitate Goya directly, as in *La Fucilazione in Campagna* (*Execution by Firing Squad in the Country,* 1938), provoked by the killing of the poet Federico García Lorca by Franco's Falangists, which was based on that archetype of protest pictures, Goya's *Third of May.* Guttuso painted the working class at work: fishermen, textile workers, sulfur miners. He did so with a fierce and disillusioned sympathy that many Italians, at the outset of his public career, found intolerable, but later came to expect, more or less as a trademark. When he won the Bergamo Prize in 1942 with his *Crucifixion*—which contains, along with bitter emblems of suffering and torment, indebted equally to *Guernica* and to the Isenheim Altarpiece, the figure of a naked woman—there were strident protests from members of the Catholic Church.

His best-known series of paintings inspired by the war, the massacres, was based on a slaughter that took place in a little-frequented suburb of Rome, the Fosse Ardeatine or Ardeatine Caves. These caverns had been used until then as a mine for *pozzolana,* the volcanic dust used in mixing concrete. On March 23, 1944, a squad of German policemen (Eleventh Company, Third Battalion, mostly German-speaking Italians who had served in Russia) was marching along Via Rasella in central Rome when it drew level with a steel trash cart which the Italian resistance, knowing their route, had packed with iron tubes filled with some eighteen kilos of TNT. The resulting explosion, faultlessly timed, killed twenty-eight police and a number of bystanders outright; others died soon after, bringing the death toll to forty-two.

This action—or atrocity, as the Germans saw it—threw the Nazis into a frenzy of vengeance. Reprisals were called for: ten Italians for every dead Nazi. (The sixteen resistance members who had actually planned and helped carry out the action were never caught.) There were difficulties in rounding up enough hostages, and many of those taken into custody not only had had nothing to do with the explosion but knew nothing about it, being already in jail when it happened. But finally, on March 25, a total of 355 Italians were forced into trucks, driven to the Ardeatine

Caves, and shot in groups of five. It took all day and produced indescribable and horrible chaos, particularly since some of the Nazi executioners were themselves so horrified by their task that they had to get drunk on Cognac to finish the job, which did not improve their aim. When the last victim was pronounced dead, a corps of German engineers sealed the caves with dynamite. They would not be opened for a year, until after the Allies entered Rome. But word of the Ardeatine slaughter leaked out very fast, and it was on this that Guttuso based his melodramatically tragic series of massacre paintings, collectively entitled *Gott mit Uns—God with Us,* the slogan on the buckles of Nazi uniform belts—which could not be publicly exhibited before the liberation of Italy, for fear of German reprisals.

Probably Guttuso's most ambitious painting was done several decades later—his enormous three-meter-square canvas *La vucciria* (1974), a panorama of the food market in central Palermo. The name of the place derives from the French *boucherie,* "butcher's shop," and that is essentially how it began: in Italian a *macelleria,* but a gigantic, encyclopedic one, where everything living or dead, from baby squid to whole hogs, from bunches of laurel to boxes of eggplant, as long as it was edible, was sold for consumption, twenty-four hours a day. Just as the old Les Halles was known as *"le ventre de Paris," "the belly of Paris,"* so the Vucciria is and was the belly of Palermo, growling, grumbling, restlessly teeming, and always alive. *"E balati ra Vucciria 'un s'asciucanu mai,"* runs a common Sicilian saying, "The paving stones of the Vucciria are never dry," meaning that the place is always in use, always being swilled and hosed down. Or, if you want to make a promise of delivery that neither you nor your hearer will believe, you can say, "When the stones of the Vucciria dry out." Into this painting Guttuso packed his feelings and observations about Palermo; the city was, as he painted it, what the city ate, an enormous and phantasmal, chaotic slaughterhouse: dead lambs, tuna split open to disclose their ruby flesh, harsh contrasts of purple eggplant, tomatoes so red-ripe as to seem on the verge of explosion, sardines awaiting their transformation into *pasta con le sarde,* pyramids of shining lemon—a massive compost of life and death.

If Guttuso's form of social realism—victims, big backsides, spaghetti-haired women, and all—proved popular with orthodox communists and rich Italians in and out of Rome, it failed to excite much imitation—and none of any quality—among Italian painters in the postwar years, and was looking decidedly tired by the 1960s.

The new rage was for abstract painting, and in particular for the work of Alberto Burri (1915–95) and Lucio Fontana (1899–1968). But Burri's work now seems to have been overtaken by the more subtle paintings of the Spaniard Antoni Tàpies, and Fontana's has come to look monotonous. (There are those who, remembering Fontana's early enthusiasm for Mussolini and Fascism, to which he was a convinced adherent, would regard this as a just punishment.) How much mileage can an artist extract, and for how long, from ripped, paint-drenched, charred burlap? The work of these "informalist" painters only reminds us, decades later, that when paintings have little or no anchorage in the world as seen, they will end up looking pretty much the same; the "freedom" of so much abstract art actually leads to monotony. Nine times out of ten, the thing that underwrites variety is a certain degree of faithfulness to things as they appear, to a world whose enormous and constantly invigorating and challenging differences cannot be surpassed by the more limited experience of a painter.

Fontana was the kind of artist whose work passed through a phase of seeming radical almost to the point of aggression and alarm, and then slumped into a semi-decorative sameness. From early Cubism onward, artists had achieved certain effects by adding material to the canvas—collaged newsprint, glued-on objects. Fontana's rhetorical device was to take material away from the canvas, leaving holes in it—either poked or slashed in its paint-burdened surface. These were christened, rather pretentiously, Concetti Spaziali (Spatial Concepts), because they showed emptiness behind the stretched canvas. Fontana's admirers saw in this an invigorating sign of pent-up energy, though today this seems more a figure of art-speech than a physical reality. Looking back on it, how pointless it seems! The real surface of Italy was full of holes, craters, gashes, all inflicted on it by the bombs of the raiders and the shells of the panzers. It was one huge landscape of damage. Little could have been more gratuitous than to take canvases and punch holes in them, as though this could add some meaning to what the real world had undergone, whose traces were so much more eloquent than anything an "advanced" artist could do to surfaces in his studio. Fontana's work could not escape the fate of novelty art which outlives its novelty.

In general, Italian painting in the 1960s seemed caught in an insoluble bind: anxious to escape the heavy, elegant burden of inherited culture, plagued by memories of its own glorious past, it could not invent a convincing way of looking brutal. In Rome it entered a phase of complacent,

pseudo-radical mannerism which made the frigid exercises of such paint-
ers as the Cavaliere d'Arpino, three centuries before, seem positively exu-
berant. The Italian art world, seemingly disoriented by the war and by
the rise of American art to prominence (and then to imperial glory in the
fifties), tended to treat as "major figures" artists whose talent and achieve-
ments were quite nugatory. One example among many was Mario Schi-
fano (1934–98), an "Italian Pop" artist who briefly enjoyed the reputation
of being Italy's answer to Andy Warhol—as if an answer were needed!—
before wrecking his slender talent and eventually killing himself with
massive intakes of cocaine. Schifano was the next-door neighbor of the
great Italian aesthete and English scholar Mario Praz, author of *The
Romantic Agony, The House of Life* (a long, meditative essay that circled
around his enormous collection), and other works. Praz loathed Schi-
fano, who was the noisiest of neighbors and, as a friend of the Rolling
Stones and a devotee of rock-and-roll, represented everything Praz found
most noxious and threatening in sixties culture. Schifano, on the other
hand, worshipped Praz, and bombarded him with invitations to meet.
He wanted, in particular, an inscribed copy of *The House of Life*. Eventu-
ally, one was left outside Schifano's door, and it was indeed inscribed by
the scholar. *"A Mario Schifano,"* the dedication ran. *"Così vicino, ma così
lontano"*—"To Mario Schifano, so near but so far away."

The 1960s and '70s were a hospitable time for conceptual art in Rome,
particularly given the Italian talent for obfuscatory theory. The most
"radical" of these gestures—one whose sharpness is most unlikely ever to
be surpassed, and which out-Duchamps Duchamp in a small way—was
Piero Manzoni's *Merda d'artista,* which is (or possibly is not) what it says
it is: the artist's shit, a small lump or turd weighing about thirty grams,
sealed in a small tin can and forever invisible.

Manzoni was born near Cremona in 1933 but lived in Rome; he had
no art training, and did not need it, since his work consisted entirely of
ideas about art rather than the making of aesthetic objects. One part of
this field was his *Achromes* (*No Colors*), white canvases covered with white
gesso that was scratched or scored with parallel lines. (They did not have
to be canvases; some *Achromes* were made of white cotton wool, or even
bread rolls—white bread, naturally, rather than the grainier brown Ital-
ian *pane integrale*.) The chief influence hovering behind these was that of
the French artist Yves Klein, whose show of monochrome canvases, all
painted the same IKB or International Klein Blue, Manzoni had seen in
Paris in 1957. Another was that of Robert Rauschenberg, who had done a

group of all-white canvases as far back as 1951; and one should not forget the Russian Malevich's *White on White* (1918).

Manzoni did single lines, drawn on a roll of paper of a precisely given length, such as a kilometer; these scrolls were rolled up and kept in polished metal drums. He designated friends (one of whom was the writer Umberto Eco) as living works of art, issuing them with certificates of authenticity. He exhibited red and white balloons which he had blown up himself and then tethered to wooden bases, under the title *Artist's Breath;* these were intended as relics or souvenirs of "creativity," though of course they did not last long; the rubber perished. In 1961, he installed an iron block in a Danish park; its title, *Base of the World,* was inscribed on it upside down, so that the viewer could imagine the whole world reposing on the block, rather than vice versa. Thus, before his early death from a heart attack in 1963, Manzoni had created a small, wry, sharp body of work; how things might have developed from there is of course unknowable. Probably, one suspects, not so very far . . .

But the little can of excrement was the signature of his career, as nobler things had been of Gian Lorenzo Bernini's. Rumor insists that he got the idea from Salvador Dalì, but in any case it was a neat conceptual *jeu d'esprit.* Opening the can would, of course, destroy the value of the artwork. You cannot know that the shit is really inside, or that whatever may be inside is really shit. The obvious target of this object, or gesture, is the overvaluation of art as a fragment of the artist's being—the idea that, in buying a work of art, one also comes to own not just a made object but a part of a creative personality. It is the kind of thought that tends to dissipate when explained, as good jokes do. It is also a point which can only be made once, which redoubles the "uniqueness" that Manzoni's idea proposes. The edition size is ninety cans, and so far none has been opened; it seems unlikely that any will be, since the last can of Manzoni's *Merda d'artista* to go on the market fetched the imposing sum of $80,000—no shit, one is tempted to add.

Other artists gathered under the umbrella of Arte Povera produced objects of some modest interest. Probably the best of them was Giuseppe Penone (b. 1947), who hit on the memorable idea of taking a wooden construction beam with knots showing and then, starting from the exposed knot ends, whittling back into the substance of the wood to disclose what had originally been the younger form of the tree, hidden inside—an intriguingly poetic reversal of time and growth.

There was, however, a limit to how much conceptual art the Italian

market and its public could continue to absorb with interest. No matter how many art followers might admire such products of Arte Povera as Mario Merz's igloo constructions of metal, glass, neon, and other mixed materials (praised at the time for their allusions to "nomadic" and "primitive" cultures), or Jannis Kounellis' *Twelve Horses* (just that: twelve live horses—straw, bridles, horseshit, and all—displayed in Rome's Galleria L'Attico in 1969, which one postmodernist art historian called "the model of prelinguistic experience, as well as . . . nondiscursive structures, and nontechnological, nonscientific, nonphenomenological artistic conventions"—enough dry jargon to choke any pony—people still seemed to want something to hang on their walls, which one could not easily do to a horse or an igloo. Enter, at this point, a brief temporary salvation in the form of the Transavanguardia.

This clunky neologism was coined by the Roman art historian Achille Bonito Oliva, who acted as ringmaster for a group of young painters, of whom the most prominent were Sandro Chia (b. 1946), Francesco Clemente (b. 1952), and Enzo Cucchi (b. 1949). It meant absolutely nothing definable but pointed to a mood of eclectic revivalism, of eager neophytes shoring fragments—of archaeology, of religion, of what you will—against their ruins. But at least it meant painting, for which a surfeit of conceptual art seldom fails to excite nostalgia, especially if the painting is of human figures. These, the Transavanguardisti supplied in some quantity. Their quality was a different matter. It produced interest in America—indeed, it was the only new Italian art to stimulate excitement on the American market. Nevertheless, this was quite short-lived.

The most dramatic painter of the three was Cucchi, who did large doom-laden panels of frantic chickens caught in what appeared to be mud slides in a cemetery, with shovelsful of brown and black paint two inches thick.

Chia, on the other hand, had a curiously revivalist flair. In the early 1980s, he appeared to be influenced by an almost forgotten figure, the Fascist painter Ottone Rosai (1895–1957), whose roly-poly figures—buttocks like blimps, ladylike coal-heaver arms—had been part of a conservative reaction against Futurism. Chia was running what appeared to be more lighthearted variations on Rosai's fatness. In the same way, he alluded to de Chirico—not the early master of strange cityscapes, but the de Chirico of the 1930s, kitschy antiquities and all. If these padded boys and dropsical nymphs were to meet the demands of real classical art, it would seem a breach of etiquette. But in the stylistic context of Chia's work,

such demands could hardly be made. Everything looked so ebullient, juicy, and harmless that non-Italians thought it "typically Italian," like a painted cart or a singing gondolier.

But at least it was less pretentious than the work of the third Trans-avanguardista, Francesco Clemente. Clemente spent part of each year in Madras, in southern India, and his work is a stew of European and Indian quotations, full of quasi-mystical teases. He acquired a reputation as a draftsman, quite undeserved: Clemente's figures are boneless, and his conventions for the human face—he is fond of portraiture—are close to a joke, with their poached-egg eyes and strained, one-expression mouths. These effete masks suggest no ability to peruse a face and its particularities. They are nothing more than figuration cut adrift and stripped of its reason for being.

One can hardly blame Clemente for this—he clearly can't do any better. And at least he isn't quite the pseudo-classical pasticheur that other Italian postmodernist contemporaries are, with their slimy parodies of neoclassical profiles and flaccid musculature. But the blame, if any, should go to the mechanisms of late-modern taste, the flaccidity induced by the market acting in concert with the supposition that only the new can be the good. It is probably true that the person with a serious curiosity about contemporary art can bypass Rome on his or her travels. Anything of that kind there is seen, as it were, under license: it has come from other galleries in other countries of Europe, or from New York. An air of distinct secondhandedness and second-rateness prevails. Rome today originates nothing. If a pilgrimizing artist in the seventeenth century, when Rome was incontestably the school of the world and all works of art were certified by their relation to the great city, had been told that this would happen within fewer than three hundred years, he would have recoiled in disbelief. Time was when the opportunity to exhibit or do a commission in Rome would have been regarded, and rightly, as the climax of an artist's career; today it hardly matters, because the Mandate of Heaven (in that expressive old Chinese phrase) has moved elsewhere, and did so many years ago.

No Italian painter or sculptor after (say) 1960 had anything like the same effect on other artists in his medium that Italian filmmakers did in theirs. Film was where the creative vitality of Italy, driven underground by World War II, re-emerged in force. First, it was visible in the neorealist movement. And by the end of the 1950s, it was crystallized in one splendidly imaginative figure.

That person, of course, was Federico Fellini, who may well have been the last completely articulate genius Italy produced in the domain of the visual arts. Fellini was not the only Italian moviemaker of exceptional talent working in Rome immediately after World War II. There were other, perhaps slightly less gifted figures: Roberto Rossellini and Vittorio De Sica come to mind. Others may yet appear, and one should never assume that the long history of Roman painting is permanently closed, deep as its hiatus now looks—though the "death of painting" is constantly announced, it never quite happens. But certainly they have not appeared yet, and even the most sanguine tour of the horizon does not reveal another talent of Fellini's order in the art of film. Not yet. Perhaps not ever.

The most enduring gift Mussolini made to Italian culture had been the creation of Cinecittà, the studio complex erected in 1937 just outside Rome. As the Duce so correctly pointed out, "Cinema is the most powerful weapon" for propaganda purposes, including a people's understanding of its own history. Within six years of the official opening of Cinecittà, a ninety-nine-acre spread which had large facilities for training, production and post-production—it was in effect Europe's only full-service production center—almost three hundred films had been made there, partly government-financed. That number is now closer to three thousand; and of course these vary extremely in quality.

Because of the disruption of war, there was little security for Cinecittà. When Italy surrendered in 1943, the whole complex was intermittently bombed by the Allies, though not heavily enough to destroy its production capability altogether. The Germans, retreating, looted Cinecittà's equipment and facilities. Immediately after the war, when it became clear that bombing the sets and sound stages was of little strategic use, the Allies converted Cinecittà into a camp for refugees and other displaced persons. It was, in effect, closed down; and Italian filmmakers, deprived of its facilities, took to the streets, using contemporary Rome as their setting and amateur actors as their players. The result was "neorealist" cinema, which amounted to a complete rebirth of the medium in Italy. One "classic" of this type was the film that made Roberto Rossellini's reputation, *Roma città aperta* (*Rome, Open City*), starring Anna Magnani and coscripted by the as yet little-known Federico Fellini, and released in 1945; it was partly shot as documentary during the actual liberation of Rome, and created a sensation when it took the Grand Prize at the 1946 Cannes Film Festival. Another neorealist landmark was Vittorio

De Sica's *Ladri di bicicletta* (*Bicycle Thieves*). The masterpiece of the neo-realist genre was, however, Rossellini's film. As not infrequently happens in times of shortage, its moody newsreel style was partly an accident, due to a lack of film stock, so that its unexplained variations in image consistency are now agreed to have been produced by poor processing and insufficient fixing. Had it not been for the war, this belt-tightening would not have taken place, and Cinecittà would probably have kept turning out the inferior, anodyne *telefono-bianco* romances and comedies that had provided much of its staple fodder in the late 1930s and early '40s. But as things stood after the triumph of *Roma città aperta,* a new form of hybrid cinema had been created, partly by design and partly by accident; quite suddenly, Italy—whose influence on movies had been slight, at best, before—was creating world standards for film from its local industry. The influence of *Roma città aperta* would be felt for more than twenty years, in such works as Ermanno Olmi's *Tree of Wooden Clogs* (1978) and Michael Cimino's much-underrated *Heaven's Gate* (1980).

It would be quite wrong to suppose that most of the productions at Cinecittà followed suit. After a grittily realist start, the movies found their natural home in a ready-made ancient Rome touched up with plaster, among what one of their titles (1984) called *Le calde notti di Caligola, The Hot Nights of Caligula.* Certain historical figures kept cropping up. One of the earliest Rome-set features, long antedating Cinecittà, was *Spartacus* (1914). It was followed by *Spartaco* (1953), and Stanley Kubrick's excellent *Spartacus,* starring Kirk Douglas (1960), followed by *Son of Spartacus* (played by that doughty American weightlifter Steve Reeves, effortlessly tossing huge chunks of foam plastic around the Forum) and, as further spin-offs from the gladiator mode, *The Revenge of Spartacus* (1965), *Spartacus and the Ten Gladiators* (1964), *Triumph of the Ten Gladiators* (1964), and, perhaps inevitably, *Gladiatress* (2004). Some sixteen features, between 1908 and 2003, bore the title of *Julius Caesar,* and Gérard Depardieu even played him in French (*Asterix et Obelix: Mission Cléopâtre,* 2002). The most famous and ruinously expensive of all the Rome reconstructions was Joseph Mankiewicz's 1963 *Cleopatra,* the cheapest and sluttiest was the Warholish *Cleopatra* (1970), starring Viva and Gerard Malanga, and the silliest was the British *Carry On Cleo* (1964). The first of the Antony-and-Cleopatra movies was released in 1908, and it was followed by more than twenty bearing the lady's name.

In the 1950s, thanks to the cheapness of Rome production and the attractions of the city itself—what American actor wasn't going to prefer

living in a grand Roman hotel to working in Hollywood?—giant international coproductions were filmed there, such as *Ben-Hur* (1959), the 1951 *Quo Vadis*, and *Spartacus* (the fourth version, 1960). But the film director whose name is most strongly, indeed indissolubly, linked to the Via Vittorio Veneto was Federico Fellini, and the movie which provided the link was his best-known one, *La dolce vita.*

No film has ever fascinated me more. This really was Europe on celluloid. It seems odd that Rome would have been rendered more attractive to a writer in his hot-potato twenties by seeing a film as intensely pessimistic as *La dolce vita*, but it was, and for a double reason. First, I was a callow and inexperienced romantic, yearning for foreign parts; second, Fellini's film was a real (if flawed) masterpiece about places and situations that seemed overwhelmingly exotic to me. There was no gainsaying either.

Shooting on *La dolce vita* had begun in March 1959, and the film was released in a storm of publicity and controversy early in 1960. It broke all box-office records; *L'osservatore romano*, the Vatican's official paper, called for its censorship; crowds queued for hours to see it; and Fellini was physically attacked at a screening in Milan. For those who have not watched it, it is about the sexual and emotional experiences of a peripheral journalist, Marcello Rubini, played by the iconically handsome Marcello Mastroianni, who makes his living purveying trivial gossip about celebrities to the Italian press. (Originally, the producer, Dino De Laurentiis, had wanted Paul Newman to play Marcello, to guarantee his investment; Fellini adamantly insisted against it.) In order to gather the gossip he peddles, which is never of the least political or cultural significance, he hangs out around the bars and cafés of the Via Veneto. (At the time Fellini was making this movie, the Via Veneto was not yet the caricature of urban glamour *La dolce vita* turned it into. But it was getting there, and the success of the movie cemented the process in the sixties. Indeed, a stone plaque on one of the buildings acknowledges Fellini's role in "creating" the Via Veneto as everyone came to know it.)

Marcello is a weakling, one of the class of people who create nothing substantial or even authentic but to whom things merely happen and create a brief, tinny resonance—the essence of voyeurism, which is how Fellini portrays journalism in general. His companion, the Sancho Panza to this ineffectual and passive Quixote—for all gossip papers need photos—is an irrepressibly cheery, fast-footed, and pea-brained photographer named Paparazzo (Walter Santesso)—whose name, such being

the film's enormous afterlife, was to become generic for gossip photographers from then to now. (The name came from the character Paparazzo in a long-disregarded novel set in Italy by the semi-bohemian English novelist George Gissing, *By the Ionian Sea,* but that title seems to have no bearing on the film. Gissing's Paparazzo does not even have a camera.)

The atmosphere of fraudulence leaking from on high is set in the very first shots—a clatter of rotor blades that announce the coming of Christ. Not the real redeemer, of course, but a hideous and vulgar ten-foot-high effigy with its loving arms extended in blessing, being hauled across the skyline of Rome by a rented helicopter, ready to be lowered onto the top of some column or dome. The pervasiveness of phony religion is as much a theme of *La dolce vita* as that of manipulated emotion, and as a newly hatched ex-Catholic I loved every minute of it: it looked and felt like revenge, which indeed it was—Fellini's own.

La dolce vita loosely unfolds through eight episodes, which are taken to typify the folly and emptiness of Roman life at the dawn of the 1960s. It shows the impulse to religious faith, of which Rome was the traditional center, becoming dried out and descending into the merest superstition. It shows family relationships—those between son and father—dying, more or less, on the branch. It shows Rome as a place given up to sterile and passing pleasure. It shows the death of fame—its descent into mere raucous celebrity. All in all, it sketches a city which can no longer nourish its human contents and yet exercises a magnetic fascination over them, so that they can no longer break from the orbits in which they hold one another.

Despite all its human oddity and theatrical décor, the weirdest moment of *La dolce vita* was, for me at least, the fish in the net at the end of the film. I have seen it three or four times and, although I am pretty good at identifying fish, I have no idea what this sea beast was: some kind of large ray, I suppose. One does not glimpse its whole body; only a glaucous eye, staring damply in close-up at the lens. Its gaze seems both judgmental and indifferent, as no doubt Fellini meant it to be. The partygoers cluster around it. What is this oddity? Where does it come from? "From Australia," someone off-camera suggests. On hearing this, I felt mildly buoyed with semi-patriotic pride. My homeland's tiny, whispered impact on Rome! It seemed like an omen of some kind. I identified with that fish in its strangeness, even though it looked so unappetizing, like a lump of mucus entangled in twine. Like me, it had come all the way from Australia to Italy, in quest of . . . something or other. Who could

know or guess what (if anything) it had been expecting, as it blundered slowly and slimily about on the bed of the Tyrrhenian? Certainly it had been haunting Fellini's imagination ever since, in 1934, he saw a huge, ugly fish stranded on a beach near Rimini.

Fellini went on to make several more movies which became classics of the Italian imagination; the most beautiful and complex of these were *8 1/2* (1963), his extraordinary meditation on the creative process itself—he wanted "to tell the story of a director who no longer knows what film he wants to make"—and *Amarcord* (1973), a convoluted essay on childhood memory. (*"Amarcord"* was Riminese dialect for *"Io mi ricordo,"* "I remember.") But though these were loaded with honors from festivals and the industry, *La dolce vita* has a special place in film history which no Italian paintings of the period can conceivably rival, and no Italian movie made in the foreseeable future is likely to equal its wide cultural impact.

The vision Fellini released of Rome as a tragic playground, filled with the promise of sensuous delight but shadowed by the impossibility of true gratification, proved to be very haunting. It also played beautifully, and to a large extent truthfully, against the Rome the visitor came to know fifty years ago. The Eternal City was a far more agreeable place to be in the early 1960s than it is today.

Of course, this may have been (to some degree) an illusion, fostered then by my own ignorance of the Italian language, and by my excessively optimistic belief in the continuity of Italian culture. At the time, those decades ago, it seemed entirely promising and real. The past fifty years have yielded little of interest, culturally, politically, or especially artistically. But the fact that Berlusconi's Rome, at the start of the twenty-first century, has been gutted by the huge and ruthless takeover of its imagination by mass tourism and mass media, does not mean that continuity didn't exist—once upon a time, when the city was slightly younger.

People, Italians included, never run out of complaints about the decay of Roman culture, both high and popular. It is gross. It is pandering. You only need to turn on the TV in your Roman hotel room to see that. Do so and you will at once be immersed in what you might call the id of the owner, Silvio Berlusconi—a nightmare territory to you perhaps, but to most Italians a sort of paradise, filled with fictions of "knowing"—the ceaseless diet of gossip and chatter and scandal and unembarrassed glitz that passes for news, the relentless barrage of sports and commentary on sports, the diet of cushion-lipped, big-breasted blonde babes who serve

as announcers, the wrestling matches, and all the rest of it. After all, it is only in Italy that a stripper named Cicciolina (briefly famous in the outside world as the spectacularly ill-treated wife of the artist Jeff Koons, and mother of their little son, Ludwig) could acquire a seat in Parliament. It is easy, after passing an idle evening with this stuff (one evening will suffice; it is pretty much all the same, whichever evening you pick), to assume that Italian popular culture has sunk below some IQ level it once occupied in the past. This is an illusion. Italian television—one is tempted to say Italian popular culture in general—is crap, always has been, and will never be anything else. It may not be the absolute worst in the world, but it is certainly way down there.

But, then, has Italian "popular" art ever been much better? We are inclined to sentimentalize about it, but should we? Reflecting on this, I sometimes find myself strolling in the galleries formerly occupied by mosaics from the Baths of Caracalla. In their heyday, these enormous *thermae,* whose stage was big enough to allow a four-horse chariot to be driven on it (this is still done in some productions there of *Aida*), were elaborately decorated with mosaics of the third century c.e. Many of these have now been transferred to the Pagan Museum of the Lateran and reapplied to its walls. Some are not without their archaeological and narrative interest, but what a vision of lumpish coarseness they present! They are gross musclemen, naked gladiators brandishing weapons that look like, and presumably were, heavy bronze knuckle-dusters with protruding flanges, the better to tear out an opponent's eye or smash in his teeth. Watching a pair of these brutes belting away at each other might have slaked most of the pleasure in violence that was satisfied by more lethal encounters with sword and trident. But as studies in heroic nakedness, these stumpy mosaic figures have nothing going for them. They are pure demonstrations of the human body as weapon of meat. They have little in common with more gracefully formalized Greek pugilists or wrestlers. And this was what the Romans liked: violence without frills, just glaring and bashing. And rubbish, too. The floor of the dining chamber depicted is covered with rubbish. Not ordinary droppings, such as might be left after a banquet of extremely messy guests, but unswept kitchen filth: fruit skins, the bones of a fish, and suchlike. Walking on it (which you cannot do, since this is a museum), you would half-expect things to go squidge and crackle underfoot. Except that they cannot and will not do so, being a couple of thousand years old, or thereabouts.

When we talk about "classical" Roman art, the word "classical" does not really mean what it might mean in Greece. It tends to signify something heavier, more grossly human, and definitely less ideal.

We cannot make the mistake with Romans of supposing that they were refined, like the Greeks they envied and imitated. They tended to be brutes, arrivistes, nouveaux-riches. Naturally, that is why they continue to fascinate us—we imagine being like them, as we cannot imagine being like the ancient Greeks. And we know that what they liked best to do was astonish people—with spectacle, expense, violence, or a fusion of all three. As Belli put it, writing about the exultant firework display that rose each year above the cupola of Saint Peter's at the pope's behest:

> *Chi ppopolo po' èsse, e cchi sovrano,*
> *Che cciàbbi a ccasa sua 'na cuppoletta,*
> *Com' er nostro San Pietr' in Vaticano?*
> *In qual antra scittà, in qual antro stato,*
> *C'è st'illuminazzione bbenedetta,*
> *Che tt'intontissce e tte fa pperde er fiato?*

> What people, and what sovereign,
> Have in their home a little dome
> Like that of our Saint Peter in the Vatican?
> In what other city, in what other country,
> Is there this blessed light
> That stuns you and takes your breath away?

The answer is still essentially what it was back then, in 1834: Rome, and only Rome. So, too, "classical," in the Roman sense, suggests something solider, more enduring, than the Greek. For all its glories, and for all the legacy it left in art, thought, and politics, Greek civilization did perish. That of Rome is still somewhat with us. One would need to be strangely indifferent not to appreciate what Ammianus Marcellinus (c. 330–95 C.E.), writing after the effective collapse of the great empire, had to say about Constantine's arrival there in 357, for there is a little Constantine left in all our reactions, in our undying sense of astonishment at this city of prodigious and overweening ambition (italics my own):

> Then, as he surveyed the sections of the city and the suburbs . . . he thought that whatever first met his gaze towered above all the rest; the sanctuaries of Tarpeian Jove so far surpassing as things divine excel those of earth; the baths built up in the manner of provinces;

the huge bulk of the Amphitheater, strengthened by its framework of travertine, to whose top human eyesight barely ascends; the Pantheon like a round city-district, vaulted over in lofty beauty; and the exalted columns which rise like platforms to which one may mount, and bear the likeness of former emperors; the Temple of the City; the Forum of Peace; the Theater of Pompey, the Odeum, the Stadium, and in their midst the other adornments of the Eternal City. But when he came to the Forum of Trajan, a construction unique under heaven, as we believe, and admirable even in the unanimous opinion of the gods, he stood fast in amazement, turning his attention to the gigantic complex about him, beggaring description and *never again to be imitated by mortal men.*

Epilogue

That summer evening of 1959, standing before the great statue of Marcus Aurelius during my first trip to Rome, I was struck with the sense that the Rome I was standing in was the Rome it had always been, and would continue to be—a pervasive naïveté, I see now, born of crude imaginings. It has been interrupted, that sense of continuity broken, by the foul, corrosive breath of our own centuries. For their own protection from terrorism, the horse and rider have now been removed to the Capitoline Museum, and they have been replaced on Buonarotti's pedestal with a replica. It won't matter that many passersby won't see that it is a replica. Just knowing it is will spoil the pleasure of its viewing.

What makes it worse is that whoever installed the great sculpture inside the Capitoline deprived it of its base and placed it slantwise, cantilevered out on an inclined ramp. This is vandalism. It is absolutely intrinsic to the meaning of the Marcus Aurelius that the horse and rider should be level and horizontal; otherwise, their firm authority is lost. In its new installation, slanting meaninglessly upward in a way Michelangelo would never have countenanced for an instant, the sculpture becomes a parody of the huge bronze of Peter the Great by the French sculptor Étienne-Maurice Falconet (1716–91), the "bronze horseman" of Pushkin's poem, riding up his rock in Saint Petersburg. It would be very hard to imagine a more stupid treatment of a great sculpture than this: "design" run amok, vulgarizing the work it was meant to clarify, ignoring all ancient meanings for the sake of an illusion of "relevance" (to what?) and "originality" (if you don't know the Falconet). But, unfortunately, that's Rome now—a city which, to a startling extent, seems to be losing touch with its own nature, and in some respects has surrendered to its own iconic popularity among visitors.

The "tourist season" of Rome used to be confined, more or less, to the months of July and August, when the city was filled with visitors, when restaurants were overcrowded, hotels jammed, and reservations for

anything hard to get. The principal "sights," such as the Vatican Museums and the Sistine, were best skirted during those eight weeks, or even avoided, by the clued-in traveler. That is no longer feasible. Today this season has lengthened to embrace the whole year. And if you think the Sistine Chapel is a tad overcrowded now, just wait another five or ten years, when post-communist prosperity has taken hold in China and expresses itself as mass tourism. A good preparation in the present would be to visit the Louvre (if you haven't done so already) and make for the gallery in which the *Mona Lisa* is displayed to a crowd: a fortress wall of blinking, clicking cameras, all taking bad, vaguely recognizable pictures of the picture, whose function is not to preserve and transmit information about Leonardo's painting but to commemorate the fact that the camera's owner was once in some kind of proximity to the insanely desired icon. All the high points of Rome will be like that, I gloomily think, before so very long. Some will survive it—at least partially; others cannot and will not, because it is not in the nature of works of art to do so. The closed spaces—museum galleries, churches, and the like—will suffer most; it will not make much difference to one's experience of the Forum, not at first. But who can tell what the big outdoor spaces of Rome will begin to feel like once they have twice as many people in them, and their perimeters are jammed even more thickly with buses?

The degree to which the Sistine Chapel is overcrowded represents the kind of living death for high culture which lurks at the end of mass culture—an end which Michelangelo, of course, could not possibly have imagined, and which the Vatican is completely powerless to prevent (and would not even if it could, since the Sistine is such an important source of revenue for the Vatican). You cannot filter the stream. Either a museum is public, or it is not. To imagine some kind of cultural means-test and try to impose it on people who want to visit the Sistine Chapel is, of course, unthinkable. But since the Sistine is one of the two things (the other being Saint Peter's Basilica itself) that every tourist in Rome has heard of and wants to see, the crush there is numbing; it defeats the possibility of concentration. At least the basilica is huge enough to accommodate crowds of people. The Sistine, and the way into it, are not.

It was not always like that. One reads in Goethe's *Italian Journey* his account of walking more or less casually into the Sistine to escape the baking heat of the Roman summer, two hundred years ago. A cool, approachable place where one could be alone, or nearly so, with the products of genius. The very idea seems absurd today: a fantasy. Mass

tourism has turned what was a contemplative pleasure for Goethe's contemporaries into an ordeal more like a degrading rugby scrum. The crowd of ceiling seekers is streamed shoulder to shoulder along a lengthy, narrow, windowless, and claustrophobic corridor in which there is no turning back. At last it debouches into an equally crowded space, the chapel itself, which scarcely offers room to turn around. These are the most trying conditions under which I have ever looked at art—and over the past fifty years I have looked at a lot of art. Some of the arts benefit from being shared with a large audience. All kinds of music, whether rock-and-roll or piano recitals, seem to. Dance sometimes does, and so might theater and poetry readings. But the visual arts, especially painting and sculpture, do not. Throngs of other people just get in the way, blocking your view and exasperating your desire for silence with their overheard comments, which are always a distraction, even if they are intelligent—which they seldom are. Fellow humans are fellow humans, endowed with certain inalienable rights which we need not go into here, but you no more want to hear their reactions in front of a Titian or below a Michelangelo fresco than you would like to have your neighbor in a concert hall beating time on the arm of his seat or humming the notes of "*Vesti la giubba*" along with (or just a wee fraction ahead of) the singer, to prove his familiarity with the piece. (When this happens, it is an invitation to murder.)

Painting and sculpture are silent arts, and deserve silence (not phony reverence, just quiet) from those who look at them. Let it be inscribed on the portals of the world's museums: what you will see in here is not meant to be a social experience. Shut up and use your eyes. Groups with guides, docents, etc., admitted Wednesdays only, 11 a.m. to 4 p.m. Otherwise, just shut the fuck up, please, pretty please, if you can, if you don't mind, if you won't burst. We have come a long way to look at these objects, too. We have not done so to listen to your golden words. *Capisce?*

The only way to circumvent this Sistine crowding is to pay what is in effect a hefty ransom to the Vatican. After closing hours, it now runs small tour groups through the Vatican Museums, guaranteeing the visitor about two hours (start to finish) with Michelangelo and Raphael and, of course, a guide, whose silence is not guaranteed; "normal" viewing time in the chapel itself is about thirty minutes, which is a good deal more than the usual visitor, harried and chivvied, is going to get. The tour groups, at present about one a week, are made up of about ten people, though there may be as many as twenty. (The very first time I went

to the Sistine, there were, by my rough count, about thirty people in the whole chapel, but that, I repeat, was some fifty years ago. It felt a little crowded then, but not intolerable, as it is today.) Each visitor, under the new tour system, pays up to five hundred dollars—some three hundred euros per person—for the privilege, and the deal is done through outside contractors, not directly with the Vatican itself. How the fee is split is not known. Of course, this is highway robbery. If you don't like it, you can always write to the pope; or else buy some postcards and study those in the calm and quiet of your hotel.

What happens inside churches also happens outside, on a vaster scale. No European city that I know has been as damaged, its civic experience as brutally compromised, by automobile and driver as Rome.

The traffic of Rome used to be bad, but now it is indiscriminately lethal. Parking in Rome used to be a challenge that required special skills, but now it is almost comically impossible. Of course, it is rendered all the more difficult—in contrast, let's say, to parking in Barcelona—by the near-impossibility of discovering an underground public garage: such amenities do exist, but they are rare, since the city government cannot dig below ground level without invariably encountering some ancient, illegible, and archaeologically superfluous buried ruin from the time of Pompey or Tarquin the Arrogant, an unwelcome discovery which will freeze all future work on the site for all ages to come—*in omnia saecula saeculorum,* as the Church used to say, before it abandoned the Latin for the vernacular Mass.

The most astonishing thing about the city used to be, until recently, the Romans' cavalier disregard for the chief thing that brought so many people there—namely, its deposit of art. People are apt to suppose that a nation which has been left enormous cultural legacies by its ancestors can automatically be assumed to be highly cultivated in the here and now. Italy is one big proof that this is not true.

Most Italians are artistic illiterates. Most people anywhere are; why should Italians be any different? Though once they pretended not to be, today most of them can't even bother to pretend. Many of them see the past as a profitable encumbrance. They like to invoke the splendors of their *patrimonio culturale,* but when it comes to doing anything about them, like turning their considerable energies toward preserving that inheritance in an intelligible way, or even to forming a solid and organized constituency of museumgoers, little or nothing is done, and nothing or little happens.

What the Italian public really cares about is *calcio,* soccer. If an Italian government were crazy enough to try to ban soccer matches, those astounding orgies of hysteria in which hundreds of thousands of fans explode into orgasms of loyalty for this team or that team, the nation would cease to be a nation; it would become ungovernable. Not only does high culture not function as a social glue in this country, it probably has less local pride invested in it than anywhere else in Western Europe. What really count are sport and TV, and their pre-eminence is assured by the fact the Italian prime minister, Silvio Berlusconi, is a multi-multi-millionaire from ownership of both, and seems to have no cultural interests, let alone commitments of any kind, apart from top-editing the harem of blondies for his quiz shows. That is why most Italians can contemplate, with relative equanimity, the very real prospect that their Ministry of Culture's already beleaguered and inadequate budget will be slashed, as is now being suggested, by as much as 30 percent by the year 2012, while its present director is replaced by the present chief of McDonald's. If that happened, how many votes would it cost Berlusconi? A few thousand, a smattering of disaffected aesthetes who never liked him to begin with and can be quite safely disregarded. And tourists, of course. But they cannot vote.

You might say that it has always been this way, but actually it has not. It has gotten worse since the sixties with the colossal, steamrolling, mind-obliterating power of TV—whose Italian forms are among the worst in the world. The cultural IQ of the Italian nation, if one can speak of such a thing, has dropped considerably, and the culprit seems to be television, as it is in other countries. What is the point of fostering elites that few care about? It bestows no political advantage. In a wholly upfront culture of football, "reality" shows, and celebrity games, a culture of pure distraction, it is no longer embarrassing to admit that Donatello, like the temperature of the polar ice cap or the insect population of the Amazon, is one of those things about which you, as a good *molto tipico* Italian and nice enough guy, do not personally give a rat's ass.

Perhaps (one hopefully adds) it only takes two or three artists to reanimate a culture. One cannot simply write a culture off because it has gone into recession, because recessions—as history amply proves—can turn out to be merely temporary. Nevertheless, at this moment, it doesn't look terribly likely. Do I feel this only because I am older, somewhat callused, less sensitive to indications of renewal? Perhaps. But do I feel it because the cultural conditions of the city itself have changed so radically—because,

in a word, the Rome of Berlusconi is no longer (and cannot possibly become again) the Rome of Fellini? That, too, is possible, and indeed more likely. In the meantime, there are at least compensations. The energies of what was once the present may no longer be there. They may have been something of an illusion, as promises and first impacts are fated to be. But the glories of the remoter past remain, somewhat diminished but obstinately indelible, under the *dreck* and distractions of overloaded tourism and coarsened spectacle. Like it or lump it, Rome is there; one cannot ignore it.

There is always a level of delight on which Rome can be enjoyed—unashamedly, sensuously, openly. Is there a solution to the present difficulties and enigmas of Rome? If there is, I freely confess that I have no idea what it might be. So many centuries of history are wound inextricably into the city and confront the visitor, let alone the resident, with apparently insoluble problems of access and understanding. It wasn't built in a day and can't be understood in one, or a week, or a month or year—in however much time you may allot to it, a decade or a guided bus ride. It makes you feel small, and it is meant to. It also makes you feel big, because the nobler parts of it were raised by members of your own species. It shows you what you cannot imagine doing, which is one of the beginnings of wisdom. You have no choice but to go there in all humility, dodging the Vespas, admitting that only a few fragments of the city will disclose themselves to you at a time, and some never will. It is an irksome, frustrating, contradictory place, both spectacular and secretive. (What did you expect? Something easy and self-explanatory, like Disney World?) The Rome we have today is an enormous concretion of human glory and human error. It shows you that things were done once whose doings would be unimaginable today. Will there ever be another Piazza Navona? Don't hold your breath. There is and can be only one Piazza Navona, and, fortunately, it is right in front of you, transected by the streams of glittering water—a gift to you and to the rest of the world from people who are dead and yet can never die. One such place, together with all the rest that are here, is surely enough.

Bibliography

Adcock, F. E. (1960; reprint of 1990) *The Roman Art of War Under the Republic*. New York: Barnes and Noble Reprints.

Ademollo, A. (1883) *Il Carnevale di Roma nei secoli XVII e XVIII*. Rome: A. Sommaruga.

Ades, Dawn, et al., eds. (1996) *Art and Power: Europe Under the Dictators, 1930–45. The Age of Neo-Classicism*. Catalogue to Council of Europe exhibit, London, 1972.

Alberti, L. B. (1965) *On the Art of Building in Ten Books*. Trans. J. Rykwert, et al. Cambridge, Mass., and London: Alec Tiranti.

Amadei, E. (1969) *Le torri di Roma*. Rome: Palombi.

Ammianus Marcellinus. (late fourth century C.E.) *Res gestae*.

Amy, R., and P. Gros. (1979) "La Maison Carrée de Nîmes." In *Gallia-Supplement*, vol. 28. Paris: Éditions du Centre National de la Recherche Scientifique.

Anderson, James C. (1997) *Roman Architecture and Society*. Baltimore: Johns Hopkins University Press.

Angeli, D. (1935) *Roma romantica*. Milano: Treves.

———. (1939) *Le cronache del Caffè Greco*. Milano: Treves.

Appian. (c. 135 C.E.) *Civil Wars*.

Argan, Giulio Carlo, et al. (1992) *Canova: A European Adventure*. Catalogue to exhibit at Correr Museum. Venice: Marsilio Publishers.

Atkinson, Rick. (2007) *The Day of Battle: The War in Sicily and Italy, 1943–1944*. New York: Henry Holt and Co.

Marcus Aurelius. (2005; c. 170) *Meditations*, vol. 2. Trans. Maxwell Staniforth. New York: Penguin.

Augustus. (c. 14 C.E.) *Res gestae*.

Bailey, C., ed. (1947; 7th ed.) *The Legacy of Rome*. New York: General Books.

Ballo, Guido (1958) *Modern Italian Painting, from Futurism to the Present Day*. Trans. Barbar Wall. New York: Frederick A. Praeger.

Barilli, Renato, ed. (1982) *Gli annitrenta: Arte e cultura in Italia*. Milano: Mazzotta.

Barnes, T. D. (1982) *The New Empire of Diocletian and Constantine*. Cambridge, Mass.: Harvard University Press.

Barrett, Anthony. (1998) *Caligula: The Corruption of Power*. New Haven, Conn.: Yale University Press.

Baynes, N. H. (1972) *Constantine the Great and the Christian Church*. London: British Academy Publications.

Beard, Mary, and John Henderson. (2001) *Classical Art from Greece to Rome.* New York: Oxford University Press.

Baracconi, G. (1906) *I rioni di Roma.* Princeton, N.J.: Princeton University Press.

Belli, G. G. (1906) *I sonetti romaneschi.* 3 vols. Castello: S. Lapi Tipografo.

Bergmann, Bettina, and Christine Kondoleon, eds. *The Art of Ancient Spectacle.* Studies in the History of Art, Symposium Paper 34. Washington, D.C.: National Gallery of Art.

Besso, M. (1903) *Roma e il Papa nei proverbi e nei modi di dire.* Firenze: Olschki.

Black, Jeremy, ed. (2003) *Italy and the Grand Tour.* New Haven, Conn.: Yale University Press.

Blunt, A. (1940) *Artistic Theory in Italy.* Oxford: Oxford University Press.

———. (1979) *Borromini.* Cambridge, Mass.: Harvard University Press.

Boardman, J., et al. (1988) *Oxford History of the Classical World.* Oxford: Oxford University Press.

Boatwright, M. T. (1987) *Hadrian and the City of Rome.* Princeton, N.J.: Princeton University Press.

Boccioni, Umberto. (1912) *Manifesto tecnico della scultura futurista.* Milano: Corso Venezia.

Boethius, A. (1960) *The Golden House of Nero.* Ann Arbor: University of Michigan Press.

———. (1978) *Etruscan and Early Roman Architecture.* Harmondsworth: Penguin.

Boni, Ada. (1983) *La cucina romana.* Rome: Newton Compton.

Bonner, Stanley. (1977) *Education in Ancient Rome.* Berkeley: University of California Press.

Borgatti, Mariano. (1890) *Castel Sant' Angelo in Roma: Storia e descrizione.* Rome: C. Voghera.

Bowersock, G. W. (1981) *Augustus and the Greek World.* Oxford: Oxford University Press.

———. (1997) *Julian the Apostate.* Cambridge, Mass.: Harvard University Press.

———. (1999) *Late Antiquity: A Guide to the Postclassical World.* Cambridge, Mass.: Belknap Press.

Borghese, D. (1955) *Vecchia Roma.* London: Prince Olsoufieff.

Bosticcio, Sergio, et al. (1970) *Piazza Navona, isola dei Pamphilj.* Rome: Fratelli Palombi.

Bowder, D., ed. (1980) *Who Was Who in the Roman World, 753 B.C.–A.D. 476.* Ithaca, N.Y.: Cornell University Press.

Bowron, E. P., and J. Rishel, eds. (2003) *Art in Rome in the Eighteenth Century.* London: Merrell Publishers.

Boyle, Nicholas. (1992) *Goethe: The Poet and the Age.* vol. 1, *The Poetry of Desire.* New York: Oxford University Press.

Bradley, K. R. (1987) *Slaves and Masters in the Roman Empire: A Study in Social Control.* New York: Oxford University Press.

Brady, F., and F. Pottle, eds. (1955) *Boswell on the Grand Tour, 1765–66.* London: Heinemann.

Brentano, Robert. (1974) *Rome Before Avignon.* Berkeley, Los Angeles, London: University of California Press.

Brigante Colonna, G. (1925) *Roma papale.* Firenze: Le Monnier.

———. (1936) *La nipote di Sisto V.* Milano: Mondadori.

Broude, Norma. (1987) *The Macchiaioli: Italian Painters of the Nineteenth Century.* New Haven, Conn.: Yale University Press.

Brown, F. E. (1961) *Roman Architecture.* New York: George Braziller.

Brummer, Hans. (1980) *The Statue Court in the Vatican Belvedere.* Stockholm: Haskell, Francis, and Nicholas Penny.

Brunt, P. A. (1988) *The Fall of the Roman Republic.* New York: Oxford University Press.

Bruschi, Arnaldo. (1977) *Bramante.* London: Thames and Hudson.

Campbell, Colen. (1715–25) *Vitruvius Britannicus, or the British Architect.*

Campbell, Duncan. (2003) *Greek and Roman Siege Machinery, 399 B.C.–A.D. 363.* Oxford: Osprey Publishing.

Canons and Decrees of the Council of Trent, Session 25, Dec. 3/4, 1563, *On Sacred Images.*

Carcopino, J. (1939) *La Vie quotidienne à Rome.* Paris: Hachette.

Carducho, Vicente. (1865) *Dialogos de la Pintura.* Madrid.

Cary, M. (1949) *The Geographic Background of Greek and Roman History.* Oxford: Clarendon Press.

Cassius Dio. (c. 229 C.E.) *Historia romana.*

Cattabiani, A. (1990) *Simboli, miti e misteri di Roma.* Rome: Newton and Compton.

Caven, B. (1980) *The Punic Wars.* New York: Palgrave Macmillan.

Ceroni, G. (1955) *I misteri di Roma.* Rome.

Cerqueglini, O. (1939) *Curiosita e meraviglie di Roma.* Rome.

Chirico, Giorgio de. (1971) *The Memoirs of Giorgio de Chirico.* Trans. Margaret Crosland. Miami: University of Miami Press.

———. (1985) *Il meccanismo del pensiero.* Turin: Einaudi.

Chisholm, Kitty, and John Ferguson. (1992) *Rome, the Augustan Age: A Source Book.* New York: Oxford University Press.

Christiansen, Keith. (2008) *Poussin and Nature.* New York: Metropolitan Museum of Art.

Cicero. (55 B.C.E.) *De Oratore,* vol. 2.

———. (55 B.C.E.) *Epistulae ad familiares.*

———. (c. 52 B.C.E.) *De provinciis consularibus.*

Clark, Martin. (1998) *The Italian Risorgimento.* New York: Longman Publishing.

———. (2005) *Mussolini.* London: Pearson.

Clarke, Georgia. *Roman House—Renaissance Palaces: Inventing Antiquity in Fifteenth Century Italy.* Cambridge, U.K.: Cambridge University Press.

Clementi, F. (1939) *Il carnevale romano.* 2 vols. Rome: Tipografia Tibernia di F. Setth.

Clements, Robert J. (1963) *Michelangelo's Theory of Art.* New York: New York University Press.

Cochrane, E. (1981) *Historians and Historiography in the Italian Renaissance.* Chicago and London: University of Chicago Press.

Condivi Ascanio. (1969) *Life of Michelangelo.* Trans. Alice Wohl. University Park: Pennsylvania State Univeristy Press.

Connolly, Peter. (1981) *Greece and Rome at War.* Englewood Cliffs, N.J.: Prentice-Hall.

Connors, Joseph. (1982) *Francesco Borromini*. In *MacMillan Encyclopedia of Architects*, vol. I.

Cowling, Elizabeth, and Jennifer Mundy. (1990) *On Classic Ground: Picasso, Léger, de Chirico and the New Classicism, 1910–1930*. Oklahoma City: Tate Publishing.

Croon, J. H., ed. (1965) *The Encyclopedia of the Ancient World*. Englewood Cliffs, N.J.: Prentice-Hall.

Cunliffe, Barry. (1978) *Rome and Her Empire*. Blacklick, Ohio: McGraw-Hill.

Daly, Gregory. (2002) *Cannae: The Experience of Battle in the Second Punic War*. London: Routledge Publishing.

D'Annunzio, G. (1992) *Le cronache de "La Tribuna."* Bologna: Boni.

D'Arrigo, Giuseppe. (1962) *Roma: Miti, riti, siti, tipi*. Rome.

———. (1964) *Uomini cose fatti leggende di Roma*. Rome.

Davey, Peter. "Outrage—the Vittorio Emanuele II Monument in Rome." *Architectural Review*, Oct. 1996.

Della Pergola, P. (1962) *Villa Borghese*. Rome: Instituto Poligrafico della Stato.

De Santis, L. (1997) *Le catacombe di Roma*. Rome: Newton & Compton.

De Tuddo, I. (1969) *I diavoli del Pantheon*. Rome: Edizioni del Tritone.

Di Castro, E. (1962) *Trastevere*.

D'Onofrio, Cesare. (1962) *Le Fontane di Roma*. Rome: Staderini.

———. (1967) *Gli obelischi di Roma*. Rome: Bulzoni.

———. (1967) *Roma vista da Roma*. Rome: Liber.

———. (1968) *Visitiamo Roma mille anni fa: La città dei mirabilia*. Rome: Roman Society Publishers.

———. (1970) *Il Tevere e Roma*. Rome: Ugo Bozzi.

———. (1973) *Renovatio Romae: Storia e urbanistica dal Campidoglio all'EUR*. Rome: Edizioni mediterranee.

———. (1974) *Scalinate di Roma*. Rome: Staderini.

———. (1978) *Castel S. Angelo e Borgo tra Roma e Papato*. Rome: Ugo Bozzi.

———. (1980) *Il Tevere: l'isola Tiberina, le inondazione, &c*. Rome: Cremonese.

———. (1989) *Visitiamo Roma del Quattrocento: La città degli umanisti*. Rome: Roman Society Publishers.

Duff, J. W. (1960) *A Literary History of Rome from the Origins to the Close of the Golden Age*. Charleston, S.C.: BiblioBaazar.

Duffy, Eamon. (1997) *Saints and Sinners: A History of the Popes*. New Haven, Conn.: Yale University Press.

Dumezil, G. (1970) *Archaic Roman Religion, with an Appendix on the Religion of the Etruscans*. Chicago and London: University of Chicago Press.

Earl, D. C. (1980) *The Age of Augustus*. New York: Exeter Books.

Ellis, P. B. (1980) *Caesar's Invasion of Britain*. New York: New York University Press.

Ellis, Simon P. (2000) *Roman Housing*. London: Duckworth.

Ettlinger, L. D. (1965) *The Sistine Chapel Before Michelangelo*. London: Oxford University Press.

Eutropius. (c. 369–70 C.E.) *Breviarium ab urbe condita*.

Everitt, Anthony. (2003) *Cicero: The Life and Times of Rome's Greatest Politician*. New York: Random House.

————. (2006) *Augustus: The Life of Rome's First Emperor*. New York: Random House.

Fagiolo dell'Arco, Maurizio, and Silvia Carandini. (1977–78) *L'effimero barocco*. 2 vols. Rome: Bulzoni.

Favoretto, Irene. (1992) "Reflections on Canova and the Art of Antiquity." In Giuseppe Pavanello and Giandomenico Romanelli, eds. *Antonio Canova*. Venice: Marsilio.

Ficacci, Luigi. (2000) *Piranesi: The Complete Etchings*. Cologne: Taschen.

Fichera, Filippo. (1937) *Il Duce e il fascismo nei canti dialettali d'Italia*. Milano: Edizione del Convivio.

Finley, M. I. (1987) *Classical Slavery*. London: Frank Cass Publishing.

————, ed. (1968) *Slavery in Classical Antiquity*. New York: Penguin.

Fontana, D. (1590) *Della trasportatione dell'obelisco Vaticano*.

Fossier, Robert, ed. (1986 reprint) *The Cambridge Illustrated History of the Middle Ages, 1250–1520*. Cambridge, U.K.: Cambridge University Press.

Fowler, W. W. (1911) *The Religious Experience of the Roman People*. London: MacMillan.

Fronto, Marcus Cornelius. (c. 150 C.E.) *Elements of History*.

Frontinus, Sextus Julius. (97 C.E.) *De aqueductibus urbis Romae*.

Gabucci, Ada. (2002) *Ancient Rome: Art, Architecture and History*. Trans. T. M. Hartmann. Los Angeles: Getty Trade Publications.

Galassi Paluzzi, C. (1975) *La Basilica di San Pietro*. Bologna: Cappelli.

Gianeri, Enrico. (1945) *Il Cesare di cartapesta: Mussolini nella caricatura*. Torino: Grandi Edizioni Vega.

Gillespie, Stuart. (1988) *The Poets on the Classics: An Anthology of English Poets' Writings on the Classical Poets and Dramatists*. London: Routledge.

Gipriani, Giovanni. (1993) *Gli obelischi egizi: Politica e cultura nella Roma barocca*. Firenze: Olschki.

Giusto, Gerolamo. (1933) *La Marcia su Roma*. Milano.

Gnoli, U. (1935) *Alberghi ed osterie di Roma nella Rinascenza*. Spoleto: C. Moneta.

————. (1941) *Cortigiane romane*. Arezzo: Edizioni della Rivista Il Vasari.

Goethe, Johann Wolfgang v. *Conversations with Eckermann, April 14, 1829*. New York: North Point Press.

————. (1982) *Italian Journey, 1786–1788*. Trans. W. H. Auden and Elizabeth Mayer. New York: Penguin.

Gooch, John. (1986) *The Unification of Italy*. London: Methuen.

Goodman, Martin. (1997) *The Roman World, 44 B.C.–A.D. 180*. London: Routledge.

Grafton, Anthony, ed. (1993) *Rome Reborn: The Vatican Library and Renaissance Culture*. New Haven, Conn.: Yale University Press.

Grant, F. C. (1957) *Ancient Roman Religion*. London, New York: MacMillan General Reference.

Grant, Michael. (1970) *The Climax of Rome*. New York: Plume.

————. (1974) *The Army of the Caesars*. New York: Macmillan.

————. (1978) *The History of Rome*. Englewood Cliffs, N.J.: Prentice-Hall.

————. (1985) *The Roman Emperors: A Biographical Guide to the Rulers of Imperial Rome*. New York: Scribner.

Greenhalgh, Michael. (1989) *The Survival of Roman Antiquities in the Middle Ages*. London: Duckworth.

Gregorovius, F. (1972) *Storia della città di Roma nel Medioevo.* 6 vols. Rome: Newton Compton.

Gregory, Timothy. (2005) *A History of Byzantium.* Hoboken, N.J.: Wiley-Blackwell.

Gulisano, Paolo. (2000) *O Roma o morte! Pio IX e il Risorgimento.* Rimini: Il Cerchio.

Gutman, Daniel. (2006) *El amor judío de Mussolini: Margherita Sarfatti. Del fascismo al exilio.* Buenos Aires: Ediciones Lumiere.

Hager, June. (1999) *Pilgrimage: A Chronicle of Christianity Through the Churches of Rome.* London: Weidenfeld & Nicolson.

Hammond, N.G.L., and H. H. Scullard. (1970) *The Oxford Classical Dictionary.* New York: Oxford University Press.

Haskell, F., and N. Penny. (1981) *Taste and the Antique.* New Haven, Conn.: Yale University Press.

Hayter, Alethea. (1968) *Opium and the Romantic Imagination.* Berkeley: University of California Press.

Hibbard, Howard. "Gian Lorenzo Bernini." In *Macmillan Encyclopedia of Architects.* vol. 1. New York: Harper & Row.

———. (1974) *Michelangelo.* New York: Harper & Row.

Hibbert, C. (1987) *The Grand Tour.* London: Putnam.

Hobhouse, Penelope. (2002) *The Story of Gardening.* London: Dorling Kindersley Publishers.

Hodge, A. Trevor. (1992) *Roman Aqueducts and Water Supply.* London: Duckworth Archaeology.

Holt, Elizabeth. (1982) *A Documentary History of Art.* vol. 2. Princeton, N.J.: Princeton University Press.

Horace. (1965) *Odes I. I.* Trans. J. Michie. London: Macmillan.

Howatson, M. C., ed. (1989) *The Oxford Companion to Classical Literature.* New York: Oxford University Press.

Hulten, Pontus, ed. (1986) *Futurismo & Futurismi.* New York: Abbeville Press.

Jannattoni, L. (1990) *Roma intima e sconosciuta.* Rome: Newton Compton.

Jenkyns, Richard, ed. (1992) *The Legacy of Rome: A New Appraisal.* New York: Oxford University Press.

Johns, Christopher. (2002) "The Entrepôt of Europe: Rome in the Eighteenth Century." In catalogue, *Art in Rome in the Eighteenth Century.* Philadelphia, Pa.: Philadelphia Museum of Art.

Jones, F. L., ed. (1964) *The Letters of Percy Bysshe Shelley.* London: Oxford University Press.

Julian. *The Works of Emperor Julian, Volume III.* Trans. Wilmer C. Wright. Loeb Classical Library. London and Cambridge, Mass.: Harvard University Press.

Justinian. (533 C.E.) *Digesta.*

Juvenal. (early second century C.E.) *Satires,* Book III.

Kagan, D., et al. (1962) *Decline and Fall of the Roman Empire: Why Did It Collapse?* Boston: Heath.

Keegan, John. (1994) *History of Warfare.* New York: Vintage.

Kinney, Dale. (June 2001) "Roman Architectural Spolia." *Proceedings of the American Philosophical Society,* vol. 145, no. 2.

Krautheimer, R. (1980) *Rome: Profile of a City.* Princeton, N.J.: Princeton University Press.

Lactantius. (c. 315 A.D.) *De mortibus persecutorum.*

Lanciani, R. (1901) *The Destruction of Ancient Rome.* London: Macmillan.

La Stella, M. (1982) *Antichi mestieri di Roma.* Rome: Newton Compton.

Lebreton, J., and J. Zeiller. (1949) *The History of the Primitive Church.* 2 vols. New York: Macmillan.

Lechtman, H., and L. Hobbs. (1986) "Roman Concrete and the Roman Architctural Revolution." In *Ceramics and Civilization,* vol. 3, *High Technology Ceramics: Past, Present and Future,* ed. W. D. Kingery. American Ceramic Society.

Leeds, Christopher. (1974) *The Unification of Italy.* New York: Putnam.

Legge, F. (1915) *Forerunners and Rivals of Christianity.* 2 vols. Cambridge, U.K.: Cambridge University Press.

Leppmann, Wolfgang. (1970) *Winckelmann.* New York: Alfred A. Knopf.

Levi, Peter. (1998) *Virgil: His Life and Times.* New York: St. Martin's Press.

Lewis, D. B. Wyndham, and Charles Lee. (1960) *The Stuffed Owl: An Anthology of Bad Verse.* London: Dent.

Lewis, Naphtali, and Reinhold Meyer. (1990) *Roman Civilization, Selected Readings: The Republic and the Augustan Age.* 2 vols. New York: Columbia University Press.

Livy. (1972) *The History of Early Rome.* Trans. Aubrey de Selincourt. Las Vegas: Heritage Press.

Longhitani, Rino. (1938) *La politica religiosa di Mussolini.* Rome: Cremonese.

Lugli, G. (1946) *Roma antica: Il centro monumentale.* Rome: G. Bardi.

MacDonald, W. L. (1976) *The Pantheon: Meaning, Design and Progeny.* London and Cambridge, Mass.: Harvard University Press

———. (1982) *The Architecture of the Roman Empire,* vol. 1. New Haven, Conn.: Yale University Press.

MacDougall, Elizabeth B. (1987) *Ancient Roman Villa Gardens.* Washington, D.C.: Dumbarton Oaks Colloquium.

———, ed. (1981) *Ancient Roman Gardens.* Washington, D.C.: Dumbarton Oaks Research Library and Collection.

MacMullen, R. (1981) *Paganism in the Roman Empire.* New Haven, Conn.: Yale University Press.

———. (1984) *Christianizing the Roman Empire.* New Haven, Conn.: Yale University Press.

Madonna, Maria Luisa, ed. (1993) *Roma di Sisto V.* Rome: Edizioni de Luca.

Magnuson, Torgil. (1986) *Rome in the Age of Bernini.* Atlantic Highlands, N.J.: Humanities Press International.

Malizia, G. (1990) *Le statue di Roma.* Rome: Newton Compton.

———. (1994) *Gli archi di Roma.* Rome: Newton Compton.

Mandowsky, E., and C. Mitchell. (1963) *Pirro Ligorio's Roman Antiquities.* London: Warburg Institute, University of London.

Marchetti Longhi, G. (1960) *L'area sacra di largo Argentina.* Rome: Istituto Poligrafico dello Stato.

Marinetti, F. T. (1991) *The Futurist Cookbook.* San Francisco: Chronicle Books.

———. (1992) *Let's Murder the Moonshine: Selected Writings.* Trans. R. W. Flint and Arthur Coppatelli. Los Angeles: Sun & Moon Press.

Mariotti Bianchi, U. (1996) *I molini sul Tevere.* Rome: Newton & Compton.

———. (1978–83) *Perche a Roma si dice . . .* 3 vols.

Martial. *Epigrams.*

Masson, Georgina. (1972) *The Companion Guide to Rome.* Wilton, Cork, Ireland: Collins Press.

Mastrigli, F. (1929) *Acque, acquedotti e fontane di Roma.* 2 vols. London.

Mazzini, G. (1845) *Italy, Austria and the Papacy.* London.

McDonald, A. H. (1940) *The Rise of Roman Imperialism.* Sydney: Australasian Medical Publishing Company.

McKay, A. G. (1975) *Houses, Villas and Palaces in the Roman World.* London: Thames and Hudson.

McManners, John, ed. (1990) *The Oxford Illustrated History of Christianity.* New York: Oxford University Press.

Meissner, W. W. (1994) *Ignatius of Loyola: The Psychology of a Saint.* New Haven, Conn.: Yale University Press.

Melani, Vasco. (1979; rev. ed.) *Itinerari Etruschi.* Pistoia: Tellini.

Menen, Aubrey. (1960) *Rome for Ourselves.* New York: McGraw-Hill.

Mollat, G. (1949) *The Popes at Avignon, 1305–1378.* Trans. J. Love. London: Nelson Publishers.

Momigliano, A., et al. (1963) *The Conflict Between Paganism and Christianity in the Fourth Century.* Oxford: Clarendon Press.

Moore, John. (1792) *A View of Society and Manners in Italy, with Anecdotes Relating to some Eminent Characters.* Paris: J. Smith English Press.

Morgan, Philip. (2007) *The Fall of Mussolini: Italy, the Italians and the Second World War.* Oxford: Oxford University Press.

Morrogh, Michael. (1991) *The Unification of Italy.* New York: Palgrave Macmillan.

Murray, Peter. (1963) *Donato Bramante.* New York: Frederick A. Praeger.

Mussolini. (1951–62) *Opera Omnia.* Firenze: La Fenice.

Nicholas, B. (1962) *An Introduction to Roman Law.* Oxford: Clarendon Press.

Nichols, Fr. (1986) *Mirabilia Urbis Romae.* New York: Italica Press.

Nicoloso, Paolo. (2008) *Mussolini architetto: Propaganda e paesaggio urbano nell'Italia fascista.* Italy: Einaudi.

Ogilvie, R. M. (1976) *Early Rome and the Etruscans.* Atlantic Highlands, N.J.: Humanities Press International.

Oldenbourg, Zoé. (1998) *Massacre at Montségur.* New Haven: Phoenix Press.

Onians, J. (1988) *Bearers of Meaning: The Classical Orders in Antiquity, the Middle Ages and the Renaissance.* Princeton, N.J.: Princeton University Press.

Osborne, John, trans. (1987) *Master Gregorvus: The Marvels of Rome.* Toronto: Pontifical Institute of Mediaeval Studies.

Ovid. (1954) *Metamorphoses.* Trans. Rolfe Humphries. Bloomington: Indiana University Press.

———. (1957) *The Loves.* Trans. Rolfe Humphries. Bloomington: Indiana University Press.

———. *Tristia*. Trans. J. Ferguson. (1980)

Painter, Borden W. (2005) *Mussolini's Rome: Rebuilding the Eternal City*. New York: Palgrave Macmillan.

Palladio, Andrea. (1997) *The Four Books of Architecture*. Cambridge, Mass.: MIT Press.

Parks, George B. (1954) *The English Traveler to Italy*. 2 vols. Palo Alto: Stanford University Press.

Pepper, D. Stephen, et al. (1988) *Guido Reni, 1525–1642*. Navora: Istituto Geografico De Agostini.

Perowne, S. (1966) *The End of the Roman World*. London: Hodder & Stoughton.

Petrie, A. (1918) *An Introduction to Roman History, Literature and Antiquities*. London.

Pietrangeli, Carlo, et al. (1992) *The Sistine Chapel: A Glorious Restoration*. New York: Abrams.

Pliny. (c. 77 C.E.) *Naturalis historiae*.

Plutarch. (75 C.E.) *Life of Aemilius Paullus*.

———. (75 C.E.) *Life of Cato the Elder*.

———. (75 C.E.) *Life of Crassus*.

Polybius. *The Histories*.

Pomeroy, Sara. (1975) *Goddesses, Whores, Wives and Slaves: Women in Classical Antiquity*. New York: Schocken.

Ponteggia, Elena, ed. (1997) *Da Boccioni a Sironi: Il mondo di Margherita Sarfatti*. Milano: Skira.

Pound, Ezra. (1935) *Fascism As I Have Seen It*. New York: Stanley Nott.

Propertius, Sextus. (c. 15 C.E.) *Elegiae*.

Rawson, E, ed. (1985) *Intellectual Life in the Late Roman Republic*. Baltimore: Johns Hopkins University Press.

Rendina, Claudio. (1984) *I Papi: Storia e segreti*. Rome: Grandi Tascabili Economici Newton.

———. (1987) *Il Vaticano: Storia e segreti*. Rome: Grandi Tascabili Economici Newton.

———. (1991) *Pasquino: Statua parlante*. Rome: Grandi Tascabili Economici Newton.

———. (2006) *Guida insolita ai misteri . . . di Roma*. Rome: Grandi Tascabili Economici Newton.

Riall, Lucy. (1994) *The Italian Risorgimento: State, Society and National Unification*. London: Routledge.

———. (2007) *Garibaldi: Invention of a Hero*. New Haven, Conn.: Yale University Press.

Richardson, E. (1976) *The Etruscans: Their Art and Civilization*. Chicago: University of Chicago Press.

Richardson, L., Jr. (1992) *A New Topographical Dictionary of Ancient Rome*. Baltimore: Johns Hopkins University Press.

Rizzo, Maria Antonietta, ed. (1989) *Pittura Etrusca al Museo di Villa Giulia*. Rome: De Luca Edizioni D'Arte.

Robinson, J. H. (1904) *Readings in European History*. Essex: Ginn & Co.

Rose, H. J. (1948) *Ancient Roman Religion*. London: Hutchinson's University Library.

Rosenberg, P., and K. Christiansen. (2008) *Poussin and Nature: Arcadian Visions.* New Haven, Conn.: Yale University Press.

Rostovtzeff, M. (1960) *Rome.* New York: Oxford University Press.

Schiavo, Alberto. (1981) *Futurismo e fascismo.* Rome: Giovanni Volpe.

Seltzer, Robert M., ed. (1987) *Religions of Antiquity.* New York: Macmillan.

Seneca. (c. 64 C.E.) *Epistulae morales ad Lucilium.*

Smith, Denis Mack. (1969) *Garibaldi.* Englewood Cliffs, N.J.: Prentice-Hall.

———. (1981) *Mussolini.* New York: Alfred A. Knopf.

———. (1985) *Cavour.* New York: Alfred A. Knopf.

———. (1988) *The Making of Italy, 1796–1870.* New York: Palgrave Macmillan.

Sozomen. (C. 440–43 C.E.) *Ecclesiastical History.*

Stack, Frank. (1985) *Pope and Horace: Studies in Imitation.* Cambridge, U.K.: Cambridge University Press.

Starr, C. G., Jr. (1982) *The Roman Empire, 27 B.C.–A.D. 476.* New York: Oxford University Press.

Statius. (c. 89–96 C.E.) *Silvae.*

Stockton, D. (1979) *The Gracchi.* New York: Oxford University Press.

Savona, A. Virgilio, and Michele L. Straniero. (1979) *Conti dell'Italia fascista.* Milan: Garzanti.

Suetonius. (1902; 110 C.E.) *The Life of Caligula.* Trans. J. C. Rolfe. Cambridge, Mass.: Harvard University Press.

———. (1914; 121 C.E.) *Claudius.* Trans. J. C. Rolfe. New York: Macmillan.

———. (2003; 121 C.E.) *Augustus.* Trans. R. Graves. New York: Penguin.

Tacitus. (109 C.E.) *Annales.*

Thompson, David, ed. (1971) *The Idea of Rome from Antiquity to the Renaissance.* Albuquerque: University of New Mexico Press.

Tinniswood, Adrian. (1998) *Visions of Power: Ambition and Architecture from Ancient Rome.* London: Mitchell Beazley.

Tinterow, Gary, and Philip Coningsbee, eds. (1999) *Portraits by Ingres: Image of an Epoch.* New York: Metropolitan Museum of Art.

Torselli, Giorgio, ed. (1981) *Trastevere.* Rome: Multigrafica Publishers.

Toynbee, A. (1965) *Hannibal's Legacy: The Hannibalic War's Effect on Roman Life.* London: Oxford University Press.

Ullmann, Walter. (1955) *The Growth of Papal Government in the Middle Ages.* London: Methuen.

Valerio, Anthony. (2001) *Anita Garibaldi: A Biography.* Westport, Conn.: Praeger.

Valla, Lorenzo. (1518) *De Falso Credita et Ementita Constantini Donatione Declamatio.* Mainz.

Varro. (c. first century B.C.E.) *De lingua latina.*

Vasari, Giorgio. (1550) *Le vite.* Florence.

Virgil. (29–19 B.C.E.; 1952) *The Aeneid of Virgil.* Trans. C. Day Lewis. London: Hogarth Press.

———. (29 B.C.E.; 1940) *The Georgics of Virgil.* London: Jonathan Cape.

———. (c. 39–38 B.C.E.; 1963) *The Eclogues of Virgil.* Trans, C. Day Lewis. London: Jonathan Cape.

Vitruvius. *On Architecture.* Trans. Frank Granger. 2 vols. Loeb Classical Library. London and Cambridge, Mass.: Harvard University Press.

Walpole, Horace. (1786) *Anecdotes of Painting in England.* London.

Wardman, A. (1976) *Rome's Debt to Greece.* London: Paul Elek.

Weiss, R. (1969) *The Renaissance Rediscovery of Classical Antiquity.* Oxford: Basil Blackwell.

Westermann, W. L. (1955) *The Slave Systems of Greek and Roman Antiquity.* Philadelphia: American Philosophical Society.

Westfall, Carroll W. (1974) *In This Most Perfect Paradise: Alberti, Nicolas V and the Invention of Conscious Urban Planning in Rome, 1447–55.* University Park: Pennsylvania State University Press.

Wheeler, R. E. (1965) *Roman Art and Architecture.* New York: Praeger.

Wilken, R. I. (1984) *The Christians As the Romans Saw Them.* New Haven, Conn.: Yale University Press.

Wilkinson, L. P. (1968) *Horace and His Lyric Poetry.* Cambridge, U.K.: Cambridge University Press.

Wilton-Ely, John. (1978) *The Mind and Art of Giovanni Battista Piranesi.* London: Thames and Hudson.

Wittkower, R. (1988) *Architectural Principles in the Age of Humanism.* London, New York: St. Martin's Press.

Zanker, P. (1988) *The Power of Images in the Age of Augustus.* Ann Arbor: University of Michigan Press.

Zonaras, Joannes. (12th century) *Epitome historion.*

Index

Illustration Credits

A NOTE ON THE TYPE

This book was set in Garamond. This version was designed for the Adobe Corporation by Robert Slimbach (born 1956), and is based on types first cut by Claude Garamond (c. 1480–1561). Garamond, a pupil of Geoffroy Tory, modeled his letter on the types of the Aldine Press in Venice, but he introduced a number of important differences, and it is to him that we owe the letter now known as "old style."

Composed by North Market Street Graphics, Lancaster, Pennsylvania
Printed and bound by Berryville Graphics, Berryville, Virginia
Designed by Peter A. Andersen with Laura Crossin